THE ARTIST IN THE MODERN WORLD

Ich wollte Künstler werden:

Ich träumte davon, in der Zeitung zu stehen, von viele
Ausstellungen, und natürlich wollte ich
etwas "Neues" in der Kunst machen.
Mein Leitfaden war der Egoismus.

Oskar Bätschmann

The Artist in the Modern World
The Conflict Between Market and Self-Expression

DUMONT

Cover illustration: Bruce Nauman, *The True Artist Helps the World by Revealing Mystic Truths*, 1967
Frontispiece: Jörg Immendorff, *Ich wollte Künstler werden ... (I wanted to become an artist)*, 1972

Library of Congress Cataloging-in-Publication Data

Bätschmann, Oskar, 1943 – [Ausstellungskünstler. English]
 The artist in the modern world:
 the conflict between market and self-expression / Oskar Bätschmann.
 p. cm.
 Includes bibliographical references and index.
 ISBN 0-300-07323-2 (Eng. edit.). – ISBN (invalid) 3-7701-4042-9 (Germ. edit.)
 1. Artists - Psychology. 2. Art - Exhibitions. 3. Art - Marketing. I. Title
N71.B36513 1997 97-38047
701'. 15–dc21 CIP

© 1997 DuMont Buchverlag, Cologne
© 1997 VG Bild-Kunst, Bonn, for the works of the artists Max Beckmann, Emile Bernard, Joseph Beuys, Louise Bourgeois, Maurice Denis, Marcel Duchamp, Rebecca Horn, Ilya Kabakov, Wassily Kandinsky, Paul Klee, Yves Klein, Wilhelm Lehmbruck, El Lissitzky, Edvard Munch, Bruce Nauman, Joseph Maria Olbrich, Pablo Picasso, Jackson Pollock, Robert Rauschenberg, Richard Serra, Jean Tinguely, Andy Warhol, Wols
Distributed throughout the world by: Yale University Press
Translation: Eileen Martin
Copy editing: Pauline Cumbers
Cover design: Groothuis + Malsy, Bremen
Composition and printing: Rasch, Bramsche
Binding: Bramscher Buchbinder Betriebe

Printed in Germany ISBN 0-300-07323-2

CONTENTS

FOREWORD

I began working on this book in 1990/91, as a Getty Scholar at the Getty Center for the History of Art and the Humanities. I am grateful to the first Director of the Getty Center, Kurt W. Forster, and the Head of the Scholar Program, Herb H. Hymans, for this major promotion of my project. The initial idea for a study of the history of the modern artist arised out of an invitation from Michael Groblewski to the symposium "Kultfigur und Mythenbildung" (The Cult Figure and Myth Formation) in 1989 in the Hessisches Landesmuseum in Darmstadt. The Swiss National Science Foundation supported the work from 1993 to 1996 by approving funding for a research assistant. The Center for Advanced Study in the Visual Arts (CASVA) of the National Gallery, Washington D.C. and its Director, Henry A. Millon, enabled me to carry out extensive research in the National Gallery and the Archives of American Art, by awarding me a Paul Mellon Senior Fellowship in 1995. The invitation from Régis Michel to the Colloque International Géricault in 1991 in the Louvre gave me an opportunity to present new ideas on Géricault as an exhibition artist, while a guest professorship at the École des Hautes Études en Sciences Sociales in Paris in 1992 provided the opportunity for a discussion on the initial outlines with my friend, Louis Marin, and with Hubert Damisch, Hans Belting, and students. I very greatly appreciated invitations to lecture at the universities of Stanford, Berkeley, Düsseldorf and Freiburg i. Br. and at the Bibliotheca Hertziana in Rome in 1995. The discussions and the criticism that followed my papers were encouraging and helped to point the direction. My thanks go particularly to Svetlana Alpers, Michael Baxandall, Lorenz Eitner, Michael Fried, Francis Haskell, Matthias Winner, Wilhelm Schlink and Hans Körner. The Séminaire du 3ème cycle, which was held in 1994 in cooperation with the art history institutes at the universities of Lausanne, Geneva, Lyons, Neuchâtel, Fribourg and Bern, was very fruitful, and culminated in the C.I.H.A. colloquium on "L'image de l'artiste" in Lausanne.

I owe warm thanks to numerous colleagues and friends for suggestions, help and critical discussion, among them Albert Boime, Petra Ten-Doesschate Chu, Elizabeth Cropper and Charles Dempsey, Françoise Forster-Hahn, Barbara and Thomas Gaehtgens, Dario Gamboni, Georg Germann, Pascal Griener, Andreas Hauser, Philippe Junod, Wolfgang Kemp, Eberhard W. Kornfeld, Jacqueline Lichtenstein, Hubert Locher, Hans A. Lüthy, Michael Podro, Wolfgang Pross, Herwarth Röttgen, Reinhard Steiner, Victor I. Stoichita, Pierre Vaisse, Richard Verdi, Martin Warnke and O.K. Werckmeister.

The book could never have been written without the many ideas and committed support of my research assistants, Peter Johannes Schneemann and Anita Haldemann. They also helped in the preparation of the lectures and seminars which I gave in connection with the project, and which led

to many stimulating discussions with the students at the University of Bern. Some students continued to work on the ideas in their final papers; they are Sandra Bachmann, Karin Frei, Thomas Schmutz and Bernadette Walter. I am also grateful for the reliable cooperation I received from Küngolt Bodmer, Myriam Chuard, Dolores Denaro, Danièle Héritier, Bernadette Walter and Kurt Girard.

INTRODUCTION

The idea of writing a history of the modern artist and his relation to exhibitions first evolved from a letter written in 1790 by Henry Fuseli to his patron William Roscoe. Fuseli had emigrated to England from Switzerland, and in this letter he comments, not without envy and disdain, on a statement by the american painter Benjamin West on how to be successful as an artist: "There are, says Mr. West, 'but two ways of working successfully, that is, lastingly, in this country, for an artist – the one is, to paint for the king; the other, to meditate a scheme of your own'. The first he has monopolized; in the second he is not idle: ... In imitation of so great a man, I am determined to pay, to hatch, and crack an egg for myself too, if I can. What it shall be, I am not yet ready to tell with certainty; but the sum of it is, a series of pictures for exhibition, such as Boydell's and Macklin's." Fuseli's vague plan took concrete shape in the Milton Gallery, which he opened in imitation of John Boydell's Shakespeare Gallery.[1]

Fuseli's letter documents the change in the career pattern of the professional artist from a post at court to work for public exhibitions. The change occurred in the second half of the eighteenth century, mainly in France and England. The exhibition artist became established as the new main type, replacing both the court artist and the artist who maintained a commercial workshop or studio, accepting commissions from various patrons or painting for the market.[2] The change only became possible when exhibitions were institutionalized and the public emerged as the new recipient for works of art and the new power in the art world. Journalist art critics responded to the competition between artists by claiming to express public opinion.[3] At the same time the traditional patrons, the church, the princes and the wealthy, acknowledged the public forum by exhibiting commissioned works before taking them into their private possession. Success at an exhibition became the main criterion by which prospective purchasers, patrons, and perhaps the artists themselves, judged.

The development in exhibitions from an annual event on a public holiday to the exclusive medium for the presentation of art, the emergence of the public and public criticism, and the orientation of artists to exhibition work, was the most decisive and consequential change in the art world since the Renaissance. Artists had to define, legitimate and finance their work in public competition with each other. Generally, the court artists were appointed to a position by contract, and the studio artists had contracts for commissions, stating the price. The patron could prove to be difficult, moody or a bad payer, and the court artist could also find himself at the mercy of advisers and intriguers.[4] The studio artist had to adjust to the changing demands of patrons and the requirements of the market.

The exhibition artist, on the other hand, worked at his own risk, to be judged by an unknown recipient, who could not always be accused of ignorance and a one-sided view. To calculate or steer public reaction,

which could vary between aggressive disdain and enthusiasm or even accla-
mation, new strategies had to be developed. The exhibition as a forum for
rivalry and an arena where artists fought for recognition intensified compe-
tition between artists. To be successful the exhibition artist had to be the
subject of public discussion, had to find access to the media and project an
interesting image to accompany his works. He was and is forced to win
from the exhibition-going public followers of like mind, media support,
buyers and patrons; and if necessary he must go to court to defend his in-
terests.[5]

The exhibitions immediately gave rise to the suspicion that artists could
be corrupted by money, mass taste, cheap applause and the pressure to suc-
ceed in the competitive art world. In 1782 Valentine Green accused the
painters Benjamin West and John Singleton Copley of speculating in exhi-
bition pieces to attract the masses and for pecuniary gain.[6] In 1855, the year
of the World Exhibition in Paris, Etienne-Jean Delécluze called the public
exhibitions bazaars, and the reason for the decline of the arts.[7] But in 1867
Edouard Manet stated that exhibitions were simply a matter of survival for
artists, not only in relation to income but because the public were a stimu-
lus and a challenge.[8] However, by 1919 Walter Gropius was calling the
bourgeois exhibition the prostitution of art, and the De Stijl group demand-
ed its replacement by interior spaces demonstrating collaborative designs.[9]

One problem is how this form of presentation and recognition affected
artists' image of themselves and their output.[10] Another, more difficult pro-
blem, is to see the new structure of the art system as inspiration and moti-
vation for artistic work. That this is necessary is evident from the fact that
in the eighteenth century the exhibition piece was invented, in the nine-
teenth the exhibition as work of art, and in the twentieth exhibition art.

In recent years a large number of publications have been concerned with
the history of exhibitions, the presentation of works of art and the propa-
ganda function of exhibitions.[11] Critical analysis has focussed not so much
on the history of exhibitions as on the effects on artists and art, although the
institutionalization of exhibitions opens up almost the whole problem of
modern art. This book is concerned with the aspects of presentation and
production, with the image of the artist, and with the public and critics.
"Modern" is used without emphasis to describe an event that we can, with
reason, see as in direct historical relation to the present. It is possible to
describe the change of 1750 as a revolution in the social system of art.[12]
Some methodological problems arise in relation to historiography. Those
that can be solved can be handled using the model of Pierre Bourdieu's
relational analyses of relatively autonomous social fields,[13] but the combina-
tion of relational analyses and history is an experiment. I regard it as all the
more important to venture upon such experiments as the information
accessible through networks and data banks becomes seemingly illimitable,
while the refinement of the instruments to process the information fruitful-
ly does not keep step with this expansion.[14]

NOTES

1. Knowles 1831, Vol. 1, pp. 174-175. - On Boydell's Shakespeare Gallery and the Milton Gallery see Ch. 5 below.

2. Warnke 1985; Haskell 1963; Baxandall 1972; Alpers 1988.

3. Habermas 1962 (1971), §§ 12, 24, pp. 112-127, 278-287; Germer/Kohle 1991.

4. Stefano Bottari analysed the difficult relations between patrons and artists in 1754: Bottari 1770.

5. Cf. the famous dispute between Whistler and Ruskin in 1877; Whistler 1892; Merrill 1992.

6. Green 1782, pp. 50-51.

7. Delécluze 1855 (1983), pp. 324-325: "C'est depuis cette institution surtout que les salons du Louvre ont pris d'année en année le caractère d'un bazar, où chaque marchand s'efforce de présenter les objets les plus variés et les plus bizarres, pour provoquer et satisfaire les fantaisies des chalands. Cet usage des expositions publiques combinées avec la formation des musées, qui date à peu près du même temps, ont anéanti l'effet moral que pouvait avoir la peinture sur les masses."

8. Manet 1867, cf. pp. 131-137.

9. Gropius 1988, vol. 3, pp. 66-70 (answers to the questionnaire from the Works Council for Art, 1919); Ahlers-Hestermann 1921; Westheim 1923, pp. 17-33, esp. p. 24. - Jaffé 1967, pp. 164-167.

10. O'Doherty 1976 and 1996; Kemp 1983.

11. Koch 1967; Holt 1980, 1982, 1988; Haskell 1981; Whitely 1981; Forster-Hahn 1985; Mainardi 1987 and 1993; Mai 1986; Stationen 1988; Klüser/Hegewisch 1992; Altschuler 1994; Drechsler 1996.

12. Luhmann 1984; Luhmann 1995; Schmidt 1987.

13. Bourdieu 1992.

14. Oechslin 1994, esp. pp. 14-23.

I THE EXHIBITION AS A MEDIUM FOR THE PRESENTATION OF ART

Institutionalizing Exhibitions

The Académie royale de Peinture et de Sculpture in Paris was not very enthusiastic about the exhibitions which the Vice-Protector Jean-Baptiste Colbert demanded in the new statutes he issued in 1663: The members of the Academy had to adorn the main salon in the Hôtel Brion with their works for the annual meeting in July.[1] Their resistance is evident from the threat of sanctions and the later amendment of the order to a bi-annual exhibition. The well-meant advice from Gian Lorenzo Bernini, which was based on the exhibition practice of the Accademia di San Luca in Rome, presumably strengthened the passive resistance of the French artists.[2] To the artists in the Academy, exhibiting their works must have seemed fatally like offering goods for sale, the practice of the artisans.[3] During the reign of Louis XIV (1661-1715) only six exhibitions were held, first on the Academy's premises in the Hôtel Brion, and then in the court of the Palais Royal. In 1699 and 1704 they were in the Grande Galerie of the Louvre. From 1725 to 1848 the exhibitions were held near the Academy's new premises, in the Salon Carré of the Louvre (fig. 1), and it is from these exhibitions that the name "Salon" for the official exhibition in Paris derives.[4]

1. Gabriel de St. Aubin, *View of the Salon in the Louvre of 1753*

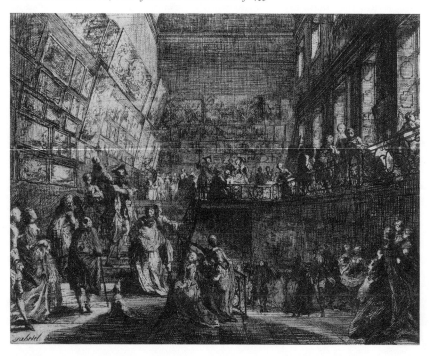

The *Mercure de France* first demanded that the Academy mount a public exhibition in 1735, claiming to speak on behalf of the general public. But it was not until 1737 that the members were prepared to respond, and then it was on express orders from the King. They published a catalogue, and continued to hold the Salon at intervals of one or two years until 1848.[5] Except for the year 1791, only the members of the Académie royale were permitted to exhibit. In response to criticism in 1747 a jury was appointed in 1748 to select the works. Until 1900 women were not admitted to classes at the Academy, but at times a limited number were accepted as members and allowed to exhibit. Between 1725 and 1755 no paintings by women artists were shown, but after that one or two women artists regularly showed their work in the Salon, except for the year 1761. Fourteen women artists exhibited at the first Salon during the French Revolution, in 1791.[6]

From 1737 a catalogue with commentary (livret) entitled *Explication des Peintures, Sculptures et Gravures de Messieurs de l'Académie royale* replaced the previous brief list of titles. The livrets of 1737 to 1789 state on the title page that the exhibition has been ordered by the Director-General of the Royal Buildings, Gardens, Arts, Academies and Manufactures at the express wish of the King.[7] The livrets enjoyed extraordinary success and huge editions were sold.[8]

The forewords to the lists and catalogues published by the Academy often describe the exhibitions as festive occasions. This would appear to reflect their origin as a cult, remnants of which had survived particularly in Italy.[9] Only after 1737 did the Académie royale realize that the Salon was an excellent vehicle for conveying its art policy, and from then until the French Revolution the members used the Salon to establish their views on art and underpin their claim to a monopoly in the art world. Each exhibition provided an occasion to display the hierarchy of the Academy artists and present the main types of painting. In 1776 the Academy succeeded in having exhibitions by the Guild of Painters and Sculptors banned and thus eliminating odious competition. The Guild's art school, the Académie de Saint-Luc, had already been banned in 1664, but it repurchased its right to operate in 1705 for the huge sum of 20,000 livres. From 1751 to 1774 it mounted seven exhibitions in competition with the Académie royale, open to all artists on payment of an exhibition charge.[10] The Academy did tolerate the Young Artists' exhibition, which was held on Corpus Christi in the Place Dauphine (fig. 2).[11]

How undecided and vacillating the attitude of the Academy was to the general public is evident from the forewords to the exhibition catalogues. In 1699 the members said they were eager to see the public's reaction. In 1737 they felt bound to praise the public for their enlightened and impartial response, while indicating as a precautionary measure, so to speak, that this should be limited to pleasure in the spectacle and respect for the works and the artists.[12] The foreword to the livret of 1745 elevated the public to an incorruptible authority, endowing its praise and criticism without prejudice or interest, and letting even the most celebrated artists feel its displeasure.[13]

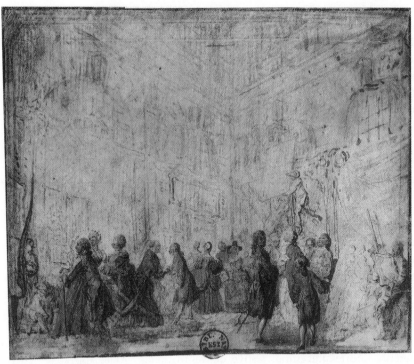

2. Gabriel de St. Aubin, *The Young Artists' Exhibition on the Place Dauphine 1769*

The prints and drawings of the exhibitions that were made in Paris and London paid much attention to the public, depicting manners and behaviour in great detail. Some illustrators concentrated on the contrast between the elegant ladies, the amateurs with catalogues in eager discussion and the gouty, bespectacled critics, casting their eagle eye on the works, or the ingenuous amateurs.[14]

The drawings and prints depicted the new public for art and the new authority it represented long before any written analyses were made. Satirical writers, on the other hand, noted the terrible din and the pestilential smell of the mass. The problem was complex. The public was a new social body and it formed an authority counter to the Academy, with its hidden network of links with artists and critics. Anyone could speak out for the public or against its judgement, public opinion could be mocked, flattered or manipulated to direct taste.[15] The Academy found it extremely difficult to acknowledge the new power of the public. To praise it as an incorruptible body, as in the livret of 1745, was contrary to the belief secretly held by the members of the Academy that visitors to the exhibitions were incapable of judging art. Indeed, from the very start, the attitude of the artists to the public as the new authority was loaded with flattery, lies, insults, role assignments, and attempts to restrict or control the power it could wield.[16] That was not only the case in France. The satirical depiction of the middle class public printed by Richard Earlom from a drawing by Charles Brandoin in

1772 (fig. 3) pokes fun at the lady illicitly flirting, the pot-bellied connoisseur, the emaciated, short-sighted critic and the gentlemen in serious discourse. The ideals of art are ironically contrasted with reality, and James Barry's *The Temptation of Adam* is elevated above the various couples in the room beneath it.[17] On the other hand, in 1754 the critic La Font de Saint-Yenne commented that the public lacked a knowledge of history, so pictures should be simple and easy to understand, or at least explanatory inscriptions should be provided.[18]

Public exhibitions were seen as the ideal way to promote the arts and artists, while the presentations of the Académie de Saint-Luc were intended to attract customers and sell the works. The effect of competition in promoting the arts and artists had been stressed on every occasion since 1699. The foreword to the livret of 1745 maintained that nothing was more likely to create competition between the arts and stimulate talent than public exhibitions. The European schools were included in the comparison, and the Paris Académie stated unequivocally that the Salon confirmed the pre-eminence of the Ecole française.[19] Architectural project paintings appear to have been included for the first time in the Salon of 1759, but it was only after 1793 that a section was devoted to architecture.[20] The architect Charles de Wailly exhibited his projects outside the Salon in 1760, in order, like Apelles, to learn the views of the public and draw the attention of potential clients to his work.[21] Charles Lévesque described two advantages of competition in his

3. Richard Earlom, *The exhibition of the Royal Academy of Painting in the year 1771*

4. Hubert Robert, *Project for the Decoration of the Great Gallery in the Louvre in 1796*

article *Exposition* of 1788: he believed that the stupid and the knowledge-able verdicts would finally culminate in proper public recognition of true talent, and that public competition between artists would prevent talent from withering away in the lonely life of the studio.[22]

So the Salons motivated artists to work hard in the service of their art and to win public regard, but they did not motivate them to earn money. The public Salon was a transition stage for the artists, the works were ultimately destined for private collections or the King. Around the middle of the century, however, the idea of public ownership of cultural works began to emerge in contrast to the idea of art as private embellishment. In 1750 the royal collection of paintings that had been in Versailles was moved to the Orangerie of the Palais du Luxembourg in Paris, and until 1779 it was open to the public on two days a week.[23] The Museo Capitolino in Rome was opened to the public earlier, in 1734, and in 1739 the last of the Medici bequeathed his collections to the City of Florence. In Germany the first museums were built in Dresden, Düsseldorf and Kassel. The idea of the public's right to share in the princely collections of art was spreading in Europe. In 1765 the Chevalier de Jaucourt reminded the readers of the *Encyclopédie* that the citizen had a historical right to the enjoyment of art, and in 1772 Sulzer demanded that the princes should promote the arts for the benefit of all and not appropriate them for their private pleasure.[24]

The realization of a project in preparation before the Revolution, namely, the establishment of a public museum in the Louvre, was decided immedi-

ately after the collapse of the monarchy in 1792. It was in 1791 preceded by the confiscation of Church property and all the artistic monuments for the nation, and the declaration of the Louvre as the national palace of the arts and sciences. The Museum of the Republic (Museum Français) was opened in 1793. Its collection was later greatly enlarged by the revolutionary confiscations and the booty amassed during the Napoleonic wars (fig. 4), particularly under the direction of Dominique Vivant-Denon from 1803 to 1814.[25] When the Musée du Luxembourg was opened in 1818, reserved for paintings and sculpture of the École moderne de France, artists in France could aspire to having their works on permanent public display during their lifetime.[26] This was the first museum of contemporary art, and it perpetuated the temporary exhibition of works which the state had deemed worth purchasing. Their subsequent transfer to the Louvre could follow as the apotheosis.

Satisfying Public Taste

The general public first had to define its behaviour and its tasks as the designated addressee of art exhibitions.[27] The early pictorial records of exhibitions illustrate a variety of attitudes, but the sparse written comments do not give us a precise idea of the effect of the works on the public or how they were judged. Exhibitions should be entertaining, it was felt, and the journalists expressed the public's desire for this. They also speak of the diffuse power of the public, but there are no contemporary surveys or analyses of the public's behaviour, its self-image, expectations or judgements. Some indication may be gained from what can be called "the Pygmalion approach". We can find evidence of this in art works and in statements on how art should be viewed, in writings, and finally in a fashionable manner of reception. The story of Pygmalion is told in Ovid's *Metamorphoses*. Pygmalion is a sculptor who makes a female statue and falls in love with it; he then succeeds in persuading Venus to bring the statue miraculously to life. Around 1750 the legend became very popular in literature, music and the fine arts.[28] Artists used it to illustrate an approach to art; they also saw Pygmalion as exemplifying identification with the artist and the artist's responsibility for the work of art he had created.

The Pygmalion approach can be described as "admiratio", wonder and admiration. The *Encyclopédie* of Diderot and d'Alembert includes an entry on "Admiration" in its supplementary volume 1 of 1776, which summarizes Sulzer's term "Bewundrung". "Admiration" in the fine arts is described as "a strong feeling which arises in the soul on the contemplation of an object that exceeds our expectations." With reference to Henry Home's *Elements of Criticism,* this intellectual passion is subdivided into "étonnement" and "admiration", the former being defined as a reaction to reality exceeding expectation, and the latter as "emotion arising from the contemplation of an extraordinary and incomprehensible force".[29]

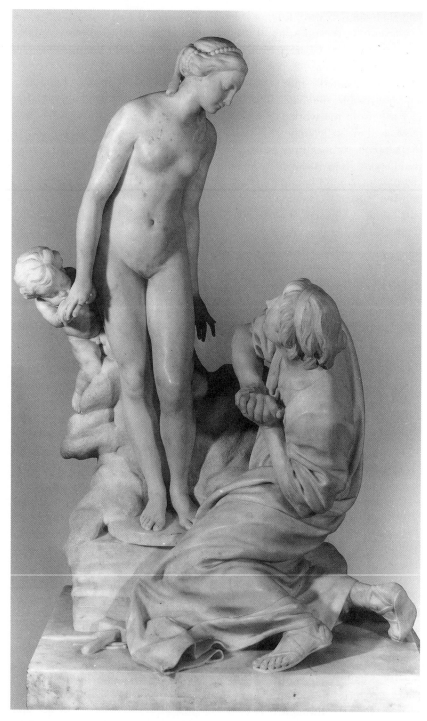

5. Etienne-Maurice Falconet, *Pygmalion at the Feet of the Statue as it comes to Life*,
Salon of 1763, replica

In the Salon of 1763 Etienne-Maurice Falconet showed a marble group *Pygmalion* (fig. 5), consisting of the statue, now come to life, the worshipping sculptor and Amor.[30] Denis Diderot wrote a long article on it for the *Correspondance littéraire*, expressing the wish to see the group in isolation in order to enjoy it the more, and maintaining that he did indeed see living flesh, not marble; the material had undergone a magic transformation. Diderot passes from the work *Pygmalion* to the creator of the group; he calls out to him and mentally embraces him.[31] This affinity with the artist is disrupted by the recollection of Prometheus, the creator of man and woman punished by the gods. He is the subject of *Prometheus Bound* by Nicolas-Sébastien Adam, which stood beside the Pygmalion group.[32] This puts an end to the embrace and takes Diderot to his aesthetic appreciation, which is speedily ended with an emotional outburst: "Oh! How unhappy is the condition of an artist! How pitiless and shallow are the critics!"[33] While Diderot recommends that Adam's work should be handed over to an executioner or an anatomist to be smashed to pieces, Falconet's group reminds him of a torso by Phidias, a fragment deserving the fullest veneration. The image of the work of art destroyed takes Diderot back to the idea of admiration, and he changes from being a viewer to being an artist by inventing a different composition for the group.[34]

Falconet's group is an exemplary case of a work of art that invites admiration, and Diderot's text is an excellent example of the Pygmalion approach. Through his emotional identification with Pygmalion and his rejection of criticism the viewer achieves a direct relation with the artist. The effect of erotic fantasies is less marked with Diderot than it is with Johann Joachim Winckelmann or his young follower Hans Heinrich Füssli.[35]

Winckelmann begins his description of the *Belvedere Torso* (fig. 6) of 1759 with the mutilated and unrecognizable work that challenges the confused viewer's imagination. The imaginative transformation of the fragment into a living work summons up erotic fantasies and the desire for direct insight into the artist's thoughts.[36] The failure to realize this desire starts the process of demystification for the viewer and thrusts the work back into a fragmentary state. The separation from the imagined perfection is like the pain of love. Winckelmann parts from the works at the end of his *History of Ancient Art* of 1764 with the same emotional intensity.[37]

The description of the torso traces its history from chaos through a flourishing peak to destruction. In *The History of Art* Winckelmann assumes that the great Greek artists all pursued the same aim. It is the one revealed in the legend of Pygmalion, namely, to overcome the tough resistance of the material and, if possible, imbue it with magic. According to Winckelmann, this noble endeavour was pursued in earlier periods of art as well, and this is what gave rise to the legend of Pygmalion and his statue.[38] So the dead fragment of art is brought to life by the imaginative power of the viewer. The comparison between the perfect, living work and the torso that has remained, the awareness of the historical gulf, shatters the momentary happy illusion.[39] The description is the account of this experience.

Diderot, Winckelmann and his followers were viewers who worked actively with their imagination on works of art. In his *Laocoon* of 1766 Gotthold Ephraim Lessing demands that artists and the arts should make it possible for the viewer to perform this work. Again raising the question of the *Paragone*, the comparison between poetry and painting, Lessing sees

6. Apollonius, Son of Nestor of Athens, *Belvedere Torso,* 1st century B.C.

painting as limited to simultaneous depiction, with no means of depicting consecutive actions.[40] Presumably this is why he insists that the fine arts should represent the fruitful moment of an action or an emotion, "the moment that makes what has gone before and what follows most comprehensible."[41] In fact, Lessing was linking two of the viewer's requirements here. Firstly, the need for his imagination to be stimulated, and secondly the need for the work to be accessible. "If the artist out of ever changing nature cannot use more than a single moment, and the Painter especially can only use this single moment with reference to a single point of view; if their works, however, are made not only to be seen but to be considered, and considered for a long time and repeatedly; then is it certain that this single moment, and the single point of view of this single moment, must be chosen which are most fruitful of effect. That alone is fruitful of effect which leaves free play to the power of imagination. The more we see, the more must we aid our sight by thought, the more must we believe we see."[42]

The demand for a work of art to be accessible, that is, easy to understand, was made on behalf of the general public. Diderot, discussing current issues in his *Essais sur la peinture* of 1766, states firmly that pictures intended for exhibition must be comprehensible: "A composition that is to be displayed to view for a crowd of different viewers is deserving of censure if it is not comprehensible to a person of good understanding."[43]

In practice, the public realized the Pygmalion approach and brought works of art to life by inventing two forms of entertainment - living pictures or "tableaux vivants", and the idea of visiting galleries by torchlight. In a supplement to Diderot's *Salon* of 1765 Friedrich Melchior Grimm says that the "tableaux vivants" are a new and instructive form of entertainment in society.[44] The difficulties of imitating art works, transposing the pictures into a theatrical presentation by dressing up as the figures and posing without moving, are described both by Goethe in *Wahlverwandtschaften (Elective Affinities)* in 1809 and by Kleist in *Das Marionettentheater (Puppet Theatre)* in 1810.[45] The effect of the living pictures should not be underestimated. Jacques-Louis David's painting *Brutus*, for instance, acquired its political relevance not from its exhibition in the Salon of 1789 but only in November 1791, when it was presented as a living picture in the theatre, after a performance of Voltaire's *Brutus*.[46] Hegel also praised the happy and appropriate idea of living pictures, complaining only of the unsuitability of ordinary faces to convey the sublime.[47]

The practice of visiting art galleries by torchlight became fashionable in the last quarter of the eighteenth century. Artists like Antonio Canova and Bertel Thorvaldsen responded to the desire of the public, they joined in the festive entertainment and showed their latest works in their studios in artificial light. In the "tableaux vivants" the public played an active part by bringing the pictures to life and transforming themselves into a picture. The custom of visiting museums and sculpture galleries at night by torchlight derived from a practice known since the sixteenth century, when statues and models were studied under artificial light.[48] Various writers have recorded

visits to galleries by torchlight. In his *Italian Journey*, Goethe speaks of "an excursion which was popular among visitors, artists, connoisseurs and dilettantes alike", to the Museo Pio-Clementino and the Museo Capitolino. For Goethe the visit was a "wonderful progress through the magnificent remnants of ancient art", "a memorable occasion which still floats before my mind's eye like a beautiful, gradually fading dream". Then he left it to Heinrich Meyer to weigh the advantages and disadvantages of the new fashion in a more pedantic mode.[49]

The habit of visiting sculptors' studios by torchlight combined the traditional method of studying art with the new function of the studio as a place of exhibition, where the artists let the public view their new creations directly.[50] In her novel *Corinne ou l'Italie*, which was published in 1807 in Paris, Mme de Stael (1766-1817) describes a visit paid to a studio by the writer Corinne and Lord Oswald Nelvil. The artist is Antonio Canova. The description of a visit to Canova's studio probably derives from Mme de Stael's stay in Rome in 1805. In the novel the torchlight is explained by the late hour, and justified by its tradition in Antiquity: "Finally, Corinna and Lord Nelvil went to visit Canova, the greatest sculptor of our time. As evening was already advancing they saw his workshop by torchlight; the statues gain much in this light, a view held by the Ancients too, who often placed statues in their bathing rooms, where daylight did not penetrate. The deeper shadows cast by torchlight melt the smooth shine of the marble, allowing the statues to appear like pale forms, with a greater, more moving expression of life and grace."[51] Antonio Canova encouraged people to visit his studio by torchlight. In a letter of 2 April 1811 he invited Vivant-Denon to his studio to see the larger than life-size statue of Napoleon by torchlight and give his opinion on it. "So that you may give me your view more fully, as I wish, I invite you to see and judge the statue at night, with torches lit."[52] We have a pictorial record of this form of the social reception of art in a drawing by Benjamin Zix of 1810, showing the visit paid by the Emperor Napoleon and his Empress Marie Louise to the Antique rooms in the Louvre (fig. 7). We see the royal couple with a great entourage before the Laocoon group that had been confiscated in Rome and which is illuminated by two servants holding lanterns.[53]

Writers commented on the advantages of seeing statues by torchlight and the greater enjoyment thus derived.[54] Only one criticized the custom as desecration - a crime against the achievements of the past and a disturbance of the dead - Bonaventura, in his *Thirteenth Night Watch* of 1804: "On the hill, in the midst of the museum of nature, they had built another small museum to art, and several connoisseurs and dilettantes now made their way there with burning torches, to imagine under the flickering light that the dead within were alive."

Bonaventura sees the collection of antiquities as divine but mutilated figures; they have been brought to light through the desecration of graves, and they are now insulted by criticism and a laughable enthusiasm. He demands that the gods should be either reburied or worshipped, but stops

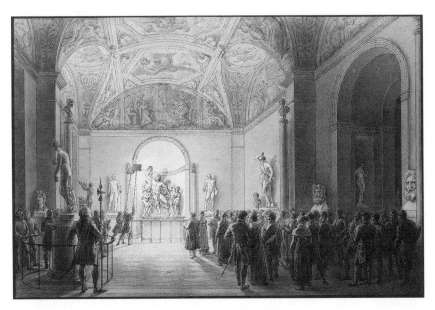

7. Benjamin Zix, *Napoleon and Marie-Louise visiting the Antique Rooms in the Louvre,* around 1810

abruptly in fear, "for under the deceptive, flickering light of the torches the whole mutilated Olympus around us suddenly seemed to come to life". The divine images regain their terrible power, but when the illusion has passed "only violent twitching movements on a battlefield" remain, while stone Furies stand threatening in the darkness beyond.[55]

Public Patronage

The Society for the Encouragement of Arts, Manufactures and Commerce (known as the Society of Arts) was founded in London in 1754. In 1774 it commissioned the engraver Valentine Green to draw up a plan for the decoration of the meeting room in its new premises in the Adelphi and to organize the execution.[56] The Society had the idea of commissioning ten selected artists to produce eight history paintings and two allegories and offer as fee the income from an exhibition to be held on the premises for a maximum of four months. The Society would meet the costs of supervision, publicity, and printing the catalogue and the entrance tickets, which were estimated at £285.[57] This combination of a commission with a commercial exhibition was a new form of patronage, commissioning and sponsorship in one.

The ten selected artists included the six members of the Royal Academy who, a year before, had unsuccessfully proposed to the Bishop of London decorating St. Paul's cathedral with history paintings on biblical subjects - Joshua Reynolds, James Barry, Angelica Kauffmann, Benjamin West, Giovanni Battista Cipriani and Nathaniel Dance. In putting forward his propo-

sal James Barry had hoped that the decoration of the cathedral would lead to the decoration of the empty Anglican churches in England, so opening up a huge new field of operation for the artists. Barry had been a member of the Royal Academy since February 1773, and at a dinner he had proposed decorating the chapel in the Academy's new premises in Somerset House with religious paintings, in order to win a public for this type of art. Joshua Reynolds, the President of the Royal Academy, countered that the artists should tackle St. Paul's cathedral.[58] It is hard to believe they were really serious in proposing this crazy idea to the Bishop of London; perhaps Barry, who was Irish and had spent many years in Italy, believed it was only possible to stimulate public patronage for biblical paintings in England. In 1782 Valentine Green, in his analysis of the state of the arts in France and England, regretted that the Academy's offer had been turned down for fear of religious controversy.[59]

The proposal by the Society of Arts combined the decoration of its premises free of charge with speculation on profits from an exhibition.[60] However, the artists recognized that labour, earnings and risk were very unequally distributed in this idea and turned the proposal down. James Barry signed the letter of rejection, while regretting that an opportunity for history painting was thereby lost.[61] The previous history of exhibitions in England throws some light on the strange offer from the Society of Arts and the artists' reaction. In 1739 the charitable Foundling Hospital was set up by private initiative. The painter William Hogarth, one of its governors, proposed that the meeting room should be decorated with biblical paintings. In the 1740s it was proposed to hold art exhibitions, the profit from which would accrue to the Hospital. In 1759 the London artists decided to hold an exhibition and charge a shilling entrance fee; the profit was to go to needy artists and the widows and orphans of artists. This would give neglected talents the opportunity to show their work in public and would also promote the arts. The Society of Arts offered the exhibition room in the Strand, but objected to an entrance fee being charged, so the artists only sold the catalogue.[62]

The question of an entrance charge caused some artists to break their links with the Society of Arts and form a new group, the Society of Artists of Great Britain. This may well have been the first group of artists formed with the express aim of holding exhibitions. The group mounted its first exhibition for charitable purposes in 1761. The title illustration in the catalogue (fig. 8) is by Samuel Wale. The charitable intention is shown in the genius of the arts giving alms to the needy from a well-filled bowl.[63] A year later, only the promotion of young and neglected artists had remained of the philanthropic aims. The catalogue to the 1762 exhibition gives a reasoned defence of the entrance charge. The aim of the exhibition was to promote art, not to enrich artists; the artists were not motivated by rivalry or vanity but by the virtuous wish for praise and the desire to achieve public recognition for artists whose merit was still unrecognized. Moreover, the entrance fee would prevent the exhibition from becoming too crowded by the curious, who were neither purchasers nor art-lovers, but whose number

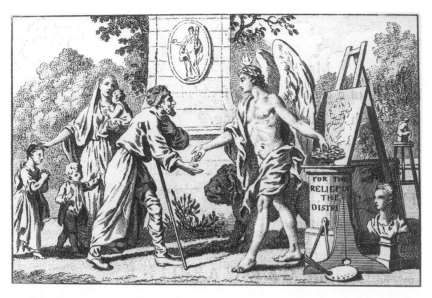

8. Samuel Wale, *The Genius of the Arts distributing Alms to the Needy,* etching by Charles Grignon, title vignette for *A Catalogue of the Exhibition of the Society of Artists of Great Britain,* London 1761

frightened away those whose approbation was most desired. In order to provide the necessary income for the artists an auction would be held at the end of the exhibition, and the entrance money would be used to compensate artists for sales below the estimated prices.[64] From 1763, the profit from the exhibitions went to the Society of Artists of Great Britain to create an academy of art. The Academy was founded in 1768; it immediately received the Royal privilege and was named the Royal Academy of Arts, but for two hundred years it had to finance its activities very largely from the income from exhibitions.[65]

The Society of Artists dissociated its exhibitions from charitable purposes in 1762, but it continued to place the greatest emphasis on public benefit. This was to ward off accusations that the artists were motivated by the desire for self-enrichment, by vanity and rivalry. It evidently remained difficult to derive income for the artists from the exhibitions; until then their income had consisted only of fees for commissions or payment for a post at court.

In 1774, when the Society of Arts, whose main aim was to promote the general economic good, proposed paying artists to decorate its room out of the income from exhibiting the works, it was moving away from its original refusal to charge an entrance fee and adopting the new, speculative system. Three years after the first plan was turned down, James Barry offered to decorate the room alone if the Society would provide the canvases, paints and models.[66] His motive in making the offer was his desire to paint history paintings. In 1775 he had shown a preparatory drawing for *The Birth of Pandora* in the Royal Academy, but the commission he was hoping for failed to materialize, and the work was not executed until 1804.[67]

25

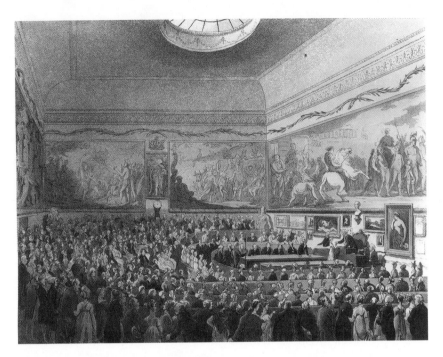

9. Thomas Rowlandson and Auguste Charles Pugin, *The Great Room of the Society for the Encouragement of Arts, Manufactures and Commerce,* 1809

In January 1775 Barry accused the British government of neglecting history painting, and suggested that the reason might be the low esteem in which the genre was held by the public and patrons, whose interest was solely in portraiture.[68] He accused the patrons of ruining artistic talent, and the artists of yielding to the corruption of commercial interests, as an artist could easily make a fortune with portraiture. He contrasted the corrupted artists with the morality of the "real artist", who stood firm against "fraud and wrong", with no thought of personal gain, doing his duty to God and his country regardless of whether he ultimately proved to be a martyr or a conqueror.[69]

Barry's paintings for the premises of the Society of Arts (fig. 9) relate the cultural history of progress, from the beginnings to the Last Judgement, in six historical and three allegorical depictions. The sequence illustrates the moral that both types of happiness, individual and general, depend on the development of human abilities.[70] The last two pictures are devoted to reward and punishment. The fifth shows the award of the Society's prizes, while the last (fig. 10) shows the Last Judgement with Elysium and Tartarus, Paradise and Hell. In his Elysium Barry has placed legislators, scholars and poets, artists and patrons, while Tartarus contains nameless figures of the cultural deadly sins.[71]

Barry found that his request for materials and models did not cover his expenditure, because the work finally took him seven years, not the two

he had originally envisaged. He had initially asked only £100 for canvas, frames and paint, and on several occasions £15 for models.[72] In April 1777 he wrote to Sir George Saville, one of the Vice-Presidents of the Society of Arts, asking for an annual fee of £100 for subsistence. He promised that the pictures would be finished in two years and that he would repay the advance of £200 from the earnings on the exhibition.[73] The two exhibitions in 1783 and 1784 yielded £503.12s from 10,052 visitors. A number of the Society's members gratefully acknowledged the inclusion of their portraits in the painting *The Awards Ceremony in the Society of Arts*.[74] The Society was delighted with the paintings, but disappointed at the low return, and considered a third exhibition. Barry, deeply depressed (fig. 11), mistrusted the Society and its accounting. In 1792 and 1793 he attempted to make some money out of the work by offering two sets of engravings of the paintings for sale, but he had little success.[75]

A year before the first exhibition of Barry's works Valentine Green discussed Barry's undertaking for the Society of Arts in his study on public patronage in England and France of 1782. He contrasted the huge commitment given by the artist with the low level of sponsorship: "This signal proof of the abilities, and laborious perseverance of Mr. Barry, will shortly be laid before the Public, and for the honour of its discernment and liberality, it cannot be doubted, as it has been spared the labour and expence of calling it into existence, it will meet with its warmest approbation; for however singular, it is a fact, that this Work was undertaken, and the Artist has been unremittingly employed in carrying it on for these five years past, with no other support than a supply of Canvas, Colours, and Models! Does this instance of Patronage stand in need of a Comment?"[76] Green recognized the good work of the praiseworthy and patriotic Society of Arts in promoting trade and manufacture, but he complained that the Society did not continuously support the arts, although it had a considerable annual income of £25,000.[77]

Green drew up a paltry list of nine public works by English painters, contrasting this with the wealth of public art in France. He also attacked All

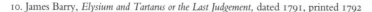

10. James Barry, *Elysium and Tartarus or the Last Judgement,* dated 1791, printed 1792

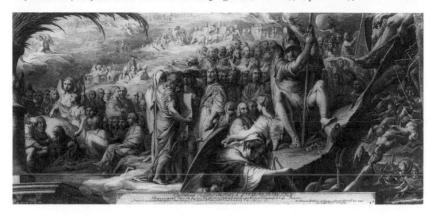

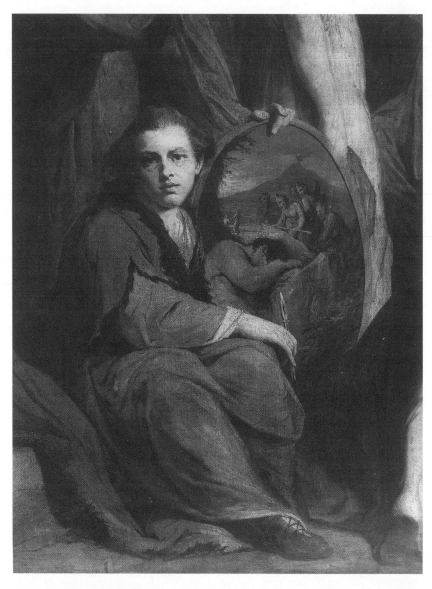

11. James Barry, *Self-Portrait as Timanthes,* detail from *The Olympian Victors,* 1783

Souls College in Oxford for commissioning an altarpiece from the German painter Anton Raphael Mengs.[78] For Green, public patronage not only meant the public display of works of art, but also, indeed always national patronage, the promotion of British artists. He tried to show that it was bad business not to sponsor the arts, by estimating the income to Greenwich Hospital from visitors to the Painted Hall at £300 a year, and a total of £25,100 since 1715.[79]

Green did not include in his list of public patronage the series of pictures on subjects from national history which Benjamin West and John Singleton

Copley had successfully introduced to the public in the Academy or in private exhibitions. Green called the works by West and Copley "works of speculation". That is, the artists had painted them in order to sell reproductions of them or to exhibit them publicly. He says bitterly: "The others were Works of Speculation, begun by the Artists themselves, without commission, or the least dependance of their ever being disposed of. If, in any of these cases, the Artist had not been known to possess abilities worthy to have been employed, the question would have been unnecessary for me to put at this time, - how it comes to pass, that, in the most peremtory and decided language, it is insisted on, that the most liberal encouragement is given to the English Artists? Is it because a Guinea is subscribed to the purchase of a Print from those Pictures, for which the Painters, in super-addition to their own speculative labours, venture on the heavy expences attending the laborious operations of Engraving them? Or is it, because from motives of prudence, impelled by the neglect they have experienced, they are unwillingly forced on the expedient of challenging attraction, by offering those Works to public view, and of setting the price of a shilling on the humiliating Practice? But this Patronage is unique, it belongs only to ourselves; and, in addition to its other merits, is likely to produce this farther brilliant effect, namely, the making "Marchands d'Estampes" of our first men of Genius, and reducing their study of their Professions to Connoisseurship in proof impressions from Engravings."[80]

In this almost forgotten piece of writing Green put forward the first fundamental criticism of the new development in the art world. The exhibition pieces that were designed directly for the public corrupted art, selling engravings and taking the profit from exhibitions humiliated artists. Green accused the artists of benefiting from a system that was corrupting them; Barry showed the other side in his account of the "real artist", who was presumably the first to regard himself as a martyr to the new system.

Exhibition Pieces

Benjamin West of Philadelphia and John Singleton Copley of Boston were the artists who succeeded in profitably launching the new genre of "exhibition pieces" in England. West's *Death of General Wolfe* (fig. 12) was the exhibition sensation of 1771, and it provided the recipe for success that determined the future course of the genre. A subject that was patriotic and of immediate concern, a large format, a simple understandable composition in the grand manner, ostentatious use of items from Christian iconography and the inclusion of numerous portraits of prominent people.[81] West chose a well-known patriotic subject from the war between the British and the French in Quebec in 1759, showing Major General James Wolfe as the dying hero. The death of Wolfe had already been painted by George Romney in 1763 and Edward Penny in 1764, and John Knox narrated the story in his book *An Historical Journal of the Campaigns in North America.*

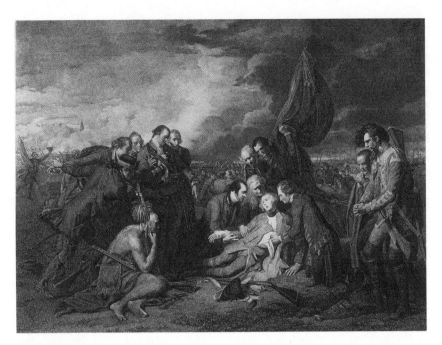

12. Benjamin West, *The Death of General Wolfe,* etching and engraving by William Woollett, 1776

While Penny was content with a small canvas, 62 x 74 cm, West chose the impressive size of a history painting. According to one anecdote, when it became known that West intended to paint a history picture with modern military uniforms, the Archbishop of York and the President of the Academy, Reynolds, visited him in his studio. Reynolds tried to persuade West to keep to the usual rules for history paintings and clothe his figures in Greek or Roman garb. West's reply is interesting: "The subject I have to represent is the conquest of a great province of America by the British troops. It is a topic that history will proudly record, and the same truth that guides the pen of the historian should govern the pencil of the artist. I consider myself as undertaking to tell this great event to the eye of the world; but if, instead of the facts of the transaction, I represent classical fictions, how shall I be understood by posterity!"[82] However, his historical accuracy was limited to the uniforms, for West had no hesitation in including portraits of persons who were never at the scene. Nevertheless, Reynolds found his arguments convincing. King George III initially decided not to buy the painting on account of the uproar over West's unconventional approach; later he commissioned a replica of the work.

The story of the victory of the artist over the authorities' concern may well have contributed to the success the painting enjoyed.[83] The episode should be seen against the background of Reynold's remarks on the "great style" in his third discourse in the Royal Academy in 1770. Reynolds demanded that local and current details should be excluded from painting, as should

fashionable elements, because a painter should address the people of every nation and every age.[84] A few years later Nathaniel Hone tried to provoke a scandal in opposition to Joshua Reynolds, by letting it be known that his painting *The Conjuror* showed Angelika Kauffmann in the nude. The offensive painting was excluded from the Royal Academy exhibition, whereupon Hone showed it in a private exhibition in 1775, with sixty-five other paintings, charging the public a shilling entrance fee; he mentioned the exclusion from the Academy exhibition in the catalogue.[85] This was the first known attempt to utilize an exhibition to raise scandal, and to exploit rejection by an institution to encourage attendance at a one-man show.

In 1778 Copley submitted several paintings to the Royal Academy for exhibition, one of which was the monumental family portrait of the loyalist Sir William Pepperell of New England. But success came to him with *Watson and the Shark*, a depiction of an unfortunate occurrence in the harbour at Havanna in 1749.[86] Copley's client, Brook Watson, was a business partner of the artist's brother-in-law Jonathan Clarke. The painting shows a shark attacking Watson in Havanna harbour when he was fourteen; thanks to the ship's crew the boy only lost a leg and not his life. Copley worked with great iconographic and expressive detail and made his painting a lesson on the dangers of carelessness and the fortunate rescue.[87] As West had done in *The Death of General Wolfe*, Copley made extensive use of iconographic formulae in response to Watson's commission, but he used an even bigger canvas for a motif that, according to the rules, should have been restricted to the usual size of a genre painting.[88]

Copley, who had been a pupil of West and then became his rival, moved to exhibition pieces with *The Death of the Earl of Chatham* (fig. 13) in 1779-81. The painting shows William Pitt, Earl of Chatham, who had been seriously ill for some time, collapsing in the House of Lords on 7 April 1778 during a debate over Britain's policy in the American War of Independence. Chatham had succeeded in winning the support of disparate groups with a liberal policy and by promoting military and commercial interests. He opposed the liberation of the American colonies, believing this would be the start of the political and commercial decline of Britain. When he rose to speak for the second time in the House of Lords he suffered a stroke and fell back in his seat. He died a month later.[89] Copley presented a preparatory drawing for his painting to the London Court of Common Council as an idea for a monument, but the Council opted for a statue by John Bacon. Benjamin West was clearly also considering tackling the subject, but he laid his work aside, discouraged when he heard of Copley's plan.[90] Copley went about the commercial exploitation of the subject systematically. In 1780 he advertised for subscriptions for the engraving, in 1781 he showed the painting in Spring Garden a few days after the Royal Academy exhibition opened. The London press printed a description of it and the list of the persons portrayed, with which Copley had supplied them. Copley's painting was on show for six weeks and about twenty thousand people came to see it, while the Royal Academy complained of a loss of a thousand pounds. The Acad-

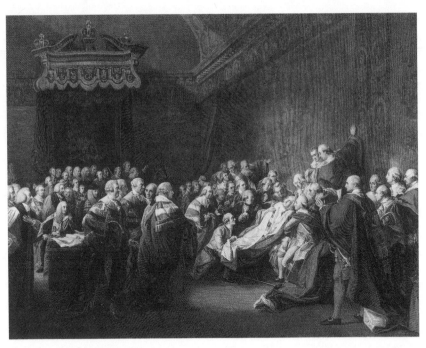

13. John Singleton Copley, *The Death of the Earl of Chatham*, engraving by Francesco Bartolozzi, 1794

emy had refused to allow Copley to use its former exhibition room in Pall Mall, and the architect William Chambers, who was then Spokesman of the Academy, called Copley's exhibition a "raree-show". The artist defended himself vigorously in the press and called the public to judge.[91]

Valentine Green and James Barry had this enterprise in mind when they wrote of "works of speculation" and the corruption of artists through portraiture. *The Death of the Earl of Chatham* was designed as a combination of a history painting with twenty-five portraits of British aristocrats. In his exhibition pieces Copley speculated on the attraction of a sensational subject combined with patriotism, emotional appeal and the public's desire to identify with the work. He was one of the first painters not to be confused by public demand but to recognize that artistic activity had to be placed on a new financial basis. With his uninhibited Boston business sense Copley responded to the situation, giving the public seriously conceived and executed exhibition pieces in return for their shilling.

In 1784 Copley rented rooms in the Haymarket (No. 28) for two months and showed his new exhibition piece, *The Death of Major Peirson* (fig. 14) with *The Death of the Earl of Chatham*.[92] The press advertised the opening and also reported that a few days earlier King George III had broken off his morning ride to study the new painting, that had been taken to Buckingham Palace. The royal perusal, which lasted three hours, culminated in praise of the work, the artist and the meritorious patron, John Boydell. In his new exhibition piece Copley took as his subject the victory of British troops

32

against the French invaders of the island of Jersey in 1781. At the moment of his triumph in the town of St. Helier Major Francis Peirson, then aged only twenty-four, was hit by a bullet and fatally wounded. The tragedy in the midst of victory is the subject of Copley's painting. Under the flags in the centre of the canvas, the British officers are seen supporting the dead hero, while in the middle ground a black soldier is shooting the man who fired the fatal shot. Two touching motifs, the wounded drummer mourning the death of the Major and the flight of a woman with her three children, frame the central emotional scene.

Copley left a large number of drawings which enable us to trace the long process from the first sketch to the simple, tripartite composition.[93] The artist has aimed to combine the traditional motif of mourning the death of Christ and his burial with a battle scene. He has also endeavoured to be precise and accurate in his account of the place, the physiognomies and the uniforms. The patriotic theme, the white, dead hero in the centre under the flags, the immediate revenge by the black soldier, the attacking British army and the terror of the populace are all designed to arouse and intensify emotions in the viewers. A flysheet was available for visitors to the exhibition. It had a key plate identifying the officers and an explanatory text in which the glorious event was narrated and the painter's factual accuracy extolled.[94]

While Copley had used his own resources for his speculation with his first exhibition piece, for the second he formed a partnership with John Boydell, a dealer in engravings and publisher of prints, who spent £800 on the commission and continued to show the painting to the public in the gallery in

14. John Singleton Copley, *The Death of Major Peirson,* etching and engraving by James Heath, 1796

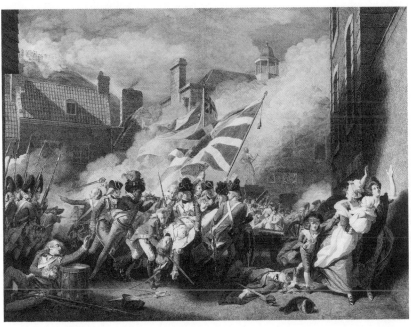

his shop, Cheapside 90, after the exhibition in the Haymarket closed.[95] Boydell had a frame designed by Robert Adam, crowned with weapons, flags and a portrait of the artist by Gilbert Stuart. The exhibition was enriched with the portraits of James Heath, an engraver of reproductions, and Josiah Boydell. Subscriptions were opened for the reproduction, but the engraving was not published until 1796.

With his second exhibition piece Copley had found a profitable formula – a financier as backer who would provide a loan for the execution of the project and then buy the product at a relatively low price, a temporary exhibition, the profits from which went to the artist, and a share in the profit from the reproduction. He had not succeeded in selling the *Death of the Earl of Chatham* after the exhibition nor in auctioning it at Christie's.[96] His agreements with Boydell and his income have not been recorded. Reproductions could be enormously profitable. The engraver Woollett earned £2,000 from sales of his engraving of West's *Death of General Wolfe* in 1776, the publisher Boydell about £15,000 and the artist about £23,000.[97] Copley wanted to publish the reproduction of the *Death of the Earl of Chatham* himself, and he commissioned Francesco Bartolozzi to engrave it for £2,000. However, he had to wait ten years for the plate.

Copley was able to repeat the advantageous combination of finance, a temporary exhibition and reproduction with *The Siege of Gibraltar*. This time the commission came from the London Court of Common Council, who wanted a painting in the Guildhall in honour of the British heroes of the successful resistance to the siege of Gibraltar by allied French and Spanish troops in 1782 (fig. 15). Copley succeeded in obtaining the commission against his rival Benjamin West on the basis of his proposal and the low price he asked, £1,050.[98] However, as he stated in 1791, his price was for a small format and a correspondingly short time to execute the work. He also succeeded in negotiating the right to show the work himself.[99] In 1791 Copley exhibited the painting, which was in the impressive dimensions of 544 x 754 cm, to the public in London in a tent specially erected in Green Park. The picture was hung in an architectural frame. The base contained a depiction of the British fleet liberating Gibraltar, and the portraits of Admiral Howe and Admiral Barrington. The illustrated entrance ticket (fig. 16) shows the exhibition tent and the eager public studying the commentary, admiring the painting, ordering the reproduction or talking beside a sketch on an easel.[100] Copley spoke of 60,000 visitors, but the number may be wrong, for the artist was not satisfied and several times demanded that the Common Council agree to pay a higher fee. His demands led to unpleasant and humiliating disputes between himself, the Council and John Boydell, who was a member of the Council and played a part that is not fully recorded.[101]

Benjamin West's later reflections on the exhibition piece are illuminating. He used the term "epic representation" for the exhibition of *The Death of Lord Nelson* in 1806 in his studio.[102] By this he meant expressive figures designed to arouse emotions in the viewers, and a composition to induce

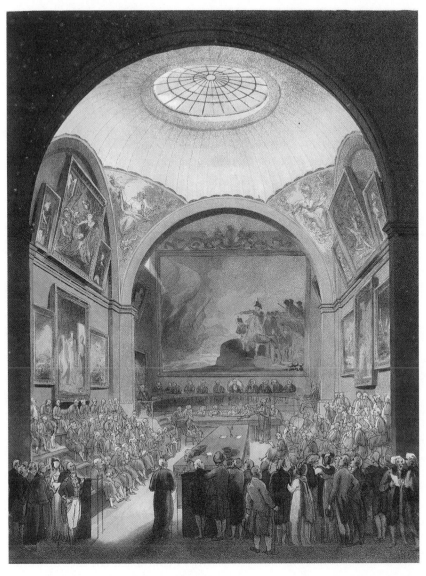

15. Thomas Rowlandson and Auguste Charles Pugin, *Common Council Chamber, Guildhall,* 1808

them to feel with these figures. Historical accuracy is subordinated to that aim. Like Copley, West presented contemporary military heroes in the middle of tripartite compositions, using Christian and popular models for contemporary subjects. The emotions and the handling of colour are designed to focus interest on the hero and the dramatic presentation of him as the victim. In the epic representation all the elements in the depiction are used to intensify the emotional impact. "To move the mind there should be a spectacle presented to raise & warm the mind, & all should be proportioned to the highest idea conceived of the hero".[103]

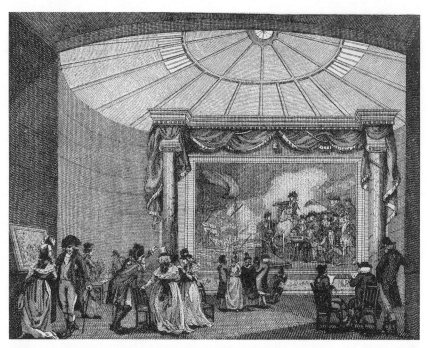

16. Ticket for the exhibition of Copley's *Siege of Gibraltar* 1791

Only after he was forced to resign as President of the Royal Academy in 1805 did West begin to hold private exhibitions, and then he generally used his own studio. He continued the practice when he had resumed his office as President of the Academy in 1806. However, in the battle for public attention the private exhibitions had acquired a major competitor in the panoramas. Robert Barker showed his first topographical panorama in London in 1789, and in 1793 the rotunda built by Robert Mitchell opened on Leicester Square, where Mitchell showed his panorama of London and another of the Russian war fleet off Spithead. In 1795 Barker presented the new panorama, *Lord Howe's Victory*, showing the British defeat of the French fleet at Queffant in 1794; this was followed by the *Battle at Sea off Abukir* in 1799, the panorama of Lord Nelson's victory over Napoleon's fleet at the mouth of the Nile on 1 August 1798. Barker used the same strategy as the private exhibitions to attract the public - patriotic themes, publicity, recommendations from authorities like Reynolds and West, an entrance fee of one shilling, an informative leaflet and the sale of reproductions. But his medium outdid conventional painting by the greater force of illusion, and he was also able to get his product on the market much faster than a painter could, as several persons were working on it.[104] West tried to work faster on his big painting of Lord Nelson (178 x 244 cm) and only eight months lay between the event, the Battle of Trafalgar on 21 October 1805, and the opening of his exhibition.

36

In 1789, the year the Shakespeare Gallery opened, James Gillray published a vengeful caricature of John Boydell's business enterprise (fig. 17). On an altar shaped like a huge book, the personification of Avarice is seated with two money bags. Boydell stands before him, robed as an alderman; he is sacrificing the works of Shakespeare, and in the rising smoke parodies can be seen of Shakespeare's figures as portrayed by Henry Fuseli, Joshua Reynolds and others. This caricature was Gillray's revenge for Boydell's refusal to employ him in the scheme.[105]

John Boydell was London's best known dealer in reproduction prints; he

17. James Gillray, *Shakespeare Sacrificed - or the Offering to Avarice,* 1789

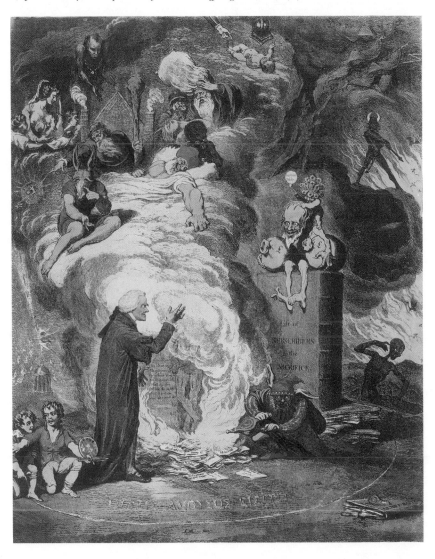

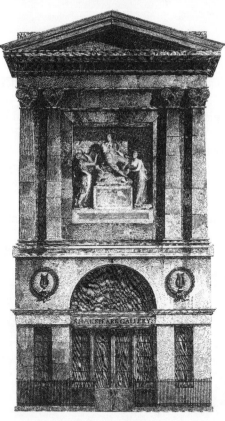

18. The facade of Boydell's *Shakespeare Gallery* with the relief by Thomas Banks, *Shakespeare between the Dramatic Muse and the Genius of Painting,* etching by S. Rawle, 1804

was also a successful publisher and organizer of commercial exhibitions. He was made an alderman and Mayor in 1790. He started his most ambitious project, the Shakespeare Gallery, in 1786, intending to employ British artists on painting pictures related to Shakespeare's dramas for an exhibition.[106] To house the exhibition the new Shakespeare Gallery (fig. 18) was built in Pall Mall, where subscriptions could also be taken for the quarto edition and the large folio reproductions.[107] Boydell was relying on the nation's patriotic interest in Shakespeare, and the merit of promoting history painting, in which the British felt they lagged behind the French. He was also hoping to profit from the public's eagerness to visit exhibitions and the brisk market in reproductions.[108] At a dinner in the Royal Academy in April 1789 Boydell was toasted as a patron with business skill - a "commercial Maecenas" - but the words had a double meaning. It is not clear whether it was Edmund Burke, Joshua Reynolds or the Prince of Wales who proposed the cynical toast.[109] The "double entente" was a reference to Boydell's successful publication *A Collection of Prints Engraved after the Most Capital Paintings in England,* which had grown to nine volumes by 1790; it was also a reference to his European sales of Woollett's reproduction of West's *Death of General Wolfe* and to his new project, the Shakespeare Gallery. Reynolds had little ground for despising Boydell, for the businessman had won him over to his project, as the leading painter of the English school, by putting £500 down on the table as an initial advance.[110]

In fact, Boydell succeeded in obtaining the participation of all the leading

38

artists in England, in his project with the exception of Thomas Gains-borough.[111] He encouraged the painters to take up themes from the works of the popular English dramatist, bought their paintings, publicized the exhibition in the Shakespeare Gallery and organized the subscription for the reproductions in various sizes on the European market.[112] Boydell was able to open his gallery in 1789 with thirty-four paintings; a year later he added another twenty-two, and in 1791 the first reproductions were printed. In

19. James Gillray, *The Monster broke loose or a peep into the Shakespeare Gallery*, 1791

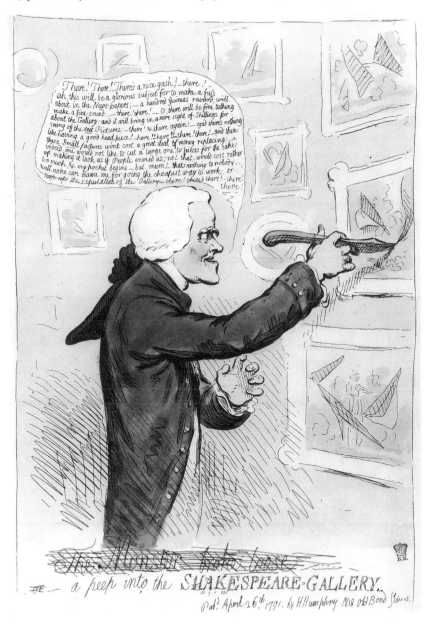

39

the foreword to the catalogue of 1789 Boydell expressly claims credit for promoting the neglected art of history painting.[113]

Boydell organized his enterprise like a manufactory, with production, reproduction, printing and sales strictly separate, and he was one of the first to combine the business of dealing in prints with the business of organizing exhibitions. He was an uncompromising business man with hard elbows, but he was also a patron of the arts, and he wanted to be honoured for promoting British painting. He brusquely rejected Joseph Wright of Derby's accusation that he paid according to the rank of the artist.[114] His refusal to yield to artists who had been content initially with a low fee but subsequently demanded compensation payments fed mistrust of his business practices. His systematic advertising in the press was also taken amiss. After an attack on the paintings by vandals in 1791 Gillray drew a caricature accusing Boydell of having slit the canvases himself in order to profit from the scandal and entice more of the press and the public into his gallery (fig. 19).[115]

The main reasons for Boydell's unpopularity and the disputes were the unequal payments to the painters and the differences between the fees paid to painters and engravers. Boydell offered the painters between £42 and £525 for a painting, while denying that he was paying different fees. By only paying the painters about half the usual fee Boydell was in effect letting them pay for the promotion of history painting. The engravers received considerably more than the painters, but at best only a third of the fee they could ask for a single reproduction. Benjamin West was paid only £525 for

20. Benjamin West, *King Lear in the Storm*, etching and engraving by William Sharpe, large folio, in: J. Boydell, *A Collection of Prints,* London 1803

his painting *King Lear in the Storm*, while the engraver, William Sharpe, was paid £840 for the big plate (fig. 20).[116]

The exhibitions got off to a brilliant start, and the subscriptions were a considerable success, but in the 1790s Boydell's business rapidly declined.[117] Many subscribers lost patience because they had to wait too long for the prints. The revolution in France and the outbreak of war with France in 1793 caused the French market to collapse and brought economic restrictions in Britain. In 1801 Boydell tried in vain to revive the continental market and save his business with sponsors. In 1803, with debts of £60,000, he had to apply to Parliament for liquidation through a lottery. It was announced on 5 April 1804, and soon 22,000 tickets at 3 guineas each had been sold.[118] John Boydell died on 12 December 1804. The lottery was held on 28 January of the following year. The main winner was William Tassie, and he won all the paintings and copies in the Shakespeare Gallery, all the ownership and copyrights of John and Josiah Boydell and the relief by Thomas Banks over the door. Josiah Boydell offered the new owner £10,000, but he decided to auction his winnings at Christie's in May 1805. However, he only realized £6,182.[119] In his *Autobiography* Boydell had dreamt of a different destiny for the Shakespeare Gallery: "I wish that this collection might be the foundation of a National Gallery, to be magnificently built at the top of the Green Park, the front facing St. James's Park and the back front Piccadilly."[120]

Boydell's combination of commissions, exhibition and trade in reproductions had imitators and competitors even before the Shakespeare Gallery commenced operating. Thomas Macklin, a dealer in prints, opened a Poet's Gallery in 1788 in the former Royal Academy rooms in Pall Mall with nineteen paintings, and in 1790 he launched a second project with illustrations of the Bible. Macklin was not very successful; right up to the end of his business activities in 1797 he had acquired fewer than forty paintings from the hundred which he had planned for the Poets' Gallery, and only published six reproductions. The miniaturist Robert Bowyer bought Gainsborough's house from his widow in 1792, intending to hold an exhibition of paintings on themes from British history with an illustrated edition of David Hume's *History of England*.[121]

Henry Fuseli, who had supplied nine paintings for the Shakespeare Gallery (fig. 21), formed a plan as early as 1790 to imitate Boydell's successful enterprises with a series of paintings on Milton's *Paradise Lost*; however, he intended to paint all the pictures himself. He was supported in his work for many years by his Liverpool Maecenas William Roscoe, a banker, philanthropist and historian.[122] Fuseli opened the exhibition with forty paintings in rooms rented from Christie's in Pall Mall on 20 May 1799. By the end of a month he had only taken £117 in entrance fees and from sales of the catalogue, and at the end of July he had to close owing to lack of attendance. The second exhibition, which opened on 21 March 1800 with seven new paintings, brought less than £100. As an artist with literary interests Fuseli had erred in the same way as Macklin and Bowyer in his judgement

of public taste. Nevertheless, he was able to sell ten pictures from the Milton Gallery, and his Maecenas agreed to take pictures in lieu of the £700 he had advanced. Moreover, Fuseli's application to join the Royal Academy after his first exhibition was successful, and on 29 June 1799 the Royal Academy appointed him professor.[123]

The Milton Gallery was an attempt by a painter to produce both a large series of pictures and make money out of them by running exhibitions. The most significant feature of the enterprise was the orientation of artistic creativity to public taste. Georg Forster's notes of 1790 on the Shakespeare Gallery contain numerous remarks on the observance of public taste by the painters and the pictures in the gallery. On Fuseli he says: "Apart from *Lear*, for which Fuseli's talents were not really adequate, he found in Shakespeare's *Midsummer Night's Dream*, in *Hamlet* and *Macbeth* the satisfaction of his inclination for the supernatural, and the unfailing means to win the admiration of his public." Forster regarded Fuseli as wholly integrated in the British school of painters, who subordinated everything to their supreme aim, effect, as they neglected beauty and grace to woo public taste.[124] He felt that West, Barry and Fuseli mistook the monstrous for the sublime in their Herculean forms, and that the Shakespeare Gallery was competing with the pictures for effect. In fact West's and Barry's tendency to depict Shakespeare's heroes as colossi had little in common with current styles of performance or illustration, and it can only be explained by the desire for effect. Fuseli, on the other hand, who had developed a marked inclination for the Antique and Michelangelo in Rome, seemed predisposed to a colossal exaggeration of the figures. The use of *The Horse Tamers* on the Quirinal for *Macbeth* (fig. 21) or the Borghese swordsman for the *Vision of the Place of the Wretched* (fig. 22) in the Milton Gallery must, however, be seen as a desire for effect as much as West's depiction of King Lear (fig. 20).[125] Fuseli's paintings cannot be seen as direct representation of the psychological problems of the individual artist. They are the product of a field that is less easy to probe, and they were the result of a number of factors, including pressure of competition, the need for financial success, and his ability to penetrate to the extremes of expression, as in his depictions of despair and depression.

With William Bullock a businessman entered the exhibition field in London who, unlike Boydell, felt little need to cloak his activities in the mantle of culture.[126] Bullock ran an entertainment and sensations business on Piccadilly from 1811, showing exotic curiosities, antiquities and works of art. In 1816 he was extremely successful with Napoleon memorabilia, which were the greatest attraction on the market since the victory at Waterloo. The big sensation was Napoleon's coach, commandeered as booty by the Prussians at Waterloo in 1815 and donated by General Blücher to the Prince of Wales. Bullock bought it from him for £2,500, and made a fortune with it. Between January and August 1816 his exhibition of the coach attracted no fewer than 220,000 visitors, and brought Bullock £35,000 pounds in entrance fees. After the exhibition the coach was almost falling to pieces; it was sent for repairs to a coachmaker, which cost £168, and finally landed

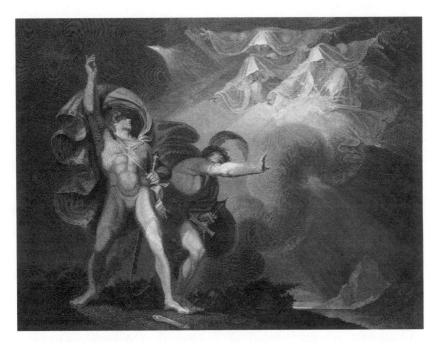

21. Henry Fuseli, *The Witches appear to Macbeth and Banquo,* engraving, etching and aquatint by J. Caldwall, large folio, in: J. Boydell, *A Collection of Prints,* London 1803

22. Henry Fuseli, *The Vision of the Place of the Wretched* (Milton, *Paradise Lost,* XI, 477-490), 1791-93

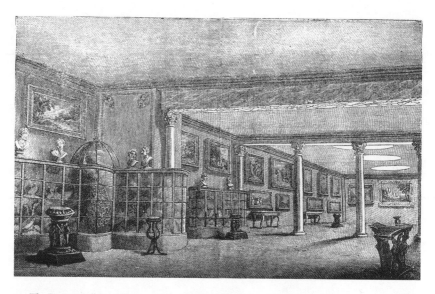

23. *The Roman Gallery* in William Bullock's *Egyptian Hall* on Piccadilly, 1816

in Madame Tussaud & Sons in 1848.[127] The portraits of Napoleon by David and Lefèvre profited from the same British mania for Napoleon memorabilia.[128] Bullock showed selected works by British painters, like Benjamin Robert Haydon, and the French artists Guillaume-Guillon Lethière and Théodore Géricault, from 1816 in his Egyptian Hall (fig. 23), advertising them as sensations and masterpieces.

French Exhibition Pieces in England

When exhibiting his painting *The Sabine Women* (fig. 24) Jacques-Louis David had to give an elaborate defence of the "exposition payante", which was hated in France. David charged an entrance fee of 1.80 francs, and said that the best way to succeed was to catch the public eye, "captiver l'attention des spectateurs". If the artist failed to do that, the public stayed away, the exhibition was a financial failure, the artist lost his artistic freedom and the fire of genius died out.[129] David very skilfully advertised his painting and invited offers for it in his text, but his tone was arrogant and didactic. He pointed out that exhibitions derived from a usage in Antiquity and were motivated not by the desire for profit but the need to maintain the independence of the artists; he lamented the sacrifice artists had to make and flattered the public. He also claimed that he was promoting young artists by indicating a source of income for them which could put an end to their impoverishment. But he destroyed any appearance of serving the general good the following year, when he added two versions of the equestrian portrait of Napoleon to his exhibition. Charles Paul Landon, who had defended the entrance charge in a preview of the exhibition of *The Sabine*

Women, condemned the painter's speculative attempt to earn double by exhibiting two paintings that had been commissioned for an agreed fee.[130] Landon accused David of using his palette, as the British artists did, for commercial ends; this was self-corruption. Jean-Baptiste Regnault and Louis Simon Boizot, who copied David's example and held exhibitions with an entrance charge, were not successful.[131]

David called the American artists West and Copley, who were working in England, models of the "exposition payante".[132] Henry Redhead Yorke comments in a letter written in 1802 that David's wife advised him to buy *The Sabine Women* for £5,000 and show it in London.[133] Tischbein, in his review of the exhibition of David's *The Oath of the Horatii* in 1785, had noted the painter's intention of having the picture engraved in England.[134] In 1788 David attempted to obtain a connection with the Royal Academy in order to show at its next exhibition, as Sir Brooke Boothby wrote to Joshua Reynolds.[135] Boothby also reported that David was working on a new picture, *Brutus*. David probably wanted the English connection in order to hold a private exhibition there, which he could not do in France. It was not until 1822 that David exhibited the second version of *The Coronation of the Emperor and the Empress* in London; he had finished it during his exile in Brussels for a touring exhibition.[136]

In his autobiography of 1793 David not only mentions the exhibition of *The Oath of the Horatii* in Rome in 1785, he actually says he owes his career and his reputation to the exhibitions.[137] In 1776, while he was Director of

24. Jacques-Louis David, *The Sabine Women*, 1799

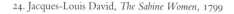

the Académie de France à Rome, a post he held from 1775 to 1781, Joseph-Marie Vien had begun to show the works of the Rome scholars in S. Luigi dei Francesi and the Palazzo Mancini, before they were despatched to Paris.[138] In doing so he was following the Roman custom of publicly displaying works intended for export. In the exhibition of 1780 David showed the painting of St. Rochus, which had been commissioned by the military hospital at Marseille.[139] In showing *The Oath of the Horatii* in 1785 David was combining this tradition with the studio exhibition. He prepared for his showing of *Brutus* in the Salon of 1789 by creating a press scandal.[140]

The political events of 1789 put an end to David's plans for an exhibition in England. However, he did succeed in holding a private exhibition in Paris on the English model when he showed *The Sabine Women* in the Louvre from 1799 to 1805; he then held a one-man show in 1814.[141] Unlike West and Copley, however, David had taken a subject from classical history painting. The relevance of the battle between the Romans and the Sabine Women lay in the pacifist message of the painting and the appeal to his native land to "stop sacrificing its children to this terrible war", which was published before the exhibition.[142]

From the stylistic repertoire of the exhibition piece, *The Sabine Women* made use of shock and epic representation. The shock came from the nude male figures. Nude figures do not appear either in David's first idea on the subject, which he sketched in prison in 1793/94, or in a more detailed sketch or the drawings. In the composition sketch the men are wearing the breastplates usual in paintings on subjects from Roman history. It is evident from the brochure for the exhibition that David was fully aware that his nude heroes would both fascinate and shock the ladies, and that the offence to public morals was deliberate, as was his contravention of what was known

25. Guillaume-Guillon Lethière, *The Judgement of Brutus upon His Sons* [Salon of 1812], line etching by Pinelli, 1816

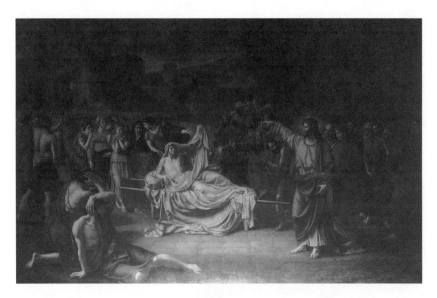

26. Jean-Baptiste-Joseph Wicar, *The Raising of the Young Man of Naim,* 1816

of practices in Antiquity. Possibly he was hoping for a press scandal. As in the British exhibition pieces, David has focussed attention on an emotional centre, by placing the women, with Hersilia, between the aggressive males and allowing them to stand out against the background of figures in combat.

In 1816 Guillaume-Guillon Lethière and Jean-Baptiste Wicar exhibited their new large paintings in London. Lethière showed his version of *Brutus* (fig. 25) in the Roman Gallery run by William Bullock. Lethière was Director of the Académie de France à Rome from 1807 to 1816, where he re-sumed work on a huge painting of Brutus condemning his sons to death. *The Judgement of Brutus upon his Sons* was 440 x 783 cm, and he first exhibited it in the choir of S. Trinità dei Monti in 1811. The *Giornale del Campidoglio* published two articles on the painting, and Friedrich Müller wrote a detailed and glowing account for Friedrich Schlegel's *Deutsches Museum* in 1812.[143] *Brutus* was shown in the Paris Salon of 1812, but it was only purchased in 1819, by the Comte de Forbin for the Musée du Luxembourg, after Lethière had been elected to the Académie on his second application.

Lethière probably acquired his links with London through Lucien Bonaparte, who had supported his appointment as Director of the French Academy in Rome as early as 1807.[144] William Bullock produced an illustrated brochure for the exhibition of Lethière's "great and celebrated picture" in his Egyptian Hall on Piccadilly. Lethière's reputation, the fact that the painting was the product of more than twenty years' work, its huge size, intensely moving subject and the apparent fame of the painting were advertisement enough.[145]

In the same year Jean-Baptiste Wicar displayed his colossal painting *The Raising of the Young Man of Naim* (570 x 900 cm) to the public in London

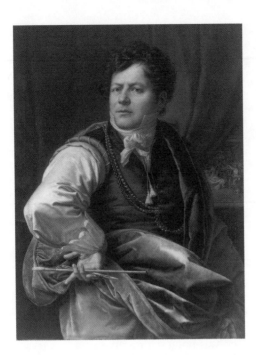

(fig. 26), probably in Benjamin West's studio. Wicar owed his contact with West to his friend Antonio Canova.[146] He was appointed Director of the Academy of Art in Naples in 1806 by Joseph Bonaparte, after directing Napoleon's raids on art treasures in Italy. In 1810 Wicar, now financially independent thanks to his publications on the Uffizi galleries and the Palazzo Pitti, returned to Rome, where he spent from 1811 to 1815 working at his great masterpiece. His proud self-portrait (fig. 27) shows him with a sketch of the work. Wicar exhibited his masterpiece in Rome, presumably in his own house on the Vicolo del Vantaggio; he received visits from Roman celebrities and won the approval of the Accademia di San Luca. In 1816 he applied to the French Embassy for a passport in order to travel to London and exhibit his painting there. His brilliant reception in London is recorded in Salvatore Betti's official obituary of him in 1835, although this appears to derive from a rumour, for the English press did not devote a single line to the French painter from Rome and his painting. Ten years later Dufay spread the news that Wicar's painting had been shown in New York, and this was believed until it was disproved by Beaucamp in 1936.[147] As protégés of the Bonaparte family Wicar and Lethière were not welcome in Paris under the Bourbons, and in 1816 they had to go to London if they wanted to find a public outside Rome. Wicar had alterations made to his house in Rome by Valadier, and Luigi Poletti designed a "gallerie di quadri" for him.[148]

Géricault showed his *Raft of the Medusa* (fig. 28) in Bullock's Roman Gallery in 1820; it was his exhibition piece "par excellence". Géricault's connection with Bullock came through Lethière, whose son Auguste had

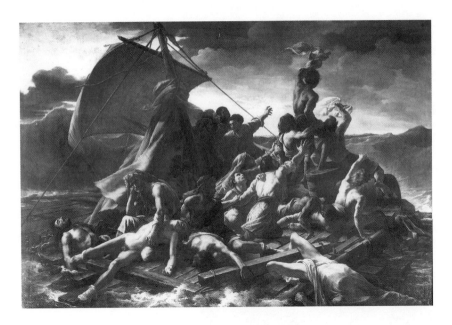

28. Théodore Géricault, *The Raft of the Medusa*, Salon of 1819

supervised the transport of the huge canvas from Paris to London. Again Bullock advertised the exhibition with notices in the press and a brochure. His notice in *The Times* promised two sensations, like his advertisements of 1816: the totally realistic illusion of an event and a supreme example of the art of painting, combining every achievement: "The warm tints of Titian, the colder chastity of Guido, the mild radiance of Corregio (sic) and the harmonious combinations of Rubens".[149] This notice was used successfully for the exhibition of Géricault's painting in London, but in Dublin the picture had to compete for viewers with *The Peristrephic Panorama of the Fatal Raft*; this proved more attractive and the exhibition was not a success.[150]

Reactions differed in London to the paintings by Lethière and Géricault and to Bullock's advertising strategies. Placing Lethière on an equal footing with Benjamin West was regarded as ridiculous. A comparison of the French school with the British touched a sore spot for the British, as they knew they lagged behind France in history painting. In Lethière's *Brutus* Bullock was presenting a history painting as a sensational masterpiece, but Géricault's *Raft of the Medusa* was a picture which corresponded much more closely to the British idea of an exhibition piece, as it dealt with a modern subject. Bullock was praised in the press for showing Géricault's painting and celebrated as promoting the British school: "If he continues to bring over chef d'oeuvres of French painters, he will do as good a thing as could be done to advance British art. Emulation is a noble teacher."[151]

The sensational tragedy on which Géricault's painting is based, the wreck of the French navy frigate off the coast of Senegal in 1816, is well known.[152] The choice of subject and the execution of the work were intended for ex-

49

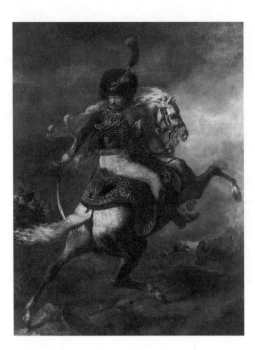

hibition. Géricault worked intensively at his painting, increasing the emotional impact of the shipwreck through his figures and the horrifying and pitiable scenes.[153] To understand the work it is necessary to know something about Géricault's successes and failures as an exhibiting artist, which is how he saw himself, according to Charles Clément, right from the start of his career. Shortly before the Salons of 1812 and 1814 opened, and in which he was determined to show works, he sought desperately for a suitable subject, and more or less by chance came upon one that accorded with his interest in horses. He painted the pictures at the last moment. In 1812 he achieved an unexpected success with an equestrian portrait (fig. 29), competing with the equestrian portraits by David and Gros. But in 1814 he misjudged public taste with his *Wounded Cuirassier*, which was anti-Napoleon. He was extremely depressed by the failure and contemplated destroying the painting.[154]

In 1814 David arranged an exhibition of *The Sabine Women* and *Leonidas at Thermopylae* (fig. 30) outside the Salon, for which he produced a brochure with descriptions and reproductions of both paintings. *Leonidas at Thermopylae* aroused great interest, although the picture did not meet with the usual enthusiasm. The Comtesse Lenoir-Laroche saw in the heroic virtue of the Spartans a direct challenge to Napoleon's army: "This painting will show the soldiers how to die for their country and the law".[155] The painter did not comment on that aspect of his work, but he did comment on the moment he had chosen to depict.[156]

Géricault's *Raft of the Medusa* encompasses the two opposites of extreme horror and distant hope on the heaving waves of the ocean. The painter has chosen the moment as a chance of rescue dawns for the men when they

sight the *Argus* on the horizon, that is, the dialectical reversal of the tragedy. In his drawings Géricault considered representing dramatic scenes of shipwreck, mutiny and cannibalism, and in compositional sketches he worked out the distance between the *Argus* and the raft. By creating the maximum distance between the raft and the ship he maintains the contrast between extreme suffering and the tiny ray of hope.[157] Géricault was aiming to convey a total emotional illusion and overwhelm his public with an aggressive composition. The narrative distance between the terrible life-size, figures, who are right at the front of the canvas, and the *Argus* on the horizon was to be filled with emotions like disgust, pity, fear and hope.[158] There is an analogy between this captivation of the public's emotions and the total illusion that the panorama was offering visitors at the time.[159] Despite his concern with public taste Géricault made a cardinal error when he first exhibited his picture, in the Salon of 1819. Clément has stated that the painter insisted that his picture be hung high up and not at eye level, and Clément believed that his friend's disappointment, and Géricault's general lack of success at the Salon of 1819, were due to this. Lorenz Eitner's analysis of the critics' response does not confirm that, but it is easy to see that hanging this work too high would very greatly diminish its effect.[160] Géricault's mistake can only be explained by the fact that he wanted his picture to have the distinction of being hung "à la cimaise", which he felt was denied him if it were hung on the level of genre pictures and other less elevated types of art.

Despite their concern with public reaction, David, Lethière, Wicar and Géricault all worked to the highest artistic standards in their exhibition

30. Jacques-Louis David, *Leonidas at Thermopylae*, 1814

31. William Bullock, *Description of a Grand Picture,* 1828, brochure on the exhibition by
Guillaume-Guillon Lethière, *The Death of Virginia,* title page with folded sheet

pieces. Bullock needed masterpieces to increase the sensational effect in his
gallery. Lethière's *Brutus* and Géricault's *Raft of the Medusa* were both ad-
vertised as combining all the supreme achievements in the art of painting.
The reasons advanced for regarding works as masterpieces were always the
length of time the artist had spent on the work and its huge format, plus the
extreme seriousness of the approach. These all testified to untiring effort and
the mobilization of ultimate resources. Lethière's *Brutus* was claimed to be
the fruit of twenty years' labour, and *The Death of Virginia* (fig. 31) twelve.
Bullock presented the latter in London, maintaining that the execution was
even more successful than that in the painting shown in 1816.[161] David set
up a mirror through which the public could look at *The Sabine Women,*
intending the reversal to show how perfect the execution was. However, he
regarded *Leonidas at Thermopylae* as his masterpiece; it took him fifteen
years.[162] Géricault spent years on *The Raft of the Medusa,* working with in-
tense effort and making countless studies. The French concept of the master-
piece was intended to banish any suspicion of corruption from the exhi-
bition piece and sanction its ultimate destination in a museum. Wicar be-
queathed his work to Lille Museum in his will, and David's *The Sabine
Women* and *Leonidas* were bought by the Musées Royaux in the same year
as Lethière's *Brutus.* Géricault's *Raft of the Medusa* was purchased by the state
after the artist's death and shown in the Musée du Luxembourg, after an
initial attempt to purchase it by the Comte de Forbin had failed in 1823.[163]
In the museum the public showing of art, which justified exhibitions, was
combined with the unlimited duration of public access.

The Problems of Critics and Artists

In the course of time, art criticism and scholarship brought to light an in-
soluble conflict. As works of art came to be more closely analysed, the old

52

opposition surfaced between two different approaches to interpretation, that which is true to the letter and looks for correctness, and that which is true to meaning and looks for truth. When Diderot was considering Falconet's *Pygmalion and Galathea*, he was prevented from being critical by his admiration for and identification with the artist. Winckelmann could not follow his enthusiastic description of the torso of Belvedere with any discussion of the style. The illusion of real life in a work and the suspension of time enabled the enthusiastic viewer to communicate directly with the artist and hindered the objectivity of critical historical analysis. Diderot actually addressed the sculptur Falconet in considering his work, Winckelmann wished to transpose himself into the spirit of the artist. For Winckelmann and his followers eulogies, as opposed to sober description were regarded as sufficient.[164]

Both Diderot and Winckelmann realized that a description of the object prevented a personal relationship with a work of art, and that critical judgement destroyed the desired tripartite relationship between the viewer, the work of art and the artist. The artists' desire that the viewer should regard a work of art with "admiratio", as expressed through the depictions of Pygmalion, was a rejection of criticism and analysis. The repeated declarations in the livrets for the Salons that the artists bowed to the judgement of the public were in reality an assurance that the Academy was ready for praise and applause, as an anonymous critic of 1748 ironically said.[165] Criticism and analysis were not inherent in enthusiastic reception, as critics, scholars and artists all realized. The conflict that broke out in the middle of the eighteenth century has not been solved, it has only been put on ice, as both sides have defined their positions and ignored each other.[166]

The artists tried to attack the critics and historians with the old polemical argument that only artists were competent to judge, a delimitation that did not only apply to contemporary art. Etienne-Maurice Falconet attacked Winckelmann in 1770 on the historical level,[167] but Herder rejected this encroachment by an artist in his defence of Winckelmann in 1777. In posing a deliberately crude question, namely, whether cooks should only cook for other cooks and poets only write for other poets, he was aiming to show how absurd Falconet's position was. Herder was, in fact, taking up the example of the ragoût in Du Bos' *Réflexions critiques* of 1719. Du Bos explained the competence to pass a judgement on art based on "sentiment" by saying that one could judge the quality of a ragoût without knowing how to make it, one judged by taste.[168] Herder, in contrast to the artists, saw the enjoyment others derive from art as its purpose, and the competence of the artists as limited to producing works of art and a general practical introduction. However, he neglected to explain what the competence to judge should be based on, and Falconet certainly did not contest the importance of enjoyment.[169]

In 1719 Du Bos stated that the right to judge was based on "sentiment", that is, the viewer's direct reaction to what was effective, moving and attractive. This not only radically separated the judgement of art from the rules of

32. François Boucher, *Painting, mocked by Envy, Stupidity and Drunkenness,* etching, frontispiece
to: Abbé Leblanc, *Lettre sur l'exposition* [Paris ?] 1747, and to Du Bos, *Réflexions,* Paris 1755

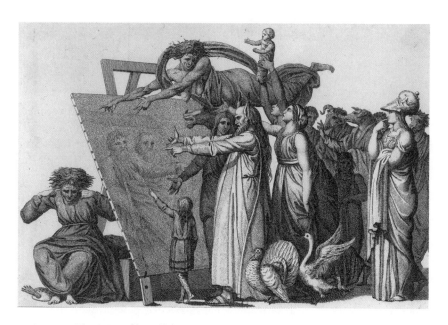

33. Anonym, *The Artist and his Public,* c. 1800

its production, avoiding the confrontation between rules and sentiment, it also maintained the higher validity of sentiment: "For the same reason the work is worthless that does not touch us at all, and if the critic cannot find any infringement of the rules it is because a work can be bad without infringing the rules, just as a work can break many of the rules and still be excellent." However, to explain the basis of the competence to judge Du Bos simply states that there is a sixth sense with which we can test whether the impression of an imitated object corresponds to that of a real object.[170] He outlines the consequences of this in a later chapter on judgement by the public; he admits that not everyone can judge political, military or scholarly merit, because this requires a knowledge of the facts or the corresponding training. But everyone can judge the arts, for these are designed for effect, and feelings are common to all. The important sentence on the ability of everyone to judge art is: "But everyone can judge verses and pictures, because everyone is sensitive, and because the effect of verses and pictures lies in the realm of feeling."[171]

In his *Réflexions* of 1747 La Font de Saint-Yenne, on the other hand, saw the public's general right to judge art as the result of the publicity given to an exhibited picture as to a published book or a play performed: "A picture exhibited is the same as a book printed and published. It is a performance in a theatre: everyone has the right to express his opinion."[172] His second argument denies one-sided subjectivity, as he believes that the public is impartial. The many voices, even if they are individually bizarre and over-hasty, rarely culminate in deception over the qualities or shortcomings of a work. In his third argument La Font de Saint-Yenne reverses the objection of lack of

competence. He not only maintains that criticism is necessary for artists, he actually accords criticism from the viewer preference over the judgement of fellow-artists, for they keep to the dry rules, while the unprejudiced and enlightened viewer relies on natural taste and sentiment. Abbé Du Bos prepared the way for this argument in his *Réflexions critiques* of 1719.[173]

The attempts to legitimate criticism, to distinguish between the competences of artists and critics and between artistic production and natural sensitivity, as well as to differentiate between the enlightened and impartial viewer and the unqualified public – the unenlightened mass – could not prevent the relationship between critics and artists from being extremely tense in the first publications.[174] Following the unfavourable reception by the critics of the Salon of 1748 the members of the Academy decided to boycot the exhibition the following year.[175] The artists felt they were once again being persecuted by envy and stupidity. François Boucher drew a frontispiece for Abbé Leblanc's *Lettre sur l'exposition* of 1747 (fig. 32), which was an attack on La Font de Saint-Yenne. The melancholy figure of Painting sits dumbly before her easel, while Envy, Drunkenness and a donkey with a crowd mock at her work. It was probably Charles-Nicolas Cochin who drew the biting caricature of the critic as a fanatic in 1753 – small, thin and shortsighted, with evil features.[176]

As exhibitions became institutionalized a difficult relationship developed between artists, public and critics, burdened right from the start by a latent

34. Louis Lagrenée the Elder, *L'amour des arts console la Peinture des écrits ridicules et envenimés de ses ennemis*, Salon of 1781

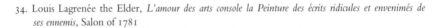

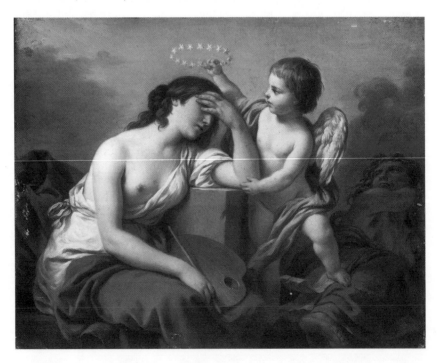

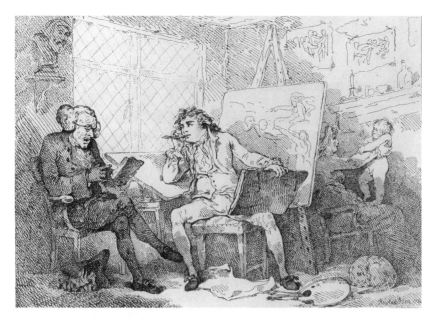

35. Thomas Rowlandson, *The Historian animating the Mind of a young Painter,* etching, 1784

aggressiveness. It found open expression in caricatures of the critic or the public (fig. 33) and even in the last quarter of the eighteenth century in mockery of artists, on which many vaudeville performances relied.[177] The artists felt they needed comfort and support. Louis Lagrenée presented a small painting in the Salon of 1781 showing Painting seeking comfort after being wounded by the writings of her enemies: *L'amour des Arts console la Peinture des écrits ridicules et envenimés de ses ennemis* (fig. 34).[178] It is significant that some critics felt they should give artists advice - La Font de Saint-Yenne and Anne Claude de Caylus in France in the middle of the century. In Germany Johann Joachim Winckelmann thought of advising artists, in Rome Carl Ludwig Fernow supported the painter Jakob Asmus Carstens, and before the end of the century Johann Wolfgang Goethe published his requirements in the *Propylaen*.[179] The 'Artists Council', which Jacob Burckhardt still regarded as a superior task for the art historian, was an offer of help from scholars and writers to artists. They felt artists needed to have the wishes of the public explained to them sensitively, they needed to be taken out of their isolation and their lack of orientation, given suitable tuition to enable them to avoid errors in form and contents and at the same time they should be protected from undue criticism.[180] However, as early as 1784 Rowlandson was laughing at the dry historian who was hoping to animate an artist by reading to him under a bust of Homer in his impoverished studio (fig. 35). Rowlandson was referring ironically to Fuseli's self-portrait in scholarly discussion with Johann Jakob Bodmer, that was exhibited in the Royal Academy in 1781.[181]

II FREEDOM AND THE SOCIAL FUNCTION OF THE ARTIST

The Open Exhibition, the Artist Liberated

The problem of the freedom of art and of the artist involves political and creative freedom, the liberty to trade and to exhibit, the freedom of art from any imposed purpose, moral license and the financial independence of the artist.[1] However, the liberation of the arts from the authority of the guilds, the princes, the state and the academies, the removal of the privileges enjoyed by the one side and the restrictions imposed on the other opened the way to new dependencies. Unexpectedly, the liberation of the artist from external authorities raised the difficult problem of artistic legitimation. It is still unsolved today.

The demands for freedom raised by artists during the French Revolution were firstly for "free" exhibitions, then for the abolition of the Academy as a remnant of despotism. The National Assembly first ended the Academy's monopoly on exhibitions in 1791, then, two years later, it dissolved the Academy itself. After the first revolutionary events in 1789 an art dealer, Lebrun, had in fact broken the monopoly on exhibitions by making his gallery available to amateurs and students for two days; the following year he showed the work of young artists for a week.[2] In 1790 a society of artists was founded under the leadership of Jacques-Louis David and Jean Bernard Restout entitled "Commune des Arts"; it opposed the despotic Academy in the name of freedom, and in 1791 put a plan to the National Assembly for a "Société des artistes", with a demand for open exhibitions.[3] In the same year Quatremère de Quincy proposed changing the Academy into a public college of art, pleading that the exhibitions should be open to all artists. He regarded open exhibitions as a means of abolishing all the privileges and abuses that had dogged the art world: "This will be for the republic of the arts what freedom of the press is for a state. A free public exhibition, open to all artists in the same place, without distinction."[4] In support of his argument Quatremère de Quincy referred to the natural rights of freedom of expression and of opinion, extending these to include unrestricted access to the means and institutions of art. He accused the Academy of infringing justice and the natural equality of all through its monopoly on exhibitions. In this text, Quatremère de Quincy was the first to raise the vision of a "republic of the arts" in analogy to the republic of letters.[5] In 1793 the Abbé Gregoire referred to a republic of letters to persuade the National Convention to abolish the academies; the decision was taken on 8 August.[6] In 1796 Quatremère de Quincy criticised France's confiscation of art treasures, which the French authorities were attempting to justify on the grounds that they were for a republic; he opposed the despoliation of Italy with the argument that Rome was the capital of the republic of the arts.[7]

The conservative party in the Academy did not give up its privileges and

its monopoly on exhibition without a protracted struggle. In April 1791 D'Angiviller, Director of the Royal Buildings, announced the King's decision that none of the artists who had joined the patriots in the "commune des arts" would be admitted to the Salon. On 16 August these artists presented a petition to the National Assembly, again pointing out that the aristocratic Academy was incompatible with freedom. Jacques-Louis David supported the petition, and on 21 August 1791 the National Assembly accepted the principle of open exhibitions, appointing a commission of seven members to be responsible for the Salon of 1791. They included the painters David and Vincent, and the lawyer and scholar Quatremère de Quincy.[8] The foreword to the livret for the Salon of 1791, which only opened at the end of the year, celebrated the triumph of the new freedom: "The arts have received a great benefit; the realm of freedom has at last been extended to them; it is breaking their chains; genius is no longer condemned to obscurity. To enable the sole and true differences of virtue and talent to be brought to light they need only be shown to their fellow citizens."[9]

The French Revolution propounded the argument that freedom was guaranteed to artists if they served the Republic. During the state before the Revolution, which was declared despotism, artists were prisoners, according to the new interpretation, they were guilty fellow travellers and were ruining the people.[10] In its call to artists to design a monument to the Revolution for the Pont-Neuf in Paris in 1794, the Committee of Public Works proclaimed that the Republic had restored freedom to the arts which they had lost under the monarchy. In return they should, in repentance for their corruption under despotism, place themselves in the service of freedom: "Under the republican regime they [the arts] will regain their freedom and repent of their former humiliation. Formerly they were corrupting public opinion, today they are helping to restore this to intellectual and moral health; they will now devote their entire strength, more than they ever gave to despotism, to freedom."[11] The Committee of Culture demanded that new principles and tasks be set for the direction of the arts, to make them worthy to serve the aims of the Revolution.[12] Jean-Guillaume Moitte designed a huge monument for the competition, showing a colossal Hercules vanquishing despotism and superstition, and bearing in his hand the globe with the allegories of freedom and equality (fig. 36).[13] The monument was never executed.

The question is whether the artists were aware of the problem of constraint and freedom, and how they expressed this. Together with the British sculptor Thomas Banks, who had received a scholarship to Rome from the Royal Academy, Henry Fuseli invented the virtuoso exercise of drawing male nudes from five dots placed arbitrarily on the paper.[14] One of the violently distorted, chained and crucified figures he thus invented was transformed into Prometheus chained to the rock (fig. 37); the inscription "MAB" (Michelangelo Buonarotti) made it a symbol of the artist confronted with the problem of freedom. The rays of a low sun illuminate the Titanic Prometheus-Michelangelo, who is opening his hand to the de-

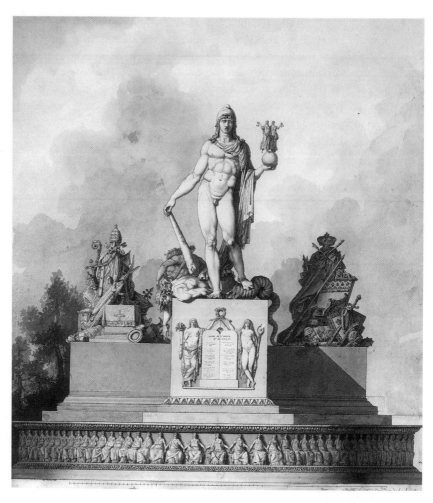

36. Jean-Guillaume Moitte, *Project for a Monument in Honour of the French People on the Pont Neuf in Paris*, 1794

scending eagle. Fuseli's greatest artistic experience in Rome was the discovery of Michelangelo; to be fascinated by him was to reject Winckelmann's criticism of his exaggeratedly muscular and grimacing figures.[15] In his five-dot drawing of 1770/1771 Fuseli associated the imprisoned and martyred Titan with the great Renaissance artist. Prometheus, punished by Zeus for creating human beings, became the topos of the Titanic artist in the last third of the eighteenth century.[16] To call Prometheus bound Michelangelo in chains could be a reference to the artist's controversy with Pope Julius II, which is recorded in the biographies of Vasari and Condivi.[17]

The link between the artist as Prometheus, not imitating what has already been created but creating like nature itself, and freedom from servitude, superstition and "obscurity" goes back to the writings of the Earl of Shaftesbury. In *A Letter concerning the Art and Science of Design* of 1712 Shaftesbury states that political freedom is essential for the development

of art. He sees this freedom as given in the British constitutional monarchy. Shaftesbury rejects the idea of an Academy and the promotion of art by the court, preferring responsibility for the promotion of the arts and sciences to be given to the "public voice", which is embodied in the enlightened Whig aristocracy.[18]

Shaftesbury's views are based on the treatise *Peri hypsus* (On the Sublime), which was ascribed to Cassius Longinus for a long time and became widely read in the translation by Nicolas Boileau-Despréaux of 1674. In Chapter 35, where he discusses the origins and the decadence of intellectual forces, Longinus considers whether the republics did not produce the greatest geniuses, and whether their decline did not also result in the decline of genius: "In fact, he added that there is perhaps nothing that raises the spirit of great men more than freedom, nothing that more strongly arouses and awakens that natural feeling in us, inducing us to emulation, and the noble wish to see ourselves raised above others."[19] Winckelmann declared freedom, with climate, to be one of the reasons for the development of Greek art, and the democratic constitution as the explanation of the great peak of art in Athens: "The independence of Greece is to be regarded as the most prominent of the causes, originating in its constitution and government, of its superiority in art. Liberty had always held her seat in this country, even near the throne of kings - whose rule was paternal - before the increasing light of reason had shown to its inhabitants the blessings of entire freedom. Thus, Homer calls Agamemnon a shepherd of his people, to signify his love for them, and his solicitude for their welfare."[20] In Herder's treatise *Ursachen des Gesunknen Geschmacks bei den verschiedenen Völkern, da er geblühet* (The Causes of the Decline in Taste among the Various Peoples where it has Blossomed), which won the award of the Königliche Akademie der Wissenschaften (Royal Academy of Sciences) in Berlin in 1773, the decline of the arts is seen as due to the loss of freedom. As soon as the republican spirit of the Greeks had perished, the fire of rhetoric was extinguished, maintains Herder in reference to Longinus, while the fine arts and comedy were able to survive here and there, in the hothouse of the courts.[21]

For Shaftesbury, political freedom certainly did not include creative freedom for the artist in the form of independence of directives from the patron. His view of the role of the patron of painters, whose work he regarded as lowly, is evident from a sketch of *The Choice of Hercules* that was given to Paolo de Matteis as instruction for the painting.[22] Falconet attacked this practice in 1769 as arrogance on the part of the client, and humiliating for the artist, while noting that a true artist would never submit to such treatment. For the rest, Falconet permitted himself the spiteful remark that Shaftesbury's sketch was no more than a description of the well-known painting by Annibale Carracci in the Palazzo Farnese. In the Salon of 1763 Diderot twice criticised the practice of commissioning works, preferring the sale of a finished work.[23] In his successful utopian novel *The Year 2440. The Boldest of Dreams*, which appeared anonymously in 1768,

37. Henry Fuseli, *Prometheus*, c. 1770-71

Louis-Sebastien Mercier describes an ideal state of the arts and the Salon. Time has swallowed up the deceptive and flattering pictures, for a long while now the arts have no longer been able to lie, the pot-bellied dilettantes who could bring artists to heel with a gold coin in their hands have disappeared and genius, free at last, no longer needs to bow and scrape but can follow its own laws.[24] Mercier could foresee no negative effects of that process.

The liberation from all constraints was also described by Wilhelm Heinse in his utopian and historical novel about a genius, *Ardinghello und die glück-seligen Inseln* (Ardinghello and the Isles of the Blessed), which first appeared in 1787. All moral constraints fall in an artists' bacchanal with beautiful Roman women. Ardinghello, painter, scholar, poet, musician and resolute man of action, is forced to flee from Rome after a second murder, and finally, after a brilliant career as pirate on the Cyclades islands between Greece and Turkey, founds a realm of freedom and equality, natural life and happiness. The vision of the political state looks back to the Greek republics, and the description of the happy primitive state of mankind is derived from Jean-Jacques Rousseau. Love is free, but rape is permitted to secure continuance of the human race, while the natural state is seen as war. As for the arts: "All the virtues and the arts must orient to the present state, if they are to have an effect and yield benefits".[25] However, the utopia of the unity of art, life and nature which Ardinghello decides to achieve is neither peaceful nor does it hold out hope of permanence, and Heinse ends his novel with the announcement of the collapse of the happy island realm.

Shaftesbury's selection of the moment in the life of Hercules that he wished to see represented showed his belief that the act of decision would

illustrate Hercules' acknowledgement that heavy labours were needed to liberate mankind from tyranny and oppression.[26] In 1791 Joseph Anton Koch, who had just fled from the Court College of Art, the Hohe Karlsschule, in Stuttgart, used the image of Hercules deciding between virtue and vice (fig. 38) for the situation of the artist. Art-Virtue, in simple Greek robes with a band bearing the inscription "Imitatio", stands beckoning on the one side, while on the other Art the Whore is enticing the artist with courtly luxury, but holding him by a chain round his ankle. The composite monster stands on twisted columns, revealing her many breasts, girt with money bags and with a train bearing the inscription "Compositio" held by a dwarf crowned with a laurel wreath and bearing a lyre, palette and malstock. In his caricature of the teaching of art in the Hohe Karlsschule, Koch described the monstrous whore as courtly taste.[27]

Koch's drawing of the artist faced with a choice was probably a reference to Shaftesbury's political interpretation of the theme of Hercules, which became available in German in 1748 and 1757.[28] However, Koch - unlike the propounders of artistic freedom - showed that the artist's virtuous choice of freedom would result in a loss of reward and distinctions. How great that loss was would be clear to everyone who read the essay *Vom Lohn der Kunst* (The Reward of Art) by one C. L. Junker, published in Johann Georg Meusel's periodical *Museum* in 1788. Junker argued that the wasteful courts often paid painters and musicians exaggeratedly high wages, making them obstinate and excessively proud.[29]

38. Joseph Anton Koch, *The Artist as Hercules at the Crossroads,* 1791

The first artist to achieve freedom from service to the state and an academy, and accept the inevitable poverty, was Asmus Jakob Carstens (fig. 39). He was appointed Professor and tutor of the plaster cast class in the Berlin Academy after successfully showing in the public art exhibition in 1790.[30] Carstens, who was directly responsible to Minister Heinitz, was given a two-year sabbatical to go to Rome in 1792, with his full salary of 250 talers, an annual subsistence allowance of 200 talers, and an advance of 100 talers to pay his debts in Berlin. But he did not fulfil the conditions attached to the stipend, namely, to report back to the Ministry and to send paintings for exhibition at the Berlin Academy. When asked for an explanation he excused himself on the grounds that he was preparing an exhibition in Rome. This was held in April and May 1795 in the studio of the late Pompeo Batoni, Via Bocca di Leone 25. Carstens showed three works in tempera, three watercolours and four drawings, and during the exhibition he finished his drawing *Night*. Without his knowledge, his friend Carl Ludwig Fernow published a glowing review in the journal *Teutscher Merkur*, which had its effect.[31] Heinitz, mollified, invited Carstens, in friendly but insistent tones, to send some of his works to the exhibition in Berlin that would open in September.[32] Carstens did so, sending three works, but he demanded that they should be returned at the state's expense or purchased by the Academy at a high fixed price; he also informed the Minister of his firm resolve to remain in Rome. He felt he could afford to take that step because his exhibition had been well received in that city and some of his works had found buyers. He therefore hoped he could live from his art, all the more as he had found in Fernow a journalist who supported him.[33]

In his reply Freiherr von Heinitz, now extremely angry, accused the artist of breach of contract. He calculated that in three years Carstens had received 1,562 talers and 12 groschen, without fulfilling his obligations or keeping his promises. Heinitz dismissed Carstens from his post as professor at the Academy, demanded the return of the full amount to the state under threat of legal proceedings, and instructed the Academy to hold the three paintings exhibited in Berlin until the debt should be paid.[34]

Carstens, deeply offended by the accusations and wounded by his dismissal and the demand for the return of his stipend, replied with a different calculation, only acknowledging a debt of 25 talers and demanding 300 zecchini in cash from the Academy for the confiscated paintings. The artist threatened to open public proceedings against a government office for injustice to a private individual. This was followed by his famous sentence on the obligation of the artist to mankind and to God, and the demand for understanding of the sacrifice made by an artist, who was accepting inevitable poverty in return for that obligation: "For the rest I must inform Your Excellency that I do not belong to the Berlin Academy but to mankind ... I shall continue to devote my whole life and strength to justifying myself to the world through my work. As you see, I renounce all worldly advan-

39. Asmus Jakob Carstens, *Self-Portrait*, c. 1784

tage, preferring poverty, an uncertain future and perhaps a sickly, helpless old age ... My abilities have been entrusted to me by God; I must make good use of them, so that when the hour comes to give account I do not have to say, Lord, I buried the talent you gave me in Berlin".[35] Carstens regarded a return to the Academy as a return to slavery.

In his article of 1795 Fernow had made some polemical remarks about German artists in Rome, and he greeted the works of Carstens as a new epoch in art.[36] This provoked a reply from Friedrich Müller in Schiller's periodical *Die Horen* of 1797, attacking Fernow, who, in turn, suggested that his words were due to wounded vanity.[37] In his biography of Carstens Fernow described the quarrel between the Minister and the artist as a fundamental conflict between the state and the genius, recalling Schiller's flight from the state of Württemberg: "In the well-ordered planetary system of our states, where everything revolves mechanically, in strict ranking order and with wise economy, around the centre of supreme power, the artist genius had no scope to ascend, free as a comet." As neither the church nor the state now needed the service of artists they were without civil rights, or they were herded together in the ghetto of the Academy. For Fernow, as for many of his contemporaries, the Academy was a costly institution, which only trained craftsmen and was not capable of producing true artists.[38] Fernow made two demands: firstly, that "true" artists should be liberated from any constraints

65

except those of humanity, morality and law, and secondly, that artists and art should cease to be the property of the state and be given to mankind.[39] For Fernow artists who preferred the comfortable cage of the Academy to free creativity were not true artists, because, unlike the genius, they were not working from compulsion. If a "true artist" like Carstens encountered unacceptable conditions and circumstances, he would inevitably become a martyr to art.[40] As Carstens died at an early age from tuberculosis, Fernow had the perfect example of a genius whose early death proved his unconditional sacrifice to art. Carstens could be declared the second martyr of art after James Barry.

In making his derogatory comparison of a comet in the planetary system and the free genius escaping from the state, Fernow showed that the consequences of freedom for the artist were to have no foothold in the state or society. In proclaiming in 1796 that he belonged to mankind, and would devote his life and strength to justifying himself through his work, Carstens must have been hoping to repeat his success of the previous year.[41] But both he and Fernow must have known that this was extremely unlikely. Karl Philipp Moritz, a patron of Carstens when he was at the Berlin Academy, said in an essay of 1785 on the concept of the artist complete in himself: "The true artist will seek to incorporate in his work supreme inner purpose or perfection; if this finds approval he will be glad, but his true purpose has already been achieved with the completion of the work". If an artist aims to give pleasure or win applause, he fails to achieve the supreme purpose of his art and shows himself to be a "false" artist. The "true" artist justifies himself through his art, while the "false" artist is satisfied with public applause.[42] In this severe definition, the artist can only be legitimated through his art, if he is not to betray himself as "false", out for applause or gain. At the same time, legitimation through art was made impossible by the abolition of the rules of execution and judgement, by the denigration of the academies and their standards, by disdain for the imitation of nature and by the justification of art solely through the artist. Fernow's comment only touches one aspect of the problem: "Art liberated, but also robbed of the support of religion, and at the same time of its constraint, now has to rely on itself, as it has in fact always relied on itself; instead of borrowing its interest from religion art has invested religion itself with a more general interest by entrancing the senses."[43]

Under these conditions, the artist could only be legitimated by maintaining he was a genius or through the testimony of his life, which again was to argue in a circle. The legitimation of their products and activity is the greatest problem artists face, and it was created by their liberation, by the abolition of the patron, and his replacement by the purchaser, by the denial of the rules of training and execution and the disdain for the mere imitation of nature. The attempt to legitimate art solely on the grounds of genius or the life of the artist made the problem insoluble. The consequences are to be seen in insecurity, self-doubt, paralysis and melancholy.

The problem of legitimation found expression in the emphatic proclam-

66

ation of the "true" or "genuine" artist, and a life lived unconditionally for art became the test of how "genuine" an artist was. In the introduction to his biography of Carstens in 1806 Fernow compares genuine artistic activity with institutional obstacles, and makes martyrdom the test of the true artist: "Genuine artistic activity is evident in a particularly impressive way where unfavourable circumstances stand in the way of its development, and its light shines all the more brilliantly where all combines to extinguish it ... Once become aware of itself, talent strives from inner compulsion towards its only true destiny; difficulties may delay it, obstacles can foil its endeavours for long, indeed, possibly for ever; intellectual strength can be defeated in the battle against the greater physical power of destiny, but the inborn drive can only be destroyed with life itself. More than one artistic spirit, highly gifted by nature but suffering a hostile fate, has thus become a martyr to his own compulsion."[44] Fernow was not only justifying Carstens' outrageous behaviour towards the Berlin Academy and the Prussian Administration, he was also establishing the factors that would play an essential part in the long history of the mystification and sublimation of the artist: The artist could suffer lack of recognition or even humiliation by his contemporaries and institutions, driven by inner compulsion and the need for unlimited freedom he would be a martyr to true art. His vocation was of religious intensity, and he would, if necessary, resist the authorities regardless of his own comfort or financial security.

The demand for artistic freedom in the form of independence of state institutions and patrons necessitated claiming the status of genius. In 1677 Roger de Piles maintained in his *Conversations*, in connection with Rubens' maxims, that nature and the genius were above the rules of art.[45] This was moving towards a limited definition of the rules of art as only capable of producing artists of skill, not geniuses, and at the end of the eighteenth century it was used as an argument against the art academies. The article *Génie* in the seventh volume of the *Encyclopédie* of 1757 attempted to define the difference between taste and genius. The genius, who always has a wild element in him, breaks the rules and the laws in order to reach the sublime. As the genius breaks the laws and rules he changes the world. However, the most significant consequence is the alienation of the genius from his own time. The genius is in advance of his time, and his light illumines the future.[46] So the genius is free of the rules, but this makes it impossible for him to be adequately acknowledged in his own time, and his recognition is postponed to the future. This was also the basis of one view of the avant-garde in art.[47]

Art philosophy, as almost always, made the problem intellectually difficult but objectively simple. In his *Kritik der Urteilskraft* (Critique of Judgement) of 1790, Kant declared that the genius was above the rules: "Genius is the talent that gives art its rules". He was referring to the fine arts, which could only be a product of genius. The genius must first and foremost have originality, and his products must be exemplary, that is, they must not be imitations, but they must offer rules for judgement. Moreover, the genius can

neither describe nor explain how his products evolve.[48] Kant did not overlook the fact that a work of art has to be produced with craftsmanship, and this must follow technical rules, and he mocked at weak minds who declared they were above the rules of execution because they were geniuses.[49] The rule given by genius cannot be a formula, according to Kant, it must be abstracted from his product. Others can test their own talent by using his product as a specimen to emulate, but not to copy. Carstens' drawing *The Battle between the Gods and the Titans* (fig. 40) of 1795 is an example of this, for it follows Michelangelo's *Last Judgement*.[50] But could this sketch claim originality or its creator claim to be a genius, except for the ability to imbue the Last Judgement with current political significance?

The simple approach to legitimation taken by a French artist, who tackled the question of earning money and applause relatively openly, is strikingly different from these seemingly insoluble complications. When Jacques-Louis David defended charging an entrance fee for his exhibition of *The Sabine Women* in 1799, his first argument was that freedom was the necessary condition for genius to unfold, and it was guaranteed by financial independence. By saying this he was not referring to political freedom or the end of service at a court, he simply meant sufficient financial independence to enable the artist to meet the costs of materials, models, costumes and his own subsistence. Poverty prevented an artist from working, wretchedness and suffering prostituted him, the pressure to earn money corrupted through humiliating commissions.[51] An exhibition realized the true end of art, a contribution to the general good, by enabling the public to participate in works of art. That was how David justified his personal profit. Financial success brought the artist recognition in an honourable way. Failure, if the public stayed away, taught him to correct his mistakes and to draw attention and hold it with better work. The public formed its taste by judging art. David bowed to the public by declaring that he knew no greater honour than to be judged by public taste. In his ideal system the artist worked in freedom, without a commission or instructions, and received his recognition through the number of visitors, which also secured him financially. Success confirmed and legitimated the artist. David eliminated the problem of the corruption of artistic standards by postulating a public that understood art.

In the rather less comfortable reality, artists like Joseph Anton Koch recognized that freedom from service at a court and financial insecurity had thrust artists into a new dependence, on the wealthy patron or the market. Koch drew a portrait of the artist prostituted and humiliated in his caricature of Lord Bristol in Rome (fig. 41). Lord Bristol was Bishop of Derry; he travelled in Rome in January every year, where he resided in the Palazzo Zuccari, spent the days drinking, but paid out one or two hundred ducats every day for new works of art.[52] Koch's satire *The Modern Chronicle of Art or Rumford Soup*, which was only printed in 1834 in Karlsruhe, takes the form of a fictitious correspondence between a friend from Manchester, who has fled to Siberia disgusted with the art world in Rome, and the painter Koch, still in the Eternal City. Koch poured out all his hatred of

40. Asmus Jakob Carstens, *The Battle between the Gods and the Titans,* 1795

the art mob and the fawning toads, who were letting themselves be both supported and disgracefully treated by Lord Bristol.[53] In *The Chronicle of Art* Koch gives a description of a satirical painting on a gold ground, parts of which relate to a drawing that has survived. It shows a long section through three rooms. In the right third is a staircase on which rival artists are fighting, in the centre starving artists are creeping up, and on the left side Bristol, the patron of the arts, is seated at a table. He is shown as Lord Plumpsack, with Midas ears, surrounded by loose women and the dishon-

est landlord. Under the table lie exhausted porters, and a dog is barking "anch io son pittore" while emptying its bladder over a canvas. In the upper centre Koch has depicted himself in helpless flight, reaching for a chimera, while Saturn is thrusting him back upon Lord Bristol as a source of earnings.[54]

Koch has described the hopeless situation of a serious artist in the Roman art world, once he had become largely dependent on a dubious patron or purchaser. But to Koch, Lord Bristol was only one of many who were ruining art. He saw art as driven out of Paradise by the seven deadly sins - the patrons, the art academies, literature, the antiquaries, the art industry and the art trade, the galleries and the over-clever connoisseurs. Altogether, the system and its rulers favoured the less talented artists, while the good artists were left to their fate, or were trodden in the dust by the art mob.[55] Koch's *Modern Chronicle of Art* shows the bitter choice - the artist either remained in the art centre, and became helpless and misanthropic, or he fled the art world and art itself into the freedom of the steppes and deserts of Asia.

The most important analysis of the position of the artist in the early nineteenth century is in an essay by Honoré de Balzac, *Des artistes*, which appeared in 1830 in the magazine *La Silhouette*. Balzac describes genius as a human disease, like the pearl in the shell. He denies that the artist is free, because he is subject to a superior will: "This is the artist: the humble tool of a despotic will, obeying a master. If he is believed free, he is a slave; if he is seen to be in movement, abandoning himself rapturously to his follies and pleasures, he is powerless and without will, he is dead. A perpetual antithesis, evident in the majesty of his power and in the vacuity of his life:

41. Joseph Anton Koch, *Caricature of Lord Bristol as Patron in Rome,* c. 1800/1810

he is always a god or always a corpse."[56] The inspired artist's indifference to the necessities of life and the vices of greed and idleness are incomprehensible to both the righteous citizen and the broad mass.

Balzac not only affirmed the gap between "society" and the artists who do not conform, he also offered a model with which artists could identify by combining unhappiness and genius with a messianic quality. Balzac declared that Christ is the model for the artist, as the artist's life is spent under the yoke of the maxim that a great man must necessarily be unhappy: "In that regard, Christ is the admirable model. The man who suffered death for the divine light which he spread over the earth, and who ascended the cross to be changed from a human being into a God, offers a powerful drama: it is more than a religion, it is an eternal type of human fame. Dante in exile, Cervantes in hospital, Milton in a small cottage, Correggio exhausted by the weight of copper coin, Poussin ignored, Napoleon on St. Helena, are all images of the great and divine spectacle that Christ offers on the Cross, dying to be resurrected, transcending his mortal remains to rule in heaven. Man and God, man first, God later, man for the majority, God for a few faithful, hardly understood, then suddenly adored; finally, become a God only because he baptized himself with his blood".[57]

The examples do not accord with the historical facts, but they have been assembled, perhaps not without irony. Balzac does appear to be serious about his most important comment on the artist: "un artiste est une religion". The artist needs a messianic faith in himself, and he needs the will to make himself a martyr to his art. He must be able to see his misfortune as essential to his artistic creativity, and as the tacit evidence of his genius. If the myth is to function, the artist needs to be convinced that he is different, he needs a community that believes in him and an environment that is uncomprehending and hostile.

The fateful consequence of these ideas is not only to subjectivize artistic creativity and its products, it is to shut the artist off, with his fellows, in an art system that is like a sect. Balzac recognized the disadvantages of this sectarian isolation, but he challenged artists to accept the envy and hatred between artists and the general aggressivity, and to see in artistic rivalry proof of the passion for art.

In this combination of religious role model and persecuted victim, of messianic belief and self-sacrifice, Balzac had already formulated the most powerful myth of the artist in 1830. At the same time Samuel Palmer painted a *Self-Portrait as Christ* - the first in a long series that, with this myth of the artist, has retained its model character to today. Albrecht Dürer's *Self-Portrait* of 1500, now in Munich, was the first example of this kind of artistic self-representation. In 1842 Jules Michelet, travelling in Germany, recognized it as an image of Christ, and for the art historian this was a major discovery.[58]

In 1795 Friedrich Schiller published a series of letters in his periodical *Die Horen* on the aesthetic education of man, at which he had worked since the summer of 1793. In the second letter he asks whether it is justifiable to concern oneself with beauty in such turbulent times - four years after the French Revolution - rather than with "the most perfect of all works of art, the building up of true political freedom". Schiller is raising the problem that had been raised in the livret for the Salon of 1793.[59] While artists in Paris were proclaiming their freedom and independence as one of the achievements of the Revolution, Schiller answered his rhetorical question by arguing that art was the medium through which man could educate himself for true political freedom. Public art is a communicative force, and it transforms life. Art is the reconciling force between the terrible realm of the external forces of nature and the sacred realm of the laws, and it frees man from all physical and moral constraints. Art sets a process of education in motion which eliminates the conflict between nature and the moral subjection of the individual. It can be the embodiment of communicative reason and the means of uniting society, because it refers to what is common to all.[60]

For Schiller, the conditions for the creation of beauty were, beside climate and morality, inter-subjectivity. Beauty cannot be created in isolation or in a crowd, it can only emerge when the extremes of alienation and community are avoided. The crucial paragraph in the 26th letter is: "Not where man hides himself troglodyte-fashion in caves, eternally individual and never finding humanity outside himself; nor where he moves nomadically in great hordes, eternally plural and never finding humanity inside himself; only where he dwells quietly in his own hut, communing with himself and, as soon as he issues from it, with the whole race - only then will her lovely bud unfold."[61]

Schiller contrasts two states of alienation - isolation and the great horde - with a free and simple being in harmony with himself. Such a person can speak with mankind and use art as a means of communication. Revolutionary France had intended the arts to serve the general good and the political aims of the Republic after their liberation. That service could not be regarded as another form of servitude, because it was not required in the name of a tyrant but in the name of freedom. Jacques-Louis David, presiding over the meeting of the National Convention on 28 Nivôse of the Year II (1794), responded to the demand for work for artists that would be worthy of Republican hands with these words: "The arts will regain all their dignity, they will no longer be prostituting themselves, as before, to retrace the deeds of a tyrant. Canvas, marble and bronze will be rivalling each other in their urge to show posterity the unflinching courage of our Republican phalanxes ... We have conquered our foes in arms, and will do so again in the arts - that is our destiny, that is the will of the genius that is sweeping over France".[62]

So the arts were incorporated in the political aims, and their tasks were

clearly defined – to serve propaganda and build up revolutionary courage, and to give a warlike demonstration of the cultural superiority of France. The comparison of the deeds of art with those of war could be said to look forward to the application of the military term "avantgarde" to the arts. However, under the Republic artists could not be regarded as the "avant-garde", originally the advance reconnaissance corps ahead of the main body of the troops, for they first had to free themselves of the accusation of corruption, declare that they were at the service of freedom, and so recognize that they were led and supervised by political reason.[63] Napoleon, both heir to the Revolution and its destroyer, incorporated the arts in the French economy, as the "Exposition de l'industrie" of 1806 showed. The exhibition had four sections, the fine arts, materials, and French mechanical and chemical products. Napoleon had founded the "Société pour l'Encouragement de l'Industrie nationale" in 1801, and he ordered an annual exhibition of industrial products. The 1806 exhibition was not held, like the others, in the court of the Louvre but on the broad esplanade before Les Invalides; more than a thousand exhibitors from all over France took part, and for the first time the fine arts were part of a French trade fair.[64]

The idea that artists could be at the head of economic and social progress first occurs in a fictitious dialogue between an artist, a scholar and an industrialist, written in 1825 by Olinde Rodrigues, a pupil and follower of Henri de Saint-Simon. The dialogue was intended to correct the marginalization of artists by the Saint-Simonists, and the discussion, which is led by the artist, is concerned with Saint-Simon's great aim, to coordinate the progressive forces in industrial society – industry, the sciences and the arts – for the huge global production apparatus. The development of the future world society not only requires human beings to be organized in a "compagnie de travailleurs", it also needs a system of theoretical and moral ideas, to ensure and communicate coherence and meaning.

In the 1825 dialogue the artist proposes to the industrialist and the scholar a fasces of the great trinity, the sciences, industry and the arts. Like the fasces, a bundle of rods with the blade of an axe protruding, it would be a symbol of power or authority, and the arts would play the part of an advance troop, or "avantgarde". This is because they command weapons of every kind and are thus particularly capable of spreading new ideas with great effect and speed, appealing as they do to the imagination, the senses and the feelings. The scholar objects to this and accuses the arts of corruption; he reminds the other two that so far the arts have flourished best under an absolute monarchy. The industrialist acknowledges that the teaching of Saint-Simon is still often regarded as the product of a confused mind and so needs interpretation, but he objects, initially, to the idea of a trinity of forces.[65] In his fragment *De l'Organisation sociale* of 1825 Saint-Simon himself said, referring to the function of the artist in the maturation process of a society: "Artists are people with imagination, and they will head the march; they will proclaim the future of mankind ... they will fill society with enthusiasm for increasing its well-being ... in order to achieve their aim they will use

all the means of art, eloquence, poetry, painting and music, in a word they will develop the poetic part of the new system."[66] Rodrigues uses the term "avantgarde", but he only accords the arts the task of making propaganda, while Saint-Simon declares the artists themselves pioneers and prophets of the future. This is a repetition of the view of genius presented in the *Encyclopédie*, ahead of his time and illuminating the future.

So the idea of an avantgarde in the arts was developed not by artists but by the imaginary figure of the artist in the Saint-Simon movement. The idea is not based on an analysis of the arts but on the concern to incorporate artists in a system that judged activities according to their usefulness – "utilité" – for social development. It is ironic that the term "avantgarde" was first used for artists when the need was felt to accord the arts a function in the global industrial system and make them propagators for the general good. In 1830 the Saint-Simonist Emile Barrault linked the orientation of artists to the future with the idea of priest-like leadership in a cult of the Fine Arts; this essay appeared at the same time as the essay by Balzac quoted above.[67]

The fundamental problem, whether art should be seen as the expression of society or as the anticipation of the future, had already been raised by Mme de Staël in 1800, in her pioneering work on the sociology of literature.[68] In 1845 Laverdant, a Fourierist, tried to combine the two functions and propound the role of the artist as prophet by affirming that artists represent progressive social tendencies: "Art is the expression of a society, and at its peak it represents the most progressive social tendencies; it is both prophecy and revelation. To discover whether art can credibly fulfil its pioneering task, whether an artist is really in the avantgarde, one naturally has to know whither mankind is heading, what his destiny is."[69] This is the happy fate that Laverdant, like Fourier, sees as the development of the spiritual abilities to beneficial and harmonious use.

These are only a few voices from a broad discussion that lasted throughout the century on the position of the artist and the arts, in society, politics and future development. Understandably, the different approaches not only produced controversial definitions of the central concepts of beauty, usefulness, society, art, progress and the future, more important, they saw these as subject to different relations and compatibilities.

In 1834 Théophile Gautier, then twenty-four, published a witty and polemical plea for freedom in the arts in the foreword to the first volume of his novel *Mademoiselle de Maupin*. After attacking the idea of art as useful, Gautier demonstrates the incompatibility of usefulness and beauty by asking what use is served by the beauty of flowers, or the beauty of women? He then goes on to identify usefulness with ugliness and repulsiveness: "Nothing is really beautiful except what can serve no end; anything that is useful is ugly, because it is the expression of a need, and the needs of man are low and repulsive, like his pitiable and infirm nature – the most useful places in a house are the latrines".[70] Gautier's objection to making art useful to society earned him Balzac's approval and much criticism. The foreword in which he attempted to strip art of its

constraint to be useful laid the basis for the so often misinterpreted slogan "l'art pour l'art".[71]

The term "l'art pour l'art" occurs as early as 1804 in the diaries of Benjamin Constant, where it is a reflection on the idealistic German theory of art which sees purpose as different from beauty. Constant expressed the new idea in a paradox: "l'art pour l'art and without purpose, for any purpose will ruin art. But art achieves a purpose it never had."[72] Art fulfils its purpose, however this may be defined, if political, economic, propagandist or moral aims are not prescribed to it, or if it is not used for such ends. Gautier's advocacy of the autonomy of art was in opposition to the bourgeois, profit-oriented society of the July monarchy. In his note on "l'art pour l'art" in his "Götzen-Dämmerung" (The Twilight of the Idols) of 1888, Nietzsche severed the connection between art and morality: "The battle against purpose in art is always a battle against the moralizing tendency in art, against its subordination to morality. 'L'art pour l'art' means 'to the devil with morality!' "[73] Freed of morality, art will find its purpose as the great stimulus to life.

This principle was shared by the Bohemians, a movement in Paris after 1830 whose aim was to evolve a life style which, according to Balzac, one of the early protagonists of the "vie bohème", differed from that of the worker, the thinker and the idler. Unrecognizable heirs to the "république des lettres et des arts", cut loose from bourgeois ideas on work and morality, cut off from the people whose poverty they often shared, and after the 1840s themselves split into the "bohème dorée" of the dandys and the "other bohemians", the intellectuals, writers and artists, the Parisian Bohemians stood for the autonomy of literary and artistic life. They built up a separate market for themselves, and they achieved recognition for their different life style and for the gap between the artist and bourgeois society.[74]

The World Exhibitions in London in 1851 and Paris in 1855, on the other hand, intensified discussion about the relationship between the economy, industry and art. The criticism of industrial production as shown in the Great Exhibition in London led Gottfried Semper to evolve his programme for eliminating the division between the fine and the technical arts in a practical aesthetics.[75] The urgent problem was not the ability of artists to illuminate the future, but the whole future of the arts in industrial production. In his major report on the Great Exhibition of 1851 in London, Léon de Laborde began by stating the general conviction: "Everyone is saying to himself: 'The future of the arts, the sciences and industry lies in their amalgamation' "[76] In 1855 Paris appeared to have taken the heat out of the debate by including the arts in the demonstration of international competition yet giving them, like industry, a separate pavillion (fig. 42), where they could appear as an autonomous field. But the problem of the relationship between industrial, craft and artistic production remained.

In his educational novel *Histoire d'un dessinateur* of 1879 Eugène Emanuel Viollet-le-Duc imagines an industrialist, Majorin, evolving a form of tuition designed not to make an artist of his pupil, little Jean, but to develop his

42. *Facade of the Palais des Beaux-Arts at the 1855 World Exhibition in Paris*

natural talent for observation and his intelligence, and so make him a useful human being. Jean is taken through the world by his mentor, learns to correct the false image of Antiquity in the interiors of Pompeii, and to see from the criticism of Louis XIV the fateful end of a policy of art that egoistically concentrated all the arts on the court, so depriving the people. Accordingly, Jean does not become an artist, he designs models for industrial production, and he dreams of founding a school with teaching centres for designers for the Paris industries which the country needs. In conclusion Viollet-le-Duc offers a rather inflexible moral: "If drawing is taught as it ought to be taught, and as M. Majorin endeavoured to teach little Jean, it is the best means of developing the intelligence and forming the ability to judge, for it teaches us to see, and seeing is knowledge."[77] In regarding drawing as playing an essential part in the development of the individual and in the applied arts, and so being of economic use, Viollet-le-Duc intensified the contrast between academic teaching and the industrial arts.[78] The idea of "free art" played no part at all in his alternative teaching method, and accordingly its problems were never raised. Even Viollet-le-Duc could no longer integrate the fine or free arts into the useful arts.

The contemporary position of the artist was hardly considered by the philosophers, economists and economic sociologists who were concerned with designing the future. Artists in turn appear to have shown little interest in the designs for the future utilitarian world society. Men of letters joined in the discussion on art and society, but only a few visual artists did so. The European renown of stars like Antonio Canova and Bertel Thorvaldsen seemed to make any discussion on the justification of art superfluous. Clearly art and utility were two different cultural fields, which existed independent of each other and would remain separate. So while the Saint-Simonists attempted to integrate the arts and artists in their design for a future world society, many artists turned back to the high esteem that had been enjoyed in earlier times and was now lost, as was the former harmonious relationship with royal or church patrons, and they chose as subjects the stories and legends of famous artists of the past.[79]

Nicolas-André Monsiau started the fashion in France for nostalgic artistic reverence with his painting *The Death of Raphael* (fig. 43) in the Salon of 1804.[80] Two years later, in the Salon of 1806, Pierre-Nolasque Bergeret showed a large painting entitled *Honneurs rendus a Raphael après sa mort* (Raphael honoured after his Death).[81] Monsiau and Bergeret followed Vasari's description of Raphael lying in state in his studio under the painting of *The Transfiguration*, but Bergeret included artists like Michelangelo, Perugino and Vasari among the mourners, as he saw fit. The subjects had immediate appeal. The "Société des Amis des Arts" bought Monsiau's painting at the 1804 Salon, and Napoleon gave Bergeret's painting to his Empress Josephine in 1806 for the music salon in Malmaison.[82]

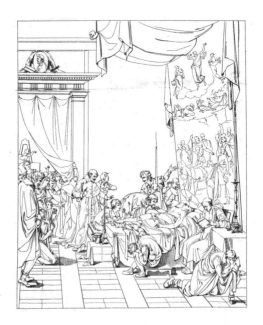

43. Nicolas-André Monsiau,
 The Death of Raphael, 1804

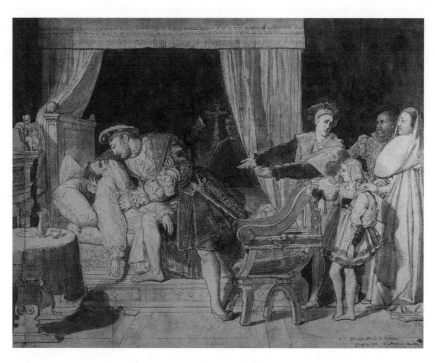

44. Jean-Auguste-Dominique Ingres, *Leonardo dying in the Arms of François Ier,* 1818

In 1824 Ingres showed three royalist paintings in the Salon - the large painting *Louis XIII taking the Oath*, which was intended for the cathedral of Montauban, and two small paintings commissioned by Count de Blacas. One showed Henri IV surprised by a visit from the Spanish Ambassador while playing with his children, and the other Leonardo on his deathbed, breathing his last in the arms of François Ier (fig. 44).[83] This small painting is not only an exemplary reminder of the king's love of art, it is a testimony to the legendary reverence of a king for a great artist. Ingres' painting was executed in 1818, and it is one of a long sequence of paintings of legendary or historic scenes from the lives of the Old Masters. They are the products of a broad and continuous concern which went on until the 1880s. Many of these works affirm the harmonious relationship between patron and artist, or they show the honours paid to an artist on his death or at his burial; some show rivalry between artists, a free and happy love life, an equally happy family life, or the wonderful discovery of young talent. They are almost all sublimations of the social integration of the artist, supreme acknowledgement of his achievements and the revelation of genius, from Masaccio to Rubens. Revenge for injured pride was a theme, but there are no paintings on the subject of independence. Ingres painted the revenge that Tintoretto is said to have taken on Aretino for injurious remarks, according to Ridolfi, who relates that the painter invited the writer to his studio to finish a portrait, but pulled a daggar from his robe and then calmed the startled visitor with the ominous remark that he only

wanted to take his measure.[84] Ingres showed his account of the revenge of an artist injured by criticism in the same Salon of 1824 in which he showed his painting of the death of Leonardo.

Subjects sublimating the artist were taken up and repeated over and over again, not only in France; they are all expressions of a nostalgic cult, with recollections of a better past. The artist's dying moments are eased by a great king, an emperor bends to pick up a paint brush from the floor (fig. 45), the artist is mourned and honoured after his death by the people, his colleagues and rivals, by cardinals and even the Pope. These pictures of artists shown respect and reverence by the people, the nobility and the clergy supported a conservative and royalist propaganda by contrasting the current gap between the artist and society with earlier harmonious relations.

This concern with the standing of the artist was chosen largely at the initiative of the artists themselves. Monsiau and Bergeret, who started the fashion in France, painted exhibition pieces for the Salon. It is easy to trace the line between the hope that the viewer will regard a work with "admiratio", through the Pygmalion legend of the artist in the mid-eighteenth century to the growing obsession with reverence for artists in the first half of the nineteenth. However, unlike the eighteenth century

45. Robert Fleury, *The Emperor Charles V Picking Titian's Brush up from the Floor,* Salon of 1843

46. Paul Delaroche, *The Artists' Assembly*, decoration for the amphitheatre in the École
 Nationale Supérieure de Paris, 1841, detail: right panel showing the painters Fra Angelico,
 Leonardo, Dürer, Raphael, Michelangelo, Poussin and others

works, the nineteenth century depictions do not show admiration and
reverence being given to the work, they are accorded directly to the out-
standing artist. The cult of the artist was not only nostalgic, its aims were
similar to the numerous assurances of the high standing of art and the
artist in Antiquity, which was followed inevitably by decadence. The de-
pictions of the veneration of dead artists (not only in deathbed scenes)
conjure up the past in order to challenge contemporaries.

The complement to this historical veneration of the artist were the ideal-
ized groupings of artists in a-historical paintings. Ingres started this trend
with *The Apotheosis of Homer* of 1827, a ceiling painting for the Louvre,
with which he followed the supreme example, Raphael's frescoes for the
Stanza della Segnatura. In 1841 Paul Delaroche provided the ideal glorifi-
cation in the Hémicycle of the Ecole des Beaux-Arts in Paris, with the
largest number of figures so far, an assembly of artists as the divine coun-
cil (fig. 46).[85] In 1840 Friedrich Overbeck painted his great *Triumph of
Religion in the Arts* for the Städel Art Institute in Frankfurt, an Elysium of
artists from Germany and Italy under the Holy Mother of Art Religion
enthroned in heaven. It was a desperate attempt to counter the contemp-
orary decline of art with its saints, Raphael and Dürer, and to combat
materialism with traditional German craftsmanship.[86]

Retrospectives and Personal Museums, West and Canova

In 1813 the British Institution mounted a retrospective of 141 works by Sir Joshua Reynolds, who had died in 1792.[1] The foreword to the catalogue, which was probably written by the Keeper, Valentine Green, states the two main aims of the exhibition: firstly, to affirm the British school of painting, and secondly, to show to what level of perfection Reynolds had raised art from a lowly state: "To those who have seen the works of the immediate predecessors of this Artist, and view the splendid Exhibition which is now offered to the Public, and, at the same time, consider that these form only a part of the superior productions of one individual, it may be unnecessary to observe, that no painter ever raised the art from so low a state of degradation, to so high a point of excellence, or has left more splendid and instructive examples for the imitation of his successors".[2] The idea for the show, which was apparently the first retrospective for an individual artist, derived from two familiar practices, the sale of work after the death of an artist, and the one-man show. However, Reynolds' retrospective of 1813 differed in that the artist had died more than twenty years earlier, and none of the works shown was for sale. The exhibition was intended both to serve the British desire to maintain a school of painting and to further the reputation of the artist.

Benjamin West immediately took up the idea of a retrospective. In the catalogue for the Reynolds exhibition the British Institution had announced that it had purchased Benjamin West's painting *Our Saviour healing the*

47. *West's Picture Gallery,* line etching by J. Le Keux from the drawing by G. Cattermole, 1821

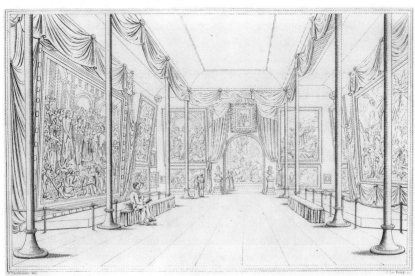

Sick in the Temple for 3000 guineas, and opened the subscription for the engraving. West used the exhibitions of his new religious paintings in 1814 and 1815 on the old premises of the Royal Academy in Pall Mall to inform the public that a retrospective of his entire output was in preparation: "Mr. West also avails himself of this opportunity to announce, that the present Picture is the precursor to the entire body of his Works, produced in the last half century, which he intends shall appear in Exhibition before the Public in the course of the two subsequent years."[3] West died before he could organize the exhibition, but shortly after his death his sons set up West's Picture Gallery (fig. 47), as a personal museum. When the initial success began to fade they tried in vain to sell the entire collection to the United States for a future national gallery. In 1829 West's works were auctioned in London.[4]

The retrospective of Reynolds' works, which was probably the first of its kind, and the posthumous West's Picture Gallery, are in stark contrast to the very much more comprehensive plans made for their posthumous fame by the two outstanding artists of the first half of the nineteenth century, the sculptors Antonio Canova and Bertel Thorvaldsen. Canova systematically promoted his reputation by publishing engravings of his works and having marble versions of plaster casts made in his workshop.[5] He was equally persistent about the installation of his monumental statue *Religion* in St. Peter's in Rome, the very centre of Christian worship, and in his project for transforming the Pantheon in Rome into a Hall of Fame for artists.[6] When these projects failed to materialize he finally embarked on the *Tempio,* in his birthplace Possagno. It was to be an imitation of the Roman Pantheon, his church and hall of fame. His step-brother, secretary and heir, Giovanni Battista Sartori, had a plaster cast museum built behind the house where Canova was born, on the model of the Vatican Museo Pio-Clementino, and transformed the house itself into a memorial to the artist, with his tools, death mask, the portrait by Thomas Lawrence and the engravings of his works. The first project for a "Museo per oggetti di scultura e numismatica" by Francesco Lazzari in 1832 took up the idea of the Pantheon.[7]

In 1812 Canova completed a colossal self-portrait (fig. 48) showing himself in heroic pose. It is strikingly similar to the marble portrait of his hero Napoleon, which he carved in 1803. According to Cicognora the portrait of Napoleon was one of the few executed works which were found in Canova's studio after his death, while the English purchaser said the bust of Napoleon came from Canova's bedroom.[8] Canova's colossal self-portrait was placed beside his and his stepbrother's tomb in the Tempio in Possagno, together with the portrait of Giovanni Battista Sartori by Cincinnato Baruzzi. In his last will and testament of 12 October 1822 Canova instructed his brother to use his entire estate to complete the *Tempio* in Possagno.[9]

The *Tempio* was to be Canova's total work of art, a combination of architecture, sculpture and painting. For the building itself he designed a combination of the Roman Pantheon with a Doric order following the Parthenon in Athens. He designed the metopes and the sculptures for the niches and,

in complete misjudgement of his abilities, also painted the altarpieces. The *Tempio* takes up the idea of changing the Pantheon in Rome into a Hall of Fame for artists and showing the history of Italian art in a hagiography of the artists. He had obtained permission from Pius VII in January 1809 to have a number of busts of artists made for the Pantheon at his own expense. This derived from the cult of Raphael, whose tomb was in the Pantheon.[10] The commissions for the portrait busts enabled Canova to give work to un-employed sculptors in Rome, but in 1820, when a number of the busts had been made, Pius VII ordered them to be moved to the Museo Capitolino. Around 1813 Canova put a proposal to the Pope to make a colossal statue of religion, *La Religione cattolica*, eight metres high, for St. Peter's at his own expense. When a half-sized model had been made the plan was foiled by the Canons of St. Peter's, and in 1818 Canova decided to use his huge fortune for a *Tempio* in Possagno.[11] Unlike the Pantheon project, however, it was to be the "opus magnum" of a single artist. Canova laid the foundation stone on 11 July 1819, dressed in red Papal uniform and decorated with all his medals.

After Canova's death on 13 October 1822 memorial services were held in many Italian cities - Venice, Possagno, Udine, Asolo, Treviso, Florence, Milan and Rome. After the service in St. Mark's the Accademia di Belle Arte in Venice held a memorial ceremony for which the room was decorated with engravings of Canova's works to demonstrate his genius. Leopoldo Cicognara, President of the Venice Academy, published an international request for subscriptions for a monumental tomb for S. Maria Gloriosa dei

Frari.[12] Canova's own design for a tomb for Titian, the greatest artist Venice
had produced, was to be used and executed with the sculptor's own chisels.[13]
Canova's heart was buried in the tomb in Venice, while the Academy kept
his right hand and his body was given to the inhabitants of Possagno for the
tomb in the *Tempio*. This macabre dismemberment to found three centres
of veneration and pilgrimage recalls the distribution of relics of a saint.

49. Giuseppe Valadier, *Memorial Service for Antonio Canova*, 1823

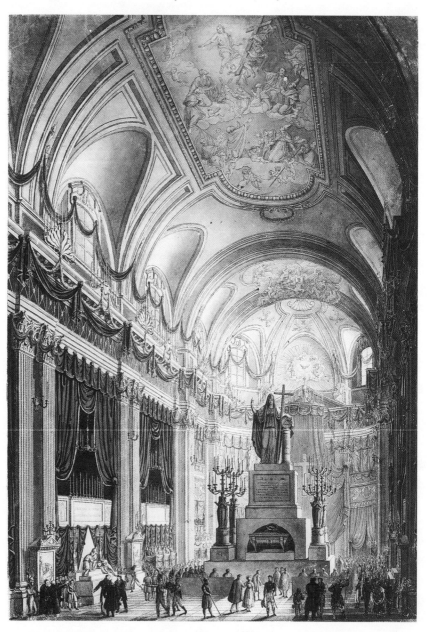

Possagno certainly succeeded in becoming a place of pilgrimage with the *Tempio*, officially opened in 1830, Canova's birthplace and the plaster cast museum, which was finished in 1836.[14]

For the memorial service held by the Accademia di San Luca in SS. Apostoli in Rome, the architect Giuseppe Valadier designed a grandiose decoration with a catafalque, a model of *La Religione cattolica* and an exhibition of the plaster models for Canova's religious works (fig. 49).[15] By placing the colossal statue on a high plinth the Academy completed the project which Canova had failed to complete for St. Peter's, and demonstrated how great a work had been lost through intrigues, as Cicognara pointed out in his memorial speech in Venice. In the 1820s a flood of publications appeared on Canova's life and works . Leopoldo Cicognara described the artist's death in his biography, recording his last words, "anima bella e pura", to affirm his sacred spirit.[16]

In 1826 Giovanni Battista Sartori sold Canova's Roman studio and took the plaster models and sculptures to Possagno, where they were installed in the plaster cast museum, built between 1831 and 1836 (fig. 50). The architecture of the museum is based on the Galleria delle Statue at the Museo Pio-Clementino. It provided a sanctuary for Canova's works; the models, with the transfer marks still on them, retained the character of the studio, from whence the works had been sold throughout Europe and America.[17]

The memorial services for Canova rivalled the first spectacular memorial ceremony for an artist, the *Esequie del Divino Michelangelo* held by the City of Florence in 1564.[18] But the events held throughout Europe to mark the

50. The great hall in the sculpture gallery in Passagno with Canova's plaster casts

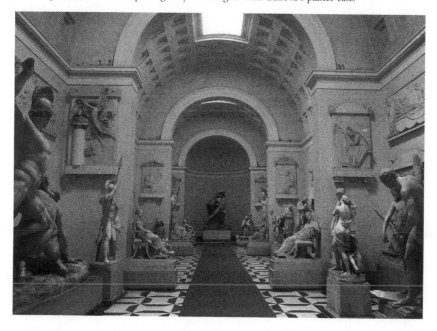

51. Karl Friedrich Schinkel, *Design for the Decoration of the Raphael Celebrations at the Akademie der Künste,* 1820

three hundredth anniversary of the death of Raphael in 1820 were of more immediate relevance for the Canova cult.[19] There had been no real inter- ruption to the reverence for Raphael since his death, but the adulation of the artist reached a peak in Italy, France and Germany in the first three or four decades of the nineteenth century. The German art-lovers and artists in Rome were particularly ardent devotees of Raphael. The first edition of Wilhelm Heinrich Wackenroder's *Herzensergiessungen eines kunstliebenden Klosterbruders* (The Heartfelt Outpourings of an Art-Loving Monk) in 1797 had a portrait of Raphael as frontispiece, with the caption *The Divine Raphael,* and the same copperplate was used a year later for Ludwig Tieck's novel about an artist, *Franz Sternbalds Wanderungen* (Franz Sternbald's Wanderings).[20] Once again admiration for an artist was so fervent he was called "divine", but this appears to be the expression of an intense and pious love of art, rather than "deus artifex - divino artista".[21] The Lukas brothers undertook an art pilgrimage in 1810 to the "sacred" birthplace of Raphael, Urbino, where they visited the house he was born in, full of admiration and longing.[22] The brothers Franz and Johannes Riepenhausen began twelve

drawings of the life of Raphael around 1806, and had them printed in Frankfurt in 1816.[23] For the Raphael festivities in the Berlin Academy Karl Friedrich Schinkel designed a decoration with copies of Raphael's main works in front of a red wall hanging and a sarcophagus surrounded by larger than life-size statues of the four arts (fig. 51).[24]

An immense stock of literary and pictorial material testifies to the idolization of Raphael. While this is relatively easy to grasp, it appears to be difficult to find explanations for the cult. That it was important for Germany to reaffirm the old connection between Raphael and Dürer and so make up the cultural backlog to Italy, is evident from the writings of Wackenroder, Tieck and Friedrich Schlegel.[25] The reverence for Dürer was the national analogy to the idolization of Raphael and it culminated in the celebrations to mark the three hundredth anniversary of his death in 1828.[26] The art-saints Raphael and Dürer recalled the glorious past of art, the ideals of which could be contrasted with the less fortunate contemporary conditions, and to postulate the ideal of an art-religion helped to restore the power of art and its position in the context of contemporary life.[27]

The Cult of the Dead Genius, Thorvaldsen's Museum

Thorvaldsen arrived in Rome on a scholarship in 1797. When he returned to Copenhagen in 1838 he was the most renowned artist in northern Europe. Like Canova, he was a child of poor parents, and like Canova he maintained a big studio in Rome where his designs were executed; again like Canova, he moved in Europe's top aristocratic circles, receiving numerous commissions from them for portraits, tombs, monuments and statues; he was ennobled several times and received every conceivable academic honour. In the first decade of the nineteenth century he was already rivalling Canova in the northern European countries. In 1806 Carl Ludwig Fernow declared that the young Danish artist was superior to the celebrated Italian.[28] Thorvaldsen made good use of the publicity, and as early as 1809 he was publishing silhouettes of his compositions by the Riepenhausen brothers, on the advice of Joseph Anton Koch. In 1833 Melchiore Missirini published a two-volume illustrated catalogue of his works in Rome, and in the same year a two-volume biography with an illustrated catalogue of all his works by the Danish writer Just Mathias Thiele appeared in Leipzig.[29]

Thorvaldsen was portrayed unusually frequently by both painters and sculptors. Some of these depictions show him in his studio, many include the attributes of the sculptor, but not one shows him working. Even where Thorvaldsen is seen in his studio, he is always absorbed in intense thought. His hands lie idle; at most they may hold a tool or are supporting the impressive leonine head, but the blue eyes are always fixed on the distant horizon (fig. 52). Contemporary portrait painters or sculptors used this concentrated absence as a sign of genial inspiration.[30]

When Thorvaldsen returned to Copenhagen in 1838 the city prepared a triumphant reception for him. As on his visit in 1819, the heavens sent northern lights to welcome the artist. Just Mathias Thiele, his biographer, saw the strange phenomenon as connected with nordic mythology and Thorvaldsen's Icelandic descent: "The northern heavens also sent a festive greeting to their great son; from the distant horizon God Thor emitted his finest rays, and the sea reflected them in its dark mirror – Thorvaldsen stood illuminated by the magnificent northern lights!" Thiele attempted to ward off any possible scepticism about the great phenomenon by pointing out that there had been many supernatural events in Thorvaldsen's life. For obvious reasons he wanted to avoid any suggestion of fairytale or invention,

52. Eduard von Heuss, *Bertel Thorvaldsen in his studio in Rome,* 1834

53. Anon., *Cartoon showing Thorvaldsen's Arrival in Copenhagen,* 1838

for Hans Christian Andersen had described the same phenomenon in his biography of the artist.[31] But as Thorvaldsen disembarked from the frigate, the heavens played their part, and the sun suddenly broke through the dense clouds while a rainbow arched over the vessel. Again Thiele thought it might be argued that the heavens had gone beyond the bounds of credibility in sending so many wondrous signs, and he called upon the painter Eckersberg, who had depicted the phenomenon, to affirm that this was the truth.[32] The crew of the vessel cheered farewell to Thorvaldsen, and bands and choirs played and sang while the sloop brought him to the quayside, where he was received by the assembled Art Academy and the throng. Again it was a reception worthy of a painting, but it also became the subject of an anonymous cartoon (fig. 53) showing the artist with a halo, blessing the kneeling and bowing crowd.[33]

In the first of several "last wills" Thorvaldsen bequeathed his art collection to the City of Copenhagen in 1830, on condition that a museum was built and named after him.[34] Copenhagen had been vying for some time with Munich to obtain the bequest of the artist's works, and a number of museum projects were put forward in Copenhagen from 1834; the first, similar to the Pantheon, Canova's *Tempio,* or Schinkel's Altes Museum in Berlin, were of a size and architecture to justify the hope of receiving at least Thorvaldsen's plaster models. An appeal for support for the museum in 1837 drew attention to the similarity with Canova's *Tempio,* but also to the difference between the two, as Canova's memorial was to be seen as testifying to the artist's piety, while the Thorvaldsen Museum would be "a

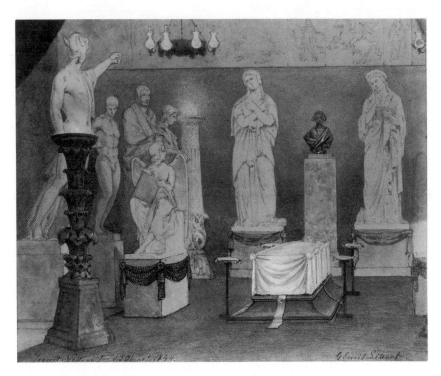

54. G. Emil Libert, *Thorvaldsen lying in State*, 1844

sacred place for art, for the benefit and honour of his native land".[35] Before returning to Copenhagen Thorvaldsen made another will, in which he made the City heir to all his works on condition that the collection remained unchanged in a museum built especially for them.[36] King Frederik VI offered the coach house behind the Palace of Christiansborg, and Thorvaldsen approved the designs by Michael Gottlieb Bindesbøll for its conversion in a Graeco-Roman-Egyptian-Etruscan style. In 1841 Thorvaldsen commenced a triumphal journey through Germany to inspect his monuments; he was received by kings, princes, academies and the citizens of Berlin, Dresden, Mainz, Frankfurt, Stuttgart and Munich, and showered with honours at innumerable ceremonies and receptions. He passed through Schaffhausen to Zurich and Lucerne, where he was celebrated beside the Lion monument, and then traversed the St. Gotthard pass to Florence, finally arriving Rome; at every station on his journey he was received and celebrated by dignitaries, artists and the populace.[37]

When Thorvaldsen died in Copenhagen in 1844 he lay in state surrounded by his works, as if they were holding the last watch (fig. 54). His museum was not yet finished. Most of the building costs were contributed by the people of Copenhagen. The frieze by Jørgen Sonne on the outside depicts the people, the celebrated artist and the craftsmen, the transportation of the works, but not the nobility or the king. 1848 was a year of revolution in Denmark as well. Thorvaldsen's remains were taken from the

Church of Our Lady to the Museum and buried in the tomb in the court-yard (fig. 55). Naturally the heavens again played an appropriate part.[38] The Museum has a frieze on the exterior showing Thorvaldsen's triumph and the arrival of his works; the interior contains the collection on three storeys, with his tools, models and works, while the innermost sanctuary, closed to the public, contains the tomb of the artist who helped restore a cultural identity to Denmark, that had suffered a traumatic political decline at the beginning of the century.[39] Presumably it was Thiele who suggested that the Museum should also be a mausoleum. Analogous to Canova's arrangement in Possagno, the Museum and mausoleum for Thorvaldsen in Copenhagen were declared the testimony to Thorwaldsen's immortality: "He will dwell there as an immortal master among artists and for art, melting the northern ice with southern warmth!"[40]

Thorvaldsen was the first artist to use his international renown deliberately and successfully to demand a personal museum in return for the bequest of his works and his collection. The museum appeared to be the institutional guarantee of immortality, which, in turn, was seen as the continuance of a cult. In the geography of his immortality, the mausoleum and museum constitute the centre, while the works, distributed between Copenhagen and Rome, England and Poland, mark the bases, and publications keep the memory of the artist alive in the minds of art-lovers and artists.

Following the triumphal cult centres for Canova and Thorvaldsen, the many artists' houses established during the nineteenth and twentieth cen-

55. C.O. Zeuthen, *The Courtyard in the Thorvaldsen Museum with the Artist's Tomb*, c. 1878

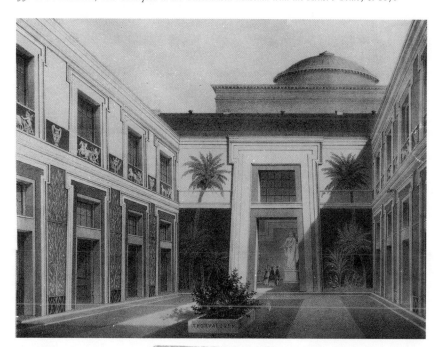

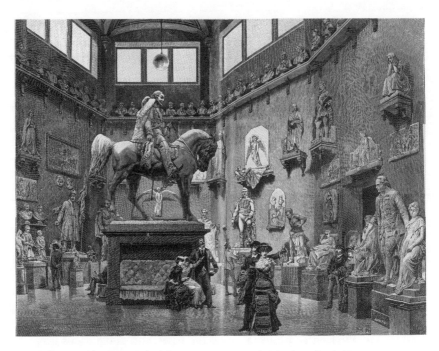

56. *The Museum of Vincenzo Vela in Ligornetto,* 1883, wood engraving after A. Bonamore

turies, during the artist's lifetime or after their death, perform the function of personal museums and memorials. Some were set up later, like the Dürer house in Nuremberg, which was opened in 1825.[41] The most remarkable variant of Canova's and Thorvaldsen's temples of fame is the residence which the celebrated artist of the Risorgimento, Vincenzo Vela, had built in his birthplace, Ligornetto in Ticino, between 1863 and 1865. It is a big building containing an octagonal exhibition room with a drum vault at the centre of the living and reception rooms. Here the artist showed the plaster models of his figures (fig. 56). Like Canova and Thorvaldsen, Vela's exhibition of his plaster models was a cross between his studio and a museum. The same site contained the artist's workshop, where his assistants also executed the marble versions of the models. Vela's residence was enthusiastically described as the "Pantheon ossia il Museo delle principale opere" (Pantheon, or the Museum of Principal Works) when he opened his collection to the public, and the artist himself was hailed as the God of Sculpture.[42] On his death in 1891, the exhibition room was used for the artist's lying in state, so it became his temporary mausoleum. As the erection of tombs outside cemeteries had been forbidden by law in Ticino since 1833, there could be no question of a permanent combination of studio, museum and mausoleum, which might otherwise have been considered in analogy to the Thorvaldsen Museum in Copenhagen. But the artist's lying in state was executed in marble by the architect Augusto Guidini and set on Vela's grave in Ligornetto cemetery.[43]

92

The more dependent artists became on the public presentation of their works, the more artistic and literary concern with the studio grew, as public interest in the place where the works were produced increased. According as artists became public personalities through exhibitions, reviews and the literature on art, the press assumed the public would want to know more about the secret place of creation to which they had no access. The magazine *L'Artiste*, established in 1831 to defend the interests of artists, published Balzac's story *Le chef-d'oeuvre inconnu* (The Unknown Masterpiece) in its first volume. Balzac describes the relationship between the artist and society through the story of the secretive painter Frenhofer and his studio, from which all visitors are barred.[44] Frenhofer is a like a troglodyte, working in the seclusion of his studio at a masterpiece that he can never finish, and catastrophe strikes when his fellow painters, Poussin and Porbus, force entry. Balzac's story is complex, and in this context it is sufficient to say that the work and the artist are ruthlessly demystified when the public, represented by two fellow-artists, gain access to the place of creation, and that this demystification leads to the destruction of the work and the death of Frenhofer.

57. *Rosa Bonheur's Studio*, 1852

58. and 59. *An Artist's Studio in the 19th Century*, pastiche after Horace Vernet, wood engraving by H. Valentin, in: *Le Magasin pittoresque*, 1849

Even before the middle of the nineteenth century the illustrated magazines in France were seeking to satisfy public curiosity about the workplace of the artist with a number of publications about artists' studios. *Le Magasin pittoresque*, for instance, published illustrated articles on artists' studios past and present from 1839. In 1849 Daumier published a series of cartoons in *Charivari* showing scenes in the studio *(Scènes d'Atelier)*. For years, *L'Illustration* regularly featured *Visites aux ateliers*, and in 1852 it was the turn of the fantastic studio maintained by the most famous woman artist of the day, Rosa Bonheur (fig. 57). The beginning of the article is informative, as it describes the route to be taken from the Jardin du Luxembourg down the Rue de l'Ouest into the mysterious and secluded Passage Vavin, where an artists colony had formed. Here one is no longer in the real world, the world of shops and businesses, the article suggests;[45] the real world is on the nearby Boulevard du Montparnasse. Here the artists have withdrawn to work in isolation and undisturbed, and only the very privileged have access. The reader enters a strange world. In the silence, the voices of the animals can be heard which Rosa Bonheur, who painted animals, kept as models, and her reassuring voice sounds in response. Then the article moves from describing the studio to narrating the impressive biography of the successful woman artist. The illustration shows the front room with the animals, and Rosa Bonheur and her companion Nathalie Micas working in the room at the back.

However, it was only about 1820 that the artist's studio in France became a secluded place of lonely creativity to which only the privileged had access.

60. *Le Monde illustré,* 8, 1864, Title page of the issue of 25 June, illustrating the visit paid by the Empress Eugénie to Rosa Bonheur's studio, wood engraving after A. Deroy

In the eighteenth century the "studio" was in most cases a workshop where a number of people were engaged in craft or artistic work.[46] The practice was continued by sculptors and studios which accepted pupils for training.[47] Horace Vernet painted his teaching room around 1820; he shows the students, admirers and a fencing scene, live and stuffed models, a horse and a dog. This lively scene was sufficiently interesting to be used by the *Magasin pittoresque* in 1849 for a two-page spread illustrating a nineteenth century artist's studio (figs. 58, 59).[48] But the rooms where artists worked in lonely concentration could also be opened temporarily, for they were occasionally used, as in the eighteenth century, for exhibitions and receptions.[49] Artists produced many depictions of their studios, and by exhibiting them they themselves made public their private workplaces; the studio, as the secret place of creative concentration, became complementary to the exhibition.

In 1864 Rosa Bonheur received a visit from the Empress Eugénie in her studio in Fontainebleau (fig. 60). This was a repeat of the mythical distinction accorded to the artist in his studio by a ruler. The outstanding example was the visit paid by Alexander the Great to Apelles, and it was followed by the Emperor Maximilian visiting a painter in his studio, Charles V visiting Titian, Napoleon with Jacques-Louis David, and Ludwig I of Bavaria visiting Thorvaldsen. Rosa Bonheur maintained that the Empress came unannounced: "On 14 June 1864 I was working at my painting of Longs Rochers ... when I suddenly heard the rattle of a coach; there was a loud bell and the crack of a whip. It all ended suddenly outside my door. At almost the same moment I saw Nathalie rush into the room like a whirlwind cry-

ing: "The Empress! The Empress is coming here! ... Take your smock off, quickly! You just have time to put this skirt and jacket on, she said, handing me the clothes. In fewer seconds than it takes to narrate, I had changed my clothes and the two wings of the studio door were flung open. The Empress was already crossing the threshold, followed by ladies in waiting and uniformed officers and courtiers. With the sovereign grace which has made her the Queen of Paris taste, Her Majesty approached. She stretched out her hand to me, I pressed it to my lips, while she said she was passing close to my house on a drive and felt the desire to meet me and see my studio."[50] Rosa Bonheur did not want to be presented to the Empress in her male working clothes, trousers and smock. In the course of the visit the Empress spoke the significant words: "Le génie n'pas de sexe" – genius does not have a sex. Her statement was publicized in an article in *Le Monde illustré*.

The Empress' visit to Rosa Bonheur's studio not only put the seal on public recognition of the already famous painter, it also helped to promote women artists. The Empress invited Rosa Bonheur to the Palace of Fontainebleau and gave her a commission. From 1849 to 1860, Rosa Bonheur had directed the public school of drawing for women, which had been established in Paris in 1802.[51] In 1860 Léon Lagrange proposed that in the municipal schools girls should be allowed to have drawing lessons like the boys, mainly to help their craft work, but he advised against admitting women to the École des Beaux-Arts.[52] The year after the Empress' first visit Rosa Bonheur was made a Chevalier of the Légion d'Honneur, the Empress making the award in the absence of Napoleon III, who did not approve of admitting women to the Légion d'Honneur.[53] The award prevented Rosa Bonheur from refusing the invitation to participate in the World Exhibition of 1867 in Paris, after she had refrained from exhibiting in the Salon from 1855 to 1866.

The Cult of the Tragic Artist, Death and Suicide in the Studio

Delacroix saw Géricault as a tragic artist. A note has survived of the conclusion of the essay he intended to write about Géricault but never finished. It is a call for subscriptions for a monument: "Subscribers of every kind, those who support the arts, you send half a dozen would-be Raphaels and Phidiases to Rome when they are still green – if you really want to encourage the arts, if you want artists to dedicate their lives to beauty, as they must, and to do so they have to abandon and sacrifice any idea of personal gain ... set up a monument to Géricault. Do this so that the artist who has spent his life with no reward other than the expectation of a little fame, with no other support than his inner voice, happily indefatigable, may cherish the faint hope that after his death he may be crowned with laurel!"[54] In 1824 Ary Scheffer painted *The Death of Géricault* (fig. 61) and showed the picture in the Salon of the same year. The emaciated corpse lies at a wall

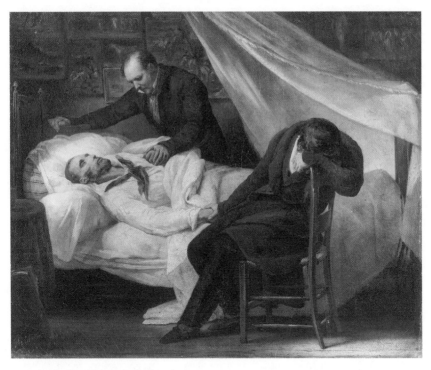

61. Ary Scheffer, *The Death of Géricault,* 1824

hung with his painted sketches. Like Raphael, he is laid out in his studio. Two friends are present; one is bending over the dead artist, the other giving way to his grief like Agamemnon in the painting by Timanthes, burying his face in the ultimate expression of despair.[55] This representation of the dead artist with his sketches not only shows the wealth of his creativity, it also shows how much will remain unfinished through this untimely death.

In Balzac's famous story of 1831, *Le Chef-d'oeuvre inconnu*, the painter Frenhofer is represented as a hermetic artist who lives like a troglodyte.[56] The young Nicolas Poussin meets him when he visits François Porbus, and experiences him as a devil and a magician, his behaviour changing abruptly from destructive criticism of others to bonhomie. In the middle of the conversation Frenhofer lapses into a state of total absence, in which he sees and hears nothing. He has been working in that same absence of mind for ten years in his studio at a painting that is to be his masterpiece. No one is allowed to enter the studio, the door to which is barricaded. But in such isolation and subjectivity Frenhofer cannot finish his painting, and in his despair he thinks he needs a model. Poussin offers him his beloved on condition that he and Porbus may see the painting. Frenhofer allows himself to be persuaded to open his studio to the two painters and show them his work (fig. 62). Instead of the wonderful living figure which Frenhofer had described, the visitors can see nothing but a shapeless cloud and a chaotic swirl of colour on the canvas. Poussin unguardedly says aloud to Porbus

that Frenhofer will have to acknowledge sooner or later that there is nothing to be seen on his canvas. Frenhofer does not survive this ruthless demystification of himself as artist and of his work; the following night he burns all his pictures and dies. In the simultaneity of the destruction of the works and the death of the painter Balzac's story is suggesting suicide.

Schiller's idea of the artist living like a troglodyte found its first literary echo in the story *Die Jesuiterkirche in G.* (The Jesuit Church in G.) which appeared in 1817 in the first part of *Nachtstücke* (Night Pieces) by E.T.A. Hoffmann.[57] The painter Berthold first paints landscapes in the manner of Philip Hackert in Italy, and one of his paintings meets with approval at an exhibition. But among the visitors is a rich Greek, born in Malta, who shakes his head in doubt over the young artist. He accuses him of missing his vocation in painting landscapes, for he is only copying a script that he fails to understand. The sacred purpose of art is "to understand nature in her deepest and most supreme significance". He wants to light the flame within the artist, and says temptingly to him: "Once you have penetrated the deeper meaning of nature your paintings will rise magnificent, even while they are still within you." The seductive words of the satanic art lover, his insistence that he must allow his genius to unfold, paralyse the young painter. Now he can only see in dreams what he would like to paint, he can no longer produce the work itself. In this state he withdraws into a grotto, where he is tormented by his fantastic dreams of art. Utterly cut off from society, he sees a vision of his ideal, and this liberates his ability to produce. But all his works are reproductions of this ideal, as his earlier vedutas were imitations of landscapes. His artistic output ceases when his ideal vision reveals herself as a princess and becomes his wife. However, their initial happiness is short-lived, and the artist again falls victim to paralysis. Finally he abandons his family. In G., where the narrator finds him, Berthold paints the church interior at night, and then returns to working in a cave. The nar-

62. Paul Cézanne, *Frenhofer showing his Masterpiece*, 1867/72

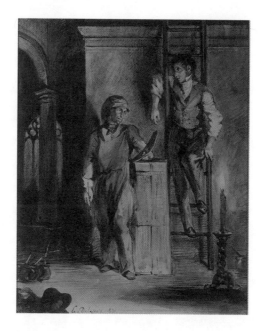

63. Eugène Delacroix, *The Jesuit Church in G.*, 1831

rator becomes the painter's garrulous assistant, transferring his sketch to the wall by torchlight.

The narrator seems to be an upright if rather narrow-minded man. He is drawn to the artist by his strange behaviour, his noble figure, his unusual clothing and the deep sorrow in his face. His comments on art are naive. He feels a need to make derogatory remarks about Berthold's architectural painting and then claims he has the right to expect the artist to produce brilliant ideas and not merely perfect handiwork. Delacroix illustrated this scene in 1831 (fig. 63). The painter realises that he is hearing the demonic demands of the Maltese again, and calls the narrator's thoughtless chatter about art criminal. He appears to be able to counter the idle talk by arguing that painting is normal work, no different from making sawmills and spinning machines. But that is an illusion, too. The painter does finish the altarpiece but then he disappears, leaving his hat behind on the river bank along with his stick.

In their stories both Hoffmann and Balzac describe a crisis that is sparked off by public presentation of a work of art. In Hoffmann's story the young painter discovers during his exhibition that he knows nothing about art, while in Balzac's story the old artist is forced to recognize, when other artists gain entry to his studio, that he has been subject to a terrible delusion. This crucial moment of presentation, when the artist's intention and the viewer's perception are revealed as two very different things, was chosen by Paul Cézanne for an early drawing to illustrate Balzac's story (fig. 62). Both Hoffmann and Balzac are saying that social relations are irreconcilable with the development of an artistic genius. The artist lives like a troglodyte and is subject to delusory imaginings, crazy dreams and deceptions like those of Pygmalion. When people from outside penetrate this unreal inner world,

64. Ferdinand von Rayski, *The Artist's Suicide in his Studio*, c. 1840

or the barricaded studio, their critical remarks, their uncomprehending faces as they look at the work, give rise to the catastrophe. At the same time the subjectivity of the artist genius proves to be an illusion, self-deception. There are two factors here, and both are fatal: the illusion is necessary for creative output, and when it is shattered the artist is paralysed and dies, or the work is destroyed; but the illusion is also a form of alienation that cannot be healed.

The stories by both Hoffmann and Balzac contradict Schiller's utopia of a community between artist and society, and the Saint-Simonist idea of the artist's usefulness. They counter the concepts of the social integration of the artist by showing him subject to self-delusion, isolated and despairing. The most trenchant pictorial expression of the artist's self-destructive delusion is a pencil drawing by Ferdinand von Rayski that is dated around 1840 (fig. 64). After slitting his canvas, the artist has hanged himself from his easel in a studio that is like a prison. Four lines of verse by the poet Friedrich Franz Freiherr von Maltitz are written on the wall like a warning: "On the highway of true art/ Life on earth is all too short// Seeds of death within him sprout//All too soon the light is out." A dagger has been thrust into the eye of the portrait of the writer of these mocking lines.[58] The lines imply that the "true" artist is legitimated by his early death, or possibly that he needs death to prove himself as an artist. Von Rayski was in Paris in 1835, and perhaps his drawing reflects the two sensational artists' suicides that occurred that year. One was the successful and celebrated Salon artist, Léopold Robert, who killed himself in his studio in Venice in March, and the

other was Antoine Jean Gros, who threw himself into the Seine near Meudon in June. It was said of Gros that an accumulation of failures in the Salons and unfavourable reviews by the critics had driven him to his death.[59] Léopold Robert had enjoyed his greatest triumph in the Paris Salon of 1831, and his suicide seemed inexplicable. It has, in fact, never been fully explained. One reason may have been despair at his failure to achieve what he himself had set as his objective in art.[60]

One of the few confessions of failure by an artist who set himself too high a standard is written on a drawing by Tommaso Minardi of 1808. The inscription, which was clearly added long after the sketch was executed, reads: "This drawing was made in 1808 upon the request of Count Crispino Rasponi of Ravenna for an oil painting for the ceiling of a room that contained supremely beautiful paintings, mainly of Dutch origin. I never executed the painting, because I wanted to take extreme care over it. Mad!! But I was not so very mad. As I knew this must be a work of grandeur, and of course hoped to overcome my lack of practical experience, months went by, indeed, years passed with nothing achieved; the same happened with many other honourable commissions; and that was really crazy!!"[61] However, Minardi was spared the ultimate consequences of his failure and enjoyed a long life.

Benjamin Robert Haydon prepared every detail of his suicide in his studio in London in 1846. Haydon was a pupil of Henry Fuseli from 1804 to 1806, and despite his impaired sight, which was due to an illness, he was

65. Benjamin Robert Haydon, *The Raising of Lazarus*, 1823, wood engraving
 by J. and G.P. Nicholls

obsessed with the ambition to become the greatest history painter in Britain. However, his intransigence towards would-be private patrons made him an increasingly tragic figure. In 1820 he showed a large painting, *Christ entering Jerusalem*, with other works, at his own expense in Bullock's Egyption Hall, and three years later he repeated the enterprise with a new work in huge format, *The Raising of Lazarus* (fig. 65). Forced by shortage of funds Haydon began to produce genre works and portraits and works on the fashionable theme of Napoleon, but he did not give up his hope of a public commission for a history painting. His dreams appeared to be near to fulfilment when a competition was announced for the decoration of the Houses of Parliament in 1842, and his former pupil Charles L. Eastlake was appointed Secretary to the Commission. However, Haydon had already noted in his diary that there could be a conspiracy against him, and he felt this was confirmed when his designs were passed over. Another exhibition at Bullock's was a failure. Haydon used the last page in his diary to ask for forgiveness, added a quotation from Shakespeare's *King Lear*, wrote the word "End" and committed suicide in front of his last painting, *Alfred and the First British Jury*, which was still unfinished.[62]

In the character of Claude Lantier, a genius who is incapable of producing work, Emile Zola gave supreme expression to his observations of painters who had failed and of the contemporary art scene. The huge exhibition piece, the masterpiece that Lantier finally embarks upon to prove himself as

66. Edouard Manet, *The Suicide*, 1881

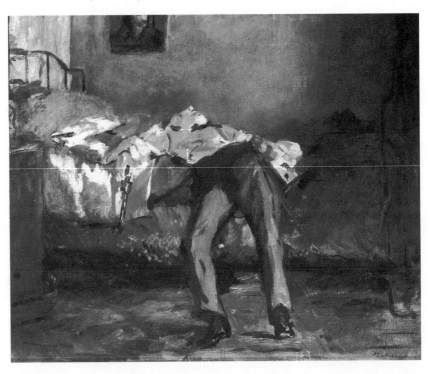

an artist, is a failure; it turns into a disaster that can never be finished and it destroys all the artist's social relations. Finally the despairing painter hangs himself in front of the destructive work, an allegory on Paris. "He hung there, in his shirt, his feet bare, a terrible sight with his black tongue and bloodshot eyes protruding from their hollows. He seemed terribly enlarged in his rigid immobility; his face was turned to his painting, very close to the woman with her sex blossoming like a mystical rose, as if he had expelled his soul in his last gasping breath but continued to look at her with his staring eyes."[63] One of the great injuries which Claude Lantier suffers in his career as an artist is the reaction to the painting of his dead son, the boy he had neglected. As Tintoretto painted his dead daughter, Lantier paints his son the night he dies, in speechless grief. He produces a masterpiece, but makes the mistake of showing this product of his private sorrow to the selection committee for the Salon. Unaware of the tragic circumstances they think *L'Enfant mort* is a brutal desecration of a corpse from the mortuary; they are revolted and angrily reject the painting. A friend manages to ar-range for it to be included in the Salon, but it is hung so badly that Lantier has to hunt for it desperately when the exhibition opens. When he finds it, the only reaction from the public he hears is an exclamation of horror.[64] Zola is describing more than the artist as failure, a theme that recurs frequently in nineteenth century novels, more than the conflict between the private and the public sphere.[65] In combination with the hybris of the romantic artist, artistic impotence, "impuissance", has fatal consequences, while the legiti-mating masterpiece becomes a nightmare, a monster that devours its victim.

In the catalogue for the auction sale held in 1881 for Jean de Cabanes, a Bohemian and composer who was suffering from tuberculosis, Zola wrote: "The truth is that he is dying for his art".[66] Edouard Manet donated his small painting *The Suicide* (fig. 66) for the sale; it shows a detail of a painting, in which a saint is looking down motionless at the dead man who has fallen back on to his bed.

The Studio and the Sketch

In describing the destructive conflict between the studio and public exhibi-tion, the novels about artists thematize the mystification of the artist and his hybris, while the perfect but unattainable masterpiece represents the decep-tive and murderous idea of the absolute work of art. The productive ten-sion between the studio and public exhibition is less easy to grasp. A pos-sible lead is Delacroix' requirement that the finished picture should retain some of the character of the sketch.

In his notes on "Copie, copier" in the *Dictionnaire* he planned, Delacroix recalls the importance of copying in the training of almost all the great masters. Formerly, when painters had first to learn their craft, he says, instead of immediately pursuing a career, as they do now, copying was one of the tasks they had to perform without endeavouring to be original.[67] Delacroix

mentions Dürer, Raphael, Tintoretto and above all Rubens, who copied the Venetian painters in Madrid when he was fifty years old. "The work of copying, which is totally neglected by the modern schools, was the source of immense knowledge".[68] What concerned Delacroix in later reflections was the distinction between the kind of copying that was necessary and productive, and the imitators who copied a style, by which he meant the difference between his own method of copying and the practice of Ingres and his school.[69] Delacroix recommended copying as a means of learning slowly, and perhaps also as a cure for hybris.

Long before Delacroix, the function of the copy and the work of copying was the subject of critical discussion in the *Encyclopédie méthodique. Beaux-Arts*, where Pierre-Charles Lévesque wrote: "Those who do not have enough talent to produce good works of art devote themselves to copying the works of others. They are copyists. Young artists copy good paintings to learn how to imitate them; they are students, pupils. Those who already have a fully formed talent copy works by the great masters to acquire the skills they lack. Poussin copied Titian, Rubens copied Raphael; these examples should show that the exercise bears little fruit if the artist already has a fully formed style."[70] Lévesque distinguished between three kinds of copying: faithful copying by a pupil, skilful but not very faithful copying and skilful and faithful copying. In his view only the third kind came close to the original and so could also be used for forgery.

Lévesque's most interesting comment is on copying the artistic idea: "If the supreme beauty of a picture consists in its general effect, one could in a certain sense enter into this effect with a sketch, copy the idea rather than the handwriting, the whole rather than the details, and follow the career of the great masters without stepping like a servant in their footsteps."[71] Instead of reproducing a work one could trace the artist's idea, and Lévesque regards the sketch as the suitable medium for this. In 1853 Delacroix, in his great essay on Poussin, took up Vauvenargues' comment that one needed to be a genius to be able to imitate. Petty imitation was the work of antiquaries, the artist rose to the spirit of the model and could appropriate this.[72]

It is necessary to trace the revaluation of the sketch from the sixteenth century to understand how this was to be conceived and done.[73] The sketch of a work made by another artist is both a direct response to the work and a reduction of it to the first expression by its originator. Direct communication between the minds of two artists can only be assumed to be possible if the sketch is seen as the first and original expression of an artistic idea, as Delacroix did. He called the "croquis" the "idée première" or "l'expression par excellence de l'idée".[74] Only so could he maintain that Poussin studied the people and the male genius of Antiquity in order to imitate and absorb their spirit, while in more recent times artists were content with meticulous exactitude and pedantic detail. In Delacroix' sketch of Christ from Rubens' *Descent from the Cross* (fig. 67) in Antwerp cathedral, the interest is concentrated on the main figure in Rubens' work, not on the composition.[75] Delacroix made many changes to the figure - he bared the

67. Eugène Delacroix, *Christ after the Deposition by Rubens*, 1839

left leg, for instance, and ignored the shadows. This is a free copy, in which the interest of the drawing is in the contrast between the limp dead body and the movement. Delacroix' lines reveal the rapid movement of his hand and the changing pressure on the pen, even where they are outlining the body. The lines in a sketch by Delacroix document how the sketch has been produced, while Ingres' careful description looks more to the model and the production process of the artist whose work he is copying.[76]

The main difference between Ingres and Delacroix, however, cannot be defined in terms of technique or line alone, although Delacroix had a very much greater range in drawing than Ingres.[77] The difference lies in the contrast between the use of a mobile, fluid line to outline a static body and movement itself. Ingres sets the line in motion, but he always sees the persons he is portraying as static, so even in his history paintings he always sets the figures in postures that demonstrate movement. While Ingres contrasts the moving line with the static body, Delacroix seeks to express physical and psychological motion through both line and contrasts of light and shade.[78] In their quintessential movement his drawings suggest the direct expression of a passionate artistic temperament.

It was Delacroix' aim to retain in the finished picture the expression of movement in the first sketch. Writers discussing his drawings generally quote the passage from his Journal of 24 April 1854: "The first idea, the sketch, is in a certain sense the egg or embryo of the idea, and usually it is

far from perfect; it does contain everything, if you like, but the whole has to be released, and that means bringing all the elements together. What makes the sketch so excellently suited to express the idea is not the suppression of the details but their complete subordination to the great overall design. So the greatest difficulty is to sustain that elimination of detail in the painting."[79]

Delacroix called the difficulty of returning to the sketch in the painting the greatest of all the obstacles the painter faces. He suspected that all major artists had to cope with this problem, while mediocre artists were not even capable of recognizing it: "For the great artists the sketch is not a dream, a confused cloud, it is more than a confusion of hardly comprehensible lines; only the great artists proceed from a fixed point, and it is this pure expression that they find so difficult to regain in the lengthy or rapid execution of the work. How could a mediocre artist, who is only concerned with his craft, achieve that with his absorption in details which confuse the idea instead of bringing it out? It is incredible how confused the first elements of the composition are in the work of most artists. So how could they be concerned to return to an idea as they work out their painting, if they never had it in the first place?"[80]

Clearly this is not just a matter of re-integrating the sketch and the imagination. Delacroix considered this question a number of times in regard to the art theory of the late seventeenth and the eighteenth centuries, and his considerations moved towards a new approach to the artistic process, taking account of the most important and the most precious ability, imagination.[81] The problem was not to confine the creative imagination to the sketch, but to develop it in executing the work instead of losing it there (fig. 68). Delacroix came back to his main problem in 1859 in a disappointingly brief note: "On the difficulty of retaining the impression of the original sketch – on the need for sacrifices – consequently – on the artists who, like Vernet, pass quickly to finishing a painting and the bad effect as a result."[82] Charles Baudelaire, who regarded the difference between the creative imagination and the merely fantastic idea as of supreme importance, quoted in his obituary of Delacroix the artist's conviction that the imagination will remain sterile if it is not served by great skill.[83]

With Delacroix, drawing is no longer merely preparation for a painting. In its combination of the quality of a sketch with imagination it constitutes a model that should be regained in the painting and in the colour. As a consequence the finished state of a painting can no longer be defined in terms of its craftsmanship. In 1859 Baudelaire contrasted the method used by Horace Vernet, who produced a painting with controlled handwork, with the production of a painting as a creative act: "A good painting that remains faithful to the dream that has given birth to it must be created like a world. Creation itself, as we see it, is the result of several processes of creation, and the earlier are always perfected and completed by the later. A painting is created in the same way if it is completed in harmony, it consists of a series of paintings, one over the other, with each new layer giving the dream more reality and bringing it one stage nearer to perfection."[84]

68. Eugène Delacroix, *Peace,* design for the ceiling painting in the Hôtel de Ville, Paris, c. 1850/52

For Delacroix the greatest difficulty lay in preventing the execution from stifling the idea that found expression in the sketch as inspiration and movement. Perfection should not be sought in the final, finished state but in the "sublime effect". The difficulty was to prevent a break between the expression of the idea and the picture intended for exhibition or decoration. The finished painting should preserve the spontaneous and private elements in the sketch, and so be the direct expression of a creative spirit abandoning himself to his imagination in his studio. Delacroix was sharply criticised for presenting paintings in the state of painted sketches. But in his view what was unfinished in the conventional view would, when exhibited, display the creative process that had taken place in the studio. The seemingly unfinished painting would induce the public to see the work that was emerging before its eyes as the experience of the sublime. But even when the public began to take an interest in what went on in an artist's studio, people found it extremely difficult not to see Delacroix's paintings as an affront and to acknowledge them as satisfying their curiosity about the artistic process.

Edouard Manet and the artists who came to be known as the Impressionists were very quick to grasp how revolutionary Delacroix' ideas were. They not only placed the sketch to the forefront of their art, they also made the involvement of the viewer a crucial element, while exploiting the potential for provocation which this held.

Apotheoses

In 1904 Paul Cézanne finally admitted to himself that he must abandon the dream he had cherished for so long of executing his painting of *The Apotheosis of Delacroix*. He wrote to Emile Bernard of the end of this unusual project: "I do not know if my indifferent health will allow me ever to realize my dream of painting his apotheosis."[85] An oil sketch (fig. 69) shows a number of figures in a landscape, raising their hands in applause, kneeling, advancing or working at an easel. The painter before the motif is Camille Pissarro, the figure seen from behind with a Barbizon hat, painter's bag and stick is Cézanne himself. On the right is Monet with a sunshade, and one of the two on the left is probably Victor Choquet, while the barking dog symbolizes Envy, that is, the critics. Delacroix's body is being born aloft on clouds by two angels, while a third angel is hovering nearer; according to Bernard's description of 1904 Cézanne intended to show an angel bearing the brushes and another holding the palette.[86]

69. Paul Cézanne, *The Apotheosis of Delacroix,* c. 1894

70. Paul Cézanne in his Paris studio
before the sketch of *The
Apotheosis of Delacroix,* photo-
graph of 1894

The oil sketch was initially dated in the mid-1870s, before the watercolour on the same subject.[87] In 1894 Cézanne was photographed in his studio in Paris before an easel on which the small oil sketch is to be seen (fig. 70). The photograph gives the impression that Cézanne was working on the sketch, but he is not shown at work, and the brush in his hand is too big for the little sketch. The photograph is not an illustration of the artist at work, it is Cézanne's act of homage to Delacroix and to his dream; this is what he is indicating with the big brush, the completion of his artistic project. Understandably, the ageing painter could not reflect on the apotheosis of Delacroix, that is, the acknowledgement and reverence shown to him after his death, without also reflecting with bitterness on his own situation.

Cézanne's project was as bizarre around 1894 as it was ten years later, when he showed the sketch to Emile Bernard, evidently in more or less the same state. It is significant that Cézanne chose to show the apotheosis of Delacroix as the artist's body being borne to heaven by angels, reminiscent of the motif of angels mourning Christ. The allegorical depiction of the critics in the barking dog was an utter anachronism by 1894 and 1904. *The Apotheosis of Delacroix* is a retrospective painting that looks back to the year of Delacroix' death. It reflects the general fate of the artist, who is glorified after his death by his followers, not as a triumphant hero but as a victim, thus perpetuating the legend of the artist subject to incessant attack and always finding disfavour with the critics. In his review of the World Exhibition of 1855 Baudelaire wrote in retrospect of Delacroix: "No artist has been more savagely attacked, more thoroughly mocked, more avidly hindered and hampered than he."[88]

In 1853 Delacroix described Nicolas Poussin as an artist who enjoyed few successes in a country that had little understanding of painting, but who nevertheless pursued his artistic aims unerringly. Poussin was represented by Delacroix as one of the boldest innovators in painting, an artist who broke

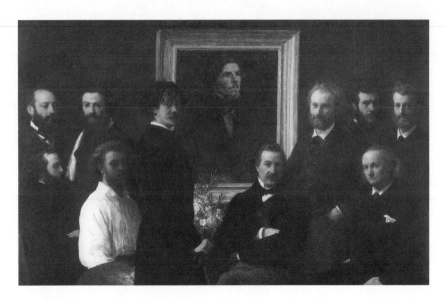

71. Henri Fantin-Latour, *Homage to Delacroix*, 1864

entirely with the false mannerist schools and led the life of a modern artist, refusing to be intimidated in his fight against the enemies of art, the misunderstanding he met with in France and his own misfortunes.[89] Delacroix made reference to Poussin's letters, which had been published in 1824 by Quatremère de Quincy: "These letters prove, more than any accounts or comments, that this is the greatest painter our country has ever produced; he was misunderstood for many years and finally received acknowledgement and applause from foreigners"[90]

Théophile Gautier began his article on Delacroix of 1864, published a year after his death in *Le Moniteur*, by describing the artist persecuted for years by the public and the critics: "Now that discussion over that great man – one whom posterity will not forget – has quietened, it is hard to imagine the tumult, the heat of battle in which he lived. Each of his works provoked a deafening outcry, thunderous storms and furious discussion. More insults and contempt could not have been bestowed on a thief or a murderer ... He was called a wild spirit, a barbarian, a madman; said to be obsessive, and crazy, he ought to be sent back to his birthplace, Charenton."[91] Gautier went on to compare these insults with the artist's unerring pursuit of his aims and his triumph in the World Exhibition of 1855, and he argued that it was usual for a genius to be misunderstood by his own generation: "This is how a genius is greeted on his appearance, it is a strange error, at which each generation may wonder after the deed, but which they naively repeat."[92] Gautier also attacked his own generation because so few had come to Delacroix' funeral on 17 August 1863.

Gautier wrote his article on the exhibition of 350 works by Delacroix in November 1864. The exhibition was in the Galerie Martinet on the Boulevard des Italiens, and it was the second triumphant exhibition that

year, after the "vente après décès" in the Hôtel Drouot in February. That ended with the auction Delacroix had requested, which was a great success.[93] Fantin-Latour exhibited his painting *Hommage à Delacroix* (fig. 71) in the Salon of 1864; it was intended as a political demonstration for contemporary art.[94] It shows ten painters, critics and writers assembled in two rows around the self-portrait by Eugène Delacroix, which is in a heavy gold frame.[95] Fantin-Latour changed his original idea of crowning a bust of Delacroix with many figures and chose a different model, Philippe de Champaigne's painting of the *Trade Prefect kneeling before the Cross with Mayors* of 1648.[96] Fantin-Latour replaced the Cross with the portrait of Delacroix, and the altar with a table and a bouquet of flowers. The selection of only ten painters and writers was defended by Duranty in 1867: "Controversial artists pay homage to the memory of one of the greatest controversial artists of our time."[97] The painters whom Fantin-Latour depicted had all been rejected by the selection committee for the Salon of 1863, and had exhibited in the Salon des refusés. Fantin-Latour's painting aroused great interest in the 1864 Salon, but his unimaginative composition and the choice of painters and writers were criticised. The artists and writers were held to be open or secret admirers of Courbet and they were accused of misappropriating Delacroix for an apotheosis of realism.[98]

When Cézanne was photographed in Paris in 1894, at the age of 55, with the sketch of his *Apotheosis of Delacroix*, he was still awaiting the public recognition he had always striven for, and without financial success, although this was easier to bear after his inheritance. In the 1870s, when Cézanne

72. Maurice Denis, *Homage to Cézanne,* 1900

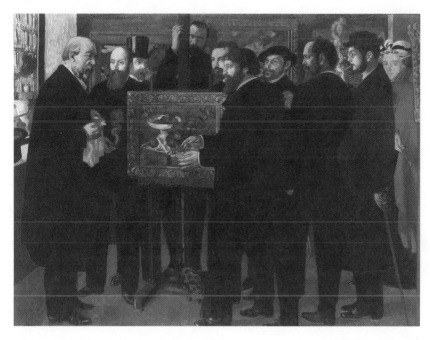

sketched out his first idea for *The Apotheosis of Delacroix*, he was well familiar with the topos of the persecuted artist from comments about himself. Georges Rivière affirmed this in an article in the magazine *L'Impressioniste* in 1877: "The artist who has been most attacked in the last fifteen years, most abused by press and public, is Cézanne. There is no insult that has not been heaped upon his name; his works have aroused shouts of laughter, and they still do."[99] At the auction of the estate of Père Tanguy that year, Cézanne's paintings were offered for between 45 and 215 francs. Not until 1895 did Ambroise Vollard hold the first one-man show for Cézanne in Paris; it was as important for the recognition of the artist as the World Exhibition of 1855 had been for Delacroix.[100]

If Cézanne retained his plan to paint the apotheosis of Delacroix right through the 1890s and beyond, he must have seen more in the dream than an idealization of the artist as victim. When he gave up the plan he also gave up his own dream of art: "My age and health will never allow me to realize my dream of art that I have been pursuing all my life".[101] The letter containing this statement was addressed to Roger Marx, editor of the *Gazette des Beaux-Arts*, who had drawn attention to Cézanne and the "culte pour Poussin" in his review of the Autumn Salon, arguing that the isolated artist had a historical connection with Courbet, Daumier, Corot and Poussin.[102] In the context of art history Cézanne's dream could be seen as constituting a link between Delacroix and Poussin. Artistically it could probably best be described as combining the objective, physical sphere, a harmonious composition and rhythmic movement throughout the whole. Cézanne regarded himself as a failure; Bernard reports that when the talk

73. Adolph Menzel, *Posthumous Fame*, in: *Künstlers Erdenwallen* (*The Artist's Life on Earth*), Sheet 6, 1834

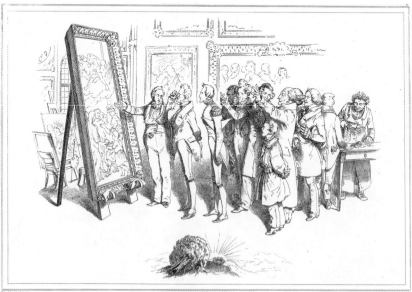

turned to the painter Frenhofer in Balzac's *Chef-d'oeuvre inconnu* Cézanne pointed to himself.[103]

At the World Exhibition of 1900 Maurice Denis showed his large painting *Hommage à Cézanne* (fig. 72). He noted in his journal of March 1898: "Paint a picture of Redon in Vollard's gallery, surrounded by Vuillard, Bonnard etc."[104] Finally Denis showed a group of artists and a critic in Ambroise Vollard's gallery assembled around Cézanne's still-life *Compotier, verre et pommes*, which is on the easel. The easel suggests the artist's studio in the gallery. The men, who are dressed in formal black, are in earnest conversation, Odilon Redon is cleaning his spectacles, Vuillard is looking attentively at him, the critic André Mellerio is lost in thought, and Vollard has stepped on to the easel at the back. Denis is looking at Redon, while Serusier is answering him; Ranson, Roussel, and Bonnard are listening eagerly, but Marthe Denis is ignoring the conversation and looking out of the picture. The still-life on the easel already had a history: Paul Gauguin owned it until 1898, then it was sold to the collector Viau, where Maurice Denis copied it. Viau lent it for the retrospective of French art in the World Exhibition of 1900. The reverence shown in *Hommage à Cézanne* is being accorded firstly to the painting, but it passes on from the painting to the absent master, whose art is being discussed by this group of Nabis and Symbolists.[105]

This homage to Cézanne was not modelled on Ingres' *Apotheosis of Homer* of 1827, nor on Paul Delaroche's painting of an assembly of artists, nor does it look to Fantin-Latour's *Hommage à Delacroix*.[106] The only possible predecessor for this homage being given to a painting in a gallery could be Adolphe Menzel's *Posthumous Fame* (fig. 73), which concludes the bitter depiction of the career of an artist in *Künstlers Erdenwallen* (The Artist's Life on Earth) of 1834. But the future triumph of the artist over his present neglect is poor comfort, as Adolph Menzel had already recognized in 1834 when he illustrated Goethe's *Künstlers Erdenwallen*.[107] Denis has changed the scene from the gallery to an art dealer's premises, and the enthusiastic supporters listening to the director of the gallery have become a group of artists engaged in eager discussion.

Self-Portraits

In the winter of 1851/52, when he was a pupil in the studio of Thomas Couture in Paris, Anselm Feuerbach painted himself as a lowering genius (fig. 74). Feuerbach was ambitious, and he had already started his first big painting, *Hafiz in the Tavern*, in the spring of 1851, hoping that it would make his reputation in both Paris and Germany.[108] Before completing this depiction of the bacchic and poetic quality of inspiration, he waited for the opening of the Salon in Paris in the spring of 1852, in order to make use of the latest trends to further his career in Paris. But his painting did not meet with a favourable response from the critics when it was exhibited in Düsseldorf in 1852, nor did it find a buyer.[109] Feuerbach painted his self-

74. Anselm Feuerbach, *Self-Portrait,*
1851/52

portrait in 1851/52 at the age of twenty-two; he felt challenged by the latest
Paris painting and impelled by his own driving ambition. He did not repeat
the historic attitude of van Dyck, as he had done in his *Self-Portrait with a
Feathered Cap* of 1847, but adopted the modern concept of the artist, rebel-
lious but determined, in smock and red sash.[110]

In 1863 Hans von Marées painted his *Self-Portrait with Franz Lenbach*
(fig. 75). The face of his friend Lenbach is shaded by his hat and his spec-
tacles; it is close to the picture plane and overlaps the strongly lit, open face
of the smiling von Marées. In its contrast between revelation and conceal-
ment, between eyes looking out at the viewer and eyes covered, this double
portrait of artists lays bare the pressing problem of vision.[111] It was paint-
ed during a brief friendship when both artists were facing an uncertain
future after completing their studies. Lenbach was commissioned to make
copies in Rome by Baron Adolf von Schack and von Marées seemed like-
ly to succumb to a life of dissipation with the bad beer in Munich. At
Lenbach's insistence, von Marées was also commissed to make some copies,
and he too went to Rome in the service of the mistrustful patron.[112]

Arnold Böcklin presented a number of self-portraits to the public. They
include a melodramatic image of himself with death playing the fiddle,
painted in 1872, and a sovereign image painted in 1873, which shows the
artist dreaming and distinguished by a classical column and laurels.[113]
Böcklin's devotees followed *Self-Portrait with Death playing the Fiddle* (fig.
76) with eager expectation from its inception; the public showing im-
mensely strengthened the painter's standing and the value of his paintings
rose enormously.[114] All the indications are that the public was presented
with an image of the artist that exactly met their expectations and confirmed

their belief that an artist showed his deepest insight in the encounter with himself. A self-portrait, especially when it contained a hint of the ultimate tragedy, was believed to be the most authentic form of expression an artist could give.

When the famous self-portrait was purchased by the Nationalgalerie in Berlin, Ferdinand Laban published an article in the periodical *Pan* in 1898 which Hugo von Tschudi called "thoughtful". Laban's most profound thought was that Böcklin's genius found twofold expression in the picture: "We have not only the compounded force, the productive strength of the person represented, his potential genius, but the activation of that gift, the moment of inspiration, the process of creation, genius in action."[115]

In the second half of the nineteenth century, artists, writers and the general public all elevated the self-portrait to a special form of art in their belief that it both confirmed the exceptional position of the artist and fulfilled the public's desire to enter into his life and work. It was assumed that the self-portrait was painted without a commission and so was the product of artistic freedom, it was direct expression and so the most authentic form of art, the key to the artist's psyche. This elevation of the self-portrait evolved when the gap between artists and the public had long become generally accepted. In 1908 Wilhelm Waetzoldt, a pupil of Wölfflin, devoted the longest chapter in his book on the portrait to "The Psychology of the Self-

75. Hans von Marées, *Self-Portrait with Franz Lenbach*, 1863

Portrait".[116] He saw the special position of the self-portrait as due to the strong motivation of the artist and the interest of the viewer. It was an autonomous act of creation, the product of the artist's "inner compulsion", and the viewer should see every self-portrait as "an intimate monologue, revealing the personality".[117] For Waetzoldt the self-portrait documented the social standing of the artist, but the repeated self-depictions show more than biographical and physiognomical development, they illustrate the path of genius.[118]

Waetzoldt tried to defend Böcklin's *Self-Portrait with Death Playing the Fiddle* against an attack by Meier-Graefe by describing the painting as the expression of an artist who had not yet found himself: "Genius is just awakening, and the eyes are half astonished, half wistful".[119] Meier-Graefe had condemned German psychological painting as "theatrical art" in his book *Der Fall Böcklin* (The Case of Böcklin), denouncing Böcklin as a kind of cheat who was only concerned to excite the public and sell cheap products to them as art.[120] Böcklin's use of the Munich portrait of Sir Bryan Tuke, a copy of a Holbein with forged additions made in the seventeenth century, was symbolic, and it was intended to stimulate the viewer's thoughts.[121] Meier-Graefe's polemics were based on Nietzsche's criticism of Richard Wagner and the distinction between the actor-artist who was playing to the gallery, and the artist who was working to advance art.[122]

Waetzoldt's combination of scientific and popular interests determined the approach to the self-portrait in art history for a long time. The literature on art suggested that the desire of the public to see and experience the soul of the artist was satisfied by the self-portrait's direct revelation. The concern with self-portraits strengthened the cult of the artist,[123] and the

growing stream of autobiographical writings and diary notes by artists gave the public even more insight into the artistic soul. The autobiography which Lovis Corinth published in 1926 is illustrated with thirty self-portraits (fig. 77) from every phase of his life; Casimir Edschmid published an anthology in 1920 entitled *Schöpferische Konfession* (Creative Confession), containing 18 such texts, and a short time later Paul Westheim published a collection of letters, pages from diaries and observations by contemporary artists under the title *Künstlerbekenntnisse* (Confessions of Artists).[124]

The enormous increase in self-portrait painting and the many depictions of themselves which artists included in paintings on other subjects in the second half of the nineteenth century needs an explanation. Courbet embarked on a long series of self-portraits in the 1840s, and often incorporated a self-portrait in other paintings. Degas recorded himself, from the melancholy youth to the sad old man. The Belgian painter James Ensor ceaselessly depicted himself, often as Christ the Man of Sorrows, while Lovis Corinth painted himself from year to year. Other artists who frequently painted self-portraits were Anselm Feuerbach, Paul Gauguin, Vincent van Gogh, Edvard Munch, Ferdinand Hodler, Paula Modersohn-Becker, Oskar Kokoschka, Otto Dix, Käthe Kollwitz and Max Beckmann, while many others, like Arnold Böcklin, Paul Klee and Pablo Picasso, only occcasionally concerned themselves with the self-portrait. Frida Kahlo continuously painted herself, Gilbert & George emerged in the 1960s as "living sculptures" and have appeared since then in all their works; Arnulf Rainer produced a continuous sequence of photographic self-portraits and then subjected them to iconoclastic attack. The idea that each self-portrait is a role image may counteract the tendency to mystification, but it does not pro-

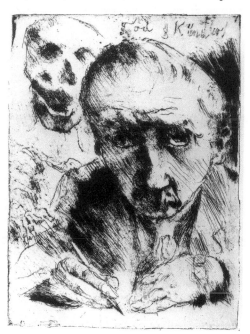

77. Lovis Corinth, *Death and the Artist,* 1922

vide a more general basis for an understanding of this trend. More detailed analyses of individual cases are needed, but the circumstances in which the portrait was painted have to be taken into account, together with its intended function and destination, the models in the work of other artists, the way the artist has presented him or herself, and the problem of legitimation.

In the autumn of 1895 Edvard Munch mounted a one-man show at Blomquist in Kristiania (Oslo) and showed his latest works, which included *Self-Portrait with Cigarette* (fig. 78). Of the less favourable responses, that by a medical student, Johan Scharffenberg, is remarkable, because he diagnoses the artist as suffering from intellectual abnormality, disease and a dangerous disposition, all with reference to Max Nordau's *Entartung* (Degeneration) of 1892/93. Another critic commented of Munch: "He seems to be either hallucinating in the artistic sense or having a joke, he looks down on the public, lowering art and human life".[125] The works were seen by both opponents of Munch and his followers as directly related to the artist's personal biography, the only uncertainty being whether he should be labelled mentally ill, a nihilist or a genius.

In 1895 Munch exhibited works in Oslo that were intended to shock, like *The Scream* and the repulsive *Madonna*, on the frame of which he had depicted growths which look like sperms and an embryo; they are also visible on the lithograph of the same title. *Self-Portrait with Cigarette* shows the artist as a ghostly figure lit from below, so that his face and hand stand out in light and an overpowering shadow is cast on an indeterminate nocturnal background. Blue-grey brush strokes in the lower part of the painting mark the front picture plane like a kind of glass pane behind which

78. Edvard Munch, *Self-Portrait with Cigarette*, 1895

79. Edvard Munch, *Self-Portrait under the Head of Medusa*, 1891/92

Munch appears. The facts in the picture show us what Munch had in mind with this image of himself: he stands, looking as if from outside, down through a window into a brightly lit room - it is the exhibition room.[126] He has painted himself as a decadent dandy, like Gavarni, Anselm Feuerbach and August Strindberg, with a cigarette. In contemporary views on vice, smoking led to neurasthenia and suicide, and of course Munch is provoking the middle class society of Oslo in depicting himself as a Bohemian and an outsider. But he is also showing himself as a worried ghost, his eyes wide as he registers the reactions to his paintings, listening to the talk of the visitors to the exhibition, attentive and fearful. This is evident from the outsize and protruding right ear. Munch's symbol of himself as artist was Medusa, the apotropaic goddess who could hold men in her power and turn them to stone. He set himself under her in his *Self-Portrait* of 1891/92 (fig. 79), and his own face, turned full front to the viewer, resembles the Medusa above. The visage holds the viewer with frightening intensity. Together with the handling of colour here, this is a redefinition and renewed statement of the power of a painting.[127] The proper place for such a work is an exhibition, the portrait is addressed to the public. Munch was a skilful manipulator of his exhibitions and he assiduously extended his reputation across Europe.

In 1892 the Berlin Artists Association invited Munich to show for the first time in Berlin, but had to close the special exhibition a week after it opened,

80. Paul Klee, *The Artist Thinking*, 1919, 71

at the insistence of Anton von Werner. However, Munch was already extremely efficient at managing his exhibitions: he immediately moved his 55 paintings to Düsseldorf and Cologne, and showed them again in Berlin at the end of the same year in a private building, the Equitable Palace.[128] According to Stanislav Przybyszevski, Munch became the butt of general disdain in Berlin: "For three weeks, as long as the exhibition was open, the entire so-called intelligentsia of Berlin giggled and howled with laughter in every existent and non-existent key." However, comments like this are characteristic of the way the followers of artists mock at the public. Berlin loved an art scandal, and it made Munch famous as the terror of the bourgeoisie. The result was that the Secession split off from the Berlin Artists Association, and the nordic Berlin Bohemians passed evenings of the deepest melancholy in The Black Sucking Pig, consuming huge quantities of alcohol and giving vent to extreme jealousy of the entrancing Norwegian, Dagny Juel, the great love of Munch, Strindberg, Schleich, Przybyszevski and others.

In 1894 Stanislav Przybyszevski published a book on Munch which included essays by Franz Servaes, Willy Pastor and Meier-Graefe as well as his own writings.[129] Przybyszevski stated that Munch's paintings were the product of a somnabulistic, transcendental consciousness. *The Scream* of 1893 was an expression of pain: "His landscape is the absolute correlative to naked perception: each vibration of nerves, laid bare in the supreme ecstasy of

pain, is translated into a corresponding colour sensation. Each pain is a speck of blood red; each long howl of pain is a belt of blue, green, yellow: unbalanced, brutally juxtaposed."[130] The comment appears to take up an entry in Munch's diary, written on 2 January 1892 in Nice in recollection of Kristiania.[131] In *Despair* the artist is shown as the lonely bearer of an overpowering sensation which is called up from memory. The first depiction of this memory is followed in 1893 by the second, *The Scream*. The figure stands against a sharply receding perspective, twisting in fear and facing the viewer. It now occupies the place taken by the shaken, lonely figure in the first version.

Paul Klee completed a set of five depictions of an artist around 1919. They range from the artist in thought (fig. 80), through the artist feeling, considering, forming, to the mystic sunk in deep meditation. In 1981 Otto K. Werckmeister put forward the provocative argument that Klee had created an image of the reception of his works by their addressees, the public, the critics and art literature.[132]

Werckmeister does not see Klee as a visionary, but as a skilful salesman who, through his dealers Walden in Berlin and Goltz in Munich, was supplying the public with the art it wanted and providing art images in the right mood for the dreamers, the high flyers and the chanters. Werckmeister's book shocked many readers, but a reassessment has certainly not yet been made.[133] The problem is that the critical ideological approach works with the fiction of the "authentic" artist and alienation. This fiction conceals both Klee's ironic treatment of the image of the artist, and the conditions of artistic creativity in the first third of the twentieth century. In fact, without public exhibition, without the skill and energy of art dealers, and without publicity in the daily press or in publications financed by the galleries an artist could no longer work. Friedrich Ahlers-Hestermann suspected as early as 1921 that the conditions under which art was presented would affect the way artists worked.[134] This needs to be compared with Klee's images of himself. Like many of his generation he firmly believed that everything came directly from inside the artist, like a vision or a deeper insight into creation. The friction, the dialectic between the self-definition of the artist and the conditions under which he created the work that was addressed to unknown persons in exhibitions, should be considered. Are Klee's five depictions of an artist in 1919 self-exploration, or was he really looking for an image of the artist that could be presented most effectively and appropriately? Or, again, should we see them as simple attempts to show the way the artist works and legitimate it, both ironically and seriously?[135] In 1921 Klee began teaching at the Bauhaus in Weimar and he concerned himself intensively with the bases of pictorial creativity, that is, the rules of dynamics and harmony on a surface, that can be taught and learned. Thus, parallel to the efforts of the Bauhaus to reconstitute the link between arts and crafts, Klee was attempting to resocialize and legitimate the artist, and this was extremely promising, at least at the beginning.

IV STRATEGIES AND CAREERS

Arranging a Scandal

In 1852 Honoré Daumier published a cartoon in *Charivari* showing members
of the bourgeoisie in the Salon looking in horror at the pictures and saying
that art in France was a lost cause (fig. 81). He drew them ugly, self-righ-
teous and disapproving, as they pronounced their negative verdict. He also
showed them from the viewpoint of the invisible picture. The viewer of
his lithograph was to see the public as the painting would looking down
from the wall and wondering at their reaction.

Gustave Courbet was the most gifted and at the same time the most typi-
cal artist of the Second Empire. The setbacks he had to suffer at the start
of his career under the July monarchy had a permanent effect on his beha-
viour, his view of himself and the strategies he adopted. In the 1840s almost
every work he submitted was rejected by the Salon selection committee.
He was only able to show one painting in 1844, 1845 and 1846. When the
February revolution of 1848 swept the Salon selection committee away as
well, Courbet seized his chance and showed ten paintings. The following
year, when the selection committee was composed of artists, seven of his
eleven submissions were accepted. Courbet was awarded a gold medal,
which meant that in future he no longer had to submit to a selection
committee, and the state bought his large-format genre painting *Une après-
dinée à Ornans* for 1500 francs.[1]

In a letter to his parents in April 1846 Courbet wrote that an artist could
never achieve a high reputation with small paintings, and that without a big
reputation he would rarely find buyers. He was planning a large painting

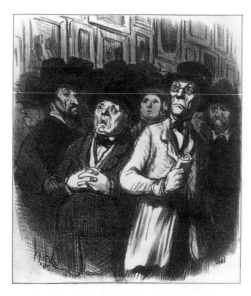

81. Honoré Daumier, *Classical Art-
Lovers, increasingly convinced that
art is lost in France,* 1852

for the exhibition the following year, in order to make his name.[2] He real-ized this project after his success of 1849, in his home town of Ornans in Franche-Comté, where he painted a huge exhibition piece *A Burial at Ornans*. It is 350 x 872 cm and contains life size portraits of nearly fifty inhabitants of the village. He painted other large works there too, among them *The Stonebreakers*. In the spring of 1850 Courbet held his first *expo-sition payante* in Ornans, Besançon and Dijon, where he was hoping to find the public he needed, relying on articles in the press written by a friend, Max Buchon, as publicity.[3] In Besançon 250 people paid the 50 centimes entrance charge to see the works, however, in Dijon Courbet had to close his exhibition after three days because it was running at a loss. No one came, and every day the premises were costing him ten francs in rent. Courbet took his new paintings to Paris and showed them in his studio in Rue Haute-feuille 32.[4]

In the Salon of 1850, which only opened at the end of the year, Courbet showed the three big genre paintings of Ornans, two landscapes of the Jura and four portraits. *A Burial at Ornans* aroused passionate discussion but most of the reaction was negative.[5] The cartoonists fell upon Courbet's paintings, and from then on the rough plebeian from the provinces and his daubs were the focus of hilarious attention (fig. 82).[6] Despite his occasional outbursts of fury the painter will no doubt have grasped the immeasurable value of the publicity the cartoons gave him. His friend, the photographer Nadar, who was one of the wittiest caricaturists of the artist, repeats a comment Courbet was said to have made in 1857: "You see I am the greatest painter work-ing today, for I am subject to the most frequent attack."[7] Courbet was not necessarily being ironic. A review of the Paris Salon of 1851 appeared in *Das Deutsche Kunstblatt*, criticising Courbet both for the disproportion between the huge format of his works and the trivial nature of their subjects, and for his confusion of artistic aims with a political message.[8] The exhibition of two paintings in Frankfurt in 1852 marked the start of the unusual success and the extraordinary impact Courbet was to have in Germany.[9] The artist told his parents and a friend that he had been so hotly debated in Frankfurt in 1852 that it had been deemed necessary to prohibit public discussion about him.[10]

In the Salons of 1852 and 1853 each artist was limited to three submis-sions. With his *Les Demoiselles de village* Courbet showed a work in the 1852 Salon for the first time that was already sold, to the Comte de Morny, the half-brother of the Prince-President Louis Napoleon who proclaimed himself Emperor after the *coup d'état* at the end of the same year. The 1853 Salon was important for Courbet in that he achieved a *succès de scandale* for the first time with *Les Baigneuses*; he also acquired a Maecenas, the banker's son Alfred Bruyas of Montpellier. *Les Baigneuses* shows a nude fat woman seen from behind, with her servant by a pool in a wood, and it not only shocked the public, it even shocked Courbet's friends Nadar and Champ-fleury. His enemies accused the artist of cultivating ugliness.[11] Bruyas bought the scandalous painting despite advice to the contrary; he also bought *The Sleeping Spinner* and had his portrait painted by Courbet. The

artist made his first commission for a representative portrait into an alliance between the Maecenas and himself by showing Bruyas with a book entitled *Etudes sur l'art moderne // Solution // A. Bruyas*.[12] The following year, 1854, Bruyas invited the painter to Montpellier; their meeting in an open field, where Courbet was welcomed by his patron and a servant, was made the subject of his celebrated painting *The Meeting, or Bonjour, Monsieur Courbet*.[13]

The controversies over Courbet's participation in the World Exhibition in Paris in 1855 and his one-man show in a separate pavilion were decisive for his position as an artist in dealing with the government. The order to hold

82. Quillenbois, *The Realistic Painting of Mr. Courbet*, in: *L'Illustration*, 21.7.1855

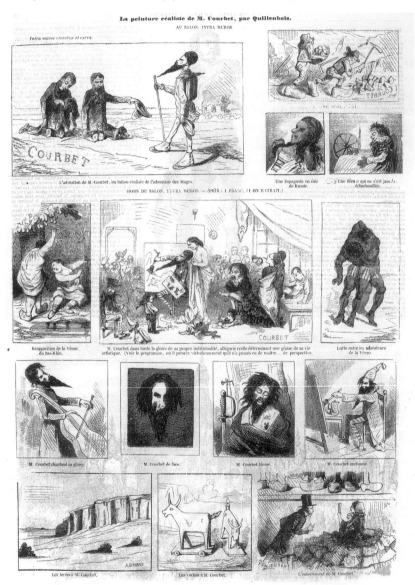

a World Exhibition of Industrial Products was issued by Napoleon III in March 1853; two months later he ordered that a fine arts exhibition, *Exposition Universelle des Beaux Arts*, should be held at the same time.[14] In the autumn of 1853 the Comte de Nieuwerkerke, Director of the Fine Arts, contacted Courbet to give him an official commission for the World Exhibition. Courbet reported the discussion, which was over lunch with two other painters, Chenavard and Français, in a letter to Alfred Bruyas. Courbet regarded Nieuwerkerke's offer as an insult because the Minister wanted a sketch for approval first, and asked Courbet to submit the painting for approval as well. Courbet saw this as an attempt to buy him for twenty or thirty thousand francs. He claimed the sole right to judge his works, said he wanted nothing from the government but freedom, and for the rest a share in the takings from the Salon of 1853 of 15,000 francs. In the letter to Bruyas, whom he described as his only ally, he glorified his heroic attitude: "I have burnt all my bridges. I have broken openly with society. I have poured scorn upon all those who clumsily tried to earn my approval. Now I face that society alone. I must conquer or die."[15]

In fact, Courbet did not have the slightest intention of refusing to participate in the World Exhibition, indeed he challenged the selection committee by sending fourteen works. They included the huge *Burial at Ornans* and *The Artist's Studio*, which was only slightly smaller and which he had painted specifically for the exhibition. The selection committee accepted a total of eleven works, but rejected those in large format and a portrait. The leading painters of the day, Ingres and Delacroix, had 40 and 35 paintings respectively in the show.[16]

Courbet took the rejection of three of his works and the way the others were hung as occasion to represent himself as a persecuted artist whom society was determined to destroy.[17] He regarded his one-man show as a manifestation of freedom and his way of ensuring the independence of art. It was held in a specially erected pavilion on Rue de Montaigne, opposite the exhibition palace for the fine arts, and he charged an entrance fee. "I am defending my freedom, I am saving the independence of art", he wrote to Bruyas, when he had finally, after much difficulty, overcome the administrative obstacles. Courbet was expecting costs of 12,000 francs for rent of the space and the construction of the pavilion. He spent 6,000 francs, about a third of the sum which Bruyas owed him for nine paintings, and he dreamt of making a hundred thousand francs, probably in the expectation that Bruyas would join him in the speculation.[18] Courbet was able to open his own pavilion, which he called *Du Réalisme*, six weeks after the World Exhibition opened. In a letter to Bruyas he called it *Le Temple*, and he showed 40 paintings and four drawings. He put posters all over Paris in the hope of attracting a large public; however, many people who came were consternated to find that the entrance fee was the same as that for the World Exhibition, one franc. Courbet also offered a four-page brochure stating his independence as an artist, including his independence of realism, and giving a catalogue of the works. This cost 10 centimes; photographs of

his works were also on sale. The brochure was entitled *Exhibition et Vente de 40 Tableaux et 4 Dessins de M. Gustave Courbet.*[19] In France the word *exposition* had come to mean a non-commercial enterprise, while *exhibition* was identified with the English practice and had acquired the stigma of egoistic commercial aims.[20] By holding an *exposition payante* and offering his works and photographs of them for sale Courbet had openly declared his commercial interests. In this, and with his many protestations of independence, he showed himself to be a new entrepreneur in the art world, a self-made man, producer, advertiser and dealer all in one.[21]

The centrepiece of the exhibition was *L'atelier du peintre* (fig. 83), a major work which Courbet described in detail even before he had finished it. In the centre is the artist in his Paris studio, working at a Jura landscape with a model and a boy watching him. On the right are his friends, and on the left the exploiters and exploited in Napoleonic society.[22] In his catalogue Courbet called the exhibition piece an *allégorie réelle*, saying it had occupied seven years of his artistic career. These seven years parallel the seven years of his rule which Napoleon III wished to celebrate with the World Exhibition.[23] Courbet was demonstrating that he was on an international stage; he also wanted to show himself as the bearer of a message to the ruler of France, who appears among the exploiters in the guise of a poacher. The message is purveyed by the landscape, by the demonstration of pure artistic activity, by the depiction of poverty and suffering and by the foreword in the catalogue entitled *Le Réalisme*. In his pavilion Courbet did not only show this grandiose *mission de l'artiste*, he also showed a self-portrait as a man fatally wounded; it was an overpainting probably made in 1854 of an earlier self-portrait with his lover (fig. 84). Courbet laid the blame for their break-up after fourteen years on society.[24] That the artist did indeed see himself in the multiple role of triumphant hero, missionary, independent apostle of

83. Gustave Courbet, *The Painter's Studio, a true allegory on the seven years of my artistic career*, 1855

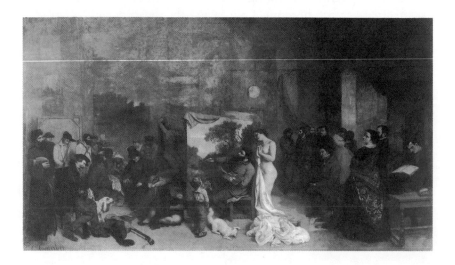

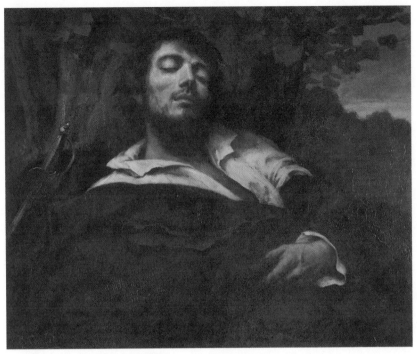

84. Gustave Courbet, *The Wounded Man*, 1844, reworked 1854

realism and martyr is confirmed by a caricature by Nadar entitled *A True Portrait of Saint Courbet, Painter and Martyr.*[25]

The following year Courbet showed some paintings in London and Brussels. He wanted an international showing not only for commercial reasons, he needed success and distinction abroad to strengthen him in his lonely struggle with the hated Second Empire and its art institutions.[26] In Paris he continued his dual strategy of enticement and scandal-raising. In the Salon of 1857 he showed two portraits, a landscape, a picture of two half-naked prostitutes on the bank of the Seine and two hunting scenes. *Les Demoiselles des bords de la Seine* aroused public indignation, while the hunting scenes satisfied public taste, and so he enjoyed a double success.[27] Friends like Champfleury were confused, because Courbet appeared to be both flattering public taste and creating a scandal, indeed, his sole concern seemed to be to gain public attention. In fact, he had first painted hunting scenes for the Salon of 1857, probably not only because he liked hunting and poaching, but because he had not failed to note the success enjoyed by the English painter Sir Edwin Landseer in the World Exhibition of 1855.[28] Courbet's calculation paid off in that he regained the 1849 medal which had been withdrawn from him, and was able to sell his two hunting scenes for the extraordinary price of 11,000 francs.[29]

Courbet profited from his success in the Frankfurt Kunstverein (Art Association) exhibition in the spring of 1858, where he showed three hunting scenes as well as *The Grain Sifters*. In the autumn of 1858 he accepted

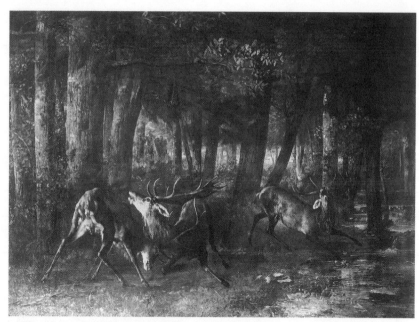

85. Gustave Courbet, *Fighting Stags, Rutting in Spring,* 1861

an invitation to Frankfurt, where he was given a studio and invited to join a number of hunting parties. He stayed in Frankfurt for six months, painting a large work, *The Hunt Picnic,* and starting the trilogy on hunting with hounds, *Hunter on Horseback, Fighting Stags, Rutting in Spring* (fig. 85) and *The Stag taking to the Water;* he also completed a view of the town and painted several portraits of wealthy people in Frankfurt. He finished the hunting trilogy in Ornans for the 1861 Salon, where he showed another animal painting and a landscape. It would appear that Courbet was aware of the problems raised by his hunting scenes and animal pieces. Certainly he wrote to Francis Wey, a friend of his youth and a writer, giving a long explanation and an astonishing justification of the pictures with reference to British taste: "It annoys me to appear at the Salon only in the categories of landscape and animal paintings. I would have liked to have sent a figure painting, had I be able to obtain an extension, but the government did not allow it, and my thumb is the cause of it all. As it is absolutely neccessary that I sell this year if I want to continue painting, I had to send those paintings; I would have sent even more if I had not broken my left thumb this winter, which prevented me from working for one and a half months."[30] His ironical complaint about the government was only a reference to their setting 1 April 1861 as the submission date for the Salon.

The hunting trilogy met with a delighted reception from the public at the 1861 Salon. But Courbet's attempts to induce the state to buy the *Fighting Stags* for the Musée du Luxembourg and to be awarded the Légion d'Honneur failed, probably owing to opposition from Napoleon III. The award of the *Rappel de 2e médaille* seemed an insult to him, and the Em-

peror's intervention an abuse of power.[31] He was consoled by an official invitation to exhibit in Antwerp, expounding on this in detail in a letter to his father as compensation for the stupidities in Paris.[32]

Courbet wanted revenge on Napoleon III. In Saintonge, where he stayed in 1862/63, he switched from adaptation to provocation with a satire on the clergy, *Le retour d'une conférence* (fig. 86).[33] In the huge format of an exhibition piece, 240 x 300 cm, he painted a scandalous procession of bawling priests staggering home drunk with a donkey. Courbet intended the astonishing picture to cause a scandal in the 1863 Salon; at the same time, he painted flower pieces to make money, as he later painted numerous portraits and pictures of the sea in the seaside resort of Trouville.[34] *Le retour d'une conférence* was not accepted for the official Salon. Courbet had made a tactical error. Instead of only sending the provocative painting, as he had originally intended, he also sent a hunting scene, a portrait and a sculpture, which were accepted. After the rejection he said: "I wanted to find out how much freedom our age permits us. I sent a painting of priests, *Le retour d'une conférence*. It fairly matched the insult the Emperor paid me the year before, and what is happening to the clergy ... I painted the picture knowing that it would be rejected. It was. That will make money for me." When the painting was also rejected on moral grounds by the Salon des Refusés, which Napoleon III had ordered, Courbet tried in vain to persuade Champfleury to start a scandal in the press, but his friend refused because he thought the painting terrible. He found it regrettable that Courbet

86. Gustave Courbet, *Returning from the Conference*, 1863

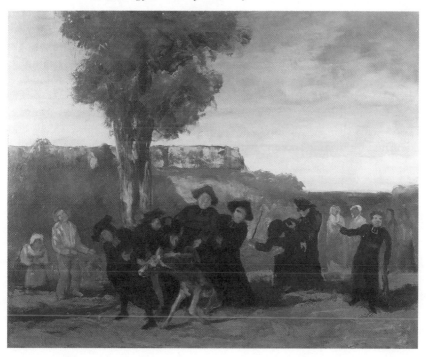

was allowing his feelings of rancour towards the government to spoil his painting. The painter, incensed, accused the writer of allowing himself to be bought by the government.[35] Courbet had recourse to the old practice of exhibiting in his studio, and, according to his own statement, as always had a big influx of visitors.[36]

The artist found defenders of his satirical painting in Jules-Antoine Castagnary, who thought it was evidence of artistic freedom, and Pierre-Joseph Proudhon, who declared that the painter was an advocate of freedom of speech and of reason above religion: "When Courbet composed his painting he did no more than make himself the interpreter of the law and of universal thought. His work ought to have a citizen's right to exhibition, a right to the Academy and the Museum."[37]

The following year Courbet's *Venus and Psyche* was rejected by the Salon on moral grounds, although the art dealer Etienne François Haro tried to exert his influence in its favour.[38] Proudhon defended the picture in a long discourse on prostitution in art, arguing that it was a satire on the repulsive aspects of the Second Empire. He concluded that the rejection of Courbet's picture proved that "the art that used to be worshipped is now, if it pursues its rightful path, foredoomed to persecution. That has already started. True artists will be despised as enemies of form; they may be castigated for offending public morals and stirring up hatred."[39]

Proudhon's allegorical interpretations of Courbet's scandalous and amoral pictures revealed the dilemma which still confronts all who concern themselves with Courbet's work. At a superficial level the pictures are obscenities, or they are kitschy hunting scenes designed to suit the taste of a few collectors and wealthy people and please the public. Courbet was, in fact, a passionate huntsman - or poacher, according to the legal standpoint. If his hunting pieces are interpreted allegorically as a depiction of the battle for survival and the difficulties the artist has to face, they are being promoted to a higher level than just decoration for Napoleon III's dining room and simple kitsch.[40]

What is disturbing about Courbet's works and his attitude as an artist, however, is that he was obsessed with exhibitions and public success, and fascinated by making money, while consistently defining the artist as outside the state. At the same time, he insisted on his right to all the means of the state. He wanted to turn things upside down, cause scandals and arouse opposition, while taking every opportunity to exploit his customers and buyers, and suit public taste. In the catalogue to his one-man show during the World Exhibition in 1867 in Paris he offered to make replicas of his paintings in any size requested.[41] It is evident that as a producer of pictures Courbet distinguished between different categories, depending on their destination. The provocative and demanding works were for exhibition and public showing, and they were intended to bring the artist honours, followers and awards. The others were simply pot boilers, intended to make money. Courbet justified this by arguing that the second type gave him the freedom and independence he needed for the first type of work.[42]

In 1844 Grandville published a wood engraving in *Un autre monde* showing works of art competing aggressively with each other and attacking the visitors to a gallery (fig. 87). The weapons they are using are obscenity, sexual attraction and physical violence; there is also a glittering light and bulging fruit, in a parody of the work of the celebrated Greek painter, Zeuxis. The gallery attendants are supposed to protect the visitors from these pictures, which constitute a danger to the public as they compete for attention on the market.[43] Grandville is arguing that the art works in the galleries have become as aggressive as the advertisements in the fight for buyers.

Edouard Manet's submissions to the Salon of 1865 and Emile Zola's early writings on Manet are also illuminating on the vicious mood that had developed between painters, the public and the critics. In the Salon which was held in the Palais des Champs Elysées, Manet's two paintings *Jesus mocked by the Soldiers* (fig. 88) and *Olympia* (fig. 89) were hung one above the

87. Grandville, *Dangerous Pictures*, 1844

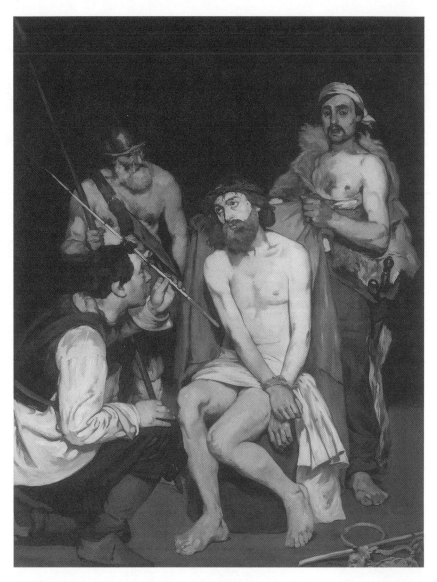

88. Edouard Manet, *Jesus mocked by the Soldiers*, 1865

other. Yet both the public and the critics only noticed the Venus. They re-
acted angrily or with derision to what they rightly thought was a wooden
and disproportioned figure and ignored the image of the suffering Christ.[44]

Manet was following a historical example with these two submissions
to the 1865 Salon. In the section on Titian in his successful *Histoire des
peintres de toutes les écoles* Charles Blanc, an art politician, writer and artist,
repeated Aretino's story that Titian presented both a Venus and a Christ
crowned with thorns to the Emperor Charles V, to satisfy the ruler's piety
and his sensuality.[45] By showing a modern Venus and a Christ mocked in
the same exhibition Manet believed that he would be satisfying the needs

of the new ruler in the art world, the public. But the reaction from this new ruler was anger and derision, and the critics accused him of trying to gain attention and success by showing scandalous pictures. That might have been the case with Courbet's calculated challenges, but it hardly applied to Manet, who was always surprised and wounded by laughter and public attack. Charles Baudelaire's irritated response to Manet's complaints at the reactions in the 1865 Salon show that the writer thought the painter over-sensitive, rather self-pitying and a bit naive.[46]

Émile Zola framed his article on Manet of 1867 with an imaginary account of the artist being stoned by Paris street youths. He describes the artist pursued by a noisy mob who are mocking and laughing at him; then they start throwing stones. The critics, whom Zola calls policemen, join the rabble. The paragraph in the introduction says: "I imagine that I am in the street and meet a crowd of youths who are following Edouard Manet, throwing stones. The art critics – pardon, our policemen – are not doing their job; they are encouraging the mob instead of trying to restore order, and God forgive me! I actually think the police themselves have huge paving stones in their hands. The uncouth violence of the mob is very distressing and it makes me, a neutral bystander behaving quietly and calmly, very sad."[47]

Zola describes how he attempts to stop the attacks by questioning the youths and the police. The writer tries to defend the painter by saying that he is an orderly citizen, a kindly married man; he works as hard as anyone, and then relaxes with his family and friends; he certainly does not lead a bohemian life. But the writer can only record the mockery and threats that are being heaped upon the painter, and he hesitantly tells the jeering

89. Edouard Manet, *Olympia*, 1863

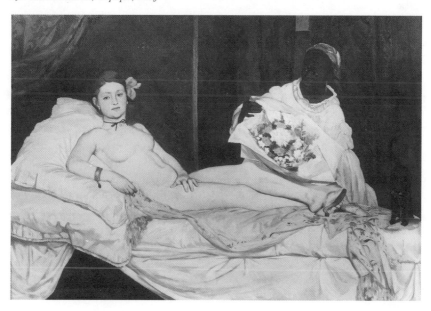

90. Honoré Daumier, *The Idiots! ... You paint a religious picture for them and they laugh ... they are not even religious about art*, caricature of the Salon of 1865

crowd that the artist already has a secure place in the Louvre.[48] As well as the future apotheosis, Zola intends to use the weapons of the writer to counter the stone throwing and heap scorn and anger upon the public and the critics.

Zola was the first to analyse the aggressions that had developed in the art world. He had already recognized that the public laughter was aggressive, and he projected this in his image of the artist mocked and stoned. Manet had been a particular target of public derision since he had exhibited *Le Déjeuner sur l'herbe* in the Salon des Refusés in 1863. He felt the public contempt and the rejection by the Salon selection committee as real injuries. *Jesus mocked by the Soldiers* can be interpreted as a statement about the artist exposed to the taunts of the critics and the public. Manet has used the familiar religious subject of Christ mocked to present an image of the artist as victim. Two contemporary depictions, a drawing and an etching by Edgar Degas, may help to understand Manet's painting. They show Manet in a similar pose to that of his Jesus, and they may be taken as supporting his view of the position of the artist.[49] This is not an implied religious connotation, but one can, presumably, draw a comparison with the victim that Balzac described in 1830 and whom the cartoonists mocked with redoubled glee.[50] *Charivari* of 1 June 1865 contained a cartoon of the Salon by Honoré Daumier (fig. 90) that may be seen as referring to Manet. It shows a bourgeois couple bursting out laughing in front of a religious picture, while the painter watches in fury. The text is a reference to the artist's mistaken belief that a religious subject would win the respect from the public which they do not show to art. His clothing shows that the artist is poor and comes from a lower social class. So the attack on the new art, that was not officially recognized by reviews, awards and medals, is linked with class consciousness.

In the nineteenth century the public concentrated their attacks on controversial or more recent artists. People went to the Salon to enjoy a good laugh at the works of artists who were not generally recognized. Derisory

laughter was the first stage; it was followed by attacks in the press, and sometimes the pictures themselves were vandalized. Charles Baudelaire was the first to identify the satanic and contradictory nature of laughter in his theory of 1855. Laughter is both recognition of total inferiority compared with the absolute being, and a sense of absolute superiority compared with animals. Baudelaire saw laughter as the constant conflict between these two extremes.[51]

Clearly it was wrong to accuse Manet of deliberately provoking scandals in order to achieve the success of notoriety. However, the reaction to his works, their rejection by the selection committees and by the critics, induced him to see his confrontation with the authorities and the critics as a battle fought out in public. The constellations of active protagonists, victims and spectators in his pictures of the sixties are a reflection of his experience of the art world as a battleground. The exhibitions are the arena where the artist fights it out, he is the victim, the authorities and the critics are the protagonists and the public is both aggressor and judge. In 1863 the historian Jules Michelet described Antoine Watteau's *Pierrot (Gilles)* (fig. 91) as the supreme example of the victim of exhibition. When the picture was first shown in Paris in 1860 it aroused much attention, but opinion was divided over whether it should be seen as a melancholy or a cheerful image. Gilles, or Pierrot, the faithful fool, is a figure from the *commedia dell'arte*. Watteau's picture shows the parade, when the actors appear on a platform in front of the theatre to attract an audience. Jules Michelet saw melancholy in the faithful clown, and he described the painting as the moment of death, with Gilles as the gladiator, the man about to die whose life passes before him in an instant as he faces the public: "For the last triumph, oppressed by success,

91. Antoine Watteau, *Pierrot (Gilles)*,
etching by E. Hedouin, in: *Gazette
des Beaux-Arts*, 3, 1860

by the screams and flowers, poor Pierrot shows himself again to the public, humbly and with head bowed, and for a moment he forgets the room; in the midst of the crowd he dreams - of how many things! Life passes before his eyes like a flash of lightning, he dreams, he is destroyed ... Morituri te salutant. I greet you, folks, I am about to die."[52]

In the foreword to the catalogue for his one-man show of 1867 in the Place de l'Alma Manet faced up to the aggressive constellation. The second World Exhibition of the Second Empire was held in Paris in 1867. Following the example of Courbet, who repeated his undertaking of 1855, Manet decided to hold his own exhibition to avoid a selection committee.[53] In the foreword to his catalogue he describes his confrontation with the authorities, the critics and the public as a battle. He maintains that his works are seen as a protest, not because he is deliberately provocative, but because the works are honest and serious. He woos the public and calls upon them to judge in his battle with the art world, which is imposing its traditional views on artists and public. Manet sees himself alone, facing an active opponent who has institutional power, practised cunning and an authoritative grasp on art. This opponent gives and withdraws access to the public, and also claims to be serving public taste while in reality directing it.[54]

To win over his public Manet presents himself as humble, almost subservient; he has always only maintained his sincerity, it was never his intention to be provocative, to denigrate traditional art or establish a new manner of painting. There is no mention of the fact that Victorine Meurent appears both as a naked prostitute in *Le Déjeuner sur l'herbe* and as *Olympia*, openly enticing the public and humiliating them by turning them into voyeurs or clients. In his 1867 catalogue Manet also rejects an essay by Zola which appeared at the beginning of the year entitled *Une nouvelle manière en peinture*. Zola bowed to public taste and changed the title of the reprint of the article to the more modest *Edouard Manet. Étude biographique et critique*; it was analogous to the title of Charles Clément's book on Géricault, which had just appeared.[55]

Manet saw no way for the artist to retreat. "Exhibiting is an existential affair, the *sine qua non* for the artist". He was not referring only to financial necessity, he was stating clearly and unequivocally that exhibiting pictures was essential for producing art and for maintaining the artist's self-confidence. An artist without the means of exhibiting was shut in, imprisoned, in Manet's view; he was a troglodyte, and his creativity would inevitably dry up. If an artist could exhibit he could defend himself against attack.

Zola's article and Manet's catalogue foreword are examples of artists writing in self-defence. The strategy which both were pursuing was to enlighten the reader. They wrote to remove misunderstanding and to soften the aggressiveness that had become a serious problem in the art world. They also wanted to show that an artist was a normal worker. Artists felt threatened. The public always seemed ready to attack, and the artists knew that in displaying their works they were exposing themselves to negative reactions

from the critics and the public. Zola recognized that the aggressions on the part of the public concealed a feeling of helplessness at their inability to understand the art, and the same applied to the mockery of the professional critics. He saw the real cause of the aggression as the lack of true guidelines in the art world. There were no longer any set rules for production, only the individual and subjectivity mattered. The public was at the mercy of flattery and changing fashions, and the critics had neither standards nor reason. The artists were forced to engage in aggressive competition on all sides and were exposed to the daily struggle for the favour of the mass and for market shares. They grabbed anything they could to attract attention and induce the buyers to purchase something.[56]

Zola was talking about the art world in the Second Empire, when Napoleon III was trying to force France to catch up with England and become the first industrial and imperial power in Europe. The art exhibitions and the World Exhibitions of 1855 and 1867 were the arenas where the products could be compared and the struggle for regard and for market shares fought out. They were also the arenas for attempts at suppression, and they held as much espionage and vicious gossip as official awards and honours. In Paris at least, the art trade seemed to be driven largely by aggressions, analogous to the aggressive competition in the commercial sphere.[57]

Manet gave the lie to his protestations that he had never deliberately provoked the public before the 1867 World Exhibition was over, for he started work on his sensational depiction of the execution of the Emperor

92. Edouard Manet, *The Death of Maximilian*, 1868

Maximilian of Mexico in July that year.[58] Probably he was hoping that he could still turn the failure of his exhibition at the Place de l'Alma into a success.[59] In 1864 he had already tried to attract public interest by exhibiting an exciting painting of a battle between two American ships before the west coast of France in Alfred Cadart's shop window on Rue Richelieu.[60] The great interest in the execution of Maximilian and the role played by France is evident from the many press reports and pictures, and the demand for Adolphe Thiers' speech containing a sharp attack on Napoleon III, which went to five editions.[61] Possibly the event and the artistic challenge posed by the need for rapid execution of the painting were what initially attracted Manet, but he was in any case disposed to favour acts of violence in civil wars and their victims. Although he could not repeat so rapid an execution, he continued to work on the theme as it became ever clearer that it would constitute an attack on Napoleon III and the Second Empire. In January 1869 the Ministry of the Interior imposed censorship on Manet by banning the lithograph (fig. 92) and announcing that his painting could not be shown in the next Salon. Zola, to whom Manet appealed, must have recommended that he appeal to the public. For more than a month, accusatory letters and notices by Manet and Zola appeared in the daily *La Tribune*, and the weekly *Chronique des Arts et de la Curiosité*, but the censorship was not relaxed. Manet was not allowed to show *The Death of Maximilian* at the 1869 Salon, and the Lemercier firm was only ready to print the lithograph in 1884, after Manet's death.[62] Manet's delight in sensation and in the political motif appears to have changed in the course of the work, and he came to concentrate more on the constellation of protagonists, victims and spectators. Above all, he appears to have identified with Maximilian, who was born in the same year as he; he took Watteau's *Gilles* as a model for the executed emperor.[63]

Group Strategies

Fantin-Latour's painting of a group of artists in *Un atelier aux Batignolles* (fig. 93) now looks programmatic. Edouard Manet is painting at an easel, but we only see the back of his canvas; on the left is the German painter Otto Scholderer, on the right Auguste Renoir before a black painting in a frame, then come Zacharie Astruc, Emile Zola, Edmond Maître, Frédéric Bazille and Claude Monet.[64] The most derisory reaction to the group portrait when it was exhibited in the Salon of 1870 came from Bertall in *Le Journal Amusant* (fig. 94). Manet was awarded the most ludicrous distinction, a halo, while the caption mockingly described the group as Jesus and his disciples.[65]

Frédéric Bazille described his plan to form a group of a few painters to exhibit independently of the Salon in letters to his parents in 1867 and 1869. Some of the prospective members are in his painting of a group in a studio (fig. 95) of 1870.[66] The Franco-Prussian War and Bazille's death in action

93. Henri Fantin-Latour, *Un atelier aux Batignolles*, 1870

forced the postponement of the plan. Then in 1873 the *Société anonyme des artistes peintres, sculpteurs, graveurs etc.* was founded, mainly with the aim of holding exhibitions. The first was held from 15 April to 15 May 1874, in the studio on Boulevard des Capucines 35 formerly occupied by the photographer Felix Nadar. The artists had to deposit a fee of 60 francs to participate; the public was charged one franc entrance fee, the catalogue cost another 50 centimes and the exhibition was open from 10.00 to 18.00 and from 20.00 to 22.00 hours. One hundred and sixty-five paintings, drawings, watercolours, pastels and etchings were on sale by 29 male artists and one woman, Berthe Morisot.[67]

The group chose to designate themselves "Société anonyme", the legal name for a company. They did not have an artistic programme, nor did the many other groups of artists who formed after 1870 and, like the dealers, contributed to swell the number of exhibitions.[68] The composition and names of the group continually changed. The 1874 exhibition has become famous as the first appearance of the Impressionists, but this is one of the many legends about these artists who were reputedly so maligned and persecuted, and one that was intensively cultivated right into the twentieth century.[69] Some critics did look for a common artistic idea or policy that would characterize the group, as in Fantin-Latour's *Hommage à Delacroix* of 1864 (fig. 71). They were called Impressionists by those wishing to emphasize their technique and their individualism; others called them "Intransigeants", after the anarchic wing of the Spanish federalist party, "Los intransigentes", to stress their apparently rebellious political line. With the

139

94. Bertall, *Jesus painting with his Disciples, or the Divine School of Manet, religious painting by Fantin-Latour*, in: *Le Journal amusant*, 21 May 1870

exception of Camille Pissarro, however, who was an anarchist, the group were more probably shocked by this political assignation. In 1876 Stéphane Mallarmé published his essay *The Impressionists and Edouard Manet* in London, calling Impressionism a movement that rejected the image of the romantic artist as dreamer in favour of the artist as a strong modern worker. He also drew a parallel to the political changes in France: "The participation of a hitherto ignored people in the political life of France is a social fact that will honour the close of the nineteenth century. A parallel is to be found in art, where the way is being prepared by an evolution which the public with rare insight dubbed, from its first appearance, "Intransigeant"; in political language that means radical and democratic."[70]

The question of a common programme did not arise for the group's second exhibition either. It was held in 1876, in the gallery run by Durand-Ruel in Rue le Peletier 11; Berthe Morisot and eighteen male artists participated. The question of a common programme was apparently only discussed during the difficult preparations for the third exhibition in 1877. In January or February that year, Gustave Caillebotte invited six painters to supper for a discussion - Degas, Monet, Renoir, Sisley, Manet and Pissarro. We can only speculate on what they discussed.[71] Presumably one topic was Pissarro's threat to leave the group; he and Cézanne had joined the group of artists around Alfred Meyer known as *L'Union*. The artists at Caillebotte's supper will certainly have proposed inviting Edouard Manet to exhibit with them; possibly they also considered the group's artistic profile as well as the organization of the next exhibition. They were now ready officially to adopt the name "Impressionistes", but only two years later they preferred

"Indépendants". For the 1877 exhibition Gustave Caillebotte rented a big apartment in Rue Peletier 6, opposite the Galerie Durand-Ruel. This came closer than the earlier venues had done to showing the pictures in domestic surroundings.

On 12 April 1870 Degas sent an open letter to the Salon selection committee concerning the hanging practice in the Salon, which was held in the Palais de l'Industrie from 1857 to 1897. Instead of hanging the pictures edge to edge all over the walls, Degas proposed limiting the selection to two rows, leaving a gap of twenty to thirty centimetres between the pictures, not attempting to match size and subjects or to separate the works according to their techniques and allowing the artists a say in the hanging. He cited as model the hanging in the British pavilion at the World Exhibition of 1867.[72]

Although they were exhibiting to sell their works, the Impressionists attempted to create a private atmosphere in their exhibitions. By establishing a certain degree of intimacy they aimed to distance themselves from the official Salon in the Palais de l'Industrie, which was more like a trade fair with goods for sale.[73] From the sparse information that has survived on the way the first three Impressionist exhibitions were presented, we may assume that the idea was something between a studio and an apartment. The pictures were hung in two rows, one above the other, and well lit. The group tried to bring out the individual qualities of each artist's work by hanging groups of works together, wherever possible. In the third exhibition, the walls of the rooms were painted in different colours. The domestic nature of the presentation showed the visitors and prospective buyers how the pic-

95. Frédéric Bazille, *Bazille's Studio,* 1870

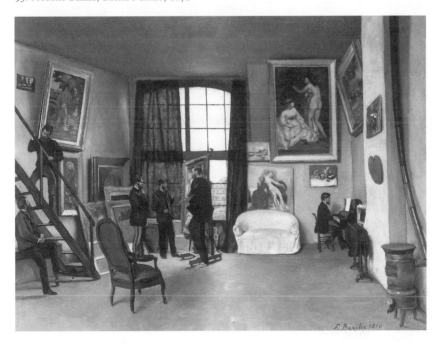

96. Claude Monet, *The Turkeys* (part of the decoration of the Grand Salon in the Château de Rottembourg), 1877

tures would look in their own homes, and the suggestion of a studio also went some way towards softening the shock of the sketchy nature of the paintings. The third exhibition, where the walls of the apartment were differently coloured, was the first where visitors could envisage the paintings as part of an interior decoration scheme. Philippe Burty wrote of the paintings in his review of the exhibition in 1877: "They offend as paintings because they look like sketches, and reveal the way they have been produced. As a whole, and as interior decoration to embellish a room, they have an undeniable clarity and freedom of effect."[74] That view was encouraged, not only by the presentation of the exhibition, but also by Claude Monet, who in 1876 showed a *Panneau décoratif* and in 1877 the painting *The Turkeys* (fig. 96), noting in the catalogue "décoration non terminée".[75] The remark gave rise to the long-lasting misconception that the picture was exhibited half-finished, but Monet was referring to an interior decoration that was not yet finished, that of the great Salon in the Château de Rottembourg; it belonged to Ernest Hoschedé, who owned a department store.

If he did not invent it, James McNeill Whistler perfected the decorative presentation of works of art. In 1874 he had the walls of the Flemish Gallery in London painted to harmonize with the works for his first one-man show.[76] Whistler regarded this as an analogy with music. He had been designing and painting his frames since the seventies, and they needed walls in appropriate colours.[77] In 1877 he was commissioned by Frederick Leyland to decorate the famous Peacock Room, a luxurious setting for a collection of porcelain; Whistler created his *Harmony in Blue and Gold*.[78] When Lucien Pissarro saw Whistler's 1883 exhibition in the Grosvenor Gallery in London, he wrote to his father: "But on Saturday I saw Whistler's exhibition. He has pinched our idea of coloured rooms. His is all white, with lemon yellow borders; the wallpaper is yellow velvet with an embroidered butterfly in the corner. The chairs are yellow, and the basketwork white. On the floor he has a yellowish Indian mat and vases in a yellow tone with varieties of yellow dandelions. Finally, the servant is in white and yellow. The colour scheme makes the room very cheerful, in contrast to the neighbouring rooms, where a dealer is showing his paintings."[79]

Whistler was appointed President of the Society of British Artists in 1886, and he not only obtained permission from Queen Victoria for the Society to use the prefix Royal, he also concerned himself intensively with the presentation of its exhibitions. He was dictatorial in reducing the number of works shown from 800 to 500, and he invented the "velarium", an arrangement of transparent material hung under the glass roof of the gallery. Whistler had the velarium patented. It enabled him to achieve a good light for the paintings and eliminate reflections (fig. 97). Whistler's apparent invention was in fact an imitation of the "velum" that had been used in the panoramas since the beginning of the century.

97. James McNeill Whistler, *The Gallery of the Society of British Artists*, 1886-87

98. Georges Seurat, *Circus*, 1890-91

Degas and Pissarro appear to have used white frames for the first time in Paris in 1877, and between 1879 and 1881 Mary Cassatt also experimented with painted frames.[80] These experiments, although they cannot be exactly proven, show that the artists were concerned with the problem of the harmony between the picture and its surroundings. As the French artists continued to experiment with frames the most important and most interesting results were achieved by Georges Seurat, who showed six paintings and three drawings in the eighth and last exhibition of the Indépendants in 1886. Two of the paintings already had borders in complementary colours, although in the case of *La Grande Jatte* these were hidden by a broad white frame.[81] Between 1886 and 1891 Seurat experimented with painted bor-

ders, painted frames and painted wooden frames. His notes for the article 'Esthétique' include a rather vague note on the frame, which needs to be read in conjunction with his terse comment "Art is harmony": "In the harmony [of the painting] the frame complements the harmony of the tone values, colours and lines".[82] Although Seurat's frames have been changed many times, forged or removed, we can still form some idea of the extent of his experimentation. He was concerned on the one hand with the relationship between the picture and its frame (fig. 98), and on the other with the decorative relationship between the frame and its surroundings. The painting itself is a scientifically proven optical mixture of colours requiring active participation from the viewer, who has to mix the colours in his eye.[83] Its contrasting border forms the transition to the painted frame.

In his painting Seurat offered a solution that was based on an inter-subjective principle, optical colour mixing, and which presupposed the participation of the viewer. If they did have a common artistic platform, the Impressionists propounded the subjective perception of the artist, the sketchiness of which could be justified by the rapidity of change. This argument made a common artistic strategy impossible right from the start, certainly one that could have gone beyond a common interest in exhibiting or in showing paintings in relation to the bourgeois domestic interior.

The group activities of the movement that is now known as Impressionism stopped after twelve years and eight exhibitions. During that time not only the name but also the composition of the group had changed several times. Even the core members - Pissarro, Degas, Monet, Renoir and Sisley - did not always exhibit with them. Degas was not present in 1882, Monet, Renoir and Sisley preferred the official Salon in 1881, "traitors", Degas called them. Towards the end, another branch was becoming evident within the heterogenous movement, artists who later came to be known as the Neo-Impressionists. The name has become as firmly attached to them as Impressionism to the earlier group, but it is just as meaningless, and it is really only due to Seurat's appearance in the last Impressionist exhibition. Seurat's method had a few imitators, but a decade later the new movement was already being pronounced dead.

There are several significant factors to note here. One is the brevity of these artists groups, another the relative isolation of the artists, even as a group. We may also note how interests that had been coordinated with some difficulty diverged again when this appeared to be to individual artists' advantage or when artists wanted to pursue independent career aims. Finally there is the subsequent projection onto them of common artistic goals under an "-ism" label to designate a movement.[84]

Social Exiles and Prophets

In October 1888 Paul Gauguin, who was then in Pont-Aven, sent a self-portrait to Vincent van Gogh in Arles. It shows Gauguin against a yellow

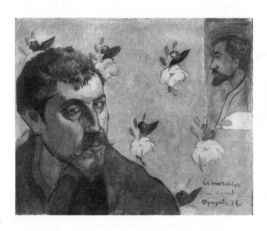
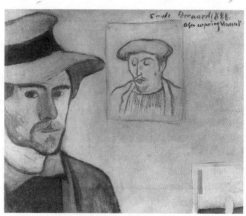

99. Paul Gauguin, *Self-Portrait with a Portrait of Émile Bernard „Les misérables"*, 1888

100. Émile Bernard, *Self-Portrait with Paul Gauguin*, 1888

Persian carpet, and it has a portrait of Emile Bernard in profile in green in the right corner (fig. 99). A short time later, Gauguin went to Arles to paint with Van Gogh, but he left again on 26 December after a bitter quarrel in which Van Gogh tried to attack him and then mutilated himself. The inscription on the self-portrait which Gauguin sent ahead of his visit cites the title of a novel by Victor Hugo, *Les misérables*. It is a reference to the saints and martyrs of society who keep their hearts pure in wretched conditions where crime flourishes, and who represent the hope that society can be changed.[85] In his letter to Van Gogh, Gauguin explains why he has adopted the mask of a bandit. It is reference to Hugo's character, Jean Valjean, who changes from being a convict to a benefactor of mankind: "And Valjean, oppressed by society and outside the law, is he not, with his love, with his strength, the image of an Impressionist today? As I depict him with my features you have my personal image and our portrait for all the poor victims of society whom we avenge by doing good."[86]

At the same time as Gauguin's self-portrait, a self-portrait of Émile Bernard arrived at Van Gogh's house. Bernard had used a similar composition, with his own head on the left edge and a drawing of his friend Gauguin pinned to the wall (fig. 100). Bernard drew Gauguin with eyes closed, a visionary or an artist whose thoughts are elsewhere, and he dedicated the picture "à son copaing Vincent" - "To his pal Vincent". Van Gogh wrote to Bernard and thanked him, assuring him that the sight of the portrait had warmed his heart. He wanted Bernard to work on portraiture: "We must win the public over later on by means of the portrait; in my opinion it is *the* thing of the future." At the end of the long letter Van Gogh came back to the effect of the two self-portraits by Gauguin and Bernard: "My house will seem more lived-in now that I am going to see the portraits in it!" Again he invites his friends to spend the winter in Arles, an invitation he had extended several times already, with very precise calculations of the costs involved.[87] The two self-portraits by Gauguin and Bernard, each containing

146

a drawing of the other, anticipated their presence in his house, while the contrasts between the profile portraits, highly modelled but cut off by the edge of the canvas, and the drawings of the subjects with downcast eyes, thematized the difference between presence and absence. Van Gogh said he saw melancholy and something of the prisoner in Gauguin's self-portrait, which he thought was due to poverty. To earn money for the brotherhood of painters for which he longed, he made a vow to please the public. He told his brother Theo that he was going to produce pictures that would sell well, with poetic subjects like a starry sky and furrowed fields.[88]

The portraits by Gauguin and Bernard were painted at Van Gogh's insistence; he wanted the mutual portraits of the two artists who were working in Pont-Aven in exchange for his own pictures. Van Gogh had already arranged exchanges of this kind when he was working in Paris, and when he was trying to establish a community of artists which he called *Le Petit Boulevard*, in contrast to *Les Grands Boulevards*, the Impressionists. In 1888 Gauguin received a self-portrait by Van Gogh in exchange for his own (fig. 101). In a letter, Van Gogh explained that the portrait showed an intensification of the personality like that of a priest or Buddhist. That was why, he wrote to his brother Theo, he had set the eyes rather slanting, like those of a Japanese.[89] This self-portrait shows him thin, his head almost bald, against an aggressive green, which is lightened with white around the head. For Van Gogh, this exchange of paintings constituted an ideal brotherhood of artists; the portraits were a substitute for the presence of Gauguin and Bernard. At the end of September 1888 he wrote to Bernard that he did not want a "freemasonry of artists", with regulations. He had in mind a community that would form naturally. He recalled the exchange of pic-

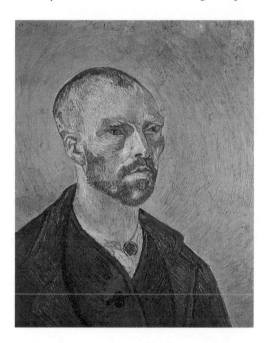

101. Vincent van Gogh, *Self-Portrait for Paul Gauguin,* 1888

tures between Japanese artists, which proved their harmony, their brotherly attitude and their avoidance of intrigues.[90]

The short-lived communities of these artists in Pont-Aven and Arles created unbearable tension and ended in conflict. Irreparable injuries were done and the friendships were shattered, never to be restored. When Gauguin planned to leave Arles, Van Gogh was deeply disturbed. A few days before the intended departure of his friend he painted two pictures of empty chairs in two different rooms. On Van Gogh's simple chair stand a pipe and tobacco pouch, Gauguin's basketwork armchair holds two novels and a candlestick with a lighted candle in it; a second candle is burning on the wall behind the chair.[91] According to Gauguin, the two artists quarrelled in a café and Van Gogh threw a glass at his head; next day he attacked him with a razor blade outside on the Place Lamartine. Gauguin succeeded in stopping Van Gogh by turning round and fixing him with a powerful gaze. After that he went to bed in the hotel while Van Gogh rushed home and during the night cut off part of one of his ears.[92] When he saw the mutilation of the left ear lobe Gauguin telegraphed to Van Gogh's brother Theo and himself returned to Paris. In letters to his brother, Van Gogh made light of the events, calling them a "simple row between artists"; he complained bitterly at Gauguin's leaving without saying good-bye, seeing his disappearance as a betrayal; he recommended a thorough medical examination and considered asking for a return of the pictures that had been exchanged.[93]

The break between Gauguin and Bernard probably came because Bernard felt that his contribution to the new Symbolist movement in painting was held in lower esteem than that of Gauguin; he also appears to have believed that Gauguin was exploiting him, or might even have stolen from him. Probably Gauguin completed one of his major works, *La vision du sermon (The Vision of the Sermon)* soon after Bernard arrived in Pont-Aven, and

102. Paul Gauguin, *Letter to Van Gogh with the watercolour sketch after 'Le Christ au jardin des oliviers'*, 1889

148

103. Paul Sérusier, *Portrait of Paul-Elie Ranson in Nabis Costume,* 1890

Bernard may have been the inspiration for this.[94] The self-portraits which Gauguin and Bernard sent to Van Gogh both show the other in the drawing on the wall as if lost in thought. In the *Exposition de peintures du Groupe Impressionniste et Synthétiste* of 1889 in the Café des Arts on the World Exhibition grounds, Gauguin tried ruthlessly to force his interests over the other eight artists.[95] In the winter of 1889 Gauguin and Bernard had started work on the subject of Christ in the Garden of Gethsemane. Bernard depicted Christ with red hair, and he gave Judas Gauguin's features. Gauguin painted his version in the summer, showing Christ with red hair and giving

104. Félix Vallotton, *The Five Painters,* 1902-1903

Him his own features. Gauguin described his picture in a letter to Van Gogh, and added a sketch (fig. 102).[96] One reviewer of the 1889 exhibition thought Bernard sensitive, ambitious but uncertain, and believed he had copied Gauguin. Gauguin not only claimed the leading role as if by right, he also broke his promise, as Bernard saw it, not to exhibit alone when he held a show of work for sale in the Hotel Drouôt in February 1891. Immediately afterwards an article appeared in *Le Mercure de France* by G.-Albert Aurier, a friend of Gauguin and Bernard, acknowledging Gauguin's leading part in the new movement in painting.[97] Later, looking back, Bernard described the two events as the cause of his breach with Gauguin; Gauguin himself never commented on the breach.[98]

In 1888 Paul Sérusier gathered a number of artists in Paris into a group who, a short time later, chose the name *Les Nabis.* They were to be prophets, illuminated, magicians, enchanters, devotees of the symbol. Les Nabis had as models Puvis de Chavannes, Odilon Redon and Paul Cézanne, but most particularly Gauguin. Sérusier had worked with Gauguin in Pont-Aven in 1888 and in Le Pouldu in 1889. In 1890 he painted a portrait of his friend Paul-Elie Ranson in Nabis costume (fig. 103). Ranson's studio in Boulevard de Montparnasse 25 was known as The Temple, and the Nabis regularly met there. Sérusier, who like Ranson was fascinated by esoteric theories, depicted his friend clothed in a tunic with the signs of the Zodiac and the emerald of Hermes Trismegistus on his collar. He is deciphering a script. In his left hand he holds a kind of bishop's staff, which ends in a

150

winged figure that passes into a snake. The wing and the snake body are decorated with a five-pointed star, an esoteric symbol of truth. An orange-coloured disc behind Ranson's head forms a halo. The painter Ranson is shown as the spiritual leader of the Nabis, with Christian attributes and esoteric symbols.[99] Twelve years later Félix Vallotton painted the group with cruel Swiss objectivity as a group of melancholy and disillusioned men (fig. 104); it was also a refutation of Maurice Denis' *Homage to Cézanne* (fig. 72) of 1900.

L'Union des Femmes Peintres et Sculpteurs

Mme Léon Bertaux (Héléna Hébert) had already exhibited in the Salon in 1849 under the pseudonyum of d'Allélit, and from 1857 she showed her sculptures in the Salons under her married name. In the relatively liberal Salon of 1864 she showed a plaster statue, *A Young Gaul taken Prisoner by the Romans* (fig. 105).[100] Mme Léon Bertaux must have known that in showing the statue of a naked young man she was overstepping the bounds of what was regarded as proper and acceptable for women artists, for whom the rules of conduct were stricter than those for men. In 1873 she opened a teaching studio, offering courses in sculpture for girls and women; the classes were so successful that in 1879 she was able to open a school of sculpture for women. The teaching reinforced her own experience of the difficulties women faced in the art world, and it gave her the idea of forming a community of women painters and sculptors, like the English Society of Female Artists that had been founded in 1857.[101]

The article on Mme Bertaux which appeared on the title page of *Le Papillon* in 1893 begins: "Mme Léon Bertaux is the best and most brilliant living proof of the argument that genius knows no sex, that is, women have the same right to it as men."[102] This was a reference to the legendary comment by the Empress Eugénie on her visit to Rosa Bonheur's studio in 1864.

At the meeting to found the *Union des Femmes Peintres et Sculpteurs* in the spring of 1881 in Paris Mme Léon Bertaux, who was its first president, said: "The woman artist is an unknown power, unrecognized, held back from developing fully! A type of social prejudice still weighs her down, and despite this, every year, the number of women committed to art increases with a frightening rapidity: I say frightening because our institutions still do nothing for the greater cultivation of these hard-working minds, so the results of so many efforts are often powerless or ridiculous." She called upon the Union of Women Artists to fight in solidarity against the resignation, the lack of regard and the lack of encouragement.[103]

The Union attracted a large number of members. At the first Salon des femmes in January 1882, it had 45 members; by 1896, fifteen years after its establishment, the membership had increased tenfold. The women's Salon contained nearly a thousand works, and from 1889 the Union campaigned

105. Mme Léon Bertaux (Héléna Hébert), *Un jeune Gaulois prisonnier*, c. 1864

ceaselessly and skilfully to have women admitted to the École des Beaux-Arts and the state competitions.[104] In 1888 the Union of Women Artists was officially recognized as a "société d'utilité publique", and from 1890 it published a weekly magazine, *Le Journal des femmes artistes*.[105] A number of established women artists, like Berthe Morisot, Mary Cassatt and Eva Gonzalès, however, kept their distance, preferring to pursue their aims either with the Impressionists, the Salon or commercial galleries.[106]

The first organization of women artists laid down its objectives in its statutes. "The objective of the Union is to exhibit the most remarkable

works of its members every year, to defend their interests unconditionally, to establish solidarity among women artists and consequently to make a contribution to raising their artistic level. Finally, it will always be obliged to support recognized and emerging talents with the best possible means."[107] The Directors were instructed to visit the various exhibitions in Paris and compare standards, in particular to make sure that a venue for the exhibition was booked in good time, the selection committee appointed and the catalogue printed. A hanging fee of five francs, but a maximum total of 20 francs, would be charged for each work accepted and hung, but contrary to the usual practice, no commission would be charged on sales. Initially the Union des Femmes Peintres et Sculpteurs did not have a jury for its exhibitions, but selection had to be introduced to limit the number of works exhibited and maintain standards. The committee was appointed from the members. The Union expressly stated that it would not undertake a further selection of the works by the way they were hung. The catalogue for the seventh exhibition in 1888 said: "To present the paintings with the best possible overall effect, their classification, and the place of honour, are not a statement of their greater or lesser worth as works of art (Meeting of the Directors on 26 November 1886). No share in the proceeds of works sold during the exhibition will be taken."[108] A reviewer of the eighth exhibition of 1889 in Firmin Javel's weekly magazine L'Art français spoke of the admirable objectives of the women artists' union, and particularly the way they were implementing them. Only in the exhibitions of the Union des Femmes Peintres et Sculpteurs were the best places not reserved for the selection committee, only here were there no intrigues in the studios and talents were promoted and encouraged irrespective of public reputation. Firmin Javel thought the women artists were setting men a good example: "One day men and women may be equal in every section of the Palais de l'Industrie. While we wait for that happy time we believe that the gentlemen can only profit from a careful study of the way the ladies behave. It is humbling for the bearded sex, but one has to admit that the ladies are acting in an exemplary fashion compared with the men."[109] This was a reference to the solidarity among the women artists; it was always cited as the main principle of the Union, distinguishing the ladies from their selfish and career-minded male colleagues.

The Union had to work hard to establish the interests of the women artists in an art world dominated by men. The art schools were almost all exclusively male. Only the City of Paris had had a public school of drawing for women since 1802; it was directed by Rosa Bonheur from 1849 to 1860.[110] Léon Lagrange had proposed that girls should be admitted to the municipal schools for drawing lessons in 1860 in an article in La Gazette des Beaux-Arts, arguing that this would improve their performance in related fields and the applied arts. But he vehemently opposed admitting women to the École des Beaux-Arts or allowing them to compete for the Prix de Rome, thus allowing them to rival men.[111] In the main, women had to pay for private tuition, as Berthe Morisot and Eva Gonzalèz did, or attend the

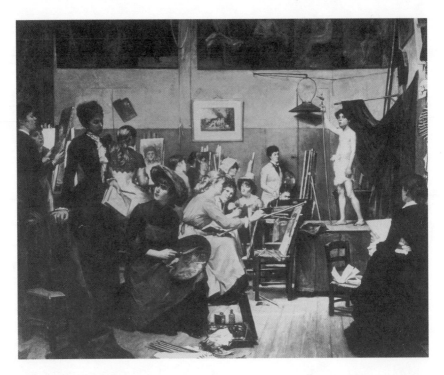

106. Marie Bashkirtseff, *The Women's Class at the Académie Julian*, 1881

women's class in the Académie Julian (fig. 106), although they were charged double the fee there.[112]

Mme Léon Bertaux campaigned for the admission of women to the École des Beaux-Arts in the Congrès International des Oeuvres et Institutions Féminines, which was held during the World Exhibition of 1889 in Paris and supported by the French Government. Her demand for a separate class for girls in the École des Beaux-Arts, with the same teaching as for male students and with the same right to apply for the Prix de Rome, was passed unanimously by the congress.[113] Mme Bertaux did not want to link the question of the admission of women to art schools with the issue of the political rights of women, which was being discussed by the dissident Congrès Français et International du Droit des Femmes at that time. Nevertheless, she and her successor, Virginie Demont-Breton, had to fight hard and persistently against the financial and moral arguments from the public, from male artists, the École des Beaux-Arts and the Ministry, before the first women were able to start a full course of study there in 1900.[114] Most of the moral objections were to women drawing from the male model.[115]

The architect Joseph Maria Olbrich inscribed words proposed by Ludwig Hevesi: "To each time its art - to art its freedom" above the entrance to the exhibition building of the Vienna Secession (fig. 107). In 1897 some mem-

107. Joseph Maria Olbrich, *Study for the Secession Building,* 1897

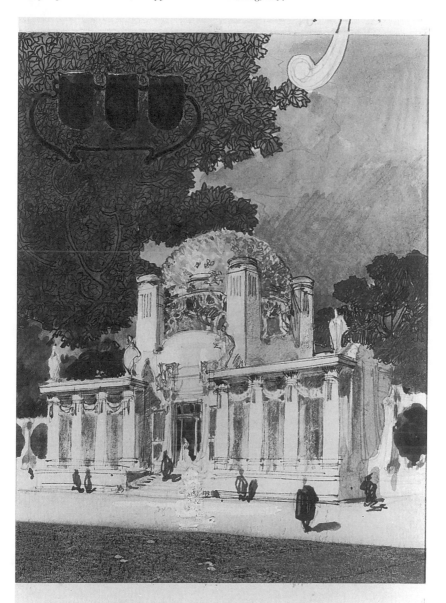

OLBRICH · 97

bers of the Künstlerhaus-Genossenschaft (Artists Cooperative) had formed a group with the objective of bringing the Vienna art scene into line with trends in Europe, holding exhibitions oriented to artistic aims instead of commercial considerations, and spreading a greater understanding of art among leading circles.[116] The move, which split the Vienna Secession off from the Künstlergenossenschaft Wiens (Fine Artists Society of Vienna), was provoked by the clumsy and authoritative reaction of the Society's president to some of the activities of the new group, for apparently the younger Viennese artists had not initially intended to split off like the Munich Secession. At the first meeting of the Vienna Secession the group decided to issue a periodical, *Ver Sacrum*, and build their own exhibition hall.[117]

Like the other Secessions in central Europe the Vienna Secession distinguished itself from the big official exhibitions by mounting élitist exhibitions of only a hundred or two hundred works, instead of several thousand. They certainly did not disdain commercial success, on the contrary, the members were extremely successful in creating a private art market. However, they fell victim to the illusion that unlike the "merchant artists" in the Society they would never make concessions. Hermann Bahr, who welcomed their first exhibition in 1898 with enthusiasm, wrote of the wonder that the exhibition did not contain a single bad picture, and of the pleasure of seeing that money could be earned with "pure" art in Vienna.[118] In the catalogue for the first exhibition, which was held in the Gartenbaugesellschaft's premises, the Secession distanced themselves from mediocre art and spoke out for selection, an élite and internationalism. As well as work by Viennese artists, the exhibition included works by Puvis de Chavannes, Rodin,

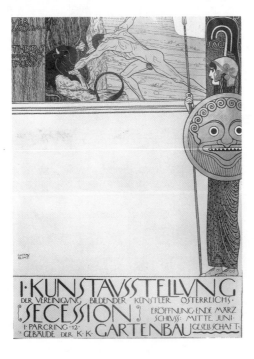

108. Gustav Klimt, *Poster for the First Art Exhibition by the Association of Austrian Fine Artists - Secession* (first version), 1898

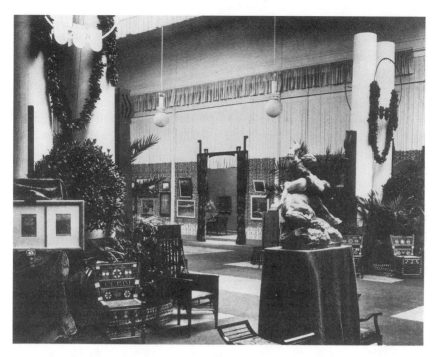

109. The main room of the first exhibition in the Vienna Secession premises (2nd Secession exhibition), November 1898

Segantini and Fernand Khnopff; also applied arts and an interior. The exhibition attracted 57,000 visitors; more than half the works were sold for a total of 85,000 gulden and net profits amounted to nearly 3,858 gulden.[119]

The slogan chosen by the Secession was the opposite of the belief stated by Otto Wagner in 1896 that art should adapt to the society in which it found itself, so contemporary art should be democratic.[120] The Vienna Secession found a good market among the upper bourgeoisie, thanks mainly to its first and most important patron, Karl Wittgenstein, an industrialist, stock market speculator and banker. Wittgenstein financed the Vienna Secession's exhibition building, and used his political connections to further rapid planning approval and construction.[121] Although the Secession was welcome in leading circles in Vienna, as it responded to the interest in the new inter-national art and interior decoration, its members projected their own ideal. Gustav Klimt designed a poster for its first exhibition (fig. 108) showing the goddess of art, Pallas Athene, holding the shield of Medusa, and Theseus killing the minotaur. This heroic depiction took up the famous Theseus group by Canova, that had been moved from the Volksgarten to the stairs of the Kunsthistorisches Museum in Vienna, which opened in 1891.[122] Klimt presented an unmistakeable allegory of victory over the enemies of the Secession, utilizing the avantgarde idea of heroism in the face of public disregard.[123] However, the censor intervened on moral grounds, for Klimt's sketch was for a nude Theseus. On the first print, the sex was

given a fig leaf, but this did not satisfy the censors, and in his second version Klimt had to cover the offensive part with trees.[124]

Right from the start, the Secession took particular pains over the decorative aspect of their exhibitions (fig. 109). Olbrich's building, which opened for the second exhibition in November 1898, was designed to permit variable arrangements, with four big, top-lit rooms and moveable partition walls. In his review Hermann Bahr praised both the adaptability of the exhibition rooms to "spatial art" and the function of the entrance as spiritual purification. On the exterior he acknowledged the qualities of the truthful and the decorative.[125] Above the interior entrance to the middle room was a glass mosaic by Koloman Moser with an allegory on art and an inscription by Bahr: "Let the artist show his world, the beauty that is born with him, that has never been before and will never be again."[126] The history of the design is interesting, for it documents the rapid change from a pompous exhibition architecture to a decorative functional building with its unique crown, a hemisphere covered with three thousand gilt metal laurel leaves.

110. Max Klinger, *Beethoven*, 1902

The highlight of the Vienna Secession's interior decoration was the overall design of the fourteenth exhibition in 1902, with Max Klinger's *Beethoven* (fig. 110) in alabaster and coloured marble as centrepiece. With white roughly plastered walls, inset wall paintings by twenty artists and a grey floor, Josef Hoffmann created "the solemn mood of a temple for one become a god". The visitors were first led into the side rooms to Klimt's *Beethoven* frieze, and this prepared them for Klinger's *Beethoven* in the main room.[127] For the private view, Gustav Mahler arranged the chorus from Beethoven's Ninth Symphony for wind instuments.[128] Klinger's *Beethoven* was a monument intended for an indoor setting, and it shows the Titanic artist on a throne, in an iconographic and cultural conglomerate of Jupiter with the eagle, Prometheus and the artist-visionary. Unlike the coloured plaster model of 1885/86, which shows the artist darkly brooding, the eyes of the genius in the finished version are no longer coloured to stand out against the white marble.[129]

In this unity of works of art and ambience, the Vienna Secession exhibitions were tending towards a total work of art, as it were, or better still, a total design. Ultimately the aim was to remove the division between art and life in the interiors where the rich and powerful dwelt and acted. Gustav Klimt expressly stated this aim of eliminating the borders between artists, society and the work of art in his speech at the opening of the 1908 art exhibition: "And we interpret the term 'artist' as broadly as we do 'work of art'. We include not only the creative, but those who enjoy art as well, those who are capable of experiencing what has been created with sensitivity and according it honour. For us, 'artists' are the ideal community of all who create and all who enjoy."[130]

Even before Vienna, and before the Wiener Werkstätten under Josef Hoffmann extended design to every area of life, a community of artists, the upper bourgeoisie and the nobility was realized in the artists' colony in Darmstadt designed by a Viennese architect, Joseph Maria Olbrich. The enterprise was under the patronage of the Grand Duke Ernst Ludwig, who wished to combine art and commerce; his primary intention was to reform everyday life and further the economic development of Hesse. The Darmstadt artists' colony is remarkable, not only for the illustrious names involved but also because it attempted to combine artistic activity with economic progress, and to elevate it with the idea of the artist as prophet and leader of men. The Grand Duke, who had taken over the government of Hesse in 1892, accepted this vision of a comprehensive design of every sphere of life and the need to harmonize the arts and crafts propounded by the young Viennese architect Joseph Maria Olbrich. After the first exhibition opened in the Vienna Secession building which he had designed, Olbrich, then barely thirty, said he wanted to build a city or have a green field on which he could create a world: "... a green field; and then we can show what we can do; the whole lay-out, down to the last detail, all imbued with the same spirit, the streets and gardens, palaces and lowly dwellings, tables and chairs, lights and spoons, should all be the expression of the same

sensitivity and perception; but in the centre, like a temple in a sacred grove, there should be a house of labour. It should be both the artists' studio and the craftsmen's workshop ..."[131] The Grand Duke took up the challenge to realize an artists colony, and he found in Olbrich the right man for the purpose.[132] Seven artists, among them the architect Peter Behrens and the sculptor Ludwig Habich, as well as Olbrich himself, were given posts with salaries of between 4,000 and 900 Marks a year, and commissioned to create the artists' studio and their living accommodation in the former Prince's park on the Mathildenhöhe. They were to share the financial risk, and the project was to be completed in less than two years.

Olbrich designed the Ernst Ludwig House as a studio building with a windowed wall fifty-five metres long and a portal in the form of a monumental omega. The portal is flanked by two colossal sculptures by Ludwig Habich, Man and Woman. As the Adam and Eve of the new art, they embody the powers of creativity and receptivity. In a niche, two geniuses in an ornamental flowering hedge are crowning the new art with laurels, while golden letters in a triumphal arch proclaim Hermann Bahr's abbreviated slogan for the Vienna Secession: "Let the artist show his world, that never was, nor ever will be."[133] The solemn Darmstadt proclamation needs to be seen in connection with the practical economic aims of the colony and the aesthetic needs of the upper middle class, which were binding and undisputed obligations. However, the artists around Olbrich glorified their role by seeing themselves as priest-leaders, who, while showing the incongruence between their world and the real world, saw their mission as promoting social harmony, creating an artistic design of life and promoting the economic welfare of Hesse.

111. Celebration to open the exhibition by the artists' colony in Darmstadt, 15 May 1901

Nevertheless, the ceremony written by Georg Fuchs for the laying of the foundation stone in 1899 proclaimed that the Prince was only laying the foundation for beauty, and that the artists would work virtuously and self-lessly.[134] At the opening of the exhibition on 15 May 1901, the ceremony *Das Zeichen* (The Sign) by the same author was performed in front of the portal in a production by Peter Behrens (fig. 111). Man and Woman led the chorus in expressing their longing for beauty in every form of life. Then the doors opened and out stepped the prophet in a scarlet cloak. He greeted the chorus with the words: "Art thou the Great, Lord in Spirit/ Leader and Seer, Master, then stay./ Art thou the Man of Knowledge, the Redeemer, the Liberator/ Then rise, perform thy office, let thy mighty fist tear open the cloth, reveal to us thy secret, let this be thy cathedral!"[135] The mystic priestly figure then presented the symbol of the new life, the crystal, solemnly named "The Diamond", with equally impressive lines.

The prophet is the priest-artist. The Festschrift for the great exhibition of 1901 bears on its cover an embossed golden medallion with the figure of a priest presenting the artists' house on the Mathildenhöhe (fig. 112). As Olbrich explained in his article *Our Next Task*, after the day's work the artist-priest steps down from his temple of labour into life, to the people, into his residence and his society.[136] The aims of the artists' colony were to combine art and life in all-embracing form and to achieve general aesthetic and social harmony, to raise the standard of living and level social differences. So labour was mystically glorified on the model of the creative man who is both artist and craftsman in one. In all this, the Grand Duke kept his eyes firmly on economic benefit and the prosperity of Hesse.

112. The artist-priest presenting the studio building, cover with embossed medal for: *Die Ausstellung der Darmstädter Künstler-Kolonie,* ed. Alexander Koch, Darmstadt 1901

The idea of the artist as seer and prophet was widespread in Europe. Even Cézanne, old and isolated in Aix-en-Provence, saw himself as the pioneer of a new art, "le primitif d'un art nouveau", and as its prophet. In a letter to the dealer Vollard around 1903, he asked whether he was a prophet and leader like Moses, or would ever achieve his goal: "I work persistently, I see the promised land before me. Will I fare like the great leader of the Hebrews, or will I be able to enter it."[137] In 1892 the young Hugo von Hofmannsthal in Vienna sketched out a drama, *The Death of Titian*, but it remained a fragment. Hofmannsthal took as his theme the cult of the last painting and the myth of the visionary artist. The old Titian does not appear in the drama, we only hear about him and his final work. The old artist is said to have rejected his earlier works for his last, a painting of Pan: "... Very difficult things were clear to him now/He came to an immense realization,/that until then he had been dull, a fumbler ..."/Should one follow him?"[138] Hofmannsthal applied the question to current issues in 1901, when he recast his verse drama *The Death of Titian* into a ceremony for the death of Arnold Böcklin.[139]

Hostility between Artists and the Public

In the aphorisms in *Menschliches, Allzumenschliches* (Human, All Too Human) of 1878 that touch on genius, artistic inspiration and the relations between artists and the public, Friedrich Nietzsche argued that artists should take care to ensure that their public could keep pace with them: "Otherwise suddenly a great gulf will yawn between the artist, creating his works on a distant height, and the public, who can no longer climb so high and finally descend again, disgruntled."[1]

Ten years later Nietzsche, having recovered from his Wagner phase, revised his demand. He had reached a better insight into relations between artists and public and he now discussed "the Wagner case" on the basis of a diagnosis of "the total transformation of art into the histrionic". For Nietzsche, the composer Richard Wagner was the supreme example of modernity, he was the protagonist of decadence and exhaustion, the modern artist par excellence. In Wagner's music Nietzsche heard the three great elements that stimulate the exhausted artist, brutality, artificiality and the idiotic; together they produce works that move the mass. Wagner, the most astonishing genius of the theatre of all time, had, according to Nietzsche, always proceeded from effect, never from the music itself: "He wants effect, he wants nothing but effect. And he knows how to get it!" Wagner was part of the rise of the actor in music, which Nietzsche saw as a major historical event: "Never before has the sincerity of musicians, their "genuineness" been tested in so dangerous a way. It is almost tangible: great success, success with the mass, is no longer for the genuine - one needs to be an actor to get it."[2]

Nietzsche raised the problem of the authenticity of the artist to a moral question by distinguishing between "guilty" and "innocent" art. In the complex 255th aphorism in *Morgenröte* (Sunrise) of 1881, a discussion on music, a Mephistophelian listener accuses another of allowing himself to be deceived by the deliberate effects of music, of abandoning his critical faculty and so ruining art and the artist: "Whenever you applaud and cheer, you have in your hands the conscience of the artists - and woe betide them if they notice that you cannot distinguish between innocent and guilty music!"[3] "Innocent" for Nietzsche was music that concentrated only on itself and forgot the public, while "guilty" music was music that kept its eye on the public and aimed for effect. The problem of the positive or ruinous relationship between the artist and the public was one to which Nietzsche repeatedly returned. In Aphorism 361 of the fifth book of *Fröhliche Wissenschaft* (The Joyful Wisdom), he considered whether the concept of the artist could be better defined by proceeding from the problem of the histrionic, the art of conformity to the public.[4]

The maxim that artists were on a higher level, or ought to be, than

the general public was widely accepted. The museum directors thought it necessary to improve the aesthetic education of the public. Hugo von Tschudi, who was Director of the Nationalgalerie in Berlin from 1896, gave a speech in 1899 in the Berlin Royal Academy of Arts in which he discussed the problem of art and the public. He affirmed that the public for art had grown enormously, and also admitted to a fearful rise in the number of exhibitions, but he complained of a serious lack of artistic culture, sensibility and impartiality among the public: "The conflict between the public's ability to understand art and artistic creativity itself becomes fully evident where artists are creating something that is really new." Exhibitions should be more educational by being restricted to "true art" and excluding all those works that descended to the level of public taste.[5] In his publication *Verwirrung der Kunstbegriffe* (The Confusion in Art Concepts) Wilhelm Trübner tried to clear away once and for all the errors to which laymen were prone and make way for "pure art".[6]

At the same time, museum curators in Germany were complaining of the gap between artists and the public. Maria Brinckmann, Max Lehrs and Otto Grautoff enthusiastically proposed making art accessible to all with posters on the street, in order to educate the mass aesthetically and win back a public for art outside the museums.[7] The gap between the people and the arts ought not to exist, argued Albert Dresdner in 1904; he set about "pointing art back on to the path of life from which it has wandered", and enabling it to regain "a function in the intellectual organism of man".[8] Dresdner believed art had a mission in world history and a national goal: "We will not prosper if we do not all become artists, each one in his own profession. That is the great mission in world history that art, as I see it, has to fulfil now, for our entire being and efficacy, for all classes of people, from the prince to the worker, and for all the problems in our national and private lives."[9]

The Biennale in Venice was to be comprehensive, nationally and internationally. Riccardo Selvatico, the Mayor of Venice and its first President, invited artists to participate in the convinction that art was one of the most valuable elements in civilization, promoted the development of the mind and united all peoples in brotherhood (fig. 113).[10] A committee of artists of different nationalities was appointed, and they eagerly set about their task of selecting artists with national reputations to mount an international exhibition in a recognized uniform style.

As the art world set about clearing away the errors on the part of the public, making art a matter for all, educating the people to art or proposing that everyone should become an artist, as they affirmed the aesthetic world language of culture and saw art as a means of international reconciliation, they came closer than ever before to a European style and taste. A common will to art united artists and the bourgeois public. Vienna learned from the speech given by Gustav Klimt at the opening of the 1908 Art Exhibition that the terms "work of art" and "artists" needed to be interpreted more widely, and that in future the public that experienced

113. *The Main Room at the 1895 Biennale in Venice,* photograph of 1895

art deeply could also be considered part of the ideal community of "artists".[11] Klimt looked back at the extraordinary success of the new art in Vienna. A year later, the fine harmony was destroyed by Oskar Kokoschka's scandalous drama *Mörder, Hoffnung der Frauen* (Murderer, Hope of Women) and the bloodthirsty poster he designed for its performance in the art society's summer theatre.[12]

In 1893 Alois Riegl objected to the "materialist" definition of style by Semper's followers and postulated that works of art were the result of a specific and deliberate "will to art". By this he meant, not the intention of artistic individuals but a general, non-individualistic orientation to a style that was limited both geographically and in time. This enabled him to eliminate the historical valuations entailed in the chronological sequence of a beginning, a peak and a decline, to redefine the late Roman art industry as the result of a specific will to art and level the difference between the applied arts and high art.[13]

Riegl's new approach was related to Art Nouveau, or Jugendstil as it was called in Germany and Austria, the expression of the European will to art between 1890 and 1910. These were the only untroubled decades art had enjoyed in Europe since the change of 1750. A dance of beauty was performed on unstable ground, lines swayed and curved in voluptuous creations based on plants and geometric ornamentation. As never before a common will to art seemed to unite artists and people, art and life.[14] Every area of life was artistically designed, furniture was in style unified, lamps, cutlery, dishes, clothing, book bindings, pictures, sculptures, all had the

flowing plant-like lines in forms that were full of joy and life. From Moscow to New York, from Taormina to Stockholm the first deliberately induced collective style for four hundred years was adored as Jugendstil and Art Nouveau. The horrors of historicism were overcome in the common effort to achieve one style, women stripped off their corsets and clothed themselves in new, "reform" dresses in which they seemed to sway like graceful elves. Henry van de Velde wrote the powerful words that laid the theoretical basis for the new western taste, claiming an inner compulsion for the decorative line and binding the prophet Nietzsche-Zarathustra in parchment with decorative gilt embossing.[15] Meantime Julius Meier-Graefe sat at his curved writing desk designed by Van de Velde, with Hodler's *Day* at his back, polemicising against the bad taste shown by the public, while the painters painted, the exhibitors exhibited, the art trade dealt in its wares, the collectors collected, and industry produced goods that looked deceptively like craftsmanship and with its mass production helped the Arts and Crafts movement in its efforts at reform, as it also helped the artists' colony in Darmstadt, the Werkbund and the Wiener Werkstätten (Viennese workshops) to be successful on a broad front. In short, the isobars did what they had to do - as Robert Musil wrote in the melancholy and ironic opening section of his great novel.

There was agreement on beauty and taste, on enrichment and power. Europe grew rich on its colonies, Gauguin fled civilization to die in wretched conditions in the poverty-stricken Paradise of the French colonial South Seas, the great powers engaged in ersatz wars in distant places as the tension grew that was to lead to the large-scale destruction of Europe, until finally, the assassination of the crown prince of a fragile empire lit the spark. But in beautiful Vienna Sigmund Freud discovered the fateful influence of men's sexual morality, neglected in the general development towards beauty, the subconscious inclination to patricide and the uneasiness in a culture that repressed drives. Incorrigible anarchists were tireless in their agitation, and in Paris and elsewhere they embarked on murder and violence; workers were exploited, the socialists were dissatisfied, the bolsheviks planned the world revolution, the suffering of the masses was plain to see, but the production of art flourished, with the will to art forming a systematic and all-embracing community with the generality of nameless artists of the upper classes.

Max Nordau, a doctor of medicine and a writer, finally provided that public with the instrument it needed to take its revenge on the fringe poets and painters of decadence, when he published *Entartung* (Degeneration). Nordau poured out his contempt for an art and a literature which he thought degenerate in two volumes that appeared in Berlin in 1892 and 1893. They enjoyed a phenomenal and immediate success all over Europe, going into three editions by 1896 and being translated into Italian, French, Dutch, Romanian, Russian and English between 1893 and 1895.[16] Misinterpreting Lombroso and Nietzsche, Nordau diagnosed the diseases of degeneration and hysteria in the literature, music, art and the physiognomies of the art-

114. Hans von Marées, *The Golden Age II*, 1880/83

ists in the second half of the nineteenth century. He accused them of selfishness, a lack of strength, a tendency to dream and mysticism. He even threatened the "degenerate" and their supporters with deportation and death, prophesied their downfall and also predicted that the twentieth century would be restored to health if it turned away from the erroneous ways of art. Despite the immediate refutation of Nordau's ideas in England by Alfred Egmont Hake, George Bernard Shaw and William Hirsch, Nordau's narrow-minded polemics did much to focus the middle class' hatred of a modern art and literature that had not bowed to their standards; later it also strengthened National Socialism in the battle against modern art. The fateful side effects of these polemics and their criminal implementation in

the Third Reich were to split the public into friends and foes of modern art and create a lasting obstacle to objective criticism.

In Germany the beautiful harmony was also disturbed by a few rebellious younger artists, by the national interests of some of the German artists who split from the Secessions in Munich, Berlin and Vienna, and by the polemics against German painting and the German public by the critic Julius Meier-Graefe, who, with reference to Nietzsche, in 1905 condemned German "contemplative painting" altogether, that is, the works of Böcklin, Thoma and Klinger, as "theatrical art".[17] For Meier-Graefe it was indisputable that the mass who constituted the public were always bound to be on the side of the "wrong" artists. His main and most successful work, *Die Entwicklungsgeschichte der modernen Kunst* (The History of Modern Art) is preceded by an analysis of the contemporary art world and the conditions under which art is produced. In it Meier-Graefe distinguishes between the few conscientious artists who are devoted to art and the mass who are deceiving the public: "It is easier in art to deceive the public than in any other profession, because, quite apart from the fact that people are easily tempted by anything that is shallow, artists are helped by their aura. There are many things that particularly favour mediocrity, yet they give the profession as such an aura of importance." According to Meier-Graefe the most important of these, art exhibitions, was a stupid institution designed for "stupid mass production."[18]

For Julius Meier-Graefe writing in 1905, the bad taste of the public was so indisputable that he could use it for his criticism of Floerke, an admirer of Böcklin: "He [Floerke] revered what the public as a whole loved at the time, that stupid and unjust mass who are always wrong, be they praising or blaming".[19] This criticism cemented for ever the split between the "authentic" artists and the incorrigible public. According to Meier-Graefe the public and the majority of critics always had been on the wrong side. They were conservative and had always opposed the artists and works that are now regarded as significant. They had always loved artists of no importance and failed to recognize true greatness. The belief that the public was always wrong was essential if the unrecognized artist was to be seen as identical with the "true" or "genuine" artist. In *The History of Modern Art* Meier-Graefe states that the problematic and unsuccessful painter Hans von Marées is the only German artist who fully justifies the accolade "true" or "genuine". Only in Von Marées, whose achievement Meier-Graefe describes as the liberation of "form from the arbitrary grasp of the personality" (fig. 114), could he see a position counter to the German theatrical artists.[20]

The group of artists known as *Die Brücke* (The Bridge) are the prime example of how the younger generation of artists in Germany built up their position and their approach to art. Their call to like-minded artists and the public in 1906, cut in wood by Ernst Ludwig Kirchner, proclaimed their faith in "a new generation of those who create and those who enjoy". It was addressed to the younger generation and so to the future; the group aimed to create freedom of movement for themselves away from the well-established

115. Ernst Ludwig Kirchner, *The Manifesto of "Die Brücke"*, 1906

older forces (fig. 115), by whom they rather vaguely meant the established bourgeois artists. Indeed, the Brücke artists had many boyish ideas about anti-bourgeois bohemianism, with their free love lives and exciting bouts of nude bathing in the Moritzburg lakes. Their artistic maxim combined their call for freedom with the demand for a community of those who were recording directly and unfalsified, what urged them to create. This is another way of describing the "true" artist who follows his creative drive without regard for conventions and in all honesty. With the exception of Max Pechstein, the painters Kirchner, Bleyl, Schmidt-Rottluff and Heckel were self-taught, they had no formal training worth mentioning and perhaps this is why they placed so much emphasis on working in a group and on life drawing. The Brücke diary was headed "Odi profanum"; the artists had not taken the quotation from Horace, as is so often maintained; it headed Meier-Graefe's onslaught on German theatrical painting.[21] The Brücke artists were very skilful at organizing exhibitions, and on the whole their reviews in the Dresden press were positive; at least initially the freshness of their onslaught against the cliques in the art world was welcomed. Even their obvious dependence on French art and Japonisme fashion were seen positively in the Dresden provinces as a total liberation from the academic tradition. At the same time, Hugo von Tschudi was under fire in the capital Berlin for buying French paintings. The nationalist opposition was growing in defence of the material interests of German artists against foreign art.[22]

In March 1914 Wilhelm Hausenstein held four lectures in the Akademie für Jedermann (Open Academy) in Mannheim, publishing them in the same year under the title *Vom Künstler und seiner Seele* (On the Artist and his Soul). Hausenstein postulated an antagonism between the ecstatic soul of the artist and the naturalistic soul of the layman, and he saw the effects of this in misunderstanding, alienation and conflict between artists and the public. The antagonism had persisted through history: what had been fought out in the Renaissance as a conflict between patrons and artists was being fought out in the modern world between the artists and the public. The artist-visionary, an amalgam of Doctor Faustus, Christ and Van Gogh was, thought Hausenstein, a double martyr: "The artist experiences what human beings can see most strongly in the most visionary way. A vision is in itself martyrdom: it is not easy to bear the face of the Earth Spirit. But for that vision the artist, the pathetic artist, that hero of mankind, is punished into the bargain: the public laughs at him for his vision - the public never experiences the ecstasies of an artist's vision and it makes him pay for that."[23]

Hausenstein wanted to help people experience the soul of the artist and put an end to their erroneous belief that art involved imitation. He established a typology of the soul of the artist by creating a hierarchic order of the emotional, nervous and objective types.[24] With the same aim of helping the public to understand the soul of the artist, Kasimir Edschmid published *Schöpferische Konfessionen* (Creative Confessions) in 1920.[25] This is a collection of artists' writings about themselves, but Edschmid's offer of a glimpse into the soul of the artist in Germany also contained ideas

on how artists could make a powerful contribution to building a new future.

Back to the Power of the Picture

In Paris and Barcelona after 1900, the young Picasso first painted the poor in melancholy blue and black, then circus folk in pink, outdoing all that had ever been done in the past in the way of virtuoso sentimentality. Picasso took up the old theme of travellers, circus folk and acrobats, the melancholy clowns in whom painters and writers had seen an image of their own situation since the mid-nineteenth century (figs. 91, 98).[26] In two paintings of 1905 Picasso himself appears in the garb of Harlequin, in the company of travelling circus folk. The complex painting *Les Saltimbanques* (fig. 116) shows the group standing in a desert under a cloudy sky; they are about to set off again after resting, but appear to be very undecided about which direction to take. Picasso is the tall Harlequin among the travellers, in whom he has represented his friends, Guillaume Apollinaire as the fat clown, André Salmon as the youth, Max Jacob as the boy and Fernande Olivier as the

116. Pablo Picasso, *Les Saltimbanques,* 1905

seated Columbine.[27] The desert is the nameless place where the travellers journey between life and death, between earth and heaven, as Apollinaire said in his poem *Crépuscule*, his response to Picasso's *Saltimbanques*. In their indecisiveness, their common departure and their rest in the desert, Picasso's travellers are in transition. This is evident in the fearful question of where the travellers have come from in Rainer Maria Rilke's *Fifth Duino Elegy*, which is not answered by identifying those who are represented. Starobinski described them as returning from the realm of the dead, between two worlds, precursors of the archaic and primitive, the new source of energy for an exhausted high culture.[28]

Picasso freed himself of the disturbing, melancholy and sentimental identification with circus people in a monstrous image of five prostitutes, *Les Demoiselles d'Avignon* (fig. 117).[29] André Derain, who saw the painting in Picasso's studio at the end of 1907, was reminded of the murderous masterpiece in Zola's *Oeuvre*, and told Daniel-Henry Kahnweiler he was afraid they would find Picasso hanged behind his painting one day. In 1951

117. Pablo Picasso, *Les Demoiselles d'Avignon*, 1907

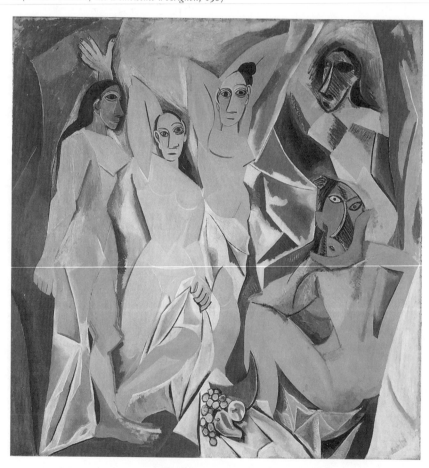

Kahnweiler remarked that he was overwhelmed with admiration when he was first shown the painting in Picasso's studio in the spring of 1907.[30] Apparently very few visitors to the Bateau-Lavoir shared Kahnweiler's enthusiasm, most were shocked and horrified. They could see that the painting was totally new and demonic, with its use of Iberian sculptures and African masks. These were subjects Picasso had found in ethnographic museums, heathen idols that had been displayed in the World Exhibitions and that he set upon figures from the repertoire of beauty and fear in European art. The woman standing with her arm raised, for instance, refers to Ingres, another with legs planted apart, to the Etruscan Gorgo Médusa. The masks are not placed before the faces, they are brutally transplanted onto the pink bodies, which are displayed in enticing and obscene postures. A still-life on the lower edge of the painting innocently illustrates the formal principle of straight and curving segments.

In the course of the long genesis of this painting, recorded in hundreds of drawings and compositional sketches, Picasso changed the subject from the depiction of a brothel scene with male visitors to a presentation of five women confronting the viewer with beauty and fear. Picasso was not simply aiming to do the impossible, he wanted to produce an aggressive and murderous masterpiece, as Derain immediately recognized. However, Picasso transformed the aggressive element into shock by transplanting the primitive masks onto the fine bodies and combining the idea of primitive magic with physical offer. In attaching the primitive image to the western heritage, Picasso was endeavouring to restore the hypnotic, magic, ruinous and frightful power these images once had. "Iconization", the transition from the narrative image to the image with supernatural force, provides the modern concept for this reinstatement of the power of the picture.[31]

In the first decade of the twentieth century, the primitive, original, art of Africa and the South Seas fascinated a number of artists in Paris like Matisse, Picasso, Derain and Brancusi, and in Germany the Brücke painters in Dresden and the Blaue Reiter group in Munich. This preoccupation with primitive art continued down to the middle of the century, through Surrealism and Abstract Expressionism.[32] The exhibitions of Paul Gauguin's works by Ambroise Vollard in 1898 and 1903 and in the Salons d'Automne of 1903 and 1906 demonstrated how the western concept of the picture could be combined with the forms and magic power of heathen idols.[33] Vollard showed Gauguin's masterpiece of 1897 with its question to mankind: *Where do we come from? What are we? Where are we going?* in his gallery in 1898; among the group of South Sea natives standing and lying, an immobile idol stands on the left with arms outstretched. His silent presence embraces the unanswered questions (fig. 118). The exhibitions of Gaugin's works in Paris not only showed the public an exotic world, they also directed attention to forms of original expression and the magic power of idols.[34] It was Gauguin's work that opened the eyes of the younger artists in Paris to the collections in the ethnographic museums and awakened their interest in original, directly expressive forms, as well as the magic powers

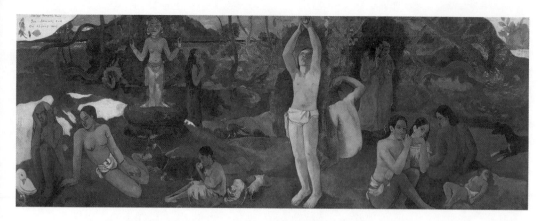

118. Paul Gauguin, *Where Do We Come From? What Are We? Where Are We Going?*, 1897

which masks and statues could possess. Both the forms and their effects were used by artists there in the first half of the twentieth century to revolution-ize pictures and sculptures, as artists worked to recapture the lost power of the image and the creative force that had been buried by western culture. Sculptures and masks from Africa and the South Seas became obligatory attributes in the studios of younger artists, from Paris to Dresden. *The Blue Rider Almanach* of 1912 had illustrations documenting the original artistic force, from children's drawings through the art of the primitives and folk art to abstract compositions; it also contained an essay by August Macke entit-led *Die Masken* (The Masks). He described masks as the expression of mysterious powers, adding the rhetorical question: "Are not savages artists with their own form, strong as the form of thunder?"[35]

Constantin Brancusi began to make wooden sculptures from African models in Paris in 1913, but he destroyed the first, which he had called *The First Step*, with the exception of the head, probably in 1914. After that he began work on a *Standing Figure* in wood, which is recognizable as the second version of *The First Step*. In order to photograph it, Brancusi placed the figu-re in *The Porch*, a primitive aedicule which he had made of roughly worked pieces of waste wood. His arrangement changed *The Porch* into an altar con-

119. *Constantin Brancusi's Studio in Paris*, in: *Minotaure*, 3-4, 1933

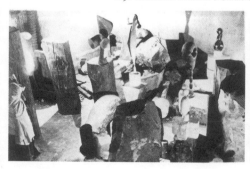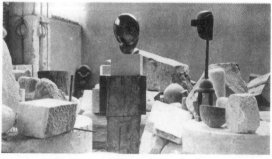

174

struction, and the figure into the image of a god. The religious arrangement was strengthened by a lamp hung above the figure and a flame on the point of the arch.[36] Louise and Walter Arensberg, who bought *The Porch* in the twenties, used it in their house in Hollywood to show a phallus *(Princesse X)* in polished bronze. The *Princesse X* had to be withdrawn from the exhibition of the Societé des Artistes Indépendents in Paris in 1920 because it was thought to be obscene.[37] It appears that Brancusi went on working on the second version of *The First Step* and by 1918 had changed it into a figure that now only consisted of two legs, a belt around the hips, a long spine and a huge head. He combined this figure with an early version of *The Endless Column* and a hemisphere with handle, making a group which he entitled *The Child in the World, Mobile Group*; however, he was unable to find a buyer.[38]

120. Louise Bourgeois, *The Winged Figure*, 1948, bronze; *Untitled, 1952, Mortise,* 1950, *Spring,* 1949

As this ensemble shows, Brancusi was trying to find a way to combine the original working of wood, which he found both in African sculptures and Romanian folk art, with elementary forms; hence his combination of the roughly worked wood with perfectly smoothed material. He set finely polished sculptures in marble or bronze on a geometrically defined body, a square or cylinder of stone, and placed that in turn on a plinth rough hewn out of the wood or stone; the plinths still bore the traces of his work and were derived from African forms.[39] Each of these sculptures attempts to trace

a line of development from the original form and working in the plinth, through the perfectly worked basic geometrical form to an elementary form of life that has been machine-polished. Brancusi's studio in Paris (fig. 119) was a kind of cave and it became his laboratory for experiments in such combinations.

The primitive element in modern art was first analysed in 1938 by the American art historian Robert Goldwater. He was married to the artist Louise Bourgeois, who at the end of the forties in the United States devoted an attention reinforced by Surrealism to the original creativity of totem-like figures.[40] The National Gallery in Washington D.C. has owned a group of sculptures by Louise Bourgeois since 1991 (fig. 120) which were made around 1950. The group consists of a totem-like winged figure with rough blocks of wood piled up on a cruciform ground plan, and it evidences the search for original creativity in the midst of Abstract Expressionism by an artist seeking to revive the force of the image through common elements with Indian art. The sculptures of Louise Bourgeois stand on high slender plinths or poles, and they give an impression of fragility and vulnerability.[41]

Social and Mystical Legitimations

Max Beckmann painted himself in a huge variety of roles – as a youthful hero, an artist with socialist sympathies, an actor and a clown. He also appears as a prophet of doom and a socialite in black tie and dinner jacket, as a black shadow in a mirror and an artist-soothsayer with a crystal ball.[42] In the Ber-

121. Max Beckmann, *Resurrection* (unfinished), 1916

122. Max Beckmann, *Christ and the Sinner,* 1917

lin Secession exhibitions Beckmann showed paintings of catastrophes and
sensational events, like the *Scene from the Earthquake of Messina* of 1909 and
The Sinking of the Titanic in 1913. For both paintings he used newspaper
reports, and in *The Sinking of the Titanic* he took as his model one of the best
known exhibition pieces, Géricault's *Raft of the Medusa.* Beckmann painted
the terrifying scenes like reportage, and he had a sure grasp of the means of
attracting a public. In the First World War he was sent to work in a military
hospital but suffered a total breakdown after a year. In 1916 he started a huge
work, *Resurrection* (fig. 121) in Frankfurt. The painting was never finished
and never used as it was originally intended, for Beckmann had hoped to
achieve religious catharsis through the representation of supreme horror, and
he wanted the painting, with four more in the same size, to be hung in
modern halls of worship.[43] Beckmann confessed his unrealistic hopes in

Kasimir Edschmid's publication *Creative Confessions*: "Make a building some day together with my pictures. Build a tower in which people could scream and give expression to all their rage and despair, all their pitiable hopes, joys and wild longings. A new church."[44] It is notable that Beckmann, his family, and his Frankfurt friends the Battenbergs appear in *Resurrection* as reverent witnesses. In *Christ and the Sinner* (fig. 122) of 1917 the painter is the focus of attention and the viewer also appears in the picture. Christ has the features of Beckmann and he is protecting the kneeling woman, who is about to be stoned as an adulteress, from aggression, so exposing himself to scorn.[45] *Self-Portrait with Red Scarf*, which was painted at the same time, shows the artist in his Frankfurt studio. His clenched right hand is at the edge of the picture under a pale yellow sun, between the spire of a local church, the Church of the Holy Trinity, and the potted plant on the balcony. The artist is turning round to look to the right, possibly into a mirror, the frame of which overlaps his right upper arm. His shirt is open at the chest, behind his head we see the cross of a window and a red socialist scarf is round his neck. Beckmann has depicted himself hemmed in by extreme constriction, a tried and exhausted rebel and martyr.[46]

Under the impact of the civil war in Germany Beckmann made ten lithographs in 1919 for a portfolio *Die Hölle* (Hell). For the title page he drew himself as performer and clown in a pay booth, inviting the public to the show, the great Beckmann spectacle in ten acts. The tone is sarcastic: "We ask the respected members of the public to step up. We offer the pleasant prospect of not being bored for perhaps ten minutes. Anyone who is not satisfied can ask for their money back." The artist clown praising his wares and wooing the public appears in the following images as well, like *Way Home*, where he meets a maimed and blind war victim; he also becomes the victim of cruel torture.[47] Die *Nacht* (Night), Number Six, is an image of horror, as is the painting of the same title executed in 1918/19 (fig. 123). They show Beckmann as the victim, being tortured and throttled in an attic, a woman being raped and a child kidnapped by a revolutionary in a round cap (Lenin?).[48] *Night* takes accusation and legitimation of the artist to extremes. It poses the question of the authenticity of the artist in the sense of his social task.[49] In an essay of 1926 entitled *Der Künstler im Staat* (The Artist in the State) Beckmann demanded a new cultural centre as a centre of faith, and the suppression of the weak, egoistic and evil elements "so as to promote the common love that will enable us to act together to carry out our great and decisive work as mankind in harmony".[50]

In 1914 Lu Märten wrote a small work for a series of *Kleine Monographien zur Frauenfrage* (Small Monographs on the Woman's Rights Issue), which she entitled *Die Künstlerin* (The Woman Artist). The book was not published until after the war, in 1919.[51] While Hausenstein was concerned with the ecstatic soul of the male artist, Lu Märten directed attention first and foremost to the economic situation of artists, then to the greater financial difficulties which women faced, and the social, mental and institutional barriers which prevented them from obtaining a training in art and from working as

artists. Of the current situation she writes: "Artists are generally disoriented as regards art and its task." Accordingly, a woman artist should not try to emulate the male artists, she should seek her task "in a demanding approach to life". Märten regarded it as conceivable that a woman artist could orient her artistic activity "to social awareness and responsibility within artistic creativity". She rightly stressed the technical competence of women artists and wanted to see them looking more to the ideas of the Werkbund than to the doctrine of restless subjectivity and the madness of genius.

Lu Märten's idea of the social function of women artists forms a remarkable contrast in every sense to Hausenstein's romantic and Faustian concept of the artist and his destiny as an unhappy, derided visionary. Nowhere does she take up the idea of the mystic artist, nor is there any hint of self-pity in her writing; there is no attempt to wallow in complaints about a lack of understanding on the part of the public or project the image of the artist misunderstood. Similarly, there is far less inclination on the part of women artists to present themselves as victims.

In 1919 the Berlin Works Council for Art sent a questionnaire to its members on the need to reform apprenticeship, on the relationship between art and the crafts, on the position of artists in the socialist state and their harmonization with the people; it also included questions on art exhibitions and other matters. Walter Gropius' answers contain the main maxims of the Bauhaus

123. Max Beckmann, *Night,* 1918/19

Programme that was drawn up the same year. Gropius proposed introducing classes on manual skills in elementary schools and turning all the art colleges into apprenticeship workshops. He wanted to take the arts back to the crafts and orient them to a great new target, the unified work of art, the great construction, in which the borderline between decorative and monumental art would be removed: "The reunification of all the art and craft disciplines - sculpture, painting, applied arts and crafts - as the essential components of a new art of building." Gropius then described the art exhibition as a freak creation by the bourgeoisie: "As art died in the real life of civilized people, it had to take refuge in those grotesque displays where it prostituted itself."[52]

Gropius succeeded in realizing his idea of a new unity in the arts with his persistence and skilful diplomacy in the Bauhaus' two first locations, Weimar and Dessau. Despite all the internal difficulties and the opposition from right-wing extremists (it was closed by the Nazis in its last location, Berlin, in 1933) the Bauhaus carried out the difficult experiment of putting the arts on the basis of the crafts, integrating the individual forces in common labour, developing new designs for textiles, objects and furniture and making prototypes for industrial production.[53] However, the attempt to demystify art and artists by returning to the crafts soon foundered, as a new hierarchic distinction was drawn between "master craftsmen" and "artist professors", and the free arts withdrew from the common task of utilizing creative abilities.

In 1925 the Spanish philosopher José Ortega y Gasset published his thesis on the basic hostility between modern art and the mass: "The new art has the mass against it, and always will have. It is essentially alien to the people; more than that, it is hostile to the people. Any product of the new art you care to mention automatically provokes a remarkable reaction from the mass. It splits them into two parties, a small party of a few who are inclined to favour it, and a large party of countless enemies (not including the questionable fauna of snobs). So the work of art is like a social divide, it creates two oppposing groups; from the great conglomerate it separates out two blocks."[54] The classes are divided according to their understanding and non-understanding. Those who do not understand modern art are humbled by its very appearance and denounced as honest citizens. According to Ortega y Gasset the avantgarde put an end to the illusory assumption of the equality of all men, and the new distinction created hostility.

This hostility provoked a number of exhibitions in the second decade of the twentieth century. Most important were the touring exhibitions, the Blue Rider, which was shown in twenty locations between 1911 and 1914, the Futurist exhibition which went from Paris to London and Berlin in 1912, and the First German Autumn Salon in Berlin in 1913, for which Hermann Walden drew up an amazing list of the scornful epithets that were poured upon it. Others were the International Art Exhibition of the Sonderbund in 1912 in Cologne the Armory Show in New York and Chicago the following year, and the First International Dada Fair in Berlin in 1920.[55]

In 1925 the *Europa-Almanach* printed a short diagnosis of the breach be-

tween artists and society by Amédée Ozenfant. He argued that artists had either become public jokers, or they had withdrawn into ivory towers or their laboratories; however, they were paying the price of not even being able to persuade themselves of the value of what they were doing.[56] Like many others, Ozenfant believed that this fatal condition could be changed by a new definition of the universal bases of art, which would have to be very sensual and very intellectual at once.

In fact, Wassily Kandinsky had put forward a hierarchic model of society in 1912, in his "spiritual triangle" (fig. 124). This consisted of a number of large sections in accordance with the theosophical doctrine of Helena P. Blavatsky. The large segments at the bottom are filled by the masses, then come smaller segments with fewer people, while there may be only one priest-visionary at the top. On all these stages there are artists, either looking up as prophets or flattering the lower needs, cheating and enriching themselves. In Kandinsky's office building of the mind, a certain mobility between the departments is envisaged, moreover, in good times the whole triangle moves up and forwards. This evolutionary movement means that a larger section that is rising can accept artists who were previously criticized as swindlers and daubers.[57] Kandinsky was trying to combine the hierarchic spiritual triangle with the idea of the progress of mankind through the artistic avant-garde.

At the start of Kandinsky's book is a contrast between two kinds of primitivism, the external kind which has no future, and the "inward-looking", which is the way to the future and springs from the renewed soul. Then Kandinsky discusses the problem of the viewer's receptivity. He criticizes the

124. Wassily Kandinsky, cover design for "Concerning the Spiritual in Art", c. 1910

181

superficial perception of works of art by the public in museums or exhibitions, but he ascribes this to the fact that the art works presented there are devoid of their purpose and hang as "l'art pour l'art". This confuses the visitors and prevents them from recognizing the art that has a higher aim, prophetic art. A dark power holds them back from rising spiritually, "an evil invisible hand" which lays stones in their path. But, Kandinsky assumes, a mysterious visionary will arise and bring salvation: "He sees and shows. This higher gift is so often a heavy cross for him to bear, and often he would like to lay it down. But he cannot. While scorn and hatred are heaped upon him he pulls the heavy, resisting cart of mankind with him, although it gets stuck amid stones, he moves ever forwards and upwards." Kandinsky optimistically deduced from this that it was the task of the artist to educate the public to the artist's standpoint. If he had succeeded, the insoluble problem of the legitimation of the artist would have disappeared.[58]

For Kandinsky the question of the relationship between the artist and the work of art could not be solved either with the doctrine of genius or through the life of the artist. The relevant chapter in his book "Concerning the Spiritual in Art" of 1912 starts with the sentence: "In a mysterious, puzzling and mystical way the true work of art is created 'from out of the artist'. Once it has separated from him it takes on a life of its own, becomes a personality, an independent subject that breathes spiritually, and that also leads a real material life, is a being." The "true" work of art is born in a mystical way out of the artist. And for this the artist needs unrestricted freedom, although this must spring from "inner necessity" if it is not to turn into crime, and if the product is not to be a deception. "Inner necessity" was Kandinsky's central concept and it is defined in a variety of ways; firstly as "the principle of the appropriate way to touch the human soul" in connection with the effect of colour, then as "the unavoidable will of the objective to express itself" as the pure and eternal artistic compulsion which is realized in a subjective and time-dependent form. Kandinsky thought there were three reasons why this inner necessity emerged, and he called them mystic: the personality of the artist, the epoch, and the pure and eternal artistic compulsion.[59] In his essay 'On Form' which appeared in the *Blue Rider Almanach* in 1912, Kandinsky used the mystic but obscene concept of a white fertilizing ray for this. He illustrated it in a harmless and ironic way with a Bavarian votive image, and as a counter image to evolution and exhaltation the "black hand of death".[60]

The belief that the work of art emerges from the artist in a mystical way abolishes rational procedures, justifiable rules and traditions. Instead Kandinsky postulated the inner necessity, which he also saw working in eternal, historic and subjective conditions.[61] It turns the artist into the mystical organism that can give birth, it justifies the freedom and the means and ensures the quality and function of the products. So the artist can only legitimate himself by his inner compulsion, not by tradition, culture, knowledge, imitation, idealization or applause, all of which constitute the sphere of "external" necessity. Kandinsky's tautological answer to the problem of legi-

125. Wassily Kandinsky, *Point. Advancing Dissolution (suggested diagonal d-a)*, in: Kandinsky, *Point and Line to Surface*, Munich 1926

timation provoked the cutting response from Kurt Schwitters: "Everything that artist spits is art".[62]

Kandinsky combined the theosophical model of the advancement of mankind with hope in the future, and did not exclude the possibility of discovering formal laws of inner necessity and developing objective bases for art. He presented these in 1926 in his Bauhaus book *Punkt und Linie zur Fläche* (Point and Line to Surface) (fig. 125). At almost the same time corresponding analyses by Paul Klee and Theo van Doesburg appeared. As Van Doesburg explained in the German edition of his work, his intention was to give a logical explanation and a defence of the new art in response to the heated attacks from the public."[63] In his speech at the opening of his exhibition in the Museum Jena in 1924 Paul Klee asked whether it was not sufficient to show the works, "for actually they ought to speak their own independent language". Klee addressed his visitors on the principles of his art, because he felt greater understanding of his pictures might be needed, as they possibly lacked "a certain character".[64]

It is significant that so many modern painters between about 1890 and 1920 became involved in a wide variety of secret doctrines, like theosophy, anthroposophy, which was derived from this, the Rosicrucian movement and Mazdaznan.[65] Kandinsky drew on Madame Blavatsky's theosophy, in 1909 Mondrian painted a triptych in the Egyptian style, *Evolution*, in the spirit of the Theosophical Society, on the awakening of material man to the spirit, while Johannes Itten introduced the ideas and practices of Mazdaznan to the Bauhaus when it started to operate in Weimar.[66] This tendency to the esoteric among modern artists - taken up again by Beuys and others - came from their opposition to a materialist civilization and their need to legitimate their work with the higher spiritual status of the initiated.

For the Major Berlin Art Exhibition of 1923 El Lissitzky constructed a three-dimensional picture, the *Prounenraum* (fig. 126). During the founding congress of the Union of Progressive International Artists in Dusseldorf in May 1922, Lissitzky had formed a Constructivist group with Theo van Doesburg and Hans Richter. They saw the Expressionists and the "Impulsivists" as they were called, as their enemies and rejected art exhibitions as a conglomerate of unrelated things. At the Dusseldorf Congress, Van Doesburg demanded, instead of an exhibition, space for demonstrating group work and the end of the separation of art and life, artists and other human beings; this was in the name of the de Stijl group.[67] In 1921 Lissitzky explained his *Proun* as the turning point between the destruction of the old and the start of the new, created out of the earth "that is fertilized with the corpses of pictures and their artists". Lissitzky thought the great iconoclastic onslaught had already taken place: "The painting collapsed, together with the Church and the God it proclaimed, together with the palace and the king who used it as a throne, together with the sofa and the philistines, for whom it was the icon of contentment."[68]

At the end of 1922 the First Russian Art Exhibition was held in the Galerie van Diemen in Berlin, after many political obstacles had been overcome. The People's Commissariat for Education used the occasion to make the new Russian art known in the West, and the profits were to help the starving in Russia - it was a repetition of the idea of an exhibition for charitable purpo-

126. El Lissitzky, *Proun Room*, 1923, reconstruction

ses. In the foreword to the catalogue the writer Arthur Holitscher pointed out that this new prophetic art was the enactment of the world revolution, and as such it differed from the merely rebellious art of the studio revolutionaries.[69] The exhibition included three paintings by Malevich entitled *Suprematism* - they were the black or red square, the black circle, *Suprematism* of 1917 and the painting *White on White*.[70]

Malevich provided the following explanation of this "ism" of art: "By Suprematism I understand the supremacy of pure perception." In 1920 Lissitzky drew up a simple historical sequence of destruction: the Futurists destroyed central perspective and left splinters, Suprematism swept away the splinters and opened the "way to infinity".[71] As the next step Lissitzky planned to replace the individualists and their paint brushes with a creative collective, and to implement Suprematism in his three-dimensional *Proun*; the following objective was related to world history, namely to construct "the uniform world city for people on earth" with *Proun* on a common Communist foundation.[72] The first *Proun* of 1923 introduced the elements of Suprematism in painted wood on the walls, a later exhibition for Hanover of 1927/28, *Room of Abstracts*, contained moveable panels and works of art that the visitors could discover or conceal by moving the panels. The possibility of changing the exhibition space by shifting panels was Lissitzky's way of enabling the visitors to take an active part in the exhibition.

The International Surrealist Exhibition of 1938 was intended to differ as far as possible from a gallery exhibition, although it was held in Georges Wildenstein's Galerie Beaux-Arts in Paris. The curator of the exhibition was Marcel Duchamp. He had begun more than twenty years before to demystify the creative act with his ready-mades, and with his *Fountain* (fig. 127) he undermined the institution of the exhibition. The ready-mades had an iconoclastic side which amused Duchamp, and a schizophrenic philosophy of which he was proud. The idea was to end the myth of the artist as

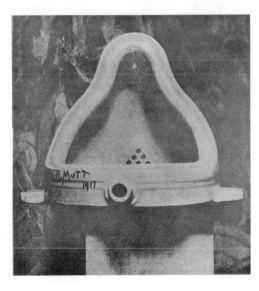

127. *The Exhibit refused by the Independents*: Marcel Duchamp, *Fountain*, 1917, porcelain, signed "R. Mutt 1917", photograph by Alfred Stieglitz, in: *The Blind Man*, 1917

185

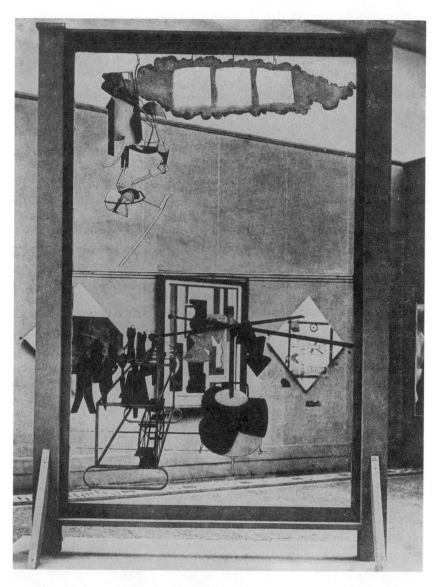

128. The exhibition in the Brooklyn Museum, New York in 1926 with works by Marcel
Duchamp, *La mariée mise à nue par ces célibataires, même*, Fernand Léger and Piet Mondrian

divine.[73] One way for the artist to disappear from public view was to conceal himself behind a pseudonym. "R. Mutt", with which Duchamp signed his *Fountain*, was the first of many.

In 1918 in Buenos Aires Duchamp wrote instructions for the viewer on a metal strip attached to a work on transparent glass: "To be viewed (from the other side of the glass) with one eye, close up, for nearly an hour". The inscription was a variation of an instruction given by Leonardo to the painter to use a pane of glass as an aid to colour perspective.[74] In Duchamp's glass nothing was to be seen from the back of the sheet that differed from what

could be seen from the front, except the instructions to the viewer. Otherwise from sides he perceived a pyramid painted on the glass in dual perspective, leaden threads, rusty metal and a magnifying glass. This small-scale work was related to the long work on *The Big Glass*, the perfidious and inventive negation of the masterpiece.[75] Catherine S. Dreier included *The Big Glass* in her exhibition *Modern Art - International Exhibition* for the Brooklyn Museum in 1926. The photographs of the exhibition, which Ozenfant reproduced in 1928 (fig. 128), combine Duchamp's work with more recent paintings by Piet Mondrian and Fernand Léger, which hang on the wall behind; so the gallery context is included in the work, but not the viewer.[76] Duchamp regarded the use of glass as an advantage, because the humiliating process of painting the background is eliminated and one can simply shift the glass if one wants a different background. *The Big Glass* is much more capable of forming ensembles with other works, and this capability is in a mysterious way part of the suggested meaning; as with Duchamp's friend Brancusi, this is the socialization of art works.

At the International Surrealist Exhibition of 1938 Salvador Dali provided the first shock in the entrance with his ivy-covered *Rain Taxi* in which the people inside – dolls – were being drenched with water. In the section *Les*

129. *Exposition Internationale du Surréalisme*, Galerie Beaux-Arts, Paris, 1938, main room, arranged by Marcel Duchamp and lit by Man Ray

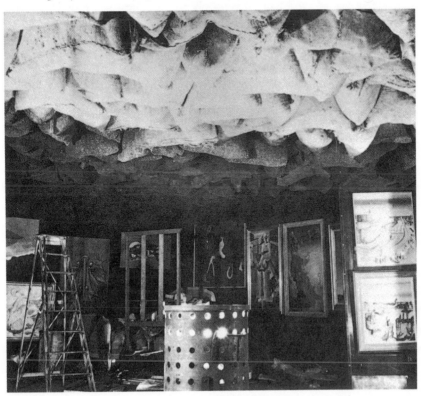

plus belles Rues de Paris shop window dolls had been altered and alienated, generally in an obscene way. The next section (fig. 129) was a grotto, deliberately badly lit and full of objects. From the ceiling hung the magic number of 1200 full coal sacks (they were stuffed with newspaper and turned upside down); the floor was covered with a thick carpet of faded leaves and a pond with waterlilies, while a "brasero", a big charcoal burner, glowed red in the centre (electrified for safety reasons). Graphics were hung on two swing doors, and in the four corners silk covers shimmered on enormously wide beds. The remaining wall spaces were covered with pictures, a coffee roasting exuded the odours of Brazil and from an invisible loudspeaker resounded hysterical laughter from the inmates of a lunatic asylum. This was intended to stop the visitors themselves from laughing and stifle on the spot any tendency to make jokes.[77] Duchamp's idea of installing automatic lighting that would be switched on by magic eyes when the visitors entered could not be realized. Instead visitors were given torches, but too many people stole them and in the end fixed lighting had to be installed.[78] Looking back at the 1938 exhibition, André Breton was keen to emphasize: "The organizers' efforts were designed to create a mood that would differ as far as possible from that aroused by an art gallery. I insist that they were not aware of following any other imperative; looking back now, however, one can see that all their efforts were excessive and they overshot the target they had set themselves."[79] Breton meant that the exhibition had since become overladen with meaning and had proved only too accurate as a prophecy of the coming suffering the war.

130. *Surrealism as an international movement,* double page spread in: *Dictionnaire abrégé du Surréalisme,* Paris 1938

131. Daniel Spoerri, *Installation on Dylaby,* Amsterdam, Stedelijk Museum 1962

The total installation by the Surrealists was not only a negation of the gallery exhibition, it also induced the visitors to a comprehensive sensual perception by arousing and captivating desires, by seeming to involve danger, by smells, sounds and finally by its visual impact. This was the first exhibi-

tion to consist of tangible experiences or adventures of sensation in the history of art. In the *Dictionnaire abrégé du Surréalisme* of 1938 the movement described itself as international, with its centre in Paris (fig. 130).[80] Total installations with a simultaneous negation of the art exhibition were repeated in 1942 in New York by Frederick J. Kiesler in Peggy Guggenheim's gallery and by Marcel Duchamp in *First Papers of Surrealism*. In this exhibition Duchamp covered floor, walls, ceiling and exhibits with a dense spider's web of, as he stated, sixteen miles of string (in fact there were only three miles). Kiesler designed an installation for the four rooms of Peggy Guggenheim's gallery, Art of this Century, with curving walls, exhibits that could be turned around and a lighting installation that steered the tempo of the visitors by lighting up and switching off.[81] This installation provided a comprehensive range of perceptions but it also made the reception difficult, because it both activated the viewers and controlled them at the same time.

The most interesting continuation of this Surrealist world of experience was *Dylaby* (fig. 131) in the Stedelijk Museum in Amsterdam in 1962. It can be regarded as the most intense interaction of artists, installation and participants. The environment extended through six rooms and consisted largely of the debris of civilization. The aim was not just to confuse the visitors' sense of orientation and frighten them with ghosts, they were to be transformed into active participants and touch things. They could move and keep changing a paleontological monster by Niki de Saint Phalle by shooting at coloured bags. After the exhibition many of the components went back into the rubbish bin; a few objects survived, most important the documentation of the construction and reception by the photographer Ed van der Elsken.[82]

Civilized Rebels, The Irascibles

Robert Motherwell gave a lecture in August 1944 which he titled 'The Place of the Spiritual in a World of Property'. He spoke in Mount Holyoke College in South Hadlex, Massachusetts. One of the most important problems which Motherwell addressed was the breach between artists and the majority of their fellow citizens: "The popular association with medieval art is its religiousness. The popular association with modern art is its remoteness from the symbols and values of the majority of men. There is a break in modern times between artists and other men whose depth and generality is without historical precedent. Both sides are wounded by the break. There is even hate at times, though we all have a thirst for love."[83] Motherwell saw this split as due to the collapse that followed the collapse of religion and left the artist isolated as an intellectual being in the midst of a world eager for possessions. The consequence was that the modern artist tended to become the last spiritually active being in the whole world.

The statement that the world of property was separate from the spiritual world of the artist might be a commonplace, but public and artists had both

By Robert Goodnough

photographs by Hans Namuth

Pollock

paints a picture

Far out on Long Island, in the tiny village of Springs, with the ocean as background and in close contact with open, tree-studded fields where cattle graze peacefully, Jackson Pollock lives and paints. With the help of his wife, Lee Krasner—former Hofmann student and an established painter in her own right—he has remodeled a house purchased there to fit the needs of the way of life they have chosen, and a short distance away is a barn which has been converted into a studio. It is here that Pollock is engrossed in the strenuous job of creating his unique world as a painter.

Before settling on the Island, Pollock worked for ten years in a Greenwich Village studio. Intermittently he made trips across the country, riding freight trains or driving a Model A Ford, developing a keen awareness of vast landscape and open sky. "You get a wonderful view of the country from the top of a freight car," he explains. Pollock loves the outdoors and has carried with him and into his painting a sense of the freedom experienced before endless mountains and plains, and perhaps this is not surprising in an artist born in Cody, Wyoming (in 1912) and raised in Arizona and northern California. Included

Jackson Pollock starts work on the 17-foot-long canvas with no specific, preconceived plan. He picks up a can of black enamel paint and with a stubby brush drips fluid sweeping rhythms across the surface.

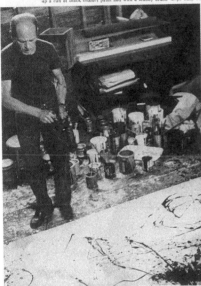
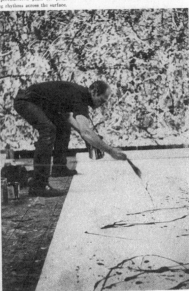

132. *Pollock paints a picture,* in: *Art News,* 1951

used it as a platform. Numerous lectures, discussions, interviews and surveys in the media dealt with the split and the lack of support for art.[84] In 1944 Motherwell referred to the public for his interpretation of medieval and modern art. Public reactions in the United States hardly differed from those in Europe, but unlike their European colleages the artists in the United States could not see any point in aiming to derive self-affirmation from general rejection. In 1948 René d'Harnoncourt of the American Federation of Arts spoke out against the prejudicial opinion that the artists of the day lacked social responsibility, maintaining that never before had so many artists concerned themselves so intensively with the structure of society He saw the collective style as related to totalitarianism, but artistic experimentation as political freedom. He argued that the divergency of social groups and the diverse movements in art were part of the same phenomenon: "The art of

the twentieth century has no collective style, not because it has divorced from contemporary society but because it is part of it."[85]

Most American artists took it for granted that they would respond to public interest, give interviews and explanations, take part in discussions, answer press surveys, demonstrate their working methods before photographers and film-makers and make use of every available form of publicity.[86] *Art News* published a number of articles around 1950 in which the methods of young American artists were illustrated and explained (fig. 132). In the case of Jackson Pollock, *Life* took up the idea already in 1949, but headed the feature with the rhetorical question: "Is he the greatest living painter in the United States?"[87] The question was doubly effective because it addressed the idea of competition with France and Picasso, then acknowledged as the greatest living artist, and also posed the question of the Number One in America. From the moment the article appeared in *Life* Pollock was a public figure.[88]

To consider the problem of the alienation between the public and modern art, the magazine *Life* invited leading critics and experts from the United States and Britain to take part in a *Round Table on Modern Art* in 1948 (fig. 133). However, it posed the questions differently from Motherwell, weighting it according to majority and minority opinion: "Is modern art, considered as a whole, a good or a bad development; that is to say, is it something that responsible people can support, or may they neglect it as a minor and passing phase of culture?"[89] The idea for the event evolved from the evident problems lay people, *Life's* readers, were encountering with modern art: they did not understand it, they thought it was ugly, incorrectly drawn

133. *Life's* Round Table in
the Museum of Modern Art,
New York, 1948

or strange. Hence, the moderator from the magazine adopted the role of the interested layman. *Life* described the danger of the gap that was growing between the general public and art, and the consequences for civilization: "How can a great civilization like ours continue to flourish without the humanizing influence of a living art that is understood and enjoyed by a large public?"[90] *Life* did not invite a single artist to take part in the discussion, unless the Dean of the School of Fine Arts at Yale, Charles Sawyer, could be described as representing them. The main concern was the disruption again emanating from European art - and therefore Picasso's *Girl before a Mirror* of 1932 was hung in the room beside other European paintings. It had been donated to the Museum of Modern Art by Mrs. Simon Guggenheim. After the war, Picasso's prominence in New York had been reconfirmed by exhibitions in the Museum of Modern Art in 1946 and in the gallery run by Samuel M. Kootz in 1947.[91] The periodical *PM* quoted Ad Reinhardt in 1947: "... the most famous living artist, the freest and most prolific artist of all time" was Picasso.[92]

However, when a second major discussion was held a year later in San Francisco under the title *The Western Round Table on Modern Art,* not only were artists invited to participate, extracts from the discussions were also published by two artists, Robert Motherwell and Ad Reinhart, in the volume *Modern Artists in America*.[93] The participants included Marcel Duchamp and Mark Tobey, the architect Frank Lloyd Wright and the composers Arnold Schönberg and Darius Milhaud. A year later the artists followed suit and in 1950 they held their *Artists' Sessions* at Studio 35 in Greenwich Village in New York; Alfred H. Barr Jr. was the only non-artist to take part, and he was assigned the role of moderator. Of the major artists working in New York only Jackson Pollock was absent, but Louise Bourgeois took part. The discussions, which lasted three days, raised many of the problems faced by artists, such as the meaning of abstraction, communication between artists, the production of a work, the relationship to the public, the contrast between France and America, the titles of works or how to name the new direction in art.[94] For the publication *Modern Artists in America*, which also carried these discussions, Bernard Karpel, Robert Motherwell and Ad Reinhardt wrote a brief statement pointing out the great interest in abstract art and the misunderstandings that were current. It ends with the words: "By impartial documentation of the event as it happens, the society in which the artist exists responsibly and the world of imagery and design in which he must exist creatively, stand manifest. This is the program of Modern Artists in America."[95] At the *Round Table* in 1950, Ad Reinhardt asked all the participants to comment on the relationship of the artist to society, but Barr had to admit that none of them was prepared to respond. The problem had become more complex, the inclination to justify their work on the grounds of an artistic "vocation" and to withdraw into an ivory tower or a monastic existence was growing, as was fear of corruption through public recognition.[96]

The younger generation of American artists did not constitute a group but

changing groupings, and they responded to the proposal by the Metropolitan Museum in New York to mount a national exhibition of American art by announcing publicly that they would boycott it. The brilliantly formulated protest by eighteen artists was addressed to the President of the Museum, Ronald L. Redmond, and accused the Director, Francis Henry Taylor, his curator and his selection committee, of disliking modern art. It was published by the *New York Times* on 22 May 1950 on the title page, under the headline "18 Painters Boycott Metropolitan; Charge Hostility to Advanced Art". Next day the *New York Herald Tribune* published a severe reprimand under the headline "The Irascible Eighteen", while the Metropolitan Museum of Art never commented on the open letter.[97] On 24 November, two weeks before the exhibition opened, the magazine *Life* asked the "Irascible Eighteen" to pose for a group photo (fig. 134) and fifteen of them appeared, dressed soberly; three – Reinhardt, Newman and Still – wore dark suits, their aim being to present themselves to the magazine's readers like bankers. The sober appearance and the positioning of the group were intended to form a parallel to the official picture of *Artists in Exile*, which had been taken in the Pierre Matisse Gallery in New York on the occasion of the exhibition by European artists in 1942.[98] It would appear that the open letter in *The New York Times*, the boycott and above all the presentation of a 'group' in *Life* were extremely important in drawing public attention to the new American painting and furthering the success which had already started.[99] In 1951 Andrew Carnduff Ritchie organized a major survey *Abstract Painting and Sculpture in America* in the Museum of Modern Art in New York, and many of the Irascible Eighteen were represented.[100]

The artists' reasons for distancing themselves publicly from the Metropolitan Museum and its selection committee, while describing themselves as representatives of advanced art and willingly accepting the epithet "Irascibles" are not just that they suspected deliberate attempts to put obstacles in their way or hostility. One indication may be this paragraph in their letter: "We draw to the attention of these gentlemen the historical fact that, for roughly a hundred years, only advanced art has made any consequential contribution to civilization."[101] In 1946 John Rewald's mystified saga of the heroic Impressionists had appeared, with its account of the daily struggle against poverty, official obstacles, hostile critics and public disdain by a small group of painters in Paris, and a celebration of their final victory over the opponents of modern art.[102] The heroic and tragic image of the artist in a hostile environment was revived everywhere. Antonin Artaud published his essay on Van Gogh in Paris in 1947, two years later the English translation was printed in *Tiger's Eye* under the title "Van Gogh. The Man Suicided by Society"; in 1948 Franz Roh published a book on the unrecognized artist, and in the same year the first edition of the successful Tragic History of Literature by Walter Muschg appeared .[103]

In spite of all this the appearance of the Irascibles in 1950/51 was cautious. This was because suspicions were already being voiced that modern art was a Communist subversion. In March 1950, three leading museums in Boston

134. *Irascible Group of Advanced Artists Led Fight against Show,* group portrait of protesting artists, in: *Life,* 15. January 1951. Rear from the left: Willem de Kooning, Adolph Gottlieb, Ad Reinhardt, Hedda Sterne; middle: Richard Pousette-Dart, William Bazoites, Jimmy Ernst, Jackson Pollock, James Brooks, Clyfford Still, Robert Motherwell, Bradley Walker Tomlin; front: Theodoros Stamos, Barnett Newman, Mark Rothko.

and New York, published a joint statement on modern art, complaining of the relapse into regionalism and nationalism and stating clearly: "We also reject the assumption that art which is esthetically an innovation must somehow be socially or politically subversive, and therefore un-American." The statement recalled the suppression of modern art in Nazi Germany and in the Soviet Union.[104] Two years later, George A. Dondero, a member of the House of Representatives, gave a speech on the threat to the American museums from a Communist plot.[105] Alfred J. Barr responded in December 1952 in the *New York Times Magazine* with a detailed account of the Nazi and Communist persecution of modern art.[106]

The Power of the Image, the Sublime

One of the problems with which the artists photographed as "The Irascibles" were concerned was how to name their art. The new designation should both ignore the great divide between "abstract" and "realistic" art, and cover the different directions or individual approaches. Various ideas were put forward and tried out, such as "The Ideographic Picture" (1947, Betty Parsons Gallery). Barnett Newman referred to the *Century Dictionary* and called the "ideograph" the "symbol for an idea"; this was also a reference to the Red Indian artist of the North West coast: "The abstract shape he used, his entire plastic language, was formed by a ritualistic will to metaphysical understanding." Newman declared that the new American painting was the modern counterpart of that original art.[107]

In 1949 a differently composed group, but again including Rothko and Reinhardt, tried out a different name for their movement in an exhibition

in the Samuel M. Kootz Gallery in New York: "The Intrasubjectives" (fig. 135). The critic Harold Rosenberg and the gallerist wrote two texts for the brochure that accompanied the exhibition. Rosenberg stated that the modern painter started from zero, and on that premise pretended to the viewers that their pictures were just as comprehensible as landscapes and still-lifes. Kootz maintained that each painting was personal in a dramatic way, and was a revelation by the artist. He concluded his commentary with these words: "The artists in this exhibit have been among the first to paint within this new realm of ideas. As their work is seen and understood, we should have more additions to their ranks; until the movement of Intrasubjectivism becomes one of the most important to emerge in America."[108]

The discussion of the sublime taken up by the painters who allowed themselves to be depicted in *Life* magazine as the Irascibles in 1951 must be seen in connection with their difficult relationship to the public. The young generation of American painters revived the idea of the power of the image after the war, both to reject French predominance in modern art and to dominate the viewer. The New York magazine *The Tiger's Eye* opened discussion on the sublime in 1948, apparently on its own initiative. Under the headline "The Ides of Art" it published the answers by the painters Kurt Seligman, Robert Motherwell, Barnett Newman and John Stephan, the writer A.D.B. Sylvester and the critic Nicolas Calas to the question: "What is sublime in art?"[109] The articles by Robert Motherwell and Barnett Newman gave a potted history of art and represented the opposition between Europe and America as a contrast between beauty and the sublime.

135. *The Intrasubjectives*, leaflet on the exhibition in the Samuel M. Kootz Gallery, New York, 14 Sept. – 3 Oct. 1949, title page

136. Jackson Pollock, *Guardians of the Secret*, 1943

Motherwell traced the history of modern art since Edouard Manet and Charles Baudelaire, describing it as a civil war between the traditional and the new. Newman, more radical and more specific, described the history of art as a battle between beauty and the sublime. All the reflections on the sublime were utterly confused, he argued, apart from Edmund Burke in his distinction between beauty and the sublime in 1757. European modern art (since the Impressionists) had destroyed beauty, but it had also destroyed the contents of the sublime, and now it was stranded in the empty world of Mondrian's geometric formalism.[110] In America's lack of tradition, which was strengthened by a total freedom from memory, legend and myth, Newman saw the chance for contemporary American art to achieve the sublime. He assured his readers that the paintings would strengthen man's natural desire for the exalted and that they could be understood by anyone.[111]

In his treatise of 1757 Edmund Burke linked the idea of the sublime with the urge to survive, and the idea of beauty with the social urge. The sense of the sublime was the strongest emotional impulse, and it could be stimulated by anything that triggered the idea of pain or danger - anything huge, infinite or powerful. If the danger is recognized as only apparent, delight is felt, while the effect of beauty is pleasure.[112] Burke defined the sublime through its perception by the observer, who passes from danger through the realization of safety to delight, and is stimulated by the great or powerful.

In the early forties Pollock turned to Red Indian themes, under the impact of the exiled European Surrealists. This is evident in works like *Guardians of the Secret* (fig. 136) and *Totem Lesson I* of 1944. He was stimulated by the Surrealists' interest in original artistic expression, as in Max Ernst's concern with Red Indian art, and the exhibition of Red Indian art in the Museum of

Modern Art in New York in 1941,[113] which may well have revived his memories of his stay in the Navajo Indian territory in Arizona. His paintings of the mid-forties have evident formal similarities with Navajo sand paintings, like the central field surrounded by the figures of the guardians and animals in *Guardians of the Secret*. In a questionnaire in 1944 Pollock commented on the relationship between his pictures and Red Indian art, saying that his works were the unintended product of earlier recollections.[114] Since 1947 he had been laying his canvases on the floor and covering them in his "dripping" process, so instead of Red Indian titles or formal similarities we now have the same procedure as in the sand paintings. Pollock commented in 1947: "My painting does not come from the easel. I hardly ever stretch my canvas before painting. I prefer to tack the unstretched canvas to the hard wall or the floor. I need the resistance of a hard surface. On the floor I am more at ease. I feel nearer, more a part of the painting, since this way I can walk around it, work from the four sides and literally be in the painting. This is akin to the method of the Indian sand painters of the West."[115] The question is whether the idea of the magical effect of the pictures came to be of importance to him above and beyond the method. The pictures created by the Navajo medicine men on the ground had magical healing powers and could summon up spirits, and they were destroyed when they had yielded up their power.[116] Pollock repeatedly declared that he was within his paintings while painting on the floor, and like Barnett Newman, he demanded that the viewer should come very close to the canvas, so that the huge formats would fill his entire field of vision and the picture would become the only object perceived.

Newman provided a short set of instructions for the viewer for his second one-man show in the Betty Parsons Gallery in 1951: "There is a tendency to look at large pictures from a distance. The large pictures in this exhibition are intended to be seen from a short distance." [117] Among the nine paintings was Newman's first work in a huge format: *Vir heroicus sublimis* (242 x 541 cm, New York, Museum of Modern art). A photograph taken in 1951 (fig. 137) shows how close the viewer had to come to the red painting with its five vertical stripes, for the work to have its intended effect: it was to occupy his entire field of vision and envelop or overwhelm the viewer. As with Pollock and Rothko, Newman's instructions for the viewer were intended to bring about direct confrontation between the picture and the viewer, and steer experience.[118] So the huge format and the lack of a compositional order were necessary components of the painting, as were uniformity and the impossibility of seeing the work as a whole. On the viewer's side the essentials were proximity, concentration and the exclusion of all other objects from the field of vision. Newman had already maintained in 1947 that the young American painters were concerned with "the reality of transcendental experience".[119]

The envelopment of the visitor by the paintings in the *Rothko Chapel* in Houston, Texas, the closed circle of the fourteen *Stations of the Cross* by Barnett Newman in the National Gallery in Washington D.C., and the project for a church by Jackson Pollock, which was never executed, best

137. Demonstration of the recommended distance of the viewer from *Vir heroicus sublimis*, 1961

illustrate how a transcendental experience was to be created for the viewer.[120] In his 1961 essay *The Abstract Sublime* Robert Rosenblum took up Newman's ideas on the sublime and connected the works of the Abstract Expressionists with painting in Northern Europe around 1800.[121] In an essay that was only published after his death Max Imdahl described the process between painting and the viewer in these words: "Newman goes behind any traditional or preformed, tangible, mathematical, geometric or aesthetically definable order, to the storehouse of absolute emotion as to an elementary human asset. The painting itself is then the occasion or the essential reason for going back to that store. Emotion here does not mean a single emotion or a combination of emotions (joy-grief), it means the experience of the sublime that is combined with a new experience and exaltation of the ego, particularly with the call to human independence, self-realization and self-development. That is Newman's intention."[122] If the intention can be stated with such didactic precision, it should be subject to critical examination, as should the works and the viewer's reactions, in regard to the revival of the power of the picture - that has been a renewed focus of attention in art history for some time. For this is power created by steering reception with media and verbal support.[123] The violent opposition that the power of the picture can arouse finds expression in acts of iconoclasm. The destructive attack on Newman's Berlin version of *Who is afraid of red, yellow and blue* of 1982 should not be overlooked in considerations on how to steer the viewers.[124]

VI ART FOR EXHIBITION

Policy and Politics

Ever since they were institutionalized, art exhibitions have been a political instrument. The Académie Royale de Peinture et de Sculpture in Paris used the Salon exhibitions to demonstrate its art policy and its artistic superiority in Europe. In every world exhibition since London in 1851 and Paris in 1855 the arts have been included in the competition between nations and the production of goods and war material. After the Franco-Prussian War of 1870/71 the German Kaiserreich competed in the cultural sphere in Paris with the nation it had defeated in war.[1] The Biennale in Venice, established in 1895 to further international understanding, became a place for political demonstrations when the national pavilions were built.[2] In 1937 Nazi Germany propagated the politically acceptable "artistic philosophy" with the *Major German Art Exhibition* in Munich, while proclaiming in the *Degenerate Art Exhibition* what was to be persecuted with all the means available, an art that was defamed as "pathological", "racially inferior", "anarchistic", "Bolshevistic" and "Jewish".[3]

West Germany after the Second World War was an ideal example of the continued pursuit of political aims through art exhibitions. In 1947 the Beaux-Arts section of the French occupation forces stationed in Freiburg im Breisgau mounted an exhibition entitled *Contemporary Masters of French Painting*, which included works by Picasso, Matisse, Léger, Chagall and Rouault.[4] In 1948 came a touring exhibition, *Abstract French Painting*. It was shown in seven towns from Stuttgart through Munich and Hamburg to Freiburg. The exhibition was a response to the first opportunity for German artists to participate in a show in Paris after the war, in the spring of 1948. The introduction to the catalogue states that the exchange was only possible in abstract art, as only abstract art was universal and could not be misused as a political instrument: "Liberated from external phenomena, but imbued with the world spirit, abstract art, which is fused in the crucible of the heart and brain of mankind, logically rises to the exalted level of freedom, the individual and universal. In view of how abstract art comes into being, it is easy to understand the attacks it has been subject to, the hatred that has been unleashed on it in certain places on earth; but abstract art is unassailable and invincible. 'Degenerate art' was howled at it yesterday, today they are calling it 'anti-human art'. What is that supposed to mean except that the obvious light quality of abstract art offers no support for weaklings, while this art refuses to place itself 'at the service' of any demagogy?"[5]

At the same time as this proclamation of the world spirit in abstract art and its invincible quality, an alarming book by Hans Sedlmayr appeared, *Verlust der Mitte* (The Lost Center). Sedlmayr saw in the art of the nineteenth and twentieth centuries symptoms of the decline of the west. He not only diagnosed an irreversible historical process, a progression from godlessness to

dehumanization and finally chaos, he also polemicized against the symptoms and the artists. Not without reason many feared that this book, which was extremely successful, was a revival and a continuance of the invectives of the Third Reich against modern art. One passage on the "upsurge of the horrific" could have given grounds for such fears: "There is an addiction for the new at any price, a superficial, cynical game and a deliberate bluff are being played; this art is being coldly exploited as a means to break down every system, there are hundreds of profit-seeking swindlers and deceit is practised by those who are deceiving themselves in a shameless depiction of the mean and low."[6] In July 1950 the *Darmstadt Discussions on Contemporary Man* were held, and they concentrated in the main on the question of whether modern art should be seen as a symptom of decline or as resistance to the general destruction.[7]

The first Documenta exhibition in Kassel was held in 1955; it was organized by Arnold Bode and Werner Haftmann, and it showed pre-war twentieth century art, that is, paintings by Paula Modersohn-Becker, the Expressionists, the Constructivists and the Surrealists; it included sculptures by Maillol, Lehmbruck and Calder, and architectural work from Gropius to Pier Luigi Nervi. The 1955 Documenta followed the 1948 Biennale in Venice, which had also shown pre-war avantgarde art, and the Freiburg exhibition of 1947, but the works were selected to repair some of the injustices done by the National Socialists and demonstrate that Germany had rejoined the modern art movement and the international exhibition activities. However, the aim was not so much to benefit the artists who had been driven into exile and suppressed, as to repair some of the damage to the German nation, as Werner Haftmann said in the catalogue: "The damage was done to the nation, to its awareness of contemporary culture, its passive will to culture. The mass anaesthesia administered by dogmas of mass happiness broke that continuity of thought in which alone the expressions of modern art can be made understandable".[8] Nevertheless, Documenta 1 presented an iconostasis of artists' portraits (fig. 138) and with Wilhelm Lehmbruck's *Woman Kneeling* on the stairs it showed one of the most prominent works that had been defamed in 1937 (fig. 139).[9]

For Documenta 2 in 1959, which included a big section of contemporary American paintings, Haftmann discussed the contrast between East and West in the catalogue, between freedom and totalitarianism. The Soviet Union had started the second Berlin crisis at the beginning of 1959, and Haftmann recalled the constant internal and external threat to modern art: "Let us not be deceived: Modern art is one of the fundamental forms of expression of personal existence, and as such it is an irritant wherever belief in authority, the will to power, contemporary varieties of political totalitarianism are opposed to the freedom of the individual." Haftmann celebrated abstract art as the first model case of a culture of mankind. For him it was the inspiration of nature and formed the necessary complement to the technical domination of nature, coming close to the romantic idea of a world culture for the first time.[10]

138. Documenta 1 1955,
The iconostasis of portraits of
artists at the entrance to the
Museum Fridericianum

Documenta 2 in 1959 gave particular prominence to the late Jackson
Pollock and Wolfgang Schulze (Wols), as the heroic purveyors of the mes-
sage of modern art. In the catalogue, the American art historian Sam Hunter
praised Pollock's painting as one of the most expressive and shattering con-
temporary expressions of artistic freedom.[11] Haftmann celebrated Wols as
the initiator of the new movement in art which in the fifties had come to be
known as "Informel": "Wols is at the start of the new direction in art which
we call 'Art Informel', and which has become the determinant form of
expression for contemporary perceptions and feelings over the last decade."
For Haftmann, Wols was a man buffeted by destiny, recording his fate - per-
secution, suffering, homelessness and constant flight: "He was the gentle
man at the mercy of fate, recording what was happening to him - not the
facts but the images that streamed out of the wound life had dealt him."
Through Wols, Haftmann activated the idea of the artist injured and suffer-
ing, emphasizing the qualities of authenticity and immediacy: "This paint-
ing is action flowing directly from existence - it is the trace of its gesture,
the choreography of its rhythm, the heartbeat of its protagonist. As nature
records its fate in geological structures, in diagrams of growth, circulation and
decay, as a wall records its story in its marks, what time and chance have
done to it, the surface of the picture is for Wols the tablet on which he can
inscribe the chronicle of his destiny - in a script consisting of line, colour and
specks, the immediate and direct registration of the twitching of the nerves
in the body of the picture."[12] Haftmann's view of abstract painting as a
world language was, in fact, already obsolete as a diagnosis, and as a progno-
sis it was mistaken, yet as a retrospective view of the fifties it was justified.[13]

All over Europe and the United States Abstract Expressionism, Tachisme or Art Informel had found their imitators. In 1950 the fashion magazine *Vogue* showed mannequins in front of Abstract Expressionist works, in 1951 they were posed in front of Pollock's drip paintings, and the Wall Street stock-brokers surrounded themselves with abstract American art. In 1950 de Kooning, Pollock and Gorky represented the United States at the Venice Biennale. Intellectuals and artists were - astonishingly - declared the storm

139. Documenta 1 1955, The stairs in the Museum Fridericianum with Wilhelm Lehmbruck's bronze sculptures *Woman Kneeling, Woman Bathing, Mother and Child,* and Oskar Schlemmer's *Group of Fifteen*

troops of freedom in the Cold War. Now that it had become extremely popular, Abstract Expressionism was regarded as a suitable way of playing off the freedom of art in the West against the totalitarianism in the East.[14]

In 1959 the magazine *Magnum* attempted to reduce the opposition to modern art by setting abstract works beside photographs of atomic mushroom clouds (fig. 140), rocket launches and masses of people. Like other publications in the wake of the World Exhibition in Brussels in 1958, it wanted to prove that painting was presenting intuitive or prophetic insights into the processes in nature, technology and society, and that the old theory of imitation could be reinstated.[15]

But the heroic epics hammered out of individual tragedies, the emotional proclamations of freedom, the recourse to nature, technology and society, and the insistence on a world language were all claimed for a direction in art that had already begun to make way for the next international fashion. Its ambience was neither on the pseudo heights of the world language nor was it to be found in a trivial existentialism, for these artists looked to "low culture", the department store and the scrap heap. Jasper Johns painted his first flag picture in 1955; it was an ironically patriotic product which posed an identity problem for any thoughtful analysis. Andy Warhol changed from being a window dresser for the consumer society to the painter of the products of mass consumption, from Campbell's soup cans through Elvis Presley to Marilyn Monroe. In Paris Jean Tinguely and Daniel Spoerri used

140. Mushroom cloud and "nuclear painting" by Wols, double page in *Magnum*, 24 June 1959

the scrap from workshops or the remains of evening meals for their art works. In 1964 the Biennale in Venice honoured Robert Rauschenberg with the major prize for painting, and the American curator Alan R. Solomon wrote a sentence in the foreword to the catalogue that was bound to anger the Europeans: "It is evident to all that the world centre of art has shifted from Paris to New York."[16] That claim to dominance in the universalized art trade was completely justified. In fact, the United States set a world standard for the western hemisphere in two consecutive decades, firstly with Abstract Expressionism for high culture, and then with Pop Art for low culture.[17]

The Performance of the Clowns

New York and Paris may have each claimed the second invention of abstraction for themselves after 1945, but they could not claim to have invented the artist as performing clown. The tragic and derided clown had been the challenging symbol of the artist since the middle of the nineteenth century.[18] In 1925 Amédé Ozenfant stated that the main problem was artist's uncertainty about the purpose of art, the alienation between public and artists, and the degradation of the artist to the role of court jester.[19]

The jokers who emerged in the late fifties in Paris did not intend to be content with the role of court jester before the throne of art. They wanted to reach a big public, but their immediate aim was to create a *tabula rasa* with irony and attacks. They wanted to oust the art of the past and install their own infernal machines in the productive vacuum where they performed their spectacular actions; subsequently, they attempted to patent the machines to protect themselves from friends or followers who were trying to steal their ideas.[20] Jean Tinguely transformed balanced compositions by Kandinsky, Malevich and Mondrian into mobile reliefs, and towards the end of the fifties he invented about sixteen machines that were capable of producing drawings like the products of action painting. From 1 to 30 July 1959 Tinguely invited the public to an exhibition entitled *Les Sculptures qui peignent* (Painting Sculptures) in the Galerie Iris Clert in Paris. Artists like Hans Arp, Marcel Duchamp and Yves Klein were delighted by the clattering drawing machines, as were the many visitors who came, while some critics fearfully predicted that the end of painting was nigh. The machine drawings were stamped on the reverse and Tinguely signed them on the front. The super drawing machine, *Méta-Matic No. 17* of 1959, could dance, make noises, spread the scent of lilies-of-the-valley and make drawings on a wide roll of paper. In response to pressure from other artists, the machine had to be withdrawn from the Musée Nationale de l'Art Moderne at the Biennale in 1959, and Tinguely had it installed in front of the building.[21] In the patent application which he submitted to the French Ministry of Industry in 1959 he described the purpose of the drawing machine: "This apparatus can be used both as a toy and to make abstract drawings and paintings; more

important, it can be exhibited and preserved for the continuous decoration of bands of paper or material, for instance."[22]

There was an iconoclastic side to the seemingly amusing machines that could produce art. This was strengthened by proclamations that "Everything is art", and confirmed by actions demonstrating the destruction of art, both planned and performed. Tinguely was obsessed with the idea of attacking Leonardo's *Mona Lisa*, as Pontus Hultén reports, and was only held back by the knowledge that he would certainly be given a prison sentence. Paradoxically, the *Mona Lisa* was spared thanks to Marcel Duchamp, for Tinguely gave up the plan when he was told that Duchamp had already carried out the attack in 1919 by adding a moustache and five letters to a reproduction.[23] In 1960 Tinguely built a machine that could crush sculptures, in the same year he installed the machine *Homage to New York* in the garden of the Museum of Modern Art in New York; it destroyed itself in front of the watching visitors (fig. 141). In 1961 came a further assemblage of scrap, which Tinguely entitled *Étude pour une fin du monde* (Study for the End of the World). It was placed in the Louisiana Museum in Humlebaek, but its self-destruction constituted a considerable danger to the spectators. The next study for the end of the world was performed as a happening commissioned for NBC television in 1962. By shifting the performance to the Nevada desert outside Las Vegas, Tinguely was able to use several hundred kilos of dynamite; he was also able to make a frivolous reference to the first atom bomb tests, which had been carried out a few hundred kilometers to the west.[24] The second apocalypse was a huge joke, although the performance was not entirely without risk for the artist, who, an amateur with explosives, had to ignite several fuses by hand.

All these destructive ideas or happenings remained within the art system, as did Duchamp's iconoclastic ready-mades. Like the ironic idea of setting compositions by Kandinsky and Mondrian in motion, the destruction of sculptures was a reference to a functioning system. It should be pointed out that the complicated construction made only to be spectacularly destroyed had its predecessors in the exploding firework architectures of the seventeenth and eighteenth centuries; again, the construction and destruction were conceived as artistic actions and regarded, documented and discussed as such. According to Bourdieu, ritual sacrilege is particularly illuminating as regards the way the art system works.[25] The exploding scrap was not only intended to be a magnificent and enjoyable image of the apocalypse, it was also intended to prepare the way for the immaterial work of art, an aim which Tinguely and his friend Yves Klein were both pursuing.

Klein's exhibition *Le vide* (The Empty space) of 1958 in the Galerie Iris Clert in Paris was the most advanced presentation to date of a "climat pictural invisible". Klein showed an empty gallery space which he himself had painted white. It was the white cube, the modern cult room for the mystic transformation of things into works of art.[26] The arrangements for the private view included an invitation card with a text by Pierre Restany; the entrance was decorated with blue fabric, members of the *garde républicaine*

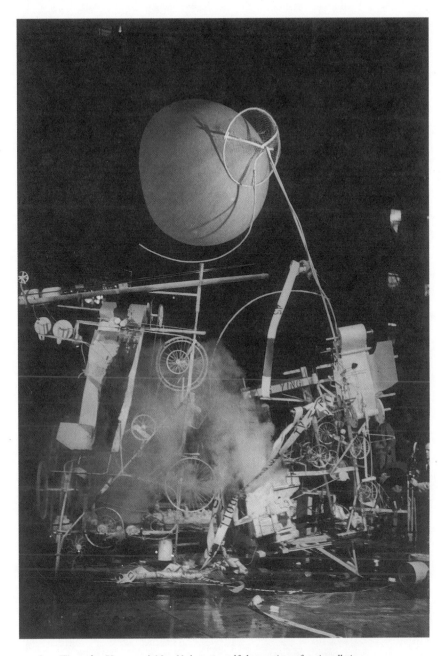

141. Jean Tinguely, *Hommage à New York*, 1960, self-destruction of an installation on 17 March 1960

kept watch, although they were thought to be actors in costume, and the guests were given a blue cocktail, which turned their urine blue. The exhibition room itself contained an empty glass case and invisible pictures, produced by mental effort on the part of the artist. The public were to per-

ceive these as "painterly sensibility", until they were sufficiently impregnated to feel what *Yves le monochrome* said he could see in the white room, namely "real blue".[27] The only damper came at the last moment, when the authorities withdrew permission to illuminate the obelisk on the Place de la Concorde with a blue light. This deprived the people of Paris of a spectacle and they were unable to imagine the blue inside the white gallery and the immaterialized blue on the illuminated obelisk on the same evening. Hence they could not see that the artist was close to his supreme aim of moving away

142. Yves Klein, *Dimanche - Le journal d'un seul jour,* Paris, 27 November 1960,
 title page of a four-page newsheet

from material and physical blue. Klein felt he was the victim of intrigues, and he appealed to the Préfecture, but in vain, although he argued that the illumination would prove a tourist attraction.[28]

Klein prepared the *Le Vide* action carefully, and he photographed every detail. The artist's intoxicated gaze registered the huge crowd in the Rue des Beaux-Arts, an uninvited iconoclast being thrown out, the wonderfully boisterous arrival of the police and the fire service, the outraged crowd, the subsequent celebration in the restaurant La Coupole and the police search the following day. It was stopped when the officers saw that this was not a swindle that could give rise to a lawsuit.

Klein continued the epoch of the *pneuma*, as he called it, which replaced his "blue epoch", stated to be in opposition to Picasso, with an air sculpture that was an amalgam of faith in technology and the esoteric, with a photomontage of the artist rising for a flight into space entitled *Théatre du Vide* (fig. 142), and with the sale of shares in a zone of immaterial painterly sensibility. For twenty grammes of fine gold prospective purchasers could buy shares in the zone from the owner of the space on two conditions: first, the gold had to be handed over against a receipt, upon which the artist kept everything and the buyer did not receive the "authentic immaterial value", that is, according to the agreed rules he was cheated of the imaginary exchange value. The second condition was that the buyer must burn the receipt, the artist got one half of the gold and the other half was ceremoniously thrown into the Seine. This secured a share in the immaterialized zone for the buyer. Klein packed up his share of the gold in a perspex box with pink and blue pigments and gold leaf, and in February 1961 took it to Saint Rita in Cascia (Umbria) as an ex voto (fig. 143). The offering bore the art-

143. Yves Klein, *Ex voto to Saint Rita in Cascia*, 1961

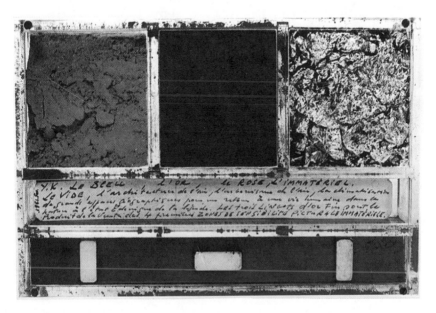

ist's wish that his work might remain unharmed and beautiful for ever, and that his coming exhibition in Krefeld might be the success of the century. Saint Rita is an expert for the improbable and the impossible.

Klein had undertaken several pilgrimages to Saint Rita in Cascia, he was a member of the Rosicrucian Order, a Judoka of the Fourth Dan and a teacher of judo to General Franco's militia in Madrid. He certainly brightened up the fading image of the artist, presenting the contradictory traits of a mystic eager for publicity, a charismatic swindler, an innocent Fascist and an absurd world revolutionary. He also adopted the poses of a fanatic iconoclast, a cheating speculator and an untiring cadger.[29] In art he revived the concept of the icon with his monochrome blue, gold and red panels, the idea of immateriality and the influence of the occult. He crossed the threshold into pure nonsense in his anthropometric actions, which display a thoughtless lack of taste. The action in which, dressed in a dinner jacket, he made imprints of the bodies of naked women in blue to the accompaniment of a monotonous symphony and in front of an audience of voyeuristic spectators, could be seen as the more or less naive cynicism of the fifties, but in his imitation of the ghostly white shade of human beings after the atom bomb was dropped on Hiroshima he seemed to have lost all sense of humanity.[30]

The attack on Andy Warhol by Valerie Solanis, a mentally deranged woman and the only member of the S.C.U.M., Society for Cutting Up Men, which she had founded, in the Factory on Union Square West 33 in New York on 3 June 1968 necessitated several hours of surgery to save her victim's life and two extensive periods in hospital. After the second operation Richard Avedon took a photograph of Warhol's torso showing the big surgical cuts. Twenty years later, in 1986, Warhol died very unexpectedly after a seemingly simple gall bladder operation in a New York hospital.[31] At the funeral service in St. Patrick's Cathedral in New York the Reverend of the Church of the Heavenly Rest invited five hundred homeless to an

144. Shopping bag with the portrait of Giuliana Benetton by Andy Warhol, 1989

210

Easter meal and also announced that for years Warhol had spent Thanksgiving, Christmas and Easter helping the poor. He had never spoken of this to anyone. The public learned with surprise that the apparently unfeeling superstar of the New York art scene had carefully concealed his piety and his charitable work behind the public image of an artist eager for fame and fortune, a favourite of the jet set.[32]

Warhol was, in fact, constantly practising a strategy of dissimulation. This was not just a simple split between the private person and the public image. Since 1963 he had always appeared in a clown-like silver wig, he willingly gave interviews but provoked absurd dialogues by refusing to answer the questions, denying any intended meaning in his products or forcing the interviewers to answer their questions themselves. His intention was not to criticise, if one may believe the somewhat confusing statements by the artist. These can be interpreted in any number of contradictory ways. They do not represent any specific position and remain on the level of party chit-chat: "If you want to know all about Andy Warhol, just look at the surface: of my paintings and films and me, and there I am. There's nothing behind it."[33] Warhol denied the splits with which we operate all the time – the split between the external and the internal, between true and false, between surface and depth, between the false that is visible and the true that is invisible, between being and appearance, between sign and meaning.[34]

In 1962 Warhol began his reproductions of Campbell's soup cans and Coca-Cola bottles, his *Do It Yourself* pictures and the portraits of Marylin Monroe and Elvis Presley. He made these products of the American consumer society subjects that filled whole pictures, or he simply repeated them, multiplying the depiction. In *Turquoise Marilyn* Marilyn Monroe's face fills all of a screenprint more than one meter in size, while the same photograph is repeated twenty-five times in the coloured panel *Marilyn Diptych* of 1962; in a black and white work, the twenty-five repetitions show the face emerging from grey and disappearing into black. Warhol was not criticizing the nature of consumer goods, he was outbidding it by making the goods absolute.[35]

Warhol produced thousands of these schematic reproductions. In 1963 he said: "The reason I'm painting this way is that I want to be a machine, and I feel that whatever I do and do machine-like is what I want to do."[36] From 1972 the jet set became addicted to being reproduced by Warhol and thus entering the gallery of stars that was gradually built up, from Monroe to Lenin, from Beethoven to Beuys. Between 1972 and 1987 Warhol produced between fifty and a hundred coloured schematic portraits a year of eager stars – from Truman Capote through Princess Caroline to Giuliana Benetton (fig. 144). The most saleable of modern artists, whose aim was simply to do good business, opened his schematic gallery of personalities of the past and the present to anyone who could pay about 50,000 dollars.[37]

In 1985 Warhol presented an invisible sculpture (fig. 145) in the New York night club *Area*, by standing on a platform, having a photograph taken and leaving a plaque behind to testify to the disappearance of the artist-art

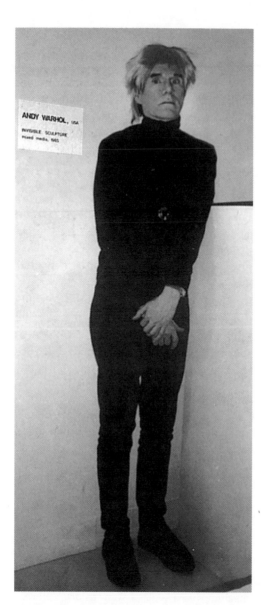

work: *Andy Warhol, USA, Invisible Sculpture. Mixed media, 1985.* Thus Warhol put an end to the last criterion of art that still existed, the authenticity that is built up by the artist's awareness of his mission and confirmed by his life.[38]

Everyman Shaman

Joseph Beuys wrote the sentence *La rivoluzione siamo Noi* in 1968 on a postcard after visiting Sils-Maria, where Nietzsche had lived.[39] Three years later the sentence appeared again in a photograph by Giancarlo Pancaldi (fig. 146),

which was used as a poster for an exhibition in the Modern Art Agency in Naples; then in 1972 it became a huge screenprint, 191 x 102 cm, and in the same year it was published by Edition Staeck in Heidelberg as a postcard. It shows the artist striding away from a closed front door, straight towards us. His left hand is swinging forwards, his right grasps his shoulder bag. Beuys is wearing soft leather boots, blue jeans, a fisherman's waistcoat and a felt hat, the clothes that had become his personal iconography since the sixties, his

146. Joseph Beuys, *La Rivoluzione siamo Noi, 1972*

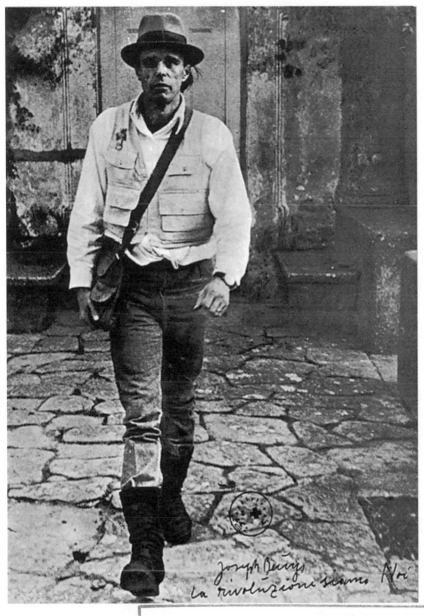

public identity. The hat can be interpreted as a reference to René Magritte's hat, or possibly Humphrey Bogart's. The jeans are not only a declaration of loyalty to America - *I like America and America likes me*, as Beuys' extraterritorial action in New York in 1974 was entitled - they may also bring to mind the full-figure portrait of Elvis Presley which Andy Warhol had been selling as a screenprint since 1963.[40] The pilot's boots are a reminder of Beuys' crash in a fighter plane in the winter of 1943 on the Crimea and his miraculous rescue, severely wounded, by nomadic Tartars. The artist had used this event to build up his personal legend since the early seventies.[41]

The proclamation "La rivoluzione siamo Noi", "*We* are the Revolution", imbued all Beuys' artistic and political activities - the establishment of the Organization for Direct Democracy in 1971 in Dusseldorf, the action *Put a Final End to Party Dictatorship*, the protests against the selective admission to the Art Academy in Dusseldorf and the occupation of the College's secretariat, which provoked his dismissal by the Minister of Education of North-Rhine Westphalia, Johannes Rau. On 1 May 1972 Beuys swept Karl-Marx-Platz in Berlin, assisted by an Asian and an African student. The three then put the rubbish into a glass case and exhibited it along with the brush. In Rome Beuys held a public discussion entitled *La rivoluzione siamo Noi* with Renato Guttuso, and at Documenta 5 in Kassel he maintained an information office for a hundred days, discussing direct democracy in the form of referenda with the public.[42]

The photograph shows the artist striding forward determinedly; it takes up the image of the artist as wanderer, which Ludwig Tieck originated and which Courbet, Van Gogh, Gauguin, Kirchner and Francis Bacon all used. The inscription, "La rivoluzione siamo Noi", revives the old - feared or celebrated - relationship between the artistic avantgarde and political radicalism. But Beuys does not appear as a revolutionary leader, he is not collecting disciples or followers, he is walking towards his public. "La rivoluzione siamo Noi" is not just Beuys in the royal plural, it also means the people who take part in the artistic and political process. Beuys was both a challenger of the public and its martyr; he offered both these roles, like Christ, as he often enough suggested, and sometimes even more, an inimitably painful physiognomy, incarnation, washing of feet and resurrection. The goal was religious and creative; there was to be political awakening and initiation, indeed, his ambition went even further - he wanted to cure society, which he saw as a wounded body, and save it through ecstatic invocations like a shaman, a priest or ancient healer, through schooling in democracy, freedom and socialism (fig. 147), through anthroposophy or alchemy, through the brotherhood of mankind or ideas on wages for housewives, through suggestions on examination regulations at universities or models for the global economy or the future social system.[43] This is total artistic work, "social sculpture", as Beuys called it in 1982 in regard to his *Stag Monuments*: "I maintain that this concept of 'social sculpture' is an entirely new category of art ... I even shout: there will be no more viable sculpture on earth in future, if this social organism is not there as a living being.

147. Joseph Beuys' School for Visitors at Documenta 6, 1977

That is the idea of the total work of art, in which every human being is an artist."[44]

On many occasions Beuys maintained, to the approving nods of his devotees, that he had widened the concept of art.[45] He was unsparing in his criticism of Marcel Duchamp for not marching straight to the "wider concept of art" with his ready-mades and preferring mysteries, subjective poetics, alchemy or silence. But the silent giant had left something for the ungrateful dwarf on his right shoulder to do, like the clown Yves Klein on his left shoulder. As far as widening the concept of art is concerned, it should be noted, despite the immense supportive literature, that what Beuys said was always related to the *concept*, and not to art. It must be questioned whether the *concept* of art could have been taken any further after Duchamp and Klein without becoming totally vacuous and unusable. Marcel Duchamp's silence, which Beuys regarded as "overdone", was consistent, while Beuys spoke ceaselessly and on everything, tirelessly repeating his horrific illogical equations of art with anything and everything, and assuming with his wider concept of art that even the most stupid or elementary could be the vehicle of creativity.[46] To the confusion of his supporters Beuys announced in 1985 that he was abandoning art, although after his extension of the concept to everything, there was nowhere he could have gone to.

In fact, the extension of the *concept* appears of secondary importance beside the more radical change, the renewed and persistent attempt to move from an art consisting of the work to an art consisting of the process, to summon up elementary experiences of protection and isolation, cold and

215

warmth, communication and giving, and make people aware of them with felt, fat, honey and chocolate. Beuys was a fantastic draughtsman and a gifted exhibition artist. Action was his medium in the sixties, then the exhibition hall became his creative space, the exhibition his action. What he wanted to show was created mainly in the exhibition hall. He did not work in the seclusion of his studio and then show to the public works he had spent one, two or three years elaborating. Before the exhibition he might only have made a few sketches or notes. Everything was created in the place where the processes of perception and recognition were to take place. The installations were to function as catalysts, insofar as they were to set a reaction in motion without themselves being consumed or permanently changed in the process. The catalyst is not art, the chemical or biochemical reaction, the process of perception and reflection are art. That is how Beuys could maintain that every human being is an artist, not because every human being creates catalysts, but because every human being can take part in the process, and this participation is necessary for art to function.[47] The invention of exhibitions, environments or installations was recorded with painstaking care from 1971, in photographs. The creative process was particularly clear in the transformation of the exhibition hall into the artist's studio in the exhibition *Zeitgeist* in the Martin Gropius Building in Berlin in 1982. It has been fully documented.

That art is a process is easy to say, easy to see and even easier to repeat; nevertheless it is not without risk for the artist and his followers. A quotation from a text by Laszlo Glozer on the installation *Zeige deine Wunde* (Show Thy Wound) in the pedestrian subway in Maximilianstrasse

148. Joseph Beuys, *The Capital Room 1970-1977,* 1980, detail

in Munich in 1976 will explain this. After maintaining that the partici-
pation of the public is part of the sculpture, the author hesitates and asks:
"The relationship between the work and the public, can it be made part
of the work of art, as a determinant, constituent feature?"[48] The hesitation
reveals the fundamental problem: the relationship between "work" and
public (namely the flows of warmth, power and energy) cannot be regarded
as part of the "work", because it would be totally wrong to reintroduce the
work-related concept of art and eliminate the participation of the public.
The statements on social sculpture and the respective suggestion of flows
of warmth and power can only be meaningful if art is seen as a process.
Otherwise they are mystifications, that is, misleading statements. The pro-
blem is that the many concepts put forward this century to make art a
process and demystify the artist have failed because they were over-taken
by the renewed mystification of the artist, or by the re-establishment of the
definition of art as a "work", with all its consequences for authorship. The
remains of Beuys' actions and installations have become works of art. They
constitute values that can be quantified and assessed for insurance purposes,
and have a considerable sales and representation value. They are also very
valuable intellectual property, and fees have to be paid for their reproduc-
tion; nevertheless they can be remade countless times. That is a problem
that ought to induce a critical re-evaluation of the concept of art as a pro-
cess and art in relation to the work, or provoke legal action. So far there
has been no indication that a smart lawyer has taken the declaration of
"social sculpture" seriously and sued on behalf of the public for a proper
share in the increase in value and the profits.

In 1980 Beuys showed his installation *The Capital Room 1970-1977* (fig.
148) in the International Pavilion at the Venice Biennale. It consisted of
thirty objects and fifty panels of left-overs from various actions. Some were
from *Celtic (Kinnloch Rannoch) Scottish Symphony* of 1970 in Edinburgh,
some from the foot washing of 1971 at the Academy of Art in Dussel-
dorf, and some from Celtic + ~~~ of 1971 in Basel. The installation also
included the unsold blackboards from Documenta 5 of 1972 in Kassel, and
finally those from Documenta 6 of 1977.[49] When the installation was
exhibited in Zurich in 1983 Beuys gave a long explanation of the vari-
ous objects, not without admitting to some difficulty in identifying the
left-overs and the silent apparatus from past actions and defining them as
signs and symbols.[50] However, he did confirm that the installation *The
Capital Room 1970-1977* assembled everything he had presented, made visible
and thought in the past seven years, from initiation to the demand for in-
sight, orientation and clean feet, from the punishment of "stupid" reason,
to the swan or pelican, indeed, all the animals, and the destruction of the
environment, from speaking and hearing to two differently marked cubes
that simply prove "the intellectual nature of man", although one can also be
taken as a joke. "This is a humorous sign, and it is intended to say how
one can heave capitalism off its pedestal: just as simply as one lifts a block
with a lever."[51]

Kunst = Kapital
Joseph Beuys

10 Jahre Capital-Kunstkompaß

Denise René Hans Mayer
Düsseldorf Grabbeplatz 2
8. Nov. – 5. Dez. 1979

149. Joseph Beuys, *Kunst=Kapital,* poster, 1980

Beuys shows how easy it really is, perhaps just as simple as deciphering according to the procedure of the primitive Structuralist, who enthusiastically divided the world into "signifiant" and "signifié". Nevertheless, even tried and trusted Beuys disciples shy away from statements on even the simplest constellations.[52] In 1979, to celebrate the tenth anniversary of the "Art Compass" drawn up by the German business magazine *Capital,* its annual ranking of artists by their market value, Beuys painted one of his equations:

"Art = Capital" in red paint on an almost life-size frontal photograph of himself in front of a mastodon (fig. 149). He deliberately painted it very slowly. It was an almost rebellious protest by an artist who had less and less fear of contact, especially as *Capital* had named him Number One the same year, replacing Robert Rauschenberg at the top of the list. The editors of *Capital* are still delighted with Beuys' equation, as the triumphant reprint in each November issue shows.

The installation *Capital Room 1970-1977* was a masterpiece in the classical sense, a review of seven years, analogous to Courbet's Studio (fig. 83) or Marcel Duchamp's compilation in *The Big Glass* (fig. 128).[53] However, in Joseph Beuys' unswerving messianic application every trace of the irony was lost with which Duchamp had taken the idea of the masterpiece ad absurdum.

The Exhibition Maker as Star

For Documenta 5 in 1972 Daniel Buren drew attention to a new problem in the art system: "Increasingly the object of an exhibition is tending to be no longer the exhibition of works of art but the exhibition of the exhibition as a work of art. Here it is the Documenta team, directed by Harald Szeemann, who are exhibiting (the works) and presenting themselves (to the critics). The works shown are the spots of colour - carefully chosen - of the picture that is created by each section (room) as a whole. There is actually an order in these colours, as they were deliberately chosen according to the concept of the section (selection) in which they appear and are presented. Even these sections (castrations), that are - carefully selected - spots of colour in the painting that the exhibition presents as a whole and as a principle, are only visible if they subject themselves to the protection of the organizer, the person who unites art by making them equal in the box or on the screen that he has provided for them. He assumes responsibility for the contradictions, and it is he who conceals them."

The quintessence of this penetrating analysis of an artist is: "So it is true that the exhibition presents itself as its own object and its own object as a work of art."[54] Buren was criticizing the first author's Documenta of 1972, when subjectivity was no longer accepted as an unavoidable blemish but seen as a basic condition for a concept. The aim of the earlier Documenta exhibitions to provide a representative showing of the classical and the ultra-modern was submerged in 1968 in the protests over the exclusion of happenings and Fluxus.[55] Harald Szeemann, the first in the new post of Secretary-General, used his wide powers of discretion to terminate the activities of the former Documenta Council and replace the awkward voting procedure with decision-making by himself. To compensate for the authoritarian attitude and procedure Joseph Beuys, who was the leading artist in Documenta 5, opened an Information Office of the Organization for Direct Democracy through Referenda and closed it again after a hundred days with

a boxing match with Christian Moebuss. In the catalogue for Documenta 5 Szeemann described the exhibition as a "dirty" compromise between an exhibition oriented to the artist and an exhibition oriented to the visitor, arguing in favour of an "integration of the eventful and of interpretation" by the viewer.[56]

Some of the concepts for Documenta 5 were published; they aroused public interest and fuelled controversy. Szeemann shocked those who believed in relevance by proclaiming that art should have no purpose, and by turning away from a democratic selection procedure he offended those who clung to the illusion of objective value. He wanted a subjective criterion, and he called it simply "a spontaneous decision based on the intensity that I sense in the work".[57] The announcement of the exhibition theme as "Questioning Reality", and the deliberately offensive proclamation of subjectivity, were enough to bring down upon the curator accusations of authoritarianism and dictatorship and of suppressing artists even before Documenta 5 opened. "What is new is to make the individual work of art anonymous by subordinating it to a system dictated by the organiser and which the artist has no possibility of influencing. So a relationship of identification with the artist becomes an authoritarian relationship."[58] Szeemann had had varying experiences with exhibitions in which the artists could have a say, in Bern in 1969 and Cologne in 1970.[59] One can sympathize with the concern of an artist like Buren, and with the difficulties other exhibition organizers experienced with the successful curator; more problematic was the suspicion, which quickly spread, that the selection had been determined less by subjective preferences than by the art trade.

Szeemann stuck to his subjective selection, in his subsequent work as well, most of which was as guest curator without a permanent post or institutional powers.[60] In the course of his long career he put forward subjective exhibition concepts as artistic creations, creating exhibitions as one might produce a work of art. His exhibition career was the realization of an imaginary "Museum of Obsessions". With Szeemann, and perhaps with Pontus Hultén as well, the curator became the realizer of his own visions and as such the rival of the exhibition artist.[61]

In-Art and Out-Art

The changes and extensions of the concept of art in the twentieth century can be ascertained the interchange between "high" and "low" art, in the attempts to bring free art closer to applied art, art to the crafts, and in the introduction of ordinary objects into exhibitions to test the elasticity of institutions and the concept. They are also evident in the use of simple materials or scrap and rubbish, in the negation of the meaning or purpose of artistic work and the declaration that iconoclasm is artistic activity. The claim that a work or activity was art could be made effective by attacking the concept as restricting creative freedom. *The Great Attack on Art* in the *First Inter-*

national Dada Fair in 1920 in Berlin included a number of aggressive slogans, like "Dilettantes, rise up against art!" or the proclamation "DADA is the deliberate subversion of bourgeois concepts".[62]

The response was to attempt to reinstate the limits that had been broken down by attacking the new ideas in the press, through acts of open violence and through the powers of the state. During the Third Reich and in the Soviet Union under Stalin the weapons of dictatorship were used; the restoration efforts were more isolationist in the United States during the withdrawal into regionalism, while in France they drew on Neo-classicism or on the claim of an artists association to a monopoly, as in Switzerland.[63]

In the fifties the narrower political interpretation of the concept of art provided the opportunity to extend the concept again, and this was repeated over long periods in ever smaller waves. In the process, the concept of art could be said to have been infinitely widened, until it ceased to apply at all. Today any object one may care to name and any creative or destructive act can be called "art" by anyone, and anyone can call themselves an "artist". It is probably right to say that today no one can identify any rules by which what is art or what is not art might be recognized according to the qualities or properties of the objects. Nevertheless, the distinction between art and non-art does exist and it functions very well. The question is how the selection works. Even if any and every product, object, combination or activity can be called art and anyone can declare that they are an artist, it is evident that by no means every product is accepted into the hallowed circle, and not everyone is successfully initiated into the ranks of the artists. Those who do not regard themselves as artists perceive that the selection system works, while the initiated artists know that it does.[64]

The general incorporation of all into a community of artists that is not defined in any greater detail is the correlative of the unregulated production of art objects. However, the declaration that every human being is an artist, in all its humanity and with its exciting challenge, did not lead to the demystification of the artists and their activities, nor to an extension of the concept of art. The Darmstadt artists' colony linked the production of crockery, carpets, houses and cutlery to a messianic mission on the part of the artist. The work of the Bauhaus in Weimar in taking the arts back to the crafts conflicted with a mystical view of the artist. Beuys propagated the removal of all limits to the concept of art and the artist, but at the same time he projected the image of the artist as prophet and martyr. In the midst of his periodic repetitions of his statement that every human being is an artist, the élitist models of the artist were evoked. In 1968 Bruce Nauman hung a witty and ironic revival of the mystic vision of the artist in the form of an illuminated sign in the window of a shop in San Francisco that he was using as a studio: "The true artist helps the world by revealing mystic truths" (fig. 150).[65]

In the last chapter of his novel *America* Franz Kafka draws an ironic picture of the Great Nature Theater of Oklahoma. The central character in the novel, Karl Rossmann, sees a poster on a street corner that reads: "Anyone who thinks of his future is one of us! All are welcome! Anyone

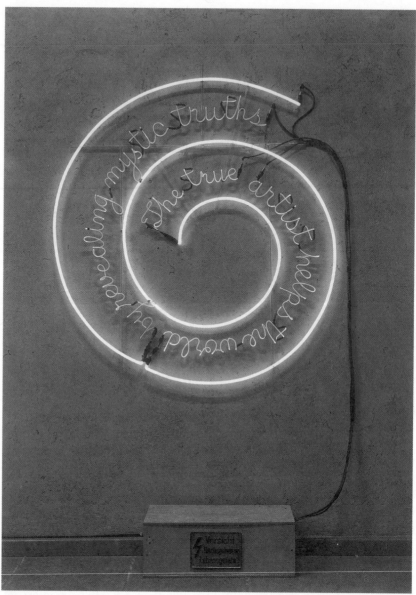

150. Bruce Nauman, *The True Artist Helps the World by Revealing Mystic Truths,* 1967

who wants to be an artist should come forward! We are the theater that needs everyone, each one in his place!"[66] However, the entrance to the happy place which few reach is guarded by an extensive bureaucracy which examines documents, asks questions about training and skills and unmasks pretensions. Finally the applicant is accepted, although the information he has given is false. But he is not appointed as an artist but on the low level of technician. This illustrates the process of classification and valuation in a closed system that proclaims openness and only applies its rules and criteria later.

The distinction between art and non-art is the result of a process in which many are involved. It includes the institutions for the presentation of art, the galleries and museums, the visitors or the public, the commentators and theoreticians who provide the necessary textual context, the media, the buyers and collectors. An object or an activity do not become art because the producer offers them or declares them to be art. This only happens with the consensus of the institutions and persons involved. The process runs through several stages for an indeterminate time, and the mystical honours it confers are the halo of genius in its contemporary form - star, superstar – and money. The price has no relation to the value of the material, of the work performed by the producer or the sales and publicity manager. Its relationship to the product, to its producer and to demand is mysterious; it is the expression of the exchange value, and as spurious as that between the nominal and selling price of shares.

Only the rite of recognition in its various degrees creates the circle in which the mystification of the artist, the recognition of the products and the price all combine in an upward movement. Kurt Schwitters' cynical comment "Everything the artist spits is art" provoked a scurrilous response from Piero Manzoni in 1961 in the form of 90 food cans entitled *Merda d'artista* - the artist's shit. In the same year he signed people and exhibited them; he also made a magic plinth that transformed everyone who stood on it into a work of art temporary.[67]

As we all know, Marcel Duchamp was the first to unmask the functioning of the art system, when he signed an industrial prefabricated product "R. Mutt", entitled it *Fountain* (fig. 127) and submitted it for exhibition to the Society of Independent Artists in New York in 1917. He turned the object upside down and so de-functionalized it. His attack on the system was precisely directed, but it continued to function. The inverted urinal was not accepted for the exhibition, and the signature was not yet known to be his pseudonym.[68] The subsequent integration of his ready-mades into the realm of art provided the grounds for the institutional definition of art in the sixties.

According to George Dickie, the definition is based on the following considerations: First it needs an artist who knows how to produce works of art; a work of art is an artefact intended for presentation to the art public; the public is composed of a number of persons who are capable to a certain extent of understanding an object when it is presented to them; the art world is the totality of all the art world systems; an art world system is the frame in which a work of art is presented by an artist to the art public.[69] This view has been called cynical, but it merely lacked empirical substantiation.[70] In 1976 Brian O'Doherty traced the interaction of art and gallery space through the development of modern art. He described the white cube of the gallery as an aesthetic cult space with an intensified presence, and which sustains a closed system of values. The cult space is shut off from the outside world and protects the objects inside from being confused with objects in that outside world. Photographs of gallery rooms with objects on show but without visi-

tors present are, according to O'Doherty, the perfect documentation of this screening function. Several examples from the New York art scene in the early sixties show that the artists had recognized the function of the white cube and reflected it in their work.[71] However, El Lissitzky had already shown an artificial gallery space as a work of art in 1923 with his *Proun Space* (fig. 126), and Yves Klein's *Le vide* displayed the empty gallery as object in 1958.

In the cult rooms of the art system – the galleries and museums – a dual magical transformation takes place: the transformation of the objects into works of art and of actions into artistic activities, and the transformation of the protagonists into artists. But this account of the process needs to be supplemented by the distinction between "in-art" and "out-art", between art that is currently in fashion and art that is not. A few examples will suffice to explain this. Towards the end of the seventies New Expressionism, or the Neue Wilde, began to penetrate the "in" field of art, and displace Concept Art and related types. Subsequently, the Neue Wilde suffered the same fate, being displaced by Installation Art. The occupation of the "in" field appears to change at intervals of seven to eight years.

The "in" field is structured by relatively constant ideas on the authenticity of the arts, on innovation, the originality of the products, and on the inner compulsion and current relevance of the works of art; it also includes the seriousness of the artist and the quality and future promise of the products. If those who occupy the field change, these ideas are projected on to them and their output and become their qualities. The products become sacrosanct, and they are surrounded with taboos. These include touching them, speaking derogatively about them or disdaining them, and confusing them with everyday objects. In-art is active, it attracts artistic energies, it diffuses them and sets a framework and conditions for the products or the nature of the activities. The new producers have to supply an acceptable amalgam of originality (distinction) and redundancy (repetition), in order to gain access to the in-field. The in-field first creates art by integrating new products, and then by stimulating creative abilities, and finally it acts as a stimulus to rebellion for new occupants to enter the field.[72]

In 1974 Gerhard Hoehme published his serious and sarcastic advice to young artists.[73] Because their training leaves something to be desired and there is little public promotion, his first piece of advice is to latch on to the most up-to-date international trend immediately, in order to obtain the evidence of relevance and internationalism that is most effective in the provinces and will interest the media. The next step, and the one that will determine whether the artist is successful or not, is to be discovered by a major gallery; the artist has to plan this step very carefully. After that, all will depend on whether he succeeds in keeping himself in the public eye as a rising market value, by gallery representation, by producing masses of work, by exhibiting in public institutions and with artists associations, and by cultivating the image of a bohemian. The artist will not learn anything about his art from the public, the gallerist or the exhibition curator, and he will have

no time for artistic development, because he will be fully occupied in re-maining "in" the art trade and not being pushed out.

The suspicion that selection and occupancy of the in-field are manipulated frequently arises among those who are outside the system; those who are in it always deny there is any steering or control. It would be naive to deny that there are attempts at control, as political regimes have repeatedly practised this. But it is difficult to prove manipulation, and to distinguish between this and the launch of new movements. Alliances of artists, gallerists, exhibition curators, collectors and the media can effectively influence the system, but it may still be beyond their power to steer it permanently.

Art = Capital

The ranking list of artists published by the German business magazine *Capital* since 1970 (fig. 151) shows their market value. It is set out like a list of the top hundred sports stars but it still bears the rather modest name "Kunstkompass" (Art Compass), which Willi Bongard invented. The maga-zine advertises its list as exclusive information on the most celebrated art-ists of the day, and, as an extra bonus, their ranking in the artists' heaven, Olympus; there are also lists of rising stars and an appropriate offer of litho-graphs or multiples. The criteria for the valuation are, surprisingly, explained. Points are given according to solo or group exhibitions, articles in the re-spectable number of four periodicals or representation in a fictive museum staffed by experts selected from the art trade. The rank is then indisputable, being the result of a mathematical calculation, simply adding up the points.[74] The calculation conceals the fact that the very way the points are allotted is questionable.

But it would be impossible to be more objective. The only compromi-sing exception was to speculate on posthumous fame in the art trade, but this was soon abandoned as not serious enough. Participation in the 1992 Documenta, for instance, was awarded 500 points, but a solo show in the Museum of Modern Art in New York only 400, the same number as a solo show in the Museum of Contemporary Art in Los Angeles, while the County Museum in the same city earned only 300 points, exactly the same as the Kunstverein (Art Association) in Cologne. However, there appear to be even more strange valuations, for in 1995 wrapping up the Reichstag in Berlin earned a full 4,100 points, catapulting the artists from the shameful middle field to Place 19, although the Reichstag had not, until then, figured as a location for the assignment of points. But "today's most celebrated artists in the world" had to be acknowledged somehow, and they had to be shown to have earned the top number of points.[75] There was no other way.

Robert Rauschenberg was able to stay in Number One position from 1970 to 1978, but had to give way to Joseph Beuys in 1979. Beuys had perforce to be moved into the Olympus of immortality in the 1987 issue, although he had in fact abandoned art at the last moment, while Baselitz took

1. Rang
Zum fünften Mal hat der Amerikaner Bruce Nauman den ersten Platz im Kunstkompaß erobert. Seine beklemmende Kunst wird weltweit ausgestellt.

Bruce Nauman

2. Rang
Der deutsche Maler Gerhard Richter nimmt seit 26 Jahren im Kunstkompaß eine Spitzenposition ein. Seine komplexen Arbeiten sind im Kunsthandel hoch begehrt.

Gerhard Richter

3. Rang
Der experimentierfreudige Künstler Sigmar Polke mischt in seinen vielgesichtigen, höchst fantasievollen Werken unbeschwert Hoch- und Trivialkultur.

Sigmar Polke

Die 100 Größten

Rang 96	Rang 95	Name, Alter, Nation	Kunstrichtung	Gesamt-Punkte 1989-96	Punkte-zuwachs 95/96	Preis in TDM für mittleres Format	Preis/Punkte-Verhältnis	Preis-bewertung	Galerie-verbindung*
1	1	Nauman, Bruce, 54, USA	Prozeßkunst	25750	3050	140	5,4	sehr günstig	Fischer
2	2	Richter, Gerhard, 64, D	Neue Malerei	19790	3500	185	9,3	günstig	Jahn
3	3	Polke, Sigmar, 55, D	Neue Malerei	18580	3350	300	16,1	preisgerecht	Klein
4	4	Baselitz, Georg, 58, D	Gestische Malerei	17145	2300	160	9,3	günstig	Werner
5	11	Sherman, Cindy, 42, USA	Fotokunst	15500	3350	30	1,9	sehr günstig	Sprüth
6	8	Kabakov, Ilya, 63, GUS	Installationskunst	15400	2400	–	–	–	Jablonka
7	5	Boltanski, Christian, 52, F	Spurensicherung	14960	1450	58	3,9	sehr günstig	Klüser
8	7	Paik, Nam June, 64, Korea	Video Art	14760	1300	250	16,9	preisgerecht	Mayer
9	10	Förg, Günther, 44, D	Neo-Konzeptkunst	14725	2200	55	3,7	sehr günstig	Grässlin
10	9	Trockel, Rosemarie, 43, D	Neo-Konzeptkunst	14305	1350	35	2,4	sehr günstig	Sprüth
11	6	Kelley, Mike, 42, USA	Kritische Kunst	14150	650	85	6,0	sehr günstig	Jablonka
12	12	Kounellis, Jannis, 60, GR	Arte Povera	13455	1750	250	18,6	preisgerecht	Fischer
13	14	Rauschenberg, Robert, 71, USA	Pop Art	12535	1300	300	23,9	teuer	Mayer
14	20	Gober, Robert, 42, USA	Neo-Konzeptkunst	12500	1750	160	12,8	preisgerecht	Hetzler
15	22	Weiner, Lawrence, 56, USA	Konzeptkunst	12445	1850	42	3,4	sehr günstig	Fischer
16	19	Christo & Jeanne-Claude, 61, USA	Aktionskunst	12425	1600	184	14,8	preisgerecht	Juda
17	13	Holzer, Jenny, 46, USA	Kritische Kunst	12415	850	81	6,5	sehr günstig	Sprüth
18	21	Serra, Richard, 57, USA	Skulptur	12210	1550	185	15,2	preisgerecht	m
19	23	Buren, Daniel, 57, F	Konzeptkunst	11980	1450	75	6,3	sehr günstig	Buchmann
20	26	Oldenburg, Claes, 67, USA	Pop Art	11870	2100	350	29,5	sehr teuer	Pace Wildenstein
21	15	Koons, Jeff, 41, USA	Neo-Konzeptkunst	11865	850	185	15,6	preisgerecht	Hetzler
22	16	Kiefer, Anselm, 51, D	Neue Malerei	11625	750	500	43,0	sehr teuer	D'Offay
23	17	Merz, Mario, 71, I	Arte Povera	11620	750	125	10,8	günstig	Fischer
24	18	Lichtenstein, Roy, 73, USA	Pop Art	11365	500	550	48,4	sehr teuer	Strelow
25	28	LeWitt, Sol, 68, USA	Minimal Art	11330	1800	128,5	11,3	preisgerecht	Franck & Schulte
26	24	Gilbert & George, 53/54, GB	Konzeptkunst	11145	1200	105	9,4	günstig	Klüser
27	25	Kosuth, Joseph, 51, USA	Konzeptkunst	11075	1300	73	6,6	sehr günstig	Crone
28	27	Johns, Jasper, 66, USA	Pop Art	10850	1250	1625	149,8	sehr teuer	Castelli
29	29	Cragg, Tony, 47, GB	Neue Skulptur	10585	1200	70	6,6	sehr günstig	Buchmann
30	31	Bourgeois, Louise, 85, USA	Skulptur	10550	1750	255	24,2	sehr teuer	Greve
31	40	Schütte, Thomas, 42, D	Neue Skulptur	10160	2100	50	4,9	sehr günstig	Fischer
32	35	Darboven, Hanne, 55, D	Konzeptkunst	10140	1650	80	7,9	günstig	Busche
33	30	Smith, Kiki, 42, USA	Skulptur	10000	1050	69	6,9	sehr günstig	D'Offay
34	43	Gerz, Jochen, 56, D	Kritische Kunst	9815	1800	50	5,1	sehr günstig	Löhrl
35	33	Clemente, Francesco, 44, I	Arte Cifra	9715	1150	157,5	16,2	preisgerecht	Bischofberger
36	53	Wall, Jeff, 50, CDN	Fotokunst	9700	2200	150	15,5	preisgerecht	Johnen & Schöttle
37	39	Kirkeby, Per, 58, DK	Gestische Malerei	9570	1400	80	8,4	günstig	Werner
38	36	Long, Richard, 51, GB	Land Art	9460	1050	80	8,5	günstig	Fischer
39	57	Stella, Frank, 60, USA	Neue Abstraktion	9335	2050	590	63,2	sehr teuer	Strelow
40	41	Hill, Gary, 45, USA	Video Art	9250	1200	200	21,6	teuer	Young

* Die Künstler haben mehrere Galerieverbindungen; es wird nur eine angegeben.

151. The Top Hundred. List of today's leading artists, 1996, in: *Capital,* November 1996

over as Number One. In 1992 he lost the position to Bruce Nauman, who has since maintained it unrivalled, although he is actually producing distasteful works, "fearful installations thematizing violence". Perhaps that is why his work has continued to show a "very favourable" price/points ratio since 1996.[76] That should be considered as an investment advice, while Louise Bourgeois or Frank Stella, for instance, who are only in Places 30 and 39 respectively, might not be such good buys, as their price/points ratio is not nearly so advantageous. That does not apply to Cindy Sherman

226

and Rosemarie Trockel, who still have "very favourable" ratios, despite ascending to the Top Ten in 1996, while the terrible moralist Jenny Holzer has been falling back continuously after a brief leap on to Place 10 in 1993; her price/points ratio is probably still advantageous for that reason. However, a calculation made in 1995 showed that an investment in Joseph Beuys would only have yielded on average 9.4 percent a year, only slightly more than the German share index; but even that was nearly twice as much as shares in Andy Warhol would have made. Both were well outstripped by Mario Merz and Enzo Cucchi, who in turn were left far behind by Sigmar Polke, with the top yield of 30.1 percent. Even Anselm Kiefer, long fallen from the Top Ten to the still relatively significant Number 22, yielded excellent returns up to 1995, namely second best, and could be recommended unreservedly to the would-be purchaser. However, some caution is needed, for failure to sell at an auction would have fatal consequences, and this possibility cannot be entirely excluded.[77] Of greatest interest to speculators, of course, are the rising stars who were previously unknown; sometimes they are called "avantgarde", and if they rise particularly fast "shooting stars". But the cautions "golden rules for buying art", put something of a damper on the enticing prospect of profit. For liability-reasons these advise the purchaser to rely on his own eye, especially if he has a trained eye, or his own nose, and against buying art as a financial investment, because that spoils the fun, and art ought to be fun.[78] Nevertheless, the facts refute this reactionary maxim, for it should be a lesson to all to see how well one can fare with a shooting star on the lively London avantgarde scene, namely Rachel Whiteread (up from 103 to 79 in 1996). One simply has to be in front by a nose: "The collector, trendsetter and advertising giant Charles Saatchi made sure he obtained her objects at an early stage, in 1992, when he was able to get them cheap."[79]

Careers, rises and falls can be traced exactly. In 1979, Beuys not only gained top place, he also painted the obvious equation *Kunst = Kapital* (Art = Capital) in red, to the delight of the magazine *Capital*, to mark the tenth anniversary of its ranking list. Despite his spelling mistake, which rather indicates that he was just keeping a minimal distance, Beuys advanced to be the uncontested favourite of the business magazine, on earth and in heaven. Bruce Nauman took exactly 22 years to rise from being an unknown, low down on the list, when it was first drawn up in 1970 (though he was in the top hundred at Number 71) to Number One, and this may confirm the incredibly naive but fully justified view of Alan Bowness, former Director of the Tate Gallery in London, which almost exactly matches the views expressed in *Capital*.

In 1989 Bowness maintained that the success of an artist is predictable, contrary to the generally held view, and that the conditions for this can be described almost exactly.[80] His aim was to illustrate a fairly simple argument: the art of outstanding artists will inevitably become established, even if it takes some time for them to be recognized, for there are always artists and experts who are capable of identifying outstanding talent. Bowness

227

lists four factors: "peer recognition, critical recognition, patronage by dealers and collectors, and finally public acclaim".[81] Public reputation is the ultimate achievement, to have the public stream en masse to a one-man show proves the artist is outstanding. Bowness estimated the time needed to rise from bottom to top to be twenty-five years: "I think it takes about twenty-five years for the truly original artist to win public recognition."[82] Artists like Van Gogh deserve censure because they lost patience too soon. Bowness sees fame, the "genuine" artist and "great" art as all connected. How good the precisely calculated ranking list in *Capital* really is can be seen at a glance, for the crown witness for Bowness and Lawrence, David Hockney, discovered by them while he was still a student, only regained Place 64 in 1996 after a long decline, and has a very unfavourable price/points ratio; he is only a few places ahead of the new shooting star, Rachel Whiteread.

It must be admitted that the business magazine *Capital* is more cautious and realistic in its prognoses than leading museum people. The magazine avoids making statements on quality, and prognoses on future values are expressly limited to trivial predictions, such as that an artist will rise up the list when his participation in the next Documenta is announced. The quality of the magazine's assessments is manifest in that it does not regard the question of whether Nauman, Baselitz and Richter will still have "world and market status" in fifty years time as worth answering, while museum directors, who rely on a quality that is evident if not specifiable, often venture far into such uncharted waters, although this may be justified as an attempt at self-fulfilling prophecy or for purchase commissions. *Capital's* snap judgements are unparalleled and widely applicable. Georg Baselitz, for instance, rose from being the slightly antiquated "Patriarch of the Wild Style" (1993) to the much more worthy "Painter Prince" in 1996, although his rank did not change (Number 4). The other "star painters", Gerhard Richter and Sigmar Polke, are still above him, on Places 2 and 3 in 1996. This may constitute an advance for Polke, for he was still being called the "Alchemist" in 1993, although he had reached Number 3; at the same time the drop in his value was being regretted. *Capital* is very cautious about calling anyone a "genius", although the magazine let a self-declared genius, Markus Lüpertz, have a say in 1996, about the terms "artistic substance", "international career", "fashionable artist's apparel" and "genius". Sadly, the only one who lays claim to this is now Number 53, and falling. Star above prince, with genius thrust far down, betrays a surprisingly acute sensitivity to the time, there can be no doubt about that. According to *Capital* the stars prove indisputably that painting, pronounced dead by ill-wishers, can still offer rich rewards, and must be pronounced very much alive. This should encourage business enterprises to keep investing in art and embellishing their premises with it. Happily, they are clever enough to follow that advice, ennobling their property to the tune of 500 million a year. They can be well satisfied, not only with a monetary investment that is as safe as it is seemly, but also at being praised by *Capital*, though this

will only happen if they show some insight into what they are buying, and if they pay due regard to German art.[83]

It is not so difficult to develop the necessary insight, for *Capital* provides it in November each year. As well as its "stock market tips" the magazine tells us that a wide variety of "styles and directions" are to be found today, or it examines carefully whether the avantgarde are fulfilling their obligations: "The stylistic directions range from Gerhard Richter's painting, with its many layers of complexity, through the Neo-Expressive pictorial art of Georg Baselitz and the commercial art of Jeff Koons to the everyday objects and installations of Mike Kelley." The up-and-coming avantgarde cannot be blamed, although they are Americans, as they are obediently fulfilling the task allotted to them and "energetically contravening traditional expectations". We all know what happens then, even with the slightly obscene works of a Mike Kelley, who for that very reason is hot on the heels of Jeff Koons on the list: "The art trade, under attack, reacts to the bawdy onslaught with even stronger demand and stable prices."[84] That the old trick is still working is less astonishing than the fact that prices have remained stable instead of following market laws. This commentary must be an insider tip just short of illegality, and experienced free riders can have no trouble deciphering it.

Designing Experience, Installations

Designing experience means providing facilities, arrangements or objects that surprise the visitors to an exhibition by confronting them with an unexpected situation or involving them in a process and so giving rise to an experience. Experience design is not primarily intended to produce works of art with a traditional form of autonomy. Unlike the long-held view that the purpose is in the work itself, experience design regards the installations as a means of starting a process for the public. It entails the difficult change from being a passive observer to an active partner (if not necessarily an easy partner), and its objectives are participation and involvement through invitation, enticement, overpowering, shock and danger.

The preferred locations for the initiation of these processes have been, and still are, exhibitions. The visitors are invited by arrangements, objects and installations to take the opportunity and go through an experiential process. In doing so they will develop new activities or, at least, cease to be merely viewers (of the works) or spectators (of actions). So this is not only a new definition of the function of the artist, it is also a redefinition of the role of the recipient and the function of the objects, facilities or installations. In the history of the exhibition artist, the experience designer constitutes a new variant.[85]

This account of experience design can best be illustrated with a few examples. In February 1976 Richard Serra installed two rust-red steel plates in a blindingly white room in the Ace Gallery in Venice, Los Angeles. These plates were industrial products, each 305 x 792 x 1.5 cm and weighing

about 2,500 kg. One of the plates was laid on the floor, the other hung on the ceiling about four metres up; it was turned 90 degrees from the plate on the floor (fig. 152). The installation, which was named *Delineator,* functioned as the initiator of experience for the visitor when he stepped on to the plate on the floor and moved to its centre.[86] In a radio interview in February 1976 Serra described the experience he expected, and which would be not visual but spatial and physical: "There's a plate on the floor and a plate overhead. And a space is being generated by those two in position. When you're outside the plates, the overhead plate appears to press upward against the ceiling. That condition reverses itself as you walk underneath. There aren't any direct paths into it. As you walk towards its center, the piece functions either centrifugally or centripetally. You're forced to acknowledge the space above, below, right, left, north, east, south, west, up, down. All your psychophysical coordinates, your sense of orientation, are called into question immediately. That's not the same experience you have if you're trying to walk across the street in L.A., nor is it the same experience you have at 'Sight Point'.[87] Serra noticed during the interview that his remarks on the possible experience sounded esoteric and he tried to change this by reference to the difference between linguistic and spatial systems and, astonishingly, the difference between "descriptive" disciplines (philosophy and science) and "empirical" disciplines (art and religion).

Obviously, *Delineator* not only induced experiences of the system of coordinates and spatial levitation in the Ace Gallery, it also gave rise to fear and imagined risks; these were stronger for visitors who remembered their prox-

152. Richard Serra, *Delineator,* 1974-75

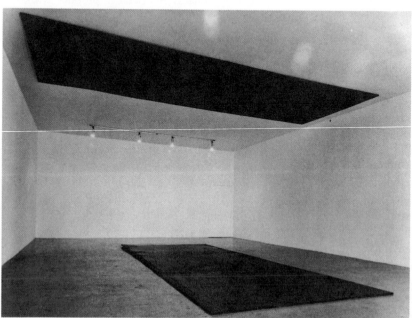

imity to the San Andreas fault. As one woman reviewer observed, many people avoided stepping under the suspended plate.[88] The critics recorded experiences analogous to the magic or mysterious ones Serra had referred to in his interview. But unlike the artist, they stressed the aggressive and provocative aspects of the installation.[89] The subsequent literature affirmed that *Delineator* and other installations by Serra provoked "experiences of existential threat", and it was maintained with some hesitation and scepticism that something like a religious aura could be felt. Some tried to provide the evidence that was lacking by relating Serra's work historically to the theory of the sublime, or at least to Kant's "negative pleasure".[90]

The problems revealed here are certainly not confined to Serra and his work. Firstly, an artist makes an installation that provokes feelings of helplessness, doubt or fear; then statements by the artist are published, in the catalogue or in interviews, as directions; they prepare visitors verbally for these experiences and lay down the linguistic context. The first problem is that of steering the participants, the second of giving rise to experience through aggressivity; there is a third problem, the nature of the experience that is to be provoked. Rebecca Horn's *The Chinese Bride* (fig. 153) of 1976 consists of a black hexagonal body nearly two and a half metres high with six narrow doors. It is a kind of cabin, though the artist calls it a temple. It contains a motor that will move the doors, and a tape recorder. The cabin or temple invites the visitor (to the exhibition) to enter freely, or to embark on an experiment. Stepping on to the floor of the cabin starts a programme that lasts for one minute. The artist herself wrote an extremely illuminating description of the sequence of experiences that someone trying out her arrangement can undergo: "A small black six-sided temple - all six doors stand open wide and wait for you to enter. Once you step on to the floor inside all the doors start to close, all at the same time, slowly, mechanically, and silently. The light around you is gradually withdrawn - darkness begins to envelop you. The real shock comes far too late, when you notice that you have entered a trap, you are shut in and cannot escape; the doors will not open. The all-too slow, smooth and natural movement of the doors - rather like the imitation of gentle breathing - could get the better of you, persuade you to stand in the room and wait. Enclosed in darkness, you try to keep your balance, you stand upright and feel the smooth polished walls in an attempt to find a hold. But suddenly you are surrounded by whispers in Chinese; a mysterious, confusing teasing and giggling distracts you, envelops you in growing confusion. Voices talk softly, they fill the narrow space, and finally they start to calm you, like the invisible breath of gentle music. You relax, it is more a yielding to the enforced situation of being shut in ... you submit to the darkness and the narrow space ... and then, much too suddenly, all the doors open and release you back into the blinding and disturbing light."[91]

What is important is the process, that is, the sequence of the participant's experiences as the mechanism runs through its programme. The temple invites the visitor to enter because it stands open. Then it turns into a trap,

153. Rebecca Horn, *The Chinese Bride*, 1976

is transformed into a dark prison, and then suddenly liberates him. The participant is outwitted by the invitation, totally isolated and shut in or imprisoned, delivered up to claustrophia. Orientation and balance are destroyed, then words he does not understand are mysteriously whispered at him weakening his resistance and inducing him to relax and surrender or submit. But hardly has that pleasant state been reached when the participant is thrust out into a light that he is now intended to experience as aggression (it is blinding). The imprisoned participant can interrupt the process at any time by activating the emergency exit button.

Bruce Nauman's *Dream Passage* (fig. 154) of 1983 confronts the person entering the narrow corridor with a different kind of experience.[92] The *Dream Passage* is constructed of slats and industrial wooden panels (fig. 155). It is twelve metres long and consists of a corridor that forms the entrance, a central cube, and a matching corridor opposite the entrance that concludes the arrangement. The entrance corridor with its bright yellow light, entices the visitor to enter and discover the central space. This is furnished with two tables and chairs in black steel. The first group is on the floor in the left corner at the entrance to the central room, the other is diagonally opposite, but inverted and attached to the ceiling. The lighting is red and white; it is part of the spatial inversion and is on both the floor and the ceiling. The final corridor, which is closed to prevent the visitor seeing down it, continues the inversion by having its lights on the floor or, to put it another way, having the ceiling where the floor usually is. The doubling and

inversion of the furniture and the lighting in the central room necessarily give rise to the discovery that one is in a three-dimensional formation with symmetrical points. Felix Thürlemann has given a precise analysis of the experiences here: the entrance zone, which reflects the spatial system of coordinates of the human body, confirms the spatial orientation. The symmetrical inversion in the central cube disrupts or shatters this in two ways. Firstly, it contradicts the real physical experience, and secondly, it can only be perceived visually and cognitively. *Dream Passage* thus has the effect of directing attention from the object back to the recipient, because the suprising or fantastic inversion (that is not possible in reality) creates the experience of having his (crucial and essential) spatial orientation undermined.[93]

Nauman's corridor installations raise the problem of steering the public or the performer. Nauman has commented a number of times on this problem, and in a review in 1988 he said: "The first corridor pieces were about having someone else do the performance. But the problem for me was to find a way to restrict the situation so that the performance turned out to be the one I had in mind. In a way, it was about control. I didn't want somebody else's idea of what could be done."[94] To describe his relationship to the public Nauman recalled the blind pianist Lenny Tristano who bombarded the public as if with blows, hitting the keys hard and playing without introduction or conclusion: "From the beginning I was trying to see if I could make art that did that. Art that was just there all at once. Like getting

233

154. Bruce Nauman, *Dream Passage*, 1983

hit in the face with a baseball bat. Or better, like getting hit in the back of
the neck. You never see it coming; it just knocks you down. I like that idea
very much: the kind of intensity that doesn't give you any hint of whether
you're going to like it or not."[95] The means by which Nauman aims to give
the public these blows or jolts are confusion, verbal attack, insults, disorien-
tation and shock.

155. Bruce Nauman, *Dream Passage*, outside view

Nauman totally rejects any kind of playful or uncontrolled participation on the part of the public, as Robert Rauschenberg envisaged in 1961 in *Black Market* (fig. 156).[96] Rauschenberg first presented *Black Market* as a "participation piece" in 1961 in the exhibition *Bewogen-Beweging* (Motion in Art) in the Stedelijk Museum in Amsterdam, and he showed it again the same year in the Leo Castelli Gallery in New York. *Black Market* is in two parts, a picture with instructions for movement and a suitcase that is connected to the picture. Numerous instructions invite the viewer to exchange things, keep making alterations and to document the changes. Any one of the four objects inside the case can be taken out and exchanged for any other object. It must be stamped with the same number as the object removed; moreover, a drawing of the new object is to be made in the book in the picture. The exchange ceased to operate because objects and drawings were removed.[97] The visitors who chose to pinch a piece of a Rauschenberg instead of transforming themselves into co-participants were reintroducing the old idea of art to this "participation piece".

Indeed, these installations, arrangements and objects are not fully removed from the relative autonomy which works of art are traditionally supposed to have when they are made into untouchable objects and surrounded with the appropriate taboos. Unlike the art works which claim autonomy, these experience facilities only function when they are used by active participants. Nevertheless, much of the gap between such arrangements and the traditional idea of the work of art is being closed and eliminated. The unsolved questions of copyright and reproduction fees, of insurance value and supervision mean that the designs for experience, stated to be incomplete by the artists,

156. Robert Rauschenberg, *Black Market*, 1961

are regaining the traditional status of art works that are fully protected and on which fees can be charged under intellectual property rights.

It is not enough just to analyse the new roles of the participants yet sustain the triangular relationship in the reception aesthetics of the artist, the work and the viewer.[98] Experience design redefines the roles of the artist and the viewer and the function of the objects or installations. The arrangements or installations that are intended to provoke experiences are incomplete without the activities of the participants. This involves more than Winckelmann's and Hegel's claim that sculptures and pictures need a viewer in order to live or to acquire an identity.[99] The visitors to an exhibition are now expected to give up the status of viewer for interaction with the installations or objects. If they do so they will find themselves directly involved in situations that can be unpleasant, alienating, dangerous or threatening, or appear to be so, or, if they agree to participate in an activity like stepping upon something or entering something, they can be manipulated. Opting for these new forms entails abandoning the aesthetics of the object for the aesthetics of a process, and seeing the process as the subject of criticism.[100]

Vito Acconci's installation *The People Machine* (fig. 157) in the Sonnabend Gallery in 1979 was intended as an extreme challenge to the visitor. Cables inside and outside the gallery kept aluminium plates suspended outside the windows. The interior cable led over the plates to an aluminium arch with a huge ball that was aimed at a blue swing and connected to a huge flag. A tape recorder endeavoured to activate the visitors by shouting

challenges and nonsensical encouragement at them. But intervening had consequences, for if one of the plates was removed all of them fell through the window, the ball shot away, the flag collapsed, and this paralysed any activity. Acconci's test question with this installation was whether the visitors could be driven to a destructive act by challenges or rage.[101] The art context functioned as the artist had expected, the visitors were inhibited, or they refused to fall into the trap and start the destructive mechanism working, and the result was a "frustrated action". In a fairly absurd interview in 1989 with Sylvère Lotringer, a Professor of Literature, Acconci could only give an affirmative answer to the question:"Is maybe simply fooling the public the function of art?" But he corrected the following question: "So the movement of the machine is the action by which you fool the public?" by saying: "by which the public agrees to the game".[102] The correction is more important than it seems, for it brings the old argument of consensus back into the aesthetic game.

In 1992/93 Ilya Kabakov (born in 1933) gave fifteen lectures in Frankfurt am Main on *The Total Installation*. At the beginning of the sixth lecture he assured his listeners that the active viewer formed the centrepiece of the total installation and everything was oriented towards him.[103] In an interview published in 1995 Kabakov stated that the relationship to the viewer was his motive for concerning himself with installations, on which he had been concentrating since 1988: "I can call this my inner, personal development. That is how the need arose to make installations, from a fundamental transformation of my relationship to the viewer. I personally have always thought that relying upon oneself is not a satisfactory approach, I was not satisfied with that ... This partner, this viewer, is not just someone to

157. Vito Acconci, *The People Machine*, 1979

whom I turn as prophet, professor or artist. I regard him as a friend, who can express himself in a passionate and objective way about my objects by looking at them attentively and utterly without prejudice."[104]

But Kabakov directs, steers, manipulates and forces this viewer-friend, and that control is the subject of essential considerations: "The reaction of the viewer on his way through the installation must be very carefully considered when it is being designed. How does one organize the attention so that it is not lost for a single moment? The loss of the viewer's attention is the end of the installation ... But even if the total installation only consists of a single room, and the viewer can grasp it all, apparently in a single moment, at one glance, the control one has thought out for his movement in this one room still plays a very important part. One achieves this 'control' of the viewer in two ways, and both use a hidden, fundamental rule that steers our attention when we enter any room: we leap constantly from the whole to the details and back to the whole" One procedure is to lead the viewer up to many small items using barriers and low walls, another is to force him to turn back repeatedly to the overall impression.[105] For Kabakov it was important to give the viewer or visitor the impression that he has arrived at a strange, inhabited and lively place, but that he does not fit in and is peering at a strange life. For Kabakov the installation is the most powerful means of making the viewer a chance observer or witness.

His installation *Community Kitchen* (fig. 158) of 1993/95 is accessible where it is installed, namely the Musée Maillol in Paris (Fondation Dina Vierny),

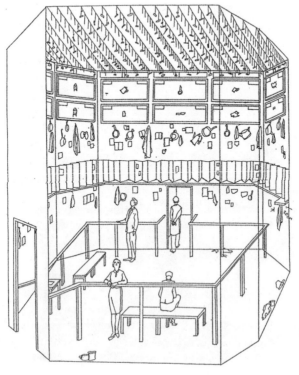

158. Ilya Kabakov,
Community Kitchen,
1991

down steps. Visitors descend the steps outside the box, which is about six metres high (and come up the other side) in order to enter through one of the two doors; the room inside is lit by two strong clear light bulbs and a narrow row of windows below the ceiling. The walls are ox-blood red up to eye level and light blue above that; a double row of panels goes right round the walls, with objects and cyrillic script (asking questions like: Who does this cup belong to?). The panel is dark green. Stretching around the whole room is a zig-zag folded paper panel showing photographs of the setting up and use of community kitchens in the Soviet Union. It also contains scraps of conversations. On the blue walls and on the green panels are kitchen utensils such as frying pans, lids, jugs and greaters. Innumerable objects, from spectacle cases to sausage skins hang on parallel lines of string from the ceiling, all labelled. *Community Kitchen* is silent, the only noises are those made by the visitors.[106]

In his installations Kabakov is not aiming simply to reconstruct these banal social rooms in a different cultural environment. He is trying to take the visitor into an interim state which he calls a state of semi-illusion, severance or half-dreaming. The visitors are to feel the burden of life in a suspended state, be here and there at once, recognize a familiar banality and feel out of place in it.[107] Unlike the total illusion of the panorama and the incredible fairytales of Disneyland, Kabakov's installations are intended to start a reflective process in the visitors by awakening their buried memories through the ordinary, everyday, bringing them back into their minds.[108]

In his fourteenth lecture in Frankfurt, which was devoted to installation as a place of ritual, Kabakov tried to describe an additional sensation, the emergence of which he could not explain by the procedure of appealing to social and cultural memory: "A great sensitivity, the introduction of individual subjective associations and memories that go far back, throughout the time spent in the installation, encourage the emergence of this additional sensation in the viewer. I myself sensed in my very first installation that this "additional product", which inevitably occurs, lends the total installation a certain standing and the significance of a ritual place."[109] This sensation leads to another conflict that cannot be eliminated, the conflict between interpreting the installation as banal or as a temple.[110] Kabakov describes constructive measures to create this other "religious" dimension – shutting off outer rooms, having one room for preparation, a centre, the lighting, the claustrophobic mood. But he dislikes calling the installations "religious places" or "temples" (with the exception of *Community Kitchen*, which was intended to be like a chapel) and he limits himself to the expression "ritual place".[111]

Artistic activities that are designed to create experience not only try to turn the visitors to exhibitions into participants, by using a wide variety of means they also tend to control the virtual participants temporarily. They isolate them, subject them to initiation rites, offer them sense perceptions of the most revolting or delightful kind, which normal life denies them, they give rise to claustrophic fears and the joy at liberation, they confuse the ele-

mentary sense of orientation by interchanging top and bottom, expose the visitors to seemingly real dangers, offer them salvation through trivial psychology, force them to submerge themselves their own memories and suggest transcendental experiences that can only be achieved outside the context of art at the price of a long rejected irrationality.

Experience design has become established as a complementary area in the civilized regulation and limitation of life. Wolf Vostell offered both political enlightenment and sense perception, Joseph Beuys wanted both to educate the visitors politically and create a mystical communication between the artist and the visitor to the exhibition, in order to intensify his installations.[112] Exhibitions and museums strengthen the status of a special place that is not only outside normal life (an old reproach) but offers unusual experiences. Robert Storr, who organized the exhibition *Dislocations* in 1991 in the Museum of Modern Art in New York, enthusiastically affirmed in the catalogue the function of the museum as the place where a visitor can be taken out of his accustomed environment and freed of himself: "To be moved by art is to be lifted out of one's usual circumstances and taken out of oneself, the better to look back upon the place one has departed and the limited identity one has left behind. With or without metaphysics, and for however brief a moment it lasts, this state may be fairly called transcendence. But where are we then? The museum is the modern paradigm of such a world apart. For some, its rooms enclose a higher spiritual region, in which case claims of transcendence may take on explicitly religious connotations. These spare and special precincts constitute a model for an otherwise unachievable human orderliness, as well as the site for rituals of meditation and adoration. Housing altars to pure intent and certain "quality", they are the uncluttered shrines for art's contemplation. To this way of thinking, art is both vehicle and destination, with the museum a protected and protective domain in which the transposition takes place. Even when conceived of in entirely secular or materialist ways, the museum as sanctuary exists in defiance of the flux outside the walls."[113]

However, cabins or temples, corridors or outsize pictures intended to be viewed from close up, all have the function of isolating individuals from the crowd of visitors to the exhibition and subjecting them to a controlled experience. The design of experience renews the power of art. But it again raises the question of the freedom of the viewer and the status of the artist. These problems are unsolved and the task must be returned to the artists. Nevertheless, the installations, more than other exhibition pieces, offer the possibility of realizing the so often propounded community of artists and public. Many installations activate the public and challenge them to active experiences which can range from sensual perception to reflection.

1 Montaiglon 1875-1909, vol. 1, p. 251: *XXV. Exposition d'ouvrage* (Deslibération des 5 février 1650 et janvier 1663). "Il sera tous les ans fait une assemblée générale dans l'Académie, au premier samedy de juillet, ou chacun des Officiers ou Académissiens seront obligés d'apporter quelque morceau de leur ouvrage, pour servir à décorer le lieu de l'Académie quelque jours seulement et après les remporter, si bon leur semble, auquel jour se fera le changement ou élection desdits Officiers, si aucun sont à élire, dont seront exclus ceux qui ne présenteront point de leurs ouvrages, et seront conviés les Protecteurs et Directeurs d'y vouloir assister." - Koch 1967, pp. 127-183; Schnapper 1990.

2 Fréart de Chantelou 1981, pp. 156-159.

3 Heinich 1993, p. 32.

4. Cf. the account of the 1667 exhibition in Testelin 1680, Foreword, and the account of the *Exposition des Ouvrages de Peinture et de Sculpture par M.rs de l'Academie dans la Galerie du Louvre en 7.bre.* (1699) in the 1700 Almanach : Almanachs 1995, no. 39, pp. 116-117.

5. 'Description abregée des Tableaux qui ont été exposez à l'Académie de Peinture et de Sculpture', in: *Mercure de France,* June 1735, 2 vols., pp. 1383-1388, cf. pp. 1387-1388: "Nous prendrons la liberté d'ajoûter au Memoire qu'on vient de lire, auquel nous n'avons aucune part, que cette exposition de Tableaux, quoiqu'en très-petite quantité et par un très-petit nombre d'Académiciens, n'a pas laissé d'attirer dans les Salles de l'Académie, un concours considérable, des Gens de l'Art, des Connoisseurs et des Amateurs, qui ont marqué beaucoup d'empressement et d'ardeur pour la Peinture, la Sculpture, la Gravûre, &c. Cet empressement semble demander hautement une exposition publique des Ouvrages de notre Académie, dont le Public n'a pas été gratifié depuis très-long-temps, malgré l'exemple fréquent qu'en donnent les Académies d'Italie. Outre le plaisir et la magnificence du Spectacle, on laisse à juger de l'utile émulation que cela donne pour l'avancement des Arts et la perfection du goût." - Deloynes 1980, no. 1198; Dresdner 1915 (1968), p. 123.

6. Harris/Nochlin 1976, pp. 36-38. - It is clear from the livrets for the Salons that most of the women artists concentrated on portraiture.

7 Legrand 1995; Koch 1967, pp. 149-157.

8. In 1759 7,227 copies of an edition of 8,100 were sold and 457 given away. In 1781 17,550 copies were sold and 565 given away out of an edition of 18,424; Sandt 1986.

9. Koch 1967, pp. 10-43; 100-123.

10. Guiffrey 1915; Guiffrey 1872; Koch 1967, pp. 167-171.

11. Dorbec 1905.

12. Livret du Salon 1699, pp. 3-4, reprint Catalogues of the Paris Salon 1977-78, vol. 1: "Monsieur Mansard Surintendant & Ordonnateur general des Bâtimens du Roy & Protecteur de l'Académie, ayant representé à Sa Majesté que les Peintres & Sculpteurs de son Académie Royale, auroient bien souhaité renouveller l'ancienne coûtume d'exposer leurs Ouvrages au Public pour en avoir son jugement, & pour entretenir entre eux cette louable emulation si necessaire à l'avancement des beaux Arts, Sa Majesté a non seulement approuvé ce dessein, mais leur a permis de faire l'exposition de leurs Ouvrages dans la grande Gallerie de son Palais du Louvre" - Livret du salon 1737, p. 5, reprint Catalogues of the Paris Salon 1977-78, vol. 2: "La Protection singuliere dont le Roy a toujours honoré l'Académie Royale, & son goût décidé pour les beaux Arts, ne pouvoient mieux se manifester que par les ordres qu'il a donnez de faire une Exposition de Tableaux & Sculptures, dans le grand Salon du Louvre. L'attention de ce sage Monarque, pour entretenir l'émulation entre les habiles Peintres & Sculpteurs de son Royaume, n'a d'effet & la suite d'un ministre qui sera à jamais l'ornement de l'Histoire, comme il fait le bonheur des Peuples. Le Public aussi éclairé qu'équitable, en prenant part à la célébrité de la Fête, reverra avec plaisir, les travaux des Excellens hommes, qui ont déja merité ses suffrages, & connoîtra par les progrès successifs de leurs talens, qu'ils ont formé ceux dont les Ouvrages paroissent pour la premiere fois dans ce lieu consacré aux Muses."

13. Livret du Salon 1745, p. 5, reprint Catalogues of the Paris Salon 1977-78, vol. 2: "Rien n'est si capable d'exciter l'émulation parmi les Arts, & d'éveiller, pour ainsi dire, les talens, que les Expositions publiques: où la verité débarrassée des égards dûs à la societé civile, dispense avec liberté la loüange & la censure, & fait appréhender aux plus fameux Artistes la sévérité de ses jugemens. Telle a été aussi l'intention de SA MAJESTÉ, & les vûes du Ministere. Le succès a répondu à un projet si juste & si beau. Chaque Académicien, animé par la gloire, s'est efforcé de sou-

tenir la superiorité presente de l'Ecole Françoise sur toutes celles de l'Europe, & les Etrangers ont paru en faire un aveu flateur, par le plaisir qu'ils ont pris à ces différentes Fêtes. Celle-ci ne sera point inférieure aux autres; puisqu'indépendamment des Ouvrages pour le Roy, le Public y verra aussi ceux qu'il a fait faire, ou qui lui sont destinez. Ce mêlange qui réünit la Peinture, la Sculpture & la Gravûre, paroîtra aux yeux des vrais Connoisseurs, comme un Parterre agréable, dirigé par le goût, & cultivé par les Muses."

14. Wrigley 1993, plates I-VIII; Koch 1967, figs. 87-92.

15. Crow 1985, pp. 1-22; Wrigley 1993, pp. 97-119.

16. Crow 1985, pp. 1-22; Wrigley 1993, pp. 97-119; Livret du Salon 1745.

17. Reynolds Catalogue 1986, no. 175, pp. 365-366.

18. Schneemann 1994, pp. 58-70; La Font de Saint-Yenne 1754 (1970), pp. 108-111.

19. Livret du Salon 1745, p. 5, reprint Catalogues of the Paris Salon 1977-78, vol. 2.

20. Livret du salon de 1793, pp. 78-81, 24 exhibits are listed, two years later the number had grown to 63; Catalogue of the Paris Salons 1977-78, vol. 1793/1795.

21. Gallet 1979, p. 6: "En 1760, en marge du Salon qui se tenait au Louvre, De Wailly exposait dans un stand personnel au Jardin de l'Infante. Là, caché derrière un rideau, il écoutait les réflexions des visiteurs. Il savait que le public des Salons, ces biennales officielles de l'Académie de peinture, était le plus averti, le plus apte à reconnaître la valeur de ses projets et à en favoriser l'exécution, en des temps déjà difficiles. La profession d'architecte était aussi encombrée que les constructions publiques étaient peu nombreuses." - I am grateful to Georg Germann for drawing my attention to architects exhibiting their projects, cf. Germann 1980; Koch 1967, p. 152; Diderot 1975, vol. 4, pp. 353-353, 366.

22. Encyclopédie Méthodique 1788, Art. 'Exposition' vol. 1, p. 272: "L'ignorance multiplie, dans ces occasions, les jugemens absurdes; & c'est du concours des jugemens du goût, & de l'ignorance, que se forme celui qui donne aux vraix talens la place qu'ils méritent. Ces expositions ont un autre avantage; celui d'entretenir l'émulation qui s'affoibliroit dans le calme des ateliers. Chaque artiste redouble d'effort, parce qu'il sait que le public doit le comparer avec ses rivaux." - Cf. Dictionnaire 1792, vol. 1, pp. 219-220. - The first discussion of exhibitions in a major reference work is in the two *Beaux-Arts* volumes of the *Encyclopédie Méthodique,* which Panckoucke published in Paris in 1788. In the article on Exposition, Pierre-Charles Lévesque distinguishes between displaying a picture at the place for which it was intended, and a public exhibition. As examples of the latter he cites the Paris Salons, the exhibitions of the Royal Academy in London, and the exhibitions held by painters in Antiquity. Encyclopédie Méthodique 1788, Art. 'Exposition', vol. 1, p. 272; article reprinted in: Dictionnaire 1792, vol. 1, pp. 219-220. - Neither Diderot's and d'Alembert's *Encyclopédie* nor Sulzer's *Allgemeiner Theorie* of 1771/74 includes such an entry.

23. The exhibition of the royal collection in the Palais du Luxembourg was probably due to the criticism from La Font de Saint-Yenne 1747 (1970), p. 40, and the proposal from Charles Coypel in the same year, cf. McClellan 1984 and 1994.

24. Encyclopédie 1751-80, vol. 12, 1765, Art. 'Peintre', pp. 252-267: "Les ouvrages des grands maîtres n'étoient alors point regardés comme des meubles ordinaires, destinés pour embellir les appartemens d'un particulier; on les réputoit les joyaux d'un état & un trésor du public, dont la jouissance étoit dûe à tous les citoyens. Qu'on juge donc de l'ardeur que les artistes avoient alors pour perfectionner leurs talens, par l'ardeur que nous voyons dans nos contemporains pour amasser du bien, ou pour faire quelque chose de plus noble pour parvenir aux grands emplois d'un état." - Sulzer 1771/74, vol. 2, art. 'Künste, Schöne Künste', pp. 609-625; Sulzer 1792-94, vol. 3, pp. 72-98. - Musées en Europe 1995.

25. Cantarel-Besson 1981; McClellan 1994, pp. 91-154. - On Vivant Denon: Lelièvre 1993; Sollers 1995.

26. Musées de France 1994, pp. 269-277.

27. Schneemann 1994, esp. Ch. 3: Das Publikum, pp. 55-93; Wrigley 1993, esp. Ch. 3: In Search of an Art Public, pp. 97-119; Crow 1985; Mattenklott 1984; Kemp 1989; Fried 1980; Dresdner 1915 (1968), esp. pp. 106-107. - On modern studies: Bourdieu/Darbel 1969; Bourdieu 1979; Gamboni 1983.

28. Ovid, Metamorphoses, lib. X, 243-297; Blühm 1988; Carr 1960; Schneider 1987. - Dinter 1979.

29. Sulzer 1792-94, vol. 1: art. 'Bewundrung', pp. 396-398; Encyclopédie 1751-80, 1. suppl. vol., art. 'Admiration', pp. 170-171: "un sentiment vif qui s'élève dans l'âme à la contemplation

d'un objet qui surpasse notre attente." - Home 1772, vol. 1, pp. 344-345.

30. In the catalogue for the Salon of 1763 Falconet said of his work: "Un Groupe de marbre, représentant Pigmalion aux pieds de sa Statue, à l'instant où elle s'anime." Cf. Explication 1763, no. 165, p. 33; Schneider 1987. - The title *Pygmalion and Galathea* is new. Cf. Meyer 1971.

31. Diderot 1975, vol. 1, pp. 245-247: "Un genou en terre, l'autre levé, les mains serrées fortement l'une dans l'autre, Pygmalion est devant son ouvrage et le regarde ... O Falconet! comment as-tu fait pour mettre dans un morceau de pierre blanche la surprise, la joie et l'amour fondus ensemble? Emule des dieux, s'ils ont animé la statue, tu en as renouvelé le miracle en animant le statuaire. Viens, que je t'embrasse; mais crains que, coupable du crime de Prométhée, un vautour ne t'attende aussi." Diderot Catalogue 1984, no. 131, pp. 451-454.

32. Diderot Catalogue 1984, no. 124, pp. 434-436. - On the myth of Prometheus see Steiner 1991.

33. "Oh! que la condition d'un artiste est malheureuse! Que les critiques sont impitoyables et plats!" Friedrich Melchior Baron von Grimm, editor of the *Correspondance littéraire,* inserted a critical comment on the philosopher's verdict and on Falconet's work at this point; Diderot, 1975, vol. 1, p. 246.

34. Diderot 1975, vol. 1, pp. 246, 247: "Si ce groupe enfoui sous la terre pendant quelques milliers d'années venait d'en être tiré avec le nom de Phidias en grec, brisé, mutilé dans les pieds, dans les bras, je le regarderais en admiration et en silence. - Pygmalion tiendrait son ciseau de la main droite et le serrerait fortement; l'admiration embrasse et serre sans réflexion ou la chose qu'elle admire ou celle qu'elle tient."

35. Winckelmann 1759; cf. Winckelmann 1968, pp. 169-173. - Winckelmann calls the famous piece *The Torso by Michael Angelo.* - Winckelmann only published the *Idealische Beschreibung* and left out the stylistic and art historical analysis, which should have formed the supplementary second part. The artistic description is also only indicated in *Geschichte der Kunst des Althertums,* cf. Winckelmann 1764, pp. 368-369. In 1765 Diderot discussed Winckelmann's 'Beschreibung' in detail in his introduction to sculpture in the Salon report: Diderot 1975, vol. 2, pp. 206-212. Justi 1956, vol. 2, pp. 51-86, esp. pp. 71-75; Szondi 1974, pp. 30-46. - On Winckelmann's description of the Apollo see Zeller 1955. - Füssli 1766. - As early as 1764 Winckelmann was praising the young man, who was then not yet twenty, a cousin of the future painter Henry Fuseli (1741-1825), as the rising star of art history, who could give his native land all the service it could desire. Justi 1956, vol. 3, pp. 70-74. - The Niobe Group was recovered in Rome in 1583 and purchased the same year by Cardinal Ferdinando de' Medici. After its restoration it was placed in the garden of the Villa Medici until 1769; then it was taken to Florence and exhibited until 1781 in the Uffizi in a room specially prepared for it; Haskell/Penny 1981, no. 66, pp. 274-279; Bätschmann 1992.

36. Winckelmann, 'Entwürfe zur Beschreibung des Torso im Belvedere im Florentiner Manuskript', in: Winckelmann 1968, p. 281: "Bey dem ersten Anblick dieses Stückes wird man nichts anderes gewahr als einen fast ungeformten Klumpen Stein, aber so bald das Auge die Ruhe angenommen, und sich fixiret auf dieses Stück, so verliehret das Gedächtniss den ersten Anblick des Steins und scheinet er weichliche zarte Materie zu werden. - Mich deucht, es bilde mir der Rücken, welcher durch hohe Betrachtungen gekrümmet scheinet, ein Haupt, welches mit einer frohen Erinnerung seiner erstaunenden Thaten beschäfftiget ist; und indem sich so ein Haupt voll von Majestät und Weisheit vor meinen Augen erhebet, so fangen sich an meinen Gedanken die übrigen mangelhaften Glieder zu bilden: es sammlet sich ein Ausfluss aus dem Gegenwärtigen und wirket gleichsam eine plötzliche Ergänzung. - O möchte ich dieses Bild in der Grösse und Schönheit sehen, in welcher es sich dem Verstande des Künstlers geoffenbaret hat, um nur allein von dem Ueberreste sagen zu können, was er gedacht hat."

37. Winckelmann 1764, pp. 430-431. Winckelmann is referring to the daughter of the Corinthian potter Dibutades, one of the inventors of the art of drawing, who drew a silhouette of her departing lover from which Dibutades made a relief portrait in profile; cf. Pliny 1978, lib. XXXV, 151, pp. 108-109.

38. Winckelmann 1764, p. 156.

39. Cf. Winckelmann's description of the Apollo in Belvedere in: Winckelmann 1764, pp. 392-394, esp. this passage: "Ich vergesse alles andere über dem Anblicke dieses Wunderwerks der Kunst, und ich nehme selbst einen erhabenen Stand an, um mit Würdigkeit anzuschauen. Mit Verehrung scheint sich meine Brust zu erweitern und zu erheben, wie diejenige, die ich wie vom Geiste der Weissagung aufgeschwellet sehe, und ich fühle mich weggerückt nach Delos und in

die Lycischen Hayne, Orte, welche Apollo mit seiner Gegenwart beehrete: denn mein Bild scheint Leben und Bewegung zu bekommen, wie des Pygmalions Schönheit." - On the sketches: Winckelmann 1968, pp. 267-279.

40. On the restriction of the fine arts to the depiction of a single moment: Félibien 1669 (1972), pp. 202-207; Du Bos 1719 (1733), vol. 1, pp. 265-272; Du Bos 1993, pp. 90-92.

41. Lessing 1766, Ch. XVI.

42. Lessing 1880, Ch. III, p. 164-165; transl. by the Rt. Hon. Sir Robert Phillimore, D.C.L., 1874, p. 28f.; cf Ch.. XVI, p. 251: "Die Mahlerey kann in ihren coexistirenden Compositionen nur einen einzigen Augenblick der Handlung nutzen, und muss daher den prägnantesten wählen, aus welchem das Vorhergehende und Folgende am begreiflichsten wird."

43. Diderot 1959, pp. 665-740: "Une composition, qui doit être exposée aux yeux d'une foule de toutes sortes de spectateurs, sera vicieuse, si elle n'est pas intelligible pour un homme de bon sens tout court.." - On the composition of the text cf. pp. 659-663: a *Traité de peinture* was written in 1766 and was published in the Correspondance littéraire the same year. *Essais de peinture* appeared in 1795. Goethe read the text in 1796, handed it on to Schiller and published his German translation with comments. See 'Diderots Versuch über die Malerei' [1799], in: Goethe 1954, pp. 201-253; Vasco 1978, pp. 4-5.

44. Diderot 1975, vol. 2, p. 155. Grimm inserted his comment after Diderot's discussion of *Mère bienaimée* by Greuze. On the growing popularity of tableaux vivants and their double meaning: Holmström 1967; Langen 1968, and in: Langen 1978, pp. 292-353; Miller 1972; Dahlhaus 1989; Bätschmann 1992.

45. On *Wahlverwandtschaften:* Fries 1975, pp. 90-130; Elm 1991; Faets 1993. - On the puppet theatre see Kleist 1967.

46. Bätschmann 1986, pp. 147-149.

47. Hegel undated, vol. 1, p. 158.

48. Pevsner 1946, pp. 39-42. In 1769 Joseph Wright of Derby (1734-1797) exhibited his painting *The Academy by Lamplight* at the London Society of Artists. It shows a figure on a pedestal in a vaulted room, surrounded by a group of young men admiring and drawing it. The artificial light, the source of which is hidden behind a curtain, bathes the group in a warm, reddish light. The statue is a plaster cast of *The Nymph with a Shell* in the Louvre, which was in the Villa Borghese in Rome until 1808 and Wright is making the point that under the artificial light the statue can hardly be distinguished from the students' real flesh. Half hidden in the shadows is a copy of The Gladiator, which Wright used in 1765 to illustrate the practice of studying by candlelight. Wright of Derby Catalogue 1990, no. 23, pp. 63-64, cf. no. 22, pp. 61-62: *Three Persons Viewing the Gladiator by Candle-Light,* 1765. Wright's students are probably drawing *The Nymph with a Shell* in an imaginary gallery, not the sculpture gallery owned by the Duke of Richmond in Whitehall, which had been available for the purposes of study since 1758. Haskell/Penny 1981, no. 67, pp. 280-282, now in the Louvre. - Neo-Classicism 1972, no. 282, p. 180.

49. Goethe, *Italienische Reise* [1816-29]; Goethe 1949-60, vol. 11, 1950, pp. 439-41, transl. by W.H. Auden and Elizabeth Mayer, 1970, p. 421. Heinrich Meyer thought the practice of visiting museums by torchlight was still relatively new in the 1780s. He thinks torchlight is a good idea for statues that are in bad light, like the *Laocoon* and the *Antinous,* but warns against the misuse of a new fashion and points out the disadvantages with works that are of lesser quality or not created to take account of light and shade. Engl. loc. cit., see also Meyer 1886, with a bibliography of Meyer's writings, pp. LI-CLXVIII. - Cf. Moritz 1792-93 (1973), vol. 1, pp. 165-166.

50. Jacques-Louis David's exhibition of *The Oath of the Horatii* in his studio in Rome in 1785 was an international success; Tischbein 1922, pp. 212-213. On David's exhibition in Rome see Crow 1978. - Sickler/Reinhart 1810/11, vol. 1, p. 286: "In der Republik der bildenden Künstler in Rom ist es eingeführt, dass jedes bedeutende Kunstwerk bald nach seiner Vollendung dem künstlerischen oder dem kunstliebenden Publicum öffentlich ausgestellt wird. Diess geschieht entweder im dem Atelier des Künstlers selbst, oder in grossen Sälen oder in Kirchen."

51. Staël undated, pp. 185-186. - Cf. Staël 1850, p. 168: "Corinne et lord Nelvil terminèrent leur journée en allant voir l'atelier de Canova, du plus grand sculpteur moderne. Comme il était tard, ce fut aux flambeaux qu'ils se le firent montrer; et les statues gagnent beaucoup à cette manière d'être vues. Les anciens en jugeaient ainsi, puisqu'ils les plaçaient souvent dans leurs thermes, où le jour ne pouvait pas pénétrer. A la lueur des flambeaux, l'ombre plus prononcée amortit la brillante uniformité du marbre, et les statues paraissent des figures pâles, qui ont un caractè-

re plus touchant et de grâce et de vie." - Inevitably, Corinna, stimulated by the greater grace and living quality of the statues, sees a similarity between Canova's *Spirit of Mourning* and Oswald Nelvil. The surprised sculptor admits this, but Lord Nelvil is disconcerted, because it reminds him of the state of mind from which Corinna has freed him. Mme de Staël's reference to the same practice in Antiquity was the general belief. It was supported by a remark by Pliny that Parian marble was cut by artificial light and regarded as containing light, cf. Griener 1989.

52. "Per potermi dare il suo sentimento con più estensione, e secondo il mio desiderio, io la inviterei a voler vedere ed esaminare la statua a lume di notte con torcia accesa." Cf. Griener 1989; Fernow, 'Über den Bildhauer Canova und dessen Werke', in: Fernow 1806-08, vol. 1, pp. 11-248. - Pavanello 1976, no. 145, p. 110.

53. Whiteley 1975; Europa 1989, no. 482, pp. 353-354.

54. Matthew 1822, vol. 1, pp. 143-144: "Abends ging ich mit einer grossen Gesellschaft, unter welcher Thorwaldsen war, den Vatikan bei Fackelschein zu besehen. Das ist durchaus nothwendig, wenn man das Verdienst dieser Statuen gehörig schätzen will; denn sie wurden für den Fackelschein als ihr eigenthümliches Element geschaffen, und die Abwechslung von Licht und Schatten, welche dadurch hervorgebracht wird, erhöht die Wirkung ausserordentlich. Es ist ein ähnlicher Unterschied zwischen den Statuen beim Tageslichte und beim Fackelscheine, wie zwischen einer Probe des Vormittags und einem erleuchteten Theater Abends." - See also the report on Towneley's Gallery in the *General Chronicle and Literary Magazine, 1811:* "Lamps were placed to form the happiest contrast of light and shade, and the improved effect of the marble amounted by this almost to animation ... To a mind replete with classical imagery the illusion was perfect."

55. Bonaventura 1945, pp. 195-203.

56. The Society for the Encouragement of Arts, Manufactures and Commerce - abbr. Society of Arts - received the royal privilege in 1908, and uses the abbreviation RSA as well as its original name. Its offices are in the house built by John Adam in 1774 in what is now John Adam Street in London. On the history of the Society of Arts: [Anonym] *A concise account of the rise, progress, and present state of the Society for the encouragement of arts [&c] by a member of the said society,* London 1763; Ackermann 1808-10 (1904), pp. 47-72; Allan/Abbott 1992; Allan 1966; and the many 'Studies in the Society's History and Archives', published since 1958 in: *Journal of the Royal Society of Arts.*

57. RSA Archive, Minutes of the Committee of Polite Arts, vol. 19, 1773-74; Barry 1783 (1), reprint of the minutes, pp. 207-216, p. 212: "That if ten eminent artists can be found, who are willing to paint the above Pictures, that the Society should allow them the profits arising from an exhibition of them, in their New Room, for a proper limited time in one year, in order, in some measure, to indemnify them for their time and trouble."

58. Barry 1783 (1), pp. 207-209: " ... that it would become us jointly to undertake the decorating this chapel with pictures; that it afforded a good opportunity of convincing the public of the possibility of ornamenting places of religious worship, with such pictures as might be useful, and could possibly give no offence in a Protestant country; that probably, this example would be followed in other chapels and churches; that it would be opening a new and noble scene of action" Reynolds thought it would be better to decorate St Paul's Cathedral. Cf. RSA Archive, Barry Letter Books, vol. I, pp. 5-10, 6 and 13 February 1782; Barry 1809, vol. 1, pp. 243-245 (letter from Barry to the Duke of Richmond, giving details of the intended decoration); Postle 1995, pp. 161-167.

59. Green 1782, pp. 37-40; Hutchison 1968 (1986), p. 41, meely touches on the idea, no details are known about the financial conditions; Green 1782, p. 38, says: "But, by a fatality of the British Arts, not only St. Paul's Cathedral has been deprived of a noble benefaction of Paintings, to which the Royal Academy had proposed to present it"

60. Green 1782, p. 52: "It may not, however, be improper to notice, that this Work has rose out of the ruins of the rejected proposal for the decorating of St. Paul's Cathedral"

61. Barry 1783 (1), p. 215; RSA Archive, Barry Letter Books, vol. I, pp. 5-10.

62. Ackermann 1808-10 (1904), pp. 66-68; Luckhurst 1951, pp. 22-27; Solkin 1993, pp. 157-175.

63. Graves 1907 (1969); Solkin 1993, pp. 157-213. - The artists, who remained in contact with The Society for the Encouragement of Arts, Manufactures and Commerce for a time, included the charitable purpose in the name of their society: Free Society of Artists associated for the Relief of distressed Brethren, their Widows and Orphans. The group's last exhibition was

held in 1764 in the rooms of the Society of Arts; cf. Luckhurst 1951, pp. 30-31; Allan/Abbott 1992, p. 2.

64. Catalogue of the Pictures 1762: "The public may justly require to be informed of the nature and extent of every design, for which the favour of the public is openly sollicited. The artists, who were themselves the first projectors of an Exhibition in this nation, and who have now contributed to the following catalogue, think it therefore necessary to explain their purpose, and justify their conduct. An Exhibition of the works of art, being a spectacle new in this Kingdowm, has rais'd various opinions and conjectures among those who are unacquainted with the practice in foreign nations; those, who set out their performances to general view, have been too often consider'd as the rivals of each other, as men actuated, if not by avarice, at least by vanity, and contending for superiority of fame, tho' not for a pecuniary prize. It cannot be denied or doubted, that all who offer themselves to criticism are desirous of praise; this desire is not only innocent but virtuous, while it is undebased by artifice and unpolluted by envy; and of envy or artifice the men can never be accused, who, already enjoying all the honours and profits of their profession, are content to stand candidates for public notice, with genius yet unexperienced, and diligence yet unrewarded; who, without any hope of encreasing their own reputation or interest, expose their names and their works only that they may furnish an opportunity of appearance to the young, the diffident, and the neglected. The purpose of this Exhibition is not to enrich the Artists, but to advance the Art; the eminent are not flatter'd with preference, nor the obscure insulted with contempt; whoever hopes to deserve public favour is here invited to display his merit. Of the price put upon this Exhibition some account may be demanded. Whoever sets his works to be shewn, naturally desires a multitude of spectators, but his desire defeats its own end, when spectators assemble in such numbers as to obstruct one another. Thou' we are far from wishing to diminish the pleasures, or depreciate the sentiments of any class of the community, we know however, what every one knows, that all cannot be judges or purchasers of works of art; yet we have already found by experience, that all are desirous to see an Exhibition. When the terms of admission were low, our room was throng'd with such multitudes as made access dangerous, and frightened away those, whose approbation was most desired. Yet because it is seldom believed that money is got but for the love of money, we shall tell the Use which we intend to make of our expected profits. Many artists of great abilities are unable to sell their works for their due price; to remove this inconvenience, an annual sale will be appointed, to which every man may / send his works, and send them if he will without his name. These works will be review'd by the committee that conduct the Exhibition. A price will be secretly set on every piece, and register'd by the secretary. If the piece exposed is sold for more, the whole price shall be the Artist's, but if the purchasers value is at less than the committee, the Artist shall be paid the deficiency from the profits of the Exhibition." - The text is not by Samuel Johnson, as assumed by Solkin 1993, pp. 176-179.

65. Hutchison 1968 (1986), pp. 15-44, esp. p. 31; Barry 1783 (1), p. 99.

66. Barry 1783 (1), pp. 216-217.

67. Pressly 1981, no. 36, p. 236; Pressly 1983, no. 85, pp. 141-142.

68. Barry 1775; cf. Barry 1783 (1), pp. 3-4: dedication to King George III., and pp. 5-39: 'Introduction'; Dobai 1974-84, vol. 2, pp. 827-831; Barrell 1986, pp. 165-173.

69. Barry 1783 (1), pp. 7-21, p. 7: "The servile, trifling views of the public, the particular patrons, or more properly the employers of the artists p. 16: However, the mischief that may be done in this way will be of short duration, when the real artist will recollect, that he is bound in duty, both to God and his country, to make head against all fraud and wrong, whatever it may cost him; our duty is easily seen, and ought to be, it not joyfully accepted, at least respectfully submitted to; whether we are martyrs or conquerors, can be no part of our concern, as it does not depend upon us; for the ends of Providence are answered sometimes one way, and sometimes the other."

70. Barry 1783 (1), pp. 40-41, and the following detailed description and interpretation of the individual pictures pp. 42-205; Allan 1974/75, pp. 100-109, pp. 98-107; Pressly 1981, nos. 22-27, pp. 233-234, pp. 86-122; Pressly 1983, pp. 79-90; Drechsler 1996, pp. 25-44.

71. Allan 1974/75, pp. 100-109, 98-107; Pressly 1981, pp. 113-119; Pressly 1983, pp. 79-100; Drechsler 1996, pp. 23-44.

72. RSA Archive, Barry Letter Books, vol. I; cf. Minutes of the Committee for Polite Arts, 1774-1775, 1777; Minutes of the Society 1777.

73. Barry 1809, vol. 1, pp. 253-256; Pressly 1981, pp. 86-92.

74. Barry 1809, vol. 1, p. 273, vol. 2, p. 463. - Lord Romney paid 100 Guineas for his portrait, Edward Hooper valued his at 20 Guineas.

75. Pressly 1981, pp. 123-132; Pressly 1983, pp. 85-97; the first series is dated 1791, but it only appeared a year later.

76. Green 1782, pp. 51-55, pp. 53-54.

77. Green 1782, pp. 36, 54-55.

78. Green 1782, pp. 46-49. - On Mengs' altarpiece *Noli me tangere* Roettgen 1993, pp. 30-32. - In a letter to the Duke of Richmond of 14 October 1773 James Barry criticized the practice of giving commissions to foreign artists; Fryer 1809, vol. 1, p. 244.

79. Green 1782, p. 56.

80. Green 1782, pp. 50-51.

81. Wind 1938/39; Mitchell 1944; Wind 1947; Erffa/Staley 1986, no. 93, pp. 211-213; Busch 1993, pp. 58-64.

82. Galt 1816-20, vol. 2, pp. 46-51, p. 47. Erffa/Staley 1986, no. 94, p. 214.

83. Galt 1816-20, vol. 2, p. 46: "About this period, Mr. West had finished his Death of Wolfe, which excited a great sensation, both on account of its general merits as a work of art, and for representing the characters in the modern military costume."

84. Reynolds 1959 (1981), Discourse III, pp. 39-53, esp. pp. 48-49.

85. *Catalogue of The Exhibition of Pictures, by Nathaniel Hone, R.A., mostly the Works of his Leisure, And many of them in his own Possession* [no place] 1775. [Copy in London, Tate Gallery]. - Nathaniel Hone, *The Pictorial Conjuror, displaying the Whole Art of Deception,* 1775, Dublin, National Gallery of Ireland. - Cf. Luckhurst 1951, p. 53; Hutchison 1968 (1986), pp. 40-41; John Newman, 'Reynolds and Hone. „The Conjuror" Unmasked', in: Reynolds Catalogue 1986, pp. 344-354; Drechsler 1996, pp. 15-22.

86. John Singleton Copley of Boston exhibited a portrait in London for the first time in 1765, whereupon Joshua Reynolds and Benjamin West urged him to move to Europe. However, it was not until 1774 that the young painter took the advice to refine and polish his careful and rather wooden style. From London he set off on the Grand Tour to Italy, and a year later brought his family to England. Copley must have had political as well as artistic reasons to move with his family to England. In 1777 he exhibited a group portrait of his family in the Royal Academy. It included his father-in-law, the rich Boston business man Richard Clarke, and was Copley's advertisement for commissions of this nature.

87. Copley Catalogue 1995, no. 3, pp. 98-102, no. 4, pp. 102-105; Busch 1993, pp. 68-80; Busch 1992, pp. 35-59; Prown 1966, pp. 267-274.

88. See Jaffe 1977, pp. 15-24; Busch 1992, pp. 55-59; Busch 1993, pp. 68-80.

89. Plumb 1963; Prown 1966, vol. 2, pp. 276-278.

90. Prown 1966, vol. 2, pp. 281-282.

91. Whitley 1928, vol. 1, p. 357.

92. Prown 1966, vol. 2, pp. 302-310; Copley Catalogue 1995, no. 18, pp. 140-141; Neff 1995.

93. Saunders 1990; Copley Catalogue 1995, nos. 19-32, pp. 142-154.

94. *Description of the Picture of the Death of Major Peirson, And the Defeat of the French Troops in the Island of Jersey. Painted by Mr. Copley for Mr. Boydell* [no place] Copy in London, Tate Gallery.

95. Prown 1966, vol. 2, pp. 306-307. - Boydell had commissioned a historical subject, *Charles I Demanding the Five Impeached Members.* Copley only finished this painting in 1795, cf. Prown 1966, vol. 2, pp. 337-352. Probably Copley himself chose the actual subject. - On Boydell's gallery see the report of Sophie von La Roche's visit to London 1787: La Roche 1791, pp. 458-462. - Other examples of speculation by artists: John Trumbull of Boston went to London in 1780 and visited West's studio. However, he preferred to do as Copley had done, and in 1789 he held an exhibition of his painting *The Sortie of the British Garrison from Gibraltar,* instead of selling it for a princely sum. Trumbull's report of the offer may not be correct, because he could have concluded a similar deal. He wanted to speculate, but he failed to make a profit; cf. Sizer 1950, pp. 76-77, no. 38 (n.p.); Sizer 1953, pp. 148-151; Whitley 1928, vol. 2, p. 111; Cooper 1982, pp. 9-10, nos. 10-12, pp. 56-62.

96. The Marquis of Buckingham found Copley's price of 2,500 Guineas (£2,625) too high; Christie's auctioned *The Death of the Earl of Chatham* in 1788 but failed to find a buyer, and

Copley was only able to sell the painting in 1806 for £2,100 through a lottery; cf. Prown 1966, vol. 2, pp. 437-438. - Assuming the exhibition attracted about 33,000 visitors, Copley would have made the fantastic sum of £5,000 in entrance charges; however, a more likely sum is about £1,650 from an entrance charge of 1 shilling per person. The only records on which such estimates can be based are contemporary press reports. On 8 June 1781 *The Morning Herald* was already reporting 20,000 visitors, while on 29 July 1781 *The Public Advertiser* spoke of peak attendances of up to 800 persons on some days; cf. V & A Press Cuttings.

97. Altick 1978, p. 106.

98. West won the commission for Greenwich Hospital Chapel in 1786 against a rival bid from Copley, cf. Erffa/Staley 1986, no. 397, pp. 384-386. - The siege of Gibraltar was an important subject for the British, whose pride was wounded by the defeat in the American War of Independence of 1783. George Carter exhibited a painting on this theme in 1785, Joseph Wright of Derby in 1785, (now lost) and John Trumbull in 1789, cf. Prown 1966, vol. 2, pp. 322-336.

99. Letter from Copley to Lord Grenville dated 7 April 1791: "... Permit me, My Lord, to state to your Lordship that the grant made by the Corporation of the City of London was equal only to the painting of a small work, and as I knew the sum to be insufficient, I agreed with them for the right of exhibiting the painting. ..." . Cf. The W.T. Whitley Papers, London, British Museum, Print Room, no. 350.

100. Only a facsimile of the entrance ticket has survived, it is now in the British Museum. The etching is ascribed to Francesco Bartolozzi, but he is not named in the catalogue, cf. Bartolozzi Catalogue 1928.

101. Prown 1966, vol. 2, pp. 332-335.

102. Erffa/Staley 1986, no. 108, pp. 220-222; Irwin 1990, pp. 43-56.

103. Erffa/Staley 1986, no. 108, p. 222, note by Joseph Farington of 10 June 1807: Farington 1978-84, vol. 2, pp. 3064-3065. - Cannon-Brookes 1991. - On the epic quality see Dobai 1974-84, vol. 2, pp. 1185-1189; in regard to West: Bromley 1793/95, vol. 2, pp. 23-24.

104. Oettermann 1980; Hyde 1988; Sehsucht Catalogue 1993.

105. Friedman 1976, pp. 77-78; Pressly 1981, pp. 143-147; Bruntjen 1985, p. 93; Reynolds Catalogue 1986, no. 180, pp. 369-370.

106. The plan was formed during a dinner on 4 November 1786 in the home of Josiah Boydell, John Boydell's nephew and partner. The guests included Benjamin West, George Romney and the bookseller George Nicol, cf. Bruntjen 1985, pp. 69-72, and Boydell's Autobiography, 1925.

107. On 1 December 1786 Boydell published a four-page subscription prospectus for a Shakespeare edition in eight volumes and *A Series of Large and Capital Prints After Pictures to be Immediately Painted by the Following Artists, from the most Striking Scenes of the Same Author*. Boydell named Angelica Kauffmann in the prospectus and the other painters who were working for him, as well as the engravers he intended to commission. - Cf. Victoria & Albert Museum Library, Boydell Publication Proposals, 103 B; Bruntjen 1985, pp. 252-256. - For a description of the Shakespeare Gallery in 1790 cf. Forster 1843, vol. 3, pp. 499-514.

108. On the illustrated editions of Shakespeare cf. Boase 1947.

109. Eaves 1992, p. 34.

110. Reynolds 1929, letter of 13 February 1787 to the Duke of Rutland. - Bruntjen 1985, pp. 74-78.

111. Thomas Gainsborough asked for a fee of £1,000 to participate in the project, but Boydell refused; cf. Whitley 1915, pp. 269-270.

112. Bruntjen 1985, pp. 69-157; Friedman 1973, pp. 396-401; Friedman 1976, pp. 3-5, 61-93. - Boydell is erroneously regarded as the first entrepreneur in the art world to separate production, exhibition and sales. Between 1774 and 1778 Abraham Wagner exhibited *Das Wagnerische Cabinett* in Berne, with Alpine landscapes by Caspar Wolff; replicas in various techniques and coloured line etchings of the works were offered for sale; cf. Raeber 1979, pp. 65-66; Boerlin-Brodbeck 1980, pp. 43-56.

113. Boydell Catalogue 1789, Foreword, p. v: "... and I am sorry to say with some truth, that the abilities of our best Artists are chiefly employed in painting Portraits of those, who, in less than half a century, will be lost in oblivion - While the noblest part of the Art - HISTORICAL PAINTING - is much neglected. To obviate this national Reflection was, as I have already hinted, the principal cause of the present undertaking." - Boydell took up the criticism from Barry in 1775 and 1783 and from Green in 1782.

114. Cf. the letter from Boydell to Joseph Wright of Derby of 3 August 1789 in: Bemrose 1885, pp. 99-100.

115. Freedberg 1985, pp. 5-6.

116. Bruntjen 1985, pp. 74-109, esp. pp. 108-109; West also received £525 from Boydell for *Ophelia,* and so was relatively badly paid for the work, for King George III paid him £1,050 for each of the larger paintings in the King's Chapel, cf. West's Account Book, in: Galt 1816/20, vol. 2, pp. 208-215, esp. pp. 211-212. The differences are similar for Hamilton (£210 for the painting), Bartolozzi (£462 for the print); the fees for the quarto reproductions were lower, James Heath received only £105 for four plates, while he was paid £2,100 in 1796 by Boydell for the plate of Copley's *Death of Major Peirson.*

117. On the interest in Boydell's enterprise see Forster 1843, pp. 463-473 and Tieck 1795; also: Tieck 1985-95, vol. 1, pp. 653-680.

118. Advertisement for the Shakespeare Gallery in: *The European Magazine and London Review,* vol. 46, July 1804, p. 1, showing the facade of the gallery as a frontispiece.

119. Bruntjen 1985, pp. 114-117.

120. Boydell 1925, p. 87.

121. Boase 1963, pp. 169-173; Bruntjen 1985, p. 121; Postle 1995, pp. 234-272.

122. Henry Fuseli, letter to William Roscoe of 17 August 1790 on the plan for the Milton Gallery, in: Weinglass 1982, p. 61: "... notwithstanding the Success of my election at the Academy, and of the Pictures I have painted for the Shakespeare-Gallery - my Situation continues to be extremely precarious. I have and am Contributing to make the Public drop their gold in purses not my own, and though I am and probably Shall be fully employed for Some time to come, the Scheme is hastening with rapidity towards its Conclusion. There are, Says Mr. West but two ways of working Successfully, that is Lastingly, in this Country, for an Artist; the one is, to paint for the king, the other to meditate a Scheme of Your own. The first he has monopolized, in the Second he is not idle: witness the prints from English History and the Late advertisement of Allegorical prints to be published from his designs by Bartolozzi. In imitation of So great a Man, I am determined to lay, hatch and Crack an egg for myself too - if I can. What it Shall be - I am not yet ready to tell with Certainty - but the Sum of it is, a Series of Pictures for Exhibition, Such as Boydells and Macklins. To obtain this, it will be necessary that I should have it in my power to work without Commission or any View of intermediate gain for, at least, three years - in which time, I am Certain, of producing at least twenty Pictures of different dimensions - the Question is what will enable me to Live in the mean time? With less than threehundred a year Certain, I cannot do it. My idea is to get a Set of Men (twenty perhaps, less if possible, but not more:) to Subscribe towards it. Suppose twenty pounds each annually, to be repaid either by small pictures, or drawings or the profits of the Exhibition, Should it Succeed, of which there can be no very great doubt. Such is, at present, the rude outline of my Scheme. It is in this Manner alone that I can exhibit that Variety of picturesque Ideas of which, I flatter myself, You have Seen Specimens amongst my productions on paper and canvas. And now Tell me Your Opinion with Your usual openness - I am in earnest." Schiff 1963, pp. 9-28.

123. Knowles 1831, vol. 1, Ch. VIII, pp. 171-238; Macandrew 1959-60; Schiff 1963, pp. 22-28; Schiff 1973, vol. 1, pp. 189-223. - On the prints from the Milton Gallery: Weinglass 1994, nos. 165-170; 180-181, 293.

124. Forster 1843, vol. 3, pp. 464-471, quotation p. 466; Forster's *Ansichten* appeared in two parts in 1791 and 1792. The third part is in diary form, cf. Forster 1791/92; on the history of the work and its influence see Gerhard Steiner's remarks in Forster 1958, pp. 337-373; Peitsch 1978, pp. 297-309; Fischer 1990.

125. On Barry's illustrations of Milton, begun in the 90s: Pressly 1981, pp. 151-171.

126. Altick 1978, pp. 235-252; Holt 1980, pp. 206-207.

127. Cf. the cartoon by George Cruikshank, *A Scene at the London Museum Piccadilly, - or - A Peep at the Spoils of Ambition, Taken at the Battle of Waterloo - Being a New Tax on John Bull for 1816 &c. &c.,* 1816.

128. Altick 1978, p. 238: "... the only natural likeness now publicly exhibiting in Europe."

129. David 1799: "... L'usage, pour un peintre, d'exposer ses ouvrages aux yeux de ses concitoyens, moyennant une rétribution individuelle, n'est point nouveau. ... De nos jours, cette pratique est observée en Angleterre, où elle est appelée exhibition. ... N'est-ce pas une idée aussi juste que sage que celle qui procure aux arts les moyens d'exister par eux-mêmes, de se soutenir par leurs propres ressources, et de jouir de la noble indépendance qui convient au génie, et sans

laquelle le feu qui l'anime est bientôt éteint? D'un autre côté, quel moyen plus digne de tirer un parti honorable du fruit de son travail que de le soumettre au jugement du public, et de n'attendre de récompense que de l'accueil qu'il veut bien lui faire? ... De tous les arts que professe le génie, la peinture est incontestablement celui qui exige le plus de sacrifices. ... Je vais plus loin: combien de peintres honnêtes et vertueux, qui n'auroient jamais prêté leurs pinceaux q'à des sujets nobles et moraux, les ont dégradés et avilis par l'effet du besoin! Ils les ont prostitués à l'argent des Phryné et des Laïs: c'est leur indigence seule qui les a rendus coupables; et leur talent, fait pour fortifier le respect des moeurs, a contribué à les corrompre."

130. Landon 1802, pp. 27-28: "Alors c'est une spéculation peu louable, d'essayer de les faire payer une seconde fois par le public."

131. *Exposition de trois Tableaux dans une des Salles du Palais National des Sciences et des Arts, Pavillon du Midi, sous le vestibule qui conduit au Quai, Par le C. en Regnault, Membre de l'Institut National,* Paris: Imprimerie de Delange, an VIII (1800).

132. David 1799, pp. 2-3; Thomé de Gamond 1826, p. 174: Thomé de Gamond quotes a comment by David in his anonymous biography of the artist, which was published in 1826: "Ce que je veux c'est naturaliser en France cette mode anglaise qui permet aus jeunes artistes de rentrer dans leurs frais en soumettant le visiteur à une modique rétribution."

133. Yorke 1804, vol. 1, letter 21, p. 300: "I met in this society, a number of very intelligent and respectable characters, and have had several opportunities of entering into conversation with M. David; but though I made repeated attempts to introduce a discussion upon the political state of France, he did not seem disposed to enter at all upon the subject. Accordingly, though by no means qualified to hold a discourse on the art of Painting, the names of several English and French artists were mentioned, but M. David never condescended to make any observations from which I could derive any instruction. His lady frequently desired me to give my opinion of his celebrated picture of the Sabines, which we had seen in the morning, and she assured me that it would be a good speculation if any Englishman would purchase it for an exhibition in London. The price is five thousand pounds sterling!" - On the international reputation of *The Sabine Women* see Caroline von Humboldt's description in Goethe's *Propyläen,* vol. 3/1, pp. 117-122, and the description in: *Helvetisches Journal für Literatur und Kunst,* vol. 1, Zürich: Füessli und Compagnie, 1802, pp. 78-88.

134. The most informative account of the exhibition of *Le Serment des Horaces* in Rome in 1785 is by Johann Heinrich Wilhelm Tischbein, cf. Tischbein 1786, pp. 169-185. Tischbein 1922, pp. 212-214. - Cf. Holt 1980, pp. 16-24; David Catalogue 1989, nos. 67-72, pp. 162-171.

135. Boothby to Reynolds: "Now, my dear Sir, to the point. Mr David tho' a remarkably modest person is ambitious of fame. He wishes to have a picture seen in England, and would send either the Horatii or the Socrates if by any mode it could be admitted into your next academical exhibition." - Bordes 1992, pp. 482-490; Carr 1993, pp. 307-315.

136. In October 1787 an article appeared in *World and Fashionable Advertiser* on the Paris Salon of 1787, and recently it has been suggested that John Boydell was the author. Boydell eloquently praises David's Death of Socrates as an astonishing work, perfect in every part, and he also praises David's amiable character and pleasant manners. Clearly the aim of the article was not so much to report on the Salon as to advertise David's exhibition in England and Boydell's future business. However, David's *Death of Socrates* was to be presented as a perfect example of the genre in which England felt it lagged behind France - history painting. Bordes 1992; Carr 1993 - David Catalogue 1989, no. 233, pp. 534-539.

137. David 1793, reprint in: Bordes 1983, pp. 174-175: "C'est à cette époque que commença sa réputation dans ce tableau esquisse des funérailles de Patrocle. ... Il fut exposé à l'Academie de France à Rome, et les Italiens artistes désirèrent faire connaissance avec lui. ... Le tableau [Rochus] était destiné pour le Lazaret, mais les Marseillais aussitôt qu'ils le virent et ayant entendu parler les éloges sans nombre qu'il avait reçu à Rome, changèrent sa destination première pour le mettre mieux en évidence et le placèrent à la consigne à côté des ouvrages du Puget sculpteur. ... Il se détermina pour ces raisons à faire le voyage avec lui [Drouais] et c'est en 1785, qu'il fit de tableau du Serment des Horaces, qui fixa sa réputation tant en Italie qu'en France et d'une manière si décisive, car s'il obtint beaucoup d'éloges dans ce pays-ci, il en fut accablé en Italie. Pendant trois semaines les rues de sa demeure ne désemplirent pas et pour éviter les malheurs les voitures allaient d'un côté des rues pendant que celles qui revenaient occupaient l'autre côté. Excusez ces petits détails, ce n'est que pour vous peindre l'effet que fit ce tableau à Rome."

138. Lapauze 1924, vol. 1, pp. 365-366; Montaiglon/Guiffrey 1887-1912, vol. 13, no. 6962,

p. 384 (letter from Vien to d'Angiviller on the exhibition of 1778). - On the use of the Palazzo Mancini on the Corso, rented by the Académie de France à Rome from 1725 for an annual sum of 1200 Scudi, cf. Lapauze 1924, vol. 1, pp. 180-181.

139. Lapauze 1924, vol. 1, p. 370; Vien, in: Montaiglon/Guiffrey 1887-1912, vol. 14, p. 32.

140. Bätschmann 1991, pp. 225-237; David catalogue 1989, nos. 85-91, pp. 194-206.

141. Antoine Schnapper, 'Les Sabines', in: David Catalogue 1989, nos. 146-156, pp. 323-353. - The exhibition lasted until May 1805, attracted about 50,000 visitors and earned David the incredible sum of more than 75,000 francs. In 1801 he invested 80,000 francs in a farm that brought him an annual income of 5,800 francs.

142. David Catalogue 1989, nos. 161-162, pp. 381-386: "Que la patrie cesse de sacrifier ses enfants à la guerre épouvantable."

143. Müller 1812, esp. pp. 347-353: 'Brutus und seine Söhne, von Lethier'.

144. Lapauze 1924, vol. 1, p. 79, mentions a recommendation by Princess Paolina. - Lucien Bonaparte had retired to Rome in 1804, where he built up his collection of paintings with the help of Lethière, who was his adviser after 1801. In 1807 Lucien finally fell out of favour owing to his refusal to separate from his second wife, whom Napoleon regarded as beneath him, and take the throne of Spain. In 1810 he attempted to flee from Civitavecchia to North America, but in Cagliari he fell into the hands of the British, who interned him in London until the fall of Napoleon in 1814. Lucien then returned to Rome, but in October 1814 he sent his superb collection of paintings to be sold in London. In 1815 and 1816 a number of paintings by Lethière from Lucien's collection were auctioned by William Buchanan and George Stanley in London and Vittore Zanetti in Manchester.

145. [Bullock] Descriptive Synopsis of the Roman Gallery, (in the Egyptian Hall, Piccadilly,) ... and Superb Pictures of the Ancient and Modern Masters; including the Great and Celebrated Picture of The Judgment of Brutus upon his Sons; painted by the President of the Academy at Rome, London: Printed for the Proprietor, 1816.

146. Mazzocca 1979.

147. Beaucamp 1939, vol. 2, pp. 479-486; Betti 1834; Dufay 1844.

148. Ansaldi 1936, pp. 65, 431.

149. Cf. Bullock 1820 (1): "The warm tints of Titian, the colder chastity of Guido, the mild radiance of Corregio (sic) and the harmonious combinations of Rubens."

150. Johnson 1954; Eitner 1972, pp. 61-65; Whiteley 1981, pp. 74-75.

151. Géricault, Bénézit, Doc. 176, p. 53.

152. The creation of the picture has been thoroughly researched: Eitner 1972; Johnson 1954; Géricault Catalogue 1991, pp. 136-171.

153. On the motif of shipwreck cf. Nicolson 1954.

154. Bätschmann 1996 (2).

155. Lenoir-Laroche: "Les guerriers devant ce tableau viendront apprendre à mourir pour la patrie et la loi." in: David 1814; David Catalogue 1989, nos. 215-226, pp. 486-512.

156. David 1814: "Le moment de ce Tableau est celui où les trompettes, en sentinelles sur une hauteur, signalent les premiers mouvemens de l'armée de Xercès. Chacun court aux armes, s'embrasse pour la dernière fois, et se dispose au combat. Léonidas, roi de Sparte, assis sur une roche au milieu de ses trois cents braves, médite, avec une sorte d'attendrissement, sur la mort prochaine et inévitable de ses amis." - Thomas Gaehtgens has shown that the concentration on the moment before the decisive act shows the influence of Lessing's Laocoon, which had appeared in French in 1802, cf. Gaehtgens 1984.

157. An anonymous response to Géricault's exhibition of the painting in 1820 in London appeared in the article 'Fine Arts', in: The New Monthly Magazine, 1 Sept. 1820, Part 2, pp. 316-317: "The great picture of M. Jerricault (sic) represents the raft of the Medusa, at the moment, when the vessel appeared, which rescued from death the fifteen miserable survivors of one hundred and fifty persons who embarked from the wreck upon this raft, which was at first towed by five boats, but very soon abandoned by them all. Of all the horrid stories of human sufferings, that of the miseries endured upon this raft is the most appalling we remember. M. Jerricault has represented, with stern fidelity, the shocking group of emaciated wretches, still lingering and clinging to life in spite of the raging ocean, the horrors of famine, thirst, disease, and murder. Some of the figures are grand in their sufferings and despair; but these subjects of physical horror are ill-chosen, because they excite disgust."

158. In representing images of horror and disgust in the immediate foreground of his paint-

251

ing Géricault was following the example of Antoine-Jean Gros in *Napoléon sur le champ de bataille d'Eylau* (Salon of 1808), which shows the slaughtered victims of the battle in the foreground. Above them the great French commander is seated on horseback, giving his orders unperturbed. The terrible sight of the dead is softened by the falling snow, and their terrible end appears to be a necessary sacrifice for the greater aims of the general. - Cf. Géricault's plans for the Affaire Fualdès, a barbarous murder in the early spring of 1817. - Eitner 1972, p. 31; Kemp 1983, pp. 104-111; Bätschmann 1996 (2).

159. Oettermann 1980; Hyde 1988.

160. Clément 1868, pp.147-148; Eitner 1972, pp. 57-67.

161. Bullock 1828.

162. Johnson 1993.

163. Eitner 1972, pp. 66-67; Chennevières-Pointel 1967, vol. 1, pp. 71-81. - On David's *Sabines and Léonidas:* David Catalogue 1989, nos. 146-156, pp. 323-339 and nos. 215-226, pp. 498-512; Angrand 1972, pp. 118-123. - On Wicar: Beaucamp 1939, vol. 2, pp. 581-586.

164. Cf. Hans Heinrich Füssli's attack on the language of Vasari, Félibien and their followers, in: Füssli 1766, pp. vi-viii.

165. 'Lettres écrites de Paris à Bruxelles sur le sallon de peinture de l'année 1748', in: *Revue Universelle des Arts*, 10, 1859, pp. 432-462.

166. The conflict is evident where alternatives are presented, as in Susan Sontag: "In place of hermeneutics we need an erotics of arts", 'Against interpretation', in: *Sontag 1966*, pp. 3-14; Germer/Kohle 1991, pp. 287-311.

167. Etienne-Maurice Falconet, *Observations sur la Statue de Marc-Aurèle, Adressées à Mr. Diderot* [1770], in: Falconet 1808, vol. 1, pp. 157-348, esp. pp. 219-235. - Cf. the discussion of antique sources in: Erasmus of Rotterdam, Adagiorum chiliades [1508], I, 6,16. Cf. Erasmus 1995, vol. 7, pp. 412-415.

168. Du Bos 1719 (1733), vol. 2, sect. 22, pp. 323-325. - Du Bos 1993, p. 276.

169. Johann Gottfried Herder, 'Denkmal Johann Winckelmanns', in: Herder 1877-1913, vol. 8, pp. 437-483. - On enjoyment as participation cf. Binder 1973; Mülder-Bach 1994. - See also Herder, 'Plastik. Einige Wahrnehmungen über Form und Gestalt aus Pygmalions bildendem Traume' [1778], in: Herder 1877-1913, vol. 8, pp. 1-87.

170. Du Bos 1719 (1733), vol. 2, sect. 22, pp. 323-340, p. 324: "Par la même raison l'ouvrage qui ne touche point & qui n'attache pas ne vaut rien, & si la critique n'y trouve point à reprendre des fautes contre les regles, c'est qu'un ouvrage peut être mauvais sans qu'il y ait des fautes contre les regles, comme un ouvrage plein de fautes contre les regles peut être un ouvrage excellent." - Du Bos 1993, pp. 276-281.

171. Du Bos 1719 (1733), vol. 2, sect. 24, pp. 354-365, p. 360: "Mais tous les hommes peuvent juger des vers & des tableaux, parce que tous les hommes sont sensibles, & que l'effet des vers & des tableaux tombe sous le sentiment." - Du Bos 1993, pp. 286-289. - On the problem: Wrigley 1983; Kaiser 1989/90.

172. La Font de Saint-Yenne 1747 (1970), p. 2: "Un Tableau exposé est un Livre mis au jour de l'impression. C'est une pièce représentée sur le théâtre: chacun a le droit d'en porter son jugement."

173. Du Bos 1719 (1733), sect. 25 and 26, pp. 365-381; Du Bos 1993, pp. 289-295.

174. Cf. the bibliography of art criticism in France from 1699-1827 by McWilliam/Schuster/Wrigley 1991.

175. Wrigley 1993, pp. 100-101; cf. *Lettre ecrite de Paris à Madame de R****, [Lettre sur la Cessation du Salon de Peinture à Madame de R.], Cologne, 1749; in: Deloynes 1980, vol. 4, no. 40. - In 1751 the leading members of the Académie royale (Boucher, Coypel, Natoire and Bouchardon) boycotted the Salon.

176. Lacombe 1753, frontispiece; cf. Crow 1985, pp. 7-9.

177. Wrigley 1993, p. 249. - McWilliam/Schuster/Wrigley 1991, no. 116, p. 549.

178. Livret du Salon 1781, no. 4, p. 4, reprint Catalogues of the Paris Salon 1977-78, vol. 5.

179. La Font de Saint-Yenne 1747 (1970) and 1754 (1970); Caylus 1755; Winckelmann 1755; Winckelmann 1968, pp. 27-59; on Carstens and Fernow cf. Ch. 9; Scheidig 1958.

180. On the „Künstlerrat" cf. Schlink 1987 for the first description.

181. Reynolds Catalogue 1986, no. 178, pp. 367-368; Paulson 1972, pp. 23, 39. - On Fuseli's painting *The Artist in discussion with Johann Jakob Bodmer*, 1778-1781: Schiff 1973, no. 366, p. 438.

1. Kallen 1942 (1969); Warnke 1985, pp. 308–328; Cast 1977, pp. 371–397; Becker 1991.

2. Deloynes 1980, vol. XIV, 408; Heim/Béraud/Heim 1989, p. 15.

3. *Procès-verbaux de la Commune des Arts et de la Société Populaire et républicaine des Arts,* ed. by Henry Lapauze, Paris 1903; Caubisens-Lasfargues 1961.

4. Quatremère de Quincy 1791, pp. 88–168, p. 102: "Il [ce moyen] sera dans la république des arts, ce que c'est la liberté de la presse dans un état. C'est la libre exposition publique accordée indistinctement à tous les artistes dans le même lieu."

5. Fumaroli 1987–88; *Respublica litteraria* is first mentioned in 1417 in a letter from Francesco Barbaro to Poggio Bracciolini to describe the scholars who appreciated Poggio's discovery of manuscripts.

6. Cf. the speeches against the academies by the Abbé Grégoire and Jacques-Louis David of 8 August 1793, in: Scheinfuss 1973, pp. 22–35, cf. David 1793. – On the continuance of the École des Beaux-Arts in the 19th century see Boime 1971.

7. Quatremère de Quincy 1796, new edition 1989, p. 119; his argument was supported by a petition signed by fifty artists on 16 August 1796, while thirty-seven other artists supported the continuance of the appropriation of art treasures on 30 October 1796, cf. pp. 141–146, and the introduction by Édouard Pommier, pp. 7–83.

8. Caubisens-Lasfargues 1961; Heim/Béraud/Heim 1989, p. 16.

9. Livret du Salon de 1791: "Les Arts reçoivent un grand bienfait; l'empire de la Liberté s'étend enfin sur eux; elle brise leurs chaînes; le génie n'est plus condamné à l'obscurité. Pour que les seuls & véritables distinctions naissent des vertus & des talents, il ne faut que les montrer à ses Concitoyens." The foreword also cites the decree by the National Assembly of 21 August 1791. – Catalogues of the Paris Salon 1977–78, vol. 1785–91.

10. Warnke 1985. pp. 308–328.

11. Scheinfuss 1973, pp. 85–86, Warnke 1985, pp. 308–328.

12. Scheinfuss 1973, p. 86.

13. Gramaccini 1993, vol. 1, pp. 107–115, vol. 2, no. 200, pp. 85–86.

14. Schiff 1973, vol. 1, p. 80, nos. 618–629, pp. 473–474.

15. Fuseli's first and second *Ode über die Kunst (Ode on Art)* of 1768/70 and 1772/75 are evidence of the change in attitude; Füssli 1973, pp. 63–64, 67–68. – In contrast cf. the critical remarks on Michelangelo, capable of producing colossi but not grace or the divine in: Winkkelmann 1764, p. 207, and in various other writings: Winckelmann 1968, passim. – But see also Reynolds' *Discourse V* of 1772 on the great style and a comparison between Raphael and Michelangelo. Both are seen as supreme, Raphael in beauty and Michelangelo in the sublime: Reynolds 1959 (1981), pp. 77–90. – Brinckmann 1944. – Milizia 1781, pp. 16–17, p. 27 (Pietà), p. 150 (Palazzo Farnese).

16. Walzel 1910; Dempsey 1967; Steiner 1991. – Cf. Goethe's *Prometheus* in: Goethe 1949–60, vol. 1, pp. 44–46.

17. Condivi 1746; Hauchecorne's biography of Michelangelo was published in 1783; it is based on Condivi, whose work first appeared in Rome in 1553, three years after the first edition of Vasari's *Vite;* Vasari 1878–85 (1906), vol. 7, pp. 135–317, esp. pp. 162–187.

18. Shaftesbury 1714 (2).

19. Boileau-Despréaux 1745, esp. pp. 120–126, p. 121: "En effet, ajoutoit-il, il n'y a peut-être rien qui élève davantage l'ame des grands hommes que la liberté, ni qui excite & réveille plus puissamment en nous ce sentiment naturel qui nous porte à l'émulation, & cette noble ardeur de se voir élevé audessus des autres." – Boileau-Despréaux translated the treatise by the pseudo Longinus around 1667. It had been discovered around 1500 and a number of Greek and Latin editions had appeared since 1554. The French translation first appeared in Boileau-Despréaux' *Œuvres diverses* in 1674.

20. Winckelmann 1764, Part 1, Ch. 4, Section 1, pp. 127–135, p. 130; transl. by G. Henry Lodge, M. D., Winckelmann 1881, p. 289.

21. Herder 1775 (1994), pp. 125–127.

22. Shaftesbury 1714 (1); first in French under a different title, Shaftesbury 1712. – Paolo de Matteis' finished painting *The Choice of Hercules* in Temple Newsam, Leeds. – Cf. Panofsky 1930, p. 131; Saleron 1951, pp. 234–258, esp. pp. 250–255; Dobai 1974–84, vol. 1, pp. 60–69.

23. Falconet 1781, vol. 1, pp. 65–76: *Observations Sur un petit Ecrit fait en Italie, en 1711 ou 1712, par le Lord Shaftsbury, sur la Peinture* is a polemic against the accumulation of patrons and the artists

who were allowing themselves to be thus humiliated. Cf. Haskell 1963, pp. 198–199; Weinshen-ker 1966, Ch. 3: The Rights of the Artist, pp. 58–82. – Cf. Diderot, Salon de 1763 (Diderot 1975, vol. 1. pp. 229–230): "C'est qu'il ne faut rien commander à un artiste, et quand on veut avoir un tableau de sa façon, il faut lui dire: "Faites-moi un tableau et choisissez le sujet qui vous conviendra … ." Encore serait-il plus sûr et plus court d'en prendre un tout fait." Cf. also Diderot 1975, vol. 1, pp. 217–218.

24. Mercier 1787, vol. 2, Chs. XXXIV-XXXVI, pp. 38–54; p. 38–39: "Il étoit défendu aux arts de mentir. Il n'existoit plus aussi de ces hommes épais qu'on nommait amateurs, & qui commandoient au génie de l'artiste, un lingot d'or en main. Le génie étoit libre, ne suivoit que ses propres loi, & ne s'avilissoit plus." – The novel was a sensational success; it first appeared in French in Amsterdam in 1770, then in English in London in 1771, and in German in Leipzig in 1772 and 1783.

25. Heinse 1787 (1911), pp. 387–397, p. 394.

26. Shaftesbury 1714, p. 351: "Of these different Periods of Time, the latter has been chosen; as being the only one of the three, which can well serve to express the *Grand Event*, or consequent *Resolution* of Hercules, and the *Choice* he actually made of a Life full of Toil and Hardship, under the Conduct of Virtue, for the deliverance of Mankind from Tyranny and Oppression." – Shaftesbury 1769, vol. 3, pp. 265–300.

27. On Koch's caricature of art as practised at the Hohe Karlsschule (1791) see Klassizismus 1993, vol. 1, no. 62, pp. 154–155; Matthias Winner, 'Gottlieb Schicks "Eva" und der "edle Contour",' in: vol. 2, pp. 269–287; Lutterotti 1985, pp. 26–27.

28. Shaftesbury 1748.

29. C. L. Junker, 'Vom Lohn der Kunst', in: *Museum für Künstler und Kunstliebhaber*, ed. Johann Georg Meusel, 3. Stück, Mannheim: Schwan und Götz, 1788, pp. 3–15.

30. Müller 1896; Busch 1981, pp. 81–92; Mai 1986/87; Berliner Akademie 1996.

31. Fernow 1795; Fernow 1806, pp. 169–177.

32. Fernow 1806, pp. 182–184.

33. Fernow 1805, pp. 184–186.

34. Fernow 1806, reprint of the letter pp. 190–192, p. 196: "Nach diesem acten mässigen Hergang, den ich mit Fleis vorausgeschickt habe, um Sie zu dem eigenen Gefühl Ihres Unrechts zu bringen, mus ich Ihnen, mein Herr! *declariren*, wie ich es als Staatshaushalter der von Sr. Königli-chen Majestät mir blos zum Wohl des Staats anvertrauten Gelder vor Allerhöchstdenenselber und vor meinem eigenen Gewissen nicht verantworten kann, eine Summe von 1562 Thaler ganz umsonst, und noch dazu an einen Ausländer, wegzuschenken." – Cf. the correspondence between Fernow and Heinitz, reprinted with commentary in: Büttner 1992.

35. Carstens in Fernow 1806, pp. 205–206; Fernow 1867, pp. p. 141, with corrections p. 258: "Übrigens muss ich Euer Exzellenz sagen, dass ich nicht der Berliner Akademie, sondern der Menschheit angehöre die ein Recht hat, die höchstmögliche Ausbildung meiner Fähigkeiten von mir zu verlangen; und nie ist es mir in den Sinn gekommen, auch habe ich nie versprochen, mich für eine Pension, die man mir auf einige Jahre zur Ausbildung meines Talents schenkte, auf Zeit-lebens zum Leibeigenen einer Akademie zu verdingen. Ich kan mich nur hier, unter den besten Kunstwerken, die in der Welt sind, ausbilden, und ich werde nach Kräften fortfahren, mich mit meinen Arbeiten vor der Welt zu rechtfertigen. Lasse ich doch alle dortige Vortheile fahren, und ziehe ihnen die Armuth, eine ungewisse Zukunft, und vielleicht ein kränkliches, hülfloses Alter, bei meinem schon jetzt schwächlichen Körper vor, um meine Pflicht gegen die Menschheit und meinen Beruf zur Kunst zu erfüllen. Mir sind meine Fähigkeiten von Gott anvertraut; ich mus darüber ein gewissenhafter Haushalter sein, damit, wenn es heisst: Thue Rechnung von deinem Haushalten! ich nicht sagen darf: Herr, ich habe das Pfund so du mir anvertrauet, in Berlin vergraben."

36. Fernow 1795.

37. Müller 1797.

38. For criticism of the Academy: Berliner Akademie 1996.

39. Fernow 1806, Introduction pp. xviii-xxiv; cf. also Fernow's letter to Hofrath Böttinger of 8 July 1805 referring to the incompatible standpoints of a Minister and an artist, in: Schopen-hauer 1810, p. 346.

40. Cf. Friedrich Noack, Art. 'Carstens', in: Thieme-Becker, Künstler-Lexikon, vol. 6, pp. 84–86. The first sentence is: "Eine der edelsten, aber auch tragischsten Erscheinungen in der neu-eren deutschen Kunstgeschichte, der Märtyrer seines hohen künstlerischen Ideals."

41. Fernow 1806, p. 205.

42. Moritz 1787. – On Moritz and Carstens: Büttner 1983.

43. Fernow 1806, p. 251: "Die freigewordene Kunst, der Stütze aber auch zugleich des Zwanges der Religion enthoben, mus hinfort auf sich selbst ruhen wie sie denn in der That auch immer auf sich selbst geruhet, und statt ihr Interesse von der Religion zu erborgen, vielmehr dieser selbst durch ihren Sinnenzauber ein allgemeineres Interesse gegeben hat."

44. Fernow 1806, pp. IX-X: "Der echte Kunsttrieb offenbart sich besonders auffallend, wo ungünstige Umstände sich seiner Entwicklung widersetzen, und er glänzt da umso heller empor, wo alles sich vereint, ihn auszulöschen. […] Einmal zum Bewußtsein erwacht, strebt es [das Talent] aus innerer Nothwendigkeit seiner einzigen Bestimmung nach; Widerwärtigkeiten können es aufhalten, Hindernisse können sein Streben lange, ja für immer vereiteln; die geistige Kraft kan im Kampfe mit der fisischen Übermacht des Schicksals erliegen, aber den ingeborenen Trieb kann diese nur mit dem Leben vertilgen. Mehr als Ein von der Natur hochbegünstigter, aber vom Schiksale befeindeter Kunstgeist ist so ein Märtirer seines Triebes geworden."

45. De Piles 1677 (1970), p. 226: "Il est constant que la nature & le genie sont au dessus des regles, & sont ce qui contribuë davantage à faire un habile homme; & que tous ceux qui ont eu le plus de connoissance d'un Art, & qui mesme en ont escrit, n'ont pas fait les plus beaux Ouvrages, ce n'est pas pour avoir ignoré les regles; mais pour avoir manqué de genie." – On de Piles: Puttfarken 1985; Lichtenstein 1989, pp. 213–243; Teyssèdre 1965. – Cf. Du Bos 1719, 1733, vol. 2, pp. 1–13: Du génie en général; Du Bos 1993, pp. 171–174.

46. Art. 'Génie' (Philosophie et Littérature), in: Encyclopédie 1751–80, vol. 7, 1757, pp. 582–584: "Dans les Arts, dans les Sciences, dans les affaires, le génie semble changer la nature des choses; son caractère se répand sur tout ce qu'il touche; & les lumières s'élançant au delà du passé & du présent, éclairant l'avenir: il devance son siecle qui ne peut le suivre; il laisse loin de lui l'esprit qui le critique avec raison, mais qui dans sa marche égale ne sort jamais de l'uniformité de la nature."

47. Poggioli 1962 (1968); Egbert 1967; Janson 1975, pp. 167–175; Böhringer 1978, pp. 90–114.

48. Kant 1790 (1968), §§ 46–49; cf. Caygill 1989.

49. Kant 1790 (1968), § 47: "Das Genie kann nur reichen Stoff zu Produkten der schönen Kunst hergeben; die Verarbeitung desselben und die Form erfordert ein durch die Schule gebildetes Talent, um einen Gebrauch davon zu machen, der vor der Urteilskraft bestehen kann." – Zilsel 1926 (1972); Joachim Ritter, Art. 'Genie', in: Ritter/Gründer 1971 –, vol. 3, Sp. 279–307. – Cf. Revolution und Autonomie 1990.

50. Carstens Catalogue 1992, no. 131, p. 220.

51. David 1799: "Je vais plus loin: combien de peintres honnêtes et vertueux, qui n'auroient jamais prêté leurs pinceaux qu'à des sujets nobles et moraux, les ont dégradés et avilis par l'effet du besoin! Ils les ont prostitués à l'argent des Phrynés et des Laïs: c'est leur indigence seule qui les a rendus coupable; et leur talent, fait pour fortifier le respect des moeurs, a contribué à les corrompre."

52. Noack 1919; Noack 1907, pp. 254–255.

53. Koch 1834 (1905), Koch 1984. – Rumford soup was a dish made of bones, blood and other cheap ingredients and served in soup kitchens. It was devised by an American, Benjamin Thompson, in the service of Kurfürst Karl Theodor in Munich; Thompson was made Reichsgraf of Rumford in 1792.

54. Koch 1834 (1905), pp. 40–42; Koch 1984, pp. 18–29.

55. Koch 1834 (1905), pp. 63–91; Koch 1984, pp. 40–67.

56. Balzac 1830 (1935), p. 353: "Tel est l'artiste: humble instrument d'une volonté despotique, il obéit à un maître. Quand on le croît libre, il est esclave; quand on le voit s'agiter, s'abandonner à la fougue de ses folies et de ses plaisirs, il est sans puissance et sans volonté, il est mort. Antithèse perpétuelle qui se trouve dans la majesté de son pouvoir comme dans le néant de sa vie: il est toujours un dieu ou toujours un cadavre."

57. Balzac 1830 (1935), p. 367: "Sous ce rapport, le Christ en est le plus admirable modèle. Cet homme gagnant la Mort pour prix de la divine lumière qu'il répand sur la terre et montant sur une croix où l'homme va se changer en Dieu, offre un spectacle immense: il y a là plus qu'une religion; c'est le type éternel de la gloire humaine. Le Dante en exil, Cervantes à l'hôpital, Milton dans une chaumière, le Corrège expirant de fatigue sous le poids d'une somme en cuivre, le Poussin ignoré, Napoléon à Sainte-Hélène, sont des images du grand et divin tableu que présente le

Christ sur la croix, mourant pour renaître, laissant sa dépouille mortelle pour régner dans les cieux. Homme et Dieu: homme d'abourd, Dieu après; homme, pour le plus grand nombre; Dieu, pour quelques fidèles; peu compris, puis tout à coup adoré; enfin, ne devenant Dieu que quand il s'est baptisé dans son sang."

58. Junod 1985; Hüttinger 1985 and 1992; Scharf 1988.

59. Livret du Salon de 1793; Catalogues of the Paris Salons 1977–78, vol. 1793/95, p. 2: "Il semblera peut-être étrange à d'austères Républicains de nous occuper des Arts, quand l'Europe coalisée assiège le territoire de la Liberté."

60. Schiller 1795 (1962); transl. by Reginald Snell, Schiller 1983, p. 25; Habermas 1985, pp. 59–64.

61. Schiller 1795 (1962), pp. 398–404; Schiller 1983, p. 124.

62. Scheinfuss 1973, p. 76; the original French text of 17 January 1794 is reprinted in: Wildenstein 1973, no. 784, p. 84: "Les arts vont reprendre toute leur dignité, ils ne se prostitueront plus comme autrefois à retracer les actions d'un tyran. La toile, le marbre, le bronze concourrent à l'envie pour transmettre à la postérité le courage infatigable de nos phalanges républicains. […] Nos ennemis, vaincus par les armes, le seront aussi par les arts, telle est notre destinée, ainsi le veut le génie qui plane sur la France." The Société populaire et républicaine des Arts proposed, among other things, erecting a temple to freedom with depictions of the heroic deeds of the Republicans; Scheinfuss 1973, pp. 74–75 and pp. 58–59. – David's speech (on 29 March 1793) at the presentation of the painting of Michel Lepeletier on his deathbed (20 January 1793) in: Wildenstein 1973, no. 427, p. 50. – Bordes/Michel 1988, esp. the chapter 'Institutions et concours' by Udolpho van de Sandt, pp. 137–165; Pommier 1991, pp. 167–208.

63. Scheinfuss 1973, pp. 61–73. – But cf. Herding 1985 and 1986, who sees an article in the *Moniteur français* of 1794 as the first evidence of a theory of the avantgarde in art; however, the article is not very specific.

64. Deloynes 1980, vol. 42, nos. 1103–1107; Europa 1989, no. 503, p. 366. – The Exposition de l'industrie of 1806 was the model for the subsequent world exhibitions from 1851 onwards; cf. Laborde 1856, vol. 1, pp. 212–234: *Histoire des expositions des arts et de l'industrie*.

65. Olinde Rodrigues, 'L'artiste, le savant et l'industrie, Dialogue' [1825], in: Saint-Simon/Enfantin 1865–78 (1963/4), vol. 10 (39); and in: Pfeiffer 1988, pp. 185–215. – Thibert first drew attention to the avantgarde metaphor in 1926; Poggioli 1962 (1968), p. 10, only mentions Laverdant 1945; Egbert 1967; Egbert 1970; Janson 1975; Böhringer 1978, pp. 90–114; Maag 1986, pp. 38–55; Pfeiffer 1988, pp. 55–80.

66. Saint-Simon, 'De l'organisation sociale. Fragments d'un ouvrage inédit', in: Saint-Simon/Enfantin, 1865–78 (1963/4), vol. 10 (39), pp. 109–172, esp. pp. 137–138: "Les artistes, les hommes à imagination ouvriront la marche; ils proclameront l'avenir de l'espèce humaine […], ils passionneront la société pour l'accroissement de son bien-être […] et ils mettront en œuvre, pour atteindre leur but, tous les moyens des beaux-arts, l'éloquence, la poésie, la peinture, la musique, en un mot, ils développeront la partie poétique du nouveau système."

67. Barrault 1830, p. 84: "[…] associons nos efforts pour entraîner l'humanité vers cet avenir; unis entre nous, comme les cordes harmonieuses d'une même lyre, commençons dès aujourd'hui ces hymnes saintes, qui seront répétées par la posterité; désormais les beaux-arts sont le culte, et l'artiste est le prêtre." – Cf. Herding 1985 and 1986.

68. Staël 1800 (1959).

69. Laverdant 1845, p. 4: "L'Art, expression de la Société, exprime, dans son essor le plus élevé, les tendances sociales les plus avancées; il est précurseur et révélateur. Or, pour savoir si l'art remplit dignement son rôle d'initiateur, si l'artiste est bien à l'avant-garde, il est nécessaire de savoir où va l'Humantié, quelle est la destiné de l'Espèce."

70. Gautier 1835 (1966), p. 23: "Il n'y a de vraiment beau que ce qui ne peut servir à rien; tout ce qui est utile est laid, car c'est l'expression de quelque besoin, et ceux de l'homme sont ignobles et dégoûtants, comme sa pauvre et infirme nature. – L'endroit le plus utile d'une maison, ce sont les latrines." The foreword appeared in advance, in 1834.

71. Cassagne 1906; Art for Art's Sake 1996.

72. Constant 1952, p. 159: "L'art pour l'art, et sans but, car tout but dénature l'art. Mais l'art atteint au but qu'il n'a pas."

73. Nietzsche, *Götzen-Dämmerung, oder wie man mit dem Hammer philosophiert* [1888], in: Nietzsche 1960, vol. 2, pp. 1004–1005.

74. Cassagne 1906, Ch. II: L'adaptation du romantisme, pp. 51–94; Bourdieu 1992, Ch.: La

conqête de l'autonomie, pp. 75–164; Easton 1964; Clark 1973; Levitine 1975; Benjamin 1982, vol. V, 1, pp. 524–569 (Materialien zum Flaneur); Brown 1985; Seigel 1986; Collins 1991; Berman 1993.

75. Semper 1852; Maag 1986.

76. Laborde 1856, vol. 1, p. 2: "Chacun s'est dit: "L'avenir des arts, des sciences et de l'industrie est dans leur association." – Maag 1986; Karlheinz Barck, Kunst und Industrie bei Léon de Laborde und Gottfried Semper. Differente Aspekte der Reflexion eines epochengeschichtlichen Funktionswandels der Kunst, in: Pfeiffer/Jauss/Gaillard 1987, pp. 241–268.

77. Eugène Emanuel Viollet-le-Duc, *Histoire d'un dessinateur. Comment on apprend à dessiner*, Paris: J. Hetzel [1879], pp. 302: "Le dessin enseigné comme il devrait être et comme M. Majorin prit la peine de l'enseigner à petit Jean est le meilleur moyen de développer l'intelligence et de former le jugement, car on apprend à voir, et voir c'ests savoir." – Cf. E. H. Gombrich and Jill Tilden, 'Viollet-les Ducs "Histoire d'un dessinateur", in: *Kinderzeichnung und die Kunst des 20. Jahrhunderts,* ed. J. Fineberg, Stuttgart: Hatje, 1995, pp. 56–69.

78. On the extremely important problems of the social and economic use of the arts, which were discussed in all the western European countries, cf. Proudhon 1865 and 1988; Pfeiffer/Jauss/Gaillard 1987; Maag 1986.

79. Haskell 1971 (1978); Levey 1981; Georgel/Lecoq 1983; Raphael Catalogue 1983.

80. Livret du Salon de 1804, no. 325, pp. 61–62; Catalogues of the Paris Salon 1977–78, vol. 1802/04; Charles Paul Landon, *Annales du Musée*, vol. 10, 1805, plates 49/50; cf. the drawing by Julien de Parme, *Les Muses et les Grâces pleurent la mort de Raphaël,* 1774, Paris, Fondation Custodia, Institut Néerlandais, and the painting by François-Guillaume Ménageot, *La mort de Léonard de Vinci dans le bras de François Ier* (Salon de 1781), Amboise.

81. Livret du Salon de 1806, no. 24, pp. 7–8, listing the persons shown and quoting the passage from Vasari, cf. Vasari 1875–85 (1906), vol. 4, pp. 381–384; Catalogues of the Paris Salon 1977–78, vol. 1806/08.

82. *Catalogue des tableaux de S. M. l'Impératrice Joséphine dans la galerie de Malmaison,* Paris 1811, no. 152; a later replica, with some changes (130 × 192 cm), is in Malmaison; cf. Raphael Catalogue 1983, no. 18, p. 78; the original is now in Oberlin, Ohio, Allen Memorial Art Museum, Oberlin College.

83. The depiction derives from a legend narrated in detail by Vasari in the first edition of *Vite* of 1550 (pp. 574–575); it is repeated in the second edition of 1568, Vasari 1878–85 (1906), vol. 4, pp. 48–49. Vasari's pious untruth was discussed extensively in France in the first half on the 19th century, cf. David and Delacroix Catalogue 1974, no. 106, pp. 498–501. – The subject was apparently first treated by Angelika Kauffmann in 1778 for the Royal Academy exhibition (now lost), then by François Guillaume Ménageot in the Salon of 1781 (now Amboise, Musée de l'Hôtel de Ville). – Cf. Haskell 1971 (1978); Eduard Hüttinger, 'Leonardo- und Giorgione-Kult. Materialien zu einem Thema des Fin de Siècle', in: Fin de siècle 1977, pp. 143–169.

85. On Ingres: Jal 1828, pp. 197–202; Amaury-Duval 1978 (1993), pp. 227–233; on Delaroche: Ziff 1977, pp. 167–183.

86. Berthold Hinz, 'Der Triumph der Religion in den Künsten Overbecks 'Werck und Wort' im Widerspruch seiner Zeit', in: *Städel-Jahrbuch,* N. F. 7, 1979, pp. 149–170.

NOTES TO CHAPTER III

1. British Institution 1813, with *Catalogue of Pictures by the Late Sir Joshua Reynolds,* pp. 15–21. The British Institution was founded in 1805. Its first exhibition was held in 1806. The Institution had three exhibition rooms in Burlington House; cf. Graves 1908; Whitley 1928, pp. 106–107.

2. British Institution 1813, p. 13.

3. West 1814, p. 16. The same in: West 1815, p. 16.

4. Delacroix 1935–38, vol. 1, p. 156, on his visit to the gallery in May 1825: "J'ai vu la galerie de M. West, pour un *schelling,* bien entendu." – Cf. the letter from West's sons to J.W. Taylor, Speaker of the House of Representatives of the United States of America, of 12 April 1826, and the auction catalogue of 1829, printed in: Dillenberger 1977, pp. 198–202; Erffa/Staley 1986, pp. 150.

5. Canova Catalogue 1993.

6. The artists' busts in the Pantheon were taken to the Museo Capitolino on 8 March 1820,

cf. *La Protomoteca Capitolina,* ed. Valentino Martinelli and Carlo Pietrangeli (Cataloghi dei Musei comunali, vol. 5), Rome: "L'Erma" di Bretschneider, 1955.

7. Giuseppe Pavanello, 'La Gipsoteca di Possagno', in: Canova Catalogue 1992, pp. 361–367.

8. Cicognara 1823–25, vol. 7, 1824, p. 271; the bust of Napoleon was sold by Sartori to the Marchioness of Aubercorn, who agreed to sell it to the Duke of Devonshire, cf. Watson 1957; Pavanello 1976, no. 142, p. 109, no. 241, pp. 121–122.

9. Canova 1994, pp. 425–426.

10. Buddensieg 1968; Schröter 1990. – I am grateful for suggestions here to Pascal Griener, who is working on a major study of Canova's reputation as an artist.

11. Pavanello 1976, nos. 273–275, pp. 125–126.

12. Cicognara 1822 (2); Biblioteca canoviana 1823–24, vol. 4, pp. 173–180: Lettera sul monumento da erigersi in Venezia alla memoria di Antonio Canova del Co. Cicognara [1822].

13. Cicognara 1822 (1); Cicognara 1822 (2). – Cf. The painting by Giuseppe Borsato, *Onoranze funebri al Canova, con l'orazione di L. Cicognara all'Accademia di Belle Arti di Venezia,* Venice, Ca'Pesaro.

14. Caccianiga 1872 (1874), pp. 267–275, p, 275: "Soltanto una gita a Possagno può dare una giusta idea del genio di Canova. È un pellegrinaggio che deve compiersi non solo dagli artisti, da da ogni persona di gusto che ami di trovare in seno d'una bella natura, una immensa raccolta d'arte, un intiereo museo, opera d'un solo uomo." – Giuseppe Pavanello, 'La gipsoteca di Possagno', in: Canova Catalogue 1992, pp. 361–367.

15. Cf. The account books in the archive of the Accademia di San Luca, Conto Proprio, Genn. 1823–1834, fol. 2 recto – 3 recto; Missirini 1823. – Valadier Catalogue 1985, no. 207, pp. 85–86.

16. Cicognara 1823, pp. 40–42; Rosini 1830.

17. The Biblioteca canoviana 1823–24 immortalized the artist in a different way; cf. the poem by Giovanni Flatini, vol. 4, p. 126.

18. Wittkower 1964.

19. On the German memorial services see *Das Kunst-Blatt,* no. 31, 17. 4. 1820 (Munich), no. 38, 11. 5. 1820 (Berlin), pp. 149–151; on the service in Mainz see *Das Dritte Sekularfest zum Andenken Raphael's Sanzio von Urbino gefeiert zu Mainz am 6ten April 1820 durch eine Gesellschaft von Kunstfreunden und Künstlern. Auf Verlangen der Gesellschaft gedruckt,* Mainz 1820. – Schröter 1990, pp. 303–397. – Raphael Catalogue 1983; Italy: Golzio 1968, vol. 2, pp. 590–650.

20. Wackenroder 1797 (1991); Tieck 1798. – The portrait was engraved by Friedrich Wilhelm Bollinger.

21. Cf. Kris/Kurz 1934, pp. 47–65; 1980 edition, pp. 38–60; Badt 1956 (1968). – Cf. Vasaris witty play on the oxymoron *uomini immortali* (immortal men) and *dei mortali* (mortal gods), among which he includes Raphael; Vasari 1875–85 (1906), vol. 4, pp. 315–316.

22. Pforr 1811; Pforr/Overbeck 1811. – Ingres made a drawing of Raphael's birthplace in Urbino in 1839, Montauban, Musée Ingres.

23. Riepenhausen 1816 and 1833.

24. Berliner Akademie 1996, Ch. III, no. 1/41, pp. 218–219.

25. Heinecken 1782, no. 437, pp. 320, 244; cf. dazu Bialostocki 1987; Salvini 1987. – Wackenroder 1799 (1991), pp. 153–160; Friedrich Schlegel, 'Vom Raffael' [1803], in: Schlegel 1959, pp. 48–60, cf. also 'Zweiter Nachtrag alter Gemälde' [1805], pp. 79–115, p. 94 advising misdirected contemporary artists to look to Dürer.

26. Hinz 1971.

27. *Morgenblatt für die gebildeten Stände,* 5, 1811, no. 141 of 13 June 1811, p. 561. – A. Halder, Art. 'Kunstreligion', in: Ritter/Gründer 1971–, vol. 4, 1976, Col. 1458–1459.

28. Fernow, 'Über den Bildhauer Canova und dessen Werke', in: Fernow 1806–08, vol. 1, pp. 1–248.

29. Missirini 1831; Thiele 1832/34.

30. On the iconography of Thorvaldsen cf. Thorvaldsen Catalogue 1992, Ch. IV, pp. 507–549.

31. Thiele 1852–56, vol. 3, pp. 3–14; Andersen 1845.

32. Thiele 1852–56, vol. 3, p. 9; cf. the painting by Christoffer Wilhelm Eckersberg, *Thorvaldsen's Arrival at the Quayside in Copenhagen on 17 September 1838,* 1839, Copenhagen, Thorvaldsen Museum, Inv. B 217; Thorvaldsen Catalogue 1992, no. 9.1, pp. 698–699.

33. Friedrich Westphal, *Thorvaldsen's Arrival in Copenhagen on 17 September 1838,* Copenhagen,

Thorvaldsen Museum, and Emil Baerentzen, *Thorvaldsen's Return in 1838,* lithograph after F. West-phal. – The artist who drew the cartoon has remained anonymous.

34. Thorvaldsen's will of 8 August 1830: Thiele 1852–56, vol. 2, pp. 236–237, 279–282; on the designs: Thorvaldsen Catalogue 1992, nos. 9.3 – 9.10, pp. 700–705.

35. Hoeyen 1837; Miss 1992.

36. Thiele 1852–56, vol. 2, pp. 335–344, unlike the first will of 1830, the will of 1838 was legally valid and this clarified the situation for Copenhagen; cf. the codicils of 25 January 1843, in Thiele 1852–56, vol. 3, pp. 154–158.

37. Report by Thiele 1852–56, vol. 3, pp. 116–148.

38. Thiele 1852–56, vol. 3, pp. 188–189.

39. Thiele 1852–56, vol. 3, pp. 184–189; Miss 1992.

40. Thiele 1952–56, vol. 3, p. 186.

41. Hüttinger 1985, pp. 9–48; Hüttinger 1992, pp. 3–42.

42. Scott 1979, p. 47; quotation from *La Gazzetta Ticinese* of 11. 9. 1868, p. 829; cf. Wasmer 1987.

43. Gamboni 1992. – In accordance with Vincenzo Vela's wishes his son Spartaco made the Swiss Confederation his heir, on condition that the works were not sold and the house remained open to the public as a museum or college of art.

44. The first number of *L'Artiste* appeared on 1. 2. 1831. – Balzac 1831 (1979). – Damiron 1954.

45. 'Visite aux ateliers: Atelier de Mademoiselle Rosa Bonheur', in: *L'Illustration, Journal universelle,* 1852, pp. 283–285: "On est ici en dehors du monde réel, du monde des affaires."

46. Hamon 1993; around 1820 architecture students began to be given the task of designing an artist's studio with a big window facing north; cf. Ary Scheffer's studio of 1830 in the Rue Chaptal 16 in Paris, that still exists.

47. Boime 1971, pp. 48–78.

48. Horace Vernet, *L'atelier de l'artiste,* around 1820, 52 × 64 cm, PB. – *Le Magasin pittoresque* compared Vernet's studio with an artist's studio in the 16th century, as in a depiction by Baccio Bandinelli (pp. 348–349).

49. On the iconography of the studio cf. *Technique de la peinture: l'atelier.* Catalogue of an exhibition in the Louvre 1976 (Les dossiers du département des peintures), ed. Jeanine Baticle and Pierre Georgel, Paris: RMN, 1976; Milner 1988.

50. Klumpke 1908, pp. 256–257: "…j'étais en train (14 juin 1864) de travailler à mon tableau les Longs Rochers … lorsque tout d'un coups j'entends un roulement de chaises de poste, un bruit de grelots, des claquements de fouets. Tout ce fracas cesse subitement devant ma porte. Presque aussitôt, je vois Nathalie se précipiter comme une trombe dans l'atelier en criant; „L'impératrice! c'est l'impératrice qui vient ici! … Enlève ta blouse au plus vite. Tu n'as que le temps de passer cette jupe et cette jaquette, ajoute-t-elle en me tendant des vêtements. En moins de secondes qu'il n'en faut pour le dire, la transformation de mon costume fut accomplie et la porte de l'atelier ouverte à deux battants. Déjà l'impératrice en touchait le seuil et derrière elle montaient des dames d'honneur, des officiers et des personnages de la cour en uniforme. Avec cette grâce souveraine qui faisait d'elle la reine du goût parisien, Sa Majesté s'approcha; elle me tendit la main que je portai é mes lèvres, et dit que, amenée par une promenade dans le voisinage de ma maison, elle avait eu le désir de me connaître et de visiter mon atelier." Cf. *Le Monde illustré,* 8, 1864, no. 376, p. 406; Stanton 1910 (1976), pp. 93–97; Boime 1981.

51. The *École gratuite de dessin pour les jeunes personnes* was founded in 1802 by Mme Frère de Montizon, and taken over by the government in 1810. In 1848 Raimond Bonheur was director of the school, which was called *L'École spéciale de dessin pour les demoiselles.* Rosa Bonheur took over as director of the school after her father's death in 1849 (in the Second Empire it was renamed *École impériale de dessin pour les demoiselles*); in 1860 Mlle Nelly Marandon de Montyel took over as director. – Boime 1981, p. 392; Klumpke 1908, pp. 217–218, speech by Arsène Houssaye at the prize giving in 1859; Garb 1994, Ch. 4, pp. 70–104.

52. Lagrange 1860.

53. Klumpke 1908, pp. 264–267.

54. Delacroix 1950, vol. 3, p. 355: "Souscripteurs de toutes couleurs, gens qui encouragez les arts, qui envoyez à Rome, tous les ans, une demi-douzaine de Raphaël et de Phidias en herbe, si vous voulez encourager véritablement, si vous voulez que l'artiste soit dévoué au beau, car il faut l'être: et pour l'être, il faut, pour lui, négliger et sacrifier tout esprit de fortune … faites un tom-

beau à Géricault. Que celui qui aura consumé sa vie sans autre fruit qu'un faible expoir de renommée, sans autre appui qu'une voix intérieure et heureusement infatigable, qu'il sache qu'après sa mort, faible espérance, un laurier lui sera consacré!"

55. Géricault Catalogue 1991, no. 152, pp. 368–369; Scheffer Catalogue 1996, no. 10, p. 24.

56. Balzac 1831 (1979). – Shroder 1961, pp. 93–122; Hofmann 1981; Stoichita 1985.

57. Hoffmann 1908–28.

58. Rayski Catalogue 1990, no. 44, p. 43: "Auf dem wahren Künstlergange // Lebt's hiernieden sich nicht lange. // Trägt in sich des Todtes Kern – // Wahre Künstler sterben gern." Hofmann 1977, p. 133, Hofmann 1979, p. 228; Schlink 1996.

59. Sells 1974, pp. 266–270.

60. Gassier 1983, p. 268; Garms 1992; Griener 1994.

61. *Disegni di Tommaso Minardi (1787–1871)*. Catalogue of the exhibition in the Galleria Nazionale di Arte Moderna Roma 1982/83, 2 vols., Rome, De Luca, 1982, vol. 1, no. 30, pp. 150–152: "Questo disegno fu fatto nel 1808 per commissione del Conte Crispino Rasponi da Ravenna per un quadro ad olio da collocarsi sul soffitto di un suo Gabinetto di bellissimi quadri principalmente fiamminghi; e che io per farlo con la maggior cura nol feci mai. Pazzia!! Non fu tanta pazzia: pensì conoscendo io l'ampiezza della pittura e mancandomi d'assai la perizia pratica, e cotesta naturalmente sperandola, di mese in mese, de' anno in anno fu cagione di finire in nulla, siccome fu di tante altre onorevoli commissioni; sicché diventò Pazzia vera!!!"

62. For all references see the essay by Schneemann 1995 which resulted from this research project.

63. Zola 1886 (1966), p. 352: "En chemise, les pieds nus, atroce avec sa langue noire et ses yeux sanglants sortis des orbites, il pendait là, grandi affreusement dans sa raideur immobile, la face tournée vers le tableau, tout près de la Femme au sexe fleuri d'une rose mystique, comme s'il lui eût soufflé son âme à son dernier râle, et qu'il l'eût regardée encore, de ses prunelles fixes." – Shroder 1961, pp. 225–234; Marchwinski 1987.

64. Zola 1886 (1966), Ch. 9, 10, pp. 230–308, p. 295: "Oh! l'horreur! est-ce que la police devrait permettre une horreur pareille!"

65. On novels about artists: Shroder 1961; Hofmann 1982.

66. Tabarant 1947, pp. 411–412: "Et la vérité est qu'il meurt de son art. [...] Vingt ans de notre enfer de Paris, nuits enfièvrées, de secousses et de privations de toutes sortes, l'ont jeté où il est." – Marchwinski 1987.

67. Delacroix 1950, vol. 3, p. 25; Delacroix 1996, p. 40.

68. Delacroix 1950, vol. 3, „science", pp. 24–25: "Cet exercice des copies, entièrement négligé par les écoles modernes, était la source d'un immense savoir." – Cf. vol. 1, p. 215 (Tintoretto).

69. Delacroix 1950, vol. 3, pp. 222–223 (1 March 1859), under „Imitation", „Imitateurs" in Index; Delacroix 1996, pp. 115–117. – Copying had a firm place in the academic curriculum as a useful and necessary exercise; the winners of the *Prix de Rome* had to make coloured reproductions of Roman works of art each year. But anyone who continued to copy after ceasing to be a student, instead of producing his own work, earned little regard. Boime 1971, pp. 42–43, Ch. VI: The copy, pp. 122–132; Vaisse 1976; Grunchec 1983; Grunchec 1984 and 1986.

70. Pierre-Charles Lévesque, art. 'copie' und 'copier', in: *Encyclopédie Méthodique* 1788, vol. 1, pp. 152–153: "Des hommes qui n'ont pas assez de talent pour produire de bons ouvrages, se consacrent à copier les ouvrages des autres: ce sont des copistes. De jeunes artistes copient les bons tableaux pour apprendre à les imiter; ce sont des étudians, des élèves. Des hommes qui ont un talent déjà formé, copient des ourages des grands maîtres pour acquérir des parties qui leur manques. Le Poussin a copié le Titien, Rubens a copié Raphael: ces exemples semblent prouver que cet exercice rapporte peu de fruit quand on a déjà une manière faite." – Cf. also: *Dictionnaire* 1792, art. 'Copie' and 'Copier', vol. 1, pp. 492–495; Johann Georg Sulzer, Art. 'Copiren', in: Sulzer 1771/74, vol. 1, pp. 231–232, and Sulzer 1792–94, vol. 1, pp. 586–587.

71. Lévesque, art. 'copier', *Encyclopédie Méthodique* 1788, vol. 1, p. 153: "Si la principale beauté d'un tableau consiste dans l'effet général, on pourra prendre, en quelque sorte, note de cet effet par une esquisse, copier la pensée plutôt que la touche, l'ensemble plutôt que les détails, & marcher dans la carrière des grands maîtres, sans repasser servilement sur leurs traces."

72. Eugène Delacroix, 'Le Poussin', in: *Moniteur Universel*, 26, 29 and 30 June 1853; and in: Delacroix 1928, vol. 2, pp. 57–104; Delacroix 1988, pp. 209–255, p. 246: "Ceci est l'art de l'antiquaire, mais non de l'artiste, qui doit remonter à l'esprit, au sens de ce qu'il s'approprie en l'imitant." – Vauvenargues 1747.

73. Cf. Held 1963.

74. Delacroix 1950, vol. 2, p. 169 (24 April 1854).

75. Haverkamp-Begemann/Logan 1988, no. 57, pp. 190–191.

76. Ingres and Delacroix Catalogue 1986, no. 77, p. 264–265, no. 165, p. 280.

77. Maurice Sérullaz, 'Das zeichnerische Oeuvre bei Eugène Delacroix', in: Ingres and Delacroix Catalogue 1986, pp. 131–146.

78. Badt 1965, pp. 9–45.

79. Delacroix 1950, vol. 2, p. 169 (24 April 1854): "L'idée première, le croquis, qui est en quelque sorte l'oeuf ou l'embryon de l'idée, est loin ordinairement d'être complet; il contient tout, si l'on veut, mais il faut dégager ce tout, qui n'est autre chose que la réunion de chaque partie. Ce qui fait précisément de ce croquis l'expression par excellence de l'idée, c'est, non pas la suppression des détails, mais leur complète subordination aux grands traits qui doivent saisir avant tout. La plus grande difficulté consiste donc à retourner dans le tableau à cet éffacement des détails … ." – Cf. Delacroix 1981, pp. 414–415.

80. Delacroix 1950, vol. II, p. 170: "Chez les grands artistes, ce croquis n'est pas un songe, un nuage confus, il est autre chose qu'une réunion de linéaments à peine saisissables; les grands artistes seuls partent d'un point fixe, et c'est à cette expression pure qu'il leur est si difficile de revenir dans l'exécution longue ou rapide de l'ouvrage. L'artiste médiocre, occupé seulement du métier, y parviendra-t-il à l'aide de ces tours de force de détails qui égarent l'idée, loin de la mettre dans son jour? Il est incroyable à quel point sont confus les premiers éléments de la composition chez le plus grand nombre des artistes. Comment s'inquiéteraient-ils beaucoup de revenir par l'exécution à cette idée qu'ils n'ont point eue?" Cf. Sérullaz 1984.

81. Mras 1962; Mras 1966, esp. pp. 72–98.

82. Delacroix 1950, vol. 3, p. 219 (9 January 1859): "Sur la difficulté de conserver l'impression du croquis primitif. – De la nécessité des sacrifices. – En suivant: sur les artistes qui, comme Vernet, finissent tout de suite, et du mauvais effet qui en résulte." Delacroix 1981, p. 736; Delacroix 1996, pp. 66–69 (ébauche) and pp. 183–189 (sublime).

83. Charles Baudelaire, 'L'œuvre et la vie d'Eugène Delacroix', in: L'Opinion nationale, 2 Sept., 14 and 22 November 1863; in: Baudelaire 1962, pp. 421–451, esp. pp. 426–427; cf. also Baudelaire 1859 (1962), pp. 305–396, esp. Ch. IV: Le gouvernement de l'imagination, pp. 324–330.

84. Baudelaire 1859 (1962), pp. 327–328: "Un bon tableau, fidèle et égal au rêve qui l'a enfanté, doit être produit comme un monde. De même que la création, telle que nous la voyons, est le résultat de plusieurs créations dont les précédentes sont toujours complétées par la suivante; ainsi un tableau conduit harmonieusement consiste en une série de tableaux superposés, chaque nouvelle couche donnant au rêve plus de réalité et le faisant monter d'un degré vers la perfection."

85. Cézanne 1937, pp. 260–261: Letter of 12 May 1904 to Émile Bernard, p. 260; the passage begins by Cézanne agreeing with Odilon Redon in admiring Delacroix, and ends with the sentence: "Je ne sais pas si ma précaire santé me permettra de réaliser jamais mon rêve de faire son apothéose." – Cézanne 1976, p. 302.

86. Bernard 1907 (1912), pp. 51–52: "Il avait en vue une Apothéose de Delacroix. Le maître romantique était emporté, mort, par des anges; l'un tenait ses pinceaux, l'autre sa palette." – More recent reprint in: Cézanne 1978, p. 69. – Adriani 1993, no. 63, pp. 195–197.

87. Venturi 1936, vol. 1, no. 245 (oil sketch), p. 119 (1873–77), no. 891 (watercolour), pp. 259–250 (1878–85); Rewald 1983, no. 68, pp. 102–103: watercolour dated 1878–80, with later reworking at uncertain date. – Cf. also Lichtenstein 1964 and Andersen 1967, pp. 137–139.

88. Charles Baudelaire, 'Exposition universelle 1855', in: Baudelaire 1962, pp. 209–240, p. 252: "Jamais artiste ne fut plus attaqué, plus ridiculisé, plus entravé." – Cf. Baudelaire 1975/76, vol. 2, pp. 575–597; Baudelaire 1977–92, vol. 2, 1983, pp. 225–253, quotation p. 246.

89. Delacroix 1853 (1928); Delacroix 1988, pp. 209–255, p. 210: "On a tant répété qu'il est le plus classique des peintres, qu'on sera peut-être surpris de le voir traiter dans cet essai comme l'un des novateurs les plus hardis que présente l'histoire de la peinture."

90. Delacroix 1853 (1928), p. 236: "Ces lettres en disent plus que toutes les narrations et que toutes les remarques: voilà le plus grand peintre que notre pays ait produit, qui, méconnu pendant de longues années et applaudi enfin par des étrangers … ." – Poussin 1824. – For Charles Clément Poussin's stay in France, his lack of success and the consequences were very important. He draws a picture of an artist driven out of his homeland: "Ce départ de Poussin, chassé de son pays par des intrigues honteuses, est déplorable." Clément 1850 (1869), p. 51.

91. Gautier 1864 (1929), p. 61: "A présent que le calme se fait autour de ce grand nom – un de ceux que la postérité n'oubliera pas, – on ne saurait imaginer au milieu de quel tumulte, dans quelle ardente poussière de combat il a vécu. Chacune de ses oeuvres soulevait des clameurs assourdissantes, des orages, des discussions furieuses. On invectivait l'artiste avec des injures telles qu'on ne les eût pas adressées plus grossières ni plus ignominieuses à un voleur ou à un assassin. ... C'était un sauvage, un barbare, un maniaque, un enragé, un fou qu'il fallait renvoyer à son lieu de naissance, Charenton."- Charenton is a famous lunatic asylum.

92. Gautier 1864 (1929), p. 62: "C'est ainsi que les génies sont salués à leur aurore, étrange erreur dont chaque génération s'étonne après coup, et qu'elle recommence naïvement."

93. Escholier 1926–29, vol. 3, pp. 266–270.

94. Fantin-Latour Catalogue 1982, nos. 54–57, pp. 165–178; the painting was exhibited in the Salon in 1864 entitled: *Hommage à Eugène Delacroix;* Fantin-Latour was apparently stimulated by Baudelaire in 1863 (1962), pp. 421–451; Baudelaire 1976, vol. 2, pp. 742–770.

95. From left to right: Louis Cordier, Edmond Duranty, Legros, Fantin-Latour, Whistler, Champfleury, Manet, Braquemond, Baudelaire, Balleroy.

96. Hofmann 1960 (1974), p. 130; Gohr 1975, pp. 41–51; Fantin-Latour Catalogue 1982, no. 57, pp. 171–175.

97. Duranty 1867, pp. 13–18: "Des artistes contestés rendant hommage à la mémoire de l'un des grands contestés de ce temps." – Fantin-Latour Catalogue 1982, p. 173.

98. For a compilation of the interesting reviews see Fantin-Latour Catalogue 1982, pp. 175–178.

99. George Rivière, in: *L'Impressioniste,* 1877, quoted in Rewald 1986, p. 112. – On Cézanne and his critics see Wechsler 1975, Hamilton 1977.

100. Vollard 1938, pp. 37–45; Rivière 1933, pp. 151–155.

101. Marx 1904, p. 463. – Cézanne 1937, no. 180, pp. 273–274: "Mon âge et ma santé ne me permettront jamais de réaliser le rêve d'art que j'ai poursuivi toute ma vie. Mais je serai toujours reconnaissant au public d'amateurs intelligents qui ont eu – à travers mes hésitations – l'intuition de ce que j'ai voulu tenter pour rénover mon art. Dans ma pensée on ne se substitue pas au passé, on y ajoute seulement un nouveau chaînon. Avec un tempérament de peintre et un idéal d'art, c'est-à-dire de la nature, il eût fallu des moyens d'expression suffisants pur être intelligible au public moyen et occuper un rang convenable dans l'histoire de l'art."

102. Marx 1904. – On the relationship between Cézanne and Poussin, which all contemporary writers mentioned, cf. Cézanne 1978, p. 80 (Bernard), p. 84 (Jourdain), p. 91 (Rivière and Schnerb), p. 97 (Osthaus), pp. 122, 129, 150, 151, 159 (Gasquet), pp. 179, 189 (Denis); Shiff 1984, Ch. 13: 'The Poussin Legend', pp. 175–184; Verdi 1990.

103. Bernard 1907 (1912), pp. 40–41.

104. Denis 1957–59, vol. 1, p. 143: "Faire un tableau de Redon dans la boutique de Vollard, entouré de Vuillard, Bonnard etc." – Denis Catalogue 1994, no. 108, pp. 258–260.

105. Gamboni 1989, p. 178.

106. On Ingres: Amaury-Duval 1878 (1993), pp. 227–233; on Delaroche: Ziff 1977, pp.167–183.

107. Menzel 1834, cf. Hofmann 1977, Hofmann 1979. – Goethe, 'Der Künstler Erdenwallen', 'Des Künstlers Vergötterung', 'Künstlers Apotheose', in: Goethe 1949–60, vol. 1, pp. 63–77, Commentaries pp. 488–490.

108. Karlsruhe Kunsthalle Catalogue 1971, vol. 1, pp. 69–70, fig. 946, p. 98; Feuerbach Catalogue 1976, no. 12, p. 161; Ecker 1991, no. 92, pp. 98–99. – On *Hafis in der Schenke (Hafiz in the tavern),* Mannheim, Kunsthalle, purchased 1913; Feuerbach catalogue 1976, no. 9, pp. 159–160; Ecker 1991, nos. 88–91, pp. 95–98.

109. Feuerbach Catalogue 1976, no. 9, pp. 159–160; 'Ein Besuch der Kunstausstellung zu Düsseldorf', in: *Deutsches Kunstblatt,* no. 28, 10 July 1852, p. 237: "Das Bild von Feuerbach dagegen 'der Dichter Hafis in einer Schenke' ist ein Missgriff. Gar zu wunderlich gebehrdet sich der Alte, und nicht nur unmalerisch sind die beiden Mädchen, die Lage der vorderen ist auch unästhetisch, sie präsentirt noch mehr als den unbekleideten Rücken; mit einer wahrhaft galoppirenden Bravour gemalt, ist es auch zu roh in der Wirkung." Cf. Allgeyer 1904, vol. 1, pp. 192–194.

110. Feuerbach wrote to his parents about the *Self-Portrait* of 1847: " ... es ist ganz van Dyckisch aufgefasst, sehr von oben herab ... ; der Kerl steht verdammt vornehm da, etwas zurückgebeugt, mit übereinandergeschlagenen Armen, er sieht sich einmal die Welt an, um ihr dann den Rücken zu kehren." Feuerbach 1912, vol. 1, p. 151; Blochmann 1991, pp. 167–197. The

young artist's testimony went to his friend Heinrich Carl Schaible, who had fled from Baden to Paris for political reasons. Schaible bequeathed Feuerbach's *Self-Portrait* to the Kunsthalle Karlsruhe in 1899.

111. Schlink 1996, with a reference to Hans von Marées' *Self-Portrait* in the Kunsthalle Bremen; Marées Catalogue 1987, no. 23, pp. 212–213, and: Peter O. Krückmann, 'Das Doppelbildnis Marées und Lenbach', pp. 33–38.

112. Lenbach Catalogue 1987, no. 72, pp. 239–240; Meier-Graefe 1909–10, vol. 1, p. 81–90, vol. 2, no. 105, pp. 79–79.

113. Blochmann 1991, pp. 108–126; Böcklin's *Self-Portrait with Death playing the Fiddle* of 1872 was exhibited the same year in the Munich Kunstverein. It was the most famous self-portrait of a contemporary artist in the nineteenth century, cf. Andree 1977, no. 259, pp. 352–354, and Nr. 267, p. 360. – On Hans Thoma's *Self-Portrait with Amor and Death* of 1875: Schlink 1989, pp. 64–71.

114. Sandreuter 1917.

115. Böcklin 1901; reprint in: Tschudi 1912, pp. 134–162. Tschudi was critical about the quality of the painting, but conceded that it had an extraordinary suggestive power, and that the painter had produced a skilful combination of Velázquez and the *Portrait of Sir Bryan Tuke* in Munich, formerly attributed to Holbein. – Laban 1898: "... nicht nur die gesammelte Kraft, das produktive Vermögen des Dargestellten, seine Genialität potentia, sondern recht eigentlich auch die Bethätigung dieser Begabung, der Augenblick der Inspiration, des Vorgangs des Schaffens, die Genialität actu."

116. Waetzoldt 1908, pp. 309–414.

117. Waetzoldt 1908, pp. 311–314.

118. Waetzoldt 1908, pp. 360–373, pp. 370–371. For his discussion of series of self-portraits as testimonies to an artist's development Waetzoldt referred to Reynolds, Goya and Böcklin.- The idea of seeing a series of self-portraits as a painted autobiography derives from Gustave Courbet, cf. Bruyas' letter of May 1854: Courbet 1996, no. 54–2, pp. 113–115; Courbet 1992, no. 54–2, pp. 122–124; Borel 1951, p. 20. – Neumann 1902, pp. 485–490: "Aneinandergereiht bilden sie eine Art Selbstbiographie, die man mit den merkwürdigsten Erscheinungen dieser Gattung ... vergleichen könnte. Bei der rein künstlerischen Gesinnung, in der Rembrandt sich selbst malte, haben sie den Wert unbefangenster Zeugnisse" As parallel see Georg Misch, *Geschichte der Autobiographie*, 4 vols., Leipzig 1907, Frankfurt 1969.

119. Waetzoldt 1908, pp. 360–373, pp. 370–371; Meier-Graefe 1905, pp. 96–99, 102–107.

120. Meier-Graefe 1905, p. 226: "Böcklin kennt nur sich selbst und den Zuschauer; der eine soll den andern packen, dafür wird alles getan."

121. Meier-Graefe 1905, pp. 97–101, 102–108.

122. Nietzsche 1881 (1960); cf. Badt 1943 (1968).

123. The later literature is largely disappointing in regard to this problem, esp. Benkard 1927. – Only recently is a critical approach to the interpretation of self-portraits evident: Junod 1985; Podro 1988; Schlink 1989 and 1996; Berman 1993; Werckmeister 1981; Werckmeister 1989; cf. Also the articles in Winner 1992. – The problems raised by the use of the self-portrait to depict changing roles and for play-acting are evident from the reception of the works of James Ensor and Max Beckmann. Cf. the latest examples in Heusinger von Waldegg 1989; Beckmann Catalogue 1993.

124. Corinth 1926; Kasimir Edschmid, *Schöpferische Konfession* 1920; Westheim 1925.

125. Kneher 1994, pp. 83–85.

126. Jedlicka 1958; Berman 1993.

127. Hofmann 1954 (1979); Kemp 1983.

128. Bock/Busch 1973, pp. 239–248; Kneher 1994, pp. 9–25.

129. Przybyszevski 1894.

130. Przybyszevski 1894, pp. 22–26: "Seine Landschaft ist das absolute Correlat zu dem nackten Empfinden: jede Vibration der in höchster Schmerzensekstase blossgelegten Nerven setzt sich in eine entsprechende Farbenempfindung um. Jeder Schmerz ein blutroter Fleck; jedes langgehende Schmerzgeheul ein Gurt blauer, grüner, gelber Flecke: unausgeglichen, brutal nebeneinander." Cfl. Vladyslava Javorska, 'Munch und Przybyszewski', in: Bock/Busch 1973, pp. 47–68.

131. Aggum 1986, p. 81; Munch Catalogue 1987, no. 29.

132. Werckmeister 1981; Werckmeister 1989. His second argument is that the panegyric and the analytical literatur on Paul Klee very largely contributed to perpetuating the artist's self-

mystification.

133. Hohl 1982; Klee Catalogue 1986; Klee Catalogue 1987; Hopfengart 1989.
134. Ahlers-Hestermann 1921.
135. Cf. Gohr 1979; Wedekind 1993.

NOTES TO CHAPTER IV

1. Courbet Catalogue 1977, pp. 22–50; no. 18, pp. 94–96; Courbet 1996, no. 49–7, pp. 80–81; Courbet 1992, no. 49–7, pp. 86–87. However, Courbet's painting, when purchased by the state, was sent to the provinces and deposited in the museum in Lille.

2. Courbet 1996, no. 45-3, p. 53–54: "C'est pourquoi il faut que l'an qui vient je fasse un grand tableau qui me fasse décidément connaître sous mon vrai jour, car je veux tout ou rien." Cf. no. 45-4, pp. 54–55. Cf. Courbet 1992, nos. 45-3, 45-4, pp. 53–55.

3. Interpretations of Courbet's paintings by Max Buchon appeared in Le Démocrate franc-comtois in Besançon on 25 April 1850, and Le peuple, Journal de la révolution sociale on 7 June 1850; cf. Clark 1969.

4. Courbet 1996, nos. 50-5, 50-6, pp. 91–94; cf. Courbet 1992, nos. 50-5, 50-6, pp. 100–101. Apart from the letter from the artist to his parents telling them of his success and that he and his paintings were on everyone's lips in Paris, there are no reports of this studio exhibition.

5. Courbet entered A Burial at Ornans in the register as Tableau de figures humaines, historique d'un enterrement à Ornans; in the Livret it was called Un enterrement à Ornans; cf. Courbet Catalogue 1977, no. 21, pp. 98–105; Livret du Salon de 1850; Catalogues of the Paris Salon 1977–78 (1850), no. 661, p. 73. – The critics, who insisted on the hierarchic large format for a history painting, objected to the disproportion here between format and subject.

6. Schuster 1978; Herding 1978; Léger 1920; Boas 1938 (1977).

7. Nadar 1857, p. 14: "Vous voyez bien que je suis le plus grand peintre, puisque c'est moi qu'on attaque le plus".

8. O. M. 1851, p. 99.

9. Courbet Catalogue 1978.

10. Courbet 1996, no. 52-3, pp. 100–101, no. 53-1, p. 103. Cf. the same note in Courbet's autobiography of 1866 in Courthion 1948–50, vol. 2, p. 30. – Courbet 1992, no. 52-3, pp. 106–108, no. 53-1, p. 110.

11. Courbet Catalogue 1977, no. 32, pp. 117–120; Courthion 1948–50, vol. 1, pp. 111–112; Delacroix 1950, vol. 2, pp. 18–19 (15 April 1853).

12. Solution became a key word for artists and patrons. Bruyas published a brochure in 1853 entitled Solution d'artiste. Sa profession de foi, and the next year he published Explication des Ouvra-ges de Peinture du Cabinet de M. Alfred Bruyas, adding Les Baigneuses, cf. Bruyas 1854, p. 8, and no. 8, pp. 12–13 (quoting the review by Théophile Gautier), 79–80. Bruyas had himself painted thirty-four times by different artists, among them Octave Tassaert in 1851 and Delacroix in 1853, cf. Bruyas 1854, nos. 14–15, pp. 16–19. Bruyas probably offered 2000 francs for Les Baigneuses, but Courbet was hoping for 3000, cf. Courbet 1996, no. 53-3, pp. 104–105, Courbet 1992, no. 53-3, pp. 111–112.

13. Courbet Catalogue 1977, no. 36, pp. 124–126; this is one of eleven works by Courbet that were shown at the World Exhibition of 1855, cf. Courbet 1996, nos. 55-3, 55-4, 55-6, pp. 126–130; Courbet 1992, nos. 55-3, 55-4, 55-6, pp. 137–144; Courbet Catalogue 1988, no. 19, pp. 116–118; Nochlin 1967 (1).

14. Mainardi 1987, pp. 40–42; Boime 1982.

15. Courbet 1996, no. 53-6, pp. 107–110, p. 107: "J'ai brûlé mes vaisseaux. J'ai rompu en visière avec la société. J'ai insulté tous ceux qui me servaient maladroitement. Et me voici seul en face de cette société. Il faut vaincre ou mourir". – Courbet 1992, no. 53-6, pp. 114–118.

16. World Exhibition 1855 (Livret), Catalogues of the Paris Salon 1977–78 (1855), vol. 1, nos. 2908–2942 (Delacroix), pp. 298–302, nos. 3336–3375, 5048 (Ingres), pp. 349–353, 580.

17. Courbet 1996, no. 55-4, pp. 127–128: "Je suis aux cent coups! Il m'arrive des choses terribles. On vient de me refuser mon Enterrement et mon dernier tableau L'Atelier, avec le Portrait de Champfleury". no. 55-5, pp. 129–130: "En un mot, on voulait en finir avec moi, on voulait me tuer. Depuis un mois je suis désespéré. Ils m'ont refusé systématiquement mes grands tableaux, en déclarant que ce n'était pas la peinture qu'ils refusaient, mais l'homme". – Courbet 1992, nos.

55-4, 55-5, pp. 139–142.

18. Courbet 1996, no. 53-6, p. 109 (the first idea of a one-man show in competition with the World Exhibition and his hopes of earning 40,000 francs from it); nos. 55-4, 55-5, 55-6, 55-7, pp. 127–132: "Je conquiers ma liberté, je sauve l'indépendance de l'art". Courbet 1992, nos. 55-4, 55-5, 55-6, 55-7, pp. 139, 145.

19. Courbet Catalogue 1855.

20. Lenormant 1833, vol. 1, p. 187, insists on the distinction between the French *exposition* and the English *exhibition:* "Les expositions sont d'origine française; les exhibitions ont pris naissance en Angleterre. Les premières impliquent quelque chose de gratuit, de général, d'officiel; les secondes ont nécessairement pour but un intérêt spécial, une spéculation privée." – Mainardi 1991.

21. Mainardi 1991, with the first reproduction of the photograph of Courbet's pavilion (p. 263).

22. For an identification of the figures cf. Toussaint 1977; cf. the description in Courbet's letter to Champfleury, Courbet 1996, no. 54-8, pp. 121–123; Courbet 1992, no. 54-8, pp. 131–134.

23. Courbet Catalogue 1855, no. 1, 1855: *L'Atelier du Peintre, allégorie réelle déterminant une phase de sept années de ma vie artistique.* – Herding 1984, pp. 223–247.

24. Courbet Catalogue 1855, no. 12: *L'Homme blessé,* dated 1854; Courbet 1996, no. 54-8, p. 123; Courbet 1992, no. 54-8, p. 133; Courbet Catalogue 1977, no. 35, pp. 122–124.

25. Nadar, 'Portrait véridique de saint Courbet, peintre et martyr', in: *Journal pour Rire,* 1857, cf. Léger, 1920, p. 38.

26. Courbet 1996, nos. 69-6, 69-7, 69-8, pp. 311–314, letters to Léon Gauchet, his parents and Jules Castagnary on the exhibitions in Munich and Brussels and the honour of being made a Knight of the Order of Merit of St. Michael by the King of Bavaria in 1869. Courbet comments: "Ça prouve qu'il n'est pas nécessaire d'être napoléonien comme en France pour faire de la peinture." – Courbet 1992, nos. 69-6, 69-7, 69-8, pp. 351–354.

27. Courbet Catalogue 1977, pp. 32–33, nos. 52, 53, pp. 141–146.

28. Landseer received a gold medal in 1855 for his hunting scenes; cf. Mainardi 1987, pp. 110–111; reproduction of *The Death of the Stag* in: *Le Magasin Pittoresque,* no. 49, December 1851, p. 385; cf. Landseer's mention of Courbet in connection with the hunting trilogy in: Courbet 1996, no. 61-6, p. 176; Courbet 1992, no. 61-6, p. 194. – Cf. Nochlin 1967 (2), p. 213.

29. Courbet 1996, no. 58-3, pp. 147–148 (reporting his success to his parents). – Courbet 1992, no. 58-3, pp. 161–163.

30. Courbet 1996, no. 61-6, pp. 175–177: "Il me fâche même de ne paraître au Salon que sous le jour du paysage et des animaux. J'aurais voulu envoyer un tableau de figures, si j'avais pu obtenir un sursis, mais le gouvernement n'en accordait pas, et mon pouce est cause de tout ça. Comme il faut absolument ue je vende cette année si je veux continuer la peinture, j'ai dû envoyer ces tableaux, et même j'en aurais envoyé davantage, si je ne m'étais pas cassé le pouce gauche cet hiver, ce qui m'a empêché de travailler pendant un mois et demi." – Cf. no. 61-3, p. 172. – Courbet 1992, no. 61-6, pp. 192–196, no. 61-3, pp. 189–190.

31. Courbet 1996, nos. 61-10, 61-11, pp. 178–180, no. 61-15, pp. 182–183; Courbet 1992, nos. 61-10, 61-11, pp. 197–199, no. 61-15, pp. 202–203.

32. Courbet 1996, no. 61-14, pp- 181–182; Courbet 1992, no. 61-14, pp. 200–201.

33. Courbet Catalogue 1978, no. 265, pp. 270–273; the big version has been destroyed, but as well as the sketch in Basel another version in a smaller size has survived, cf. Fernier 1977, nos. 339, 340.

34. Courbet 1996, nos. 65-14, 65-15, 65-16, pp. 239–241; Courbet 1992, nos. 65-14, 65-15, 65-16, pp. 267-269.

35. Courbet 1996, no. 63-13, pp. 201–203; the accusation caused an irreparable break in the friendship. – Courbet 1992, no. 63-13, pp. 223–226.

36. Courbet 1996, no. 63-12, pp. 200–201; Courbet 1992, no. 63-12, pp. 222–223. – Courbet thought he could earn the fantastic sum of 50,000 francs with a spectacular touring exhibition through Europe, but the plan ended in miserable failure in London, cf. Courbet 1996, no. 63-16, pp. 204–205; Courbet 1992, no. 63-16, pp. 227–228.

37. Proudhon 1865, ch. XVII, pp. 264–278, p. 278: "… et quand Courbet a composé son tableau, il n'a fait que se rendre l'interprète de la loi et de la pensée universelle. Son œuvre avait droit de bourgeoisie à l'Exposition, droit à l'Académie et au Musée."

38. Courbet 1996, nos. 64-4, 64-5, pp. 213–214, no. 64-8, pp. 215–216; Courbet 1992, nos. 64-4, 64-5, pp. 237–239, no. 64-8, pp. 240–241.

39. Proudhon 1865, p. 263: "L'art, jadis adoré, est destiné de nos jours, s'il poursuit sa route légitime, à éprouver la persécution. Elle est déjà commencée. Les artistes véridiques seront honnis comme ennemis de la forme, et peut-être punis comme outrageant la morale publique, excitant à la haine des citoyens les uns contre les autres."

40. Courbet Catalogue 1978, nos. 247–252, pp. 243–253; Fried 1990, pp. 171–188.

41. Courbet Catalogue 1867: "L'exiguité de la galerie ne permettant pas à l'auteur d'exposer toutes ses œuvres en une fois, il se propose de faire plusieurs renouvellement de tableaux, au fur et à mesur des envois qui lui seront faits."

42. Letters to Bruyas in connection with the 1867 World Exhibition pavilion (a good use for the money): Courbet 1996, nos. 67-11, 67-17, pp. 276–277, 279–280; Courbet 1992, nos. 67-11, 67-17, pp. 311–312, 314–315.

43. Grandville 1844; reprint in *Paris futur. Exposition de l'avenir,* fig. 24: Galerie des Beaux-Arts, in: Gavarni and Grandville 1868, vol. 3, by p. 39. – On Grandville cf. Benjamin 1982, vol. V., I, pp. 232–268.

44. Manet Catalogue 1983, nos. 64, 87, pp. 174–189, 226–229. – In a long essay written in 1867 Zola mentioned only the title of the religious painting, while he discussed *Olympia* in detail as a masterpiece and analysed public reaction to it. – Zola 1867.

45. Blanc 1877, pp. 11–15; Blanc follows Aretino's anecdote in illustrating his brochure by reproducing on two pages first Titian's *Danae* in the Prado and then his *Crown of Thorns* from the Louvre. – Reff 1970.

46. Graber 1941, pp. 98–99.

47. Zola 1989, pp. 87–88: "J'imagine que je suis en pleine rue et que je rencontre un attroupement de gamins qui acompagnent Edouard Manet à coups de pierre. Les critiques d'art – pardon, les sergents de ville – font mal leur office; ils accroissent le tumulte au lieu de le calmer, et même, Dieu me pardonne! il me semble que les sergents de ville ont d'énormes pavés dans leurs mains. Il y a déjà, dans ce spectacle, une certaine grossièreté qui m'attriste, moi passant désinteressé, d'allures calmes et libres." – Zola 1867.

48. Zola 1989, p. 139: "Et voilà comme quoi une troupe de gamins a rencontré un jour Edouard Manet dans la rue, et a fait autour de lui l'émeute qui m'a arrêté, moi passant curieux et désinteressé. J'ai dressé mon procès-verbal tant bien que mal, donnant tort aux gamins, tâchant d'arracher l'artiste de leurs mains et de le conduire en lieu sûr. Il y avait là des sergents de ville – pardon, des critiques d'art – qui m'ont affirmé qu'on lapidait cet homme parce qu'il avait outrageusement souillé le temple de Beau. Je leur ai répondu que le destin avait sans doute déjà marqué au musée du Louvre la place future de l'*Olympia* et du *Déjeuner sur l'herbe.*" –

49. Degas Catalogue 1988, nos. 72, 73, pp. 128–129. Bätschmann 1992 (2) and 1993 (1); Fried 1996, esp. pp. 596–597.

50. Balzac 1830 (1935). – Cf. Bätschmann 1989 and 1992 (2).

51. Baudelaire 1855 (1962). – Gay 1993 (1996).

52. Michelet 1867, p. 319: "Au dernier triomphe, écrasé de succès, de cris et de fleurs, revenu devant le public, humble et la tête basse, le pauvre Pierrot un moment a oublié la salle; en pleine foule, il est comme abîmé … Morituri te salutant. Salut, peuple, je vais mourir." – Adhémar 1950, p. 187; Starobinski 1970; Haskell 1972 (1978); Watteau Catalogue 1984, no. 69, pp. 430–436.

53. Mainardi 1987.

54. Manet Catalogue 1867; cf. Graber 1941, pp. 109–111, and Krell 1982. – The statement of sincerity and the way it is misunderstood is from Thoré 1858/60, vol. 2, p. XIV.

55. *Le Revue du XIXe siècle* called Zola's essay "une étude hardie" in an editorial. – Clément 1868.

56. Zola 1989, pp. 71–73, 136–139. – Cf. Manet's *Portrait d'Émile Zola* of 1868 and *Autoportrait à la palette* (around 1879). Manet Catalogue 1983, nos. 106, 164, pp. 280–285, 405–407; Stoichita 1991/92.

57. Manet Catalogue 1982; Clark 1985; Mainardi 1987. – Gay 1993 (1996).

58. Manet Catalogue 1981; Manet Catalogue 1992; Bätschmann 1993 (1); Fried 1996, pp. 346–364.

59. Courbet's exhibition in 1867 was relatively well received, unlike his exhibition in 1855, while Manet's exhibition was a failure. Napoleon III's was a huge success. Manet had borrowed the enormous sum of 18,305 francs from his mother to build the pavilion and mount the exhibition, and he spent it all. – Courbet 1996, nos. 67-17, 67-18, 67-19, 67-20, pp. 279–281; Courbet 1992, nos. 67-17, 67-18, 67-19, 67-20, pp. 314–317 – Tabarant 1947, p. 135; Hamilton

1954, pp. 87–111.

60. Manet Catalogue 1983, no. 83, pp. 218–221.

61. Thiers 1867. Napoleon III's venture onto the world political stage in Mexico is a prime example of a dastardly undertaking. The aim was political, but Napoleon was also hoping for financial gain. He wanted to push back the United States, which was embroiled in the civil war, compensate Austria-Hungary for the loss of Lombardy by giving it the Mexican throne, and he also hoped to repeat the sensational Californian gold finds in Mexico. However, the immediate impetus to the poker game was the prospect of easily exploiting a highly indebted country. Adolphe Thiers, in a speech in the French Parliament, calculated the catastrophic loss to France's standing in the world, and its influence and power in Europe. He pointed out the decisive changes 1866 had brought and prophesied France's coming defeat by Prussia.

62. Zola 1869. The documents on the censorship affair of 1869 are reprinted in the Manet Catalogue 1983, pp. 529–531.

63. Boime 1973 points out that the names of the three victims begin with the same letter as Manet's name, and he maintains that there is a similarity between Manet and Maximilian.

64. Fantin-Latour Catalogue 1982, no. 73, pp. 205–210; Fried 1996, pp. 340–344.

65. *Le Journal amusant,* 21 May 1870: The caption states: "Jésus peignant au milieu de ses disciples, ou La divine école de Manet, tableau religieux par Fantin-Latour. – en ce temps-là, J. Manet dit à ses disciples: en vérité, en vérité, je vous le dis, Celui qui a ce truc pour peindre est un grand peintre. Allez et peignez, et vous éclairerez le monde, et vos vessies seront les lanternes."

66. Poulain 1932, pp. 207–208 (letters to his parents in May 1867 and May 1869). Cf. Bazile Catalogue 1978, p. 180.

67. Impressionism Catalogue 1974, pp. 221–270; Rewald 1946; Rewald 1982; Tucker 1984; Tucker 1986.

68. Vaisse 1981; Vaisse 1995, esp. Ch. IV, pp. 94–116; Bouillon 1986.

69. John Rewald's highly mythicized *The History of Impressionism* is a continuation of the Impressionist legends; the book was written during the Second World War in New York and published in 1946.

70. Mallarmé 1876 (1986), p. 33. – Cf. Eisenmann 1986.

71. Bretell 1986.

72. Reff 1968; cf. The anonymous critique in the article 'A l'Exposition anglaise' in: *La Vie parisienne,* 20 April 1867, pp. 276–277. – On the Salons in the Palais de l'industrie cf. Mainardi 1987 and 1988.

73. Ward 1991.

74. Burty 1877: "Elles heurtent comme tableaux, par leur aspect d'ébauches, par leurs indications de frottis. Elles ont, en place et comme décors, une valeur de clarté, de franchise d'effet qui ne sont pas niables."

75. Catalogue de la 2e exposition de peinture, 1876, no. 162, p. 16: *Panneau décoratif* (now *Le déjeuner: panneau décoratif,* Paris, Musée d'Orsay, Inv. R. F. 2774); Catalogue de la 3e exposition de peinture, 1877, no. 101, p. 9: *Les dindons* (décoration non terminée), appartient a M. H. ... (now: *Les dindons,* Paris, Musée d'Orsay, Inv. R. F. 1944–18); cf. New Painting 1986, no. 53, pp. 225–226.

76. Spencer 1987; David Park Curry, 'Total control: Whistler at an Exhibition' in: Whistler 1987, pp. 67–82.

77. Horwitz 1979/80.

78. Whistler Catalogue 1995, no. 81–82, pp. 164–167; the room is now in the Freer Art Gallery, Washington D. C. – The dispute between the patron and the artist over the fee – £ 40,000 in today's prices – is interesting, because it was over the question of decoration or paintings. Cf. Whistler's famous suit against John Ruskin for defamation: Merrill 1992. – Perfect Harmony 1995, pp. 87–95.

79. Pissaro 1950, pp. 31–33: "Par contre, samedi j'ai vu l'exposition de Whistler. Il nous a chipé l'idée des salles de couleur. La sienne est complètement blanche avec des bordures jaune citron; les tentures sont en velours jaune avec son papillon brodé sur le coin. Les chaises sont jaunes et la paille blanche. Par terre il y a une natte indienne jaunâtre, puis des vases en terre jaune avec des espèces de pissenlit jaune. Enfin, le domestique est habillé en blanc et jaune. Cet arrangement donne a la salle un grand air de gaîté a côté des alles voisines où sont exposé les tableaux d'un marchand." Cf. Pissarro 1980–91, vol. 1, nos. 119, 120, pp. 176–178.

80. Ward 1991, pp. 610–613. – On the harmonization of painting and frame between 1850

and 1920 cf. Perfect Harmony 1995.

81. Seurat Catalogue 1991, nos. 117–143, pp. 204–256, cf. the reproduction of the white frame (now lost) in *Les Poseuses* of 1886–88, pp. 309–335; Seurat 1989; Perfect Harmony 1995, pp. 149–162 (Matthias Waschek).

82. Seurat 1991, Annexe E, pp. 429–431: "Le cadre est dans l'harmonie opposée a celles des tons, des teintes et lignes du tableau." – Kemp 1983, pp. 86–102.

83. Kemp 1983, esp. p. 101, on the fundamental change: "Das Sehen ist bereits in der rezeptionsästhetisch durchformulierten Faktur berücksichtigt, die Produktion leistet, was vordem Aufgabe der Präsentation war."

84. Signac 1899 (1978).

85. Hugo 1862 (1985).

86. Gauguin 1983, nos. 33.1, 33.4, pp. 242–249, p. 245: "Et ce Jean Valjean que la société opprime mis hors la loi, avec son amour sa force, n'est-il pas l'image aussi d'un impressioniste aujourd'hui. Et en le faisant sous mes traits vous avez mon image personelle ainsi que notre portrait à tous pauvres victimes de la société nous en vengeant en faisant le bien."

87. Van Gogh 1958–88, vol. III, no. B-19, pp. 517–517. – The belief that the future lay in the portrait was based on Jouin's argument in 1888, the speech by Jules-Antoine Castagnary in 1887 proposing a gallery of artists' portraits in the Louvre, and the exhibition *Portraits nationaux* held in 1878 in the Trocadéro during the World Exhibition.

88. Van Gogh 1955–88, vol. III, no. 545, p. 66.

89. Van Gogh 1955–88, vol. III, no. 537, p. 37 f., no. 545, p. 66-7 (letters to his brother Theo), vol. III, no. 544a, p. 63 (letter to Gauguin). – Cf. Van Gogh Catalogue 1984, no. 99, pp. 170–171.

90. Van Gogh 1955–88, vol. III, no. B-18, p. 516.

91. Van Gogh 1955–88, vol. III, no. 626a, p. 256, letter of February 1890 to Albert Aurier. – *Gauguin's Chair* in Amsterdam, Rijksmuseum Vincent van Gogh, L. 133, *Van Gogh's Chair* in London, Tate Gallery.

92. Gauguin 1924, pp. 20–23, first published by Charles Morice, 'Paul Gauguin' in: *Mercure de France*, 48, no. 166 of October 1903, pp. 100–135; Morice 1919.

93. Van Gogh 1955–88, vol. III, nos. 566–573, pp. 110–126; no. 569, pp. 113 f.

94. Gauguin Catalogue 1989, no. 50, pp. 123–125.

95. Bernard Catalogue 1990, pp. 51–53.

96. Gauguin Catalogue 1989, no. 90, pp. 170–172; Gauguin 1983, no. 37.2, pp. 283, no. 37.4, p. 286. – On the exhibition cf. Bernard 1939.

97. Aurier 1891 (1991).

98. Bernard 1939, p. 12; Bernard, 'L'aventure de ma vie', printed as an introduction to Gauguin 1954, pp. 11–46.

99. Nabis Catalogue 1993, no. 107, pp. 252–253.

100. Livret du salon 1864; Catalogues of the Paris Salon 1977–78, vol. 1864, no. 2504, p. 419: *Jeune Gaulois prisonnier des Romains;* – Lami 1914–21, vol. 1, pp. 108–111; Lepage 1911, pp. 21–38.

101. Lepage 1911, p. 46. – Cf. Yeldham 1984, vol. 1, pp. 88–113.

102. Jouval 1883, p. 1: "Mme Léon Bertoux (sic) est le meilleur et le plus brillant des arguments vivants en faveur de cette thèse que le génie n'a pas de sexe, c'est-à-dire qu'il peut être l'apanage de la femme aussi bien que de l'homme."

103. Lepage 1911, pp. 47–50 (opening speech): "Une force ignorée, méconnue, retardée dans son essor est celle de la femme artiste! Une espèce de préjugé social pèse sur elle, et, cependant, chaque année, le nombre des femmes qui se vouent a l'art, va grossissent, avec une rapidité effrayante: je dis effrayante parce que nos institutions ne faisant rien encore pour la grande culture de ces intelligences en ardent travail, les résultats de tant d'efforts sont souvent impuissants ou ridicules." – Garb 1994, Ch. 2, pp. 19–41.

104. Garb 1994: Garb 1989.

105. The report by the Vice-President, Mme Aron-Caën, on the general meeting of 1885 closes with a quotation from the speech by the President, Mme Léon Bertaux: "Courage, mesdames, si notre société n'est pas encore reconnue d'utilité publique, elle a le droit de se dire 'd'intérêt générale'." Cf. Aron-Caen 1885. – Cf. Also the anonymous report in: *Moniteur des Arts*, 17 December 1886, p. 406: "L'union des femmes peintres et sculpteurs, fondée en 1881, par Mme Léon Bertaux, un sculpteur de talent, s'est réunie dimanche dernier, a trois heures, au palais de l'Industrie. Les sociétaires, après avoir pris connaissance du tableau des dépenses de l'année, et de

l'excédent de leurs recettes qui se monte à 11,691 fr. 05, ont décidé de demander au gouverne-
ment de les reconnaître comme société d'utilité publique. Le résultat, qu'elles sont sûres d'obtenir,
donnera une sanction officielle aux efforts qu'elles ont tentés depuis six ans, pour établir entres les
femmes artistes la même solidarité qu'entre les artistes males et contribuer a l'élévation de leur
niveau artistique."

106. Lindsay 1990; Mary Cassatt supported the advancement of women in the United States
but not in France; Eva Gonzalès only appears to have exhibited with the Union in 1882; Garb
1994, pp. 37–38.

107. *Union des Femmes Peintres et Sculpteurs. Exposé de la société* [Paris] 1888, Bibliothèque Natio-
nale, [80 Wz. 4013 (1881)], "Article 1: Le but de la Société est d'exposer chaque année les œuv-
res les plus remarquables de ses membres, de prendre en toute circonstance la défence de leurs
interêts, d'établir une solidarité entre les femmes artistes et, par suite, de contribuer chez celles-ci
a l'élévation du niveau artistique. Enfin de produire avec le plus d'avantage possible les talents
acquis et les talents naissants qu'elle se fera un devoir de servir en toute occasion."

108. *Union des Femmes Peintres et Sculpteurs. Septième Exposition 1888. Palais des Champs-Élisées,
Porte No. 5, ouverte du 21 février au 14 mars*, p. 12: "Afin de présenter les tableaux dans leurs meil-
leur effet d'ensemble, leur classement ainsi que la place de cimaise d'indiqueront pas une valeur
artistique plus ou moins grande (Séance du comité du 26 novembre 1886). Il ne sera perçu aucun
droit sur les ouevres vendus a l'Exposition." (Ex. Paris, Bibliothèque Nationale, [8 Wz 4012]). The
exhibition consisted of 482 paintings and 28 sculptures. – Cf. Alice Guyard-Charvey, 'Causerie
sur le placement des oeuvres d'art dans une exposition ', in: *Journal des femmes artistes*, 5, no. 44,
January 1894, pp. 2–3.

109. Javel 1889, pp. 1–2: "Un jour peut-être il en sera de même dans toutes les parties du Palais
de l'Industrie. En attendant cet heureux âge, nous croyons que messieurs les artistes-hommes ne
pourraient que gagner a étudier de près la manière d'être de mesdames les artistes-femmes. C'est
humiliant pour le sexe barbu, mais il faut bien convenir que celles-ci sont infiniment plus exem-
plaires que ceux-là."

110. Cf. *École gratuite de dessin pour les jeunes personnes* Chapter III, Note 51. – On the question
of art education for women in England and France see the excellent work by Yeldham 1984.

111. Lagrange 1860.

112. Fehrer 1984; Julian Academy 1989.

113. Actes 1890, p. 389: "Le Congrès émet le voeu qu'il soit créé à l'Ecole des Beaux-Arts une
classe spéciale séparé des hommes, où la femme pourra, sans blesser les convenances, recevoir le
même enseignement que l'homme, avec faculté dans les conditions qui règlent cette école d'être
admise à tous les concours d'esquisses ayant pour conséquence l'obtention du Prix de Rome."

114. Mme Léon Bertaux' submission to the Ministry of Public Education and the Fine Arts
was published in the first number of the *Journal des femmes artistes*, 1890, p. 4. – Garb 1994, Ch. 4,
pp. 70–104. The *Association mutuelle des Femmes Artistes de Paris* was founded in 1900, and the *Union
Internationale des Femmes Artistes* in 1907; others followed, cf. Yeldham 1984, vol. 1, pp. 107–115.

115. Frauen in der Kunst 1980, vol. 2, pp. 101–109; Garb 1993.

116. Letter from Gustav Klimt on behalf of the Vereinigung bildender Künstler Österreichs to
the Directorate of the Genossenschaft bildender Künstler Wiens of 1897 in: Nebehay 1969, no.
3a, p. 135.

117. Wiener Secession 1971, pp. 23–39; *Ver Sacrum*, Vienna, 1, 1989–6, 1903; Ver Sacrum
1982.

118. Bahr 1898 (1900), p. 15; Jensen 1994, esp. Ch. 6: Secessionism, pp. 167–200.

119. *Ver Sacrum* 1, 1898, no. 5, May 1898, p. 1 (Report of the exhibition); Wiener Secssion
1971, pp. 40–43.

120. Wagner 1895; Oechslin 1994.

121. Michel 1986, pp. 180–191. – Karl Wittgenstein enabled Klimt to buy back the paintings
for the Faculty of Medicine in 1905. – Clark 1967; Olbrich Catalogue 1972, nos. 10070–10088,
pp. 25–35.

122. Lhotsky 1941; Wyss 1995.

123. Hevesi 1906 (1984), esp. the section on Klimt ' Verkannte Kunstwerke'.

124. Klimt published the sketches in *Ver Sacrum* 1, 1 March 1898, pp. 2 and 8; Strobl 1980, p.
140, nos. 326–330.

125. Bahr 1898 (1900).

126. The sentence is: "Seine Welt zeige der Künstler, die Schönheit, die mit ihm geboren

wird, die niemals noch war und niemals mehr sein wird." Cf. Edward Burne-Jones who said his art should be a picture of a beautiful romantic dream of something that never was and can never be, in a light that no one can name or remember, and which one can only long for, like the forms of divine beauty. Cf. Catalogue Staatsgalerie Stuttgart, 19th Century, p. 39, with bibliography; Löcher 1973, p. 19.

127. Hevesi 1906 [1984], p. 390; Bisanz-Prakken 1992 (with photographs of the exhibition).

128. Alma Mahler-Werfel, *Erinnerungen an Gustav Mahler – Briefe an Alma Mahler*, ed. Donald Mitchell, Berlin and Frankfurt am Main, Propyläen 1971, pp. 62–63; First edition *Gustav Mahler: Erinnerungen und Briefe*, Amsterdam: Allert de Lange, 1940, p. 49: "Im Mai 1902 rüstete man in der Sezession zu einer intimen Feier für Max Klinger. Die Maler der Sezession hatten in der selbstlosesten Weise Fresken an die Wand gemalt, von denen nur die von Gustav Klimt gerettet wurden. Man hat sie mit ungeheuren Kosten von der Wand gelöst. Alle Wände waren also geschmückt mit allegorischen Fresken, die sich auf Beethoven bezogen, und in der Mitte sollte zum ersten Mal das Beethoven-Denkmal von Max Klinger zur Auf- und Ausstellung gelangen. Da kam Moll mit der Bitte zu Mahler, bei dieser Eröffnung zu dirigieren, und er hat diese Idee liebevoll ausgeführt. Er setzte den Chor aus der Neunten: 'Ihr stürzt nieder Millionen? / Ahnest Du den Schöpfer, Welt?/ Such' ihn überm Sternenzelt!/ Brüder! Überm Sternenzelt / Muss ein guter Vater wohnen.' für Bläser allein, studierte es mit den Bläsern der Hofoper ein und dirigierte den Chor, der, auf solche Art uminstrumentiert, grantistark klang. Der scheue Klinger betrat den Saal. Wie angewurzelt blieb er stehen, als von oben her diese Klänge einsetzten. Er konnte sich vor Rührung nicht halten, und Tränen rannen ihm langsam über das Gesicht herab."

129. Schmoll 1966; Klinger Catalogue 1992, nos. 186–190, pp. 329–331, article by Georg Bussmann pp. 38–49.

130. Nebehay 1969, p. 394: "Und weit wie den Begriff 'Kunstwerk' fassen wir auch den Begriff 'Künstler'. Nicht nur die Schaffenden, auch die Genießenden heißen uns so, die fähig sind, geschaffenes fühlend nachzuerleben und zu würdigen. Für uns heißt 'Künstlerschaft' die ideale Gemeinschaft aller Schaffenden und Genießenden."

131. Olbrich in: Bahr 1901, pp. 45–52: "... ein Feld; und da wollen wir dann zeigen, was wir können; in der ganzen Anlage und bis ins letzte Detail, alles von demselben Geiste beherrscht, die Straßen und die Gärten und die Paläste und dei Hütten und die Tische und die Sessel und die Leuchter und die Löffel Ausdruck derselben Empfindung, in der Mitte aber, wie ein Tempel in einem heiligen Haine, ein Haus der Arbeit, zugleich Atelier der Künstler und Werkstätte der Handwerker"

132. On 1898 Grand Duke Ernst Ludwig negotiated a contract with the Alsatian artist Rupert Carabin (1862–1932) in Paris, offering him an annual salary of 12,000 marks and a house; cf. Colette Merklen-Carabin in: Carabin Catalogue 1974, pp. 35–6, – Franz 1983; Olbrich 1988.

133. Accordingly the artist's world was a different world, it could never be realized. Hermann Bahr, from whom this derives, actually meant by the world of the artist personalized beauty; cf. note 126. – Karl Kraus, *Die Fackel*, II, no. 56, October 1900, pp. 21–24, had a low opinion of Bahr, a Viennese writer and journalist.

134. Fuchs 1899/1900.

135. 'Das Zeichen, Festliche Dichtung von Georg Fuchs', in: Dokument Deutscher Kunst 1901. pp. 63–66: "Bist du der Große, der Herre im Geiste, // Führer und Seher, der Meister: so weile. // Bist du der Wissende, Lösende, Freiste: // Auf, so verrichte dein Amt, so zerteile // Mächtigen Griffes das Tuch, so enthülle // Uns dein Geheimnis, hier sei dein Dom!"

136. Olbrich 1900, pp. 366, 368–369: "Endlich eine kleine begeisterte arbeitsfreudige Gesellschaft, in einer Stadt, die so glücklich ist, weder Glaspalast noch Akademie zu besitzen, doppelt glücklich, weil damit auch die beengenden Normen und Paragraphen für unsere schöne Kunst fehlen... Ein weites baum- und blumenreiches Terrain, die Grossherzogliche Mathildenhöhe, gibt den Plan. Oben am höchsten Streif soll das Haus der Arbeit sich erheben; dort gilt, gleichsam in einem Tempel, die Arbeit als heiliger Gottesdienst... Im abfallenden Gelände: die Wohnhäuser der Künstler, gleich einem friedlichen Ort, zu dem nach des Tages emsiger Arbeit von dem Tempel des Fleisses herabgestiegen wird, um den Künstler mit dem Menschen einzutauschen."

137. Cézanne 1937, no. 159, p. 252: "Je travaille opiniâtrement, j'entrevois la Terre promise. Serai-je comme le grand chef des Hébreux ou bien pourrai-je y pénétrer?"

138. Hofmannsthal, 'Der Tod des Tizian' (1892), in: Hofmannsthal 1982, pp. 37–51, 331–409, quotation on p. 42: "'... Sehr schwere Dinge seien ihm jetzt klar, // Es komme ihm ein unerhört Verstehen, // Daß er bis jetzt ein matter Stümper war ...' // Soll man ihm folgen?"

139. On the memorial ceremony for Böcklin: 'Der Tod des Tizian (1901)' cf. Hofmannsthal 1982, pp. 221–235, 735–754; Andree 1977, p. 34.

NOTES TO CHAPTER V

1. Nietzsche, *Menschliches, Allzumenschliches. Ein Buch für freie Geister* [1878], in: Nietzsche 1960, vol. 1, pp. 554-582, Aphorismus 168, p. 538. "Sonst entsteht auf einmal jene große Kluft zwischen dem Künstler, der auf abgelegener Höhe seine Werke schafft, und dem Publikum, welches nicht mehr zu jener Höhe hinaufkann und endlich mißmutig wieder tiefer hinabsteigt."

2. Nietzsche, *Der Fall Wagner. Ein Musikanten-Problem* [1888], in: Nietzsche 1960, vol. 2, pp. 905-938; p. 925. "Noch nie wurde die Rechtschaffenheit der Musiker, ihre ›Echtheit‹ gleich gefährlich auf die Probe gestellt. Man greift es mit Händen: der große Erfolg, der Massen-Erfolg ist nicht mehr auf Seite der Echten – man muß Schauspieler sein, ihn zu haben." - Badt 1956 (1968).

3. Friedrich Nietzsche, *Morgenröthe. Gedanken über die moralischen Vorurteile*, Chemnitz: E. Schmeitzer, 1881, in: Nietzsche 1960, vol. 1, pp. 1175-1177 "Immer, wenn ihr klatscht und jubelt, habt ihr das Gewissen der Künstler in den Händen – und wehe, wenn sie merken, daß ihr zwischen unschuldiger und schuldiger Musik nicht unterscheiden könnt!"

4. Nietzsche, *Die fröhliche Wissenschaft*, Book Five [1887], in: Nietzsche 1960, vol. 2, pp. 234-235. Instead of clarifying this problem the author goes on to express his hatred of women and his anti-Semitism.

5. Von Tschudi 1899: "Der Zwiespalt zwischen dem künstlerischen Auffassungsvermögen des Publikums und der künstlerischen That tritt in voller Stärke da ein, wo diese etwas Neues schafft."; cf. Paul 1993; Paret 1980. - Schlink 1992; Ursprung 1996; Von Tschudi Catalogue 1996. - On the museum visit cf. the work by Else Biram, *Die Industriestadt als Boden neuer Kunstentwicklung*, Jena: Diederichs, 1919; this was printed in 1914 but not put on the market until 1919.

6. Trübner 1898; cf. the brochure which Trübner published anonymously: Trübner 1892.

7. *Plakatausstellung*. Catalogue of the exhibition in the Museum für Kunst und Gewerbe Hamburg 1896/97, afterword by Maria Brinckmann; *Ausstellung künstlerischer Plakate*. Catalogue of the exhibition in the Kupferstichkabinett Dresden 1896 (Max Lehrs); Otto Grautoff, *Das moderne Plakat*, Leipzig 1899, p. 12.

8. Dresdner 1904, pp. VI-VIII.

9. Dresdner 1904, pp. VII-VIII: "Wir werden nicht gedeihen, wenn wir nicht Alle, jeder in seinem Berufe, Künstler werden. Das ist die große, die weltgeschichtliche Mission, die die Kunst, wie ich meine, gegenwärtig für unser ganzes Sein und Wirken, für alle Stände des Volkes vom Fürsten bis zum Arbeiter, für alle Probleme unseres nationalen und privaten Lebens zu erfüllen hat."

10. Invitation to the first Biennale by Riccardo Selvatico, Venice, Archivio Storico della Biennale di Venezia; *Prima Esposizione internazionale d'arte della Città di Venezia. Catalogo illustrato*, Venice: Fratelli Visentini, 1895. The Biennale was Venice's contribution to the 25th anniversary of the marriage of the Italian King and Queen.

11. Nebehay 1969, p. 394. - Dresdner and Klimt must be seen as the originators of Beuys' "Every human being is an artist"; cf. Bodenmann-Ritter 1972 (1991).

12. Oskar Kokoschka, *Mein Leben*, Munich: Bruckmann, 1971, pp. 63-69; *Oskar Kokoschka. Exhibition catalogue Ghent and Liège 1987*, Liège: Soledi, 1987, pp. 39-48 (Hilde Haider-Pregler).

13. Riegl 1893 and 1901; Schapiro, 'Style' [1953], in: Schapiro 1994, pp. 51-102.

14. For the United States: Burns 1996; for Europa: Wyss 1996.

15. *Henry van de Velde. Ein europäischer Künstler seiner Zeit*. Exhibition catalogue Hagen, Weimar etc. 1992-94, ed. Klaus-Jürgen Sembach and Birgit Schulte, Cologne: Wienand Verlag, 1992.

16. Nordau 1892/93; "Nordau" is Max Simon Südfeld's pseudonym; Engl.: Degeneration, New York: D. Appleton, 1895; see also Max Nordau, *On Art and Artists*, transl. by W. F. Harvey, London: Fisher Unwin, 1907. - Cf. Foster 1954; Jens Malte Fischer, 'Dekadenz und Entartung. Max Nordau als Kritiker des Fin de siècle', in: *Fin de siècle 1977*, pp. 93-111; Neumann 1986, pp. 160-163; 220-224.

17. Meier-Graefe 1905, p. 226: "Böcklin kennt nur sich selbst und den Zuschauer; der eine soll den andern packen, dafür wird alles getan."

18. Meier-Graefe 1904, vol. 1, pp. 9-29: "Die Täuschung des Publikums gelingt in der Kunst leichter als in irgendeinem andern Beruf, weil dem Künstler, ganz abgesehen von der leichten Empfänglichkeit des Volkes für alles Seichte, der Nimbus zu Hilfe kommt und eine Fülle von gerade die Mittelmäßigkeit begünstigenden Einrichtungen, die dem Stand als solchem eine scheinbare Bedeutung erhalten."; cf. the last edition with an afterword by Hans Belting, Munich and Zürich: Piper, 1987, vol. 2, pp. 727-760; Moffett 1973.

19. Meier-Graefe 1905, p. 260: "Er [Floerke] verehrte, was zu seinerzeit das ganze Publikum liebte, die dumme und ungerechte Masse, die immer irrt, ob sie lobt oder tadelt."; cf. Meier-Graefe 1904, Einleitung: 'Die Träger der Kunst früher und heute'.

20. Meier-Graefe 1904, vol. 2, pp. 367-386; in Meier-Graefe 1905, pp. 73-78, the difference of opinion to Hugo von Tschudi is very evident in the discussion of the "personality"; Meier-Graefe shared his admiration for and defence of the more recent French painting; cf. von Tschudi 1912, pp. 119-127, 134-162.

21. Meier-Graefe 1905, quoted as a motto from the inside title page: "Odi profanum vulgus et arceo".

22. Carl Vinnen (ed.), *Ein Protest deutscher Künstler*, Jena: E. Diederichs, 1911; Theodor Alt, *Die Herabwertung der deutschen Kunst durch die Parteigänger des Impressionismus*, Mannheim: F. Nemnich, 1911; in contrast: *Deutsche und französische Kunst*, ed. Alfred Walter Heymel, Munich: R. Piper, 1911.

23. Hausenstein 1914, p. 88: "Der Künstler ist der Mensch, der die dem Menschen möglichen Gesichte am stärksten, am visionärsten erlebt. Eine Vision ist an sich selber schon ein Martyrium: es ist nicht leicht, das Antlitz des Erdgeistes zu ertragen. Aber für diese Vision wird der Künstler, der pathetische Künstler, dieser Heros der Menschheit, obendrein noch gestraft: denn das Publikum lacht ihn dafür aus – es hat mit den Ekstasen des künstlerischen Visionärs nichts zu tun und dafür läßt es ihn büßen."

24. Hausenstein 1914, p. 9. Michelangelo, El Greco, Rembrandt, Delacroix and Van Gogh represent the emotional or heroic type, while Botticelli, Cranach, Frans Hals, the Impressionists, the Japanese and Rodin are cited as the nervous type, and Mantegna, Leonardo, Dürer, Courbet and Leibl, among others, are described as objective. The types are ordered hierarchically, the emotional or heroic being supreme, but the lower, naturalistic or nervous type can rise to this height. Among the older artists Hausenstein distinguishes between an aimiable talent, working in an imitating or epigonal manner for a prince or for art politics, and the genius, violent and destructive. Among more recent artists the distinction is drawn between "genuine" and "false" emotion. False emotion is created by clothing a naturalistic form with literature, ideas or humanity (Hodler, Klinger); El Greco and Van Gogh are examples of genuine emotion.

25. Schöpferische Konfession 1920.

26. Starobinski 1970; Reff 1971; Haskell 1972 (1978); Clark 1973; Kellein 1995.

27. Reff 1971 on the identification of the figures; cf. E.A. Carmean, Picasso: *The Saltimbanques*, Washington, D.C.: National Gallery of Art, 1980.

28. Starobinski 1970.

29. Picasso Catalogue 1988 (with detailed documentation); Rubin 1983; Hofmann 1986; Chave 1994. - Gelett Burgess, 'The Wild Men of Paris', in: *The Architectural Record*, 27, no. 5, pp. 401-414, with the first reproduction of *Les Demoiselles d'Avignon* (p. 408). - The painting was first shown in 1916 in the exhibition L'art moderne en France in the Salon d'Antin in Paris; it was sold through the mediation of André Breton in 1924 to Jacques Doucet. The dealer Jacques Seligmann purchased it from his widow in 1937 for 260,000 Francs, and showed it with other works by Picasso the same year in his gallery in New York, where the Museum of Modern Art bought it for 28,000 dollars. However, the painting remained in Seligmann's hands until 1939, until the payment was settled, for this included the sale of a painting by Degas from the Museum's collection.

30. Daniel-Henry Kahnweiler, 'Picasso et le cubisme', in: *Picasso*. Exhibition catalogue Lyon, Musée des Beaux-Arts, 1953; Daniel-Henry Kahnweiler, *Mes galeries et mes peintres. Entretiens avec Francis Crémieux*, Paris: Gallimard, 1961; Engl.: My Galleries and Painters, New York: Viking Press, 1972, p. 38.

31. Rubin 1983; Hofmann 1986; Freedberg 1989; Belting 1990.

32. "Primitivism" in 20th Century Art 1984, 2 vols.

33. Gauguin Catalogue 1989.

34. "Primitivism" in 20th Century Art 1984, vol. 1, pp. 179-209 (Kirk Varnedoe).

35. Der Blaue Reiter 1912, pp. 21-26: "Sind nicht die Wilden Künstler, die ihre eigene Form haben, stark wie die Form des Donners?"; cf. Goldwater 1938 (1967), pp. 121-122. - On the relation between the Brücke artists and primitive art cf. "Primitivism" in 20th Century Art 1984, vol. 2, pp. 369-403 (Donald E. Gordon).

36. Brancusi Catalogue 1995, pp. 128-129, 134-135, 154-155.

37. Brancusi Catalogue 1995, pp. 140-141; Chave 1993, pp. 93-123.

38. Brancusi Catalogue 1995, pp. 154-155, the title "Petite fille française" is not by Brancusi.

39. "Primitivism" in 20th Century Art 1984, vol. 2, pp. 345-367 (Sidney Geist); Chave 1993.

40. Goldwater 1938 (1967); Christiane Meyer-Thoss, *Louise Bourgeois. Konstruktionen für den freien Fall. Designing for Free Fall*, Zürich: Ammann, 1992.

41. "Primitivism" in 20th Century Art 1984, vol. 2, pp. 615-659 (Kirk Varnedoe); Bourgeois Catalogue 1982.

42. Hildegard Zenser, *Max Beckmann. Selbstbildnisse*, Munich: Schirmer/Mosel, 1984; Beckmann Catalogue 1993.

43. Reinhard Piper, *Nachmittag. Erinnerungen eines Verlegers*, Munich: Piper, 1950, p. 19. - Beckmann Catalogue 1994, no. 11, pp. 76-81.

44. Max Beckmann, in: Schöpferische Konfession 1920, pp. 61-67: "Einmal Gebäude zu machen zusammen mit meinen Bildern. Einen Turm zu bauen, in dem die Menschen all ihre Wut und Verzweiflung, all ihre arme Hoffnung, Freude und wilde Sehnsucht ausschreien können. Eine neue Kirche."

45. Gustav Friedrich Hartlaub, *Kunst und Religion. Ein Versuch über die Möglichkeit neuer religiöser Kunst*, Leipzig: K. Wolff, 1919, pp. 83-85: In 1919 Hartlaub affirmed the change in Beckmann's style from Internationalism to the Germanic, and the elimination of the decorative by grotesque, ghostly forms, out of which a tragic artist always speaks, in all his demonic obsession, a tough, deep man who takes life very hard. - Beckmann Catalogue 1994, no. 13, pp. 85-87.

46. Beckmann, in: Schöpferische Konfession 1920, and in: Max Beckmann, *Die Realität der Träume in Bildern. Schriften und Gespräche 1911-1950*, ed. Rudolf Pillep, Munich and Zürich: Piper, 1990.

47. Beckmann Catalogue 1983: "Wir bitten das geehrte Publikum näher zu treten. Es hat die angenehme Aussicht sich vielleicht 10 Minuten nicht zu langweilen. Wer nicht zufrieden ist, bekommt sein Geld zurück."

48. Beckmann Catalogue 1983, pp. 94-100; Beckmann Catalogue 1984, pp. 204-206.

49. Hans Belting, *Max Beckmann. Die Tradition als Problem in der Kunst der Moderne*, Munich, Berlin: Deutscher Kunstverlag, 1984, pp. 58-74.

50. Max Beckmann, 'Der Künstler im Staat', in: *Europäische Revue*, 1927, no. 3, pp. 288-291: "... zugunsten der gemeinsamen Liebe, die uns ermöglichen wird, die großen entscheidenden Arbeiten als Menschheit gemeinsam auszuführen".

51. Märten 1919 (1990); on Lu Märten's position in the largely narrow-minded discussion in Germany on the artistic talent of women cf. Geisel 1990.

52. *JA! Stimmen des Arbeitsrates für Kunst in Berlin*, Charlottenburg: Photographische Gesellschaft, 1919, pp. 7-35; Answers by Gropius pp. 30-35; Gropius 1988, vol. 3, pp. 66-70: "Da die Kunst im wirklichen Leben der zivilisierten Völker erstarb, mußte sie sich in jene grotesken Schauhäuser flüchten und sich dort prostituieren."; - cf. On the Works Council: Steneberg 1987. - Cf. Also the speech by Gropius to the representatives of industry and the crafts in the spring of 1919 in Weimar; Whitford 1992, p. 46. - On the Bauhaus programme of 1919 with Lyonel Feininger's woodcut cf. Wingler 1975, pp. 38-41. - The de Stijl group demanded the abolition of exhibitions in 1922, cf. De Stijl, no. 4, 1922, pp. 59-64.

53. Wingler 1975; Whitford 1992; Bauhaus-Ideen 1994; Itten Catalogue 1994, esp. pp. 215-281 (Klaus Weber).

54. Ortega y Gasset 1964.

55. On this and other exhibitions, the reviews and reactions of the public cf. Stationen 1988; Klüser/Hegewisch 1992; Altshuler 1994.

56. Ozenfant 1925. - Cf. Jeanneret-Gris/Ozenfant 1918, and: L'Esprit Nouveau 1987.

57. Kandinsky 1912, Ch. 2 and 3. - The work was finished in 1910, according to Kandinsky, and it was published in Decamaber 1911 after he had revised it; cf. the later editions ed. Max Bill, Bern: Benteli, from 1952.

58. Kandinsky 1912, pp. 64-71: "Er sieht und zeigt. Dieser höheren Gabe, die ihm oft ein

schweres Kreuz ist, möchte er sich manchmal entledigen. Er kann es aber nicht. Unter Spott und Haß zieht er die sich sträubende, in Steinen steckende schwere Karre der Menschheit mit sich immer vor- und aufwärts."

59. Kandinsky 1912; Ringbom 1970, esp. Ch. 3: 'The Work of Art and the Artist', pp. 109-141.

60. Wassily Kandinsky, 'Über die Formfrage', in: *Der Blaue Reiter 1912*, pp. 74-100, p. 74; for the text cf. the new documentary edition by Klaus Lankheit, 3rd ed. Munich and Zürich: R. Piper, 1979, pp. 132-182. - Ringbom 1970, pp. 109-141.

61. Ringbom 1970, esp. pp. 109-141.

62. Lissitzky/Arp 1925, p. XI: "Alles, was ein Künstler spuckt, ist Kunst."

63. Kandinsky 1926; the new editions by Max Bill (Bern: Benteli, since 1955) have a different format, typeface and binding. - Klee 1925; Klee 1979; van Doesburg 1925; the text by Van Doesburg first appeared in 1919 entitled 'Grondbegrippen der nieuwe beeldende kunst' in *Het Tijdschrift voor Wijsbegeerte*, 13, 1, 1919, pp. 30-49, and 2, 1919, pp. 169-188.

64. Klee 1945, p. 9.

65. Ringbom 1970; Friedrich Wilhelm Fischer, 'Geheimlehren und moderne Kunst. Zur hermetischen Kunstauffassung von Baudelaire bis Malewitsch', in: *Fin de siècle 1977*, pp. 344-377: Spiritual in Art 1986; Okkultismus und Avantgarde 1995.

66. Spiritual in Art 1986; Itten Catalogue 1994; Okkultismus und Avantgarde 1995.

67. De Stijl, no. 4, 1922, pp 59-64; Jaffé 1967, pp. 164-167. - In September 1922 a strange group of Dadaists and Constructivists in Weimar founded the Constructivist Internationale; cf. Berlin-Moskau 1995, pp. 157-161 (Bernd Finkeldey).

68. El Lissitzky, Lecture on 23 September 1921, cf. the translation in: Lissitzky 1977, pp. 21-34, and the abbreviated and revised reprint in De Stijl, no. 6, June 1922, pp. 82-85; Jaffé 1967, pp. 167-171; Lissitzky 1992, pp. 348-349.

69. *Erste Russische Kunstausstellung Berlin 1922*. Catalogue of the exhibition, Berlin: Galerie van Diemen, 1922; reprint Cologne: König, 1988; cf. Stationen 1988, pp. 184-215; Berlin-Moskau 1995, pp. 157-161 (Bernd Finkeldey).

70. Malevich's fifth painting was The Knife Sharpener of 1912; cf. Stationen 1988, pp. 184-215. - Malevich created the analogy between his Suprematist paintings and icons, as in the celebrated exhibition in St. Petersburg in 1915, by hanging them leaning slightly forwards, like icons, or placing them in the top corners of the rooms; cf. Milner 1996, esp. pp. 120-165.

71. Malevich 1927 (1980), pp. 65-100; Lissitzky 1977, pp. 15-20, first published in the almanach UNOWIS, no. 1, Vitebsk 1920; cf. Lissitzky 1992, pp. 331-334. - "Supremacy" means the Pope's supremacy over the bishops. - Cf. Wyss 1996 (1), pp. 218-242.

72. Lissitzky 1977, pp. 21-34, esp p. 32-33.

73. Francis Roberts, 'Interview with Marcel Duchamp' (Oct. 1963), in: *Art News*, 67, 1968, no. 8, pp. 46-47, 62-64; Duchamp 1992, pp. 153-158. - Gamboni 1997, pp. 295-297.

74. Schwarz 1969, no. 256, p. 173: "À regarder (l'autre côté du verre) d'un oeil, de près, pendant presque une heure." - Leonardo 1883 (1970), vol. 1, Nr. 294, pp. 158-159; Leonardo Catalogue 1990, p. 355.

75. Belting 1992.

76. *Modern Art - International Exhibition for the Brooklyn Museum*. Catalogue ed. Katherine S. Dreier, New York: Société Anonyme, Museum of Modern Art, 1926; Ozenfant 1928, p. 122.

77. Ray 1983, p. 274. - Cf. the testimonies by contemporaries: B. 1938; Beaux-Arts 1938; Jean/Meze 1959, pp. 281-289; Breton 1967, pp. 124-125; Cabanne 1972. - More recent literature: Schwarz 1969, pp. 506-507; Dunlop 1972, pp. 198-223; Abadie 1981; Schneede 1992; Altshuler 1994, pp. 116-135.

78. Cf. the detailed description in Jean/Meze 1959, pp. 280-289, the report on the private view in *Beaux-Arts* of 21 January 1938, pp. 1-2, and Duchamp's comments on the torches in *Cabanne* 1972, pp. 124-125. - Klüser/Hegewisch 1992, pp. 94-101 (Uwe M. Schneede); Altshuler 1994, pp. 116-135;

79. Breton 1967, p. 105: "Les efforts des organisateurs avaient, en effet, tendu à créer une ambiance qui conjurât autant que possible celle d'une galerie „d'art". J'insiste sur le fait qu'ils n'obéissaient consciemment à aucun autre impératif: à s'y reporter aujourd'hui l'ensemble de leurs tentatives n'en a pas moins transcendé le but qu'ils se proposaient."

80. Dictionnaire abrégé du Surréalisme 1938.

81. First Papers of Surrealism, Whitelaw Reid Mansion, French Relief Society, 451 Madison

Ave, New York, 14 October to 7 November 1942, organized by André Breton and Marcel Duchamp. - Cf. Schwarz 1969, p. 515; Altshuler 1994, pp. 152-154. - Opening exhibition at the Art of this Century Gallery run by Peggy Guggenheim in New York, 20 October 1942 to May 1947. - Cf. Klüser/Hegewisch 1992, pp. 102-109 (Thomas M. Messer). The critic Henry McBride objected to this attempt to force the viewer into a kind of puppet role in his review of the exhibition in the *New York Sun* in October 1942; cf. Altshuler 1994, pp. 150-151. - Kiesler Catalogue 1996.

82. *Dylaby* (Dynamic Labyrinth), exhibition in Amsterdam, Stedelijk Museum 30 August to 30 September 1962, with Daniel Spoerri, Martial Raysse, Robert Rauschenberg, Per Olof Ultvedt, Niki de Saint Phalle and Jean Tinguely. - Cf. Kamber 1990, pp. 35-38; Klüser/-Hegewisch 1992, pp. 156-165 (Ad Petersen).

83. Published under the title 'The Modern Painter's World'; cf. Motherwell 1992, pp. 27-35, p. 29.

84. Cf. the survey by *The Magazine of Art* in 1945 on the conditions in which artists lived: McCausland 1946. A reprint was distributed by The Artists League of America.

85. Harnoncourt 1948. - The background to this was the book by Robsjohn-Gibbings that had appeared in 1947 with a sensational argument relating modern art to Fascism; cf. the review by Margaret Miller, in: *Magazine of Art*, January 1948, pp. 34-36; March 1948, pp. 116-118.

86. Cf. for example the one-hour interview which Jackson Pollock gave to William Wright, his neighbour in Springs L.I., presumably in 1949. The neighbour, who admits to knowing little about art, starts by asking: "Mr. Pollock, in your opinion what is the meaning of modern art?" He goes on to ask about the unconscious, about the difference between modern and classical artists, and about the development of modern art. The interview becomes more and more like a cross-examination of a witness, with questions like: "Can you tell us how you developed your painting? And why you paint as you do?" Or: "Can you explain why you enjoy working big?" Tape recording, Archives of American Art, Washington, D.C., J. Pollock Papers. - Cf. also the introduction by Robert Goldwater in: *Artists on Art* 1945, pp. 7-19; Smith 1958.

87. *Life*, 8 August 1949, p. 42.

88. A year later, in 1950, Hans Namuth made a documentary film about Jackson Pollock, showing the artist at work. It connects the image of the rebellious artist with that of the energetic American, as we see Pollock producing his art in his free actions; cf. Walter 1997.

89. The first *Life Round Table* discussed the problem of "the pursuit of happiness" (*Life*, 12 July 1948), the second modern art. Cf. *Life*, 11 October 1948, pp. 56-78. - Cf. Collins 1991.

90. *Life*, 11 October 1948, p. 56.

91. Picasso Catalogue 1946.

92. *PM*, 14 January 1947, p. 10.

93. Modern Artists in America 1951, pp. 25-38. - Additional material in the Andrew C. Ritchie Papers in the Archives of American Art, Washington, D.C.

94. Modern Artists in America 1951, pp. 8-22.

95. Modern Artists in America 1951, pp. 5-6 (A Statement by the Editors).

96. Seitz 1983, pp. 139-149; Rosenberg/Fliegel 1965.

97. The open letter was dated 20 May 1950 and sent to the *New York Times*; in addition, a very correctly dressed Barnett Newman personally delivered a copy to the editor next day, Sunday, 21 May.

98. Artists in Exile 1942; Katz 1983; Sawin 1995.

99. Friedman 1978; Collins 1991.

100. Abstract Painting and Sculpture 1951.

101. A copy of the open letter is in Washington D.C., Archives of American Art, J. Pollock Papers. Cf. Collins 1991.

102. Rewald 1946.

103. Artaud 1947; Engl.: 'Van Gogh The Man Suicided by Society', transl. Bernard Frechtman, in: *The Tiger's Eye on Arts and Letters*, no. 7, March 1949, pp. 93-115; new edition in: Artaud 1956-94, vol. 13, pp. 9-64; Roh 1948; Muschg 1948, four editions of the book were published by 1969.

104. A Statement on Modern Art by The Institute of Contemporary Art, Boston, The Museum of Modern Art, New York, Whitney Museum of American Art, March 1950, 4 pages, p. 4.

105. George A. Dondero, 'Communist Conspiracy in Art Threatens American Museums (17

March 1952)', in: *Congressional Record. Proceedings and Debates of the 82nd Congress*, Second Session, 7 pages. - Dondero's main target was the Artists Equity Association.

106. Barr 1952.

107. *The Ideographic Picture*. Leaflet for the exhibition in the Betty Parsons Gallery in New York, N.Y. 1947, text by Barnett Newman: "Spontaneous, and emerging from several points, there has arisen during the war years a new force in American painting that is the modern counterpart of the primitive art impulse. ... It is now time for the artist himself, by showing the dictionary, to make clear the community of intention that motivates him and his colleagues. For here is a group of artists who are not abstract painters, although working in what is known as the abstract style." - As well as the young generation of American artists the Betty Parsons Gallery also represented Northwest Coast Indian Art and Pre-Columbian Mexican Art. - Cf. "Primitivism" in 20th Century Art 1984, vol. 2, pp. 615-659 (Kirk Varnedoe).

108. *The Intrasubjectives*. Leaflet for the exhibition in the Samuel M. Kootz Gallery, New York, 14 Sept.-3. October 1949.

109. Tiger's Eye 1948.

110. Newman 1948, p. 53, but cf. p. 51 the suggestion of a hint between the Surrealists and Burke: "To me Burke reads like a Surrealist manual." - Newman 1990, pp. 170-173.

111. Newman 1948, p. 53: "The failure of European art to achieve the sublime is due to this blind desire to exist inside the reality of sensation (the objective world, whether distorted or pure) and to build an art within a framework of pure plasticity" ... ; cf. p. 53: "I believe that here in America, some of us, free from the weight of European culture, are finding the answer, by completely denying that art has any concern with the problem of beauty and where to find it. ... We are reasserting man's natural desire for the exalted, for a concern with our relationship to the absolute emotions. ... The image we produce is the self-evident one of revelation, real and concrete, that can be understood by anyone who will look at it without the nostalgic glasses of history."

112. Burke 1757; on the historical background to these concepts see the article 'Erhaben, das Erhabene', in: Ritter 1972, Col. 624-635. - On the current discussion: Nancy 1988; Pries 1989.

113. Indian Art 1941. - Ernst 1970, pp. 80-82; article by Sigrid Metken, '„Zehntausend Rothäute ...“', Max Ernst bei den Indianern Nordamerikas', in: Ernst Catalogue 1991, pp. 357-362; "Primitivism" in 20th Century Art 1984, vol. 2, pp. 535-593 (Evan Maurer).

114. Pollock 1944; "Primitivism" in 20th Century Art 1984, vol. 2, pp. 615-659 (Kirk Varnedoe).

115. Pollock 1947/48. Cf. reprint in Pollock Catalogue 1978, vol. 4, D71, p. 241. - Cf. Chipp 1968, pp. 546-548; Prange 1996 (1).

116. Newcomb/Reichard 1937; Reichard 1939. The illustrations are of copies and folklore objects deliberately left incomplete, in order not to give them magic powers.

117. Newman 1990, p. 178. This is the statement which Newman wrote for his one-man show in the Betty Parsons Gallery in New York (23 April to 12 May 1951). It was typewritten and pinned to the wall.

118. Cf. Newman's statement for his first one-man show in the Betty Parsons Gallery in New York in 1950: "These paintings are not "abstractions," nor do they depict some "pure" idea. They are specific and separate embodiments of feeling, to be experienced, each picture for itself. They contain no depictive allusions. Full of restrained passion, their poignancy is revealed in each concentrated image." - Rothko 1947, p. 44: "A picture lives by companionship, expanding and quickening in the eyes of the sensitive observer. It dies by the same token. It is therefore a risky and unfeeling act to send it out into the world. How often it must be permanently impaired by the eyes of the vulgar and the cruelty of the impotent who would extend their affliction universally!"

119. Newman 1947, p. 164: "The Americans evoke their world of emotion and fantasy by a kind of personal writing without the props of any known shape. This is a metaphysical act. With the European abstract painters we are led into their spiritual world through already known images. This is a transcendental act. To put it philosophically, the European is concerned with the transcendence of objects while the American is concerned with the reality of the transcendental experience."

120. Barnes 1989; Strick 1989, pp. 90-91; Rosenberg 1978, pp. 71-74; Carmean 1982.

121. Rosenblum 1961. - For a detailed account of the argument that there is a nordic tradition in modern art independent of Paris cf. Rosenblum 1975. - Rosenblum's 1961 article

became famous because Erwin Panofsky made a printer's error the occasion for a steady stream of polemics against Newman, but the end result was defeat for the art historian. Unknown to him, Meyer Schapiro had supplied the painter with his philological arguments, cf. Wyss 1994.

122. Imdahl 1989, pp. 234-235: "Newman greift hinter jegliche mitgebrachte oder vorgeprägte, begrifflich, mathematisch, geometrisch oder auch ästhetisch determinierbare Ordnung zurück auf den Fundus der absoluten Emotion (›absolute emotion‹) als auf ein elementares menschliches Vermögen. Das Bild selbst ist dann der Anlaß oder die Nötigung, auf diesen Fundus zurückzugehen. Mit Emotion ist hier nicht ein einzelner Affekt oder ein Ensemble von Affekten (Freude – Trauer) gemeint, sondern das Erlebnis des Erhabenen, das sich verknüpft mit einer neuen Erfahrung und Erhöhung (›exaltation‹) des eigenen Selbst gerade unter dem Aufruf zur menschlichen Selbständigkeit, Selbstverwirklichung und Selbstentfaltung. Genau darauf zielt Newmans Absicht." - cf. e.g Rosenberg 1978, pp. 83-84: "Standing before a painting by Newman, the spectator may experience exaltation. Or he may be charged by a flood of sensations. The shifting between sublimity and cold visual fact is evidence of the ritual effectiveness of Newman's canvases. The potency of ceremonial objects of all creeds is at once both real and unreal."

123. Ullmann 1983; Kauffmann 1988; Freedberg 1989; Marin 1993.

124. Gamboni 1983, pp. 19-21; Pickshaus 1988, pp. 65-123; Gamboni 1997, pp. 206-211.

NOTES TO CHAPTER VI

1. Forster-Hahn 1985.

2. Alloway 1968; Christoph Becker and Annette Lagler, Biennale Venedig. *Der deutsche Beitrag 1895-1995*, Ostfildern: Cantz, 1995; Schneemann 1996.

3. Stationen 1988, pp. 276-313; *Die 'Kunststadt' München 1937. Nazionalsozialismus und 'Entartete Kunst'*, ed. by Peter-Klaus Schuster, Munich 1987; Entartete "Kunst" 1937; Roh 1962; Entartete Kunst 1991.

4. Meister französischer Malerei 1948. - The exhibition was arranged by the Gouvernement Militaire du Pays de Bade and the Landesamt für Museen, Sammlungen and Ausstellungen.

5. Ottomar Domnick, 'Zum Geleit', in: *Französische abstrakte Malerei 1948*, n.p.: "Abgelöst von den äußeren Erscheinungen, aber durchdrungen vom Weltgeist erreicht die abstrakte Kunst, deren Schmelztiegel das Herz und das Hirn des Menschen sind, konsequenterweise die erhabene Ebene der Befreiung, das Individuell-Universelle. Wenn man sich die Vorgänge klarmacht, dann kann man sich leicht die Angriffe, den Haß erklären, die an gewissen Punkten des Erdballs gegen die abstrakte Kunst entfesselt werden, die doch unangreifbar und unbesiegbar ist. Degenerierte Kunst, heulte man gestern. Anti-menschliche Kunst, stimmt man heute an; was soll das bedeuten, als daß die offensichtliche Helligkeit der abstrakten Kunst den Schwächlichen den Halt nimmt und daß andererseits diese Kunst sich weigert, sich ›in den Dienst‹ jeder Demagogie zu stellen."

6. Sedlmayr 1948, p. 133: "Es gibt die Sucht nach Neuem um jeden Preis, es gibt das oberflächliche zynische Spiel und den bewußten Bluff, es gibt die kalte Ausnützung dieser Kunst als Mittel alle Ordnungen aufzulösen, es gibt hundertfach den gewinnsüchtigen Schwindel und den Betrug der Selbstbetrogenen, die schamlose Darstellung des Gemeinen." - It is easy to find an analogy to the persecution of artists under National Socialism, cf. Entartete „Kunst" 1937: "Dummheit oder Frechheit - oder beides - auf die Spitze getrieben!" - Cf. the reactions at the Second German Historians Congress in Munich in 1949 in: *Kunstchronik*, 2, 1949, pp. 227-233, and the review by Franz Roh in: *Kunstchronik*, 2, 1949, pp. 294-298. - Seven hard cover editions of Sedlmayr's book had appeared by 1956 and eight paperback editions were published between 1955 and 1963; Engl. transl. by Brian Battershaw, *Art in Crisis: The Lost Center*, London: Hollis & Carter, 1957, and Chicago: H. Regnery, 1958.

7. Menschenbild in unserer Zeit 1950; cf. *Kunstchronik, 3, 1950, pp. 166-169*. Those involved were Sedlmayr, Hartlaub, Jedlicka, Baumeister, Itten, Roh and others.

8. Documenta 1 1955, pp. 16-17: "Der Schaden wurde vielmehr der Nation angetan, ihrem Bewußtsein von zeitgenössischer Kultur, ihrem passiven Kulturwollen. Sie wurde durch den massierten Einsatz der Betörungsmittel der Massenglücksdogmen gerade aus jener Kontinuität des Denkens herausgeschreckt, in der allein die Äußerungen der modernen Kunst ihr verständlich werden konnten." - Cf. Haftmann 1954. - On the history and criticism of the Documenta cf.

Mythos Documenta 1982; Schneckenburger 1983; Grasskamp 1987; Germer 1992.

9. Lehmbruck, *Kniende*, 1911, cf. Schubert 1990, pp. 155-168. - In the "Degenerate Art" exhibition in Munich in 1937 Lehmbruck's sculpture was in the sixth room on the upper floor, with paintings by Lovis Corinth and Franz Marc.

10. Documenta 2 1959, vol. 1, p. 14: "Man täusche sich auch nicht: – als eine der grundlegenden Ausdrucksformen der persönlichen Daseinsweise ist die moderne Kunst überall dort ein Ärgernis, wo der Glaube an Autorität, der Wille zur Macht, die zeitgenössischen Spielarten des politischen Totalitarismus zur Freiheit des Einzelnen in Gegensatz stehen. Von Europa über die beiden Amerika, über Afrika und Asien bis hin zum Fernen Osten hat sie innere Übereinstimmungen wachrufen können und diese Übereinstimmung in eine Sprachform einbetten können, die eine unmittelbare Kommunikation möglich macht." - The American works had been selected by Porter A. McCray of the Museum of Modern Art in New York. - Stationen 1988, pp. 426-435.

11. Documenta 2 1959, vol. 1, p. 326, with transl. Extracts from the text in the Pollock Catalogue 1956/57.

12. Documenta 2 1959, vol. 1, pp. 450-451: "Malen wird jetzt direktes Handeln aus der Existenz: – Spur ihrer Gestik, Choreographie ihrer Rhythmik, Herzschlag ihres Täters. Wie die Natur ihr Schicksal in geologischen Strukturen, in Diagrammen von Wachstum, Umlauf und Verfall aufzeichnet, wie eine Mauer ihre Geschichte, die ihr Zeit und Zufall antaten, in den Merkzeichen ihrer Versehrung bewahrt, so ist die Bildfläche für Wols die Schrifttafel, auf der die Chronik seines Schicksals sich einzeichnet, – in einer Schrift aus Linie, Farblicht und Gefleck, die das Zucken der Nerven unmittelbar im Bildleib registriert."

13. Poensgen/Zahn 1958.

14. The propagation and recognition of Abstract Expressionism in Europe were related to the need for the West to emphasize its position in the Cold War with the Soviet Union. However, there is no evidence that this was a strategy on the part of the United States, as Guilbaut 1983, pp. 204-205, maintained.

15. *Magnum*, 24 June 1959; cf. Moderne Kunst 1959.

16. 'Stati Uniti d'America', in: *Biennale 1964*, pp. 275-280, p. 275: "Tutti riconoscono che il centro mondiale delle arti si è spostato da Parigi a New York."

17. High and Low 1990; Schneemann 1996.

18. Starobinski 1970; Haskell 1972 (1978); Kellein 1995.

19. Ozenfant 1925.

20. Yves Klein tried to patent his blue and his aerial sculpture; on 19. 5. 1960 he was given a patent for the surface structure but not for the colour ultramarine. He quarrelled with Tinguely over the aerial sculpture, as Tinguely patented his drawing machine. Cf. Klein Catalogue 1994, pp. 79, 160, 168-169.

21. Hultén 1967; Tinguely Museum 1996, exhibition catalogue pp. 40-47, Collection catalogue pp. 44-46.

22. Nouveaux réalistes 1986, pp. 261-262; the patent (no. 1.237.934) was granted on 27 June 1960: "Cet appareil est utilisable soit comme jouet, soit pour la réalisation de dessins ou peintures abstraits plus importants susceptibles d'être exposés et conservés, soit encore pour la décoration en continu de bandes, de papier ou de tissu."

23. Hultén 1967, p. 35; Gamboni 1983, Ch. IV, pp. 85-104; Gamboni 1997, esp. pp. 255-286.

24. Tinguely Museum 1996, Collection Catalogue, pp. 46-55.

25. Bourdieu 1977; cf. Luhmann 1995; Gamboni 1997, esp. pp. 276-286.

26. O'Doherty 1976 and 1996. - Cf. the reconstruction of Le Vide in der Ausstellung Yves Klein in the Museum Ludwig in Cologne 1994/95, Klein Catalogue 1994, no. 36.

27. Yves Klein, 'Préparation de l'exposition du 18 avril chez Iris Clert, 3, rue des Beaux-Arts à Paris. La spécialisation de la sensibilité à l'état matière première en sensibilité picturale stabilisée. Époque pneumatique', in: Klein 1959, pp. 4-13. - Cf. Restany 1974 (1982), pp. 48-50; Klein Catalogue 1994, pp. 131- 157.

28. Klein Catalogue 1983, p. 187; cf. Klein's letter of 12 May 1959 in the Yves Klein Archive, Paris: Musée national d'art moderne.

29. Stöhr 1993; Klein Catalogue 1983; Klein Catalogue 1994. - From 1956 Klein was pursued by Pierre Restany, who later wrote the three manifestos of the *Nouveaux Réalistes*, who have earned a place in the history of the vanity of writers on art, cf. *Nouveaux réalistes* 1986,

pp. 264-265, 266-267, 272-273. The sanctuary of St. Rita in Cascia, Umbria, was rebuilt between 1937 and 1947. St. Rita lived from 1379-1457 and suffered a mystic wound from a thorn from the crown of thorns on a crucifix.

30. Cf. the anthropometries "Hiroshima»" (ANT 79) and "Aerial Architecture" (ANT 102); cf. also the modest critical comments in: Klein Catalogue 1995, pp. 185-186, which differ somewhat from Restany's thoughtlessness; Restany 1974 (1982), pp. 87-143; Wyss 1996 (2), pp. 374-379.

31. Attack on 3 June 1968: Warhol/Hackett 1980, pp. 272-279; Bourdon 1989, pp. 278-291. - Death on 22 February 1987: Warhol 1989, p. 730; Bourdon 1989, pp. 413-418. Cf. the reproduction of the photograph by Avedon in Warhol Catalogue 1989.

32. Warhol Catalogue 1989, pp. 417, 446; Kuspit 1993, Ch. 5: Fame as the Cure-All. The Charisma of Cynicism - Andy Warhol, pp. 64-82.

33. Warhol Catalogue 1989, p. 449; Engl. Edition p. 457. Cf. Berg 1967; Warhol 1975; van Graevenitz 1993; Whiting 1987.

34. Buchloh 1989.

35. Warhol Catalogue 1989, esp. cat. nos. 204-212; Collins 1988; Baudrillard 1988, p. 12: "Le héros moderne n'est plus celui du sublime de l'art, il est celui de l'ironie objective du monde de la marchandise, que l'art incarne par l'ironie objective de sa propre disparition."

36. Swenson 1963, p. 26. Cf. Warhol Catalogue 1989, p. 449; Livingstone 1989.

37. Warhol 1975, p. 92.

38. On attempts to restore authenticity see e.g. Crow 1987.

39. Gieseke/Markert 1996, pp. 194-199.

40. Schneede 1994, no. 29, pp. 330-353; on this action see Strauss 1990.

41. Groblewski 1993; Gieseke/Markert 1996, pp. 182-183.

42. Schneede 1994.

43. Bodenmann-Ritter 1975 (1991); Murken 1979; Burckhardt 1986; Kuspit 1993, Ch. 6, pp. 83-99; Prange 1996 (2).

44. Zeitgeist 1982, illustration section (n.p.): "Ich behaupte, daß dieser Begriff Soziale Plastik eine völlig neue Kategorie der Kunst ist. ... Ich schreie sogar: es wird keine brauchbare Plastik mehr hienieden geben, wenn dieser soziale Organismus als Lebewesen nicht da ist. Das ist die Idee des Gesamtkunstwerkes, in dem jeder Mensch ein Künstler ist." - Stüttgen 1988, pp. 148-187.

45. From 1980 Beuys called his office in the Academy of Art in Düsseldorf "Forschungsinstitut Erweiterter Kunstbegriff" (Research Institute for the Wider Concept of Art); cf. Adriani/Konnertz/Thomas 1981, pp. 343, 345.

46. Burckhardt 1986, p. 162: [Beuys]: "In bezug auf den erweiterten Kunstbegriff bin ich auf der Suche nach dem Dümmsten. Und wenn ich den Dümmsten, der auf dem allerniedrigsten Niveau ist, gefunden habe, dann habe ich sicher den Intelligentesten gefunden, den potentiell am meisten Vermögenden. Und der ist Träger der Kreativität."

47. Bodenmann-Ritter 1975 (1991).

48. Beuys Catalogue 1976: "Die Beziehung zwischen Werk und Publikum, kann sie als bestimmendes, konstituierendes Merkmal zum Kunstwerk geschlagen werden?", n.p.; cf. Körner/Steiner 1982.

49. Schneede 1974, no. 22, pp. 266-273; no. 23, pp. 274-299; Verspohl 1984; Raussmüller-Sauer 1988, pp. 88- 127 (article by J. Stüttgen); Kramer 1991.

50. Gesamtkunstwerk 1983, pp. 421-426; Beuys in: Raussmüller-Sauer 1988, pp. 128-139.

51. Beuys in: Raussmüller-Sauer 1988, p. 134: "Das ist ein humoristisches Zeichen und soll ausdrücken, wie man den Kapitalismus aus den Angeln hebt: ebenso einfach, wie man einen Block anhebt, mit einem Hebel."

52. Stüttgen 1988, pp. 114-116; Beuys Catalogue 1991, no. 89, n.p.

53. Belting 1992.

54. Daniel Buren, 'Exposition d'une exposition', in: Documenta 5 1972, 17.29; and in: Buren 1991, vol. 1, pp. 263-264: "De plus en plus le sujet d'une exposition tend à ne plus être l'exposition d'oeuvres d'art, mais l'exposition de l'exposition comme oeuvre d'art. Ici, c'est bien l'équipe de Documenta, dirigée par Harald Szeemann, qui expose (les oeuvres) et s'expose (aux critiques). Les oeuvres présentées sont les touches de couleurs - soigneusement choisies - du tableau que compose chaque section (salle) dans son ensemble. Il y a même un ordre dans ces couleurs, celles-ci étant cernées et composées en fonction du dess(e)in de la section (sélection)

dans laquelle elles s'étalent/se présentent. Ces sections (castrations), elles-mêmes „touches de couleurs" - soigneusement choisies - du tableau que compose l'exposition dans son ensemble et dans son principe même, n'apparaissent qu'en se mettant sous la protection de l'organisateur, celui qui ré-unifie l'art en le rendant tout égal dans l'écrin-écran qu'il lui apprête. Les contradictions, c'est l'organisateur qui les assume, c'est lui qui les couvre. ... Il est vrai alors que c'est l'exposition qui s'impose comme son propre sujet, et son propre sujet comme oeuvre d'art."

55. Schneckenburger 1983, pp. 91-110 (Krise der Documenta 4).

56. Documenta 5 1972, pp. 10-11.

57. Szeemann interviewed by Willi Bongard, in: *Die Welt*, Tuesday, 21 March 1972; reprint in: Staeck 1972, pp. A 2.6-2.9; the interview caused heated discussion. - Some of the concepts for Documenta 5 are in the volume published by Staeck; the full material is in the Documenta-Archiv in Kassel.

58. Staeck 1972, pp. A 2.1-A 2.4 (statement by Martin Kunz).

59. When Attitudes Become Form 1969. - The exhibition was in Bern from 22.3. to 27.4.1969, and in the Institute of Contemporary Arts in London from 28.9.-27.10.1969. - Cf. Klüser/Hegewisch 1992, pp. 212-219. - Happening & Fluxus 1970; Cf. Szeemann's polemical answer to the negative criticism of the exhibition in the Kölner Kunstverein, Szeemann 1971.

60. Szeemann in *Kunstvermittlung zwischen Kommerz, Trend und Verantwortung*, Schweizerische Akademie der Geistes-und Sozialwissenschaften, Bern 1995, pp. 11-19; Heinich 1995.

61. Szeemann 1981; Hultén 1996.

62. "Dilettanten, erhebt Euch gegen die Kunst"; "DADA ist die willentliche Zersetzung der bürgerlichen Begriffswelt." - Stationen 1988, pp. 156-183; Klüser/Hegewisch 1991, pp. 70-75; Altshuler 1994, pp. 98-115.

63. France: Silver 1989, Canto d'Amore 1996; Germany: Entartete Kunst 1991, Zuschlag 1995; USA: Doss 1991.

64. Luhmann 1995, esp. pp. 469-488.

65. Nauman Catalogue 1990, pp. 9-23 (Franz Meyer); Nauman Catalogue 1994, Nr. 92, p. 216.

66. Franz Kafka, *Amerika*, ed. by M. Brod, Munich: Wolff, 1927; new edition Frankfurt/M: S. Fischer, 1953, last ch.: 'Das Naturtheater von Oklahoma': "Wer an seine Zukunft denkt, gehört zu uns! Jeder ist willkommen! Wer Künstler werden will, melde sich! Wir sind das Theater, das jeden brauchen kann, jeden an seinem Ort!"

67. Lissitzky und Arp 1990, p. XI; Westkunst 1981, pp. 249-250. Contrary to the label, Manzoni's cans mostly contained sand, according to a verbal report by Daniel Spoerri, who checked the contents of one of the cans. This was to avoid fermentation and all the evil-smelling consequences.

68. Zaunschirm 1993; De Duve 1992, esp. Ch. 2: Given the Richard Mutt Case.

69. Dickie 1974 and 1984; cf. Davies 1991 on the discussion; Danto 1981.

70. Cf. the comprehensive analysis of the art system in Luhmann 1995, esp. Ch. 7: Self-description, pp. 393-507.

71. O'Doherty 1976; cf. the commentary by Wolfgang Kemp in O'Doherty 1996; Florian Rötzer, 'Schwierigkeiten mit der Kunst - einige Variationen', in: *Destruktion des ästhetischen Scheins 1992*, pp. 105-150.

72. Immendorf 1973; Grasskamp 1986.

73. Hoehme 1974.

74. *Capital. Das Wirtschaftsmagazin*, 1992, no. 11, pp. 150-155, the experts in 1992 were Leo Castelli, New York, and Annely Juda, London; in 1993 this interesting valuation by members of the art trade was dropped.

75. *Capital. Das Wirtschaftsmagazin*, no. 11, 1995, pp. 356-371.

76. *Capital. Das Wirtschaftsmagazin*, no. 11, November 1996, pp. 272-289.

77. *Capital. Das Wirtschaftsmagazin*, no. 11, November 1995, pp. 356-372; the "Calculation of the Top Ten after 25 years of the Art Compas". The assessment of the investment used Beuys' equation, Art = Capital (p. 218), hardly surprising, for Beuys wrote it in 1979 in the Galerie Hans Mayer in Düsseldorf to celebrate "Ten Years of Capital's Art Compas". He painted the slogan in red on a larger than life-size photograph of himself, very slowly, as is said.

78. *Capital. Das Wirtschaftsmagazin*, no. 11, November 1993, p. 218.

79. *Capital. Das Wirtschaftsmagazin*, no. 11, 1996, p. 278.

80. Bowness 1989.

81. Bowness 1989, p. 11.

82. Bowness 1989, p. 47.

83. *Capital. Das Wirtschaftsmagazin*, no. 11, November 1996, pp. 272-289.

84. *Capital. Das Wirtschaftsmagazin*, no. 11, 1993, pp. 222, 224; no. 11, 1996, p. 282.

85. Bätschmann 1996 (3).

86. Delineator: a person who draws or sketches, or an instrument used in surveying.

87. Serra 1976, bes. pp. 37-38. - Serra 1994, pp. 35-42.

88. Wortz 1976, p. 84: "The imagined threat (greatly increased, as one observer pointed out, by the proximity of the Ace Gallery to the San Andreas fault) that the upper slab would fall made most people, to avoid being flattened in case of a disaster, edge along the lateral walls in making their way from the front to the back of the gallery. Only a few, myself not included, ventured to stand any length of time beneath the suspended steel in the center of the gallery."

89. Wortz 1976, p. 84: " 'Delineator', while aggressive and monumental, speaks to ineffable realms of the psyche in a most provocative manner. - Marmer 1976, p. 74: Serra counts the viewer as the vertical element of his construct, a necessary formal link between top and bottom. And when one has stepped onto the steel stage and taken up a position under the aphotic metal plate, one does indeed feel absorbed into the drama of the piece, a participant in the structure, willingly or not. What a viewer also experiences is an atavistic awareness of the fragile nature of that thankful form, the human vertical."

90. Bois 1987; Zweite 1987.

91. Horn 1977, p. 57: *Die Chinesische Verlobte*, 1976; cf. Horn 1994, no. 24.

92. Bruce Nauman began to make corridor and room installations in 1969, cf. Nauman Catalogue 1994: *Performance Corridor*, 1969 (no. 151, p. 234), *Corridor Installation (Nick Wilder Installation)*, 1970 (no. 172, p. 241), *Corridor Installation with Mirror - San José Installation*, 1970 (no. 173, p. 242), *Green Light Corridor*, 1970 (no. 180, p. 245) etc.; *Dream Passage (Version I)*, 1983 (no. 301, p. 284) and the Schaffhauser version *Dream Passage (Version II)*, 1983 (no. 302, pp. 284-285). - Nauman Catalogue 1973; Bruggen 1988; Graulich 1989, pp. 120-128; Thürlemann 1990.

93. Thürlemann 1990.

94. Simon 1988, p. 147.

95. Simon 1988, p. 142 - Cf. The article by Paul Schimmel in: Nauman Catalogue 1994, pp. 69-82.

96. Simon 1988, p. 147.

97. Bewogen-Beweging (Motion in Art). Exhibition in Amsterdam, Stedelijk Museum, 16 March to 17 April 1961, organized by Daniel Spoerri with contributions by Jean Tinguely and Pontus Hultén. - Wissmann 1970; Rauschenberg 1980, no. 17, p. 296; Kotz 1990, pp. 129-139. Naturally the suitcase is a reference to Duchamp, like the suitcase which Daniel Spoerri put together with the help of other artists and opened in an action in Cologne the same year, cf. Kamber 1990, pp. 58-59. - On participation: Popper 1975, esp. 'New forms of spectator participation', pp. 13-32.

98. Kemp 1983 and 1992; Shearman 1992.

99. Winckelmann 1759; cf. Winckelmann 1968, pp. 169-173. Bätschmann 1992 (1). - Hegel 1966, pp. 282-283.

100. Schmidt 1971; Graulich 1989, pp. 170-203.

101. Acconci 1979, pp. 16-17; Acconci 1980, pp. 32-34; Perucchi-Petri 1994, pp. 13-17.

102. Lotringer 1989, p. 126.

103. Kabakov 1995 (1), p. 45: "Die wichtigste handelnde Person in der totalen Installation, das Zentrum, dem alles zugewandt, auf das alles ausgerichtet ist, ist ihr Betrachter - ein ganz besonderer Betrachter."

104. Pouillon 1995, p. 20: "On peut aussi parler de mon évolution intérieure, personnelle. De ce point de vue, le désir de faire des installations est né d'une modification profonde de ma relation avec le spectateur. J'ai toujours pensé, personnellement, que le repli sur soi n'était pas une démarche satisfaisante: cela ne me suffisait plus. ... Cet interlocuteur, ce spectateur n'est pas quelqu'un à qui je m'adresse en tant que prophète, professeur ou artiste. Je le considère comme un ami, qui peut s'exprimer de manière sereine et objective sur mes objets, en les regardant avec attention et en toute impartialité."

105. Kabakov 1995 (1), p. 46: "Die Reaktion des Betrachters auf seinem Weg durch die Installation ist bei ihrem Aufbau am sorgfältigsten zu bedenken: wie organisiert man seine Aufmerksamkeit so, daß sie nicht einen einzigen Moment schwindet? Der Verlust der Aufmerksam-

keit des Betrachters ist das Ende der Installation. ... Aber selbst wenn die totale Installation nur aus einem einzigen Raum besteht und der Betrachter sie scheinbar in einem einzigen Moment, auf einen Blick, vollständig erfaßt, spielt die durchdachte Steuerung seiner Bewegung in diesem einen Zimmer dennoch eine sehr wichtige Rolle. Diese ›Steuerung‹ des Betrachters erreicht man auf zwei Wegen, und beide nutzen eine verborgene, fundamentale Regel, unsere Aufmerksamkeit beim Betreten eines beliebigen Raums zu steuern: ein ständiges Springen vom Ganzen zu den Details und wieder zurück zum Ganzen Das eine Verfahren ist, mit Barrieren und niedrigen Mauern den Betrachter an viele kleine Stücke heranzuführen, das andere, den Betrachter zu zwingen, sich wiederholt dem Gesamteindruck zuzuwenden."

106. Kabakov 1995 (2), pp. 128-131: "La cuisine communautaire... Vaste sujet, inépuisable! Elle est digne d'être au centre de notre univers. Magique, telle une boule de cristal, elle focalise et reflète sur ses facettes notre vie de tous les jours, avec ses maux, ses problèmes et ses espérances." - Kabakow 1993, p. 29: "Le coeur de l'appartement communautaire est incontestablement la cuisine. Tel un cristal magique, elle focalise et reflète toutes les facettes de la vie quotidienne de l'appartmenet, ses maux, ses problèmes et ses espérances. Tout y trouve sa place; la bassesse et la grandeur, le banal et le romantique, l'amour ou la bagarre autour d'un verre cassé, la générosité ou la misérable discussion sur la facture d'électricité; l'offre d'un gateau tout chaud et le contentieux autour de la poubelle à sortir."

107. Kabakov 1995 (1), pp. 49-50: "Versuchen wir, das Profil zu beschreiben, das nach unserer Auffassung den Kern der psychischen Reaktion ausmacht, wenn der Betrachter eine totale Installation erlebt:Das momentane, konzentrierte Empfinden des eigenen Lebens als unbezwingbare Last und gleichzeitig - das Gefühl eines Anstosses, der Befreiung von dieser Last; eine sonderbare Gespaltenheit, ein gleichzeitig hier und dort sein, das Gefühl, über diesem Leben und der Situation, in der man sich befindet, zu hängen oder zu schweben." - Cf. Boris Groys interviewing Kabakov on the situation of Russian artists in the West, Groys 1992.

108. Kabakov 1995 (1), p. 48: "Die bekannte Situation und die eingebaute Illusion führen ihn [den Betrachter], wenn er durch die Installation spaziert, in einen Korridor der eigenen Erinnerung und rufen von dort eine Welle von Assoziationen auf, die bislang friedlich auf ihrem Grunde schlummerten. Die Installation hat diesen 'Grund' nur gestreift, geweckt, berührt, und die Erinnerungen kommen hoch und ergreifen das Bewusstsein des Betrachters."

109. Kabakov 1995 (1), pp. 111-115: "Eine große Empfänglichkeit, das Einschalten individueller subjektiver Assoziationen und einer weit zurückreichenden Erinnerung während der gesamten in ihr zugebrachten Zeit befördern die Entstehung dieser zusätzlichen Empfindung beim Betrachter. Ich selbst habe schon bei meiner allerersten Installation gespürt, daß dieses ›Mehrprodukt‹, das unausweichlich entsteht, der totalen Installation ein bestimmtes Aussehen und den Sinn eines rituellen Orts verleiht."

110. Kabakov 1995 (1), p. 114: "Der Betrachter steht vor einem alltäglichen sozialen Raum, einem bewusst profanen Milieu, doch der Grundriss, die Gestaltung, die gesamte Anlage und oft auch die Anordnung der profanen Exponate ist so (und alles wird auch so beleuchtet), als handele es sich um einen bewusst sakralisierten Ort, einen für eine sakrale Handlung bestimmten Raum."

111. Cf. Pouillon 1995.

112. On Wolf Vostell's *Dé-coll/age*-Actions cf. Jappe 1993, p. 18; Schilling 1978, pp. 113-133; Vostell 1987; Vostell 1993. - On Joseph Beuys cf. Adriani 1981; Harlan 1976; Schneede 1994. - At Documenta 5 in 1972 Beuys opened the Information Office of the Organization for Direct Democracy through Referenda for a hundred days, cf. Documenta 1972, pp. 16.3-4, 16.91-96; Kramer 1991, pp. 191-194.

113. Storr 1991, pp. 18-19.

SELECT BIBLIOGRAPHY

Abbreviations

AB	Art Bulletin
BM	Burlington Magazine
GBA	Gazette des Beaux-Arts
JWCI	Journal of the Warburg and Courtauld Institutes
RMN	Réunion des Musées Nationaux
SIK	Schweizerisches Institut für Kunstwissenschaft
ZAK	Zeitschrift für Schweizerische Archäologie und Kunstgeschichte
ZfK	Zeitschrift für Kunstgeschichte

Abadie 1981
Abadie, Daniel, 'L'Exposition internationale du surréalisme, Paris 1938', in: *Paris 1937 - Paris 1957*. Exh. cat. Paris, Centre Georges Pompidou 1981, Paris: Centre Georges Pompidou, 1981, pp. 72-74.

Abrams 1985
Abrams, Ann Uhri, *The Valiant Hero, Benjamin West and Grand Style History Painting*, Washington, D.C.: Smithsonian Institution Press, 1985.

Abstract Painting and Sculpture 1951
Abstract Painting and Sculpture in America. Exh. cat. New York, Museum of Modern Art 1951, ed. by Andrew C. Ritchie, New York: Museum of Modern Art, 1951.

Acconci 1979
Acconci, Vito, 'Interview by Robin White at Crown Point Press, Oakland, California, 1979', in: *View*, 2, 5/6, 1979.

Acconci Catalogue 1980
Vito Acconci. A Retrospective: 1969-1980. Exh. cat. Chicago 1980, ed. by Judith R. Kirshner, Chicago: Museum of Contemporary Art, 1980.

Ackermann 1808-10 (1904)
Ackermann, Rudolph, *The Microcosm of London, or London in Miniature*, London: Methuen & Co, 1808-10; new edn 1904.

Actes 1890
Actes du Congrès International des Oeuvres et Institutions Féminines, publiés par les soins de la Commission nommée par le Comité d'organisation, Paris: Bibliothèque des annales économiques, 1890.

Adhémar 1950
Adhémar, Hélène, *Watteau, sa vie - son oeuvre*, Paris: P. Tisné, 1950.

Adriani/Konnertz/Thomas 1981
Adriani, Götz, Konnertz, Winfried and Tho-mas, Karin, *Joseph Beuys - Leben und Werk*, Cologne: DuMont, 1973; new enlarged edn 1981.

Adriani 1993
Adriani, Götz, *Cézanne Gemälde*. Exh. cat. Tübingen 1993, Cologne: DuMont, 1993.

Ästhetische Erfahrung 1996
Ästhetische Erfahrung heute, ed. by Jürgen Stöhr, Cologne: DuMont, 1996.

Aggum 1986
Aggum, Arne, *Edvard Munch*, Stuttgart: Klett Cotta, 1986.

Ahlers-Hestermann 1921
Ahlers-Hestermann, Friedrich, 'Kunstausstellungen', in: *Genius*, 1, 1921, p. 20.

Alberts 1978
Alberts, Robert C., *Benjamin West: A Biography*, Boston: Houghton Mifflin, 1978.

Allan 1966
Allan, David G.C., *The Houses of the Royal Society of Arts. A History and a Guide*, London: The Society of Arts, 1966; revised edn 1974.

Allan/Abbott 1992
Allan, David G.C. and Abott, John L. (Ed.), *The Virtuoso Tribe of Arts and Sciences. Studies in the Eighteenth Century Work and Membership of the London Society of Arts*, Georgia: University of Georgia Press, 1992.

Allgeyer 1904
Allgeyer, Julius, *Anselm Feuerbach*, 2 vols, Berlin and Stuttgart: W. Spemann, 1904.

Alloway 1968
Alloway, Lawrence, *The Venice Biennale, 1885-1968. From Salon to Goldfish Bowl*, Greenwich, Conn.: New York Graphic Society, 1968.

Almanachs 1995
Les effets du soleil. Almanachs du règne de Louis XIV. Exh. cat. Paris 1995, ed. by Maxime Préaud, Paris: RMN, 1995.

Alpers 1988
Alpers, Svetlana, *Rembrandt's Enterprise*, Chicago: Chicago University Press, 1988.

Altick 1978
Altick, Richard D., *The Shows of London*, Cambridge, MA and London: Harvard University Press, 1978.

Altshuler 1994
Altshuler, Bruce, *The Avant-Garde in Exhibition. New Art in the 20th Century*, New York: Abrams, 1994.

Amaury-Duval 1878 (1993)
Amaury-Duval, *L'atelier d'Ingres, édition critique de l'ouvrage publié à Paris en 1878*, ed. by Daniel Ternois, Paris: Arthena, 1993.

Ammann/Szeemann 1970

Ammann, Jean-Christophe and Szeemann, Harald, *Von Hodler zur Antiform. Geschichte der Kunsthalle Bern*, Bern: Benteli, 1970.

Andersen 1845
Andersen, Hans Christian, *Bertel Thorwaldsen. Eine biographische Skizze*, trans. Julius Reuscher, Berlin: Wolff, 1845.

Andersen 1967
Andersen, Wayne V., 'Cézanne, Tanguy, Chocquet', in: *AB*, 49, 2, 1967, pp. 137-139.

Andree 1977
Andree, Rolf, *Arnold Böcklin. Die Gemälde* (SIK, Oeuvrekataloge Schweizer Künstler, vol. 6), Basel: F. Reinhardt, and Munich: Prestel, 1977.

Angrand 1972
Angrand, Pierre, *Le Comte de Forbin et le Louvre en 1819*, Lausanne and Paris: La Bibliothèque des Arts, 1972.

Anonymous 1802
[Anon.] 'Beschreibung des Gemäldes der Sabinerinnen, von David', in: *Helvetisches Journal für Litteratur und Kunst*, 1, 1802, pp. 78-89.

Ansaldi 1936
Ansaldi, Giulio Romano, *Documenti inediti per una biografia di G.B. Wicar* (Reale Accademia Naz. dei Lincei, 333, 1936, series 6, vol. 5, Fascicolo 5), Rome: G. Bardi, 1936.

Aron-Caën 1885
Aron-Caën, L., 'Union des Femmes Peintres et Sculpteurs au Palais des Champs-Elysées', in: *Moniteur des Arts*, December 11, 1885, p. 378.

Arp/Lissitzky s. Lissitzky/Arp 1925

Art for Art's Sake 1996
Art for Art's Sake 1996 and Literary Life. How Politics and Markets helped shape the Ideology and Culture of Aestheticism 1790-1990, ed. by Gene H. Bell-Villada, Lincoln, London: University of Nebraska Press, 1996.

Art and Power 1995
Art and Power: Europe under the Dictators, 1930-4. Exh. cat. London 1995, London: Hayward Gallery, 1995.

Art in Theory
Art in Theory 1900-1990. An Anthology of Changing Ideas, ed. by Charles Harrison and Paul Wood, Oxford and Cambridge, MA: Blackwell, 1992.

Artaud 1947
Artaud, Antonin, *Le suicidé par la société*, Paris: Gallimard, 1947.

Artaud 1956-94
Artaud, Antonin, *Oeuvres complètes*, 26 vols, Paris: Gallimard, 1956-94.

Artists in Exile 1942
Artists in Exile. Exh. cat. New York 1942, New York: Pierre Matisse Gallery, 1942.

Artists on Art 1945
Artists on Art from the XIV to the XX Century, ed. by Robert Goldwater and Marco Treves, New York: Pantheon Books, 1945.

Aurier 1891 (1991)
Aurier, G.-Albert, 'Le Symbolisme en peinture. Paul Gauguin', in: *Mercure de France*, no. 15, March 1891, pp. 155-165; new edn, ed. by P.L. Mathieu, Caen: L'Echoppe, 1991.

B. 1938
B., 'Ein Kunstsalon als Tollhaus', in: *Münchner Abendblatt*, no. 19, January 24, 1938, p. 2.

Badt 1943 (1968)
Badt, Kurt, 'Artifex vates und Artifex rhetor' [1943], in: *Kunsttheoretische Versuche. Ausgewählte Aufsätze*, ed. by Lorenz Dittmann, Cologne: DuMont, 1968, pp. 39-83.

Badt 1965
Badt, Kurt, *Eugène Delacroix. Werke und Ideale*, Cologne: DuMont, 1965.

Badt 1956 (1968)
Badt, Kurt, 'Der Gott und der Künstler' [1956], in: Kurt Badt, *Kunsttheoretische Versuche. Ausgewählte Aufsätze*, ed. by L. Dittmann, Cologne: DuMont, 1968, pp. 85-101.

Bätschmann 1986
Bätschmann, Oskar, 'Das Historienbild als "tableau" des Konfliktes': Jacques-Louis Davids "Brutus" von 1789, in: *Wiener Jahrbuch für Kunstgeschichte*, 39, 1986, pp. 145-162, 281-292.

Bätschmann 1989
Bätschmann, Oskar, 'Edouard Manet im Salon von 1865: *Olympia* und *Jésus insulté*', in: *Bildfälle. Die Moderne im Zwielicht*, ed. by Beat Wyss, Zürich: Artemis & Winkler, 1989, pp. 21-29.

Bätschmann 1991
Bätschmann, Oskar, 'Jacques-Louis David's Paintings in the Salon of 1789', in: *La Grecia Antica. Mito e Simbolo per l'Età della Grande Rivoluzione. Genesi e Crisi di un Modello nella Cultura del Settecento*, Milan: Guerini, 1991, pp. 225-237.

Bätschmann 1992 (1)
Bätschmann, Oskar, 'Pygmalion als Betrachter. Zur Rezeption von Malerei und Skulptur in der zweiten Hälfte des 18. Jahrhunderts', in: Kemp 1992, pp. 237-278.

Bätschmann 1992 (2)
Bätschmann, Oskar, 'L'artiste exposé', in: *Traverses*, n.s. 3, 1992, pp. 48-57.

Bätschmann 1993 (1)
Bätschmann, Oskar, *Edouard Manet: Der Tod des Maximilian*, Frankfurt/M: Insel Verlag, 1993.

Bätschmann 1993 (2)

Bätschmann, Oskar, 'Ausstellungskünstler. Zu einer Geschichte des modernen Künstlers', in: Bätschmann/Groblewski 1993, pp. 1-35.

Bätschmann/Groblewski 1993
Bätschmann, Oskar and Groblewski, Michael (Ed.), *Kultfigur und Mythenbildung. Das Bild vom Künstler und sein Werk in der zeitgenössischen Kunst*, Berlin: Akademie-Verlag, 1993.

Bätschmann 1996 (1)
Bätschmann, Oskar, 'Selbstbildnisse im 20. Jahrhundert', in: *Freiburger Universitätsblätter*, 132, 1996, pp. 153-174.

Bätschmann 1996 (2)
Bätschmann, Oskar, 'Géricault artiste d'éxposition', in: *Géricault* (Louvre conférences et colloques), ed. by Régis Michel, 2 vols, Paris: La Documentation française, 1996, vol. 2, pp. 679-699.

Bätschmann 1996 (3)
Bätschmann, Oskar, 'Der Künstler als Erfahrungsgestalter', in: *Ästhetische Erfahrung* 1996, pp. 248-281.

Bahr 1898 (1900)
Bahr, Hermann, 'Über das neue Gebäude der Secession', in: *Die Zeit*, 17, no. 211, October 15, 1898, pp. 42-43; new edn: *Secession*, Vienna: Wiener Verlag, 1900, pp. 60-65.

Bahr 1901
Bahr, Hermann, *Bildung. Essays*, Leipzig: Insel, 1901.

Balzac 1830 (1935)
Balzac, Honoré de, 'Des artistes', in: *La Silhouette*, vol. 26, in three series, 25.2., 11.3. and 22.4.1830; in: *Oeuvres diverses*, ed. by Marcel Bouteron and Henri Longnon, Paris: L. Conard, 1935, vol. 1, pp. 351-360.

Balzac 1831 (1979)
Balzac, Honoré de, 'Le Chef-d'Oeuvre inconnu', in: *La Comédie humaine* (Bibliothèque de la Pléiade), vol. 10: Etudes philosophiques, ed. by Pierre-Georges Castex, Paris: Gallimard, 1979, pp. 413-438.

Barnes 1989
Barnes, Susan J., *The Rothko Chapel. An Act of Faith*, Austin: University of Texas Press, 1989.

Barr 1952
Barr, Alfred J., Jr., 'Is Modern Art Communistic?', in: *New York Times Magazine*, December 14, 1952, pp. 22-30.

Barrault 1830
Barrault, Émile, *Aux Artistes. Du passé et de l'avenir des Beaux-Arts (Doctrine de Saint-Simon)*, Paris: A. Mesnier, 1830; excerpts in: Pfeiffer 1988, pp. 251-288.

Barrell 1986
Barrell, John, *The Political Theory of Painting from Reynolds to Hazlitt: "The Body of the Public"*, New Haven and London: Yale University Press, 1986.

Barry 1775
Barry, James, *An Inquiry into the Real and Imaginary Obstructions to the Acquisition of the Arts in England*, London: T. Becket, 1775.

Barry 1783 (1)
Barry, James, *An Account of a Series of Pictures in the Great Room of the Society of Arts, Manufactures, and Commerce at the Adelphi*, London: T. Cadell and J. Walter, 1783.

Barry 1783 (2)
Barry, James, *Catalogue of a Series of Pictures upon the Subject of Human Culture. Painted for the Society for the Encouragement of Arts, Manufactures, and Commerce*, London, 1783.

Barry 1809
[Barry, James] *The Works of James Barry*, 2 vols, London: Cadell & Davies, 1809.

Bartolozzi Catalogue 1928
Francesco Bartolozzi, Catalogue des estampes et notice biographique d'après les manuscrits de A. de Vesme, ed. by Augusto Calabi, Milan: Guido Modiano, 1928.

Baudelaire 1855 (1962)
Baudelaire, Charles, 'De l'essence du rire et généralement du comique dans les arts plastiques' [1855], in: Baudelaire 1962, pp. 241-263.

Baudelaire 1859 (1962)
Baudelaire, Charles, 'Salon de 1859', in: *Revue française*, June-July 1859; in: Baudelaire 1962, pp. 305-396.

Baudelaire 1863 (1962)
Baudelaire, Charles, 'L'oeuvre et la vie d'Eugène Delacroix', in: *L'Opinion nationale*, Sept. 2, 14 and November 22, 1863; in: Baudelaire 1962, pp. 421-451.

Baudelaire 1962
Baudelaire, Charles, *Curiosités esthétiques. L'Art romantique et autres Oeuvres critiques*, ed. by Henri Lemaître, Paris: Garnier, 1962.

Baudelaire 1975/76
Baudelaire, Charles, *Oeuvres complètes*, ed. by François Pichois, Paris: Gallimard, 2 vols, 1975/76.

Baudelaire 1977-92
Baudelaire, Charles, *Sämtliche Werke/Briefe*, ed. by Friedhelm Kemp, Claude Pichois, Wolfgang Drost, 8 vols, Munich-Vienna: Hanser, 1977-92.

Baudrillard 1988
Baudrillard, Jean, 'De la marchandise absolue', in: *Artstudio*, 8, Spécial Andy Warhol, 1988; and in: Warhol Catalogue 1995, pp. 15-21.

Bauhaus-Ideen 1994
Bauhaus-Ideen 1919-1994. Bibliografie und Beiträge zur Rezeption des Bauhausgedankens, ed. by Andreas Haus, Berlin: Reimer, 1994.

Baxandall 1972
Baxandall, Michael, *Painting and Experience in Fifteenth Century Italy. A Primer in the Social History of Pictorial Style,* Oxford: Clarendon Press, 1972.

Baxandall 1985
Baxandall, Michael, *Patterns of Intention. On the Historical Explanation of Pictures,* New Haven and London: Yale University Press, 1985.

Bazille Catalogue 1978
Bazille and Early Impressionism. Exh. cat. Chicago 1978, Chicago: The Art Institute, 1978.

Bazin 1987-90
Bazin, Germain, *Théodore Géricault. Etude critique, documents et catalogue raisonné,* 5 vols, Paris: La Bibliothèque des Arts, 1987-1990.

Beaucamp 1939
Beaucamp, Fernand, *Le Peintre Lillois Jean-Baptiste Wicar (1762-1834), son oeuvre et son temps,* 2 vols, Lille: Emile Raoust, 1939.

Beausire 1988
Beausire, Alain, *Quand Rodin exposait,* Paris: Musée Rodin, 1988.

Beaux-Arts 1938
[Le grincheux jovial], 'Le vernissage de l'exposition surréaliste vu par le Grincheux Jovial', in: *Beaux-Arts,* January 21, 1938. pp. 1-2.

Becker 1991
Becker, Jochen, 'Die funkelnden Farben der Freiheit: zu einem schillernden Begriff in Historiographie und Kunsttheorie', in: Zeichen der Freiheit 1991, pp. 99-115.

Beckmann Catalogue 1983
Max Beckmann. Die Hölle, 1919. Exh. cat. Kupferstichkabinett Berlin 1983, ed. by Alexander Dückers, Berlin: Staatliche Museen Preussischer Kulturbesitz, 1983.

Beckmann Catalogue 1984
Max Beckmann - Retrospektive. Exh. cat. Munich, Berlin, Saint Louis, Los Angeles 1984/5, ed. by Carla Schulz-Hoffmann and Judith Weiss, Munich: Prestel, 1984.

Beckmann Catalogue 1993
Max Beckmann: Selbstbildnisse. Exh. cat. Hamburg and Munich 1993, Stuttgart: Hatje, 1993.

Beckmann Catalogue 1994
Max Beckmann. Meisterwerke 1907-1950. Exh. cat. Staatsgalerie Stuttgart 1994, ed. by Karin v. Maur, Stuttgart: Hatje, 1994.

Becq 1982
Becq, Annie, 'Expositions, peintres et critiques: Vers l'image moderne de l'artiste', in: *Dix-Huitième Siècle,* 14, 1982, pp. 131-149.

Belting 1990
Belting, Hans, *Bild und Kult. Eine Geschichte des Bildes vor dem Zeitalter der Kunst,* Munich:

Beck, 1990.

Belting 1992
Belting, Hans, ' "Das Kleid der Braut". Marcel Duchamps "Grosses Glas als Travestie des Meisterwerks" ', in: Destruktion des ästhetischen Scheins 1992, pp. 70-90.

Bemrose 1885
Bemrose, William, *The Life and Works of Joseph Wright,* London: Derby, Bemrose & Sons, 1885.

Benjamin 1936 (1974)
Benjamin, Walter, 'Das Kunstwerk im Zeitalter seiner technischen Reproduzierbarkeit' [1936], in: *Gesammelte Schriften,* ed. by R. Tiedemann and H. Schweppenhäuser, vol. I/2, Frankfurt/M: Suhrkamp, 1974, pp. 433-508.

Benjamin 1982
Benjamin, Walter, *Das Passagen-Werk,* in: *Gesammelte Schriften,* ed. by R. Tiedemann and H. Schweppenhäuser, vol. V/1,2, Frankfurt/M: Suhrkamp, 1982.

Benkard 1927
Benkard, Ernst, *Das Selbstbildnis vom 15. bis zum Beginn des 18. Jahrhunderts,* Berlin: H. Keller, 1927.

Berg 1967
Berg, Gretchen, 'Andy: My True Story', in: *Los Angeles Free Press,* 17th of March 1967, p. 3.

Berlin-Moskau 1995
Berlin-Moskau 1900-1950. Exh. cat. Berlin and Moskau 1995, ed. by Irina Antonowa and Jörn Merkert, Munich and New York: Prestel, 1995.

Berliner Akademie 1996
"Die Kunst hat nie ein Mensch allein besessen." Dreihundert Jahre Akademie der Künste und Hochschule der Künste. Exh. cat. Berlin 1996, Berlin: Henschel, Akademie der Künste und Hochschule der Künste, 1996.

Berman 1993
Berman, Patricia G., 'Edvard Munch's *Self-Portrait with Cigarette:* Smoking and the Bohemian Persona', in: *AB,* 75, 1993, pp. 627-646.

Bernard 1907 (1912)
Bernard, Emile, *Souvenirs sur Paul Cézanne* [1907], Paris: Société des Trente, 1912.

Bernard 1939
Bernard, Émile, *Souvenirs inédits sur l'artiste peintre Paul Gauguin et ses compagnons lors de leur séjour à Pont-Aven et au Pouldu,* Preface by René Maurice, Lorient: Impr. du Nouvelliste du Morbihan, [1939].

Bernard Catalogue 1990
Émile Bernard 1868-1941. A Pioneer of Modern Art - Ein Wegbereiter der Moderne. Exh. cat. Mannheim and Amsterdam 1990, ed. by Mary

Anne Stevens, Zwolle: Waanders Verlag, 1990.

Betti 1834
Betti, Salvatore, *Notizie intorno alla vita e alle opere del Cav. Giambattista Wicar, pittore di Lilla, dette all'Insigne e Pontificia Accademia romana di S. Luca,* Rome: A. Boulzaler, 1834.

Beuys Catalogue 1976
Joseph Beuys: "zeige deine Wunde". Exh. cat. Kunstforum in der Fussgängerunterführung Maximilianstrasse/Altstadtring in Munich 1976, Munich: Verlag Schellmann & Klüser, 1976.

Beuys Catalogue 1991
Joseph Beuys. Werbung für die Kunst. Exh. cat. Munich 1991, ed. by Peter Weiss and Florian Britsch, Munich: Schneider-Henn, 1991.

Beuys Catalogue 1993
Joseph Beuys. Exh. cat. Zürich 1993/94, Zürich: Kunsthaus, 1993.

Białostocki 1987
Białostocki, Jan, 'Raffaello e Dürer come personificazioni di due ideali artistici nel Romanticismo', in: *Studi su Raffaello,* 2 vols, ed. by Micaela Sambucco Hamud and Maria Letizia Strocchi, Urbino: Quattri Venti, 1987, vol. 1, pp. 133-143.

Biblioteca canoviana 1823-24
Biblioteca canoviana ossia Raccolta delle migliori prose, e de' più scelti componimenti poetici sulla vita, sulle opere ed in morte di Antonio Canova, 4 vols, Venice: Gio. Parolari, 1823-24.

Biennale 1964
Catalogo della XXXII Esposizione Biennale Internazionale d'Arte Venezia, Venice: Biennale di Venezia, 1964.

Bild der Ausstellung 1993
Das Bild der Ausstellung. Exh. cat. Vienna 1993, Vienna: Hochschule für angewandte Kunst, 1993.

Bild des Künstlers 1978
Das Bild des Künstlers. Selbstdarstellungen. Exh. cat. Hamburg 1978, ed. by Siegmar Holsten, Hamburg: H. Christians, 1978.

Binder 1973
Binder, Wolfgang, ' "Genuss" in Dichtung und Philosophie des 17. und 18. Jahrhunderts', in: *Archiv für Begriffsgeschichte,* 17, 1973, pp. 66-92.

Bisanz-Prakken 1992
Bisanz-Prakken, Marian, 'Der Beethovenfries', in: *Gustav Klimt.* Exh. cat. Zürich 1992, ed. by Toni Stooss and Christoph Doswald, Stuttgart: Hatje, 1992, pp. 33-41.

Blanc 1861-77
Blanc, Charles, *Histoire des peintres de toutes les écoles,* 14 vols, Paris: Renouard, 1861-1877.

Blanc 1877

Blanc, Charles, *Histoire des peintres de toutes les écoles. École vénitienne: Titien, Vecelli,* Paris: Renouard, 1877.

Blochmann 1991
Blochmann, Georg M., *Zeitgeist und Künstlermythos: Untersuchungen zur Selbstdarstellung deutscher Maler der Gründerzeit: Marées, Lenbach, Böcklin, Makart, Feuerbach,* Münster: Lit, 1991.

Blühm 1988
Blühm, Andreas, *Pygmalion. Die Ikonographie eines Künstlermythos zwischen 1500 und 1900* (Europäische Hochschulschriften, Reihe 28, Kunstgeschichte, vol. 90), Frankfurt a.M., Bern (etc.): Peter Lang, 1988.

Boas 1938 (1977)
Boas, Georges, 'Courbet and his Critics' (1938), in: *Courbet and the Naturalistic Movement. Essays read at the Baltimore Museum of Art, May 1938,* ed. by George Boas, New York: Russell & Russell, 1967, pp. 47-57; new edn in: Petra Ten Doesschate Chu (Ed.), *Courbet in Perspective,* Englewood Cliffs: Prentice-Hall, 1977, pp. 42-52.

Boase 1947
Boase, T.S.R, 'Illustrations of Shakespeare's Plays in the Seventeenth and Eighteenth Centuries', in: *JWCI,* 10, 1947, pp. 83-108.

Boase 1963
Boase, T.S.R., 'Macklin and Bowyer', in: *JWCI,* 26, 1963, pp. 148-177.

Bock/Busch 1973
Bock, Henning and Busch, Günther (Ed.), *Edvard Munch. Probleme, Forschungen, Thesen* (Studien zur Kunst des 19. Jahrhunderts, vol. 21), Munich: Prestel, 1973.

Bodenmann-Ritter 1975 (1991)
Bodenmann-Ritter, Clara, *Joseph Beuys. Jeder Mensch ein Künstler. Gespräche auf der documenta 5/1972,* Frankfurt/M: Ullstein, 1975, 3rd edn 1991.

Böcklin 1901
[Arnold Böcklin] *Königliche Museen zu Berlin. Die Werke Arnold Böcklins in der Nationalgalerie,* text by Hugo von Tschudi, Munich: Photographische Union, 1901.

Böhringer 1978
Böhringer, Hannes, 'Avantgarde - Geschichte einer Metapher', in: *Archiv für Begriffsgeschichte,* 20, 1978, pp. 90-114.

Boerlin-Brodbeck 1980
Boerlin-Brodbeck, Yvonne, *Caspar Wolf (1735-1783). Landschaft im Vorfeld der Romantik.* Exh. cat. Basel 1980, Basel: Kunstmuseum, 1980.

Boileau-Despréaux 1745
Boileau-Despréaux, Nicolas, 'Traité du Sublime, ou du Merveilleux dans le Discours. Traduit du Grec de Longin', in: *Oeuvres,* 2

vols, Paris: David l'aîné et Durand, 1745, vol. 2, pp. 1-126.

Boime 1971
Boime, Albert, *The Academy and French Painting in the XIXth Century*, London: Phaidon, 1971.

Boime 1973
Boime, Albert, 'New Light on Manet's *Execution of Maximilian*', in: *Art Quarterly*, 36, 1973, pp. 172-208.

Boime 1981
Boime, Albert, 'The Case of Rosa Bonheur: Why should a woman want to be more like a man', in: *Art History*, 4, 1981, pp. 384-409.

Boime 1982
Boime, Albert, 'The Second Empire's Official Realism', in: Gabriel P. Weisberg (Ed.), *The European Realist Tradition*, Bloomington: Indiana University Press, 1982, pp. 31-123.

Boime 1990
Boime, Albert, *Art in an Age of Bonapartism 1800-1815* (A Social History of Modern Art, vol. 2), Chicago and London: University Press, 1990.

Bois 1987
Bois, Yves-Alain, 'Ein pittoresker Spaziergang um *Clara-Clara* herum', in: Ernst-Gerhard Güse (Ed.), *Richard Serra*, Stuttgart: Gerd Hatje, 1987, pp. 44-64.

Bois 1989
Bois, Yves-Alain, 'Exposition: Estétique de la distraction, espace de démonstration', in: *Les Cahiers du Musée national d'art moderne*, no. 29, 1989, pp. 57-79.

Bonaventura 1945
Die Nachtwachen des Bonaventura, in: *Journal von neuen deutschen Original-Romanen*, 3, 1804; new edn Zürich: Pegasus-Verlag, 1945.

Bordes 1983
Bordes, Philippe, *Le Serment du Jeu de Paume de Jacques-Louis David. Le peintre, son milieu et son temps de 1789 à 1792* (Notes et documents des musées de France, vol. 8), Paris: *RMN*, 1983.

Bordes/Michel 1988
Bordes, Philippe and Michel, Régis (Ed.), *Aux armes et aux arts! Les arts de la révolution 1789-1799*, Paris: Editions Adam Biro, 1988.

Bordes 1992
Bordes, Philippe, 'Jacques-Louis David's anglophilia on the eve of the French Revolution', in: *BM,* 134, 1992, pp. 482-490.

Borel 1951
Borel, Pierre (Ed.), *Lettres de Gustave Courbet à Alfred Bruyas*, Genf: Cailler, 1951.

Bottari 1770
[Bottari, Giovanni Gaetano] *Dialoghi sopra le tre Arti del Disegno corretti e accresciuti,* Florence

[s.e.] 1770 [first published anonymously Lucca 1754] [Cicognara, no. 24, 25].

Bouillon 1986
Bouillon, J.-P., 'Sociétés d'artistes et institutions officielles dans la seconde moitié du XIXe siècle', in: *Romantisme,* 54, 1986, pp. 88-113.

Bourdieu 1977
Bourdieu, Pierre, 'La production de la croyance. Contributions à une économie des biens symboliques', in: *Actes de la recherche en sciences sociales,* no. 13, February 1977, pp. 4-43.

Bourdieu 1979
Bourdieu, Pierre, *La distinction. Critique sociale du jugement,* Paris: Editions de minuit, 1979; German: *Die feinen Unterschiede. Kritik der gesellschaftlichen Urteilskraft,* Frankfurt/M: Suhrkamp, 1982.

Bourdieu 1992
Bourdieu, Pierre, *Les règles de l'art. Génèse et structure du champ littéraire,* Paris: Seuil, 1992.

Bourdieu/Darbel 1969
Bourdieu, Pierre and Darbel, Alain, *L'amour de l'art. Les musées d'art européens et leur public,* Paris: Editions de minuit, 1969.

Bourdon 1989
Bourdon, David, *Warhol,* Cologne: DuMont, 1989.

Bourgeois Catalogue 1982
Louise Bourgeois. Exh. cat. New York 1982, ed. by Deborah Wye, New York: Museum of Modern Art, 1982.

Bowness 1989
Bowness, Alan, *The Conditions of Success. How the Modern Artist rises to Fame,* London: Thames and Hudson, 1989.

Boydell 1925
Boydell, John, 'An Autobiography of John Boydell, the Engraver', in: *Flintshire Historical Society Publications,* 11, 1925, pp. 79-87.

Boydell Catalogue 1789
[John Boydell] *A Catalogue of the Pictures in the Shakspeare Gallery, Pall Mall,* London, 1789; further edns 1790, 1792, 1793, 1796 and 1802.

Brancusi Catalogue 1995
Constantin Brancusi 1876-1957. Exh. cat. Paris and Philadelphia, Paris: Centre Pompidou and Gallimard, 1995.

Breton 1967
Breton, André, 'Devant le rideau', in: André Breton, *La clé des champs,* Paris: Jean-Jacques Pauvert, 1967, pp. 104-114.

Brettell 1986
Richard R. Brettell, 'The "First Exhibition of Impressionist Painters" ', in: New Painting 1986, pp. 189-202.

Brinckmann 1944

Brinckmann, Albert E., *Michelangelo. Vom Ruhme seines Genius in fünf Jahrhunderten*, Hamburg: Hoffmann & Campe, 1944.

British Institution 1813
British Institution for Promoting the Fine Arts in the United Kingdom, London: W. Bulmer, 1813.

Bromley 1793/95
Bromley, Robert Anthony, *History of the Fine Arts, Painting, Sculpture, and Architecture; with occasional Observations on The Progress of Engraving, in its several Branches ... in four parts*, 2 vols, London: T. Cadell, J. Robson, Hookham, C. Dilly, 1793/95.

Brown 1985
Brown, Marilyn, *Gypsies and other Bohemians. The Myth of the Artist in Nineteenth-century France*, Ann Arbor: UMI Research Press, 1985.

Brown 1988
Brown, Milton W., *The Story of the Armory Show*, New York: Abbeville Press, 1988.

Bruggen 1988
Bruggen, Coosje van, *Bruce Nauman*, Basel: Wiese Verlag, 1988.

Bruntjen 1985
Bruntjen, Sven H.A., *John Boydell, 1719-1804. A Study of Art Patronage and Publishing in Georgian London* (Outstanding Dissertations in the Fine Arts), New York and London: Garland, 1985.

Bruyas 1854
Bruyas, Alfred, *Explication des Ouvrages de Peinture du Cabinet de M. Alfred Bruyas*, Paris: Plon Frères, 1854.

Buchloh 1989
Benjamin H.D. Buchloh, 'Andy Warhols eindimensionale Kunst', in: Warhol Catalogue 1989, pp. 37-57.

Buddensieg 1968
Buddensieg, Tilmann, 'Raffaels Grab', in: *Munuscula Discipulorum. Kunsthistorische Studien Hans Kauffmann zum 70. Geburtstag 1966*, ed. by Tilmann Buddensieg and Matthias Winner, Berlin: Bruno Hessling, 1968, pp. 45-70.

Bullock 1819
[Bullock, William] *A Concise Description of Monsieur Jerricault's Great Picture Representing the Surviving Crew of the Medusa French Frigate, after Remaining 13 Days on a Raft*, London: Smith, 1819.

Bullock 1820 (1)
[Bullock, William] *A Concise Description of Monsieur Jerricault's Great Picture, Twentyfour Feet long by Eighteen high, Representing the Surviving Crew of the Medusa French Frigate (15 out of 150,) after Remaining thirteen Days on the Raft, Partly immersed in Water, and without Provision, Just describing the Vessel that rescued them from their dreadful Situation ...* , London: Smith, 1820.

Bullock 1820 (2)
[Bullock, William] *Mr. Haydon's Picture of Christ's Triumphant Entry into Jerusalem,and other pictures; now exhibiting at Bullock's Great Room, Egyptian Hall*, London: C. H. Reynell, 1820.

Bullock 1828
[Bullock, William] *Description of a Grand Picture now exhibiting in the Roman Gallery, of the Egyptian Hall, Piccadilly, representing that pathetic Incident in Roman History, the Death of Virginia, painted by Monsieur Le Thiere, Professor of Painting in Paris, and Member of the Institute of France; the Artist, who so successfully exhibited, in the same Gallery, a few Years since, a Picture of similar Magnitude, entitled "The Judgment of Brutus"*, London: James Bullock, 1828.

Burckhardt 1986
Burckhardt, Jacqueline (Ed.), *Ein Gespräch. Joseph Beuys, Jannis Kounellis, Anselm Kiefer, Enzo Cucchi*, Zürich: Parkett-Verlag, 1986.

Buren 1991
Buren, Daniel, *Les Écrits (1965-1990)*, ed. by Jean-Marc Poinsot, 3 vols, Bordeaux: Musée d'art contemporain, 1991.

Burke 1757
Burke, Edmund, *A Philosophical Enquiry into the Origin of our Ideas of the Sublime and Beautiful*, London: R. and L. Dodsley, 1757.

Burns 1996
Burns, Sarah, *Inventing the Modern Artist. Art and Culture in Gildes Age America*, New Haven and London: Yale University Press, 1996.

Burty 1877
Burty, Philippe, 'Exposition des impressionistes', in: *La République française*, April 25, 1877.

Busch 1981
Busch, Werner, 'Akademie und Autonomie. Asmus Jakob Carstens' Auseinandersetzung mit der Berliner Akademie', in: *Berlin zwischen 1789 und 1848. Facetten einer Epoche*. Exh. cat. Berlin 1981, Berlin: Frölich & Kaufmann, 1981, pp. 81-92.

Busch 1992
Busch, Werner, 'Copley, West, and the Tradition of European High Art', in: *American Icons. Transatlantic Perspectives on Eighteenth- and Nineteenth-Century American Art*, ed. by Thomas W. Gaehtgens and Heinz Ickstadt, Santa Monica, CA: Getty Center for the History of Art and the Humanities, 1992, pp. 35-59.

Busch 1993
Busch, Werner, *Das sentimentalische Bild. Die Krise der Kunst im 18. Jahrhundert und die Geburt der Moderne*, Munich: Beck, 1993.

Bussmann 1993
Bussmann, Klaus (Ed.), *Hans Haacke, Bodenlos: Biennale Venedig 1993. Deutscher Pavillon,* Stuttgart: Edition Cantz, 1993.

Büttner 1983
Büttner, Frank, 'Asmus Jakob Carstens und Karl Philipp', in: *Nordelbingen,* 52, 1983, pp. 95-127.

Büttner 1992
Büttner, Frank, 'Der Briefwechsel zwischen Asmus Jakob Carstens und Minister Friedrich Anton von Heinitz', in: *Asmus Jakob Carstens: Goethes Erwerbungen für Weimar.* Exh. cat. Schleswig 1992, ed. by Renate Barth and Margaret Oppel, Schleswig: Schleswig-Holsteinisches Landesmuseum Schloss Gottorf, 1992, pp. 75-95.

Cabanne 1972
Cabanne, Pierre, *Gespräche mit Marcel Duchamp* (Spiegelschrift, 10), Cologne: Galerie Der Spiegel, 1972.

Caccianiga 1872 (1874)
Caccianiga, Antonio, *Ricordo della provincia di Treviso,* Treviso: L. Zoppelli, 1872; 2nd edn 1874.

Cannon-Brookes 1991
Cannon-Brookes, Peter, 'From the "Death of General Wolfe" to the "Death of Lord Nelson": Benjamin West and the Epic Composition', in: *The Painted Word: British History Painting, 1750-1830,* ed. by Peter Cannon-Brookes, Woodbridge: Boydell Press for the Heim Gallery, 1991, pp. 15-22.

Canova Catalogue 1992
Antonio Canova. Exh. cat. Museo Correr Venice 1992, Venice: Marsilio Editore, 1992.

Canova Catalogue 1993
Canova e l'incisione. Exh. cat. Rome and Bassano del Grappa 1993/94, ed. by Grazia Pezzini Bernini and Fabio Fiorani, Bassano del Grappa: Ghedina & Tassotti, 1993.

Canova 1994
Canova, Antonio, *Scritti* (Edizione nazionale delle opere di Antonio Canova), vol. 1, ed. by Hugh Honour, Rome: Istituto poligrafico e zecca dello stato, 1994.

Cantarel-Besson 1981
Cantarel-Besson, Yveline, *La naissance du musée du Louvre. La politique muséologique sous la Révolution d'après les archives des musées nationaux* (Notes et documents des musées de France, vol. 1), 2 vols, Paris: RMN, 1981.

Canto d'Amore 1996
Canto d'amore: klassizistische Moderne in Musik und bildender Kunst, 1914-1935. Exh. cat. Basel 1996, ed. by Gottfried Boehm, Ulrich Mosch and Katharina Schmidt, Basel: Öffentl.Kunstsammlungen und Paul Sacher-Stiftung, 1996.

Carabin Catalogue 1974
L'oeuvre de Rupert Carabin 1862-1932. Exh. cat. Paris, Paris: Galerie du Luxembourg, 1974.

Carmean 1982
Carmean, E.A., 'The Church Project: Pollocks Passion Themes', in: *Art in America,* 70, 6, 1982, pp. 110-122.

Carr 1993
Carr, Gerald L., 'David, Boydell and Socrates: A mixture of anglophilia, self-promotion and the press', in: *Apollo,* 137, 1993, pp. 307-315.

Carr 1960
Carr, J.L., 'Pygmalion and the *Philosophes*', in: *JWCI,* 23, 1960, pp. 239-255.

Carstens Catalogue 1992
Asmus Jakob Carstens: Goethes Erwerbungen für Weimar. Exh. cat. Schleswig 1992, ed. by Renate Barth and Margaret Oppel, Schleswig: Schleswig-Holsteinisches Landesmuseum Schloss Gottorf, 1992.

Cassagne 1906
Cassagne, Albert, *La théorie de l'art pour l'art en France chez les derniers romantiques et les premiers réalistes,* Paris: Hachette, 1906; new edn Seyssel: Champ Vallon, 1997.

Castelnuovo 1981
Castelnuovo, Enrico, 'Arti e rivoluzione. Ideologie e politiche artistiche nella Francia rivoluzionaria', in: *Ricerche di Storia dell'Arte,* 1981, no. 13-14, pp. 5-20.

Catalogue of the Pictures 1762
A Catalogue of the Pictures, Sculptures, Models, Drawings, and Prints,.&c. Exhibited by the Society of Artists of Great-Britain, at the Great Room, in Spring Gardens, Charing Cross. May the 17th, Anno 1762. Being the Third Year of their Exhibition, London 1762.

Catalogues of the Paris Salon 1977-78
Catalogues of the Paris Salon 1673 to 1881, ed. by Horst Janson, 60 vols, New York and London: Garland, 1977-78.

Caubisens-Lasfargues 1961
Caubisens-Lasfargues, Colette, 'Le salon de peinture pendant la révolution', in: *Annales historiques de la révolution française,* 33, 1961, pp. 193-214.

Caygill 1989
Caygill, Howard, *Art of Judgement,* Cambridge, Mass.: Basil Blackwell, 1989.

Caylus 1755
Caylus, Anne-Claude-Philippe de, *Nouveaux Sujets de Peinture et de Sculpture,* Paris: Duchesne, 1755.

Cézanne 1937
Cézanne, Paul, *Correspondance,* ed. by John Rewald, Paris: Bernard Grasset, 1937.

Cézanne 1962
Cézanne, Paul, *Briefe,* trans. John Rewald,

Zürich: Diogenes, 1962.

Cézanne 1978
[Paul Cézanne] *Conversations avec Cézanne,* ed. by P.M. Doran, Paris: Macula, 1978.

Chave 1993
Chave, Anna C., *Constantin Brancusi. Shifting the Bases of Art,* New Haven and London: Yale University Press, 1993.

Chave 1994
Chave, Anna C., 'New Encounters with *Les Demoiselles d'Avignon:* Gender, Race, and the Origins of Cubism', in: *AB,* 76, 1994, pp. 597-611.

Chennevières-Pointel 1967
Chennevières-Pointel, Charles-Philippe de (Ed.), *Archives de l'art français: recueil de documents inédits relatifs à l'histoire des arts en France,* 12 vols, Paris: J.B. Dumoulin and Tross, 1851-66; Reprint, 6 vols, Paris: F. de Noblele, 1967.

Chipp 1968
Chipp, Herschel B., *Theories of Modern Art. A Source Book by Artists and Critics,* Berkeley, Los Angeles, London: University of California Press, 1968.

Cicognara 1822 (1)
Cicognara, Leopoldo, *Orazione in morte del March. Antonio Canova, letta al giorno delle sue esequie,* Venice: G. Picotti, 1822; Reprint Rome, 1823.

Cicognara 1822 (2)
Cicognara, Leopoldo, *Sul monumento da erigersi in Venezia alla memoria di Canova,* Venice: G. Picotti, 1822.

Cicognara 1823
[Leopoldo Cicognara] *Biografia di Antonio Canova, scritta dal Cav. Leopoldo Cicognara,* Venice: G. Missaglia, 1823.

Cicognara 1823-25
Cicognara, Leopoldo, *Storia della Scultura dal suo risorgimento in Italia fino al secolo di Canova, per servire di continuazione all'opere di Winckelmann e di d'Agincourt,* 7 vols, 2nd edn, Prato: Giachetti, 1823-25.

Clark 1967
Clark, Robert Judson, 'Olbrich and Vienna', in: *Kunst in Hessen und am Mittelrhein,* 7, 1967, pp. 27-51.

Clark 1969
Clark, Timothy J., 'A Bourgeois Dance of Death', in: *BM,* 111, 1969, pp. 208-212 and 286-290.

Clark 1973
Clark, Timothy J., *Image of the People. Gustave Courbet and the 1848 Revolution,* London: Thames and Hudson, 1973.

Clark 1985
Clark, Timothy J., *The Painting of Modern Life. Paris in the Art of Manet and his Followers,* New York: Knopf, 1985.

Clément 1868
Clément, Charles, *Géricault. Etude biographique et critique avec le catalogue raisonné de l'oeuvre du maître,* Paris: Didier & Cie. [1867], 1868.

Clément 1850 (1869)
Clément, Charles, 'Nicolas Poussin' [1850], in: *Études sur les beaux-arts en France,* new edn, Paris: M. Lévy frères, 1869, pp. 1-97.

Collier/Lethbridge 1994
Collier, Peter and Lethbridge, Robert, *Artistic Relations. Literature and the Visual Arts in Nineteenth-Century France,* New Haven and London: Yale University Press, 1994.

Collins 1988
Collins, Bradford R., 'The Metaphysical Nosejob: The Remaking of Warhola, 1960-1968', in: *Arts Magazine,* 62, 6, 1988, pp. 47-55.

Collins 1991
Collins, Bradford R., '*Life* Magazine and the Abstract Expressionists, 1948-51: A Historiographic Study of a Late Bohemian Enterprise', in: *AB,* 73, 1991, pp. 283-308.

Condivi 1746
Condivi, Ascanio, *Vita di Michelagnolo Buonarroti pittore scultore architetto e gentiluomo fiorentino pubblicata mentre viveva dal suo scolare Ascanio Condivi. Seconda edizione corretta ed accresciuta di varie annotazioni col ritratto del medesimo ed altre figue in rame,* Florence: Gaetano Albizzini, 1746; new edn, ed. by Emma Spina Barelli, Milan: Rizzoli, 1964.

Cooper 1982
Cooper, Helen A., *John Trumbull, The Hand and Spirit of a Painter,* New Haven: Yale University Art Gallery, 1982.

Copley Catalogue 1995
John Singleton Copley in England. Exh. cat. Washington, DC and Houston, 1995/96, ed. by Emily Ballew Neff, London: Merrell Holberton, 1995.

Corinth 1926
Corinth, Lovis, *Selbstbiographie,* Leipzig: S. Hirzel, 1926.

Courbet 1992
[Gustave Courbet] *Letters of Gustave Courbet,* ed. by and trans. Petra ten-Doesschate Chu, Chicago and London: University of Chicago Press, 1992.

Courbet 1996
[Gustave Courbet] *Correspondance de Courbet,* ed. by Petra ten-Doesschate Chu, Paris: Flammarion, 1996.

Courbet Catalogue 1855
Exhibition et Vente de 40 Tableaux et 4 Dessins de M. Gustave Courbet, Avenue Montaigne, 7, Champs-Elysées, o.O.; Reprint in: Reff 1981,

vol. 38.

Courbet Catalogue 1867
Exposition des Oeuvres de M. G. Courbet. Rond-Point du Pont de l'Alma (Champs-Elysées), Paris: Lebigre-Duquesne Frères, 1867; Reprint in: Reff 1981, vol. 38.

Courbet Catalogue 1882
Exposition des oeuvres de Gustabe Courbet à l'École des Beaux-Arts (Mai 1882) Catalogue. Exh. cat. 1882; Reprint in: Reff 1981, vol. 38.

Courbet Catalogue 1977
Gustave Courbet (1819-1877). Exh. cat. Paris 1977/78, Paris: RMN, 1977.

Courbet Catalogue 1978
Courbet und Deutschland. Exh. cat. Hamburg and Frankfurt/M. 1978/79, Cologne: DuMont, 1978.

Courbet Katalog 1988
Courbet Reconsidered. Exh. cat. New York and Minneapolis 1988/89, ed. by Sarah Faunce and Linda Nochlin, New Haven and London: Yale University Press, 1988.

Courthion 1948-50
Courthion, Pierre (Ed.), Courbet raconté par lui-même et par ses amis. Ses écrits, ses contemporains, sa postérité, 2 vols, Genf: P. Cailler, 1948-50.

Crow 1978
Crow, Thomas, 'The Oath of the Horatii in 1785, Painting and Pre-Revolutionary Radicalism in France', in: Art History, 1, 1978, pp. 428-471.

Crow 1985
Crow, Thomas E., Painters and Public Life in Eighteenth-Century Paris, New Haven and London: Yale University Press, 1985.

Crow 1987
Crow, Thomas, 'Saturday Disasters: Trace and Reference in Early Warhol', in: Art in America, 75, 5, 1987, pp. 129-136.

Crow 1995
Crow, Thomas, Emulation. Making Artists for Revolutionary France, New Haven and London: Yale University Press, 1995.

Dahlhaus 1989
Dahlhaus, Carl, Vom Musikdrama zur Literaturoper. Aufsätze zur neueren Operngeschichte (Serie Musik Piper Schott, vol. 8238), Munich: Piper, and Mainz: Schott, 1989 (revised new edn, Munich, Salzburg: Emil Katzbichler, 1983).

Damiron 1954
Damiron, Susanne, 'La Revue "L'Artiste". Histoire administrative, présentation technique, graveurs romantiques hors texte', in: GBA, 96, 1955, pp. 191-202.

Danto 1981
Danto, Arthur Coleman, The transfiguration of the commonplace. A philosophy of Art, Cambridge, MA: Harvard University Press, 1981.

Daumier 1978
Honoré Daumier 1808-1879. Bildwitz und Zeitkritik. Sammlung Horn. Exh. cat. Münster and Bonn 1978/79, Münster: Westfälisches Landesmuseum, 1978.

David 1793
David, Jacques-Louis, Discours du citoyen David, député du Département de Paris, sur la nécessité de supprimer les académies, séance du 8 août 1793 (Convention nationale), Paris: Impr. nationale, [1793]; Reprint in: Wildenstein 1973, no. 477, pp. 56-57.

David 1799
[David, Jacques-Louis] Le tableau des Sabines, exposé publiquement au Palais National des Sciences et des Arts, Salle de ci-devant Académie d'Architecture. Par le Cen David, Membre de l'Institut National, Paris: Didot l'aîné, An VIII [1799].

David 1814
[David, Jacques-Louis] Explication du Tableau des Thermopyles de M. David, Membre de l'Institut de France, Officier de la Légion d'Honneur, etc.: avec Gravures, Paris: Imprimerie d'Hacquart, 1814.

David 1880-82
David, J.-L.-Jules, Le peintre Louis David 1748-1825. Souvenirs et documents inédits, Paris: V. Havard, 1880-1882.

David Catalogue 1981
David e Roma. Exh. cat. Rom 1981/82, Rome: De Luca, 1981.

David Catalogue 1989
Jacques-Louis David 1748-1825. Exh. cat. Paris 1989/90, Paris: RMN, 1989.

David and Delacroix Catalogue 1974
De David à Delacroix. La peinture française de 1774 à 1830. Exh. cat. Paris 1974/75, Paris: RMN, 1974.

Davies 1991
Davies, Stephen, Definitions of Art, Ithaca and London: Cornell University Press, 1991.

Degas Catalogue 1988
Degas. Exh. cat. Paris, Ottawa and New York 1988/89, Paris: RMN, 1988.

De Duve 1992
De Duve, Thierry, Kant after Duchamp, Cambridge and New York: Cambridge University Press, 1992.

De Piles 1677 (1970)
De Piles, Roger, Conversations sur la connaissance de la peinture et sur le jugement qu'on doit faire des tableaux, Paris: Nicolas Langlois, 1677; Reprint, Genf: Slatkine, 1970.

Delacroix 1853 (1928)
Delacroix, Eugène, 'Le Poussin', in: Moniteur Universel, June 26, 29 and 30, 1853; in:

Delacroix 1928, vol. 2, pp. 57-104.

Delacroix 1928
Delacroix, Eugène, *Oeuvres Littéraires,* 2 vols, Paris: Crès, 1928.

Delacroix 1935-38
Delacroix, Eugène, *Correspondance générale,* 5 vols., ed. by André Joubin, Paris: Librairie Plon, 1935-38.

Delacroix 1950
Delacroix, Eugène, *Journal,* new edn, ed. by André Joubin, 3 vols, Paris: Librairie Plon, 1950.

Delacroix 1981
Delacroix, Eugène, *Journal 1822-1863,* Preface by Hubert Damisch, Paris: Plon, 1981.

Delacroix 1988
Delacroix, Eugène, *Ecrits sur l'art,* ed. by François-Marie Deyrolle and Christophe Denissel, Paris: Librairie Séguier, 1988.

Delacroix 1996
Delacroix, Eugène, *Dictionnaire des beaux-arts,* ed. by Anne Larue, Paris: Hermann, 1996.

Delécluze 1855 (1983)
Delécluze, Étienne-Jean, *Louis David. Son école & son temps,* Paris: Didier, 185; new edn Paris: Macula, 1983.

Deloynes 1980
Collection Deloynes, 63 vols, Paris, Bibliothèque Nationale, Cabinet des Estampes, 516 Microfiches, Paris: Bibliothèque Nationale, 1980.

Delteil 1969
Delteil, Loys, 'Honoré Daumier', in: *Le peintre-graveur illustré, 19e et 20e siècles,* vols 20-29, Paris, Chez l'auteur, 1925-30; Reprint New York: Da Capo Press, 1969.

Démoris 1993
Démoris, René (Ed.), *L'Artiste en représentation,* Actes du Colloque Paris III-Boulogne, April 1991, Paris: Editions Desjonquères, 1993.

Dempsey 1967
Dempsey, Charles, 'Enanthes Redivivus: Rubens' Prometheus Bound', in: *JWCI,* 30, 1967, pp. 420-425.

Denis 1913 (1920)
Denis, Maurice, *Théories 1890-1910. Du symbolisme et de Gauguin vers un nouvel ordre classique,* [1913], 4th edn, Paris: Rouart et Watelin, 1920.

Denis 1957-59
Denis, Maurice, *Journal 1893-1943,* 3 vols, Paris: La Colombe, 1957-59.

Denis Catalogue 1994
Maurice Denis 1870-1943. Exh. cat. Lyon, Cologne, Liverpool and Amsterdam 1994/95, Gent: Snoeck-Ducaju et Zoon, 1994.

Der Blaue Reiter 1912
Der Blaue Reiter, ed. by Wassily Kandinsky and Franz Marc, Munich: R. Piper, 1912.

Destruktion des ästhetischen Scheins 1992
Nach der Destruktion des ästhetischen Scheins. Van Gogh, Malewitsch, Duchamp, ed. by H.M. Bachmayer, D. Kamper, F. Rötzer, Munich: K. Boer, 1992.

Dickie 1974
Dickie, George, *Art and the Aesthetic. An Institutional Analysis,* Ithaca: Cornell University Press, 1974.

Dickie 1884
Dickie, George, *The Art Circle. A Theory of Art,* New York: Haven, 1984.

Dictionnaire 1792
Dictionnaire des Arts de Peinture, Sculpture et Gravure, ed. by Claude-Henri Watelet and Pierre-Charles Lévesque, 5 vols, Paris: L.F. Prault, 1792.

Dictionnaire abrégé du Surréalisme 1938
Dictionnaire abrégé du Surréalisme, Paris: Galérie Beaux-Arts, 1938.

Diderot 1959
Diderot, Denis, 'Essais sur la peinture', in: *Oeuvres esthétiques,* ed. by Paul Vernière, Paris: Garnier, 1959, pp. 665-740.

Diderot 1975
Diderot, Denis, *Salons,* ed. by Jean Seznec and Jean Adhémar, 4 vols, Oxford: Clarendon Press, 1957-67; 2nd edn 1975.

Diderot 1984
Diderot, Denis, *Ästhetische Schriften,* 2 vols, ed. by Friedrich Bassenge, Berlin and Weimar: Aufbau-Verlag, 1967; Reprint Berlin: Das europäische Buch, 1984.

Diderot Catalogue 1984
Diderot & l'Art de Boucher à David. Les Salons: 1759-1781. Exh. cat. Paris 1984/85, Paris: RMN, 1984.

Dillenberger 1977
Dillenberger, John, *Benjamin West. The Context Of His Life's Work With Particular Attention to Paintings with Religious Subject Matter,* San Antonio: Trinity University Press, 1977.

Dinter 1979
Dinter, Annegret, *Der Pygmalion-Stoff in der europäischen Literatur, Rezeptionsgeschichte einer Ovid-Fabel* (Studien zum Fortwirken der Antike, vol. 11), Heidelberg: Winter, 1979.

Disler 1983
Disler, Martin, *Bilder vom Maler,* Dudweiler: AQ Verlag, 1980; 2nd edn 1981; 3rd edn 1983.

Dobai 1978
Dobai, Johannes, *Die bildenden Künste in Johann Georg Sulzers Aesthetik. Seine "Allgemeine Theorie der Schönen Künste"* (308. Neujahrsblatt der Stadtbibliothek Winterthur), Winterthur 1978.

Dobai 1974-84
Dobai, Johannes, *Die Kunstliteratur des Klassizismus und der Romantik in England*, 4 vols, Bern: Benteli, 1974-84.

Documenta 1 1955
Documenta. Kunst des XX. Jahrhunderts. Exh. cat. Kassel 1955, Munich: Prestel, 1955.

Documenta 2 1959
II. documenta. Kunst nach 1945. Exh. cat. Kassel 1959, 3 vols, Cologne: DuMont, 1959.

Documenta 5 1972
Documenta 5. Befragung der Realität, Bildwelten heute. Exh. cat. Kassel 1972, Kassel: Verlag documenta GmBH and Gütersloh: Bertelsmann, 1972.

Dokument Deutscher Kunst 1901 (1979)
Ein Dokument Deutscher Kunst. Grossherzog Ernst Ludwig und die Ausstellung der Darmstädter Künstler Kolonie, ed. by Alexander Koch, Darmstadt: Alex. Koch, 1901; Reprint in: *Die Ausstellung der Darmstädter Künstlerkolonie*, ed. by Alexander Koch, Darmstadt: Verlag zur Megede, 1979.

Dorbec 1905
Dorbec, Prosper, 'L'Exposition de la Jeunesse au 18e siècle', in: *GBA*, 57, 1905, pp. 456-470, and 34, 1905, pp. 77-86.

Doss 1991
Doss, Erika, *Benton, Pollock, and the Politics of Modernism: From Regionalism to Abstract Expressionism*, Chicago and London: University of Chicago Press, 1991.

Drechsler 1996
Drechsler, Maximiliane, *Zwischen Kunst und Kommerz. Zur Geschichte des Ausstellungswesens zwischen 1775 und 1905*, Munich and Berlin: Deutscher Kunstverlag, 1996.

Dresdner 1904
Dresdner, Albert, *Der Weg der Kunst,* Jena and Leipzig: Diederichs, 1904.

Dresdner 1915 (1968)
Dresdner, Albert, *Die Kunstkritik. Ihre Geschichte und Theorie. Erster Teil: Die Entstehung der Kunstkritik im Zusammenhang der Geschichte des europäischen Kunstlebens,* Munich: F. Bruckmann, 1915; new edn with a Preface by Peter M. Bode, Munich: Bruckmann, 1968.

Du Bos 1719 (1733)
[Du Bos, Abbé Jean-Baptiste] *Réflexions critiques sur la Poesie et sur la Peinture,* 2 vols, Paris: Pierre-Jean Mariette, 1719; enlarged new edn 1733; Reprint Genf: Slatkine, 1967.

Du Bos 1993
Du Bos, Abbé Jean-Baptiste, *Réflexions critiques sur la poésie et sur la peinture* (Collection Beaux-arts histoire), Paris: Ecole nationale supérieure des Beaux-Arts, 1993.

Duchamp 1992

Duchamp, Marcel, *Interviews und Statements,* ed. by Serge Stauffer, Stuttgart: Staatsgalerie, 1992.

Dufay 1844
Dufay, J.-C., *Notice sur la Vie et les Ouvrages de Wicar,* Lille: Puisaye, 1844.

Dunlop 1972
Dunlop, Ian, *The Shock of the New. Seven Historic Exhibitions of Modern Art*, London: Weidenfeld & Nicolson, 1972.

Duranty 1867
Duranty, Edmond, 'Ceux qui seront les peintres', in: *Almanach Parisien pour 1867,* Paris, 1867, pp. 13-18.

Easton 1964
Easton, Malcolm, *Artists and Writers in Paris. The Bohemian Idea, 1803-1867*, London: Edward Arnold, 1964.

Eaves 1992
Eaves, Morris, *The Counter-Arts Conspiracy. Art and Industry in the Age of Blake*, Ithaca and London: Cornell University Press, 1992.

Ecker 1991
Ecker, Jürgen, *Anselm Feuerbach. Leben und Werk. Kritischer Katalog der Gemälde, Ölskizzen und Ölstudien,* Munich: Hirmer, 1991.

Egbert 1967
Egbert, Donald D., 'The Idea of "Avant-Garde" in Art and Politics', in: *The American Historical Review,* 73/2, 1967, pp. 339-366.

Egbert 1970
Egbert, Donald D., *Social Radicalism and the Arts: Western Europe, A Cultural History from the French Revolution to 1968,* New York: Knopf, 1970.

Eisenman 1986
Eisenman, Stephen F., 'The Intransigent Artist or How the Impressionists Got Their Name', in: New Painting 1986, pp. 51-59.

Eitner 1967
Eitner, Lorenz, 'Reversals of Direction in Géricaults Compositional Projects', in: *Stil und Ueberlieferung in der Kunst des Abendlandes* (Akten des 21. Internationalen Kongresses für Kunstgeschichte, Bonn 1964), vol. 3: Theorien und Probleme, Berlin: de Gruyter, 1967, pp. 126-133.

Eitner 1972
Eitner, Lorenz, *Géricault's Raft of the Medusa,* London and New York: Phaidon, 1972.

Eitner 1983
Eitner, Lorenz, *Géricault. His Life and Work,* London: Orbis, 1983.

Elm 1991
Elm, Theo, *Johann Wolfgang Goethe. Die Wahlverwandtschaften* (Grundlagen und Gedanken zum Verständnis erzählender Literatur), Frankfurt/M: Diesterweg, 1991.

Encyclopédie 1751-80

L'Encyclopédie ou Dictionnaire Raisonné des Sciences, des Arts et des Métiers, par une Société de Gens de Lettres, ed. by Denis Diderot and Jean d'Alembert, 17 vols, 11 vols plates, 4 Suppl.-vols, 2 Index vols, Paris: Briasson, David l'aîné, Le Breton, Durand, Pancoucke, and Amsterdam: Rey, 1751-80.

Encyclopédie Méthodique 1788
Encyclopédie Méthodique. Beaux-Arts, [ed. by Pierre-Charles Lévesque and Claude-Henri Watelet], 3 vols, Paris: Panckoucke, and Liège: Plomteux, 1788.

Entartete "Kunst" 1937
Entartete "Kunst". Exhibition guide, ed. by Fritz Kaiser, Berlin: Verlag für Kultur und Wirtschaftswerbung, 1937; Reprint in: Stationen 1988.

Entartete Kunst 1991
Degenerate art: The fate of the avant-garde in Nazi Germany. Exh. cat. Los Angeles, Chicago, Washington, D.C. and Berlin 1991/92, ed. by Stephanie Barron, New York: H.N. Abrams, 1991.

Erasmus 1995
Erasmus von Rotterdam, Ausgewählte Schriften, 8 vols, ed. by Werner Welzig, Darmstadt: Wissenschaftliche Buchgesellschaft, 1995.

Erffa/Staley 1986
Erffa, Helmut von and Staley, Allen, The Paintings of Benjamin West, New Haven and London: Yale University Press, 1986.

Ernst 1970
Ernst, Max, Ecritures, Paris: Gallimard, 1970.

Ernst Catalogue 1991
Max Ernst. Retrospektive zum 100. Geburtstag. Exh. cat. London, Stuttgart, Düsseldorf and Paris 1991/92, ed. by Werner Spies, Munich: Prestel, 1991.

Escholier 1926-29
Escholier, Raymond, Delacroix peintre, sculpteur, écrivain, 3 vols, Paris: H. Floury, 1926-29.

Europa 1989
Europa 1789. Aufklärung, Verklärung, Verfall. Exh. cat. Hamburg 1989, ed. by Werner Hofmann, Cologne: DuMont, 1989.

Exhibiting Cultures 1991
Exhibiting Cultures. The Poetics and Politics of Museum Display, ed. by Ivan Karp and Steven D. Lavine, Washington, D.C. and London: Smithsonian Institution Press, 1991.

Explication 1763
Explication des peintures, sculptures, et gravures des messieurs de l'académie royale, Paris: Jean-Thomas Hérissant, 1763; Catalogues of the Paris Salon 1977-78, vol. 3.

Exposition imaginaire 1989
L'Exposition imaginaire. The Art of Exhibiting in the Eighties, ed. by Evelyn Beer and Riet de Leeuw, 's-Gravenhage: Rijksdienst Beeldende Kunst, 1989.

Faets 1993
Faets, Ann-Therese, "Überall nur eine Natur". Studien über Natur und Kunst in Goethes Wahlverwandtschaften (Europäische Hochschulschriften, Deutsche Sprache und Literatur, vol. 1385), Frankfurt/M, Bern [etc.]: Peter Lang, 1993.

Falconet 1781
Falconet, Etienne Maurice, Oeuvres, contenant plusieurs Écrits relatifs aux Beaux Arts, 6 vols, Lausanne: Société Typographique, 1781.

Falconet 1808
Falconet, Etienne Maurice, Oeuvres complètes, 3 vols, Paris: Dentu, 1808.

Fantin-Latour Catalogue 1982
Fantin-Latour. Exh. cat. Paris, Ottawa and San Francisco 1982/83, Paris: RMN, 1982.

Farington 1978-84
Farington, Joseph, The Diary of Joseph Farington, 16 vols, ed. by Kenneth Garlick and Angus Macintyre (vols 1-6), and Kathryn Cave (vols 7-16), New Haven and London: Yale University Press, 1978-84.

Félibien 1669 (1972)
Félibien, André, Conférences de l'Académie royale de Peinture et de Sculpture pendant l'année 1667, Paris: Frédéric Léonard, 1669; Reprint Portland: Collegium Graphicum, 1972.

Fehrer 1984
Fehrer, Catherine, 'New Light on the Académie Julian and its Founder (Rodolphe Julian)', in: GBA, 126, 1984, pp. 207-216.

Fernier 1977
Fernier, Robert, La vie et l'oeuvre de Gustave Courbet, Catalogue raisonné, Lausanne and Paris: La Bibliothèque des Arts, 1977.

Fernow 1795
Fernow, Carl Ludwig, 'Über einige neue Kunstwerke des Hrn. Prof. Carstens', in: Der Neue Teutsche Merkur, 1795, vol. 2, pp. 158-189.

Fernow 1806
Fernow, Carl Ludwig, Leben des Künstlers Asmus Jakob Carstens, ein Beitrag zur Kunstgeschichte des achtzehnten Jahrhunderts, Leipzig: Johann Friedrich Hartknoch, 1806.

Fernow 1806-08
Fernow, Carl Ludwig, Römische Studien, 3 vols, Zürich: H. Gessner, 1806-08.

Fernow 1867
Fernow, Carl Ludwig, Carstens, Leben und Werke, ed. by Herman Riedel, Hannover: C. Rümpler, 1867.

Feuerbach 1912
Feuerbach, Henriette, Ihr Leben in ihren Briefen, ed. by Hermann Uhde-Bernays, 2

vols, Berlin and Vienna: Meyer Jessen, 1912.

Feuerbach Catalogue 1976
Anselm Feuerbach 1829-1880. Gemälde und Zeichnungen. Exh. cat. Karlsruhe 1976, Karlsruhe: Kunsthalle, 1976.

Fin de siècle 1977
Fin de siècle. Zu Literatur und Kunst der Jahrhundertwende, ed. by R. Bauer u.a., Frankfurt/M: V. Klostermann, 1977.

Fischer 1990
Fischer, Rotraut, '*Georg Forsters "Ansichten vom Niederrhein". Die "Wahrheit" in den "Bildern des Wirklichen"* ' (Athenäum Monografien, Literaturwissenschaft, vol. 94), Frankfurt/M: Hain, 1990.

Fohrbeck/Wiesand 1975
Fohrbeck, Karla and Wiesand, Andreas Johannes (Ed.), *Der Künstler-Report. Musikschaffende, Darsteller/Realisatoren, Bildende Künstler/Designer,* Munich: Hanser, 1975.

Forster 1791/92
Forster, J. Georg, *Ansichten vom Niederrhein, von Brabant, Flandern, Holland, England und Frankreich, im April, Mai und Junius 1790,* 2 vols, Berlin: Vossische Buchhandlung, 1791/92.

Forster 1843
Forster, J. Georg, *Sämtliche Schriften,* 9 vols, Leipzig: Brockhaus, 1843.

Forster 1958
Forster, J. Georg, *Georg Forsters Werke: Sämtliche Schriften, Tagebücher, Briefe,* 18 vols, ed. by Gerhard Steiner, vol. 9: Ansichten vom Niederrhein, von Brabant, Flandern, Holland, England und Frankreich im April, Mai und Junius 1790, ed. by Gerhard Steiner, Berlin: Akademie-Verlag, 1958.

Forster-Hahn 1985
Forster-Hahn, Françoise, ' "La Confraternité de l'art": Deutsch-französische Ausstellungspolitik von 1871 bis 1914', in: *ZfK,* 48, 1985, pp. 506-537.

Foster 1954
Foster, Milton P., *The Reception of Max Nordau's "Degeneration" in England and America,* Ph.Dissertation University of Michigan, 1954, unpubliziert.

Fumaroli 1987-88
Fumaroli, Marc, 'La République des lettres', in: *Annuaire du Collège de France,* 1987-88, pp. 417-432.

Franz 1983
Franz, Eckhart G. (Ed.), *Erinnertes. Aufzeichnungen des letzten Grossherzoges von Hessen und bei Rhein, Ernst Ludwig,* Darmstadt: Roether, 1983.

Französische abstrakte Malerei 1948
Wanderausstellung französischer abstrakter Male-

rei. Exh. cat. Stuttgart, Munich, Düsseldorf, Hannover, Hamburg, Frankfurt and Freiburg 1948, ed. by Ottomar Domnick, Stuttgart, 1948.

Frauen in der Kunst 1980
Frauen in der Kunst, ed. by Gislind Nabakowski, Helke Sander and Peter Gorsen, 2 vols, Frankfurt/M: Suhrkamp, 1980.

Fréart de Chantelou 1981
Fréart de Chantelou, Paul, *Journal de Voyage du Cavalier Bernin en France,* Paris: Pandora, 1981.

Freedberg 1985
Freedberg, David, *Iconoclasts and their Motives* (The Second Gerson Lecture, University of Groningen 1983), Maarssen: Gary Schwartz, 1985.

Freedberg 1989
Freedberg, David, *The Power of Images. Studies in the History and Theory of Response,* Chicago and London: Chicago University Press, 1989.

Fried 1980
Fried, Michael, *Absorption and Theatricality. Painting and Beholder in the Age of Diderot,* Berkeley, Los Angeles, London: University of California Press, 1980.

Fried 1990
Fried, Michael, *Courbet's Realism,* Chicago and London: University of Chicago Press, 1990.

Fried 1996
Fried, Michael, *Manet's Modernism or The Face of Painting in the 1860s,* Chicago and London: University of Chicago Press, 1996.

Friedman 1978
Friedman, B.H., 'The Irascibles: A Split Second in Art History', in: *Arts Magazine,* 53, September 1978, pp. 96-102.

Friedman 1973
Friedman, Winifred H., 'Some Commercial Aspects of the Boydell Shakespeare Gallery', in: *JWCI,* 36, 1973, pp. 396-401.

Friedman 1976
Friedman, Winifried H., *Boydell's Shakespeare Gallery* (Outstanding Dissertations in the Fine Arts), New York and London: Garland, 1976.

Fries 1975
Fries, Thomas, *Die Wirklichkeit der Literatur. Drei Versuche zur literarischen Sprachkritik,* Tübingen: Niemeyer, 1975

Fryer 1809
Fryer, Edward (Ed.), *The Works of James Barry,* 2 vols, London: T. Cadell & W. Davies, 1809.

Fuchs 1900
Fuchs, Georg, 'Zur Weihe des Grundsteins. Ein festliches Spiel', in: *Deutsche Kunst und Dekoration,* 3, 8, 1900, pp. 357-365.

Füssli 1766
Füssli, Hans Heinrich, 'An den Uebersezer von Herrn Webbs Versuch, über die Mah-

lerey', in: [Daniel Webb] *Untersuchung des Schönen in der Mahlerey und der Verdienste der berühmtesten alten und neuern Mahlern. Durch Daniel Webb, Rittern. Aus dem Englischen ins Deutsche übersezt* [von Hanns Conrad Vögelin], Zürich: Orell, Gessner and Comp., 1766, pp. I-LXXX.

Füssli 1973
Füssli, Johann Heinrich, *Sämtliche Gedichte,* ed. by Martin Bircher and Karl S. Guthke, Zürich: Orell Füssli, 1973.

Gaehtgens 1984
Gaehtgens, Thomas, 'Jacques-Louis David: Leonidas bei den Thermopylen', in: *Ideal und Wirklichkeit der bildenden Kunst im späten 18. Jahrhundert* (Frankfurter Forschungen zur Kunst, vol. 11), ed. by H. Beck, P.C. Bol and E. Maek-Gérard, Berlin: Mann, 1984, pp. 211-251.

Gallet 1979
Gallet, Michel, 'Sur Charles de Wailly (1730-1798)', in: *Charles de Wailly, peintre architecte dans l'Europe des Lumières,* Paris: Caisse nationale des monuments et sites, 1979, pp. 6-15.

Galt 1816/20
Galt, John, *The Life, Studies and Works of Benjamin West,* London: T. Cadell & W. Davies, Edinborough: W. Blackwood, 2 vols, 1816/20.

Gamboni 1983
Gamboni, Dario, *Un iconoclasme moderne. Théorie et pratiques contemporaines du vandalisme artistique,* Zürich: SIK, and Lausanne: Editions d'en bas, 1983.

Gamboni 1989
Gamboni, Dario, *La plume et le pinceau. Odilon Redon et la littérature,* Paris: Éditions de minuit, 1989.

Gamboni 1992
Gamboni, Dario, 'La dernière demeure de Vincenzo Vela', in: *Unsere Kunstdenkmäler,* 43, 1992, pp. 523-538.

Gamboni 1997
Gamboni, Dario, *The Destruction of Art. Iconoclasm and Vandalism since the French Revolution,* London: Reaktion Books, 1997.

Garb 1989
Garb, Tamar, 'Revising the Revisionists: The Formation of the Union des Femmes Peintres et Sculpteurs', in: *Art Journal,* 48, 1989, pp. 63-70.

Garb 1993
Garb, Tamar, 'The Forbidden Gaze: Women Artists and the Male Nude in Late Eighteenth-Century France', in: *The Body Imaged. The Human Form and Visual Culture since the Renaissance,* ed. by Kathleen Adler and Marcia Pointon, Cambridge: Cambridge University Press, 1993, pp. 33-42.

Garb 1994
Garb, Tamar, *Sisters of the Brush. Women's Artistic Culture in Late Nineteenth-Century Paris,* New Haven and London: Yale University Press, 1994.

Garms 1992
Garms, Jörg, 'Léopold Robert e il suo grande ciclo italiano', in: *Ricerche di Storia dell'Arte,* no. 46, 1992, pp. 15-33.

Gassier 1983
Gassier, Pierre, *Léopold Robert,* Neuenburg: Ides et Calendes, 1983.

Gauguin 1923
Gauguin, Paul, *Avant et après,* Paris: Crès, 1924.

Gauguin 1946
Gauguin, Paul, *Lettres à sa femme et à ses amis,* ed. by Maurice Malingue, Paris: B. Grasset, 1946.

Gauguin 1950
Gauguin, Paul, *Lettres à Daniel de Monfreid,* ed. by Mme Joly-Segalen, Paris: G. Falaize, 1950.

Gauguin 1954
Gauguin, Paul, *Lettres de Paul Gauguin à Émile Bernard,* ed. by Pierre Cailler, Genf: P. Cailler, 1954.

Gauguin 1983
Gauguin, Paul, *45 Lettres à Vincent, Theo et Jo van Gogh,* ed. by Douglas Cooper, s'Gravenhage: Staatsuitgeverij, and Lausanne: La Bibliothèque des Arts, 1983.

Gauguin Catalogue 1989
Gauguin. Exh. cat. Paris, Washington, D.C. and Chicago 1988/89, Paris, Grand Palais 1989, Paris: RMN, 1989.

Gautier 1835 (1966)
Gautier, Théophile, *Mademoiselle de Maupin,* 2 vols, Paris 1835-36; new edn, ed. by Adolphe Boschot, Paris: Garnier, 1966.

Gautier 1864 (1929)
Gautier, Théophile, 'Eugène Delacroix', in: *Moniteur,* 18th of November 1864; Reprint in: *Critique artistique et littéraire*, ed. by Ferdinand Gohin and Roger Tisserand, Paris: Larousse, 1929, pp. 61-71.

Gautier 1994
Gautier, Théophile, *Critique d'Art. Extraits des Salons (1833-1872),* ed. by Marie-Hélène Girard, Paris: Séguier, 1994.

Gavarni/Granville 1868
Gavarni and Grandville, *Le diable à Paris. Paris et les parisiens à la plume et au crayon,* 3 vols, Paris: J. Hetzel, 1868.

Gay 1993 (1996)
Gay, Peter, *The Cultivation of Hatred* (The Bourgeois Experience, Victoria to Freud, vol. 3), New York: Norton, 1993; German: *Kult der Gewalt. Aggressionen im bürgerlichen Zeitalter,*

trans. M. Noll, R. Schubert, U. Enderwitz, Munich: Beck, 1996.

Gehlen 1960
Gehlen, Arnold, *Zeit-Bilder: zur Soziologie und Ästhetik der modernen Malerei*, Frankfurt/M: Athenäum, 1960.

Geisel 1990
Geisel, Beatrix, 'Von der namenlosen Genialität der Frau', in: *Kunstforum*, 106, March/April 1990, pp. 138-141; First edn in: Ines Linder, Sigrid Schade, Silke Wenk, Gabriele Werner (Ed.), *Blick-Wechsel. Konstruktionen von Männlichkeit und Weiblichkeit in Kunst und Kunstgeschichte*, Berlin: Reimer, 1989, pp. 187-197.

George 1948
George, Eric B., *The Life and Death of Benjamin Robert Haydon*, London and New York: Oxford University Press, 1948.

Georgel/Lecoq 1983
Georgel, Pierre and Lecoq, Anne-Marie, *La peinture dans la peinture*. Exh. cat. Dijon 1983, Dijon: Musée des Beaux-Arts, 1983.

Géricault Catalogue 1991
Géricault. Exh. cat. Paris 1991/92, ed. by Sylvain Laveissière and Régis Michel, Paris: RMN, 1991.

Gerlach-Laxner 1980
Gerlach-Laxner, Ute, *Hans von Marées. Katalog seiner Gemälde*, Munich: Prestel, 1980.

Germann 1980
Germann, Georg, 'Der farbige Architekturentwurf', in: *Von Farbe und Farben. Albert Knoepfli zum 70. Geburtstag*, Zürich: Manesse, 1980, pp. 187-191.

Germer 1992 (1)
Germer, Stefan, 'Documenta als anachronistisches Ritual', in: *Texte zur Kunst*, 2, 6, 1992, pp. 49-63.

Germer 1992 (2)
Germer, Stefan, 'In Search of a Beholder: On the Relation between Art, Audiences, and Social Spheres in Post-Thermidor France', in: *AB*, 74, 1992, pp. 19-36.

Germer/Kohle 1991
Germer, Stefan and Kohle, Hubertus, 'Spontanität und Rekonstruktion. Zur Rolle, Organisationsform und Leistung der Kunstkritik im Spannungsfeld von Kunsttheorie und Kunstgeschichte', in: Kunsttheorie 1991, pp. 287-311.

Gesamtkunstwerk 1983
Der Hang zum Gesamtkunstwerk. Europäische Utopien seit 1800. Exh. cat. Zürich, Düsseldorf and Vienna 1983, Aarau and Frankfurt/M: Sauerländer, 1983.

Gieseke/Markert 1996
Gieseke, Frank and Markert, Albert, *Flieger, Filz und Vaterland. Eine erweiterte Beuys Bio-graphie*, Berlin: Elefanten Press, 1996.

Goethe 1949-60
Goethe, Johann Wolfgang, *Werke*, 14 vols, ed. by Erich Trunz [a.a.], Hamburg: Wegner, 1949-60.

Goethe 1954
Goethe, Johann Wolfgang, *Gedenkausgabe der Werke, Briefe und Gespräche*, vol. 13: Schriften zur Kunst, ed. by Ernst Beutler, Zürich: Artemis, 1954.

Gogh 1965-68
Gogh, Vincent van, *Sämtliche Briefe*, 6 vols, ed. by Fritz Erpel, trans. Eva Schumann, Berlin: Henschel, 1965-68.

Gogh Catalogue 1984
Van Gogh in Arles. Exh. cat. New York 1984, ed. by Ronald Pickvance, New York: Harry N. Abrams and Metropolitan Museum of Art, 1984.

Gohr 1975
Gohr, Siegfried, *Der Kult des Künstlers und der Kunst im 19. Jahrhundert. Zum Bildtyp des Hommage*, Cologne and Vienna: Böhlau, 1975.

Gohr 1979
Gohr, Siegfried, 'Symbolische Grundlagen der Kunst Paul Klees', in: *Paul Klee. Das Werk der Jahre 1919-1933: Gemälde, Handzeichnungen, Druckgraphik*. Exh. cat. Cologne 1979, Cologne: Kunsthalle, 1979, pp. 81-83.

Goldscheider 1989
Goldscheider, Cécile, *Auguste Rodin. Catalogue raisonné de l'oeuvre sculpté. Tome I: 1840-1886*, Lausanne and Paris: Wildenstein Institute, Bibliothèque des Arts, 1989.

Goldwater 1938 (1967)
Goldwater, Robert, *Primitivism in Modern Painting*, New York and London: Harper and Brothers, 1938; enlarged edn: *Primitivism in Modern Art*, New York: Random House, 1967.

Golzio 1968
Golzio, Vincenzo, 'La fortuna critica di Raffaello', in: *Raffaello. L'Opera, le fonti, la fortuna*, 2 vols, ed. by Mario Salmi, Novara: Istituto geografico De Agostini, 1968.

Graber 1941
Graber, Hans (Ed.), *Edouard Manet nach eigenen und fremden Zeugnissen*, Basel: B. Schwabe, 1941.

Gramaccini 1993
Gramaccini Gisela, *Jean-Guillaume Moitte (1746-1810). Leben und Werk*, 2 vols, Berlin: Akademie Verlag, 1993.

Grandville 1844
Grandville, *Un autre monde*, Paris: Fournier, 1844.

Grasskamp 1986
Grasskamp, Walter, 'Raumbilder', in: *Deutsche*

Kunst im 20. Jahrhundert. Malerei und Plastik 1905-1985. Exh. cat. Stuttgart 1986, ed. by Ch.M. Joachimides, N. Rosenthal, W. Schmied, Munich: Prestel, 1986, pp. 125-133.

Grasskamp 1987
Grasskamp, Walter, 'Die unbewältigte Moderne: "Entartete Kunst" und documenta I', in: Museum der Gegenwart - Kunst in öffentlichen Sammlungen bis 1937. Exh. cat. Düsseldorf 1987, Düsseldorf: Kunstsammlung Nordrhein-Westfalen, 1987, pp. 13-24.

Grasskamp 1989
Grasskamp, Walter, Die unbewältigte Moderne. Kunst und Öffentlichkeit, Munich: Beck, 1989.

Graulich 1989
Graulich, Gerhard, Die leibliche Selbsterfahrung des Rezipienten - ein Thema transmodernen Kunstwollens (Kunst, Geschichte und Theorie, vol. 13), Essen: Die Blaue Eule, 1989.

Graves 1907 (1969)
Graves, Algernon, The Society of Artists of Great Britain 1760-1791. The Free Society of Artists 1761-1783. A Complete Dictionary of Contributors and their Work from the Foundation of the Societies to 1791, London 1907, Reprint Bath: Kingsmead Reprints, 1969.

Graves 1908
Graves, Algernon, The British Institution 1806-1867. Complete Dictionary of Contributors and Their Work, London: G. Bell and Sons, 1908.

Green 1782
Green, Valentine, A Review of the Polite Arts in France at the Time of their Establishment under Louis the XIVth. Compared with their State in England … , London: Cadell, 1782.

Griener 1989
Griener, Pascal, The Function of Beauty. The Philosophes and the Social Dimension of Art in Late Eighteenth Century France, with particular regard to Sculpture (Ph. Dissertation, Oxford 1989), unpublished.

Griener 1994
Griener, Pascal, ' "un genre qu'on ne connaît pas encore...". Léopold Robert et l'élévation du genre sous la monarchie du Juillet', in: Kunst und Architektur in der Schweiz, 45, 1994, pp. 346-353.

Groblewski 1993
Groblewski, Michael, ' "... eine Art Ikonographie im Bilde." Joseph Beuys - Von der Kunstfigur zur Kultfigur?', in: Bätschmann/Groblewski 1993, pp. 37-68.

Gropius 1988
Walter Gropius, ed. by Hartmut Propst and Christian Schädlich, 3 vols, Berlin: Ernst & Sohn, 1988.

Grunchec 1983
Grunchec, Philippe, Le grand prix de peinture.

Les concours des prix de Rome 1747-1863, Paris: École nationale supérieure des Beaux-Arts, 1983.

Grunchec 1984
Grunchec, Philippe, Le Grand Prix de Rome. Paintings from the Ecole des Beaux-Arts 1797-1863. Exh. cat. Washington, D.C. and Paris 1984, Washington, D.C.: International Exhibitions Foundation, 1984.

Grunchec 1986
Grunchec, Philippe, Les concours d'esquisses peintes 1816-1863. Exh. cat. Paris 1986, Paris: École nationale supérieure des Beaux-Arts, 1986.

Guiffrey 1872
Guiffrey, Jules-Joseph, Livrets des expositions de l'Académie de Saint-Luc à Paris pendant les années 1751, 1752, 1753, 1756, 1762, 1764 et 1774, avec une notice bibliographique et une table, Paris: Baur et Détaille, 1872.

Guiffrey 1873
Guiffrey, Jules-Joseph (Ed.), Notes et documents inédits sur les expositions du XVIIIe siècle, Paris: J. Baur, 1873.

Guiffrey 1915
Guiffrey, Jules, Histoire de l'Académie de Saint-Luc (Archives de l'art français, nouv. période, t. IX), Paris: E. Champion, 1915.

Guilbaut 1983
Guilbaut, Serge, How New York Stole the Idea of Modern Art. Abstract Expressionism, Freedom and the Cold War, Chicago and London: University of Chicago Press, 1983.

Habermas 1962 (1971)
Habermas, Jürgen, Strukturwandel der Öffentlichkeit: Untersuchungen zu einer Kategorie der bürgerlichen Gesellschaft, Neuwied and Berlin: Luchterhand, 1962; 5th edn 1971.

Habermas 1985
Habermas, Jürgen, Der philosophische Diskurs der Moderne, Frankfurt/M: Suhrkamp, 1985.

Haftmann 1954
Haftmann, Werner, Malerei im 20. Jahrhundert, Munich: Prestel, 1954.

Hager 1989
Hager, Werner, Geschichte in Bildern. Studien zur Historienmalerei des 19. Jahrhunderts, Hildesheim: Olms, 1989.

Hamilton 1954
Hamilton, George Heard, Manet and his Critics, New Haven: Yale University Press, 1954.

Hamilton 1977
Hamilton, George Heard, 'Cézanne and His Critics', in: Cézanne. The Late Works, ed. by William Rubin, New York: Museum of Modern Art, 1977, pp. 139-149.

Hamon 1993

Hamon, Philippe, 'Le topos de l'atelier', in: Démoris 1993, pp. 125-144.

Happening & Fluxus 1970
Happening & Fluxus: Materialien. Exh. cat. Cologne 1970/71, ed. by Hans Sohm, Cologne: Kölnischer Kunstverein, 1970.

Hargrove 1990
Hargrove, June (Ed.), The French Academy. Classicism and its Antagonists, Newark: University of Delaware Press, and London and Toronto: Associated University Presses, 1990.

Harlan 1976
Harlan, Volker, Rappmann, Rainer and Peter Schata, Soziale Plastik. Materialien zu Joseph Beuys, Achberg: Achberger Verlagsanstalt, 1976.

Harnoncourt 1948
Harnoncourt, René de, 'Challenge and Promise: Modern Art and Society', in: Magazine of Art, 41, November 1948, pp. 251-252.

Harris/Nochlin 1976
Harris, Ann Sutherland and Nochlin, Linda (Ed.), Women Artists: 1550-1950. Exh. cat. Los Angeles, Austin, Pittsburgh and New York, 1976/77, New York: Alfred A. Knopf 1977.

Haskell 1963
Haskell, Francis, Patrons and Painters. A Study in the Relations Between Italian Art and Society in the Age of the Baroque, London: Chatto & Windus, 1963.

Haskell 1971 (1978)
Haskell, Francis, 'The Old Masters in 19th Century French Painting', in: Art Quaterly, 34, 1971, pp. 55-85; and in: Francis Haskell, Past and Present in Art and Taste. Selected Essays, New Haven and London: Yale University Press, 1987, pp. 90-115.

Haskell 1972 (1978)
Haskell, Francis, 'The Sad Clown: Some Notes on a Nineteenth-Century Myth' [1972], in: Haskell, Past & Present in Art & Taste. Selected Essays, New Haven and London: Yale University Press, 1978, pp. 116-128.

Haskell 1981
Haskell, Francis (Ed.), Saloni, Gallerie, Musei (Atti del XXIV congresso internazionale di storia dell'arte, Bologna 1979, vol. 7), Bologna: Clueb, 1981.

Haskell/Penny 1981
Haskell, Francis and Penny, Nicholas, Taste and the Antique: the Lure of Classical Sculpture 1500-1900, New Haven and London: Yale University Press, 1981.

Hauchecorne 1783
Hauchecorne, l'Abbé, Vie de Michel-Ange Buonarroti, peintre, sculpteur et architecte de Florence, Paris: L. Cellot, 1783.

Hausenstein 1914
Hausenstein, Wilhelm, Vom Künstler und seiner Seele. Vier Vorträge gehalten in der Akademie für Jedermann in Mannheim, Heidelberg: R. Weissbach, 1914.

Haverkamp-Begemann/Logan 1988
Haverkamp-Begemann, Egbert and Logan, Carolyn, Creative Copies. Interpretative Drawings from Michelangelo to Picasso, London: Sotheby, 1988.

Heckel 1927
Heckel, Hans, 'Die Gestalt des Künstlers in der Romantik', in: Literaturwissenschaftliches Jahrbuch der Görres Gesellschaft, 2, 1927, pp. 50-83.

Hegel
Hegel, Georg Wilhelm Friedrich, Aesthetik, Preface by Georg Lukács, ed. by Friedrich Bassenge, 2 vols, Frankfurt/M: Europäische Verlagsanstalt, no year.

Hegel 1966
Hegel, Georg Wilhelm Friedrich, Vorlesungen über die Philosophie der Religion, vol. 1: Begriff der Religion, ed. by G. Lasson, Hamburg: Meiner, 2nd edn 1966.

Heim/Béraud/Heim 1989
Heim, Jean-François, Béraud, Claire, Heim, Philippe, Les Salons de peinture de la Révolution française 1789-1799, Paris: C.A.C. Sarl. Édition, 1989.

Heinecken 1782
[Friedrich von Heinecken], Abrégé de la vie des peintres, dont les tableaux composent la galerie électorale de Dresde. Avec le détail de tous les Tableaux de cette Collection & des Eclaircissements historiques sur ces Chefs-d'oeuvres de la Peinture, Dresden: Walther, 1782.

Heinich 1986
Heinich, Nathalie, La gloire de van Gogh. Essai d'anthropologie de l'admiration, Paris: Minuit, 1986.

Heinich 1993
Heinich, Nathalie, Du peintre à l'artiste: artisans et académiciens à l'âge classique, Paris: Minuit, 1993.

Heinich 1995
Heinich, Nathalie, Harald Szeemann. Un cas singulier. Entretien, Paris: L'Échoppe, 1995.

Heinse 1787 (1911)
Heinse, Wilhelm, Ardinghello und die glückseeligen Inseln. Eine Italiänische Geschichte aus dem sechszehnten Jahrhundert, 2 vols, Lemgo: Meyersche Buchhandlung, 1787; new edn Leipzig: Insel, 1911.

Held 1963
Held, Julius S., 'The early appreciation of drawings', in: Studies in Western Art (Akten des 20. Internationalen Kongresses für Kunstgeschichte, New York 1961), 3 vols,

Princeton: Princeton University Press, 1963, vol. 3, pp. 72-95.

Herder 1775 (1994)
Herder, Johann Gottfried, *Ursachen des gesunknen Geschmacks bei den verschiedenen Völkern, da er geblühet* [1775], in: *Werke*, 10 vols, ed. by G. Arnold u.a., vol. 4: Schriften zu Philosophie, Literatur, Kunst und Altertum 1774-1787, Frankfurt/M: Deutscher Klassiker Verlag, 1994, pp. 109-148.

Herder 1877-1913
Herder, Johann Gottfried Herder, *Sämtliche Werke*, ed. by Bernhard Suphan, 33 vols, Berlin: Weidmann, 1877-1913.

Herding 1978
Herding, Klaus, 'Courbets Modernität im Spiegel der Karikatur', in: Courbet Catalogue 1978, pp. 502-521.

Herding 1984
Herding, Klaus (Ed.), *Realismus als Widerspruch. Die Wirklichkeit in Courbets Malerei*, 2nd revised edn, Frankfurt/M: Suhrkamp, 1984.

Herding 1985
Herding, Klaus, 'Décadence und Progrès als kunsttheoretische Begriffe bei Barrault, Baudelaire und Proudhon', in: *Wissenschaftliche Zeitschrift der Humboldt-Universität zu Berlin,* 34, 1985, pp, 35-54.

Herding 1986
Herding, Klaus, 'Fortschritt und Niedergang in der bildenden Kunst: Nachträge zu Barrault, Baudelaire und Proudhon', in: Wolfgang Drost (Ed.), *Fortschrittsglaube und Dekadenzbewusstsein im Europa des 19. Jahrhunderts. Literatur, Kunst, Kulturgeschichte,* Heidelberg: C. Winter, 1986, pp. 239-258.

Herding 1991
Herding, Klaus, ' "... Woran meine ganze Seele Wonne gesogen...". Das Galerieerlebnis - eine verlorene Dimension der Kunstgeschichte?', in: Kunsttheorie 1991, pp. 257-286.

Hess 1969
Hess, Thomas B., *Barnett Newman*, New York: Walker, 1969.

Heusinger von Waldegg 1989
Heusinger von Waldegg, Joachim, 'James Ensor: "Selbstbildnis mit Staffelei" (1890), eine Allégorie réelle', in: *Wallraf-Richartz-Jahrbuch,* 50, 1989, pp. 251-269.

Hevesi 1906 (1984)
Hevesi, Ludwig, *Acht Jahre Sezession/März 1897-Juni 1905): Kritik, Polemik, Chronik,* Vienna: C. Konegen, 1906; Reprint: ed. by Otto Breicha, Klagenfurt: Ritter, 1984.

High and Low 1990
High and Low: Moderne Kunst und Trivialkultur. Exh. cat. New York, Chicago, Los Angeles 1990/91, ed. by Kirk Varnedoe and

Adam Gopnik, trans. Bram Opstelten and Magda Moses, Munich: Prestel, 1990.

Hinz 1971
Hinz, Berthold, *Dürers Gloria. Kunst, Kultur, Konsum,* Berlin: Mann, 1971.

Historienmalerei 1988
Triumph und Tod des Helden. Europäische Historienmalerei von Rubens bis Manet. Exh. cat. Cologne, Zürich and Lyon 1988, ed. by Ekkehard Mai and Anke Repp-Eckert, Milan: Electa, 1988.

Historienmalerei 1990
Historienmalerei in Europa. Paradigmen in Form, Funktion und Ideologie, ed. by Ekkehard Mai and Anke Repp-Eckert, Mainz: Ph. v. Zabern, 1990.

Hoehme 1974
Hoehme, Gerhard, 'Die Isolation ist dein Aug' und dein Schatten. Ein Künstler über den Künstler', in: *Künstler und Gesellschaft,* 1974, pp. 182-196.

Hoeyen 1837
Hoeyen, Niels Lauritz, *Om Thorvaldsen og hans Museum, i Anlednning af den udstedte Indbeldse,* Kopenhagen, 1837.

Hoffmann 1908-28
Hoffmann, E.T.A., 'Die Jesuiterkirche in G.', in: *Historisch-kritische Gesamtausgabe,* ed. by Carl Georg von Maassen, Munich and Leipzig: G. Müller, 1908-28, vol. 3, pp. 104-135.

Hofmann 1954 (1979)
Hofmann, Werner, 'Zu einem Bildmittel Edvard Munchs', in: *Alte und Neue Kunst. Wiener Kunstwissenschaftliche Blätter,* vol. 3, 1954, pp. 20-40; Reprint in: *Bruchlinien,* Munich: Prestel, 1979, pp. 111-127.

Hofmann 1960 (1974)
Hofmann, Werner, *Das irdische Paradies: Motive und Ideen des 19. Jahrhunderts,* Munich: Prestel, 1960; 2nd edn 1974.

Hofmann 1977
Hofmann, Werner, 'D'une alinéation à l'autre. L'artiste allemand et son public au XIXe siècle', in: *GBA,* 119, 1977, pp. 124-136; German: 'Entfremdungen', in: *Bruchlinien. Aufsätze zur Kunst des 19. Jahrhunderts,* Munich: Prestel, 1979, pp. 214-231

Hofmann 1982
Hofmann, Werner, 'Der Künstler als Kunstwerk', in: *Jahrbuch der Deutschen Akademie für Sprache und Dichtung,* 1982, pp. 50-65.

Hofmann 1986
Hofmann, Werner, 'Réflexions sur "l'Iconisation" à propos des "Demoiselles d'Avignon" ', in: *Revue de l'Art,* no. 71, 1986, pp. 33-42.

Hofmannsthal 1982
Hofmannsthal, Hugo von, *Sämtliche Werke, kri-*

tische Ausgabe, vol. 3: Dramen 1, ed. by Götz E. Hübner, Klaus-Gerhard Pott and Christoph Michel, Frankfurt/M: S. Fischer, 1982.

Hohl 1982
Hohl, Reinhard, 'Paul Klees Zwischenreich', in: *Sich selbst erkennen. Modelle der Introspektion*, ed. by Th. Wagner-Simon and G. Benedetti, Göttingen: Vandenhoeck & Ruprecht, 1982, pp. 142-153.

Holmström 1967
Holmström, Kirsten G., *Monodrama, Attitudes, Tableaux Vivants. Studies in some Trends of Theatrical Fashion* (Acta Universitatis Stockholmiensis. Stockholm Studies in Theatrical History, vol. 1), Stockholm: Almqvist & Wiksell, 1967.

Holt 1980
Holt, Elizabeth Gilmore (Ed.), *The Triumph of Art for the Public. The Emerging Role of Exhibitions and Critics*, Washington, D.C.: Decatur House Press, 1980.

Holt 1982
Holt, Elizabeth Gilmore (Ed.), *The Art of all Nations 1850-1873. The Emerging Role of Exhibitions and Critics*, Princeton N.J.: University Press, 1982.

Holt 1988
Holt, Elizabeth Gilmore (Ed.), *The Expanding World of Art 1874-1902. Universal Exhibitions and State-Sponsored Fine Arts Exhibitions*, vol. 1, New Haven and London: Yale University Press, 1988.

Home 1772
Home, Henry, *Elements of Criticism*, 3 vols, Edinburgh: A. Miller, London and A. Kincaid & Bell, 1762-65; German: *Grundsätze der Kritik*, trans. Joh. Nic. Meinhard, 2 vols, Leipzig: Dyckische Buchhandlung, 1772.

Hopfengart 1989
Hopfengart, Christine, *Klee. Vom Sonderfall zum Publikumsliebling. Stationen seiner öffentlichen Resonanz in Deutschland 1905-1960*, Mainz: Ph. von Zabern, 1989.

Horn Catalogue 1977
Rebecca Horn. Zeichnungen, Objekte, Fotos, Video, Filme. Exh. cat. Cologne and Berlin 1977, ed. by Rebecca Horn and Wulf Herzogenrath, Cologne: Kölnischer Kunstverein, 1977.

Horn Catalogue 1994
Rebecca Horn. Exh. cat. New York, Eindhoven, Berlin, Vienna, London 1993-5, Stuttgart: Cantz, 1994.

Horwitz 1979/80
Horwitz, Ira M., 'Whistler's Frames', in: *Art Journal*, 39, 1979/80, pp. 124-131.

Hüttinger 1985
Hüttinger, Eduard (Ed.), *Künstlerhäuser von der Renaissance bis zur Gegenwart*, Zürich: Waser, Munich: Prestel, 1985.

Hüttinger 1992
Hüttinger, Eduard (Ed.), *Case d'artista. Dal Rinascimento a oggi*, Preface by Salvatore Settis (Nuova Cultura, vol. 31), Turin: Bollati Boringhieri, 1992.

Hugo 1862 (1985)
Hugo, Victor, *Les misérables,* Paris: Paguerre, 1862, and in: *Oeuvres complètes*, ed. by Jacques Seebacher, 8 vols, Paris: Laffont, 1985, vol. 2.

Hultén 1967
Hultén, Pontus, *Jean Tinguely "Méta"*, Paris: P. Horay, 1967; engl.: *Jean Tinguely "Méta"*, London: Thames and Hudson, 1975.

Hultén 1996
Hultén, Pontus, *Das gedruckte Museum von Pontus Hultén: Kunstausstellungen und ihre Bücher*, ed. by Lutz Jahre, trans. Ursula Schmalbruch, Ostfildern-Ruit: Cantz, 1996.

Hutchison 1968 (1986)
Hutchison, Sidney C., *The History of the Royal Academy 1768-1968*, London: Chapman and Hall, 1968; 2nd edn London: R. Royce, 1986.

Hyde 1988
Hyde, Ralph, *Panoramania! The Art and Entertainment of the 'All-embracing' View*, London: Barbican Art Gallery and Trefoil Publications, 1988.

Imdahl 1989
Imdahl, Max, 'Barnett Newman: Who's afraid of red, yellow and blue III', in: Pries 1989, pp. 233-252.

Immendorff 1973
Immendorff, Jörg, *Hier und jetzt: Das tun, was zu tun ist: Materialien zur Diskussion, Kunst im politischen Kampf; auf welcher Seite stehst Du, Kulturschaffender?* Cologne and New York: König, 1973.

Impressionismus Catalogue 1974
Centennaire de l'impressionisme. Exh. cat. Paris 1974, Paris: RMN, 1974.

Indian Art 1941
Indian Art of the United States. Exh. cat. New York 1941, ed. by Frederic H. Douglas and René d'Harnoncourt, New York: Museum of Modern Art, 1941.

Ingres und Delacroix Catalogue 1986
Ingres und Delacroix. Aquarelle und Zeichnungen. Exh. cat. Tübingen and Brüssel 1986, Cologne: DuMont, 1986.

Irwin 1969
Irwin, David, 'Fuseli's Milton Gallery: Unpublished Letters', in: *BM*, 101, 1969, pp. 436-440.

Itten Katalog 1994
Das frühe Bauhaus und Johannes Itten. Exh. cat. Weimar, Berlin and Bern 1994/5, ed. by

Rolf Bothe, Peter Hahn and Hans Christoph von Tavel, Ostfildern: Gerd Hatje, 1994.

Jaffe 1977
Jaffe, Irma B., 'John Singleton Copley's *Watson and the Shark*', in: *The American Art Journal*, 9, 1977, pp. 15-25.

Jaffé 1967
Jaffé, Hans L.C., *Mondrian und De Stijl*, Cologne: DuMont, 1967.

Jal 1828
Jal, A., *Esquisses, Croquis, Pochades ou Tout ce qu'on Voudra sur le Salon de 1827*, Paris: Dupont, 1828.

Janson 1975
Janson, Horst W., 'The Myth of the Avant-Garde', in: *Art Studies for an Editor: 25 Essays in Memory of Milton S. Fox*, ed. by Friederich Hardt, New York: H. N. Abrams, 1975, pp. 167-175.

Jappe 1993
Jappe, Elisabeth, *Performance, Ritual, Prozess*, Munich: Prestel, 1993.

Javel 1889
Javel, Firmin, 'Les femmes peintres et sculpteurs', in: *L'Art français*, 2, no. 95 from February 16, 1889, pp. 1-2.

Jean/Meze 1959
Jean, Marcel and Meze, Arpad, *Histoire de la peinture surréaliste*, Paris: Editions du Seuil 1959.

Jeanneret-Gris/Ozenfant 1918
Jeanneret-Gris, Charles-Edouard and Ozenfant, Amédée, *Après le Cubisme*, Paris: Editions des Commentaires, 1918; Reprint: Turin: Bottega d'Erasmo, 1975.

Jedlicka 1958
Jedlicka, Gotthard, 'Ueber einige Selbstbildnisse von Edvard Munch', in: *Wallraf-Richartz-Jahrbuch*, 20, 1958, pp. 225-260.

Johnson 1954
Johnson, Lee, 'The *Raft of the Medusa* in Great Britain', in: *BM*, 96, 1954, pp. 249-252.

Johnson 1993
Johnson, Dorothy, *Jacques-Louis David. Art in Metamorphosis*, Princeton N.J.: Princeton University Press, 1993.

Jouin 1888
Jouin, Henri, *Musée des portraits d'artistes ... nés en France et y ayant vécu, état de 3000 portraits*, Paris: H. Laurens, 1888.

Jouval 1883
Jouval, Feo de, in: *Le Papillon*, 2, no. 47, March 11, 1883, p. 1.

Julian Academy 1989
The Julian Academy List of Students and Professors, 1869-1939. Exh. cat. New York 1989, ed. by Catherine Fehrer, New York: Shepherd Gallery, 1989.

Junod 1985
Junod, Philippe, '(Auto)portrait de l'artiste en Christ - Das (Selbst)portrait des Künstlers als Christus', in: *Das Selbstportrait im Zeitalter der Photographie. Maler und Photographen im Dialog mit sich selbst*. Exh. cat. Lausanne, Stuttgart, Berlin 1985, ed. by Erika Billeter, Bern: Benteli, 1985, pp. 59-79.

Junod 1994
Junod, Philippe, 'Du péché de la littérature chez les peintres: origine et portée d'un débat', in: *Annales d'Histoire de l'Art & d'Archéologie*, 16, 1994, pp. 109-127.

Justi 1956
Justi, Carl, *Winckelmann und seine Zeitgenossen*, 5th edn, ed. by Walther Rehm, 3 vols, Cologne: Phaidon, 1956.

Kabakov 1995 (1)
Kabakov, Ilya, *Über die "totale" Installation*, Ostfildern: Cantz, 1995.

Kabakov 1995 (2)
Ilya Kabakov. Installations 1983-1995. Exh. cat. "Ilya Kabakov: C'est ici que nous vivons" Paris, Paris: Centre Georges Pompidou, 1995.

Kaiser 1989/90
Kaiser, T.E., 'Rhetoric in the Service of the King: The Abbé Dubos and the Concept of Public Judgment', in: *Eighteenth-Century Studies*, 23, 1989/90, pp. 182-199.

Kallen 1942 (1969)
Kallen, Horace M., *Art and Freedom*, New York: Duell, Sloan and Pearce, 1942; 2nd edn New York: Greenwood Press, 1969.

Kamber 1990
Kamber, André (Ed.), *Stichworte zu einem sentimentalen Lexikon um Daniel Spoerri und um ihn herum*. Exh. cat. Paris, Antibes, Vienna, Munich, Genf and Solothurn 1990/91, Paris: Musée national d'art moderne, 1990.

Kandinsky 1912
Kandinsky, Wassily, *Ueber das Geistige in der Kunst*, Munich: Piper, 1912.

Kandinsky 1926
Kandinsky, Wassily, *Punkt und Linie zur Fläche. Beitrag zur Analyse der malerischen Elemente* (Bauhausbücher 9), Munich: A. Langen, 1926, 2nd edn 1928.

Kant 1790 (1968)
Kant, Immanuel, *Critik der Urtheilskraft*, Berlin and Libau: Lagarde and Friedrich, 1790; new edn, ed. by Karl Vorländer, Hamburg: Meiner, 1968.

Karl 1988
Karl, Frederick R., *Modern and Modernism. The Sovereignty of the Artist 1885-1925*, New York: Atheneum, 1988.

Karlsruhe Kunsthalle Katalog 1971
Kunsthalle Karlsruhe. Katalog Neuere Meister 19.

und 20. Jahrhundert, 2 vols, ed. by Jan Lauts and Werner Zimmermann, Karlsruhe: Staatliche Kunsthalle, 1971.

Kassák/Moholy-Nagy 1922
Buch neuer Künstler, ed. by Ludwig Kassák and Lazlo Moholy-Nagy, Vienna: Zeitschrift "MA", 1922; Reprint Baden: Lars Müller, 1991.

Katz 1983
Katz, Jane B., *Artists in Exile*, New York: Stein and Day, 1983.

Kauffmann 1988
Georg Kauffmann, *Die Macht des Bildes - Über die Ursachen der Bilderflut in der modernen Welt* (Rheinisch-Westfälische Akademie der Wissenschaften. Geisteswissenschaften, Vorträge G 295), Opladen: Westdeutscher Verlag, 1988.

Kellein 1995
Kellein, Thomas, *Pierrot. Melancholie und Maske,* Munich: Prestel, 1995.

Kemp 1983
Kemp, Wolfgang, *Der Anteil des Betrachters. Rezeptionsästhetische Studien zur Malerei des 19. Jahrhunderts,* Munich: Mäander, 1983.

Kemp 1989
Kemp, Wolfgang, 'Die Kunst des Schweigens', in: *Laokoon und kein Ende: Der Wettstreit der Künste* (Literatur und andere Künste, vol. 3), ed. by Thomas Koebner, Munich: Edition Text und Kritik, 1989, pp. 96-119.

Kemp 1992
Der Betrachter ist im Bild. Kunstwissenschaft und Rezeptionsästhetik, ed. by Wolfgang Kemp, Cologne: DuMont, 1985, new edn Berlin: Reimer, 1992.

Kemp 1993
Kemp, Wolfgang, 'Verstehen von Kunst im Zeitalter ihrer Institutionalisierung', in: *Bild der Ausstellung 1993*, pp. 54-60.

Kiesler Catalogue 1996
Frederick Kiesler, Artiste-architecte. Exh. cat. Paris 1996, Paris: Centre Georges Pompidou, 1996.

Klassizismus 1993
Schwäbischer Klassizismus zwischen Ideal und Wirklichkeit 1770-1830. Exh. cat. Stuttgart 1993, 2 vols, ed. by Christian von Holst, Stuttgart: Staatsgalerie, 1993.

Klee 1925
Klee, Paul, *Pädagogisches Skizzenbuch* (Bauhausbücher 2), Munich: A. Langen, 1925; Reprint Mainz and Berlin: F. Kupferberg, 1966.

Klee 1945
Klee, Paul, *Ueber die moderne Kunst,* Bern: Benteli, 1945; 2nd edn, 1979.

Klee 1979
Klee, Paul, *Beiträge zur bildnerischen Form-*

lehre. Faksimilierte Ausgabe des Originalmanuskripts von Paul Klees erstem Vortragszyklus am staatlichen Bauhaus Weimar 1921/22, ed. by Jürgen Glaesemer, 2 vols, Basel and Stuttgart: Schwabe, 1979.

Klee Catalogue 1986
Paul Klee Spätwerke 1937-1940. Exh. cat. Chur 1986, ed. by Marcel Baumgartner and Beat Stutzer, Chur: Kunstmuseum, 1986.

Klee Catalogue 1987
Paul Klee. Exh. cat. New York, Cleveland and Bern 1987, ed. by Carolyn Lanchner, New York: Museum of Modern Art, 1987.

Klein 1959
Klein, Yves, *Le dépassement de la problématique de l'art,* La Louvaine: Édition de Montbliard, 1959.

Klein Catalogue 1983
Yves Klein. Exh. cat. Paris 1983, Paris: Musée national d'art moderne, 1983.

Klein Catalogue 1994
Yves Klein. Exh. cat. Cologne and Düsseldorf 1994/95, Stuttgart: Cantz, 1994.

Kleist 1967
Kleists Aufsatz über das Marionettentheater. Studien und Interpretationen, epilogue ed. by Helmut Sembdner, Berlin: E. Schmid, 1967.

Klinger Katalog 1992
Max Klinger 1857-1920. Exh. cat. Frankfurt/M, Wuppertal and Leipzig 1992, ed. by Dieter Gleisberg, Frankfurt/M: Städel, 1992.

Klüser/Hegewisch 1992
Klüser, Bernd and Hegewisch, Katharina (Ed.), *Die Kunst der Ausstellung. Eine Dokumentation dreissig exemplarischer Kunstausstellungen dieses Jahrhunderts,* Frankfurt/M: Insel, 1992.

Klumpke 1908
Klumpke, Anna, *Rosa Bonheur, sa vie, son oeuvre,* Paris: Flammarion, 1908.

Kneher 1994
Kneher, Jan, *Edvard Munch in seinen Ausstellungen zwischen 1892 und 1912. Eine Dokumentation der Ausstellungen und Studie zur Rezeptionsgeschichte von Munchs Kunst* (Manuskripte zur Kunstwissenschaft, vol. 44) Worms: Wernersche Verlagsgesellschaft, 1994.

Knowles 1831
Knowles, John, *The Life and Writings of Henry Fuseli,* 3 vols, London: H. Colburn and R. Bentley, 1831.

Koch 1967
Koch, Georg Friedrich, *Die Kunstausstellung. Ihre Geschichte von den Anfängen bis zum Ausgang des 18. Jahrhunderts,* Berlin: de Gruyter, 1967.

Koch 1834 (1905)
Koch, Joseph Anton, *Moderne Kunstchronik,*

oder Die Rumfordische Suppe gekocht und geschrieben von Joseph Anton Koch in Rom, ed. by Ernst Jaffé, Innsbruck: Wagner'sche Universitäts-Buchhandlung, 1905.

Koch 1984
Koch, Joseph Anton, *Moderne Kunstchronik, Briefe zweier Freunde in Rom und der Tartarei über das moderne Kunstleben und Treiben; oder die Rumfordische Suppe, gekocht und geschrieben von Joseph Anton Koch in Rom*, ed. by Hilmar Frank, Hanau: Müller und Kiepenheuer, 1984.

Kodera/Rosenberg 1993
Kodera, Tsukasa and Rosenberg, Yvette (Ed.), *The Mythology of Vincent van Gogh*, Tokyo: Asahi Broadcasting, Amsterdam: J. Benjamins, 1993.

Körner/Steiner 1982
Körner, Hans and Steiner, Reinhard, ' "Plastische Selbstbestimmung"? Ein kritischer Versuch über Joseph Beuys', in: *Das Kunstwerk*, 35, June 1982, pp. 32-41.

Kotz 1990
Kotz, Mary Lynn, *Rauschenberg. Art and Life*, New York: Abrams, 1990.

Kramer 1991
Kramer, Mario, *Joseph Beuys. "Das Kapital Raum 1970-1977"*, Heidelberg: Edition Staeck, 1991.

Krell 1982
Krell, Alan, 'Manet, Zola and the "Motifs d'une exposition particulière" 1867', in: *GBA*, 124, 1982, pp. 109-115.

Kris/Kurz 1934
Kris, Ernst and Kurz, Otto, *Die Legende vom Künstler. Ein geschichtlicher Versuch*, Vienna: Krystall-Verlag, 1934; 2nd edn, Frankfurt/M: Suhrkamp, 1980; Engl. edn: *Legend, Myth, and Magic in the Image of the Artist. A historical Experiment*, Preface by E. H. Gombrich, New Haven and London: Yale University Press, 1979.

Künstler und Gesellschaft 1974
Künstler und Gesellschaft, ed. by A. Silbermann and R. König, in : *Kölner Zeitschrift für Soziologie und Sozialpsychologie*, Sonderheft 17, 1974, Cologne: Westdeutscher Verlag, 1974.

Kunstheorie 1991
Kunst und Kunsttheorie 1400-1900, ed. by Peter Ganz, Martin Gosebruch, Nikolaus Meier, Martin Warnke (Wolfenbütteler Forschungen, vol. 48), Wiesbaden: Harrassowitz, 1991.

Kuspit 1993
Kuspit, Donald, *The Cult of the Avant-Garde Artist*, Cambridge and New York: Cambridge University Press, 1993.

L'Esprit Nouveau 1987
L'Esprit Nouveau. Le Corbusier und die Industrie 1920-1925. Exh. cat. Zürich, Berlin and Strassburg, ed. by Stanislaus von Moos, Zürich: Museum für Gestaltung, 1987.

La Font de Saint-Yenne 1747
[La Font de Saint-Yenne] *Réflexions sur quelques Causes de l'État présent de la Peinture en France. Avec un examen des principaux Ouvrages exposés au Louvre le mois d'Août 1746*, Den Haag: Jean Neaulme, 1747; Reprint, Genf: Slatkine, 1970.

La Font de Saint-Yenne 1754
[La Font de Saint-Yenne], *Sentimens sur quelques ouvrages de peinture, sculpture et gravure écrits à un particulier en province*, s.l. 1754; Reprint, Genf: Slatkine, 1970.

La Roche 1791
La Roche, Sophie von, *Tagebuch einer Reise durch Holland und England*, Offenbach/M: Ulrich Weiss und Carl Ludwig Brede, 2nd edn 1791; 1st edn 1788.

Laban 1898
Laban, Ferdinand, 'Der Musaget Böcklins', in: *Pan*, 4, 1898, pp. 236-240.

Laborde 1856
Laborde, Léon de, *De l'union des arts et de l'industrie*, 2 vols, Paris: Imprimerie impériale, 1856.

Lacombe 1753
Lacombe, Jacques, *Le Salon de 1753*, Paris [ohne weitere Angaben].

Lagrange 1860
Lagrange, Léon, 'Du rang des femmes', in: *GBA*, 2, 1860 pp. 30-43.

Lami 1914-21
Lami, Stanislas, *Dictionnaire des sculpteurs de l'école française au dix-neuvième siècle*, 4 vols, Paris: E. Champion, 1914-1921.

Landon 1802
[Charles Paul Landon] 'Exposition de deux tableaux de David. Réflexions sur ce genre de spéculation', in: *Journal des Bâtimens civils, des monumens et des arts*, 4, no. 110, an X [1802], pp. 27-28.

Langen 1968
Langen, August, 'Attitüde und Tableau in der Goethe-Zeit', in: *Jahrbuch der deutschen Schillergesellschaft*, 12, 1968, pp. 194-258.

Langen 1978
Langen, August, *Gesammelte Studien zur neueren deutschen Sprache und Literatur*, Berlin: E. Schmidt, 1978.

Lapauze 1924
Lapauze, Henry, *Histoire de l'Académie de France à Rome*, 2 vols, Paris: Plon, 1924.

Laubriet 1961
Laubriet, Pierre, *Un catéchisme estétique. "Le Chef-d'oeuvre inconnu" de Balzac*, Paris: Didier, 1961.

Laverdant 1845
Laverdant, Désiré, 'De la mission de l'art et du rôle des artistes', in: *La Phalange. Revue de la science sociale*, I, 1845; special printing Paris: Bureaux de la Phalange, 1845.

Léger 1920
Léger, Charles, *Courbet selon les caricatures et les images*, Paris: Paul Rosenberg, 1920.

Legrand 1995
Legrand, Ruth, 'Livrets des salons: fonction et évolution', in: *GBA*, 137, pp. 237-248.

Leiris 1969
Leiris, Alain de, *The Drawings of Edouard Manet*, Berkeley and Los Angeles: University of California Press, 1969.

Lelièvre 1993
Lelièvre, Pierre, *Vivant Denon. Homme des lumières, "Ministre des Arts" de Napoléon*, Paris: Picard, 1993.

Lenbach Catalogue 1987
Franz von Lenbach 1836-1904. Exh. cat. Munich 1986/87, Munich: Städtische Galerie im Lenbachhaus, 1987.

Lenormant 1833
Lenormant, C., *Les Artistes Contemporains*, Paris: Mesnier, 1833.

Leonardo 1883 (1970)
Leonardo da Vinci, *The Literay Works,* ed. by Jean Paul Richter, 2 vols, London: Sampson Low, Marston, Searle & Rivington, 1883; new edn u.d.T. *The Notebooks,* 2 vols, New York: Dover, 1970.

Leonardo Catalogue 1990
Leonardo da Vinci, *Sämtliche Gemälde und die Schriften zur Malerei,* ed. by André Chastel, Munich: Schirmer and Mosel, 1990.

Lepage 1911
Lepage, Edouard, *Une conquête féministe: Mme Léon Bertaux,* Paris, 1911.

Lessing 1766
Lessing, Gotthold Ephraim, *Laokoon oder über die Grenzen der Malerei und Poesie*, Berlin: o.V., 1766.

Lessing 1880
Lessing, Gotthold Ephraim, *Laokoon,* 2nd revised and enlarged edn, ed. by Hugo Blümner, Berlin: Weidmannsche Buchhandlung, 1880, 1. Ausg. 1876.

Levey 1981
Levey, Michael, *The Painter Depicted Painters as a Subject in Painting*, London: Thames and Hudson, 1981.

Levitine 1975
Levitine, Georges, 'Les origines du Mythe de l'Artiste Bohème en France, Lantara', in: *GBA*, 118, 1975, pp. 49-60.

Lhotsky 1941
Lhotsky, Alphons, *Die Baugeschichte der Museen und der Neuen Burg,* Vienna: F. Berger, 1941.

Lichtenstein 1989
Lichtenstein, Jacqueline, *La couleur éloquente. Rhétorique et peinture à l'âge classique,* Paris: Flammarion, 1989.

Lichtenstein 1964
Lichtenstein, Sara, 'Cézanne and Delacroix', in: *AB*, 46, 1964, pp. 55-67.

Lindsay 1990
Lindsay, Suzanne G., 'Berthe Morisot: Nineteenth-Century Woman, as Professional', in: *Perspectives on Morisot,* ed. by Teri J. Edelstein, New York: Hudson Hills Press, 1990, pp. 79-90.

Lissitzky/Arp 1925
Die Kunstismen, ed. by El Lissitzky and Hans Arp, Erlenbach-Zürich, Munich and Leipzig: Eugen Rentsch Verlag, 1925; Reprint Baden: Lars Müller, 1990.

Lissitzky 1977
Lissitzky, El, *Proun und Wolkenbügel. Schriften, Briefe, Dokumente,* ed. by by Sophie Lissitzky-Küppers and Jen Lissitzky, Dresden: VEB Verlag der Kunst, 1977.

Lissitzky 1992
Lissitzky, El, *Erinnerungen, Briefe, Schriften,* ed. by Sophie Lissitzky-Küppers, 4th edn, Dresden: Verlag der Kunst, 1992.

Livingstone 1989
Livingstone, Marco, 'Do It Yourself: Anmerkungen zu Warhols Arbeitstechniken', in: Warhol Katalog 1989, pp. 59-74.

Loers 1993
Loers, Veit (Ed.), *Joseph Beuys, documenta-Arbeit.* Exh. cat. Kassel 1993, Stuttgart: Cantz, 1993.

Lotringer 1989
Lotringer, Sylvère, 'Vito Acconci. House Trap', in: *Flash Art*, 147, 1989, pp. 124-128.

Luckhurst 1951
Luckhurst, Kenneth W., *The Story of Exhibitions,* London and New York: Studio Publications, 1951.

Luhmann 1984
Luhmann, Niklas, *Soziale Systeme. Grundriss einer allgemeinen Theorie,* Frankfurt/M: Suhrkamp, 1984.

Luhmann 1995
Luhmann, Niklas, *Die Kunst der Gesellschaft,* Frankfurt/M: Suhrkamp, 1995.

Lutterotti 1985
Lutterotti, Otto R. von, *Joseph Anton Koch, 1768-1839: Leben und Werk: mit einem vollständigen Werkverzeichnis,* Vienna: Graphische Sammlung Albertina, 1985.

Maag 1986
Maag, Georg, *Kunst und Industrie im Zeitalter der ersten Weltausstellungen. Synchronische Ana-*

lyse einer Epochenschwelle (Theorie und Geschichte der Literatur und der Schönen Künste, vol. 74), Munich: Fink, 1986.

Macandrew 1959/60
Macandrew, Hugh, 'Henry Fuseli and William Roscoe', in: Liverpool Libraries, Museums & Arts Committee Bulletin, 8, 1959/60, pp. 5-52.

Märten 1919 (1990)
Märten, Lu, Die Künstlerin (Kleine Monographien zur Frauenfrage, vol. 2), Munich: A. Langen, 1919; new edn: Lu Märten, Die Künstlerin. Texte zur Ästhetik und Kultur der Frau, ed. by Chryssoula Kambas, Darmstadt and Neuwied: Luchterhand, 1990.

Mahler-Werfel 1940 (1971)
Mahler-Werfel, Alma, Gustav Mahler: Erinnerungen und Briefe, Amsterdam: Allert de Lange, 1940; new edn title Erinnerungen an Gustav Mahler - Briefe an Alma Mahler, ed. by Donald Mitchell, Frankfurt/M and Berlin: Ullstein, 1971.

Mai 1986
Mai, Ekkehard, Expositionen. Geschichte und Kritik des Ausstellungswesens, Munich and Berlin: Deutscher Kunstverlag, 1986.

Mai 1986/87
Mai, Ekkehard, 'Die Berliner Kunstakademie zwischen Hof und Staatsaufgabe 1696-1830. Institutionsgeschichte im Abriss', in: Leids Kunsthistorisch Jaarboek, V-VI, 1986-1987, pp. 320-329.

Mainardi 1987
Mainardi, Patricia, Art and Politics of the Second Empire. The Universal Expositions of 1855 and 1867, New Haven and London: Yale University Press, 1987.

Mainardi 1988
Mainardi, Patricia, 'The Eviction of the Salon from the Louvre', in: GBA, 130, 1988, pp. 31-40.

Mainardi 1991
Mainardi, Patricia, 'Courbet's Exhibitionism', in: GBA, 133, 1991, pp. 253-266.

Mainardi 1993
Mainardi, Patricia, The End of the Salon. Art and the State of the Early Third Republic, Cambridge and New York: Cambridge University Press, 1993.

Malevich 1927 (1980)
Malewitsch, Kasimir, Die gegenstandslose Welt (Bauhausbücher 11), Munich: A. Langen, 1927; Nachdruck Mainz and Berlin: F. Kupferberg, 1980.

Mallarmé 1876 (1986)
Mallarmé, Stéphane, 'The Impressionists and Edouard Manet', in: The Art Monthly Review, 1, no. 9, September 30, 1876, pp. 117-122,

Reprint in: Carl Paul Barbier, Documents Stéphane Mallarmé, 7 vols, Paris: Nizet, 1968-80, vol. 1, pp. 66-86, and in: New Painting 1986, pp. 27-35.

Manet Catalogue 1867
Manet, Edouard, Catalogue des Tableaux de M. Edouard Manet exposés Avenue de l'Alma en 1867, Paris: Imprimerie L. Poupart-Davyl, 1867.

Manet Catalogue 1884
Exposition des Oeuvres de Edouard Manet. Exh. cat. Paris 1884, Preface by Emile Zola, Paris: A. Quantin, 1884.

Manet Catalogue 1981
Edouard Manet and the 'Execution of Maximilian'. Exh. cat. Providence 1981, Providence, RI: Brown University, 1981.

Manet Catalogue 1982
Manet and Modern Paris. Exh. cat. Washington, D.C. 1982/83, ed. by Theodore Reff, Chicago: University Press, 1982.

Manet Catalogue 1983
Manet 1832-1883, Exh. cat. Paris 1983, Paris: RMN, 1983.

Manet Catalogue 1992
Edouard Manet. Augenblicke der Geschichte. Exh. cat. Mannheim 1992/93, ed. by Manfred Fath and Stefan Germer, Munich: Prestel, 1992.

Marchwinski 1987
Marchwinski, Alena, 'The Romantic Suicide and the Artists', in: GBA, 129, 1987, pp. 62-74.

Marées Catalogue 1987
Hans von Marées. Exh. cat. Munich 1987/88, Munich: Prestel, 1987.

Marin 1993
Louis Marin, Des pouvoirs de l'image. Gloses, Paris: Éditions du Seuil, 1993.

Marx 1904
Marx, Roger, 'Le salon d'automne', in: GBA, 46/2, 1904, pp. 458-474.

Mattenklott 1984
Mattenklott, Gert, 'Die neue Kunst und ihr Publikum. Rezeptionsweisen einer erweiterten Oeffentlichkeit', in: Ideal und Wirklichkeit der bildenden Kunst im späten 18. Jahrhundert, ed. by Herbert Beck u.a., Berlin: Mann, 1984, pp. 31-43.

Matthew 1822
Matthew, Heinrich, Tagebuch eines Invaliden auf einer Reise durch Portugal, Italien, die Schweiz und Frankreich in den Jahren 1817, 1818 und 1819, trans. Friedrich Schott, 2 vols, Dresden: Hilscher, 1822.

Mazzocca 1979
Mazzocca, Fernando, 'Canova e Wicar', in: Florence et la France, Actes du Colloque 1977, Florence: Centro Di, and Paris: Editart, 1979,

pp. 399-436.

McCausland 1946
McCausland, Elizabeth, 'Why can't America afford Art?', in: *Magazine of Art,* 39, January 1946, pp. 18-21.

McClellan 1984
McClellan, Andrew L., 'The Politics and Aesthetics of Display: Museums in Paris 1750-1800', in: *Art History,* 7, 1984, pp. 438-464.

McClellan 1994
McClellan, Andrew, *Inventing the Louvre. Art, Politics, and the Origins of the Modern Museum in Eighteenth-Century Paris,* Cambridge, New York, Melbourne: Press Syncicate of the University of Cambridge, 1994.

McWilliam 1991
McWilliam, Neil (Ed.), *A Bibliography of Salon Criticism in Paris from the Ancien Régime to the Restoration, 1699-1827,* Cambridge and New York: Cambridge University Press, 1991.

McWilliam/Schuster/Wrigley 1991
McWilliam, Neil, Schuster, Vera and Wrigley, Richard, *A Bibliography of salon criticism in Paris from the Ancien Régime to the Restoration, 1699-1827,* Cambridge: Cambridge University Press, 1991.

Meier-Graefe 1904
Meier-Graefe, Julius, *Entwicklungsgeschichte der modernen Kunst,* 3 vols, Stuttgart: J. Hoffmann, 1904; new edn, 2 vols, Munich and Zürich: Piper, 1987.

Meier-Graefe 1905
Meier-Graefe, Alfred Julius, *Der Fall Böcklin und die Lehre von den Einheiten,* Stuttgart: J. Hoffmann, 1905.

Meier-Graefe 1909-10
Meier-Graefe, Julius, *Hans von Marées. Sein Leben und sein Werk,* 3 vols, Munich and Leipzig: Piper, 1909-10.

Meister französischer Malerei 1948
Die Meister französischer Malerei der Gegenwart. Exh. cat. Freiburg i.Br. 1947, ed. by Maurice Jardot and Kurt Martin, Baden-Baden: W. Klein, 1948.

Menschenbild in unserer Zeit 1950
Das Menschenbild in unserer Zeit (Darmstädter Gespräch I), ed. by Hans Gerhard Evers, Darmstadt: Neue Darmstädter Verlagsanstalt, 1950.

Menzel 1834
Menzel, Adolph, *Künstlers Erdenwallen,* Berlin: L.Sachse, 1834.

Mercier 1787
[Louis-Sébastien Mercier] *L'An deux mille quatre cent quarante. Rêve s'il en fût jamais,* Nouvelle édition avec Figures, 3 vols, s.l., 1787

Merrill 1992

Merrill, Linda, *A Pot of Paint. Aesthetics on Trial in Whistler v. Ruskin,* Washington and London: Smithsonian Institution Press, 1992.

Meyer 1886
Meyer, Heinrich, *Kleine Schriften zur Kunst,* Heilbronn: Henninger, 1886.

Meyer 1971
Meyer, Reinhold, 'The Naming of Pygmalion's animated Statue', in: *Classical Journal,* 66, 1971, pp. 316-319.

Michaud 1989
Michaud, Yves, *L'artiste et les commissaires. Quatre essais non pas sur l'art contemporain mais sur ceux qui s'en occupent,* Paris: J. Chambon, 1989.

Michel 1986
Michel, Bernard, 'Les mécènes de la Sécession', in: *Vienne 1880-1938. L'Apocalypse joyeuse.* Exh. cat. Paris 1986, Paris: Centre Pompidou and Spadem, 1986.

Michelet 1867
Michelet, Jules, *Histoire de France au dix-huitième siècle. La Régence,* in: *Histoire de France,* 17 vols, Paris: Hachette, Chamerot and Lauwereyns, 1833-67, vol. 15, 1867.

Milizia 1781
Milizia, Francesco, *Dell'arte di vedere nelle belle arti del disegno secondo i principii di Sulzer e di Mengs,* Venice: Giambatista Paquali, 1781.

Miller 1972
Miller, Norbert, 'Mutmassungen über lebende Bilder, Attitüde und "tableau-vivant" als Anschauungsformen des 19. Jahrhunderts', in: *Das Triviale in Literatur, Musik und bildender Kunst,* ed. by Helga de la Motte-Haber, Frankfurt/M: Klostermann, 1972, pp. 106-130.

Milner 1990
Milner, John, *The Studios of Paris. The Capital of Art in the Late Nineteenth Century,* New Haven and London: Yale University Press, 1988.

Milner 1996
Milner, John, *Kazimir Malevich and the Art of Geometry,* New Haven and London: Yale University Press, 1996.

Miss 1992
Miss, Stig, 'Das Thorvaldsen Museum', in: Thorvaldsen Catalogue 1992, pp. 341-354.

Missirini 1823
Missirini, Melchior, *Solenni Esequie celebrate ad Antonio Canova nella chiesa de' Ss. XII Apostoli di Roma, con l'Orazione recitata dall'Abate Melchior Missirini,* Venice: Gio. Pavolari, 1823.

Missirini 1831
Missirini, Melchior, *Intera Collezione di Tutte le Opere inventate e scolpite dal Cav. Alberto Thorwaldsen,* 2 vols, Rome: Pietro Aurelij, 1831.

Mitchell 1944
Mitchell, Charles, 'Benjamin West's "Death of General Wolfe" and the Popular History Piece', in: *JWCI*, 7, 1944, pp. 20-33.

Modern Art in Paris 1981
Modern Art in Paris. Two-Hundred Catalogues of the Major Exhibitions, ed. by Theodore Reff, 47 vols, New York and London: Garland, 1981.

Modern Artists in America 1951
Modern Artists in America, ed. by Robert Motherwell and Ad Reinhardt, New York: Wittenborn Schultz, 1951.

Moderne Kunst 1959
Fünfzig Jahre moderne Kunst (Dokumentation der Kunstausstellung zur Weltausstellung in Brüssel 1958), Cologne: DuMont, 1959.

Moffett 1973
Moffett, Kenworth, *Meier-Graefe as Art Critic* (Studien zur Kunst des neunzehnten Jahrhunderts, vol. 19), Munich: Prestel, 1973.

Montaiglon 1875-1909
Montaiglon, Anatole de (Ed.), *Procès-verbaux de l'Académie Royale de Peinture et de Sculpture 1648-1792*, 11 vols, Paris: J. Baur and Jean Schemit, 1875-1909.

Montaiglon/Guiffrey 1887-1912
Montaiglon, Anatole de and Jules Guiffrey (Ed.), *Correspondance des directeurs de l'Académie de France à Rome, avec les surintendants des bâtiments*, 18 vols, Paris: J. Schemit, 1889-1912.

Moreau-Nélaton 1926
Moreau-Nélaton, Etienne, *Manet, raconté par lui-même*, 2 vols, Paris: H. Laurens, 1926.

Morice 1919
Morice, Charles, *Paul Gauguin*, Paris: H. Floury, 1919; 2 edn 1920.

Moritz 1785
Moritz, Karl Philipp, 'Versuch einer Vereinigung aller schönen Künste und Wissenschaften unter dem Begriff des in sich selbst Vollendeten', in: *Berlinische Monatsschrift*, 5, 1785, 3rd piece, pp. 225-236.

Moritz 1792-93 (1973)
Moritz, Karl Philipp, *Reisen eines Deutschen in Italien in den Jahren 1786 bis 1788 in Briefen*, 3 vols, Berlin: F. Maurer, 1792-93; Reprint in: *Werke*, ed. by Jürgen Jahn, 2 vols, Berlin and Weimar: Aufbau-Verlag, 1973.

Motherwell 1992
[Robert Motherwell] *The Collected Writings of Robert Motherwell*, ed. by Stephanie Terenzio, New York and Oxford: Oxford University Press, 1992.

Moulin 1967
Moulin, Raymonde, *Le marché de la peinture en France*, Paris: Minuit, 1967, 2nd edn 1989; Engl.: *The French Art Market. A sociological View*, trans. Arthur Goldhammer, New Brunswick: Rutger's University Press, 1987.

Moulin 1992
Moulin, Raymonde, *L'artiste, l'institution et le marché*, Paris: Flammarion, 1992.

Mras 1962
Mras, George P., 'Literary Sources of Delacroix's Conception of the Sketch and the Imagination', in: *AB*, 44, 1962, pp. 103-111.

Mras 1966
Mras, George P., *Eugène Delacroix's Theory of Art*, Princeton N.J.: Princeton University Press, 1966.

Mülder-Bach 1994
Mülder-Bach, Inka, 'Eine "neue Logik für den Liebhaber". Herders Theorie der Plastik', in: *Der ganze Mensch. Anthropologie und Literatur im 18. Jahrhundert* (DFG - Symposion 1992), ed. by Hans-Jürgen Schings, Stuttgart: Metzler, 1994, pp. 341-370.

Müller 1797
Müller, Friedrich, 'Schreiben Herrn Müllers Mahlers in Rom über die Ankündigung des Herrn Fernow von der Ausstellung des Herrn Professor Carstens in Rom', in: *Die Horen. Eine Monatsschrift*, ed. by Friedrich Schiller, vol. 9, 1797, 3rd piece, pp. 21-44, 4th piece, pp. 4-16.

Müller 1812
Müller, Friedrich, 'Kunstnachrichten aus Rom', in: *Deutsches Museum*, ed. by Friedrich Schlegel, vol. 1, 4, 1812, pp. 336-353; Reprint Darmstadt: Wissenschaftliche Buchgesellschaft, 1975.

Müller 1896
Müller, Hans, *Die Königliche Akademie der Künste zu Berlin 1696 bis 1896*. Part 1: Von der Begründung durch Friedrich III. von Brandenburg bis zur Wiederherstellung durch Friedrich Wilhelm II. von Preussen, Berlin: R. Bong, 1896.

Munch Catalogue 1987
Edvard Munch. Exh. cat. Essen and Zürich 1987/88, Essen: Museum Folkwang, and Zürich: Kunsthaus, 1987.

Murken 1979
Murken, Axel Hinrich, *Joseph Beuys und die Medizin*, Münster: F. Coppenrath, 1979.

Muschg 1948
Muschg, Walter, *Tragische Literaturgeschichte*, Bern: Francke, 1948.

Musées de France 1994
La jeunesse des musées. Les musées de France au XIXe siècle. Exh. cat. Paris 1994, ed. by Chantal Georgel, Paris: RMN, 1994.

Musées en Europe 1995
Les musées en Europe à la veille de l'ouverture du Louvre. Actes du colloque au Louvre 1993, ed. by Édouard Pommier, Paris: Louvre and

Klincksieck, 1995.

Mythos Documenta 1982
Mythos Documenta. Ein Bilderbuch zur Kunstgeschichte (Kunstforum International, vol. 49), Cologne 1982.

Nabis Catalogue 1993
Die Nabis. Propheten der Moderne. Exh. cat. Zürich 1993, ed. by Claire Frèches-Thory and Ursula Perucchi-Petri, Munich: Prestel, and Zürich: Kunsthaus, 1993.

Nadar 1857
Nadar, Félix, Nadar - Jury au Salon de 1857. 1000 comptes rendus, 150 dessins, à la librairie nouvelle et partout!, Paris: Librairie nouvelle, L. Bourdilliat, 1857.

Nancy 1988
Du Sublime, ed. by Jean-Luc Nancy, Paris: Berlin, 1988.

Nauman Catalogue 1973
Bruce Nauman. Werke von 1965 bis 1972. Exh. cat. Los Angeles, New York, Bern, Düsseldorf, Cologne and Eindhoven 1972/73, ed. by Jane Livingston and Marcia Tucker, Los Angeles: County Museum, 1972.

Nauman Catalogue 1990
Bruce Nauman, Skulpturen und Installationen, 1985-1990. Exh. cat. Basel and Frankfurt 1990/91, ed. by Jörg Zutter, Cologne: DuMont, 1990.

Nauman Catalogue 1994
Bruce Nauman. Exhibition catalogue and cata-logue raisonné. Exh. cat. Madrid, Minneapolis, Los Angeles, Washington, D.C. and New York, 1993-95, ed. by Joan Simon, Janet Jenkins and Toby Kamps, Minneapolis: Walker Art Center and Basel: Wiese Verlag, 1994.

Nebehay 1969
Nebehay, Christian M., Gustav Klimt. Dokumentation, Vienna: Verlag der Galerie Nebehay, 1969.

Neff 1995
Neff, Emily Ballew, 'The History Theater. Production and Spectatorship in Copley's The Death of Major Peirson', in: Copley Catalogue 1995, pp. 61-90.

Neo-Classicism 1972
The Age of Neo-Classicism. Exh. cat. London 1972, London: The Arts Council of Great Britain, 1972.

Neumann 1902
Neumann, Carl, Rembrandt, Berlin and Stuttgart: W. Spemann, 1902.

Neumann 1986
Neumann, Eckhard, Künstlermythen. Eine psychohistorische Studie über Kreativität, Frankfurt/M and New York: Campus, 1986.

New Painting 1986
The New Painting. Impressionism 1874-1886.

Exh. cat. San Francisco and Washington, D.C. 1986, ed. by Charles S. Moffett, Washington, D.C.: National Gallery, and San Francisco: The Fine Arts Museum, 1986.

Newcomb/Reichard 1937
Newcomb, Franc J. and Reichard, Gladys A., Sandpainting of the Navajo Shooting Chant, New York: J.J. Augustin, 1937; Reprint New York: Dover, 1975.

Newman 1947
Newman, Barnett, 'Response to Clement Greenberg [1947]', in: Newman 1990, pp. 161-164; 1st edn: Hess 1969, pp. 36-38.

Newman 1948
Newman, Barnett, 'The Sublime Is Now', in: The Tiger's Eye, 6, 1948, pp. 51-53.

Newman 1990
Newman, Barnett, Selected Writings and Interviews, ed. by John P. O'Neill, ed. by Mollie McNickle, Berkeley and Los Angeles: University of California Press, 1990.

Nicolson 1954
Nicolson, Benedict, 'The "Raft" from the point of view of subject-matter', in: BM, 96, 1954, pp. 241-249.

Nietzsche 1960
Nietzsche, Friedrich, Werke, 3 vols, 2nd edn, Munich: Hanser, 1960.

Noack 1907
Noack, Friedrich, Deutsches Leben in Rom 1700-1900, Stuttgart and Leipzig: Cotta Nachfolger, 1907.

Noack 1919
Noack, Friedrich, 'Lord Bristol, der absonderliche Kunstfreund', in: Cicerone, 11, 1919, pp. 693-700.

Nochlin 1967 (1)
Nochlin, Linda, 'Gustave Courbet's Meeting: A Portrait of the Artist as a Wandering Jew', in: AB, 49, 1, 1967, pp. 209-222.

Nochlin 1967 (2)
Nochlin, Linda, 'The Invention of the Avant-garde: France, 1830-1880', in: Arts New Annual, 34, 1967, pp. 11-18.

Nordau 1892/3
Nordau, Max, Entartung, 2 vols, Berlin: C. Duncker, 1892/93.

Nouveaux réalistes 1986
1960. Les nouveaux réalistes. Exh. cat. Paris 1986, Paris: Musée d'Art Moderne de la Ville, 1986.

O'Doherty 1976
Brian O'Doherty, 'Inside the White Cube: Notes on the Gallery Space. Part I', in: Artforum, March 1976, pp. 24-30; 'The Eye and the Spectator', in: Artforum, April 1976, pp. 26-34; 'Context as Content', in: Artforum, November 1976, pp. 38-44.

O'Doherty 1996
Brian O'Doherty, *In der weissen Zelle - Inside the White Cube*, ed. by Wolfgang Kemp, Berlin: Merve, 1996.

Oechslin 1994
Oechslin, Werner, *Stilhülse und Kern. Otto Wagner, Adolf Loos und der evolutionäre Weg zur modernen Architektur*, Zürich: gta-Verlag, 1994.

Oettermann 1980
Oettermann, Stephan, *Das Panorama. Die Geschichte eines Massenmediums*, Frankfurt/M: Syndikat, 1980.

Okkultismus und Avantgarde 1995
Okkultismus und Avantgarde: von Munch bis Mondrian, 100-1915. Exh. cat. Frankfurt, ed. by Veit Loers, Ostfildern: Edition Tertium, 1995.

Olbrich 1900
Olbrich, Joseph Maria, 'Unsere nächste Arbeit', in: *Deutsche Kunst und Dekoration*, 6, 1900, pp. 366-369.

Olbrich 1988
Olbrich, Joseph Maria, *Architektur. Vollständiger Nachdruck der drei Originalbände von 1901-1914*, Tübingen: E. Wasmuth, 1988.

Olbrich Catalogue 1972
Joseph Maria Olbrich, Die Zeichnungen in der Kunstbibliothek Berlin. Kritischer Katalog, ed. by K.H. Schreyl and D. Neumeister, Berlin: Mann, 1972.

O.M. 1851
O.M., 'Die Pariser Kunstausstellung von 1850-51', in: *Deutsches Kunstblatt*, no. 13, March 31, 1851, pp. 99-101.

Ortega y Gasset 1964
Ortega y Gasset, José, 'La deshumanización del arte' [1925], in: *Die Vertreibung des Menschen aus der Kunst,* Munich: DTV, 1964, pp. 7-39; and in: *Gesammelte Werke,* trans. Helma Flessa u.a., 6 vols, Stuttgart: Deutsche Verlags-Anstalt, 1978, vol. 2, pp. 229-264.

Ozenfant 1925
Ozenfant, Amédée, 'Kunst, Wissenschaft und die Gesellschaft von morgen', in: *Europa Almanach,* ed. by Carl Einstein and Paul Westheim, Potsdam: G. Kiepenheuer, 1925; Reprint Leipzig and Weimar: G. Kiepenheuer, 1984, pp. 192-205.

Ozenfant 1928
Ozenfant, Amédée, *Art,* Paris: Jean Budry, 1928.

Panofsky 1930
Panofsky, Erwin, *Hercules am Scheideweg und andere antike Bildstoffe in der neuen Kunst* (Studien der Bibliothek Warburg, XVIII), Leipzig and Berlin: B.G. Teubner, 1930.

Paret 1980
Paret, Peter, *The Berlin Secession: Modernism and its Enemies in Imperial Germany*, Cambridge, MA: Belknap Press of Harvard University Press, 1980.

Paris-New York 1991
Paris-New York 1908-1968. Exh. cat. Paris 1977, Paris: Editions du Centre Pompidou, 1991.

Pasinetti 1985
Pasinetti, P. M., *Life for Art's Sake. Studies in the Literary Myth of the Romantic Artist*, New York and London: Garland, 1985.

Paul 1993
Paul, Barbara, *Hugo von Tschudi und die moderne französische Kunst im Deutschen Kaiserreich* (Berliner Schriften zur Kunst, vol. 4), Mainz: von Zabern, 1993.

Paulson 1972
Paulson, Ronald, *Rowlandson, A New Interpretation*, London: Studio Vista, and New York: Oxford University Press, 1972.

Paulson 1982
Paulson, Robert, *Book and Painting. Shakespeare, Milton and the Bible. Literary Texts and the Emergence of English Painting*, Knoxville, Tenn.: University of Tennessee Press, 1982.

Pavanello 1976
Pavanello, Giuseppe, *L'opera completa del Canova,* Preface by Mario Praz, Milan: Rizzoli, 1976.

Peitsch 1978
Peitsch, Helmut, *Georg Forsters "Ansichten zum Niederrhein": zum Problem des Übergangs vom bürgerlichen Humanismus zum revolutionären Demokratismus*, Frankfurt/M, Bern, Las Vegas: Lang, 1978.

Penrose 1927
Penrose, Alexander P.D. (Ed.), *The Autobiography and Memoirs of Benjamin Robert Haydon,* London: G. Bell and Sons, 1927.

Perucchi-Petri 1994
Amerikanische Zeichnungen und Graphik. Von Sol LeWitt bis Bruce Nauman. Aus den Beständen der Graphischen Sammlung des Kunsthauses Zürich (Sammlungsheft 19), ed. by Ursula Perucchi-Petri, Zürich: Kunsthaus, 1994.

Pevsner 1946
Pevsner, Nikolaus, *Academies of Art, Past and Present*, Cambridge: Cambridge University Press, 1946.

Pfeiffer/Jauss/Gaillard 1987
Pfeiffer, Helmut, Jauss, Hans Robert and Gaillard, Françoise (Ed.), *Art social und art industriel. Funktionen der Kunst im Zeitalter des Industrialismus* (Theorie und Geschichte der Literatur und der Schönen Künste, vol. 77), Munich: Fink, 1987.

Pfeiffer 1988
Pfeiffer, Helmut, *Der soziale Nutzen der Kunst. Kunsttheoretische Aspekte der frühen Gesell-*

schaftstheorie in Frankreich (Theorie und Geschichte der Literatur und der schönen Künste, vol. 78), Munich: Wilhelm Fink, 1988.

Pforr 1811
Pforr, Franz, 'Reise zweyer jungen deutschen Mahler und ihrer Freunde nach Rafaels Vaterstadt', in: Morgenblatt für gebildete Stände, 5, no. 141 of June 13, 1811, pp. 561-562.

Pforr/Overbeck 1811
Pforr, Franz and Overbeck, Johann Friedrich, 'Unsere Wallfahrt nach Urbino', in: Morgenblatt für gebildete Stände, 5, no. 142 of June 14, 1811, pp. 565-566.

Picasso Katalog 1946
Picasso: Fifty Years of His Art. Exh. cat. New York 1946, ed. by Alfred J. Barr, Jr., New York: Museum of Modern Art, 1946; Reprint New York: Arno Press, 1980.

Picasso Katalog 1988
Les Demoiselles d'Avignon. Exh. cat. Musée Picasso Paris 1988, 2 vols, Paris: RMN, 1988.

Pickshaus 1988
Pickshaus, Peter , Kunstzerstörer. Fallstudien: Tatmotive und Psychogramme, Reinbek: Rowohlt, 1988.

Pissarro 1950
Pissarro, Camille, Lettres à son fils Lucien, présentées, avec l'assistance de Lucien Pissaro par John Rewald, Paris: Michel, 1950.

Pissarro 1980-91
Pissarro, Camille, Correspondance de Camille Pissaro, 5 vols, ed. by J. Bailly-Herzberg, Paris: Presses universitaires de Frances, 1980-91.

Plinius 1978
Plinius Secundus, C., Naturalis Historiae Libri XXXVII, lat.-German edn, ed. by R. König, Munich: Heimeran, 1978.

Plumb 1963
Plumb, John H., 'The Earl of Chatham', in: Men and Places, London: Cresset Press, 1963, pp. 107-114.

Podro 1988
Podro, Michael, 'The Portrait: Performance, Role and Subject', in: Individualität (Poetik und Hermeneutik, vol. 13), ed. by M. Frank and A. Haverkamp, Munich: Fink, 1988, pp. 577-586.

Poensgen/Zahn 1958
Poensgen, Georg and Zahn, Leopold, Abstrakte Kunst eine Weltsprache, Baden-Baden: W. Klein, 1958.

Poggioli 1962 (1968)
Poggioli, Renato, Teoria dell'arte d'avanguardia, Bologna: Il Mulino, 1962; engl.: The Theory of the Avant-Garde, trans. Gerald Fitzgerald, Cambridge, MA and London: Harvard University Press, 1968.

Pollock 1944

Pollock, Jackson, 'Answers to a Questionnaire', in: Arts and Architecture, 61, Feb. 1944; Reprint in: Pollock Catalogue 1978, vol. 4, p. 232.

Pollock 1947/48
Pollock, Jackson, 'My Painting', in: Possibilities, 1, Winter 1947/48, p. 79.

Pollock Catalogue 1956
Jackson Pollock. Exh. cat. New York 1956/57, text of Sam Hunter, New York: Museum of Modern Art, 1956.

Pollock Catalogue 1978
Jackson Pollock: A Catalogue Raisonné of Paintings, Drawings, and Other Works, ed. by Francis V. O'Connor and Eugene V. Thaw, 4 vols, New Haven and London: Yale University Press, 1978.

Pollock 1992
Pollock, Griselda, Avant-Garde Gambits 1888-1893: Gender and the Color of Art History, London: Thames and Hudson, 1992.

Pommier 1991
Pommier, Edouard, L'art de la liberté. Doctrines et débats de la Révolution française, Paris: Gallimard, 1991.

Popper 1975
Popper, Frank, Art - action and participation, London: Studio Vista, 1975.

Postle 1995
Postle, Martin, Sir Joshua Reynolds: The subject pictures, Cambridge: University of Cambridge Press, 1995.

Pouillon 1995
Pouillon, Nadine, 'Le musée: temple ou décharge. Ilya Kabakov, entretien avec Nadine Pouillon', trans. Galina Kabakova and Karine Lech, in: Kabakov 1995 (2), pp. 20-25.

Poulain 1932
Poulain, Gaston, Bazille et ses amis, Paris: La Renaissance du livre, 1932.

Poussin 1824
[Nicolas Poussin] Collection des lettres de Nicolas Poussin, ed. by Quatremère de Quincy, Paris: Firmin Didot, 1824.

Prange 1996 (1)
Prange, Regine, Jackson Pollock: Number 32, 1950, Frankfurt/M: Fischer, 1996.

Prange 1996 (2)
Prange, Regine, 'Bericht über das Joseph Beuys-Symposium in Kranenburg 1995', in: Kunstchronik, 49, 1996, pp. 356-362.

Pressly 1981
Pressly, William L., The Life and Art of James Barry, New Haven and London: Yale University Press, 1981.

Pressly 1983
Pressly, William L., James Barry. The Artist as Hero. Exh. cat. London 1983, London: Tate

Gallery Publications, 1983.

Pries 1989
Pries, Christine (Ed.), *Das Erhabene. Zwischen Grenzerfahrung und Grössenwahn*, Weinheim: VCH, Acta humanoria, 1989.

"Primitivism" in 20th Century Art 1984
"Primitivism" in 20th Century Art. Affinity of the Tribal and the Modern, 2 vols, ed. by William Rubin, New York: Museum of Modern Art, 1984.

Proudhon 1865
Proudhon, Pierre-Joseph, *Du Principe de l'Art et de sa Destination sociale*, Paris: Garnier, 1865.

Proudhon 1988
Proudhon, Pierre-Joseph, *Von den Grundlagen und der sozialen Bestimmung der Kunst*, trans. Klaus Herding, Berlin: Spiess, 1988.

Prown 1966
Prown, J.D., *John Singleton Copley*, 2 vols, Cambridge, MA: Harvard University Press, 1966.

Przybyszewski 1894
Przybyszewski, Stanislaw (Ed.), *Das Werk des Edvard Munch. Vier Beiträge von Stanislaw Przybyszewski, Franz Servaes, Willy Pastor und Julius Meier-Graefe*, Berlin: Fischer, 1894.

Puttfarken 1985
Puttfarken, Thomas, *Roger de Piles' Theory of Art*, New Haven and London: Yale University Press, 1985.

Pye 1845
Pye, John, *Patronage of British Art, a Historical Scetch. An Account of the Rise and Progress of Art and Artists in London, from the Beginning of the Reign of George the Second*, London: Longman, Brown and Green, 1845.

Quatremère de Quincy 1791
Quatremère de Quincy, Antoine Chrysostome, *Considérations sur les Arts du Dessin en France, Suivies d'un plan d'Académie, ou d'Ecole publique, et d'un système d'encouragemens*, Paris: Desenne, 1791; Reprint, Genf: Slatkine, 1970.

Quatremère de Quincy 1796
[Quatremère de Quincy, Antoine Chrysostome] *Lettres sur le préjudice qu'occasionneroient Aux Arts et à la Science, le Déplacement des Monumens de l'Art de l'Italie, le Démembrement de ses Écoles, et la Spoliation des ses Collections, Galeries, Musées, etc. Par A. Q.*, Paris: Desenne, Quatremère et les Marchands de Nouveautés, An IV [1796]; new edn Édouard Pommier, Paris: Macula, 1989.

Raeber 1979
Raeber, Willi, *Caspar Wolf (1735-1783). Sein Leben und sein Werk. Ein Beitrag zur Geschichte der Schweizer Malerei des 18. Jahrhunderts* (SIK, Oeuvrekataloge Schweizer Künstler,

vol. 7), Aarau, Frankfurt a/M and Salzburg: Sauerländer, and Munich: Prestel, 1979.

Raffael Catalogue 1983
Raphaël et l'art français. Exh. cat. Paris 1983/84, Paris: RMN, 1983.

Rauschenberg Catalogue 1980
Robert Rauschenberg. Werke 1950-1980. Exh. cat. Berlin, Düsseldorf, Humlebaek/Kopenhagen, Frankfurt a.M., Munich and Düsseldorf 1980/81, Berlin: Staatliche Kunsthalle, 1980.

Raussmüller-Sauer 1988
Joseph Beuys und das Kapital, ed. by Christa Raussmüller-Sauer, Schaffhausen: Halle für neue Kunst, 1988.

Ray 1942
Ray, Man, *Selbstporträt. Eine illustrierte Autobiographie*, trans. Reinhard Kaiser, Mosel: Schirmer, 1983.

Rayski Catalogue 1990
Ferdinand von Rayski 1806-1890. Ausstellung zum 100. Todestag. Exh. cat. Dresden and Munich 1990/91, Dresden: Staatliche Kunstsammlungen, 1990.

Reff 1968
Reff, Theodore, 'Some unpublished Letters of Degas', in: *AB*, 50, 1968, pp. 87-94.

Reff 1970
Reff, Theodore, 'Manet and Blanc's 'Histoire des Peintres', in: *BM*, 112, 1970, pp. 456-458.

Reff 1971
Reff, Theodore, 'Harlequins, Saltimbanques, Clowns and Fools', in: *Artforum*, 10, no. 2, October 1971, pp. 30-43.

Reichard 1977
Reichard, Gladys A., *Navajo Medicine Man*, New York: J.J. Augustin, 1939; Reprint title: *Navajo Medicine Man Sandpaintings*, New York: Dover, 1977.

Reinhardt 1991
[Ad Reinhardt] *Art as Art: The Selected Writings of Ad Reinhardt*, ed. by Barbara Rose, Berkeley and Los Angeles: University of California Press, 1991.

Reliquien 1989
Reliquien - Verehrung und Verklärung. Exh. cat. Cologne 1989, ed. by A. Legner, Cologne: Schnütgen-Museum, 1989.

Restany 1974 (1982)
Restany, Pierre, *Yves Klein. Le Monochrome*, Paris: Hachette, 1974; German: *Yves Klein*, Munich: Schirmer/Mosel, 1982.

Revolution und Autonomie 1990
Revolution und Autonomie. Deutsche Autonomieästhetik im Zeitalter der Französischen Revolution. Ein Symposium, ed. by Wolfgang Wittkowski, Tübingen: Niemeyer, 1990.

Rewald 1946

Rewald, John, *The History of Impressionism*, New York: Simon and Schuster, 1946.

Rewald 1979 (1982)
Rewald, John, *Die Geschichte des Impressionismus. Schicksal und Werk der Maler einer grossen Epoche*, Cologne: DuMont, 1979; 2nd edn 1982.

Rewald 1983
Rewald, John, *Paul Cézanne: The Watercolours. A Catalogue Raisonné*, London: Thames and Hudson, 1983.

Rewald 1986
Rewald, John, *Cézanne. A Biography*, London: Thames and Hudson, 1986.

Reynolds 1929
Reynolds, Joshua, *The Letters of Sir Joshua Reynolds*, ed. by Frederick W. Hilles, Cambridge: Cambridge University Press, 1929.

Reynolds 1959 (1981)
Reynolds, Joshia, *Discourses on Art*, ed. by Robert R. Wark, San Marino, CA.: Huntington Library, 1959; new edn: New Haven and London: Yale University Press, 1981.

Reynolds Catalogue 1986
Reynolds. Exh. cat. London 1986, ed. by Nicholas Penny, London: Weidenfeld and Nicolson, 1986.

Ridolfi 1914/24
Ridolfi, Carlo, *Le maraviglie dell'arte. Ovvero le vite degli illustri pittori veneti e dello stato* [1648], ed. by Detlev Freiherrn von Hadeln, 2 vols, Berlin: G. Grote'sche Verlagsbuchhandlung, 1914/24.

Riegl 1893
Riegl, Alois, *Stilfragen. Grundlegungen zu einer Geschichte der Ornamentik*, Berlin: G. Siemens, 1893; Reprint Munich: Mäander, 1985.

Riegl 1901
Riegl, Alois, *Spätrömische Kunstindustrie*, Vienna: Oesterreichische Staatsdruckerei, 1901; Reprint Darmstadt: Wissenschaftliche Buchgesellschaft, 1973.

Riepenhausen 1816
Riepenhausen, Franz and Johannes, *Leben Raphael Sanzio's von Urbino in zwölf Bildern dargestellt von F. und J. Riepenhausen in Rom*. Copper engravings C. Barth, Gottlieb Rist and Friedrich Schultze, Frankfurt am Main: J.F. Wenner, o.J. [1816].

Riepenhausen 1833
Riepenhausen, Johannes, *Vita di Raffaelle da Urbino disegnata ed incisa da Giovanni Riepenhausen in XII tavole*, Rome, 1833.

Ringbom 1970
Ringbom, Sixten, *The Sounding Cosmos. A Study in the Spiritualism of Kandinsky and the Genesis of Abstract Painting* (Acta Academiae Aboensis, ser. A, Humaniora, vol. 28, no. 2),
Abo: Abo Akademi, 1970.

Ritter/Gründer 1971-
Ritter, Joachim and Gründer, Karlfried (Ed.); *Historisches Wörterbuch der Philosophie*, Basel: Schwabe, 1971 (until 1995 nine vols are published).

Rivière 1933
Rivière, Georges, *Cézanne, le peintre solitaire*, Paris: Floury, 1933.

Rizzi and Martino 1982
Rizzi, Paolo and Enzo di Martino, *Storia delle Biennale, 1895-1982*, Milan: Electa, 1982.

Robsjohn-Gibbings 1947
Robsjohn-Gibbings, Terence H., *Mona Lisa's Mustache: A Dissection of Modern Art*, New York: A.A. Knopf, 1947.

Roettgen 1993
Roettgen, Steffi, *Anton Raphael Mengs 1728-1779 and his British Patrons*, London: A. Zwemmer/English Heritage, 1993.

Roh 1948
Roh, Franz, *Der verkannte Künstler. Studien zur Geschichte und Theorie des kulturellen Missverstehens*, Munich: Heimeran, 1948; new edn with a Preface by Wulf Herzogenrath, Cologne: DuMont, 1993.

Roh 1962
Roh, Franz, *Entartete Kunst. Kunstbarbarei im Dritten Reich*, Hannover: Fackelträger-Verlag, Schmidt-Kunster, 1962.

Rosenberg 1972
Rosenberg, Harold, *The De-definition of Art*, Chicago and London: The University of Chicago Press, 1972.

Rosenberg 1978
Rosenberg, Harold, *Barnett Newman*, New York: Harry N. Abrams, 1978.

Rosenberg/Fliegel 1965
Rosenberg, Bernard, and Fliegel, Norris, *The Vanguard Artist: Portrait and Self-Portrait*, Chicago: New Amsterdam, 1965.

Rosenblum 1961
Rosenblum, Robert, 'The abstract sublime', in: *Art News*, 59, 10, 1961, pp. 38-41, 56-58.

Rosenblum 1975
Rosenblum, Robert, *Modern Painting and the Northern Romantic Tradition: Friedrich to Rothko*, London: Thames and Hudson, 1975.

Rosini 1830
Rosini, Giovanni, *Saggio sulla vita e sulle opere di Antonio Canova*, 2nd edn, Pisa: Niccolò Capurro, 1830.

Rothko 1947
Rothko, Mark, 'Statement', in: *The Tiger's Eye*, 1, 2, 1947, p. 44; Wiederabdruck in: Art in Theory 1992, p. 565.

Rouart/Wildenstein 1975
Rouart, Denis and Wildenstein, Daniel,

Edouard Manet. Catalogue raisonné, 2 vols, Lausanne-Paris: Bibliothèque des Arts, 1975.

Rouquet 1755
Rouquet, Jean-André, *L'Etat des Arts en Angleterre,* Paris: Ch. Ant. Jombert, 1755.

Rubin 1980
Rubin, James H., *Realism and Social Vision in Courbet & Proudhon,* Princeton: Princeton University Press, 1980.

Rubin 1983
Rubin, William, 'From Narrative to "Iconic" in Picasso: The Buried Allegory in *Bread and Fruitdish on a Table* and the Role of *Les Demoiselles d'Avignon*', in: *AB,* 65, 1983, pp. 615-649.

Rubin 1987
Rubin, James H., *Eugène Delacroix. Die Dantebarke. Idealismus und Modernität,* Frankfurt/M: Fischer, 1987.

Saint-Simon/Enfantin 1865-78 (1963/4)
Saint-Simon, Claude-Henri de and Enfantin, Barthélemy, *Oeuvres de Saint-Simon et d'Enfantin,* 24 vols, Paris: Dentu and Leroux, 1865-78; Reprint, 47 vols, Aalen: Otto Zeller, 1963/4.

Salerno 1951
Salerno, Luigi, 'Seventeenth-Century English Literature on Painting', in: *JWCI,* 14, 1/2, 1951, pp. 234-258.

Salvini 1987
Salvini, Roberto, 'Raffaello e Dürer', in: *Studi su Raffaello,* 2 vols, ed. by Micaela Sambucco Hamud and Maria Letizia Strocchi, Urbino: Quattri Venti, 1987, vol. I, pp. 145-150.

Sandreuter 1917
Sandreuter, Hans, 'Briefe und Tagebücher, Teil II', in: *Basler Kunstverein,* annual report 1916, Basel 1917, pp. 5-65.

Sandt 1984
Sandt, Udolpho van de, 'Le salon de l'Académie de 1759 à 1781', in: *Diderot & l'Art de Boucher à David. Les Salons: 1759-1781.* Exh. cat. Paris 1984/85, Paris: RMN, 1984, pp. 79-93.

Sandt 1986
Sandt, Udolpho van de, 'La fréquentation des Salons sous l'Ancien Régime, la Révolution et l'Empire', in: *Revue de l'Art,* 73, 1986, pp. 43-48.

Saunders 1990
Saunders, Richard H., 'Genius and Glory: John Singleton Copley's *The Death of Major Peirson*', in: *American Art Journal,* 22, 3, 1990, pp. 5-39.

Sawin 1995
Sawin, Martica, *Surrealism in Exile and the Beginning of the New York School,* Cambridge, MA: MIT Press, 1995.

Schapiro 1994
Schapiro, Meyer, *Theory and Philosophy of Art: Style, Artist and Society. Selected Papers,* New York: Braziller, 1994.

Scharf 1988
Scharf, Barbara, *Der leidende Christus. Ein Motiv der Bildkunst Frankreichs im ausgehenden neunzehnten Jahrhundert* (Reihe Kunstgeschichte, vol. 29), Munich: Tuduv, 1988.

Scheffer Katalog 1996
Ary Scheffer: 1795-1858. Exh. cat. Paris, Paris: Paris-Musées, 1996.

Scheidig 1958
Scheidig, Walther, *Goethes Preisaufgaben für bildende Künstler: 1799-1805* (Schriften der Goethe-Gesellschaft, vol. 57), Weimar: H. Böhlau, 1958.

Scheinfuss 1973
Scheinfuss, Katharina (Ed.), *Von Brutus zu Marat. Kunst im Nationalkonvent 1789-1795,* Dresden: Fundus, 1973.

Schiff 1963
Schiff, Gert, *Johann Heinrich Füsslis Milton-Galerie* (SIK, Schriften no. 5), Zürich and Stuttgart: Fretz und Wasmuth, 1963.

Schiff 1973
Schiff, Gert, *Johann Heinrich Füssli 1741-1825* (SIK, Oeuvrekataloge Schweizer Künstler, vol. 1), 2 vols, Zurich: Berichthaus, and Munich: Prestel, 1973.

Schiller 1795 (1962)
Schiller, Friedrich, 'Über die ästhetische Erziehung des Menschen in einer Reihe von Briefen' [1795], in: Schiller, *Werke,* Nationalausgabe, vol. 20, ed. by Benno Wiese, Weimar: H. Böhlaus Nachf., 1962, pp. 304-412.

Schilling 1978
Schilling, Jürgen, *Aktionskunst: Identität von Kunst und Leben? Eine Dokumentation* (Bucher Report, 2), Luzern, Frankfurt a.M.: C.J. Bucher, 1978.

Schlegel 1959
Schlegel, Friedrich, *Kritische Friedrich-Schlegel-Ausgabe,* vol. 4: Ansichten und Ideen von der christlichen Kunst, ed. by H. Eichner, Munich, Paderborn, Vienna: F. Schöningh, Zürich: Thomas-Verlag, 1959.

Schlink 1987
Schlink, Wilhelm, 'Jacob Burckhardts Künstlerrat', in: *Städel-Jahrbuch,* N.F. 11, 1987, pp. 269-290.

Schlink 1989
Schlink, Wilhelm, 'Thoma, gedankenschwer - Der Maler im Spiegel seines Selbstbildnisses von 1875', in: *Hans Thoma. Lebensbilder.* Exh. cat. Freiburg i.Br. 1989, Königstein i.Taunus: Köster, 1989, pp. 64-71.

Schlink 1992
Schlink, Wilhelm, ' "Kunst ist dazu, um geselligen Kreisen das gähnende Ungeheuer, die Zeit, zu töten ...". Bildende Kunst im Lebenshaushalt der Gründerzeit', in: *Bildungsbürgertum im 19. Jahrhundert, Teil III: Lebensführung und ständische Vergesellschaftung,* ed. by M. Rainer Lepsius, Stuttgart: Klett-Cotta, 1992, pp. 65-81.

Schlink 1996
Schlink, Wilhelm, 'Verletzliche Gesichter. Bildnisse deutscher Künstler im 19. Jahrhundert', in: *Freiburger Universitätsblätter,* 132, 1996, pp. 131-151.

Schmidt 1971
Schmidt, Siegfried J., *Ästhetische Prozesse. Beiträge zu einer Theorie der nicht-mimetischen Kunst und Literatur,* Cologne and Berlin: Kiepenheuer und Witsch, 1971.

Schmidt 1987
Schmidt, Siegfried J., *Kunst: Pluralismen, Revolten,* Bern: Benteli, 1987.

Schmoll 1966
Schmoll gen. Eisenwerth, J.A., 'Zur Geschichte des Beethoven-Denkmals', in: *Saarbrücker-Studien zur Musikwissenschaft,* 1, Kassel u.a.: Bärenreiter, 1966, pp. 242-277.

Schnapper 1990
Schnapper, Antoine, 'The Debut of the Royal Academy of Painting and of Sculpture', in: June Hargrove (Ed.), *The French Academy. Classicism and its Antagonists,* Newark: University of Delaware Press; and London and Toronto: Associated University Presses, 1990, pp. 27-36.

Schneckenburger 1983
Schneckenburger, Manfred (Ed.), *Documenta. Idee und Institution. Tendenzen, Konzepte, Materialien* (Pantheon Colleg), Munich: Bruckmann, 1983.

Schneede 1994
Schneede, Uwe M., *Joseph Beuys: Die Aktionen. Kommentiertes Werkverzeichnis mit fotografischen Dokumentationen,* Ostfildern-Ruit: Hatje, 1994.

Schneemann 1994
Schneemann, Peter Johannes, *Geschichte als Vorbild. Die Modelle der französischen Historienmalerei 1747-1789* (Acta humaniora. Schriften zur Kunstwissenschaft und Philosophie), Berlin: Akademie-Verlag, 1994.

Schneemann 1995
Schneemann, Peter Johannes, 'Ausstellungsstrategie und Selbstzerstörung: Die tragische Figur des englischen Historienmalers Benjamin Robert Haydon (1786-1846)', in: *ZfK,* 58, 1995, pp. 226-239.

Schneemann 1996

Schneemann, Peter Johannes, 'Die Biennale von Venedig. Nationale Präsentation und internationaler Anspruch', in: *ZAK,* 53, 1996, pp. 313-321.

Schneider 1987
Schneider, Mechthild, 'Pygmalion - Mythos des schöpferischen Künstlers. Zur Aktualität eines Themas in der französischen Kunst von Falconet bis Rodin', in: *Pantheon,* 45, 1987, pp. 111-123.

Schöpferische Konfession 1920
Schöpferische Konfession (Tribüne der Kunst und der Zeit. Eine Schriftensammlung, ed. by Kasimir Edschmid, vol. 13), Berlin: E. Reiss, 1920; Reprint: Nendeln/Liechtenstein: Kraus, 1973.

Schopenhauer 1810
Schopenhauer, Johanna, *Carl Ludwig Fernow's Leben,* Tübingen: G. Cotta, 1810.

Schröter 1990
Schröter, Elisabeth, 'Raffael-Kult und Raffael-Forschung. Johann David Passavant und seine Raffael-Monographie im Kontext der Kunst und Kunstgeschichte seiner Zeit', in: *Römisches Jahrbuch der Bibliotheca Hertziana,* 26, 1990, pp. 303-390.

Schubert 1990
Schubert, Dietrich, *Die Kunst Lehmbrucks,* 2nd enlarged edn, Worms: Wernersche Verlagsgesellschaft, 1990; 1st edn 1981.

Schuster 1978
Schuster, Peter-Klaus, 'Der karikierte Courbet', in: *Courbet und Deutschland.* Exh. cat. Hamburg and Frankfurt/M 1978/79, Cologne: DuMont, 1978, pp. 494-500.

Schuster 1987
Schuster, Peter-Klaus (Ed.), *Kunststadt München 1937: Nationalsozialismus und Entartete Kunst.* Exh. cat. Munich, Staatsgalerie moderner Kunst 1987, Munich: Prestel, 1987.

Schwarz 1969
Schwarz, Arturo, *The Complete Works of Marcel Duchamp with a Catalogue Raisonné,* London: Thames and Hudson, 1969.

Scott 1979
Scott, Nancy J., *Vincenzo Vela 1820-1891,* New York and London: Garland, 1979.

Sedlmayr 1948
Sedlmayer, Hans, *Verlust der Mitte. Die bildende Kunst des 19. und 20. Jahrhunderts als Symptom und Symbol der Zeit,* Salzburg: O. Müller, 1948.

Sehsucht 1993
Sehsucht: das Panorama als Massenunterhaltung des 19. Jahrhunderts. Exh. cat. Bonn 1993, Frankfurt/M and Basel: Stroemfeld and Roter Stern, 1993.

Seigel 1986

Seigel, Jerrold, *Bohemian Paris. Culture, Politics, and the Boundaries of Bourgeois Life, 1830-1930,* New York: Viking, 1986.

Seitz 1983

Seitz, William C., *Abstract Expressionist Painting in America,* Cambridge, MA: Harvard University Press, 1983.

Sells 1974

Sells, Christopher, 'The Death of Gros', in: *BM,* 116, 854, 1974, pp. 266-270.

Semper 1852

Semper, Gottfried, *Wissenschaft, Industrie und Kunst. Vorschläge zur Anregung nationalen Kunstgefühls,* Braunschweig: Viehweg, 1852.

Semper 1966

Semper, Gottfried, *Wissenschaft, Industrie und Kunst und andere Schriften über Architektur, Kunsthandwerk und Kunstunterricht,* ed. by H.M. Wingler (Neue Bauhausbücher), Mainz and Berlin: F. Kupferberg 1966.

Serra 1976

Serra, Richard, 'Sight Point '71-'75/Delineator '74-'76' [Radio-Interview of Liza Bear, February 23, 1976], in: Serra 1994, pp. 35-43; in: *Art in America,* 64, 3, 1976, pp. 82-86.

Serra 1994

Serra, Richard, *Writings. Interviews,* Chicago and London: The University of Chicago Press, 1994.

Sérullaz 1984

Sérullaz, Maurice, 'L'oeuvre dessiné d'Eugène Delacroix', in: *Dessins d'Eugène Delacroix 1798-1863* (Musée du Louvre, Cabinet des Dessins: Inventaire général des dessins. Ecole française), ed. by Maurice Sérullaz u. a., 2 vols, Paris: RNM, 1984.

Seurat 1989

The *Grande Jatte* at 100, in: *The Art Institute of Chicago Museum Studies* (Special Issue), 14, 2, 1989.

Seurat Catalogue 1991

Seurat. Exh. cat. Paris 1991, Paris: RMN, 1991.

Shaftesbury 1712

Shaftesbury, Anthony Ashley Cooper, Earl of, 'Le Jugement d'Hercule ou Dissertation sur un Tableau, dont le Dessin est pris de l'histoire de Prodicus qu'on trouve chez les Choses Mémorables de Xénophon, liv. II', in: *Journal des Savants,* Amsterdamer-Ausgabe, 52, Nov. 1712.

Shaftesbury 1714 (1)

Shaftesbury, Anthony Ashley Cooper, Earl of, 'Notion of the Historical Draught or Tablature of the Judgment of Hercules', in: *Characteristicks of Men, Manners, Opinions and Times,* 2nd edn, 3 vols, London [o.V.], 1714, vol. 3, pp. 345-391.

Shaftesbury 1714 (2)

Shaftesbury, Anthony Ashley Cooper, Earl of, 'A Letter Concerning the Art, or Science of Design, Written From Italy, on the occasion of the Judgement of Hercules to My Lord', in: *Characteristicks of Men, Manners, Opinions and Times,* 3 vols, 2nd edn, London [o.V.], 1714, vol. 3, pp. 393-411.

Shaftesbury 1748

'Schaftesbury über das Gemälde vom Urtheil des Herkules', in: *Neuer Büchersaal der schönen Wissenschaften und der freyen Künste,* 7, 1748; and in: *Bibliothek der schönen Wissenschaften und der freyen Künste,* 2, 1757, pp. 1-56.

Shaftesbury 1769

[Earl of Shaftesbury] *Les Oeuvres de Mylord Comte de Shaftsbury ...* Traduits de l'Anglois en François sur la dernière édition, 3 vols, Genf 1769.

Shearman 1992

Shearman, John, *Only connect ...; Art and the Spectator in the Italian Renaissance,* Princeton N.J.: Princeton University Press, 1992.

Shiff 1984

Shiff, Richard, *Cézanne and the End of Impressionism. A Study of the Theory, Technique, and Critical Evaluation of Modern Art,* Chicago and London: University of Chicago Press, 1984.

Shroder 1961

Shroder, Maurice Z., *Icarus. The Image of the Artist in French Romanticism* (Harvard Studies in Romance Languages, vol. 27), Cambridge, MA: Harvard University Press, 1961.

Sickler/Reinhart 1810/11

Almanach aus Rom für Künstler und Freunde der bildenden Kunst, ed. by F. Sickler and C. Reinhart, 2 vols, Leipzig: G.J. Göschen, 1810/11.

Signac 1899 (1978)

Signac, Paul, *D'Eugène Delacroix au néo-impressionisme* [1899], Paris: Hermann, 1978.

Silver 1989

Silver, Kenneth E., *Esprit de Corps: The Art of the Parisian Avant-Garde and the First World War, 1914-1945,* Princeton: Princeton University Press, 1989.

Simon 1988

Simon, Joan, 'Breaking the Silence: An Interview with Bruce Nauman', in: *Art in America,* 76, 9, 1988, pp. 141-149, 203.

Sizer 1950

Sizer, Theodore, *The Works of Colonel John Trumbull, artist of the American revolution,* New Haven: Yale University Press, and London: Oxford University Press, 1950.

Sizer 1953

Sizer, Theodore (Ed.), *The Autobiography of Colonel John Trumbull, Patriot-Artist, 1756-1843,*

New Haven: Yale University Press 1953; new edn, New York: Kennedy Graphics, 1970.

Smith 1958
Smith, James Steel, 'Art in the Mass Circulation Magazines', in: *College Art Journal*, 17, 1958, pp. 422-427.

Solkin 1993
Solkin, David H., *Painting for Money. The Visual Arts and the Public Sphere in Eighteenth-Century England*, New Haven and London: Yale University Press, 1993.

Sollers 1995
Sollers, Philippe, *Le cavalier du Louvre: Vivant Denon (1747-1825)*, Paris: Plon, 1995.

Sontag 1966
Sontag, Susan, *Against Interpretation, and Other Essays*, New York: Farrar, Strauss & Giroux, 1966.

Spencer 1987
Spencer, Robin, 'Whistler's First One-Man-Exhibition Reconstructed', in: *The Documented Image. Visions in Art History*, ed. by Gabriel P. Weisberg and Laurinda S. Dixon, Syracuse, NY: Syracuse University Press, 1987, pp. 27-49.

Spiritual in Art 1986
The Spiritual in Art: Abstract Painting 1890-1985. Exh. cat. Los Angeles, Chicago and Den Haag 1986/87, New York: Abbeville Press, 1986.

Staeck 1972
Befragung der Documenta oder die Kunst soll schön bleiben, ed. by Klaus Staeck, Göttingen: G. Steidl, 1972.

Staël 1800 (1959)
Staël, Mme de [Anna Louise Germaine de Staël-Holstein], *De la littérature considérée dans ses rapports avec les institutions sociales*, 2 vols, Paris 1800; critical edn P. van Tieghem, 2 vols, Paris: Hachette, 1959.

Staël 1850
Staël, Mme de [Anna Louise Germaine de Staël-Holstein], *Corinne ou l'Italie*, Paris: Didot, 1850; 1st published: Paris: H. Nicolle, 1807.

Staël
Staël, Mme de [Anna Louise Germaine de Staël-Hohlstein], *Corinna oder Italien*, trans. Friedrich Schlegel, Leipzig: Ph. Reclam jun., no year.

Stanton 1910 (1976)
Stanton, Theodore (Ed.), *Reminiscences of Rosa Bonheur*, New York 1910; Reprint New York: Hacker Art Books, 1976.

Starobinski 1970
Starobinski, Jean, *Portrait de l'artiste en saltimbanque*, Genf: Skira, 1970; German: *Porträt des Künstlers als Gaukler*, Frankfurt/M: Fischer, 1985.

Stationen 1988
Stationen der Moderne. Die bedeutenden Kunstausstellungen des 20. Jahrhunderts in Deutschland. Exh. cat. Berlin 1988, Berlin: Nicolaische Verlagsbuchhandlung, 1988.

Steiner 1991
Steiner, Reinhard, *Prometheus. Ikonologische und anthropologische Aspekte der bildenden Kunst vom 14. bis zum 17. Jahrhundert*, Munich: Klaus Boer, 1991.

Steneberg 1987
Steneberg, Eberhard, *Arbeitsrat für Kunst, Berlin 1918-1921*, Düsseldorf: Marzona, 1987.

Stöhr 1993
Stöhr, Jürgen, *Yves Klein und die ästhetische Erfahrung*, Essen: Blaue Eule, 1993.

Stoichita 1985
Stoichita, Victor I., 'Le "chef-d'oeuvre inconnu" et la présentation du pictural', in: *La Présentation, recherches poïétiques*, ed. by René Passeron, Paris: CNRS, 1985, pp. 77-92.

Stoichita 1991/92
Stoichita, Victor I., 'Manet raconté par lui-même', in: *Annales d'Histoire de l'Art & d'Archéologie*, 13 and 14, 1991 and 1992, pp. 79-94, 95-110.

Storr 1991
Dislocations. Exh. cat. New York 1991/92, ed. by Robert Storr, New York: Museum of Modern Art, 1991.

Strauss 1990
Strauss, David Levi, 'American Beuys: "I Like America & America Likes Me" ', in: *Parkett*, 26, 1990, pp. 124-136.

Strick 1989
Strick, Jeremy, *Twentieth-Century Painting and Sculpture. Selections for the Tenth Anniversary of the East Building*, Washington, DC: National Gallery of Art, 1989.

Strobl 1980
Strobl, Alice, *Gustav Klimt. Die Zeichnungen, 1878-1903* (Veröffentlichungen der Albertina, no. 15), 3 vols, Salzburg: Verlag Galerie Welz, 1980.

Stüttgen 1988
Stüttgen, Johannes, *Im Kraftfeld des erweiterten Kunstbegriffs von Joseph Beuys. Sieben Vorträge im Todesjahr von Joseph Beuys*, Stuttgart: Urachhaus, 1988.

Sulzer 1771/74
Sulzer, Johann Georg, *Allgemeine Theorie der Schönen Künste*, 2 vols, Leipzig: M.G. Weidemanns Erben und Reich, 1771/74.

Sulzer 1792-94
Sulzer, Johann Georg, *Allgemeine Theorie der Schönen Künste. Neue vermehrte zweyte Auflage*, 4 vols and register, Leipzig: Weidmannsche Buchhandlung, 1792-94; Reprint with a

Preface by G. Tonelli, Hildesheim: G. Olms, 1967-70.

Swenson 1963
Swenson, G. R., 'What is Pop Art. Answers from 8 Painters, part 1: Jim Dine, Robert Indiana, Roy Lichtenstein, Andy Warhol', in: *Art News*, 62, 7, 1963, pp. 24-27, 60-63.

Szeemann 1971
Szeemann, Harald, 'Happening + Fluxus zum Beispiel oder das Negative ist das Positive', in: *Kunst Nachrichten*, 7, 6, 1971, n.p.

Szeemann 1981
Szeemann, Harald, *Museum der Obsessionen*, Berlin: Merve, 1981.

Szondi 1974
Szondi, Peter, *Poetik und Geschichtsphilosophie I: Antike und Moderne in der Aesthetik der Goethezeit. Hegels Lehre von der Dichtung* (Studienausgabe der Vorlesungen, vol. 2), ed. by S. Metz and H.-H. Hildebrandt, Frankfurt/M: Suhrkamp, 1974.

Tabarant 1947
Tabarant, A., *Manet et ses oeuvres*, Paris: Gallimard, 1947.

Tancock 1976
Tancock, John L., *The sculpture of Auguste Rodin. The collection of the Rodin Museum Philadelphia*, Philadelphia: Museum of Art, 1976.

Testelin 1680
Testelin, Henry, *Sentimens des plus habiles Peintres sur la pratique de la Peinture et Sculpture*, Paris: Vve Marbre-Cramoisy, 1680; 2nd edn 1696.

Teyssèdre 1965
Teyssèdre, Bernard, *Roger de Piles et les débats sur le coloris au siècle de Louis XIV*, Paris: Bibliothèque des Arts, 1965.

Thibert 1926
Thibert, Marguerite, *Le Rôle social de l'art d'après les Saint-Simoniens*, Poitiers: Impr. du Poitou, and Paris: Libr. Marcel Rivière, 1926.

Thiele 1832/34
Thiele, Just Mathias, *Leben und Werke des dänischen Bildhauers Bertel Thorvaldsen*, 2 vols, Leipzig: F.A. Brockhaus, 1832/34.

Thiele 1852-56
Thiele, Just Mathias, *Thorvaldsen's Leben nach den eigenhändigen Aufzeichnungen, nachgelassenen Papieren und dem Briefwechsel des Künstlers*, trans. Henrik Helms, 3 vols, Leipzig: Carl B. Lorck, 1852-56.

Thieme/Becker 1907-50
Thieme, Ulrich and Becker, Felix (Ed.), *Allgemeines Lexikon der bildenden Künstler von der Antike bis zur Gegenwart*, 37 vols, Leipzig: Wilhelm Engelmann, 1907-50.

Thiers 1867

Thiers, Adolphe, *Discours prononcés au corps législatif les 9 et 10 juillet 1867 sur le Mexique*, Tours: E. Mazereau, 1867.

Thomé de Gamond 1826
[A. Thomé de Gamond] *Vie de David*, Paris: Marchands de nouveautés, 1826.

Thoré 1858/60
Thoré, Théophile [W. Bürger], *Les Musées de la Hollande*, 2 vols, Paris: J. Renouart, 1858/60.

Thorvaldsen Catalogue 1992
Künstlerleben in Rom. Bertel Thorvaldsen (1770-1844): Der dänische Bildhauer und seine deutschen Freunde. Exh. cat. Nuremberg and Schleswig 1992, ed. by Gerhard Bott and Heinz Spielmann, Nuremberg: Germanisches Nationalmuseum, 1992.

Thürlemann 1990
Thürlemann, Felix, 'Bruce Nauman - "Dream Passage"' in: *Vom Bild zum Raum. Beiträge zu einer semiotischen Kunstwissenschaft*, Cologne: DuMont, 1990, pp. 139-151.

Thuillier 1986
Thuillier, Jacques, 'L'artiste et son public: problèmes de méthode', in: *ZAK*, 43, pp. 343-347.

Tieck 1795
Tieck, Ludwig, 'Ueber die Kupferstiche nach der Shakspearschen Gallerie in London', in: *Neue Bibliothek der schönen Wissenschaften und der freyen Künste*, 55, 2nd piece, 1795, pp. 187-226.

Tieck 1798
Tieck, Ludwig, *Franz Sternbalds Wanderungen. Eine altdeutsche Geschichte*, 2 vols, Berlin: J.F. Unger, 1798.

Tieck 1985-95
Tieck, Ludwig, *Schriften in zwölf Bänden*, ed. by Manfred Frank et al., Frankfurt/M: Deutscher Klassiker Verlag, 1985-95.

Tiger's Eye 1948
'The Ides of Art. 6 Opinions on What ist Sublime in Art?', in: *The Tiger's Eye*, 6, December 1948, pp. 46-57.

Tinguely Museum 1996
Museum Jean Tinguely Basel, 2 vols, Bern: Benteli, 1996.

Tischbein 1786
Tischbein, Johann Heinrich Wilhelm, 'Briefe aus Rom über neue Kunstwerke jetzt lebender Künstler', in: *Der Teutsche Merkur*, February 1786, pp. 169-185.

Tischbein 1922
Tischbein, Wilhelm, *Aus meinem Leben* [1861], ed. by Lothar Brieger, Berlin: Propyläen-Verlag, 1922.

Toussaint
Toussaint, Hélène, 'Le dossier de *L'Atelier*

de Courbet', in: Courbet Catalogue 1977, pp. 241-272.

Trübner 1892
[Wilhelm Trübner] *Das Kunstverständnis von Heute,* Frankfurt/M: Literarische Anstalt Rütten & Loening, 1892.

Trübner 1898
Trübner, Wilhelm, *Die Verwirrung der Kunstbegriffe,* Frankfurt/M: Literarische Anstalt Rütten & Loening, 1898; 2nd edn 1900.

Tucker 1984
Tucker, Paul H., 'The First Impressionist Exhibition and Monet's *Impression: Sunrise*: A Tale of Timing, Commerce and Patriotism', in: *Art History,* 7, 1984, pp. 465-476.

Tucker 1986
Tucker, Paul H., 'The First Impressionist Exhibition in Context', in: New Painting 1986, pp. 93-117.

Ullmann 1983
Von der Macht der Bilder. Beiträge des C.I.H.A.-Kolloquiums "Kunst und Reformation", ed. by Ernst Ullmann, Leipzig: E.A. Seemann, 1983.

Ursprung 1996
Ursprung, Philipp, *Kritik und Secession. "Das Atelier". Kunstkritik in Berlin zwischen 1890 und 1897,* Basel: Schwabe, 1996.

V & A Press Cuttings
Press cuttings from the English newspapers on matters of artistic interest 1686-1835, 9 vols, London: National Art Library, Victoria & Albert Museum.

Vaisse 1976
Vaisse, Pierre, 'Charles Blanc und das "Musée des Copies" ', in: *ZfK,* 39, 1976, pp. 54-66.

Vaisse 1981
Vaisse, Pierre, 'Salons, Expositions et Sociétés d'artistes en France 1871-1914', in: Haskell 1981, pp. 141-155.

Vaisse 1995
Vaisse, Pierre, *La troisième république et les peintres,* Paris: Flammarion, 1995.

Valadier Catalogue 1985
Valadier. Segno e architettura. Exh. cat. Rome 1985/86, ed. by Elisa Debenedetti, Rome: Multigrafia Editrice, 1985.

van Doesburg 1925
van Doesburg, Theo, *Grundbegriffe der neuen gestaltenden Kunst* (Bauhausbücher 6), Munich: A. Langen, 1925; Reprint Mainz and Berlin: F. Kupferberg, 1966.

van Graevenitz
van Graevenitz, Antje, 'Warhols Tausch der Identitäten', in: Bätschmann/Groblewski 1993, pp. 69-91.

Vasari 1878-85 (1906)
Vasari, Giorgio, *Le vite de' più eccelenti pittori, scultori, ed archittetori,* ed. by Gaetano Milanesi, 9 vols, Florence: G.C. Sansoni, 1878-85; edn of 1906.

Vasco 1978
Vasco, Gerhard M., *Diderot and Goethe. A Study in Science and Humanism* (Bibliothèque de la revue de littérature comparée, no. 119), Genf: Slatkine, and Paris: Champion, 1978.

Vauvenargues 1747
Vauvenargues, Luc de Clapiers, Marquis de, *Introduction à la connoissance de l'esprit humain, suivie de Réflexions et de maximes,* 2nd edn, Paris: A.-C. Briasson, 1747; 1st edn 1746.

Venturi 1936
Venturi, Lionello, *Cézanne, son art - son oeuvre,* 2 vols, Paris: Paul Rosenberg, 1936.

Venturi 1964 (1969)
Venturi, Lionello, *Storia della critica d'arte,* Turin: Einaudi, 1964; French: *Histoire de la critique d'art,* Paris: Flammarion, 1969.

Ver Sacrum 1982
Ver Sacrum. Die Zeitschrift der Wiener Secession 1898-1903. Exh. cat. Vienna 1982/83, Vienna: Historisches Museum, 1982.

Verdi 1990
Verdi, Richard, *Cézanne and Poussin: the Classical Vision of Landscape.* Exh. cat. Edinburg 1990, London: Lund Humphries, 1990.

Verspohl 1984
Verspohl, Franz-Joachim, *Joseph Beuys: Das Kapital Raum 1970-1977. Strategien zur Reaktivierung der Sinne,* Frankfurt/M: Fischer, 1984.

Violent Muse 1994
The Violent Muse. Violence and the Artistic Imagination in Europe, 1910-1939, ed. by Jana Howlett and Rod Mengham, Manchester and New York: Manchester University Press, 1994.

Vollard 1938
Vollard, Ambroise, *En écoutant Cézanne, Degas, Renoir,* Paris: Grasset, 1938.

von Tschudi 1899
von Tschudi, Hugo, *Kunst und Publikum. Rede zur Feier des Allerhöchsten Geburtstages Seiner Majestät des Kaisers und Königs am 27. Januar 1899 in der öffentlichen Sitzung der Königlichen Akademie der Künste gehalten,* Berlin: E.S. Mittler & Sohn, 1899; in: von Tschudi 1912, pp. 56-75.

von Tschudi 1912
von Tschudi, Hugo, *Gesammelte Schriften zur neueren Kunst,* ed. by E. Schwedeler-Meyer, Munich: Bruckmann, 1912.

von Tschudi Catalogue 1996
Manet bis van Gogh. Hugo von Tschudi und der Kampf um die Moderne. Exh. cat. Berlin and Munich 1996/97.

Vostell 1993
Vostell. Leben=Kunst=Leben. Exh. cat. Gera

1993, Leipzig: E.A. Seemann, 1993.

Wackenroder 1797 (1991)
[Wilhelm Heinrich Wackenroder and Ludwig Tieck] *Herzensergiessungen eines kunstliebenden Klosterbruders,* Berlin: Johann Friedrich Unger, 1797 [recte 1796]; new edn in: Wackenroder 1991, vol. 1, pp. 51-145.

Wackenroder 1991
Wackenroder, Wilhelm Heinrich, *Sämtliche Werke und Briefe. Historisch-kritische Ausgabe,* ed. by Silvio Vietta and Richard Littlejohns, 2 vols, Heidelberg: C. Winter, 1991.

Wackenroder/Tieck 1799 (1991)
Tieck, Ludwig and Wackenroder, Wilhelm Heinrich, *Phantasien über die Kunst, für Freunde der Kunst,* Hamburg: Friedrich Perthes, 1991; new edn in: Wackenroder 1991, vol. 1, pp. 147-247.

Waetzoldt 1908
Waetzoldt, Wilhelm, *Die Kunst des Porträts,* Leipzig: F. Hirt, 1908.

Wagner 1895
Wagner, Otto, *Moderne Architektur. Seinen Schülern ein Führer auf diesem Fachgebiete,* Vienna: Schroll, 1895, other edns 1896, 1899 and 1902; 4th edn title: *Die Baukunst unserer Zeit. Dem Baukunstjünger ein Führer auf diesem Kunstgebiete,* Vienna: Schroll, 1914; Reprint: Vienna: Löcker, 1979.

Walter 1997
Walter, Bernadette, *Das Bild des Künstlers im Spiel- und Dokumentarfilm* (Lizentiatsarbeit, Universität Bern, 1997).

Walzel 1910
Walzel, Otto, *Das Prometheussymbol von Shaftesbury bis Goethe,* Berlin and Leipzig: Teubner, 1910; 2nd edn Munich: Hueber, 1932.

Ward 1991
Ward, Martha, 'Impressionist Installations and Private Exhibitions', in: *AB,* 73, 1991, pp. 599-622.

Warhol 1975
Warhol, Andy, *The Philosophy of Andy Warhol (From A to B and back again),* New York: Harcourt Brace Jovanovich, 1975.

Warhol 1989
Warhol, Andy, *The Andy Warhol Diaries,* New York: Warner Books, 1989.

Warhol Catalogue 1989
Andy Warhol: A Retrospective. Exh. cat. New York and Cologne, ed. by Kynaston McShine, New York: Moma, 1989, and Munich: Prestel, 1989.

Warhol Catalogue 1995
Andy Warhol. Paintings 1960-1986. Exh. cat. Luzern 1995, ed. by Martin Schwander, Stuttgart: G. Hatje, 1995.

Warhol/Hackett 1980
Warhol, Andy and Hackett, Pat, *POPism: The Warhol Sixties,* New York and London: Harcourt Brace Jovanovich, 1980.

Warnke 1985
Warnke, Martin, *Hofkünstler. Zur Vorgeschichte des modernen Künstlers,* Cologne: DuMont, 1985, 2nd edn 1996; French: *L'artiste et la cour: aux origines de l'artiste moderne,* Paris: Editions de la Maison des Sciences de l'Homme, 1990; Engl.: *The Court Artist: On the Ancestry of the Modern Artist,* trans. David McLintock, Cambridge and New York: Cambridge University Press, 1993.

Wasmer 1987
Wasmer, Marc-Joachim, *Museo Vela in Ligornetto TI* (Schweizerische Kunstführer), Bern: GSK, 1987.

Watson 1957
Watson, F.J.B., 'Canova and the English', in: *The Architectural Review,* 122, 731, 1957, pp. 403-406.

Watteau Catalogue 1984
Watteau 1684-1721. Exh. cat. Washington, DC, Paris and Berlin 1984/85, Paris: RMN, 1984.

Wechsler 1975
Wechsler, Judith (Ed.), *Cézanne in Perspective,* Englewood Cliffs, NJ: Prentice Hall, 1975.

Wedekind 1993
Wedekind, Gregor, *Der Künstler als Pictor doctus. Selbstthematisierung modernen Künstlertums bei Paul Klee,* Dissertation Berlin, 1993.

Weinglass 1982
Weinglass, David H., *The Collected English Letters of Henry Fuseli,* Millwood, London and Nendeln: Kraus International Publications, 1982.

Weinglass 1994
Weinglass, David H., *Prints and Engraved Illustrations By and After Henry Fuseli. A Catalogue Raisonné,* Hants: Scholar Press, 1994.

Weinshenker 1966
Weinshenker, Anne B., *Falconet: His Writings and his Friend Diderot,* Genf: Droz, 1966.

Werckmeister 1981
Werckmeister, Otto Karl, *Versuche über Paul Klee,* Frankfurt/M: Syndikat, 1981.

Werckmeister 1989
Werckmeister, Otto Karl, *The Making of Paul Klee's Career 1914-1920,* Chicago and London: University of Chicago Press, 1989.

West 1814
[Benjamin West] *Christ rejected. Catalogue of the Picture representing the above Subject; together with Sketches of other scriptural Subjects; painted by Benjamin West ... ,* London: C. Reynell, 1814.

West 1815

[Benjamin West] *Catalogue of Pictures representing Christ rejected, Christ Healing in the Temple, and a Design of Our Saviour's Crucifixion; with Sketches from other scriptural Subjects; painted by Benjamin West ...* , London: C. Reynell, 1815.

Westheim 1923
Westheim, Paul, *Für und Wider. Kritische Anmerkungen zur Kunst der Gegenwart,* Potsdam: G. Kiepenheuer, 1923.

Westheim 1925
Westheim, Paul (Ed.), *Künstlerbekenntnisse. Briefe, Tagebuchblätter, Betrachtungen heutiger Künstler,* Berlin: Propyläen-Verlag, o.J. [1925].

Westkunst 1981
Westkunst. Zeitgenössische Kunst seit 1939. Exh. cat. Cologne 1991, ed. by Laszlo Glozer. Cologne: DuMont, 1981.

When Attitudes Become Form 1969
When Attitudes Become Form. Works - Concepts - Processes - Situations - Information. Exh. cat. Bern 1969, Bern: Kunsthalle, 1969.

Whistler 1892
Whistler, James McNeill, *The Gentle Art of Making Enemies,* New Edition, London: W. Heinemann, 1892.

Whistler 1987
James McNeill Whistler. A Reexamination, ed. by Ruth E. Fine (Studies in the History of Art, vol. 19), Washington, D.C., National Gallery of Art, 1987.

Whistler Catalogue 1995
Whistler, 1834-1903. Exh. cat. London, Washington, DC and Paris 1994/95, ed. by Richard Dorment and Margaret MacDonald, Paris: RMN, 1995.

Whiteley 1975
Whiteley, J.J.L., 'Light and Shade in French Neo-Classicism', in: *BM,* 117, 1975, pp. 768-773.

Whiteley 1981
Whiteley, Jon, 'Exhibitions of Contemporary Painting in London and Paris 1760-1860', in: Haskell 1981, pp. 69-87.

Whitford 1992
The Bauhaus. Masters and Students by Themselves, London: Conran Octopus, 1992.

Whiting 1987
Whiting, Cécile, 'Andy Warhol, the Public Star and the Private Self', in: *Oxford Art Journal,* 10, 2, 1987, pp. 58-75.

Whitley 1915
Whitley, William T., *Thomas Gainsborough,* London: Smith, Elder & Co., 1915.

Whitley 1928
Whitley, William T., *Artists and their Friends in England 1700-1799,* 2 vols, London: The Medici Society, 1928.

Wiener Secession 1971
Die Wiener Secession. Eine Dokumentation von Robert Waissenberger, Vienna and Munich: Jugend und Volk, 1971.

Wildenstein 1973
Wildenstein, Guy and Daniel, *Louis David. Recueil de documents complémentaires au catalogue complet de l'oeuvre de l'artiste,* Paris: Fondation Wildenstein, 1973.

Winckelmann 1755
Winckelmann, Johann Joachim, *Gedancken über die Nachahmung der Griechischen Werke in der Mahlerey und Bildhauerkunst,* s.l. [Friedrichstadt: Ch. H. Hagenmüller], 1755.

Winckelmann 1759
Winckelmann, Johann Joachim, 'Beschreibung des Torso im Belvedere zu Rom', in: *Bibliothek der schönen Wissenschaften und der freyen Künste,* V, 1759, pp. 29-41.

Winckelmann 1764
Winckelmann, Johann Joachim, *Geschichte der Kunst des Althertums,* Dresden: Walther, 1764.

Winckelmann 1968
Winckelmann, Johann Joachim, *Kleine Schriften, Vorreden, Entwürfe,* ed. by Walther Rehm, Berlin: de Gruyter, 1968.

Wind 1938/39
Wind, Edgar, 'The revolution of history painting', in: *JWCI,* 2, 1938/39, pp. 116-127.

Wind 1947
Wind, Edgar, 'Penny, West & the Death of Wolfe', in: *JWCI,* 10, 1947, pp. 159-162.

Wingler 1975
Wingler, Hans M., *Das Bauhaus 1919-1933. Weimar, Dessau, Berlin und die Nachfolge in Chicago seit 1937,* Bramsche: Rasch & Co., 3rd edn 1975; Engl.: *The Bauhaus. Weimar, Dessau, Berlin, Chicago,* trans. W. Jabs and B. Gilbert, Cambridge, Mass. and London: MIT Press, 1969, 2nd edn 1981.

Winner 1992
Der Künstler über sich in seinem Werk (Internationales Symposium der Bibliotheca Hertziana Rom 1989), ed. by Matthias Winner, Weinheim: VCH Acta humaniora, 1992.

Wissmann 1970
Wissmann, Jürgen, *Robert Rauschenberg: Black Market* (Werkmonographien zur bildenden Kunst, no. 140), Stuttgart: Reclam, 1970.

Wittkower 1963
Wittkower, Rudolf and Margot, *Born under Saturn. The Character and Conduct of Artists. A Documented History from Antiquity to French Revolution,* New York: Random House, 1963.

Wittkower 1964
Wittkower, Rudolf and Margot (Ed.), *The Divine Michelangelo. The Florentine Academy's Homage on his Death in 1564,* London:

Phaidon, 1964.

Wortz 1976

Wortz, Melinda, 'The Nation: Los Angeles: Magic and Mysteries', in: *Art News*, 75, 5, 1976, pp. 83-84.

Wright of Derby Catalogue 1990

Wright of Derby. Exh. cat. New York 1990, ed. by Judy Egerton, New York: Metropolitan Museum, 1990.

Wrigley 1983

Wrigley, Richard, 'Censorship and Anonymity in Eighteenth-Century French Art Criticism', in: *Oxford Art Journal*, 6, 1983, pp. 17-26.

Wrigley 1993

Wrigley, Richard, *The Origins of French Art Criticism. From the Ancien Régime to the Restauration*, Oxford: Clarendon Press, 1993.

Würtenberger 1961

Würtenberger, Franzsepp, 'Das Maleratelier als Kultraum im 19. Jahrhundert', in: *Miscellanea Bibliothecae Hertziana*, Festschrift für Leo Bruhns (Römische Forschungen der Bibliotheca Hertziana, vol. 16), 1961, pp. 502-513.

Wyss 1985

Wyss, Beat, *Trauer der Vollendung. Von der Ästhetik des Deutschen Idealismus zur Kulturkritik an der Moderne,* Munich: Matthes & Seitz, 1985.

Wyss 1994

Beat Wyss, 'Ein Druckfehler', in: *Erwin Panofsky. Beiträge des Symposions Hamburg 1992,* ed. by Bruno Reudenbach, Berlin: Akademie-Verlag, 1994, pp. 191-199.

Wyss 1995

Wyss, Beat, 'Habsburgs Panorama. Zur Ikonologie und "Psychoanalyse" der Wiener Museumsbauten', in: *Jahrbuch der Kunsthistorischen Sammlungen in Wien*, 91, 1995, pp. 125-139.

Wyss 1996 (1)

Wyss, Beat, *Der Wille zur Kunst. Zur ästhetischen Mentalität der Moderne,* Cologne: DuMont, 1996.

Wyss 1996 (2)

Wyss, Beat, 'Ikonographie des Unsichtbaren', in: Ästhetische Erfahrung 1996, pp. 360-380.

Yeldham 1984

Yeldham, Charlotte, *Women Artists in Nineteenth-Century France and England. Their Art Education, Exhibition Opportunities and Membership of Exhibiting Societies and Academies,* 2 vols, New York and London: Garland, 1984.

Yorke 1804

Yorke, Henry Readhead, Esq., *Letters from France in 1802,* 2 vols, London: H.D. Symonds, 1804.

Zaunschirm 1983

Zaunschirm, Thomas, *Bereites Mädchen. Readymade,* Klagenfurt: Ritter, 1983.

Zeichen der Freiheit 1991

Zeichen der Freiheit. Das Bild der Republik in der Kunst des 16. bis 20. Jahrhunderts. Catalogue of the 21th European Art Exhibition Bern 1991, ed. by Dario Gamboni and Georg Germann, Bern: Stämpfli, 1991.

Zeitgeist 1982

Zeitgeist. Exh. cat. Berlin 1982, ed. by Christos M. Joachimides and Norman Rosenthal, Berlin: Frölich und Kaufmann, 1982.

Zeller 1955

Zeller, Hans, *Winckelmanns Beschreibung des Apollo von Belvedere,* Zürich: Atlantis, 1955.

Ziff 1977

Ziff, Norman D., *Paul Delaroche. A Study in Nineteenth-Century French History Painting* (Outstanding Dissertations in the Fine Arts), New York and London: Garland, 1977.

Zimmermann 1993

Zimmermann, Olaf, 'Erfolgsrezepte des Kunsthandels', in: *Kritische Berichte,* 21, 1993, pp. 74-80.

Zilsel 1926 (1972)

Zilsel, Edgar, *Die Entstehung des Geniebegriffs. Ein Beitrag zur Ideengeschichte der Antike und des Frühkapitalismus,* Tübingen: Mohr, 1926; Reprint with a Preface by Heinz Maus, Hildesheim and New York: Olms, 1972.

Zola 1867

Zola, Émile, 'Une nouvelle manière en peinture. Edouard Manet', in: *Revue du XIXe siècle,* January 1, 1867; new edn in: Emile Zola, *Salons,* ed. by F.W.J. Hemmings and R.J. Niess, Genf: Droz and Paris: Minard, 1959, pp. 83-103; German: Emile Zola, *Schriften zur Kunst. Die Salons von 1866 bis 1896,* trans. U. Aumüller, Frankfurt/M: Athenaeum, 1988, pp. 47-75.

Zola 1869

Zola, Émile, 'Coups d'épingle', in: *La Tribune,* no. 35, 4th of February 1869.

Zola 1886 (1966)

Zola, Émile, *L'Oeuvre,* Paris 1886; in: Zola, Les Rougon-Macquart, 5 vols, Paris: Bibliothèque de la Pléiade, 1966, vol. 4, pp. 9-363.

Zola 1959

Zola, Émile, *Salons,* ed. by F.W.J. Hemmings and R.J. Niess, Paris: Minard, and Genf: Droz, 1959; German: *Schriften zur Kunst. Die Salons von 1866 bis 1896,* Frankfurt/M: Athenäum, 1988.

Zola 1989

Zola, Emile, *Pour Manet,* ed. by J.-P. Leduc-Adine, Paris: Editions Complexe, 1989.

Zuschlag 1995
 Zuschlag, Christoph, *"Entartete Kunst": Aus-
 stellungsstrategien im Nazi-Deutschland,* Worms:
 Wernersche Verlagsgesellschaft, 1995.
Zweite 1987

Zweite, Armin, 'Evidenz und Selbsterfahrung.
Zu einigen raumbezogenen Skulpturen von
Richard Serra', in: Ernst-Gerhard Güse (Ed.),
Richard Serra, Stuttgart: Gerd Hatje, 1987, pp.
8-27.

LIST OF ILLUSTRATIONS

1804, London, British Museum, Department of Prints.

19. James Gillray, *The Monster broke loose or a peep into the Shakespeare Gallery,* 1791, etching, hand-coloured, 34 x 23.2 cm, London, British Museum, Department of Prints.

20. Benjamin West, *King Lear in the Storm,* etching and engraving by William Sharpe, large folio, in: J. Boydell, *A Collection of Prints,* London 1803, vol. 2, Washington, D.C., National Gallery, Library.

21. Henry Fuseli, *The Witches appear to Macbeth and Banquo,* engraving, etching and aquatint by J. Caldwall, large folio, in: J. Boydell, *A Collection of Prints,* London 1803, vol. 2, Washington, D.C., National Gallery of Art, Library.

22. John Henry Fuseli, T*he Vision of the Place of the Wretched* (Milton, *Paradise Lost,* XI, 477-490), 1791-93, pencil with wash, heightened in white, 56.5 x 66 cm, Zurich, Kunsthaus, Graphische Sammlung.

23. *The Roman Gallery* in William Bullock's *Egyptian Hall* on Piccadilly, in: W. Bullock, *Descriptive Synopsis of the Roman Gallery,* London 1816, p. 18.

24. Jacques-Louis David, *The Sabine Women,* 1799, oil on canvas, 385 x 522 cm, Paris, Louvre.

25. Guillaume-Guillon Lethière, *The Judgement of Brutus upon His Sons* [Salon of 1812], line etching by Pinelli, 14.3 x 24 cm, in: W. Bullock, *Descriptive Synopsis of the Roman Gallery,* London 1816.

26. Jean-Baptiste-Joseph Wicar, *The Raising of the Young Man of Naim,* 1816, c. 500 x 900 cm, Lille, Musée des Beaux-Arts.

27. Jean-Baptiste-Joseph Wicar, *Self-Portrait in Spanish Costume,* c.1815/16, oil on canvas, 99 x 75.3 cm, Lille, Musée des Beaux-Arts.

28. Théodore Géricault, *The Raft of the Medusa,* Salon of 1819, 491 x 716 cm, Paris, Louvre.

29. Théodore Géricault, *Cavalry Officer of the Imperial Guard Charging,* Salon of 1812, 349 x 266 cm, Paris, Louvre.

30. Jacques-Louis David, *Leonidas at Thermopylae,* 1814 (395 x 531 cm, Paris, Louvre), line etching by E. Bourgeois in: David Catalogue, Paris 1814.

31. William Bullock, *Description of a Grand Picture,* 1828, Brochure on the exhibition by Guillaume-Guillon Lethière, *The Death of Virginia,* title page with folded sheet.

32. François Boucher, *Painting, mocked by Envy, Stupidity and Drunkenness,* etching, frontispiece to: Abbé Leblanc, *Lettre sur l'exposition* [Paris ?] 1747, and to Du Bos, *Réflexions,* Paris 1755, Berne, Institut für Kunstgeschichte.

33. Anon., *The Artist and his Public,* c. 1800, Paris, Bibliothèque Nationale, Cabinet des estampes.

34. Louis Lagrenée the Elder, *L'amour des arts console la Peinture des écrits ridicules et envenimés de ses ennemis,* Salon of 1781, 21,5 x 27 cm, Paris, Louvre.

35. Thomas Rowlandson, *The Historian animating the Mind of a young Painter,* 1784, etching, 18.8 x 27,2 cm, London, British Museum.

36. Jean-Guillaume Moitte, *Project for a Monument in Honour of the French People on the Pont Neuf in Paris,* 1794, pen and ink with wash, 56.5 x 48 cm, Paris, Bibliothèque Nationale, Cabinet des estampes.

37. John Henry Fuseli, *Prometheus,* c. 1770-71, pen and ink with wash, 15 x 22.6 cm, Basel, Öffentliche Kunstsammlung, Kupferstichkabinett.

38. Joseph Anton Koch, *The Artist as Hercules at the Crossroads,* 1791, pen and ink with watercolour, 18.7 x 22.6 cm, formerly Stuttgart, Staatsgalerie, Graphische Sammlung.

39. Asmus Jakob Carstens, *Self-Portrait,* c. 1784, pastel, 32.8 x 20,6 cm, Hamburg, Kunsthalle.

40. Asmus Jakob Carstens, *The Battle between the Gods and the Titans,* 1795, pen and ink with wash and watercolour, 32.2 x 22.5 cm, Basel, Öffentliche Kunstsammlung, Kupferstichkabinett.

41. Joseph Anton Koch, *Caricature of Lord Bristol as Patron in Rome,* c. 1800/1810, pen and ink, 26.6 x 39.7 cm, Munich, Staatliche Graphische Sammlung.

42. *Facade of the Palais des Beaux-Arts at the 1855 World Exhibition in Paris,* woodcut in: *L'Illustration,* 1855, p. 269.

43. Nicolas-André Monsiau, *The Death of Raphael,* in: C.P. Landon, *Annales du Musée et de l'École moderne des Beaux-Arts,* Paris, 1805, vol. 10, title series 49.

44. Jean-Auguste-Dominique Ingres, *Leonardo dying in the Arms of François Ier,* 1818, pencil, pen and ink with wash, 38 x 48 cm, Paris, Louvre, Département des Arts Graphiques.

45. Robert Fleury, *The Emperor Charles V Picking Titian's Brush up from the Floor,* Salon of 1843, woodcut in: *Le Magasin Pittoresque,* 1843, p. 165.

46. Paul Delaroche, *The Artists' Assembly,* decoration for the amphitheatre in the École Nationale Supérieur de Paris, 1841, detail: right panel showing the painters Fra Angelico, Leonardo, Dürer, Raphael, Michelangelo, Poussin and others, wood engraving in Charles Blanc, *Histoire des peintres,* École française, vol. 3, Paris, undated.

47. *West's Picture Gallery,* 1821, line etching by J. Le Keux after G. Cattermole drawing, 11 x 17.4 cm, London: J. Warren, 1821, London, British Museum, Department of Prints and Drawings.

48. Antonio Canova, *Self-Portrait,* 1812, marble, 70 x 50 x 45 cm, Possagno, Tempio, engraving in: *Cicognara* 1823-25, title series 64.

49. Giuseppe Valadier, *Memorial Service for Antonio Canova,* 1823, pen and ink with watercolour, 43.5 x 30 cm, Rome, Biblioteca dell'Istituto di Archeologia e Storia dell'Arte, coll. Lanciani, Rome, XI.100, vol. 2, no. 63.

50. The great hall in the sculpture gallery in Passagno with Canova's plaster casts.

51. Karl Friedrich Schinkel, *Design for the Decoration of the Raphael Celebrations at the Akademie der Künste,* 1820, pencil with watercolour, 20 x 28.7 cm, Berlin, SMPK, Kupferstichkabinett.

52. Eduard von Heuss, *Bertel Thorvaldsen in his studio in Rome,* 1834, oil on canvas, 191 x 152 cm, Mainz, Landesmuseum.

53. Anon., *Cartoon showing Thorvaldsen's Arrival in Copenhagen,* 1838, pencil, Copenhagen, Royal Library.

54. G. Emil Libert, *Thorvaldsen lying in State,* 1844, pencil, pen and ink with wash, 12.5 x 15.5 cm, Copenhagen, Thorvaldsen Museum.

55. C.O. Zeuthen, *The Court in the Thorvaldsen Museum showing the Artist's Tomb,* c. 1878, colour lithograph, Copenhagen, Thorvaldsen-Museum.

56. *The Museum of Vincenzo Vela in Ligornetto,* 1883, wood engraving after A. Bonamore, in: *Ausstellungs-Zeitung der Schweizerischen Landesausstellung 1883,* nos. 19 & 20, pp. 186/187.

57. *Rosa Bonheur's Studio,* in: *L'Illustration. Journal universel,* 19, 1852, p. 284, wood engraving.

58. and 59. *An Artist's Studio in the 19th Century,* pastiche after Horace Vernet, wood engraving by H. Valentin, in: *Le Magasin pittoresque,* 1849, pp. 380-381.

60. *Le Monde illustré,* 8, 1864, title page of the issue of 25 June, illustrating the visit paid by the Empress Eugénie to Rosa Bonheur's studio, wood engraving after A. Deroy.

61. Ary Scheffer, *The Death of Géricault,* 1824, oil on canvas, 36 x 46 cm, Paris, Louvre.

62. Paul Cézanne, *Frenhofer showing his Masterpiece,* 1867/72, pencil, pen and ink, 10.3 x 17 cm, Basel, Öffentliche Kunstsammlung, Kupferstichkabinett.

63. Eugène Delacroix, *The Jesuit Church in G.,* 1831, pen and ink with watercolour, heightened in white, 26 x 10.7 cm, Bremen, Kunsthalle.

64. Ferdinand von Rayski, *The Artist's Suicide in his Studio,* graphite, 21.3 x 29.2 cm, Dresden, Staatliche Kunstsammlungen, Kupferstich-Kabinett.

65. Benjamin Robert Haydon, *The Raising of Lazarus,* 1823, wood engraving by J. and G.P. Nicholls, in: *The Art Journal,* no. 2, 1856, p. 181.

66. Edouard Manet, *The Suicide,* 1881, oil on canvas, 38 x 46 cm, Zurich, Stiftung Sammlung E.G. Bührle.

67. Eugène Delacroix, *Christ after the Deposition by Rubens,* 1839, pen and ink, 32.2 x 21.1 cm, Rotterdam, Museum Boymans-van Beuningen, Inv. F II 84.

68. Eugène Delacroix, *Peace,* design for the ceiling painting in the Hôtel de Ville, Paris, c. 1850/52, oil on canvas, diameter 78 cm, Paris, Musée Carnavalet.

69. Paul Cézanne, *The Apotheosis of Delacroix,* c. 1894, oil on canvas, 27 x 35 cm, Paris, Musée d'Orsay.

70. Paul Cézanne in his Paris studio before the sketch of *The Apotheosis of Delacroix,* photograph of 1894, in: Paul Cézanne, *Correspondance,* Paris: Grasset, 1937.

71. Henri Fantin-Latour, *Homage to Delacroix,* 1864, oil on canvas, 160 x 250 cm, Paris, Musée d'Orsay.

72. Maurice Denis, *Homage to Cézanne,* 1900, oil on canvas, 180 x 240 cm, Paris, Museé d'Orsay.

73. Adolph Menzel, *Posthumous Fame,* in: *Kuenstlers Erdenwallen (The Artist's Life on Earth),* sheet 6, lithograph, Berlin: L. Sachse, 1834.

74. Anselm Feuerbach, *Self-Portrait,* 1851/52, oil on canvas, 42 x 33 cm, Karlsruhe, Staatliche Kunsthalle.

75. Hans von Marées, *Self-Portrait with Franz Lenbach,* 1863, oil on canvas, 54.3 x 62 cm, Munich, Bayerische Staatsgemäldesammlungen, Neue Pinakothek.

76. Arnold Böcklin, *Self-Portrait with Death*

playing the Fiddle, 1872, in: *Königliche Museen zu Berlin. Die Werke Arnold Böcklins in der Nationalgalerie.* 6 photogravures with commentary by Hugo von Tschudi, Munich: Photographische Union, 1901, title series 1.

77. Lovis Corinth, *Death and the Artist,* 1922, in: Lovis Corinth, *Selbstbiographie (Autobiography),* Leipzig: S. Hirzel, 1926, p. 146.

78. Edvard Munch, *Self-Portrait with Cigarette,* 1985, oil on canvas, 110.5 x 83.5 cm, Oslo, Nasjonalgalleriet.

79. Edvard Munch, *Self-Portrait under the Head of Medusa,* 1891/92, oil on cardboard, 69 x 43.5 cm, Oslo, Munch Museum.

80. Paul Klee, *The Artist Thinking,* 1919, 71, oil on paper, 26.1 x 17.9 cm, Berne, private collection.

81. Honoré Daumier, *Classical Art-Lovers, increasingly convinced that art is lost in France,* 1852, lithograph (D. 2295), in: *Charivari,* 7 May 1852.

82. Quillenbois, *The Realistic Painting of Mr. Courbet,* in: *L'Illustration,* 21.7.1855, p. 52.

83. Gustave Courbet, *The Painter's Studio, a true allegory on the seven years of my artistic career,* 1855, 361 x 598 cm, Paris, Musée d'Orsay.

84. Gustave Courbet, *The Wounded Man,* 1844, reworked 1854, oil on canvas, 81 x 97 cm, Paris, Musée d'Orsay.

85. Gustave Courbet, *Fighting Stags, Rutting in Spring,* 1861, oil on canvas, 355 x 507 cm, Paris, Musée d'Orsay.

86. Gustave Courbet, *Returning from the Conference,* 1863, oil on canvas, 73 x 92 cm, Basel, Öffentliche Kunstsammlung, Kunstmuseum.

87. Grandville, *Dangerous Pictures,* 1844, wood engraving, in: Grandville, *Un autre monde,* Paris: Fournier, 1844.

88. Edouard Manet, *Jesus mocked by the Soldiers,* 1865, oil on canvs, 191.5 x 148.3 cm, Chicago, Art Institute.

89. Edouard Manet, *Olympia,* 1863, oil on canvas, 130.5 x 190 cm, Paris, Musée d'Orsay.

90. Honoré Daumier, *The Idiots! ... You paint a religious picture for them and they laugh ... they are not even religious about art,* caricature of the Salon of 1865, in: *Le Charivari,* 1 Juni 1865.

91. Antoine Watteau, *Pierrot (Gilles),* etching by E. Hedouin, in: *Gazette des Beaux-Arts,* 3, 1860, beside p. 261.

92. Edouard Manet, *The Death of Maximilian,* 1868, lithograph, 33.2 x 43.1 cm, second print [1884], Mannheim, Kunsthalle.

93. Henri Fantin-Latour, *Un atelier aux Batignolles,* 1870, oil on canvas, 204 x 273.5 cm, Paris, Musée d'Orsay.

94. Bertall, *Jesus painting with his Disciples,* or *the Divine School of Manet,* religious painting by Fantin-Latour, in: *Le Journal amusant,* 21 May 1870.

95. Frédéric Bazille, *Bazille's Studio,* 1870, oil on canvas, 98 x 128,5, Paris, Musée d'Orsay.

96. Claude Monet, *The Turkeys* (part of the decoration of the Grand Salon in the Château de Rottembourg), 1877, 175 x 172 cm, Paris, Musée d'Orsay, R.F. 1944-18.

97. James McNeill Whistler, *The Gallery of the Society of British Artists,* 1886-87, pen and ink over pencil, 20 x 15.8 cm, Oxford, Ashmolean Museum.

98. Georges Seurat, *Circus,* 1890-91, oil on canvas, 55.5 x 46.5 cm, Paris, Musée d'Orsay.

99. Paul Gauguin, *Self-Portrait with a Portrait of Émile Bernard "Les misérables",* 1888, oil on canvas, 45 x 55 cm, Amsterdam, Rijksmuseum Vincent van Gogh.

100. Émile Bernard, *Self-Portrait with Paul Gauguin,* 1888, oil on canvas, 46.5 x 55.5 cm, Amsterdam, Rijksmuseum Vincent van Gogh, L. 133.

101. Vincent van Gogh, *Self-Portrait for Paul Gauguin,* 1888, oil on canvas, 62 x 52 cm, F. 476, Cambridge Mass., Fogg Art Museum.

102. Paul Gauguin, *Letter to Van Gogh with the watercolour sketch after 'Le Christ au jardin des oliviers',* 1889, Amsterdam, Rijksmuseum Vincent van Gogh.

103. Paul Sérusier, *Portrait of Paul-Elie Ranson in Nabis Costume,* 1890, oil on canvas, 60 x 45 cm, PB.

104. Félix Vallotton, *The Five Painters,* 1902-1903, oil on canvas, 145 x 187 cm, Winterthur, Kunstmuseum.

105. Mme Léon Bertaux *(Héléna Hébert), Un jeune Gaulois prisonnier,* plastercast, Nantes, Musée des Beaux-Arts.

106. Marie Bashkirtseff, *The Women's Class at the Académie Julian,* 1881, oil on canvas, 145 x 185 cm, Dnepropetrovsk, Museum of Art.

107. Joseph Maria Olbrich, *Study for the Secession Building,* 1897, watercolour, 19.6 x 12.4 cm, Vienna, Historisches Museum.

108. Gustav Klimt, *Poster for the First Art Exhibition by the Association of Austrian Fine Artists - Secession* (first version), 1898, lithograph, Vienna, Museum der Stadt.

327

Child, and Oskar Schlemmer's *Group of Fifteen.*

140. Atomic mushroom and "nuclear painting" by Wols, double page in *Magnum,* 24 June 1959, pp. 8/9.

141. Jean Tinguely, *Hommage à New York,* 1960, self-destruction of an installation on 17 March 1960, Photo: David Gahr, New York.

142. Yves Klein, *Dimanche - Le journal d'un seul jour,* Paris, 27 November 1960, title page of a four-page newsheet, 55,7 x 38 cm, Paris, Centre Georges Pompidou, Yves Klein Archive.

143. Yves Klein, *Ex voto to Saint Rita in Cascia,* front, 1961, 1, plexiglass, blue and pink pigments, gold, paper, c. 22 x 15 x 4 cm, Cascia (Umbria), Augustinian convent

144. Shopping bag with the portrait of Giuliana Benetton by Andy Warhol, 1989, offset print, Berne, PB.

145. Andy Warhol, *Invisible Sculpture,* 1985, mixed media, photograph.

146. Joseph Beuys, *La Rivoluzione siamo Noi,* 1972, screen print on foil, 191 x 102 cm, Heidelberg, Edition Staeck.

147. Joseph Beuys' School for Visitors at Documenta 6, 1977, Kassel, Documenta Archiv.

148. Joseph Beuys, *The Capital Room 1970-1977,* 1980, detail, Schaffhausen, Hallen für neue Kunst.

149. Joseph Beuys, *Kunst=Kapital,* poster, 1980, Dusseldorf: Galerie Hans Meyer.

150. Bruce Nauman, *The True Artist Helps the World by Revealing Mystic Truths,* 1967, Neon tubes and glass, 149.9 x 139.7 x 5.1 cm, Basel, Öffentliche Kunstsammlung, Museum für Gegenwartskunst.

151. The Top Hundred. by List of today's leading artists, 1996, in: *Capital,* November 1996, p. 275.

152. Richard Serra, *Delineator,* 1974-75, two steel plates, each 2.5 x 305 x 792 cm, installed in Venice, California, Ace Gallery, February 1976, Collection of the Gallery and Richard Serra.

153. Rebecca Horn, *The Chinese Bride,* 1976, black laquered wood, metal structure, engine, tape recorder playing Chinese women's voices, 248 x 238 cm, private collection.

154. Bruce Nauman, *Dream Passage,* 1983, wood panels, 2 steel tables, 2 steel chairs, tubular lights, corridor, 1200 x 106.5 cm, height of central space 286.5 x 246 cm, other height variable, Schaffhausen, Hallen für neue Kunst.

155. Bruce Nauman, *Dream Passage,* outside view.

156. Robert Rauschenberg, *Black Market,* 1961, oil, paper, wood, metal, rope, four paper clips and case with rubber stamps and various objects, 152 x 127 cm, Cologne, Museum Ludwig.

157. Vito Acconci, *The People Machine,* 1979, audio-installation in New York, Sonnabend Gallery.

158. Ilya Kabakov, *Community Kitchen,* 1991, drawing of the installation, Fondation Dina Vierny, Musée Maillol, Paris.

SOURCES OF ILLUSTRATIONS

Amsterdam, Rijksmuseum Vincent van Gogh 99, 100; Stedelijk Museum 102. - Basel, Öffentliche Kunstsammlung (Photo Martin Bühler) Cover, 37, 40, 62, 86, 150. - Berlin, SMPK, Kupferstichkabinett (Photo Jörg P. Anders) 51. - Berne, Author's archive 6, 8, 23, 25, 31, 32, 42, 43, 45, 46, 48, 50, 56, 57, 58, 59, 60, 65, 70, 76, 77, 82, 87, 91, 94, 103, 106, 109, 111, 112, 115, 119, 125, 127, 128, 130, 132, 133, 134, 135, 137, 140, 144, 148, 151, 154, 155; Kunstmuseum 80. - Boston, Museum of Fine Arts 118. - Bremen, Kunsthalle 63. - Chicago, Art Institute 88. - Cambridge, Harvard University Art Museums/ Harvard University 101. - Cologne, Galerie Michael Werner Frontispiece; Museum Ludwig 156. - Dresden, Staatliche Kunstsammlungen, Kupferstich-Kabinett (Photo Schurz) 64. - Dusseldorf, Kunstsammlung Nordrhein-Westfalen (Photo Walter Klein) 123; Galerie Hans Meyer 149. - Eindhoven, Van Abbe-Museum 126. - Hamburg, Kunsthalle (Photo Elke Walford) 39. - Heidelberg, Edition Staeck 146. - Karlsruhe, Staatliche Kunsthalle 74. - Kassel, (Photo Carl-Heinz Eberth) 138; Dokumenta Archiv 139, 147. - Copenhagen, Royal Library 53; Thorvaldsen Museum (Photo Kit Weiss) 54, 55. - Leipzig, Museum der bildenden Künste 110. - Lille, Musée des Beaux-Arts 26, 27. - London, British Museum 3, 9, 13, 14, 15, 16, 18, 19, 35, 47; Paul Mellon Centre 10; Royal Society of Art 11. - Mainz, Landesmuseum 52. -

Mannheim, Kunsthalle 92. - Munich, Staatliche Graphische Sammlung 41; Bayerische Staatsgemäldesammlungen, Neue Pinakothek 75, 114; Städtische Galerie im Lenbachhaus 124. - Nantes, Musée des Beaux-Arts 105. - New York, Museum of Modern Art 117; Sonnabend Gallery 157; David Gahr 141. - Oslo, Munch Museum 79; Nasjonalgalleriet (Photo J. Lathion) 78. - Oxford, Ashmolean Museum 97. - Paris, Bibliothèque nationale, Cabinet des estampes 1, 2, 33, 36, 81, 90; Photographie Giraudon 89; Service photographique de la RMN 4, 5, 7, 24, 28, 29, 30, 34, 44, 61, 69, 71, 72, 83, 84, 85, 93, 95, 96, 98; Photothèque des Musées de la Ville de Paris 68; Centre Georges Pompidou/Photothèque 142; Musée Maillol 158. - Rom, Biblioteca dell' Istituto di Archeologia e Storia dell'Arte, coll. Lanciani 49. - Rotterdam, Museum Boymans-van Beuningen 67; Ed van der Elsken, Nederlandsfotoarchief 131. - Saint Louis, Art Museum (Curt Valentin) 122. - San Francisco, Museum of Modern Art 136. - Santa Monica, C.A., The Getty Center for the History of Art and the Humanities 73. - Stanford C.A., University Museum 17. - Stuttgart, Staatsgalerie, Graphische Sammlung 12, 38, 121. - Venice, Archivio Storico della Biennale di Venezia 113. - Washington, D.C., National Gallery of Art 20, 21, 116, 120. - Vienna, Historisches Museum 107; Museum der Stadt 108. - Zurich, Kunsthaus, Graphische Sammlung 22; Stiftung Sammlung E.G. Bührle 66.

INDEX

(Italicized numbers refer to pages with illustrations)